Rembrandt's Women

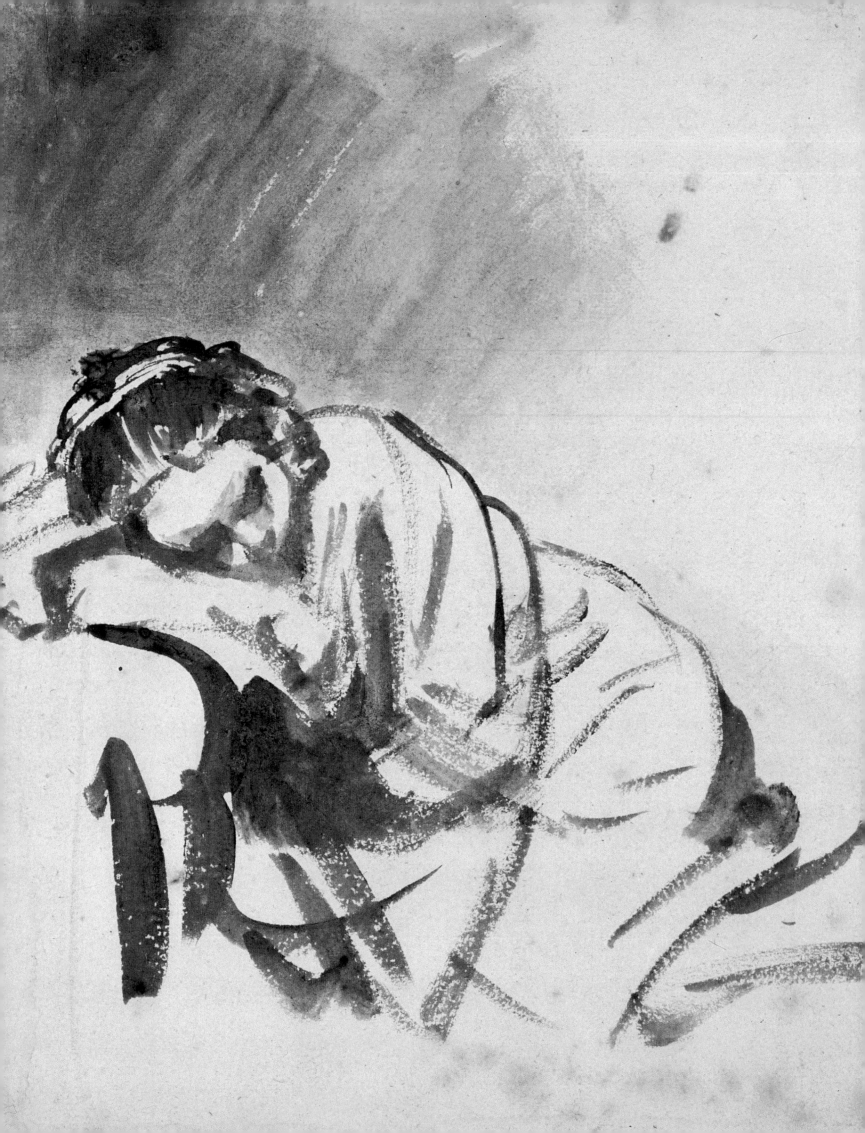

Julia Lloyd Williams

With contributions from
S. A. C. Dudok Van Heel, E. De Jong,
Volker Manuth, Eric Jan Sluijter
and Marieke De Winkel

Rembrandt's Women

National Gallery of Scotland

in collaboration with the
Royal Academy of Arts, London
2001

Published by the Trustees of the National
Galleries of Scotland on the occasion of the
exhibition *Rembrandt's Women* held at the
National Gallery of Scotland, Edinburgh from
8 June to 2 September 2001 and at the Royal
Academy of Arts, London from 22 September
to 16 December 2001.

© Trustees of the National Galleries of Scotland,
Edinburgh 2001

ISBN 1 903278 18 X *paperback*
ISBN 1 903278 21 X *hardback*

Designed by Dalrymple
Typeset in Enschedé Renard by Brian Young
Printed by BAS Printers, Over Wallop

Front cover illustration: Rembrandt
Hendrickje Stoffels (?), *c*.1654–9 (detail)
National Gallery, London (cat.125)

Back cover illustration: Rembrandt
Three Women's Heads, *c*.1637 (detail)
British Museum, London (cat.63)

Frontispiece: Rembrandt
*A Young Woman Sleeping
(Hendrickje Stoffels?)*, *c*.1654 (detail)
British Museum, London (cat.118)

Lenders to the Exhibition

Her Majesty Queen Elizabeth II
painting cat.5

Amsterdam, Rijksmuseum
paintings cat.25, 85 *on loan from Foundation Van Weede*
drawings cat.9, 76, 77, 101, 116, 132
etchings cat.3, 4, 7, 16, 37, 47, 82, 83, 93, 95, 98, 107, 108, 109, 112, 114, 115, 131

Berlin, Gemäldegalerie, Staatliche Museen, Preussischer Kulturbesitz
paintings cat.120, 126

Berlin, Kupferstichkabinett, Staatliche Museen, Preussischer Kulturbesitz
drawings cat.39, 52, 110

Budapest, Szépmüvészeti Múzeum
drawing cat.55

Cambridge, Fitzwilliam Museum
etchings cat.28, 102, 128, 129, 130, 133, 134

Cambridge, Fogg Art Museum, Harvard University Art Museums
drawing cat.96

Chicago, Art Institute of Chicago
drawing cat.135

Dresden, Gemäldegalerie Alte Meister, Staatliche Kunstsammlungen
painting cat.21

Dresden, Kupferstichkabinett, Staatliche Kunstsammlungen
drawings cat.6, 67

Drumlanrig Castle, Dumfriesshire, Collection of the Duke of Buccleuch and Queensberry KT
painting cat.121

Edinburgh, National Gallery of Scotland
painting cat.100

Epinal, Musée départmental d'art ancien et contemporain
painting cat.137A

Glasgow, Hunterian Art Gallery, University of Glasgow
etching cat.111

Groningen, Groninger Museum
drawing cat.41

Haarlem, Teylers Museum
drawing cat.81

The Hague, Royal Cabinet of paintings, Mauritshuis
painting cat.69

Hamburg, Kupferstichkabinett, Hamburger Kunsthalle
drawing cat.24

Leiden, Prentenkabinet van de Universiteit Leiden
drawing cat.72

London, British Museum:
drawings cat.8, 10, 44, 56, 57, 78, 80, 84, 118, 124
etchings cat.1, 2, 11, 12, 13, 15, 32, 33, 35, 40, 62, 63, 64, 65, 73, 74, 75, 90, 92, 94, 97, 113, 136

London, Courtauld Institute Gallery
drawings cat.14, 45, 48, 68, 89, 91, 103

London, Trustees of Dulwich Picture Gallery
painting cat.104

London, National Gallery
paintings cat.36, 125, 137

Los Angeles, J. Paul Getty Museum
drawing cat.71

Los Angeles, Armand Hammer Collection, UCLA Hammer Museum
painting cat.140

Maastricht, Noortman Gallery
painting cat.18

Madrid, Museo del Prado
painting cat.31

Munich, Alte Pinakothek, Bayerische Staatsgemäldesammlungen
painting cat.26A

Munich, Staatliche Graphische Sammlung
drawing cat.43

New York, Metropolitan Museum of Art
paintings cat.26, 119, 127
drawings cat.38, 138, 139

New York, Pierpont Morgan Library
drawings cat.53, 66, 79

Ottawa, National Gallery of Canada
painting cat.20

Oxford, Visitors of the Ashmolean Museum
drawings cat.42, 117

Paris, Musée du Louvre
drawings cat.23, 49, 50, 59

Paris, Collection Frits Lugt, Institut Néerlandais
drawings cat.29, 54, 58, 60, 88

Paris, Petit Palais, Musée des Beaux Arts de la ville de Paris
drawing cat.46

Penrhyn Castle, Gwynedd
painting cat.122

Rotterdam, Boijmans Van Beuningen Museum
drawings cat.61, 70, 86

St Petersburg, State Hermitage Museum
paintings cat.27, 99

Stockholm, Nationalmuseum
painting cat.19
drawings cat.34, 87, 105, 106, 123

Vienna, Albertina, Graphische Sammlung
drawings cat.22, 30, 51

Vienna, Gemäldegalerie der Akademie der Bildenden Künste
painting cat.17

Washington, National Gallery of Art
painting cat.141

Preface

Rembrandt's portrayals of women have become some of the most famous images in the history of Western art, prompting emotive reactions amongst his strongest critics and enthusiastic admirers alike. This exhibition is the first to examine how he chose to paint, draw and etch women in his work. The exhibits range from grand history pieces and commissioned portraits to scribbled informal sketches, encompassing drawings of daily life, erotic prints and Biblical scenes, young girls, mothers with toddlers, rich heiresses and wizened old women, studies of the female nude, pictures of goddesses and historical heroines. In displaying them in roughly chronological order, *Rembrandt's Women* shows how Rembrandt's artistic approach changed over the years, how the women themselves altered as his style developed and how he revisited certain themes again and again throughout his life.

The exhibition has been devised by Julia Lloyd Williams, Senior Curator at the National Gallery of Scotland, and we extend our gratitude to her for bringing this project to a successful conclusion.

She has been assisted by a most distinguished Committee of Honour, the members of which have offered invaluable advice throughout.

Rembrandt's Women represents the third collaboration in recent years between the National Galleries of Scotland and the Royal Academy, the others being *Alberto Giacometti 1901–1966* in 1996 and *The Scottish Colourists 1900–1930* in 2000. We hope there will be many more such joint enterprises, especially once the Royal Scottish Academy building in Edinburgh has been successfully restored as part of the Playfair Project (the first phase of which is due for completion in 2003).

Rembrandt's Women is only made possible through the generosity of many lenders, both individual and institutional, in Europe and the United States and we offer our heartfelt thanks to them for their understanding in parting temporarily with the treasures in their care.

Finally, ambitious loan exhibitions are increasingly impossible without generous subvention, and for the London showing we gratefully acknowledge the magnificent sponsorship of Reed Elsevier.

TIMOTHY CLIFFORD
Director-General, National Galleries of Scotland

MICHAEL CLARKE
Director, National Gallery of Scotland

PHILLIP KING CBE
President, Royal Academy of Arts

NORMAN ROSENTHAL
Exhibitions Secretary, Royal Academy of Arts

Committee of Honour

DR CHRISTOPHER BROWN
Director of the Ashmolean Museum, Oxford

MARTIN ROYALTON-KISCH
Assistant Keeper, Department of Prints and Drawings, British Museum

DR PETER SCHATBORN
Former Keeper of the Rijksprentenkabinet, the Rijksmuseum, Amsterdam

PROFESSOR DR ERNST VAN DE WETERING
Head of the Rembrandt Research Project

SIR CHRISTOPHER WHITE CVO FBA
Former Director of the Ashmolean Museum, Oxford

Sponsor's Preface

REED ELSEVIER

Reed Elsevier has a long tradition of supporting the arts and is proud to have been associated with the Royal Academy since 1988. We are particularly pleased to be the sponsors of *Rembrandt's Women* which promises to be one of the highlights of the art world this year.

The works in this exhibition have been carefully chosen to show not only the artist's depiction of women as the heroines of his masterpieces but also how his technique evolved over the years. Among Baroque painters, Rembrandt's mastery of light and shade, his use of colour and his brushwork set him apart from his peer group.

We at Reed Elsevier are committed to supporting excellence in the arts; this echoes our long-term dedication to the highest standards of publishing. The provision of high quality information to the scientific, legal, education and business communities and our enthusiasm to embrace new technology have established us as one of the world's leading global publishers.

We hope that you enjoy this wonderful exhibition and that this catalogue will serve as a permanent reminder of Rembrandt's genius.

CRISPIN DAVIS
Chief Executive Officer, Reed Elsevier plc

Acknowledgements

My first debt of thanks is to those who kindly agreed to belong to the Committee of Honour for this exhibition, all leading Rembrandt scholars: Christopher Brown, Martin Royalton-Kisch, Peter Schatborn, Ernst van de Wetering and Sir Christopher White. All have been unfailingly generous with advice and encouragement for the project. They have put up with my various questions with great patience, as have the essay contributors: S.A.C. Dudok van Heel, Eddy de Jongh, Volker Manuth, Eric Jan Sluijter and Marieke de Winkel, who have produced extremely informative and thought-provoking essays on different aspects of the subject of Rembrandt's women. While I have benefited hugely from the expertise of all of the above, any mistakes are, sadly, all my own. I should also like to thank Erik Hinterding for his kindness in sharing some of his research into etchings with me.

This exhibition would be impossible without the co-operation of the lenders. The National Gallery of Scotland and the Royal Academy of Arts are both enormously grateful to them for allowing us to borrow their works by Rembrandt van Rijn, especially in the knowledge that these are so frequently requested, and so much missed when they are gone. Many others have also been of great assistance in connection with various aspects of the exhibition. We should especially like to thank the following: Her Majesty Queen Elizabeth II; His Grace the Duke of Buccleuch and Queensberry KT; Robert Anderson, Reinholt Baumsterk, Stephanie Belt, Charlotte Benedik, Mària Berge-Gerbaud, Holm Bevers, Maria Bisanz-Prakken, Peter Black, Szilvia Boduóv, Jaap Bolten, Christopher Brown, Virginia Budny, Cynthia M. Burlingham, Quentin Buvelot, Mungo Campbell, Görel Cavalli-Björkman, Gilles Chazal, Fernando Checa, James Cuno, Chris P.E. Dercon, Amy Dove, Douglas Druick, Alexander Dukkers, Charles Dumas, Frederik J. Duparc, E. Ebbinge, Lucy Eldridge, Everett Fahy, Tilman Falk, Jan Piet Filedt-Kok, A. Fisher, Carmen Garrido, Anat Gilboa, Jeroen Giltaij, Geraldine Glynn, George Goldner, Olle Granath, Deborah Gribbon, Antony Griffiths, William Griswold, Torsten Gunnarsson, Craig Hartley, Lee Hendrix, Poul ter Hofstede, Hanna Hohl, Wolfgang Holler, Sarah Hyde, David Jaffé, Guido Jansen, Catherine Johnston, Fouad Kanaan, Laurence B. Kantor, Jan Kelch, Thomas Ketelsen, Fritz Koreny, Annegret Laabs, Alastair Laing, Ronald van Leeuw, Walter Liedtke, Susan Lockhart, José de Los Llanos, Christopher Lloyd, Catherine Loisel, Reyn van der Lugt, Ger Luiten, Suzanne Folds McCullagh, Neil MacGregor, Manuela Mena Marqués, Catherine Martin, Harald Marx, Marjolein Menalda, Norbert Middelkoop, Philippe de Montebello, Miklós Mojzer, John Murdoch, Ute Neidhardt, Robert Noortman, Michael Pantazzi, Allegra Pesenti, Ann Philibin, Charles E. Pierce Jr, Mikhail Piotrovsky, Peter van de Ploeg, Michael Plomp, Marie-Louise van der Pol, Earl A. Powell III, Catherine Puetz, Konrad Renger, Duncan Robinson, William Robinson, Petra Roettig, André Roth, Martin Royalton-Kisch, Axel Rüger, Jef Schaeps, Marijn Schapelhouman, Peter Schatborn, Uwe M. Schneede, Peter Schoon, Peter Klaus Schuster, David Scrase, Manfred Sellink, Desmond Shawe-Taylor, Suzanne L. Shenton, Stephen Somerville, Irina Sokolova, Sàra Kulisàr Szabó, Pierre Théberge, Margarete Titz, Renate Trnek, Carel van Tuyll van Serooskerken, Kees van Twist, Shirley Veer, Alejandro Vergara, Françoise Viatte, Thea Vilnau-Wilberg, Marianne de Voogd, John Walsh, Cindy van Weele, Arthur K. Wheelock Jr and James N. Wood. We also gratefully acknowledge the Dutch Ambassador to the Court of St James, His Excellency Willem O. Bentinck van Schoonheten, for his support.

Many have worked enormously hard on the production of this catalogue. Excellent translations of four of the contributor's essays have been produced: S.A.C. Dudok van Heel and Eddy de Jongh's work by Michael Hoyle, Eric Jan Sluijter's by Diane Webb and Volker Manuth's by Jonathan Bikker. This publication, designed by Robert Dalrymple with his customary flair, and painstakingly typeset by Brian Young, has been brought to press by the head of Publications at the National Gallery of Scotland, Janis Adams, with the assistance of Christine Thompson and Helen Nicoll. I am most grateful to Duncan Thomson for his meticulous editorial work and to Michael Clarke and Janis Adams for reading through the text and for their suggestions.

There are many other colleagues at the National Galleries of Scotland who have helped in the long preparation for this exhibition. I should like to thank Brian Ivory, Chairman of the Trustees, and Timothy Clifford for their support and Michael Clarke for his enthusiasm for the project. Suzanne Trevethan has dealt with the large correspondence generated by such an exhibition, and valuable assistance has also been given by Sheila Scott. I also wish to thank my colleagues Anne Buddle and Agnes Valencak-Kruger, our Handling Team and Conservation Department for overseeing the intricate practicalities of the transport and care of the exhibits. Indeed, the exhibition has seen the hard work of almost every department in the National Galleries of Scotland. I also gratefully acknowledge the help of three interns at the National Gallery of Scotland, Anna Tummers, Alice Klaassen and Caroline Rhodius, who have all been involved with the show at different stages and in different ways. At the Royal Academy of Arts, I should also like to thank Isabel Carlisle, David Gordon, Norman Rosenthal and Susan Thompson for their enthusiastic reaction to the proposal for this exhibition and their subsequent collaboration.

Finally, my heartfelt thanks go to my family and friends for their forbearance, as well as gratitude to my late father, Kenneth Lloyd Williams, who (admittedly partisan) would have liked to have seen this show.

JULIA LLOYD WILLIAMS

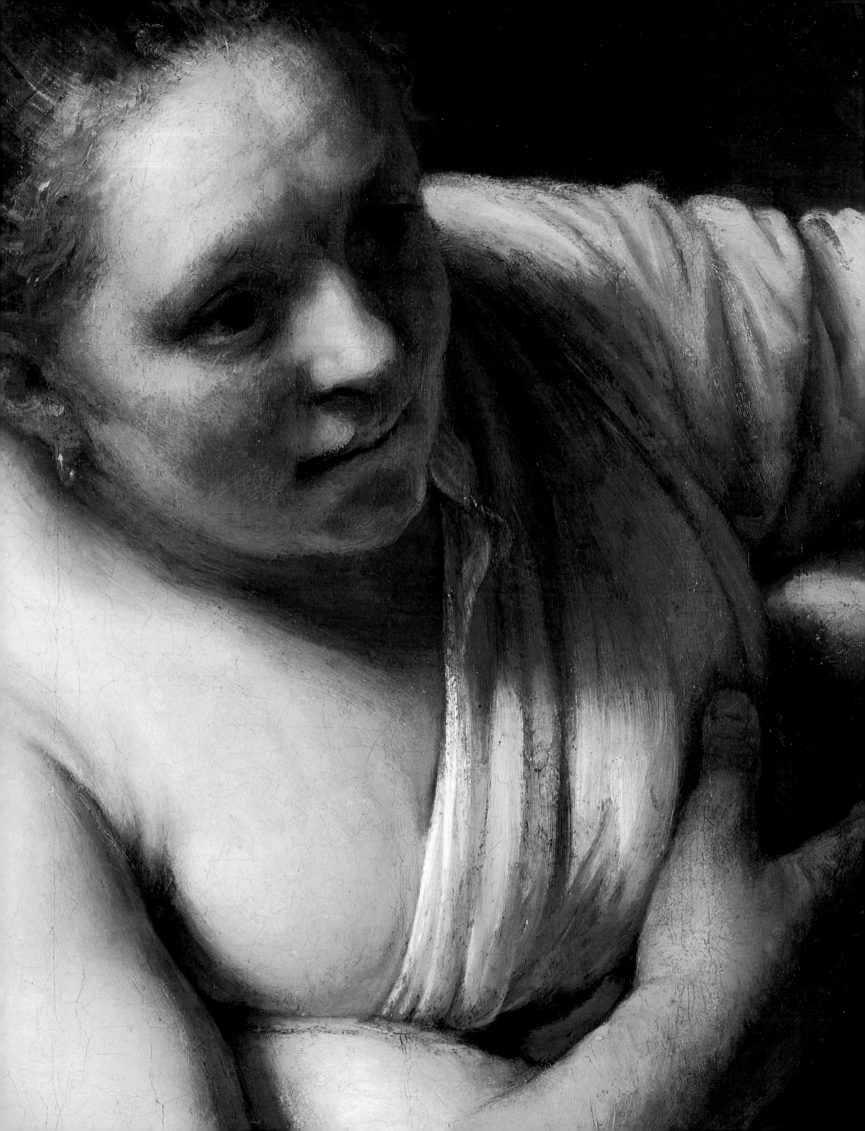

An introduction to *Rembrandt's Women*

JULIA LLOYD WILLIAMS

The inspiration for *Rembrandt's Women* was provided by Rembrandt's painting of *A Woman in Bed*, now in the National Gallery of Scotland. Though never doubted as a work of the master, the model and the subject of the painting have been much debated.[1] In 1892, one of the leading Rembrandt specialists of that era, the German art historian Wilhelm von Bode (1845–1929), discussed the painting, noting,

> At a glance one can see that this is not the mere head of a model, as she lies in bed, raising herself to put aside the curtain as if she heard a well-known footstep. It is clearly a woman in whom Rembrandt had a personal interest.[2]

The melding of private life and public paintings has always held a fascination in the case of Rembrandt's work and Bode was not the first to assume that the perceived emotional link between artist and female sitter must indicate a psychological or physical relationship between the two, born either of blood or bed. Indeed, virtually every picture of an unknown woman by Rembrandt was once thought to represent his mother, sister, lover or wife – an understandable reflection of the deep-felt insight recognised in these works. Even the Buccleuch painting of *An Old Woman Reading* has been called Rembrandt's grandmother in its time; a triumph of hopeful identification over fact, as the work was painted some years after the death of his mother, let alone his grandmother (cat.121). It was, of course, not only the paintings of women which were thus named. There were a number of pictures which were entitled 'Rembrandt's Father', and 'Rembrandt's Brother', but the depictions of women in Rembrandt's work have provoked a reaction that the nineteenth-century desire to find personal links to his own life has done little to dispel.[3]

Bode's observation was taken further and imbued with extra sentiment, by another reviewer, writing in *The Scotsman* newspaper on 5 August 1929:

> ...go and look at [The Woman in Bed]. Do not be in a hurry; wander round the Gallery and then come back to her again. If you try to find the secret of her painting she will not tell you... Look at the exquisite painting of the embroidery on the pillow and note the delicious quality of the paint. Go round the Gallery once more, and come back to her once more. Take your time. Are you not beginning to feel that you know that gentle peasant woman, and read something of the tragedy of her life, one of the few friends, faithful and loving to the end, of the great painter, discredited, bankrupt, sinking into obscurity after a short period of fame and flattery? As you get to know her better, do you not begin to find something universal in her, as universal as Hamlet – the tragedy and beauty of all the human story?[4]

A Woman in Bed, due to confusion about its date, is the only painting in the artist's oeuvre which has been associated with all of the three women with whom Rembrandt was romantically involved. But what do we actually know about the women in Rembrandt's life? S.A.C. Dudok van Heel's essay in this catalogue, *Rembrandt: his life, his wife, the nursemaid and the servant*, plots the story of these facts, integrated into the larger picture of Rembrandt's life and work, but it is perhaps useful to summarise here the key figures whom we know were connected with the artist, and who have been thought to appear in many of the works in this exhibition.

BLOOD RELATIONS

The first woman whom Rembrandt (1606–1669) is thought to have portrayed is his mother, Neeltgen Willemsdr (c.1568–1640), who later went by the more genteel name of Cornelia Willemsdr van Zoutbroeck (see cat.1–5). Though we do not have any properly authenticated portrait of her, the wrinkled old lady who features in a number of early works by the artist is believed to be Neeltgen, this identification being tangentially corroborated by a description of an etching of the same figure as 'Rembrandt's mother' in an inventory of the Amsterdam print dealer Clement de Jonghe (1624/5–1677).[5] Rembrandt also had two sisters, Machtelt and Lysbeth (Elisabeth), but though some unidentified paintings of young women from the early 1630s were later given the latter's name (such as cat.19), we have no idea what either of them looked like.[6]

SASKIA

This is not the case with Saskia van Uylenburgh who married Rembrandt on 22 June 1634, presumably a match arranged through her first cousin, the art dealer Hendrick Uylenburgh, in whose Amsterdam house Rembrandt had lived since c.1631. We have Rembrandt's exquisite silverpoint portrait of her made the previous year (fig.1), on which he wrote 'this is the likeness of my wife Saskia aged 21 years old, made the third day after our betrothal, 8 June 1633' ('*Dit is naer mijn huisvrouw geconterfeit do sij 21 jaer oud was den derden dach als wij getroudt waeren den 8 junijus 1633*').[7] Apart from a drawing made of Saskia's sister Titia (cat.87), it is the only certain representation of a female member of Rembrandt's family, and the standard by which all the other perceived likenesses of Saskia are judged.[8] Saskia was born in 1612 and died in 1642. Her will made Rembrandt sole guardian for their only surviving son, Titus, born just seven months before her death (see cat.92 and 93). Their three other children had all died in early infancy (see cat.48, 61, 77 and 87). Her husband had full possession of her property and any benefits from it until a possible remarriage or his death, a stipulation that would have had a severe effect upon Rembrandt's finances had he contravened it, and presumably contributed to his decision not to marry again.

GEERTJE

Sometime about the date of Saskia's death, or a little time before when she became seriously ill, Geertje Dircks (Dircx), the widow of a ship's trumpeter from Ransdorp near Edam, came to look after the baby Titus, and act as housekeeper. Geertje, born between about 1600 and 1610, was about the same age as Saskia. No firmly identifiable portrait of her is known to exist, although two drawings of a woman in North Holland regional dress have been supposed to represent her, on the basis of an inscription on the reverse of one of the sheets, stating that this was the 'wet-nurse of Titus son of Rembrandt' (see cat.80 and 81). However, Geertje could not have been a wet-nurse as she was childless, so the annotation is open to some doubt. Another document of 28 March 1647 may suggest that Rembrandt did paint her since a picture by the artist is there described as '*minnemoer van Rembrant*'.[9] However, this can be translated either as '*Rembrandt's children's nurse*' or as '*Cupid's mother by Rembrandt*', so the interpretation is again equivocal. Geertje became ill in 1648 and made Titus her heir. However, the following year Rembrandt and Geertje quarrelled and she lodged a claim that Rembrandt had slept with her and was in breach of promise to marry her. Though this was unproven, he was ordered to pay her a sum to discharge her debts and an annual pension in compensation. Furthermore, it appears that when she was then imprisoned in the House of Correction in Gouda, Rembrandt connived at trying to prolong her detention.[10]

HENDRICKJE

The first known mention of the servant girl Hendrickje Stoffels (1626–1663) is in connection with the legal proceedings brought against Rembrandt by Geertje. Hendrickje, an unmarried twenty-three-year-old working in Rembrandt's household, gave a deposition on 1 October 1649 in favour of her employer against Geertje's accusations. Given Hendrickje's later role as Rembrandt's mistress, it is difficult to know how impartial her evidence can have been. In July 1654, she appeared before the church council where she was found guilty of living in 'whoredom' with Rembrandt, a fact difficult to refute since she was then some months pregnant with their illegitimate daughter, Cornelia, who was born in October. The lack of a wedding did not appear to have been a serious problem outside the Church, however, for a deposition made on 20 October 1660 describes her as the painter's '*huysvrouw*' or wife, implying that she was accepted as such without stigma.[11] Following Rembrandt's declaration of insolvency in 1656, Hendrickje and Titus set up an art dealing business in 1660 as protection from creditors, which Titus continued after Hendrickje's death, probably from plague, in 1663. There is no documented portrait of Hendrickje either, but the presence of a dark-haired, dark-eyed woman who figures in many of Rembrandt's paintings from the mid-1650s has been thought to represent her (see cat.119, and 125–7).

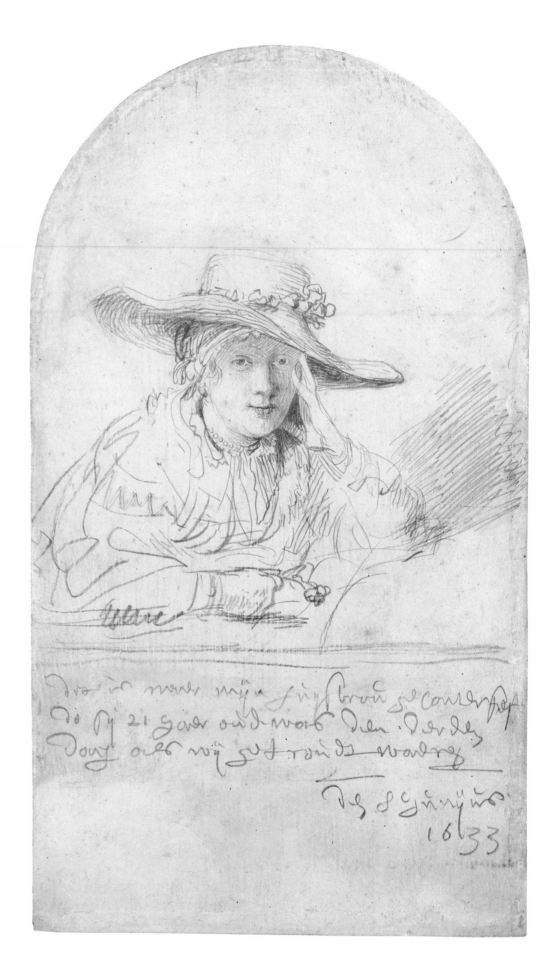

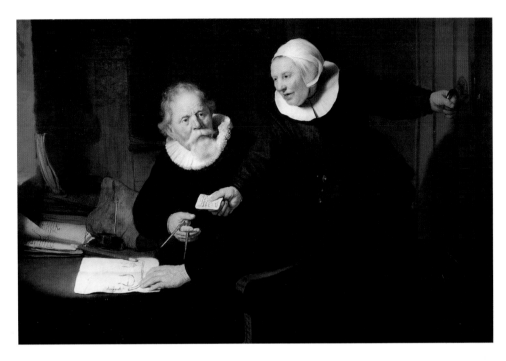

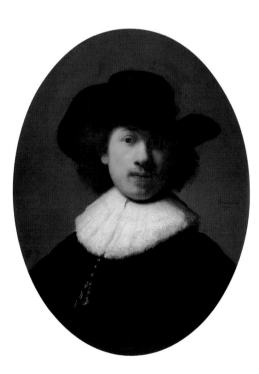

Fig.1 *opposite* | Rembrandt, *Portrait of Saskia van Uylenburgh*, 1633
Kupferstichkabinett, Staatliche Museen zu Berlin, Preussischer Kulturbesitz

Fig.2 *above* | Rembrandt, *The Shipbuilder Jan Rijcksen and his Wife, Griet Jans*, 1633
Her Majesty Queen Elizabeth II

Fig.3 | Rembrandt, *Self-portrait*, 1632
Glasgow Museums and Art Galleries: Burrell Collection

PORTRAITURE

The obvious question that occurs in relation to the women in Rembrandt's life is to what extent can we say that they actually appear in his work? The first observation is that there are remarkably few works which can be seen as straightforward portraits. Initially this seems strange. After all, when Rembrandt left Leiden as a young, ambitious artist in about 1631, it was to work in Hendrick Uylenburgh's studio predominantly as a portrait painter, with commissions obtained through the dealer's network of clients in the large city of Amsterdam. The *Portrait of a Young Woman* (cat.17) and the *Portrait of a Lady aged Sixty-two* (possibly Saskia's older cousin Aeltje, cat.18) show that he was perfectly able to fulfil the rigours expected of formal portraiture, as does the grand depiction of *A Young Woman, probably Maria Trip* a few years later (cat.85). And it was, after all, as a portraitist that he first appeared at the court of the House of Orange at The Hague, presumably on the recommendation of Prince Frederik Hendrik's secretary Constantijn Huyghens, to paint the likeness of Amalia van Solms in 1632 (see cat.19, fig.86).

On the other hand, there is no evidence that Rembrandt was particularly renowned for his portraits of women. One patron, Diego D'Andrada, even brought a case against the artist in 1654, stating that a portrait showed 'no resemblance at all to the image of the young girl' as commissioned.[12] Rembrandt, cavalierly confident, declared that he would retouch it as asked only if the Guild of St Luke could see no likeness on the picture's completion. Horst Gerson commented rather sweepingly on Rembrandt's portraits of women: 'The results are charming indeed, but from the first, [they] lack the animation and spontaneity

of his men.'[13] This must primarily be explained by the expectations of the clients and the traditional limitations placed on what was considered seemly in formal portraits of the female sex.[14] In Rembrandt's commissioned pendant portraits, it has been observed that the quality of painting of the men is often superior.[15] There is a slight indication that the artist was occasionally prone to making more alterations to details in the women's portraits than those of their husbands (see, for example, cat.137),[16] but it is not known if this implies that these particular compositions had a more complicated genesis than those of the males because of some indecision on the artist's part,[17] or whether the patrons themselves wished for changes to be made. The majority of portraits of women were, of course, designed as pendants to those of their husbands and there were few exceptions to this rule (see cat.85 and 122). Rembrandt did not paint noticeably more commissioned portraits of women than his contemporaries did, and a rough head count sets the proportion of his total ouput at about one-third women to two-thirds men. He made no commissioned etchings of women as far as we know, but this is not unduly surprising given the domestic sphere most women occupied within Dutch seventeenth-century society (discussed in detail in E. de Jongh's essay, *The model woman and women of flesh and blood*).

Rembrandt only seems to have painted three commissioned double portraits.[18] One (now lost) depicted Abraham van Wilmerdonx and Anna van Beaumont of *c*.1640,[19] another showed the *Shipbuilder Jan Rijcksen and his Wife, Griet Jans* of 1633 (fig.2),[20] and the third, the Mennonite preacher *Cornelis Claesz Anslo and his Wife Aeltje Gerritsdr Schouten* of 1641 (fig.69).[21] In the surviving two works, the portraits revolve around the men in their professional capacity, with the wife of Jan Rijcksen as helpmeet, delivering a business message to her husband's office, whilst the patient, pious Aeltje listens as the preacher delivers his sermon. Both are far from the formal severity of the pendants of *Jacob Trip* and *Margaretha de Geer* (cat.137), and, as Simon Schama has commented, 'Instead of representing the *institution* of marriage, Rembrandt has painted the lived reality of it.'[22]

The closest Rembrandt got to depicting his own marriage was in a little etching of 1636, *Self-portrait with Saskia* (cat.40). There the artist is shown drawing while Saskia looks on, their life together enmeshed with his profession, just as with the portraits of Rijcksen and Anslo with their wives. Perhaps it should not surprise us that, unlike them, Rembrandt did not show himself and Saskia in contemporary clothes. In all of Rembrandt's many self-portraits, he can only once be said to have depicted himself in the aspirational costume of a contemporary burgher of Amsterdam (fig.3).[23] In the same way, apart from the little silverpoint drawing he made of Saskia in 1633, there does not

seem to be a single painting of her which shows her in clothing which was not either imaginary or which harked back to another age (a topic discussed in Marieke de Winkel's essay, *Fashion or fancy? Some interpretations of the dress of Rembrandt's women re-evaluated*). We do not know what the now lost 'two portraits of the artful painter Rembrandt with his wife' (*twee efigien van den constrijcken schilder Rembrandt met sijn vrouw*), recorded in a 1648 inventory, looked like, nor yet the appearance of another 'likeness of Rembrandt van Rijn and his wife' (*een contrefeytsel van Rembrandt van Rijn en sijn huysvrouw*), listed in a 1677 inventory of Titus's former guardian Louys Crayers.[24] However, on the evidence of the paintings which have survived, there is no reason to suppose that they would have been formal portraits of the pair in contemporary dress.[25] The latter picture was formerly thought to be *The Prodigal Son in the Tavern*, now in Dresden (see cat.39, fig.104).[26] But it is impossible to see this as an identifiable portrait of Rembrandt and his well-born wife Saskia given his professional and social aspirations in the mid-1630s – what wife (moreover, one with a Calvinist preacher for a relative) would have allowed herself to be recognisably painted as a prostitute, on the knee of her drunken husband for all the world to see?

'*TRONIES*' AND IMAGINATION

Looking at the paintings which Rembrandt made of women, with the exception of commissioned portraits, it is possible to recognise certain facial types which recur in his work. Pinning down who looks like whom is clearly a subjective venture, particularly in the case of Hendrickje and Geertje, of whom we have no documented portraits. In 1937, Herbert Read, then editor of *The Burlington Magazine*, declared of the Edinburgh *Woman in Bed*:

> *I still think … that you go too far in saying the portrait bears no resemblance to Saskia. As far as resemblances go, she might just as well be Rembrandt's sister. It is all a question of the relative value of evidence, and I doubt whether modern scholars are any more reliable than Tronchin (but this is not meant to be personal!).*[27]

This *caveat* accepted, it seems that the most likely scenario is that, while some of the faces appear to resemble those believed to be his wife Saskia or the dark-eyed woman we think Hendrickje must have been, Rembrandt developed a form of 'generalised' female face for many of his paintings. This became part of his artistic repertoire, to be employed when the composition demanded. Nor did it remain static but was adapted during the course of his life, as the pictures in this exhibition show.

In the early stages of his career when Rembrandt was in Leiden, he made a number of paintings of heads and bust-length figures, both male and female, which were called '*tronies*', meaning, literally, 'face', but which signified a study of a figure, rather than a portrait (for example, see cat.5).[28] These could certainly be based on a specific model, but the purpose was to explore lighting effects, fanciful costume, different poses and expressions, which demonstrated the artist's skill and imagination rather than focusing upon the depiction of the precise features of a particular sitter. The sixteenth-century clothing used in, for example, *Bust of a Young Woman Smiling* (cat.21) belongs to this tradition, even if the figure is modelled on Saskia. What is intriguing is that Rembrandt was already painting a reddish-blonde with a similar profile in 1632 (cat.19), before he may have even met his wife. We cannot know whether Saskia's features happened to fit his preconceived image of the female face for his *tronies*, Biblical and history paintings at that period. In any case, it seems doubtful if Rembrandt would have needed another model beyond Saskia and liberal amounts of imagination to concoct the features of his Floras (cat.27 and 36), *Bellona* (cat.26), the Virgin in his *Holy Family* (cat.26A) or the *Bust of a Young Woman* (cat.25). The similarity is there, too, in the *Artemesia* (cat.31) and in the etching of '*The Jewish Bride*' (cat.35), as creative variations on a facial theme. But though roughly based upon the features of his own wife, the 'Saskia-like' woman in these works must also have been suggested by the taste of the time and the perception of the ideals of Baroque art in the 1630s, partially (but by no means exclusively) based on Rubensian prototypes.

Following Saskia's death in 1642, the echoes of her face disappear from the artist's work, and his paintings of the mid- to late-1640s show a variety of women, from the dark-haired Susanna in *Susanna and the Elders* in Berlin (cat.110, fig.140) and Mary in the Hermitage *Holy Family* (cat.99), to the young girl in the Dulwich *Girl at a Window* (cat.104) or, indeed, the Edinburgh *Woman in Bed* (cat.100). No one figure type dominates and it is only in the 1650s that a new facial 'theme' re-occurs: the woman whom we assume to have been Hendrickje. There is a similarity between the features that are captured in, for example, three paintings in this exhibition, two entitled *Hendrickje Stoffels*, in London and New York (cat.125 and 127), and *A Woman at an Open Door* (cat.126), as well as in drawings also thought to represent her (cat.118–19 and 123–4). In these, one becomes of aware of a range of artistic variations on a facial theme, but none, like many of the works resembling Saskia mentioned above, can be regarded in the straight-forward realm of portraiture. Rembrandt's ability, demonstrated earlier, to adapt the specific into the general is again employed, and the woman who is seen in the New York *Flora* (cat.119) and even the Louvre's *Bathsheba* (fig.48), may be seen as probable variations on a type, distancing the contemporary viewer from direct – and potentially embarrassing – identification. These were, after all, paintings for sale.

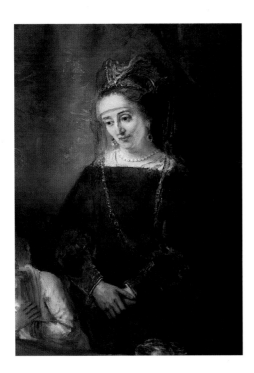

Fig.4 | Rembrandt, *Jacob Blessing the Sons of Joseph*, 1656
(detail of Asenath)
Gemäldegalerie Alte Meister, Staatliche Museen, Kassel

Fig.5 *below left* | Rembrandt, *Family Portrait*, *c*.1666
Herzog Anton-Ulrich Museum, Braunschweig

Fig.6 *below right* | Rembrandt, *'The Jewish Bride':
Isaac and Rebecca*, *c*.1662
Rijksmuseum, Amsterdam

DID SHE OR DIDN'T SHE?

Nobody suggests that Saskia modelled nude for Rembrandt's *Diana at her Bath* (cat.11), *Susanna and the Elders* (cat.69) or the *Danaë* (fig.46). The artist, observant as always, could, of course, have brought the knowledge of his wife's body to his art, but it is highly unlikely that she, a respectable married woman, would have taken her clothes off for him to paint, either in Hendrick Uylenburgh's house or afterwards in a studio full of pupils. As Volker Manuth discusses in his essay, *'As stark naked as one could possibly be painted': the reputation of the nude female model in the age of Rembrandt*, social position was compromised by such immodest behaviour. But with Hendrickje it is not quite so clear cut. The daughter of a sergeant, her two brothers both served in the army company of Ploos van Amstel, and her older sister married a soldier.[29] This may not seem particularly significant nowadays, but the female figures in the guardroom scenes of the artist Jacob Duck (*c*.1600–1667) have been referred to as: 'liminally positioned on the perimeters of society itself'[30] and the women who formed part of the groups of camp followers connected with the military during this period were generally considered to be of easy virtue.[31]

But whether this means that Hendrickje would have actually modelled in the nude for a picture such as the Paris *Bathsheba* is a moot point. Many believe she did. Gary Schwartz has suggested that it was modelling for the *Bathsheba* of 1654 that contributed to Hendrickje being called before the church council that year, but in fact her pregnancy would have provided quite sufficient evidence of lax morals for the church at the time.[32] *Rembrandt's Studio with a Model* (cat.117), of about the same date, has also been thought to show Hendrickje, but the existence of another study of the same scene by one of Rembrandt's pupils makes one wonder whether the artist, let alone Hendrickje, would have allowed others to have sketched her

stripped naked to the waist. But *A Woman Bathing* in the National Gallery, London (fig.143),[33] is harder to judge under such criteria. Though scantily clad, she is not naked, and the small scale of the work and the informality and sensuality of the pose, in conjunction with the extremely broad manner of the brushstrokes, give the picture a sense of impulsive, direct appeal and intimacy that is hard to gainsay. And, yet, the work must have been considered finished for it is signed, and it was presumably offered for sale and not kept as a private painting, unlike Rubens's intimate portrayal of his half-naked second wife, *Het Pelsken*[34] (although Rubens, admittedly, was not dogged by Rembrandt's financial constraints and could afford to keep it). However, Hendrickje clearly did inspire Rembrandt, but, as with Saskia, the muse seems to have taken on an artistic life of her own for the painter: Asenath in *Jacob Blessing the Sons of Joseph* (fig.4), *Juno* (cat.140), *Lucretia* (cat.141 and fig.165), the woman in the Braunschweig *Family Portrait* (fig.5),[35] and Rebecca in *'The Jewish Bride'* (fig.6)[36] – not one of these is Hendrickje but each bears traces of her and attests to her importance in Rembrandt's mind's eye.

BEAUTY

The subjects which seems to have prompted most criticism of Rembrandt's portrayal of women has been their perceived beauty, or lack of it, particularly in relation to his nudes (a theme discussed in detail in Eric Jan Sluiter's essay *'Horrible nature, incomparable art': Rembrandt and the depiction of the female nude*). In 1681, after his death, Rembrandt was criticised for flouting the accepted classical tradition of portraying women by Andries Pels, the Dutch poet, who complained that Rembrandt deliberately chose to represent ugly, flabby, vulgar peasant women rather than the physical refinement of a 'Greek Venus' who would have been more

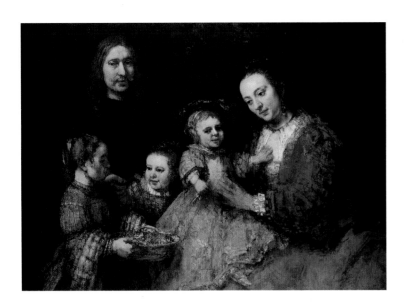

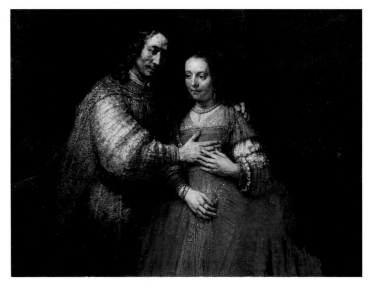

appropriate to the genre.[37] His distaste was later echoed by Benjamin Robert Haydon (1786–1846) who peevishly remarked that Rembrandt's 'notions of the delicate forms of women would have frightened an arctic bear'.[38] At first glance this might be seen to tally with Constantijn Huyghens's reproach that Rembrandt chose not to travel to Italy (where Huyghens presumed he might have learnt better aesthetic manners).[39] The irony is that Rembrandt was no stranger to Italian art, although mainly through the medium of prints, as his own collection demonstrated.[40] However, it is also interesting that Rembrandt owned a Rubens which he bought in 1637 from Jan Jansz Uyl and sold in *c.*1644 to Lodewyck van Ludick, entitled *Hero and Leander* (fig.7)[41] and he knew about Dürer's female nudes as demonstrated by his own etching of *Adam and Eve* (cat.73). In addition he owned the German artist's *Book of Proportions* that showed broad-hipped women with bulging thighs as part of the canon of the ideal human form.[42] But it is clear that what Kenneth Clark regarded as Rembrandt's Northern approach to the nude[43] was certainly not made without knowledge of classical prototypes and Italian old masters. The details of sagging flesh or wrinkles Rembrandt depicted were not made in ignorance but by choice. Perhaps it is this very imperfection which forces the viewer into a direct encounter with a human subject, rather than an impossible ideal, that continues to captivate our attention and imagination.

EVERYDAY WOMEN

This concern with 'real' women is also demonstrated in Rembrandt's studies of household life which he worked up to varying degrees, some rapid line sketches, others finished with subtle washes. He made a number of drawings of women with children from about the mid-1630s, a time which roughly coincided with his own marriage and his leaving Hendrick Uylenburgh's studio to set up on his own in Amsterdam in 1635. Given the paucity of portraiture during the next few years (perhaps as the result of a less than harmonious split with Uylenburgh who had probably provided most of the portrait commissions) and Rembrandt's subsequent concentration on history painting, it may be that this proliferation of domestic sketches points to the artist being thrown back on his own resources. In any case, the drawings of women and children in 1630s and 1640s occupy an important place in Rembrandt's work. Women employed in domestic chores, often with babies and toddlers, formed part of the artist's repertoire which he could incorporate into the development of various compositions. The presence of this subject in his work may have been recognised in Rembrandt's lifetime. His contemporary, the artist Jan van der Cappelle (1626–1679), owned about five hundred drawings by Rembrandt and the inventory of the collection made in 1680 notes that some one

hundred and thirty-five drawings were assembled into an album entitled '*het vrouwenleven met kinderen van Rembrandt*' – 'Rembrandt's Lives of Women with Children'.[44] Though this title does not appear in the 1656 inventory of Rembrandt's collection (when the works were probably included amongst the unspecified 'sketches'), it is reasonable to suggest that Rembrandt may have assembled them himself in this manner for use in his studio, studies which could be redeployed in etchings and paintings when required. In this way quick sketches from life of a mother and child might be worked up into an etching of the Madonna or a painting of the Holy Family, while the poignant studies of women in bed,[45] which probably record Saskia's history of pregnancies and sickness, could not have helped but inform Rembrandt's depiction of *The Death of the Virgin* (cat.83).

DETERMINING PATTERNS

Is it possible to discern any recurring themes or motifs in Rembrandt's depiction of women? The changing face of the women seen in many of his Biblical and historical works and *tronies* has been discussed above. The studies of women in bed, already mentioned, were made between about 1635 to 1641, during the artist's marriage to Saskia. However, the drawings of the 'lives of women' recur over a number of years. For example, the earliest of his sketches of women teaching toddlers to walk date from the mid-1630s, the last from about 1656, now in the British Museum (see cat.56–7 and also 106–7).[46] Rembrandt also re-used certain compositional motifs during his life, such as women framed by a window or doorway (cat.76, 103–4, 123 and 126) or women reading (cat.37–8, 118 and 121). Some topics make only a brief appearance in his work, however. The few erotic prints which he made date from 1642 to 1646 (cat.97–8 and 108–9), presumably following Saskia's death and at a period when Rembrandt had probably started his affair with Geertje Dircks.[47] The latter two, *The Monk in the Cornfield* and '*The French Bed*' both show couples *in flagrante* but are perhaps most notable precisely for their lack of flagrant detail. Far from the anatomical rendering of copulation provided by the prints of Carracci's *Lascivie* and Marcantonio Raimondi's rendering of Giulio Romano's designs for *I Modi*, an explicit guidebook of sexual positions for amorous satyrs and goddesses, Rembrandt's depictions are not prudish but nonetheless show a private human act rather than the pornographic congress of immortals.[48]

However, Rembrandt returned to some themes throughout his career, sometimes after a gap of decades, his treatment influenced by the development of his own style and the alteration of his artistic preoccupations. Though his earliest depictions of the female nude date to about 1630/1 (cat.10–12) and continue sporadically throughout

Fig.7 *above* | Peter Paul Rubens (1577–1640), *Hero and Leander*, *c.*1619
Gemäldegalerie Alte Meister, Staatliche Kunstsammlungen, Dresden

Fig.8 *right* | Rembrandt, *Diana and Actaeon*, *c.*1666
Kupferstichkabinett, Staatliche Kunstsammlungen, Dresden

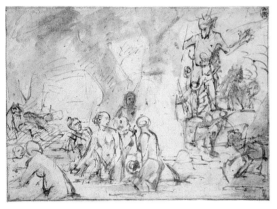

his career (with his last painting being the *Bathsheba* of 1654), it is not until the late 1650s and early 1660s that Rembrandt returned to this theme with renewed vigour, in both drawings and etchings, producing an extraordinary group of works (cat.128–33 and 135–6). He also revisited particular subjects such as *Flora* (cat.27, 36 and 119), *Jupiter and Antiope* (cat.13 and 134) or *Susanna and the Elders* (cat.69, 110 and 116). The subject of one of his more complicated earlier attempts at the depiction of the female nude, *Diana Bathing; with the Stories of Callisto and Actaeon* of c.1634,[49] was abandoned for more than thirty years until Rembrandt made what is believed to be his last drawing, of c.1662–5, showing *Diana and Actaeon* (fig.8),[50] but both his depictions of the subject were based upon Antonio Tempesta prints.[51] It is fair to say that Rembrandt was fascinated by the theme of women observed, sometimes asleep, sometimes simply unaware of the observer (occasionally the role played by the viewer of the picture). This theme appears in his work again and again, whether it be Diana interrupted by Actaeon, Antiope sleeping, Bathsheba bathing or Susanna spied upon. Not surprisingly, this tendency has been much discussed by scholars of gender issues in art, in particular by Mieke Bal.[52]

A number of Rembrandt's Biblical and historical subjects can be seen in the terms of exemplars of 'The Power of Women', an extremely popular theme in the sixteenth century in both literature and art. Lucas van Leyden made two sets of woodcuts depicting such stories (which Rembrandt may have owned),[53] while Hans Baldung Grien, Lucas Cranach, Albrecht Altdorfer, and Hans Burgkmair also portrayed the same topic from about 1512 to 1520.[54] 'The Power of Women' related to the female's 'ability through beauty, charm, ruse and wile to attract man, gain power over him and thus bring about his destruction.'[55] Lucas van Leyden's subjects included *Samson and Delilah*, and *Adam and Eve*, both of which Rembrandt was to portray,[56] but, by extension, the theme might also be said to encompass *Judith and Holofernes* (the composition underneath Rembrandt's *Flora* of 1635, cat.36), or even Potiphar's wife's attempt to seduce Joseph (cat.28 and 120). However, it is perhaps true to say that the overriding impression of Rembrandt's women in such works is less that of the potentially predatory female than of the victim of circumstance. Moreover, the sympathy he brings to his portrayals of Bathsheba, Susanna and Lucretia is undeniable, if difficult to define.

For in attempting to evaluate what can be said about Rembrandt's women as objectively as possible, a crucial factor has been deliberately, and of necessity, overlooked: that of emotion. Previous generations have been less circumspect about declaring how Rembrandt's paintings made them feel. The French art historian Elie Faure (1873–1937) discussed Rembrandt thus in 1909:

His humanity is truly formidable…he is there when the cradle lights up. He is there when the young girl appears to us leaning out the window with her eyes which do not know and a pearl between her breasts. He is there when we have undressed her, when her firm torso beats to the heat of our fever. He is there when the woman opens her thighs to us with the same maternal emotion as when she opens her arms to the child. He is there when she has matured, when her belly is furrowed, her breasts hanging, her legs heavy. He is there when she has aged, when her wrinkled face is encircled with a bonnet and when her dried hands cross at the waist to say that she wants nothing of life that means pain. He is there when we are old, when we look fixedly at the side of the night that comes, he is there when we are dead…[57]

From cradle to grave, Rembrandt charts human emotion, but the reaction for viewers is twofold, encompassing both the chord struck which they themselves feel on looking at the work, and the emotion which they consequently assume Rembrandt to have felt while painting or drawing the figure concerned. This is, of course, also true of Rembrandt's pictures of men, but the possible link to the artist's own life in some of his works portraying women means that a romantic relationship, or psychological tie, is probably perceived as present more often than in his pictures of men. However quickly after the death of Saskia he assuaged his grief in Geertje Dircks's arms, however brutal he may have been when he wanted rid of Geertje in favour of Hendrickje Stoffels, however mercenary or callous he may have been in failing to marry Hendrickje, the fact remains that 'The Jewish Bride' still contains one of the most tender gestures between man and woman ever to have been painted. Rembrandt was too great an artist to have portrayed what was personal only to him. His genius is to make it personal and relevant to us, nearly four hundred years later. As Vincent van Gogh wrote to his brother Theo from Arles in 1888:

And so what Rembrandt has alone or almost alone among painters, that tenderness in the gaze which we see whether it's in … the Jewish Bride, or in some such strange angelic figure as the picture you have had the luck to see – that heartbroken tenderness, that glimpse of a superhuman infinite that there seems so natural…. And then the portraits grave or gay … like the Saskia, he is full of them above all.[58]

It is this 'tenderness in the gaze', this 'superhuman infinite', so clearly seen in Rembrandt's portrayal of womenkind – old, young, merry, sad – combining the individual and the universal, the Italian and the Northern traditions, with an extraordinary breadth of vision that *Rembrandt's Women* hopes to reveal.

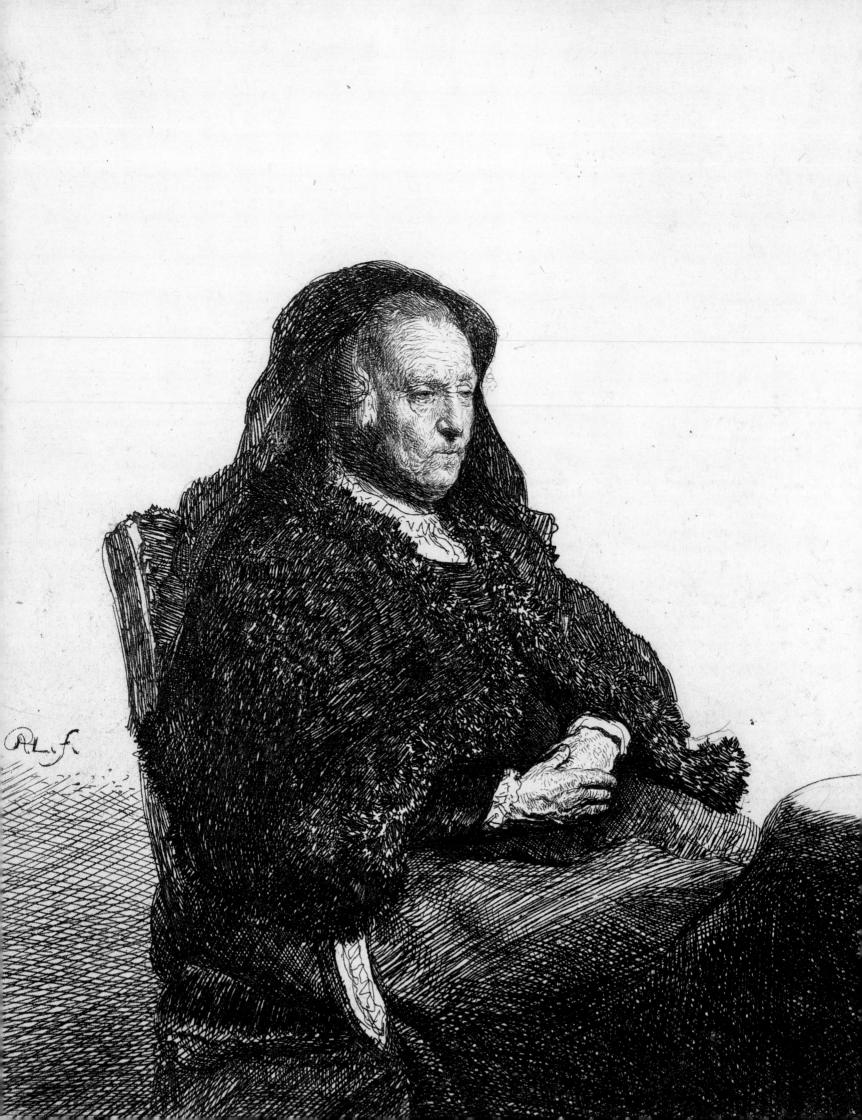

Rembrandt: his life, his wife, the nursemaid and the servant

S.A.C. DUDOK VAN HEEL

Rembrandt has become a household name, partly because of the staggering prices that his works fetch at auction. However, the details of the life of this great exponent of chiaroscuro are still not widely known. But the situation was even worse when his statue was unveiled on Amsterdam's Rembrandtplein in 1852. Then his life was a complete and utter mystery. His wife's name was unknown, as was his date of death. All anyone had to go on was a book published in 1718, and that dealt more with the interpretation and criticism of his work – the fact that he had failed to follow the classical artists – than about his life. Rembrandt's wife makes only a brief appearance: '[She] was a little peasant woman from Raarep or Ransdorp in Waterland, rather small of stature but of comely appearance and plump of frame. Her portrait can be seen beside his own in one of his prints' (see cat.40).[1]

This snippet of information is something of a mystery, for the woman in the portrait is not a peasant but a burgomaster's daughter, Saskia van Uylenburgh (1612–1642),[2] whom Rembrandt married in 1634. The peasant woman from Ransdorp (cat.81) is nowadays identified with the dry-nurse Geertje Dircks (1600/10–1656), who looked after the couple's surviving son Titus and was to play the role of the *femme fatale* in the artist's life. Information about this extramarital relationship, which came to the notice of officialdom when she was replaced by the young servant-girl Hendrickje Stoffels (1626–1663),[3] was not unearthed in the archives until later in the nineteenth century, but was considered so shocking that it was hidden away in a desk drawer and not published for many years.[4] It was only in the 1960s that these facts were given a place in the artist's biography.[5] Nineteenth-century morality cast a long shadow, but as early as 1936 and 1942 the film industry used the information by showing Geertje Dircks and Hendrickje Stoffels fighting and pulling each other's hair in Rembrandt's kitchen. In his recent film, the French painter and cineast Charles Matton shows the more maternal side of Geertje Dircks, who finds it hard to accept her fate (fig.9).[6]

Clearly, if these facts about Rembrandt's private life had been known in 1852 the statue would never have been erected, for national figures had to be of exemplary character.[7] One only has to think of the Calvinistic ideals that ruled this land of pastors and schoolmasters in the nineteenth century. The money for the monument took years and a great deal of trouble to collect, and the statue was made of iron. The Belgians, who had seceded from the Netherlands had lost no time in erecting a bronze statue of their Rubens (1840), but as an artist-cum-diplomat he embodied many of the classical ideals of his day.

Rembrandt's life unfolded mainly in the two largest cities of the province of Holland: Leiden and Amsterdam. These were the years of the revolt against Spain, better known as the Eighty Years' War (1568–1648), during which the Republic of the United Provinces emerged in the north of the Low Countries. One consequence of the revolt was mass migration to the northern provinces. The populations of Leiden and Amsterdam quadrupled in a very short space of time, and both cities had to expand beyond their cramped mediaeval walls to cope with the influx. In Rembrandt's youth Leiden had 45,000 inhabitants and Amsterdam 106,000. Leiden was particularly attractive to people working in the cloth industry, but most of the great merchants from Antwerp and people with specialist skills came to Amsterdam. A small group of Calvinists who were very active politically also moved to the north, where they formed a permanent source of unrest.

The immigration of people with skills and experience was a major economic and cultural stimulus for the province of Holland. With the foundation of the United East Indies Company in 1602 and the West Indies Company in 1622, the Republic established itself as a world power alongside its enemy, Spain. The revenues from this trade flowed chiefly to Amsterdam, where both companies had their headquarters. This period of economic prosperity, which lasted from 1630 to 1670, coincided with Rembrandt's Amsterdam period. Leiden had no share in this, but it had been graced with a university in reward for its early support of William the Silent in the revolt against Spain. Its purpose, naturally enough, was to train Protestant clergymen. At the beginning of the seventeenth century the theological faculty hummed with discussions about the opposing views of various professors, and they were closely followed by the populace at large. There was also an increase in political tensions, because the Calvinist minority had not yet succeeded in establishing a state church in the Republic, the only country in Europe not to have one, whatever the persuasion. The United Provinces was to remain a refuge where there was no persecution of the heterodox, Catholics and Calvinists alike, but it was not achieved without a struggle.

YOUTH

Rembrandt's father, Harman Gerritszn (1568–1630), came from an old milling family. Their mill stood outside Leiden, and was burned down by the besieging Spanish at the beginning of the Dutch revolt. In 1574, after the siege had been lifted, the painter's grandmother was given permission to rebuild the mill on one of the ramparts within the city walls. It was called 'De Rijn' after the river Rhine, which is how Rembrandt's father came to be known as Harman Gerritszn van den (of the) Rijn (fig.10). In 1589 he married Neeltgen Willemsdr (1568–1640), a baker's daughter, whom we later encounter under the far more genteel name of Cornelia Willems van Zuytbroeck (see cat.1–5).

Detail from cat.3

Surnames were a rarity in the sixteenth century, but they were increasingly adopted by prosperous families, and Rembrandt's was no exception.

Neeltgen Willemsdr bore a child almost every year. There were at least ten of them, with Rembrandt as the youngest son.[8] The family prospered, and because of Rembrandt's obvious intelligence it was decided that he was to be educated for something better than an ordinary trade.

[They] sent him to school so that in the course of time he would learn Latin and could then enter the Leiden Academy [the University], and so that eventually, upon reaching maturity, he would be best able to serve and promote the [interests of the] city and the community with his knowledge. But he had no desire or inclination whatever to do so, because by nature he was moved towards the art of painting and drawing. His parents were therefore compelled to take their son out of school, and according to his wish they brought and apprenticed him to a painter from whom he could learn the basic rules and principles of art.

Burgomaster Orlers, who wrote this first biography of his famous thirty-five-year-old fellow citizen in 1641,[9] does not tell us what course of study Rembrandt's parents had planned for him, but the most likely, given the family background, was theology.[10] Rembrandt was indeed enrolled at the university on 20 May 1620, shortly before his fourteenth birthday, but by then the theological faculty had undergone great changes.

The conflict at the beginning of the century centred around the interpretation of the doctrine of predestination, and it was followed with great interest and fervour throughout the entire Republic. As so often happens, the opposing parties became entangled in a political battle that led to a schism. In 1610, the Remonstrants under Johannes Wtenbogaert (1557–1644; fig.11) began distancing themselves from the orthodox Calvinists, the champions of a state church. The tensions within the congregation became so great that, to the delight of Rome and Spain, there was a real threat of civil war. The orthodox side won, thanks to military intervention by the stadholder, Prince Maurits. Remonstrantism was condemned at the Synod of Dordrecht in 1619. Persecution followed, and Wtenbogaert and his colleagues went into exile. In the meantime, Maurits had dismissed the libertarian regents of the cities, who sympathised with the Remonstrant cause, and replaced them with men of a more orthodox Calvinist stamp. Leiden's Remonstrants were so harried that they were forced to move to the village of Warmond in order to worship in peace.[11] It is there that one finds the family of Rembrandt's brother Adriaen van Rijn (1597–1652) as members of the Remonstrant congregation.[12] Rembrandt's family clearly did not belong to the orthodox wing of the Protestant church, and we can assume that he himself shared their sympathies. That must have

been a good reason to abandon any thought of studying at the orthodox theology faculty. Interestingly, Rembrandt joined neither the Reformed nor the Remonstrant congregations in Amsterdam. His brother Adriaen's descendants were overwhelmingly Catholic.[13]

The faithful were people of the Word. Printers who specialised in editions of the Bible made fortunes. Painting, with its classical nudes, was an abomination to them, and music for pleasure's sake was also beyond the pale. It is not surprising, then, that Rembrandt's teachers were Catholics, and that they had spent years in Italy studying the art of the ancients and of the great contemporary masters. The first, Jacob Isaacszn van Swanenburg (1571–1638), had returned to his native Leiden in 1617 after living in Naples for twenty-five years. Rembrandt evidently learned no more than the basic principles of painting from him, because so far nothing of Swanenburg's influence has been detected in his work. Matters were very different with his second teacher, Pieter Lastman (1583–1633), who was a celebrated history painter in Amsterdam.[14] He was in Italy from 1602 to 1607, and then lived as a bachelor with his mother at number 59, Sint Anthonisbreestraat. Rembrandt came to him for six months around 1625 in order to round off his studies.[15]

Sint Anthonisbreestraat was the main street in the first city expansion of 1586 on the east side of town. Many painters had settled in the new district, and it had a flourishing art market. The Zuiderkerk, the Republic's first purpose-built Protestant church, opened its doors across the street from the Lastman home in 1611. Protestantism had not yet found its identity, and in every area many of the old, Catholic traditions were followed in the construction of the church. Moreover, in stark contrast to the removal of statues and paintings from the churches which the Protestants had taken over from the Catholics, the Zuiderkerk had stained-glass windows with figured scenes. One was a window for the guild of gold- and silversmiths, which was designed by Lastman and showed the return of the vessels which Nebuchadnezzar had looted from the Temple. The scene is set in front of the rebuilt Temple of Solomon, for which Lastman used the dome of St Peter's in Rome (fig.12). Later, evidently, this was found offensive, for the windows were removed in the 1660s, supposedly because they were keeping out too much light. These were the surroundings and ambience in which Rembrandt was trained as a history painter around 1625.

The influence, imitation and assimilation of Lastman in Rembrandt's art has been discussed at great length,[16] but to date insufficient attention has been paid to the subjects chosen by Lastman and his contemporaries that reflect the political events and developments of their day. It is well known that history painters sought their inspira-

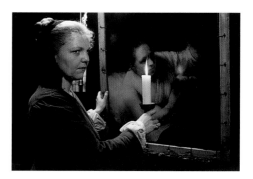

Fig.9 | Still from the film *Rembrandt* by Charles Matton showing Geertje Dircks beside the painting of *A Woman in Bed*
Photo: Yann Matton © Ognon Pictures

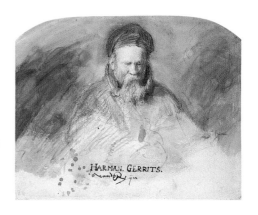

Fig.10 | Rembrandt, *The Artist's Father, Harman Gerritszn van den Rijn*
Ashmolean Museum, Oxford

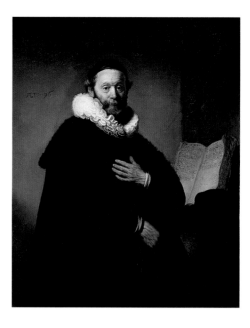

Fig.11 | Workshop of Hendrick Uylenburgh, Rembrandt, *Johannes Wtenbogaert (1557–1644),* 1633
Rijksmuseum, Amsterdam

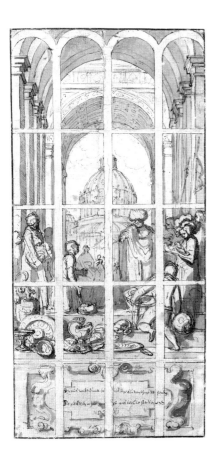

Fig.12 | Pieter Lastman (1583–1633), Design for *King Cyrus Returning the Vessels of the Temple to the Jews, with St Peter's in Rome as Solomon's Temple* Kupferstichkabinett, Staatliche Museen zu Berlin, Preussischer Kulturbesitz. Photo: Jörg P. Anders

Fig.13 | Pieter Lastman (1583–1633), *Hippocrates Visiting Democritus at Abdera*, 1622 Rembrandthuis, Amsterdam

tion in the Old and New Testaments and the literature of classical antiquity. Several of the subjects were associated with the foundation of the Republic as the new promised land or the new Rome, but certain choices from this repertoire were also comments on current events, in both literature and the visual arts. Even the Catholics were involved. They loyally participated in the struggle against Spain, but had an equal abhorrence of orthodox Calvinism and sympathised with the libertarian regents.[17] The stoning of St Stephen, a subject depicted by both Lastman and Rembrandt, must be an allusion to the persecution of the Remonstrants by the orthodox Calvinists, which generally took the form of pelting them and their meetings with stones. Lastman's *Battle of the Milvian Bridge* of 1613 signifies not just the triumph of Christianity.[18] What was more important to the artist's contemporaries was that Emperor Constantine had ordered a halt to the persecution of Christians. Rather more difficult to interpret is the subject *Hippocrates Visiting Democritus at Abdera*, of 1622 (fig.13). It shows a moment from the story of the Abderites, renowned for their bigotry and stupidity, who wanted to have the philosopher Democritus locked up, believing him to be mad. They asked the advice of the learned physician Hippocrates, who found him to be far from mad, but saw just how foolish the Abderites were. He refused to accept a fee for the consultation because of the great honour it had been to meet such a wise man. The painting shows the Abderites gathered around the temple in the background (the parishioners around the church) awaiting Hippocrates' diagnosis, in a direct allusion to the Remonstrants' opponents. The subject of *Hippocrates and Democritus* was borrowed from a play written in 1603. It was considered that it lampooned the orthodox, and the 'unedifying piece' was condemned at a synod. It was the first time that the church had openly attacked the theatre.[19] The subject of Rembrandt's as yet unexplained *History piece* of 1626 should very probably be sought in the same sphere of contemporary political events.[20]

The death of Prince Maurits in 1625 robbed the orthodox party of its chief supporter, and its waning political power opened up the way for the return of the libertarian regents. The last disturbances took place in Amsterdam in 1627. Soon afterwards the preachers, like the priests, were placed under the supervision of the civil power. They were removed from the political stage and had to confine themselves thereafter to the care of souls. The libertarian ideal had triumphed, and the prospect of a state church evaporated. The Calvinists' privileged position in the Republic was quite enough.

INDEPENDENT AND DEPENDENT ARTIST

Rembrandt returned to Leiden as a fully fledged master after his period of study in Amsterdam. He would have set up his first studio in his parents' house, just as the bachelor Pieter Lastman did at his mother's. There he worked with another skilled young man of Leiden, Jan Lievens (1607–1674), who had studied with Lastman in 1619. Around 1628 the two young artists caught the eye of Constantijn Huygens (1596–1687), the erudite secretary to the Prince of Orange and a man thoroughly grounded in the classics. He was enthusiastic about their work, but could not stand the arrogance of these two small-town painters. They rejected his advice to perfect their art by going to Italy and seeing the work of Raphael and Michelangelo with their own eyes.

This is plainly a touch of idiocy in intelligences that in other respects are quite exceptional, and he who succeeds in driving it out of these young minds will have given them more than they need to repair the only lack in the perfection of their art.[21]

They did not go, and for the rest of his life Rembrandt relied on prints for his knowledge of Italian art, and took his inspiration from Italian paintings that came on to the Dutch art market.

Rembrandt acquired two pupils for his Leiden studio in 1628, Gerrit Dou (1613–1675)[22] and Isack Jouderville (1612–1645/8), the latter paying 100 guilders in tuition fees a year, which would have kept a labourer's family for months. It made Rembrandt the highest paid teacher in the Republic.[23] During his stay with Lastman Rembrandt must also have got to know the painter and art dealer Hendrick Uylenburgh (1587–1661),[24] who travelled a great deal to pick up stock. His seat of business was in Amsterdam, where he lived in a rented house in Sint Anthonisbreestraat, on the corner near the lock, next-door to what is now the Rembrandthuis. He had set up a workshop there, but rarely painted in it himself.

The house had belonged to the painter Cornelis van der Voort (1576–1624), who was known for his imposing, full-length portraits, and in 1637 it was owned by the portrait painter Nicolaes Eliaszn Pickenoy (1588–1650/6).[25] They all seem to have used the north-facing workshop (figs.14–19), which was also suitable for the large civic guard pieces and Rembrandt's *Anatomy Lesson of Dr Nicolaes Tulp* of 1632. Uylenburgh seems to have taken over and continued this workshop, possibly complete with the inventory. This may have involved the business of portrait painting, of which Uylenburgh himself was no great master.[26] There were plenty of commissions, and it seems that he offered this lucrative work to Rembrandt in 1631. Rembrandt travelled to Amsterdam regularly, taking his former pupil Jouderville along to help with the details.[27] There must have been a large number of pupils and assistants, for in Rembrandt's portraits of the period no fewer than four different hands can be distinguished in the lace collars alone.[28] When Johannes Wtenbogaert was in Amsterdam for a large gathering of Remonstrants in April 1633, he

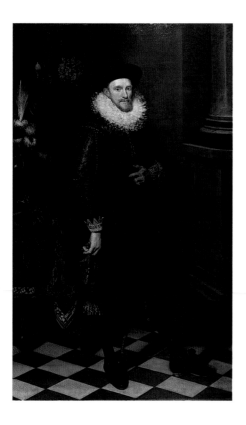

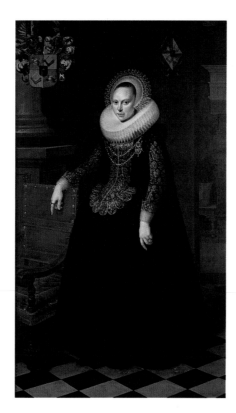

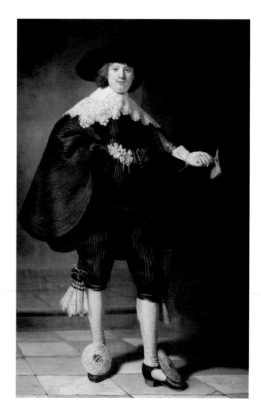

went to Uylenburgh's studio on the thirteenth of the month to be painted by Rembrandt, who left the finishing of the hands to an assistant (see fig.11).[29] Only a single artistic hand can be detected in portraits executed in and around the court at The Hague in 1632, and of the family of a Remonstrant brewer in Rotterdam in 1634.[30]

After two years Rembrandt gave up his Leiden studio and settled in Amsterdam permanently,[31] becoming a member of the Guild of St Luke the following year. As a master-painter he soon put his stamp on Uylenburgh's workshop, where a great deal of copying was done. Most of those copies and freer imitations of Rembrandt's work are generally of a high standard, and this has caused considerable headaches for the Rembrandt Research Project (figs.20, 21). One reason why they are so difficult to resolve is that we simply do not know enough about who worked in Uylenburgh's shop, or how it was organised.[32]

Hendrick Uylenburgh came from a Mennonite family and introduced Mennonite themes of 'Christ and his disciples' into Rembrandt's work (figs.20 and 21).[33] His shop maintained close ties with Lambert Jacobszoon (1598–1637), another painter-dealer and a preacher to a Mennonite congregation in Leeuwarden, whose apprentices around 1630 included the painters Jacob Backer (1608–1651) and Govert Flinck (1614–1660), both of Mennonite stock. Although it is said that Flinck wished to study under Rembrandt,[34] the more likely explanation for his move to Amsterdam is that Hendrick Uylenburgh wanted him in his workshop, where he proved to be the perfect Rembrandt follower. Hendrick Uylenburgh's studio had enjoyed a heyday, so much so that it was later referred to as Uylenburgh's Academy.[35] When Rembrandt left the shop in 1635, Flinck remained

behind as the master-painter. Output evidently dropped after Rembrandt's departure. Even the printmaking after the work of Rembrandt by Jan van Vliet (1600/10–1660), which Uylenburgh had organised, stopped abruptly in 1636 and was never finished.[36] Uylenburgh moved to number 53, Sint Anthonisbreestraat, which had once been the workshop of the art dealer and painter Pieter Isaacszn (1569–1625). The house on the corner near the lock was bought by Nicolaes Eliaszn Pickenoy, who continued producing portraits there, as well as civic guard pieces.

It is interesting that as soon as Rembrandt had set up as an independent master he stopped painting portraits and devoted himself entirely to history painting once again. Now that he had his own workshop he had become Uylenburgh's competitor. It is doubtful whether they parted on good terms. By not taking Huygens's advice and going to Italy, Rembrandt clearly did not follow the developments of the classicist fashion (which is why he was later passed over for large commissions from the court and the city). The breakup of the partnership between Rembrandt and Hendrick Uylenburgh in 1635 did neither of them any good. Rembrandt lacked Uylenburgh's organisational talent, while Uylenburgh had to carry on without the artistic drive and expressive talents of his master-painter. The symbiosis had led to a brief flowering of the Academy, and one can only wonder what would have transpired if they had continued showing the lead to Dutch artists and the art trade.

MARRIAGE

Rembrandt clearly had a golden touch. It had probably been in order to bind him more closely to his workshop that Hendrick Uylenburgh had hit upon the idea of marrying his first cousin Saskia van

Fig.14 *left* | Cornelis van der Voort (1576–1624), *Arent Harmensz van der Hem 1586–1656* Kunsthandel Frye und Sohn, Münster

Fig.15 *centre* | Cornelis van der Voort (1576–1624), *Margaretha Reijersdr Vos 1593–1638* Verwaltung der Staatlichen Schlösser und Gärten, Hessen Bad Homburg von der Höhe

Fig.16 *right* | Workshop of Hendrick Uylenburgh, Rembrandt, *Marten Soolmans 1613–1641, 1634* Rothschild Collection, Paris

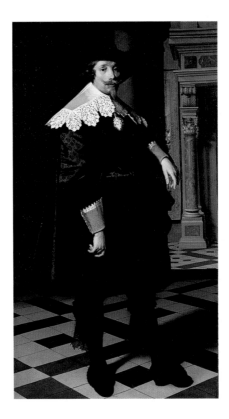

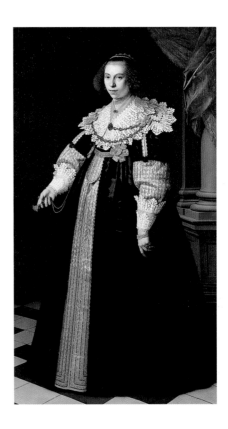

Fig.17 *left* | Workshop of Hendrick Uylenburgh, Rembrandt,
Oopjen Coppit 1611–1689, 1634
Rothschild Collection, Paris

Fig.18 *centre* | Nicolaes Eliaszn Pickenoy
(1588–1650/6), *Cornelis de Graeff 1599–1664*, 1636
Gemäldegalerie, Staatliche Museen zu Berlin, Preussischer Kulturbesitz
Photo: Jörg P. Anders

Fig.19 *right* | Nicolaes Eliaszn Pickenoy, *Catharina Hooft
1618–1691*, 1636
Gemäldegalerie, Staatliche Museen zu Berlin, Preussischer Kulturbesitz
Photo: Jörg P. Anders

Uylenburgh to his master-painter. Reams and
reams have been written about the marriage of the
miller's son to the burgomaster's daughter. It was
said that he was marrying up but the truth was very
different. Saskia may have been the daughter of a
burgomaster, but she was the youngest of eight
surviving children.[37] Her father had died in 1625
leaving an encumbered estate, and Saskia was fated
to live the life of a spinster, providing an extra
helping hand in the family household when
necessary. Rembrandt was a prime catch, and
because Saskia had little property to speak of they
married without a prenuptial contract. However,
by the standards of the day, Saskia was clearly a
beautiful woman.

The couple moved in with Uylenburgh, but
Rembrandt began looking around for a home and
workshop of his own, and on 1 May 1635 he found
them at number 20, Nieuwe Doelenstraat, a newly
built house which he rented. It was there that they
had their first child, Rumbartus. He was baptised
in the Oude Kerk on 15 December 1635, with
Saskia's family as the godparents, and was buried in
the Zuiderkerk precisely two months later. The
second child, Cornelia, was born in 1638 but lived
only three weeks. The third, also called Cornelia,
survived for just two weeks in 1640.

By the time of Saskia's death in 1642, which
may have been precipitated by her last childbirth,
Rembrandt had amassed a fortune of more than
40,000 guilders, half of which would pass to
Saskia's heirs, of whom there was just one – their
nine-month-old son Titus van Rijn (1641–1668).
Because all the other children had died within a few
weeks of birth, little Titus was not expected to live
long either. Saskia's family kept a nervous eye on
their nephew's progress. One did not want to miss
out on an inheritance of that size. In the language

of the day they were *watching over* (inloeren) the
inheritance, a very common occurrence. The loving
concern of Saskia's relatives for Titus's well-being,
which is detailed at such length in the literature,
thus had a distinct element of self-interest. That is
why Rembrandt tried to conceal the size of his
estate for so long, but in 1647 he was forced to
open up his books.[38] It was with tense expectancy
that he awaited his son's fourteenth birthday, for
that was the earliest age at which a person could
make a will. When it arrived Rembrandt saw to it
that Titus drew up a will appointing his father as
his universal legatee.[39] And that is the last we hear
of Saskia's family.

THE REMBRANDTHUIS

After living and working in various rented houses,
Rembrandt contracted to buy the house later
known as the Rembrandthuis in January 1639 for
13,000 guilders (fig.22). It turned out to be a
terrible investment. The house had been built in
1606 and had been owned by the wealthy Pieter
Belten of Antwerp (1565–1626). He had enlarged it
at the rear, and had a gallery built in the inner
courtyard. In 1627, his children called in the
architect and painter Jacob van Campen (1595–
1657) to carry out further modernisation, which
included the present facade. Belten's children lived
in grand style as if they were nobility. However,
while the rebuilding was going on, the elite moved
en masse from the old, mediaeval city centre to the
new districts arising along the fashionable
Herengracht and Keizersgracht canals. The price of
housing around Sint Anthonisbreestraat plum-
meted, and when Belten's children decided to sell
in the 1630s they could find no takers at the sum
they were asking, and the house remained on the
market for years. Meanwhile, Rembrandt must

have been looking for a workshop suitable for him to work on his commission for *The Nightwatch*, among other paintings, and which would reflect his social standing.[40] Many of the houses were sold off cheaply to Jewish merchants, but Rembrandt paid the full price for his. It was not a happy omen.[41]

The house had been built on very marshy soil too soon after the site had been prepared. The earth used to raise the land bedded down too much, with the result that the houses in the neighbourhood began to experience severe subsidence. Shoring up the foundations and repairing the damage cost a great deal of money. When Rembrandt's neighbour decided to raise his house in 1653, Rembrandt refused to make it a joint project, despite the fact that they shared a party wall. He was presented with the bill for this all the same.[42] The truth was that he could not afford to do so. Moreover, he had stopped paying the instalments on his house in 1649, and he was also presented with a bill for those in 1653 (fig.23).[43] It was the prelude to his bankruptcy.

THE DRY-NURSE

Geertje Dircks must have entered the household as a dry-nurse while Saskia was still alive. While Saskia's life slowly ebbed away, Geertje took over the care of Titus and ran the household. She was the childless widow of a trumpeter, and someone in her position could only expect a life of poverty on the margins of society unless she remarried. She had landed on her feet in the Sint Anthonisbreestraat, particularly when her attentions extended to the master of the house. Rembrandt's artistic output was low at the time, and it would only have been natural for him to be depressed after Saskia's death. He would have concentrated on running his workshop, which included training young pupils, each of whom paid him around 100 guilders a year – and he must have had a large number of them. But why were there signs that Rembrandt was under financial pressure at the end of the 1640s, when the Republic was at the height of its prosperity and the Treaty of Münster had just been signed? Tales of him living the grand life had been doing the rounds for years. Were Rembrandt's reduced circumstances due to Geertje Dircks? One clue is that she had appropriated an expensive rose-cut diamond ring that had belonged to Saskia, although she claimed that Rembrandt had given it to her to pledge his troth. This is highly unlikely. Living together as man and wife was one thing; solemnising the relationship was another matter altogether. The difference in social status between them was simply too great.

Geertje Dircks entered Rembrandt's household with few possessions to her name. In her will of 1648 she stipulated that her mother was to receive the statutory share of her estate, which amounted to her clothes. Highly unusually, her gold, silver and jewellery which she had acquired from

Rembrandt were excluded.[44] Young Titus van Rijn was named as her universal heir, and she bequeathed her portrait to a former charge she had raised in Hoorn.[45]

The relationship between Geertje Dircks and Rembrandt cooled to such an extent that she left the house in June 1649. Her departure was prompted by the arrival of the young servant-girl Hendrickje Stoffels (1626–1663) to help the sickly Geertje. Rembrandt had given Geertje 160 guilders and promised to pay her sixty guilders a year, but she felt she had a right to more. She appealed to the city's Commissioners of Marital Affairs, not so much in the hope of forcing Rembrandt to wed her as in the desire for a more generous allowance: although she may have been unlettered,[46] she knew full well that the social differences between them were too great to be bridged by marriage. Before the case was heard Rembrandt offered to increase the sum to 160 guilders a year, but eventually he was ordered to pay 200 guilders annually. In the meantime, Geertje had pawned her valuables, which incensed Rembrandt because they had belonged to Saskia. Geertje got on his nerves so much that in 1650 he took action and had her locked up in the House of Correction in Gouda at his own expense. This may put him in a less than flattering light, but one must remember that although it was a society run by men, for men, the bench of aldermen did not hand out such sentences lightly. Geertje Dircks was freed in the spring of 1655,[47] but Rembrandt had to continue paying her allowance.

THE NEW MUSE

Hendrickje Stoffels (cat.125) was the daughter of a sergeant, and when he died and her mother married a widower with three small children she was sent out into the world to enter domestic service. Many girls did the same, saved up for their bottom drawer,[48] and then went looking for a husband (often during the September *kermis* (fair)). Hendrickje Stoffels had registered with the church in Amsterdam, which provided women with the best opportunities for social contacts. Rembrandt fell for her so quickly that it must have aroused Geertje Dircks's jealousy. After the latter's departure, Rembrandt made painting after painting of Hendrickje, and while she was pregnant by him painted the masterly nude *Bathsheba with King David's Letter* of 1654 (fig.48). Rembrandt had never been inspired like this by Geertje Dircks. It is true that she owned a portrait that he must have painted, but it cannot be identified and is probably lost. It has been said that she posed for *A Woman in Bed* (cat.100), but her age of about forty seems to argue against it.

The church council began taking an interest in the pregnant Hendrickje Stoffels in the summer of 1654. That was its moral duty, for she was practising 'whoredom' with Rembrandt, in the sense of pre-marital cohabitation. After confessing that this was

Fig.20 | Rembrandt, *The Incredulity of Thomas*, 1634
Pushkin Museum, Moscow / Bridgeman Art Library

Fig.21 | Rembrandt (?), *The Incredulity of Thomas*, 1634
Bill Manhard Collection, Chicago

Fig.22 | H.J. Zantkuyl, *Reconstruction of the Rembrandthuis in Rembrandt's Day*. The house was raised to its present height in 1661.

Fig.23 | Invoice of 1653, Rembrandt Documents, 1653/6 City Archives, Amsterdam

so she was given only a lenient punishment: exclusion from the Lord's Supper.[49] When her child Cornelia was baptised in the Oude Kerk on 30 October 1654, she was registered as the daughter of Rembrandt van Rijn and Hendrickje Stoffels. The entry does not reveal that Cornelia was born out of wedlock, for the authorities assumed that the couple would marry anyway. They were living in a metropolis, after all. There could be no question of marriage as the church understood it, because Rembrandt was no longer able to pay Titus the money he owed him from his mother's estate, and without the approval of Saskia's family for the settlement the artist could not get permission to remarry from the Commissioners of Marital Affairs. The secular and ecclesiastical powers did not toe the same line, but it was the politicians who had the final say. Titus's claim, though, remained outstanding.

THE FIRST ANGLO-DUTCH WAR (1652-54)

The Republic found itself at war again only four years after the Treaty of Münster, this time with England. The prize was maritime supremacy, and the Dutch merchantmen suffered severe losses. One of the consequences was a sharp drop in the demand for luxuries, including art. This made life very difficult for Rembrandt and added to his own financial problems.

He did have an admirer and patron during this troubled period in the person of Jan Six (1618-1700), who had already commissioned an etched portrait of himself as a poet in 1647, and now in

1654 ordered a masterly portrait – the last one by Rembrandt still in the hands of the sitter's descendants.[50] The etchings and drawings for Six's poetic works, *Medea* and *Pandora*, are also still in the Six collection. Jan Six was an extremely wealthy man and could permit himself such expenses, but was no good at all at managing his money.[51] His mother must have worried about him, for she arranged for him to marry a daughter of the orthodox burgomaster Nicolaes Tulp (1593-1674), the leader of the church party at the Town Hall.[52] This, among other things, led to him breaking off the relationship with Rembrandt. He had lent the painter 1,000 guilders in 1653 but now hurriedly disposed of the bond. Given this sort of calculated behaviour one must wonder whether Jan Six really qualifies for the title of Maecenas of the great artist.

FROM INSOLVENT TO BANKRUPT

It was in December 1655 that Rembrandt tried to raise money by selling some of his paintings, valuables and collections at a series of auctions he organised himself in the Keijserscroon Inn.[53] They did not fetch what they were worth, and he was now forced to acknowledge that he could not meet his financial obligations.

Shortly after Geertje Dircks started proceedings against the painter, Rembrandt appeared before the city's Chamber of Orphans to have the title to his house transferred to his son Titus, clearly in order to put it beyond reach of his creditors.[54] Two months previously, Baruch Spinoza (1632-1677) had tried to place himself under the guardianship of the Chamber of Orphans in the hope of extracting the inheritance left him by his mother from his father's insolvent estate. That would have removed him from the supervision of the parnassim, and many Jewish merchants would have suffered serious losses. Both Rembrandt and Spinoza were trying to slip through loopholes in the law, but the city authorities moved swiftly to block them. A new bye-law came into effect on 31 July 1656 that made it impossible to remove property or goods from an insolvent estate in this way.[55]

Rembrandt was granted *cessio bonorum* on 14 July 1656.[56] By surrendering his estate like this he was clearly indicating that he had no intention of coming to an agreement with his creditors and was presenting them with a *fait accompli*.[57] Soon afterwards the Chamber of Insolvent Estates drew up an inventory of his paintings, curiosities and art on paper. Everything would go under the hammer – including the house, thanks to the authorities' intervention. He was actually bankrupt, because his insolvency was partly fraudulent. An insolvent could emerge from the affair with honour, but fraudsters were social outcasts, which was why most bankrupts left the city in order to avoid showing their faces until they had rehabilitated themselves. Rembrandt did not do so. He remained in Amsterdam, moving to rented accommodation

at number 184, Rozengracht, in the working-class Jordaan district lying outside the choice residential area of the city's ring of canals.

A LAST CHANCE

In 1648, to celebrate the peace, construction work started on Amsterdam's new Town Hall on Dam Square. It was a classicist design by Jacob van Campen (1595–1657) who had earlier re-designed the Rembrandthuis. It was hailed as the eighth wonder of the world. An extensive programme of decorations was devised, and numerous artists were employed to carry it out. Some of them had already collaborated on a comparable programme for the House of Orange at Huis ten Bosch in The Hague. After painting two overmantels for the Town Hall for 1,500 guilders each, Govert Flinck was awarded the largest commission of all: 12,000 guilders for the twelve lunettes in the gallery. This becomes less surprising when one learns that Flinck was on very friendly terms with the De Graeff family (fig.18), which occupied the most powerful positions in the city government. In addition, Flinck had by now abandoned his Rembrandtesque style and was working in a more colourful, classicist manner influenced by the French. It was therefore felt that he would produce more balanced works which would fit in with the style of the building itself.

Govert Flinck must have remained on good terms with Hendrick Uylenburgh, which Rembrandt could never have done, his lifestyle and extramarital affairs being anathema to a strict Mennonite. After Flinck had set up as an independent master in the famous *Schilderhuis* (Painting House) at number 78, Lauriergracht in 1644,[58] Uylenburgh had moved his art business to Dam Square, the centre of world trade. He is documented there in 1647, renting from the city authorities. Setting up shop on Dam Square could not have been coincidental, for Uylenburgh also received commissions for work on the Town Hall, such as cleaning and restoring all the paintings owned by the city, for which he was paid 1,130 guilders in 1657. His art dealing business had also suffered during the Anglo-Dutch War, and in 1654 he owed 1,400 in back rent, 400 guilders of which was remitted by the city in 1658, though it is not known why.[59]

It was impossible for the burgomasters and treasurers to supervise the execution of the entire decorative programme themselves, and Hendrick Uylenburgh would have been the ideal person to do it for them. There are no documents that could shed any light on this, for the administration and accounts for the construction work have not survived. Flinck died in January 1660, two months after he had been awarded the commission for the lunettes. Hendrick Uylenburgh took over his workshop in Lauriergracht, but in March 1661 he too had died. The commission was not then

entrusted to a single painter but split up, with the inherent risk to the overall cohesion of the programme. Rembrandt was allowed to contribute *The Conspiracy of Claudius Civilis*. The painting was hanging in the Town Hall in the summer of 1662 but was considered unsatisfactory and removed. Jürgen Ovens (1623–1678), who worked in Uylenburgh's workshop (now run by his son), was commissioned to finish Govert Flinck's design. Rembrandt was not paid his 1,000 guilders, and sold a fragment of the painting (now in the Nationalmuseum, Stockholm) and then reused the rest of the huge canvas.[60]

THE CLOSING YEARS

In 1660, after all his possessions had been sold off, Rembrandt entered into a contract for a new art business with Titus and Hendrickje Stoffels, with him as their employee.[61] It made him a dependent painter once again. In contrast to his time in Uylenburgh's shop, however, he would be protected from his creditors. It would have been a way of safeguarding the money earned from the Town Hall project.

Rembrandt may have become a social outcast but there were still people who admired his art and came to visit him. His late work was as expressive as ever. His *Syndics of the Cloth-Makers' Guild*, completed in 1662, is perhaps the best-known group portrait of an Amsterdam municipal body after the Treaty of Münster put an end to the painting of civic guard pieces. The only sitters known by name in portraits from his late period are Frederick Rihel (1621–1681), in a large equestrian piece; the parents of the Trip brothers, who built a canalside palace; and a neighbour in Rozengracht, the art dealer Lodewijck van Ludick (1607–1669; fig.24), Rembrandt's almost exact contemporary who shared his inability to manage money.[62] The commission from the Trip family seems to have been sizable, but the main order had gone to Ferdinand Bol (1616–1680), so Rembrandt was the family's second choice. There are no known portraits of members of the ruling elite from his late period, and the chance that any will be found among the remaining anonymous portraits is slight.

Poverty had forced Rembrandt to sell Saskia's grave in the Oude Kerk, and he even dipped into his daughter Cornelia's savings.[63] However, he was not so poor that Hendrickje Stoffels had to be buried in the paupers' cemetery after she died of the plague in the summer of 1663. She was interred in a rented grave in the Westerkerk, as was Rembrandt himself six years later. Their location in the church is completely unknown, and in any case they would have been cleared many years ago to make way for other impecunious citizens.

Rembrandt was left alone with his two children. There had been no money for his son to study and so he had trained him up in his own business, but

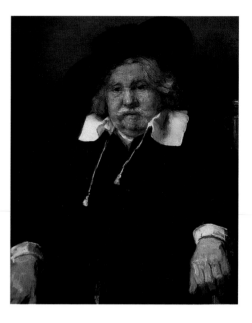

Fig.24 | Rembrandt, *Lodewijck van Ludick 1607–1669* Mauritshuis, The Hague

Titus lacked the talents of his father and for that reason he was active on the art dealing side, just like Uylenburgh's son. Rembrandt lived long enough to see his son married to a cousin, Magdalena van Loo (1641-1669). Just a couple of month later Titus fell sick during a visit to Leiden. In the night of the 31 August and 1 September 1668 he had a will made up, covered with numerous amendments and alterations. It was a complicated document because Titus's inheritance had to be kept out of the hands of his father's creditors.[64] Six days later Titus van Rijn was buried in Amsterdam. His daughter Titia van Rijn (1669-1715) was born posthumously and was to be the last of Rembrandt's lineage in Amsterdam.

Shortly after the death of her father, Cornelia van Rijn (1654-1685) was married off at the young age of fifteen to the painter Cornelis Suythof (1641-1691), who went with her to seek his fortune in the East Indies. There he ended up as a warder of the prison in Batavia. Their children all perished before his own death in 1691, so that there were no further descendants of the great master.[65]

EPILOGUE

The women's lives in Rembrandt's biography all lack the happy endings so characteristic of Barbara Cartland novels. Each began with great expectations but all ended in classic drama, Rembrandt's included. In a normal marriage Saskia would have given birth to a child almost every year, just as her mother and her mother-in-law had done. The total could easily reach as many as fourteen. The intervals of two years between the births of her children are an indication that Saskia differed from the other Dutch matrons of her day. What she had over her successors was her status as a lady – as much through birth as by marriage.

The question of why Rembrandt did not make an acceptable second marriage, like Rubens or Flinck, is intriguing. For a young widower of high reputation this must surely have been possible in direct contrast to Ruben's numerous heirs.[65] Presumably here we touch on the undisciplined side of the painter and his lack of conformity with social convention. His not going to Italy and not remaining in Uylenburgh's studio as an employee may indicate his unwillingness to be further educated and disciplined. The organisation of his own life must have caused him huge troubles. Failure to make a marriage contract with Saskia later played its part in them.

The most difficult problems to understand, though, are those between Rembrandt and Geertje Dircks, and the settlement they reached. Could this have happened because the painter, like so many gentlemen of his day, paid his servants irregularly, if at all? It did not matter after a while, as Rembrandt and Geertje were living as man and wife. During this period, on her own initiative, Geertje Dircks must have begun to deck herself out in her predecessor's jewels, including a string of pearls. But later, when the relationship soured, Rembrandt was unsuccessful in trying to recover Saskia's valuables from her. By 1648, it seems that the painter already lacked the cash to buy them back, or to pay her for her many years of service. He only succeeded in pressing her to make a will in young Titus's favour, so that the jewels would come back to his son in due course. It makes his rage understandable, when Geertje Dircks pawned them to the Lombard in 1650 and he had her locked up. Her release in 1655 was a serious threat to him as she was one of his most aggressive creditors.

Their background from Dutch sailor- and soldier-families destined both Geertje Dircks and Hendrickje Stoffels for a serving role in the community. This meant employment in a household when they were lucky, if not, then working on the very fringes of society. In struggling for survival they were hardly likely to shrink away from the role of model. Their social status would have been little influenced by it and at most only their respectability would have suffered. This is not to say that they did not act as models. Geertje Dircks would seem to have been too old, but Hendrickje Stoffels must have been an extremely suitable young and attractive model. The paintings of *Bathsheba* (fig.48) and the *Woman Bathing* of 1654 (fig.143), with their heavily erotic charge, were painted at the moment when the art market was collapsing due to the Anglo-Dutch war. Rembrandt had dire need of ready cash, because the birth of their child would cost him a good deal of money. It is remarkable that Rembrandt painted no other similar works after Hendrikje was called before the church authorities. The moral persuasion of the church's intervention must have taken its effect.

The last hundred and fifty years have seen the contours of Rembrandt's biography continually become more defined. It was first modelled according to the standards of Dutch bourgeois morals of the nineteenth century, but the rapidly increasing number of newly discovered documents forced researchers to reshape the painter's life. These documents bear witness to a complex individual in complicated circumstances. This essay itself goes further than previous efforts in 1991. Until very recently, the women of the painter were given no attention in their own right. Geertje Dircks was the first to whom a serious separate study was dedicated in 1965.[66] Saskia van Uylenburgh[67] and Hendrickje Stoffels[68] have now each prompted a novel in their name, while in the 1980s the town of Bredevoort erected a bronze statue of their most famous citizen. Our insight into the master Rembrandt continues to increase, and the women in his life gradually begin to take their places as individuals – but without their relationship to the painter they would have remained virtually unknown.

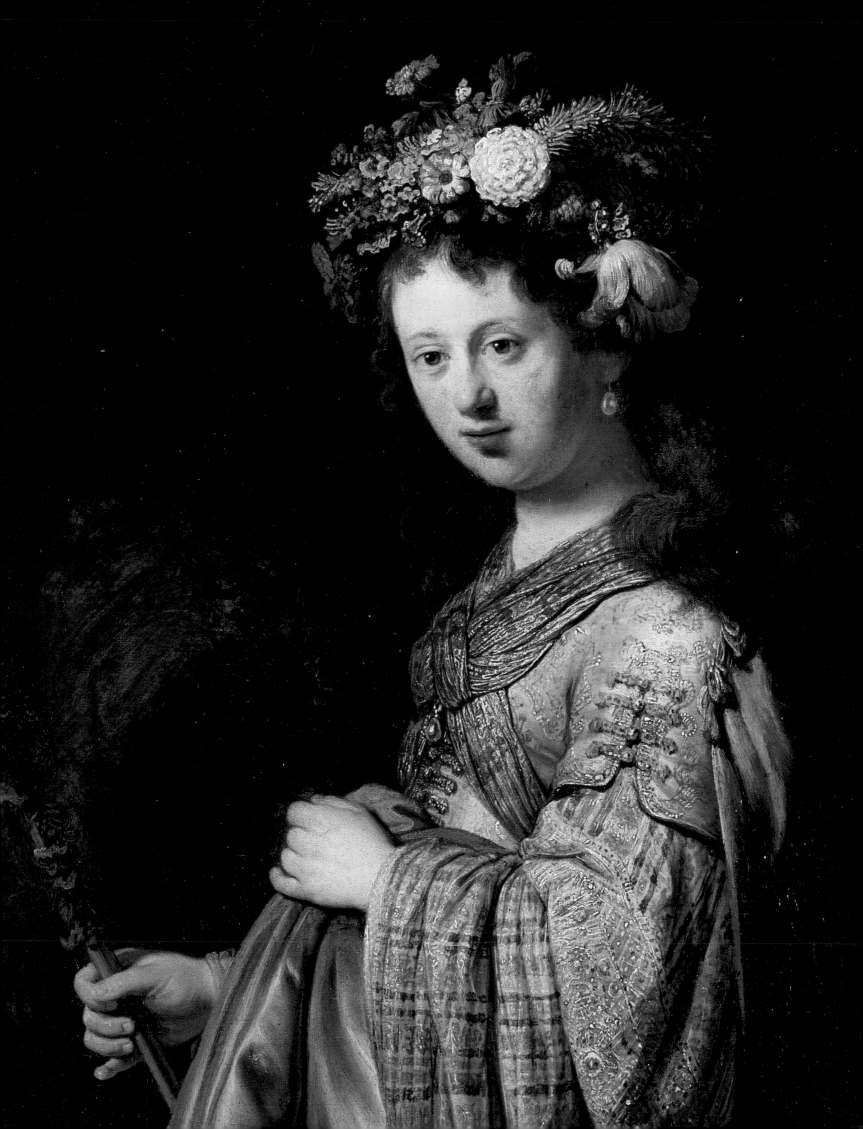

The model woman and women of flesh and blood

E. DE JONGH

Anyone seeking an introduction to the women of the seventeenth-century Dutch Republic should be aware that there were 750,000 of them in this small country at the beginning of the century, and around one million at the end.[1] Needless to say, there was no such thing as a typical Dutch woman. Then, as now, women differed from each other, not just in their appearance, but in their morals and habits, religion, social class, role in society and degree of personal development. This self-evident sociological truth is a potential stumbling-block for the historian who is forced into abstraction and generalisation, particularly when space is limited.[2] However, it is possible to trace certain historical factors that affected all the groupings to a greater or lesser extent. In theory, at least, there was a consensus on how Dutch women should comport themselves, and of their position in marriage and society. Contemporary conduct books and other moralistic writings speak loud and clear,[3] but it will come as little surprise to learn that daily practice for women of flesh and blood did not, in many cases, live up to the strict guidelines laid down by the moralists.

One should not underestimate the longevity of some old notions. Far-fetched as it may sound, the position and status of the seventeenth-century woman was ultimately determined in part by the dubious reputation of the first woman – by the Biblical count.[4] It was Eve, after all, who was held responsible for original sin, which altered the course of human history so drastically. By inciting Adam to take a bite of the apple she condemned her daughters to opprobrium for centuries. In the middle ages, and often enough thereafter, women were regarded as subordinate beings, inferior to men and sometimes as innately more sinful.[5] The most rabid theologians even went so far as to place women on the same level as animals.[6]

Passages from the Bible were cited in support of this view of women's inferiority, and classical authors also supplied plenty of ammunition. Not only was it said that women had fewer mental faculties than men, but according to Aristotelian and Galenic ideas (some of which have lived on into modern times) they were also less developed physically, with all that that entailed. Woman was in fact less complete, as demonstrated by the fact that her sexual organs had remained internal. The possession of a uterus also had an adverse effect on the quality of the female mind.[7]

One curious example of the persistence of a centuries-old outlook is found in a book by the jurist Hugo Grotius, *Inleijdinghe tot de Hollandsche rechts-geleerdheijdt* (Introduction to the Jurisprudence of Holland) of 1631. In order to explain the mental differences between the two sexes physiologically the author resorted to traditional humoral pathology, the theory of the bodily fluids. 'Moreover,' Grotius argued, 'the female sex is generally colder and moister than the male sex, and

less fitted for affairs which require understanding: therefore the male sex is given by nature a sort of authority over women.'[8]

The hierarchy of the sexes was also hewn in stone in a passage from St Paul's epistle to the Ephesians (5:22–4), a passage which was repeated and paraphrased with monotonous regularity in both theological and lay writings: 'Wives, submit yourselves unto your own husbands, as unto the Lord. For the husband is the head of the wife, even as Christ is the head of the church: and he is the saviour of the body. Therefore as the church is subject unto Christ, so let the wives be to their own husbands in every thing.' This is a crucial text. A woman was expected to be submissive and also obedient, by many Dutch moralists of the sixteenth and seventeenth centuries.[9] But the model woman was not only obedient, she was also quiet and modest, home-loving, pious and chaste. Above all chaste. Chastity was the virtue that was almost always prized above all others. The woman who was not very particular about her chastity lost her honour for ever, and honour, one's good name in the eyes of others, was a crucial structural principle in the contemporary culture of shame. *Eer is teer* (Honour is fragile), is the resonant motto of an emblem in the compendium *Maechden-plicht* (A Maiden's Duty) by the popular poet, statesman and moralist Jacob Cats, who hammered away at this theme whenever the occasion arose (fig.25).[10]

Domesticity implied that the home was the appointed place for the woman. It was also the safest place, for there she could not succumb to temptation. Women, after all, were sexually insatiable, as many a moralist argued in imitation of the classical physician Galen. With her *insatiabilis vulva*, a mediaeval author declared, a single woman could exhaust an entire people.[11] Cats would have dismissed that as an exaggeration, but he neverthe-less felt that men should be on their guard. In his influential and much-reprinted conduct book, *Houwelyck* (Marriage) (fig.26), he urged men to keep an eye on their bedfellows, and employed a fairly evocative metaphor, as was customary in those days: 'For should her unruly heart once ignore your commandment, her tender lap will become a door without a lock.'[12]

What we know about the reality of the Dutch woman in the seventeenth century comes from archival records and personal documents, as well as from a large number of depictions – although the latter can be treacherous as sources of information. One discovers all too often that the meaning of images cannot be taken at face value. We know a lot, but there is a lot that is hidden from us. How close can we get to a woman who lived three to four centuries ago? The sound of her voice, the way she moved, her odour, her facial expressions, her laugh, the way she showed her feelings – all are unknown to us.

And did she always resemble her depiction? As

Detail from cat.27

far as the countless portraits from the period are concerned, one suspects that a lot of sitters had no objection to a certain amount of flattery, and that some patrons even gave the artists specific instructions on this point.[13] Not every painted peach-bloom skin would have been a faithful reflection of reality. One telling instance was noted down by Arnold Houbraken, the artists' biographer, in an anecdote about the fashionable painter Nicolaes Maes:

A certain lady (whose name I do not wish to mention), far from the fairest in the land, had her portrait painted by him, which he depicted as it was with all the pockmarks and scars. When she arose and beheld herself in all her ugliness she said to him: 'The devil, Maas, what kind of monstrous face have you painted of me! I do not wish it thus, the dogs would bark at it were it to be carried in the street like this.' Maas, who saw in a trice what was required of him, said: 'Madam, it is not yet finished,' and asked her to be seated once more. He took a badger-hair brush and removed all those pockmarks, put a blush on the cheeks and said: 'Madam, now it is ready, please come and inspect it.' Having done so she said: 'Yes, that is as it should be.' She was satisfied when it did not resemble her.[14]

The kind of ruined face of the woman who posed for Maes would have been no rarity in the seventeenth century. Many women (and men, for that matter) must have looked like that. It is known that a pockmarked face aroused feelings of shame, particularly in ladies of high birth. Smallpox was a dreaded disease for which there was no cure, and if the sufferer did not die he or she was often left with a scarred face. Yet one very rarely encounters pockmarks or other facial blemishes in seventeenth-century portraiture, so Maes could not possibly have been the only painter who made pockmarks vanish with a wave of his brush.[15]

What is so striking about many women in portraits, and in various depictions of nudes (not usually portraits) is their corpulence. Here, though, there was probably no manipulation of reality, and there was little call to do so. Obesity, fuelled by the daily intake of beer and fatty foods, was no stigma, and the ideal of feminine beauty was far from slender. Rubens's depiction of his bounteously proportioned wife Hélène Fourment in the painting commonly known as 'Het Pelsken' (The Little Fur, fig.27), be it a *portrait historié* or not, speaks volumes, as do various other women painted by Rubens, or by Jacob Jordaens.[16] Not only was a certain degree of corpulence considered sexually attractive, but on a more general level the roll of fat was taken as a sign of wealth. In addition, fleshiness was often associated with fertility.[17] However, the physician Johan van Beverwijck did urge moderation in his authoritative manual *Schat der gesontheit* (Treasury of Health). A woman who wanted children, he warned, should not fatten herself up too much – a piece of advice undoubtedly

prompted in part by the acres of female flesh he had seen in his practice. He added that chickens fattened with too much bread or barley laid few if any eggs.[18]

Van Beverwijck's friend Jacob Cats also used the poultry metaphor in a collection of proverbs and sayings about men and women: 'A hen that's fat and a cock that's thin, that's what's thought to be just the thing.' Cats had more pronouncements about a woman's build in his repertoire. 'There's no better face powder than health and fat', he wrote elsewhere, and on yet another occasion he expressed his admiration for 'a sturdy lass of twenty-six' who was 'fat, fleshy, full-breasted'.[19] A certain amount of chubbiness was also valued in children. Cats's daughter wrote to him in 1630 expressing her satisfaction with her own small girl: 'Our daughter is growing apace, and is steadily becoming large and fat.'[20] The poet and courtier Constantijn Huygens noted approvingly of his daughter Susanna, who had just learned to walk, that she was 'fat and rosy of face'.[21]

Houbraken, who mistook Rembrandt's housekeeper and lover Geertje Dircks for his wife, described her as being 'of comely appearance and plump of frame'.[22] The poet Joost van den Vondel, tellingly enough, uses the same word *poezel* (plump) when speaking pleonastically of *een vette poezel* (a plump fatty) in his description of the personification of *het ongebreydelt Vleysch* (unbridled flesh), one of the Three Temptations, the enemies of the human soul.[23]

As with all the tangible aspects of life, Rembrandt was at home with female flesh. The depiction of nudes was obviously not new in the seventeenth century, and artistic tradition lent it a certain status. That said, some of his contemporaries, perhaps many, found the nude rather problematic. Moralists like Cats did not shrink from dishing out criticism, even of depictions of Biblical and mythological figures in their natural state, and we can reasonably assume that they were not just speaking for themselves.[24] In a society in which women were usually shrouded in textiles from neck to feet, the portrayal of a woman without any clothes on must have had a different effect from that in our society, where nudity is proffered in large, daily doses.

Rembrandt seldom sought slimness. The form he gave Potiphar's wife in an etching of 1634 could lay claim to Vondel's 'plump fatty' label, leaving aside the provocative pose the artist gave her to illustrate her art of seduction (cat.28). Some other etched nudes are, to quote Kenneth Clark, 'embarrassingly fat', and unabashedly display their obesity and flabbiness.[25] *Diana at her Bath* and *A Seated Female Nude*, both executed around 1631, have the physical characteristics that were evidently found attractive in those days: plump shoulders, relatively modest breasts, a very pronounced belly and sturdy legs (cat.10 and 11).[26] Both etchings have often

Fig.25 | Anonymous after Adriaen van de Venne (1589–1662), *Eer is teer* (Honour is fragile), emblem from Jacob Cats, *Maechden-plicht (A Maiden's Duty)*, Middelburg, 1618
Leiden University

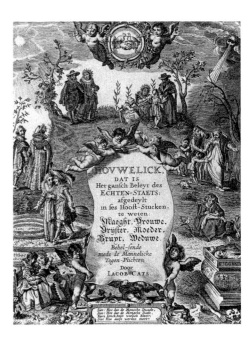

Fig.26 | Adriaen van de Venne (1589–1662), frontispiece from Jacob Cats, *Hovwelick (Marriage)*, 1625. Amsterdam edition, 1642

Fig.27 | Peter Paul Rubens (1577–1640), *Hélène Fourment in a Fur Coat ('Het Pelsken')*
Kunsthistorisches Museum, Vienna

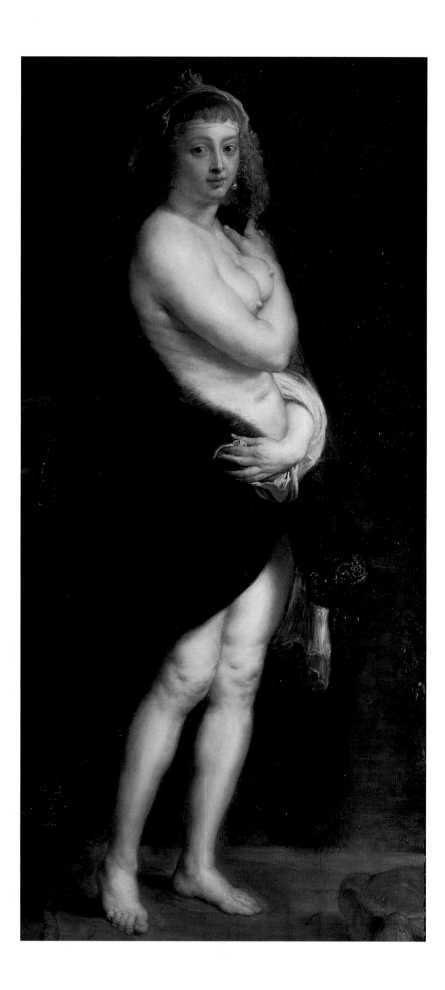

been associated with the censorious lines of verse that Andries Pels penned about Rembrandt's nudes in 1681.[27] As a diehard classicist, he condemned the direct 'imitation of Nature' and disgustedly listed all sorts of details which he considered objectionable, such as flabby breasts, distorted hands and garter-marks on the legs. Oddly enough, he says not a word about corpulence, probably because he had no objection to that in itself.[28]

One can well ask whether some of Rembrandt's painted nudes, among them the famous *Danaë* and *Bathsheba*, lifelike, sensual and unidealistic as they are, could have passed muster in the classicist camp (figs.46 and 48).[29] Classicist critics simply had different criteria from the average seventeenth-century man, whose orientation would have been more sexual than theoretical. If we are right in our assessment (scholarship sometimes demands X-ray vision) some of the clothed women whom Rembrandt depicted had similarly voluptuous figures, such as the *Woman in Bed* with her fleshy face, stocky torso and coarse hands, and the full-figured *Juno* of the 1660s (cat.100 and 140). It does not seem at all audacious to suppose that Rembrandt himself, like many of his contemporaries, had a preference for women with a good bit of flesh on their bones. It should be said, though, that by no means all of the women whose portraits Rembrandt painted were statuesque. Perhaps a touch of slenderness was preferred in the patrician milieu.[30]

It was in part foreign travellers of the sixteenth and seventeenth centuries who acted as proto-anthropologists by describing certain characteristics of Dutch women, not only concerning their appearance but their conduct as well. The model woman of the pious tracts seldom features in their observations. Remarkably, most of the accounts agree by and large, which might indicate that the characterisations are extremely reliable, but this could also be evidence of the contagious cliché. It seems to me that those tags are certainly not absent in the constant reiteration of the entrepreneurship, urge for freedom, carping and assertiveness, pride, imperiousness and even insolence of Dutch women of the seventeenth century. This was the kind of woman, some foreign travellers suggest, that made for henpecked husbands. 'I may boldly say, that the women of these parts [Holland], are above all other truly taxed with this unnatural domineering over their husbands', wrote the Englishman Fynes Moryson at the end of the sixteenth century.[31] That remark reminds one of contemporary satirical literature and stage farces that explored every variety of the topsy-turvy world to great popular delight.[32] One of the favourite clichés, of course, was the legendary cleanliness of the Dutch housewife – a trait which still attracts interest today and has elicited profundities from the historian Simon Schama in his celebrated book, *The Embarrassment of Riches*.[33]

There may be reasons to take the characterisations of the seventeenth-century Dutch woman with a pinch of salt, but that she (or her servant) made a habit of keeping the home neat and tidy can hardly be doubted, although one does wonder whether she was aware of the symbolism – cleanliness associated with spiritual purity – which Schama believes can be inferred from the Dutch mania for dusting, sweeping and scrubbing.

For the sake of balance it is perhaps worth adding that hygiene out on the street was often downright deplorable. In many towns and cities it was compulsory for people (in practice this meant the women) to clean their own doorsteps,[34] but that was often where the cleanliness stopped. Lists of punishable offences show that it was certainly not uncommon for human excrement and urine to be thrown out into the street or a canal, along with 'the carcasses of dead dogs, pigs or other rubbish', or for people to attend to a call of nature in public.[35] Jan Steen depicted this in a painting, with a woman unashamedly relieving herself in the middle of a crowd (fig.28). Steen's scene is not necessarily a depiction of a specific moment, but we do know from documents that such things did happen in the street, although with what frequency it is difficult to judge. Nor can we say how typical the action is of the old crone throwing the contents of a chamberpot out of an upstairs window in an engraving by Hendrick Bary after Frans van Mieris (fig.29).[36]

Many a moralist would have had difficulty with the great independence of Dutch women and the associated activities that took place outside the home. Foreigners visiting the Republic were certainly amazed by it.[37] Their travel journals ensured that this evidently conspicuous characteristic became yet another commonplace. This is not to deny that the independence cliché reflected reality – for there is plenty of documentary evidence to support it. It was, above all, businesswomen who raised eyebrows.[38] They came in different types and operated at different levels. The reason, for example, why seamen's wives (and the Netherlands was a seafaring nation) went into business was partly because their husbands were often away from home for long periods. Legally, a married woman who worked was under the guardianship of her husband and was not considered to be of full legal capacity, which meant that she could not enter into contracts without his permission, or sell goods. In practice, though, this law was more honoured in the breach than the observance, with the tacit acceptance of the authorities. There was certainly a very large number of these 'public tradeswomen', as they were known, and they were not the sort of women who allowed themselves to be forced into a passive role.[39] Widows, incidentally, were considered to be of full legal capacity, as were spinsters when they reached the age of majority.

Many women from the lowest strata of society, for whom the Golden Age was anything but golden, were forced by domestic or family circumstances to go into paid employment. Both married and unmarried women hired themselves out to earn a living as second-hand dealers, bleaching girls, lace workers, spinners, seamstresses or washerwomen, or as domestic servants to the wealthier classes (fig.30). Or they became prostitutes, a booming business, particularly in a port city like Amsterdam.[40] There were more women than men in the second half of the seventeenth century, and that undoubtedly had an adverse effect on the living conditions of working-class women. They were usually paid considerably less than men, no matter how hard they worked.[41]

Middle-class women were also sometimes forced to combine household duties with work, either full- or part-time, especially if they had lost their husbands. Many a widow took over the running of her husband's business, and did so with great drive. Even some grand patrician ladies were involved in the family business in one capacity or another, but then it was more a question of managing the capital of a large, international trading company.[42]

Political life remained hermetically sealed for women, but those from the upper classes did play prominent roles as the governesses of hospitals, orphanages, almshouses and other welfare and charitable institutions (fig.31). In some cases they formed the counterparts of a male administrative body, which could assume the dominant position.

There were also very few openings for women in the various church congregations.[43] Catholics were forbidden to worship in public, and the Reformed

Fig.28 *above* | Jan Steen (1626–1679), *The Peasant Kermis*, *c*.1662–4
Frans Halsmuseum, Haarlem

Fig.29 *below* | Hendrick Bary (*c*.1640–1707) after Frans van Mieris the Elder (1635–1681), *The Old Crone*
Rijksmuseum, Amsterdam

Fig.30 *above*| Jacob Duck (1600–1660), *A Woman Ironing*, 1650–65
Centraal Museum, Utrecht. Photo: Ernst Moritz

Fig.31 *below*| Adriaen Backer (1635/6–1684), *Regentesses of the Civic Orphanage in Amsterdam*, 1683
Amsterdams Historisch Museum, Amsterdam

Church stuck rigidly to the Pauline injunction that women should be silent in church. Yet women refused to be condemned to complete inactivity in the religious sphere. The Catholics had their *klopjes* (lay sisters) who visited parishioners more or less clandestinely, taught catechism and tended the altars in the domestic churches to which the authorities usually turned a blind eye. Even in the Reformed Church, with its often rigid views, women did not permit men to force them into entirely passive roles. Recent research has at any rate demonstrated that there was a disproportionately large number of women in the Reformed Church.[44]

The women who undertook church-related activities would as a rule not have been among the less educated. Many women were still illiterate, but there were quite a few who could read, or both read and write. For the elite, children's education often began at home, and enlightened parents who could afford to do so sent not just their sons to the French School but their daughters as well (fig.32). Girls were barred from the Latin School, which had higher admission criteria.[45] The erudite poet Constantijn Huygens, who gave his children an excellent private education, had his sons taught Latin, the language of scholars, but did not consider it necessary for his daughter Susanna.[46]

Despite all the social obstacles, there was a female intellectual elite – a small number of women who had been given a reasonable education and who had then broadened its scope on their own, often to an amazing degree.[47] They included the two daughters of the Amsterdam humanist and writer Roemer Visscher, Anna and Maria Tesselschade, both talented poets, and the interna-

tionally famed savante Anna Maria van Schurman (fig.33), who had command of no fewer than twelve languages, Greek, Latin and Hebrew among them.[48] This exceptional person corresponded with many male scholars of her day both at home and abroad, and in an unheard-of step was even permitted to attend lectures at Utrecht University, although her presence in the hall was concealed by a curtain. One of Schurman's Latin publications deals with the suitability of the female mind for a life of scholarship and letters. She was not the only one to write a feminist tract; some male authors, too, championed women and their dignity.[49] Schurman was also a dilettante painter and draughtswoman, as were several hundred other women – far more than was thought to be the case until quite recently.[50]

Rembrandt would rarely, if ever, have encountered such educated women, at least not on terms of friendship. Of his partners, all three of whom came from very different social backgrounds, it was only Saskia who fitted the traditional, idealised picture of a wife. She ran the household and bore him children. She was also of good family, her father having risen to become Burgomaster of Leeuwarden. But neither Saskia, who died young, nor the women who followed her, appear ever to have filled roles that required a keen intellect. It is difficult to assess how good an education Saskia had received, but it was certainly better than that of Rembrandt's two other choices of partner.[51]

After Saskia's death it was the illiterate Geertje Dircks who looked after Titus, ran the household and shared Rembrandt's bed until a serious conflict with far-reaching consequences put a drastic end to their relationship.[52] Her younger successor, Hendrickje Stoffels, who also lived with the artist out of wedlock, was a member of the Reformed Church, which summoned her before its council and punished her for 'whoredom', with exclusion from the Lord's Supper. Hendrickje was later to make herself useful by following the example of the 'public tradeswoman' and going into a business partnership with Titus in order to manage Rembrandt's affairs after his massive debts led to him being declared insolvent in 1656.[53]

Rembrandt was not unique in living with someone out of wedlock. It was a practice abominated by the churches, which zealously advocated official marriage ceremonies. The girls, of course, were expected to be virgins. The marriage market was governed by certain rules: one should marry someone of one's own class and preferably of one's own age and denomination. Money and property played a part, sometimes a considerable part, depending on the couple's social standing. Many believed that love should form the basis of a marriage, others more cynically inclined took the line that love was not necessarily an impediment. Generally speaking, there was considerable latitude in choosing a partner, at least among the burgher

class, although minors had to have their parents' permission (men came of age on their twentieth birthday, women on their twenty-fifth).[54] There was less freedom in aristocratic and patrician circles, where major interests were often involved, and the wishes and demands of the parents could clash with their children's ideals concerning affairs of the heart.[55]

Almost every couple wanted to have children, or regarded it as a divine charge. Motherhood, though, and pregnancy in particular, was anything but a bed of roses in the seventeenth century. Infant mortality was very high, with only one child in two reaching the age of five, and many young mothers died in childbirth along with their babies (fig.34).[56] Expecting a baby must have been absolutely terrifying for many women, because they knew the risks involved. Pregnancy was surrounded by superstition, as was so much of life. In some places, a woman who had died in childbirth was carried to her grave by expectant mothers, who hoped that in this way they would ensure themselves of an easy confinement, or at least be spared complications.[57]

The doctor or surgeon could hardly be relied on at critical junctures. Midwives, despite their generally poor reputation, seem to have been far better at bringing a child into the world.[58] Medical science was virtually powerless in the face of the high infant mortality rate, and equally so in alleviating the dangers to the mother. Seventeenth-century physicians simply did not have the knowledge to combat infections and epidemics properly, to say nothing of dealing with gynaecological complications. The ignorance about hygiene, too, had disastrous consequences, particularly for infants and young children.[59]

On average, women had to go through many pregnancies if they wanted to have a few children at the end. The nuclear family in the seventeenth-century Republic (extended family households were rare) was therefore small, consisting of four or at most five people. Couples with many children who reached adulthood were the exception.[60]

That kind of good fortune was not granted to Rembrandt and Saskia. Three of their four children died soon after birth, from a few weeks to two months old.[61] Only their son Titus survived, but even he died two weeks short of his twenty-seventh birthday. He also grew up without a mother, being only nine months old when Saskia died. Many years later Rembrandt was to have an illegitimate child by Hendrickje Stoffels which was christened Cornelia, like two of his deceased children by Saskia. It is not known how long this third Cornelia lived.[62]

After Saskia's death, in other words, Rembrandt was left behind with a baby on his hands. It was a precarious situation, but by no means uncommon. There were many widows with small children, particularly among the wives of sailors who had perished at sea. A widower with an infant, and

perhaps with other small children as well, soon started looking around for someone to help in the household, and preferably as a potential candidate for a new marriage. The wet- or dry-nurse employed to care for the baby usually came from the lower classes, like the trumpeter's widow Geertje Dircks who looked after Titus.[63]

A great deal was written in the seventeenth century about the suckling of children, either by the mother or a wet-nurse.[64] The few aristocratic families in the Republic usually farmed out their infants for suckling, but mothers from the burgher class gave their children the breast themselves, unless they were unable to do so for one reason or another. Rembrandt depicted this maternal activity a few times in drawings (fig.35).[65] Moralists like Cats and the physician Van Beverwijck firmly recommended maternal breast-feeding. 'One who bears her children is a mother in part; /But she who suckles her child is a mother in full', wrote Cats in his *Houwelyck*.[66] Both authors were convinced that drinking mother's milk not only strengthened the bond between parent and child but that the milk transferred some of the mother's character traits to the infant. Cats, in particular, was against hiring a wet-nurse, who, 'often discontented, gives ireful breasts'.[67]

Was the death of a child as painful and traumatic an event as it is today? Social and family historians have been arguing the point for the past few decades, partly in the light of the concept of 'mother love'.[68] The notion that everything is constantly evolving and that human sensitivity is no exception sounds logical enough, but at the same time it has led to some outlandish ideas. The French sociologist Elisabeth Badinter took the view that mother love is quite a recent phenomenon in the history of civilisation. True mother love, she maintains, only originated in the eighteenth century – a temporal demarcation that speaks of a very parsimonious attitude towards preceding generations.[69] There are plenty of Dutch documents from the seventeenth century which give the lie to this categorical assertion.

It should be added, however, that the sources (chiefly so-called ego documents) do not present an unambiguous picture of the feelings that seventeenth-century parents had for their children, particularly in critical situations. In addition to expressions of unmistakable love there is also evidence of a remarkable poverty of feeling, judged by our standards anyway. There were parents who were laconic, even indifferent, in the face of a child's death, yet on the other hand there were those who were inconsolable and displayed a variety of psychosomatic symptoms under the weight of their loss.[70]

We are utterly in the dark about how Rembrandt and his wife reacted to the death of their babies. As far as we know he never depicted them on their deathbeds, nor did he ever portray

Fig.32 | Jacques de Gheyn II (1565–1629), *Mother and Child Studying a Drawing Book*, c.1620
Kupferstichkabinett, Staatliche Museen zu Berlin, Preussischer Kulturbesitz

Fig.33 | Anna Maria van Schurman (1607–1678), *Self-portrait*, 1640
Rijksmuseum, Amsterdam

himself with his wife and child.[71] But as a draughts-man he was attentive to his wife's pregnancies, and on one occasion of her fresh young motherhood.[72] One of his drawings shows Saskia in bed with a bassinet on the floor beside her as a sign of her anticipation of the happy event (cat.77). Another sheet bears four studies of Saskia, in two of which she (very cursorily indicated) clasps a reclining child to her breast. This must be Rumbartus, who was baptised on 15 December 1635 – a date that agrees stylistically with the time the sketch was made (cat.61).[73]

Further evidence of an interest in pregnancy or birth might be provided by Rembrandt's depictions of Flora. This is raised here as a mere hypothesis, in the full awareness that one should generally guard against reading biographical information from works of art.[74] Is there a connection between the pregnancies or motherhood of Saskia and Hendrickje and this specific iconography? The works in question are several paintings on which opinions differ. Are all these flower-laden women meant to be the goddess Flora, and do they or do they not have the features of Saskia or Hendrickje?[75] For the purposes of the hypothesis we will assume that they are all Floras in her role as the goddess of fertility, and that the figures are graced with at least some of the lineaments of Rembrandt's women. An annotation by the master on the back of a drawing shows that the name 'Flora' was certainly well-known in his workshop.[76]

It seems hardly coincidental that the dates of three of these Floras, those of 1635 (cat.36), 1641 and 1654 (fig.144 and cat.119), coincide roughly with the births of Rumbartus, Titus and the third Cornelia, or with the preceding pregnancies. What is intriguing is that the *Flora* of 1635, which clearly has Saskia's features, was originally conceived as Judith with the head of Holofernes, and that the artist decided to change the subject halfway through.[77] That he replaced the bloodthirsty Judith with the charming, fecund Flora must, in my view, be connected with the birth or impending birth of Rembrandt's and Saskia's first child. Rembrandt's floral offensive actually began in 1634, the first year of their marriage, and that too can surely be no coincidence. It was in that year that he painted his first, very flowery *Flora* (cat.27).[78] After Titus's birth in September 1641 there was a babyless and Flora-less interlude of thirteen years, which ended when Hendrickje was either carrying or had just given birth to Cornelia in October 1654. Flora then became relevant once more.

In the light of our hypothesis one is struck by the antithesis between the auspicious figure bearing flowers and the vain attempts to beget viable progeny, quite apart from the early death of Saskia herself. There is also the stark contrast with the large number of magnificent fruits which Rembrandt's fourth woman, Lady Pictura, bore for him, and thus for us, their public heirs.

Fig.34 | Bartholomeus van der Helst (1613–1670), *Dead Child*, 1645
Museum St Catherine's Hospital
Collectie Stedelijke Musea, Gouda

Fig.35 | Rembrandt, *Study of a Woman Seated on the Ground Suckling a Child*, c.1646
Nationalmuseum, Stockholm

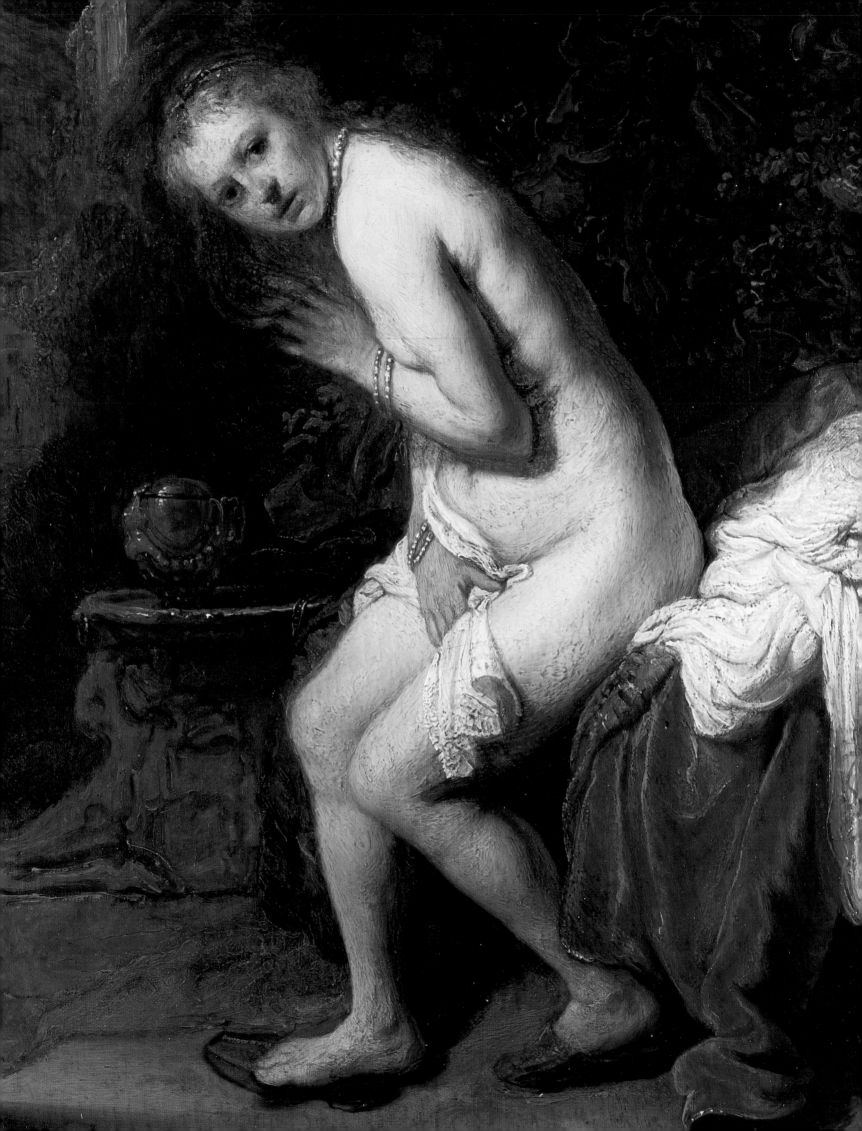

'Horrible nature, incomparable art': Rembrandt and the depiction of the female nude

ERIC JAN SLUIJTER

At the beginning of the eighteenth century, when Arnold Houbraken devoted a passage in his biography of Rembrandt to the latter's portrayals of the female nude, he first stated that naked women were 'the most glorious object of the artist's brush' and had been depicted by the most renowned masters since time immemorial.[1] This introduction, however, is followed by devastating comments on Rembrandt's nudes: they are too pathetic for words – disgusting, no less – and, he maintains, it is surprising that such a great man could be so obstinate as to depict them thus. He adds that Rembrandt took the same view as Caravaggio (1571–1609/10), who, according to Karel van Mander (1548–1606), is supposed to have said that one should only imitate nature, anything not painted from life being a futility.

Houbraken was by no means the first to voice such criticism and he would certainly not be the last. That he combines his criticism with an explicit reference to the ideology of Caravaggio, as well as with the idea that all great masters have painted the female nude because this is the loftiest aim a painter can strive for, makes his commentary, as we shall shortly see, very enlightening indeed. Like Houbraken, Rembrandt, too, must have been well aware of the special prestige enjoyed by this tradition: everything points to the fact that rivalry with the celebrated painters of the past was of great importance to Rembrandt as regards this kind of subject matter in particular. In painting the female nude he hoped to secure a place among the greatest in his profession.

Why, then, did the outcome vary so much from the prevailing conventions, with the result that for centuries his nudes were found distasteful? Were Rembrandt's nudes a subject of controversy in his own day or, as has been continually stated in recent decades, did they become controversial only after his death, by which time theoretical views of art and beauty had changed?[2] To begin answering these questions we shall first have to follow Rembrandt's earliest steps in the field of the female nude, a field that has traditionally been full of pitfalls in the history of Western art, not least because of the sexual overtones implicit in male observation of a nude female body portrayed by, and for, men.

When Rembrandt made his first appearance around 1630/1 as a painter of the female nude with his depiction of *Andromeda* (fig.36), which was also his first painting of a mythological subject, he was no doubt well aware of his many illustrious predecessors who had already depicted this theme.[3] In portraying Andromeda Rembrandt chose a subject which, more than any other representation of a nude, had been frequently depicted in prints at the end of the sixteenth and beginning of the seventeenth century by the renowned Hendrick Goltzius and artists of his circle (fig.37).[4] Rembrandt would also have learned from reading

Karel van Mander's biography of the admired Titian that this great master of the nude had painted a famous *Andromeda*, and he probably knew a print of this composition as well. And from hearsay he might have known that Rubens had even painted the subject on the garden façade of his house. Moreover, from Van Mander's biographies of painters of antiquity, he could have heard of the erstwhile existence of a naked Andromeda by the celebrated Greek painter Nicias.[5]

Its traditional pictorial scheme – Andromeda chained to a rock, rendered frontally as a nude figure forming the focal point of the composition – made it the perfect subject for an artist who wanted to show off his ability at depicting naked female beauty. The four engravings after designs by Goltzius, therefore, provide fine examples of his ideas regarding the portrayal of the anatomy and proportions of the female body, ideas which changed radically during the course of his career.[6] That the subject could function as a kind of showpiece was probably an important reason for Rembrandt's choice of Andromeda for his first nude. In addition, it was a distinctly 'exciting' subject that demanded the rendering of powerful emotions, something that occupied Rembrandt intensely during this period.[7] Besides, the Andromeda theme is a prime example of a subject with great erotic appeal, featuring a young woman famous for her beauty, who finds herself in an extremely distressing situation: chained up and threatened by a ghastly sea monster. The hero of the story, who falls in love the moment he sees her naked, fettered body, will save her at peril to his own life.

Because the overall design of Rembrandt's composition conformed with the basic scheme usually seen in representations of Andromeda, the effect produced by the deviations was all the more powerful. By leaving Perseus' battle with the monster 'out of the picture' – something that had never been done before – and having Andromeda react to something we cannot see, Rembrandt created a strong feeling of suspense.[8] The most striking feature, however, is the fact that Andromeda's naked body is not idealised in the slightest, in stark contrast to all the examples of this subject which Rembrandt could have known.[9] In Rembrandt's painting there is no trace of the customary, elegant contraposto. Rembrandt visualised what her attitude could actually have been. Andromeda's body moves in a tense curve away from the monster, and her arms, tied together at the wrist, twist in a painful and far from elegant manner. The expression of fear is therefore more intense than in any earlier depiction of this subject. The very fact that the well-known compositions by Goltzius would have been the main point of reference, for Rembrandt as well as for connoisseurs of that time, clearly shows just how radical the deviations are. In contrast to what we observe

in Goltzius, here we see a body completely lacking in stylisation, whose narrow upper body, twisted arms, breasts hanging to the side, hefty hips and bulky, protruding stomach all suggest that it was observed from life.

The pointed rejection of what was customary must have been a conscious choice on Rembrandt's part and would have been recognised by connoisseurs as something completely new.[10] Rembrandt used all the means at his disposal to intensify the viewer's empathy. The lack of stylisation results in the nude being brought much closer to the viewer's sphere of perception. It strengthens the impression of the girl's helpless vulnerability, which Rembrandt further heightened by highlighting her naked body against the dark and threatening background. The texture and colour of her skin – contrasting sharply with the hard, rough rocks – makes the fragility of human skin almost palpable. Rembrandt strove to suggest the skin of a living being by means of subtle shifts in tone, making use of visible brushstrokes that follow the bodily forms. In his first nude Rembrandt succeeded, even in this small format, in suggesting a nearly tangible female body.

In the same period or slightly later, Rembrandt produced two famous etchings from nude models (cat.11 and 12). It is these etchings in particular that have been regarded with aversion over the years, eliciting, for instance, the following response from Kenneth Clark: '[They are] some of the most unpleasing, not to say disgusting, pictures ever produced by a great artist.' The portrayal of *Diana*, of which there is also a preparatory drawing (cat.10), probably originated first.[11] When drawing this nude, Rembrandt must have had several renowned prints in mind (which he probably owned himself). An etching of *Susanna and the Elders* by Annibale Carracci (fig.38), an etching by Willem Buytewech (fig.39), as well as Buytewech's immediate example, a print after a composition by none other than Raphael (fig.40)[12] – the last two representing Bathsheba at her toilet – were his respectable predecessors. Rembrandt, however, characterised her as Diana bathing in the woods by adding water, background greenery and a quiver.[13] She sits not on a nondescript drapery but on an undergarment whose cuff hangs down, which strengthens the impression that she has just undressed.

Placing the nude in this context has distinctly voyeuristic implications for the viewer, because any art lover familiar with the conventions of painting and printmaking who saw an undressed Diana bathing would immediately recall the popular representation in which Actaeon spies on the naked Diana and her nymphs, a subject that Rembrandt would also depict a few years later in a painting.[14] This means that the viewer sees a woman, who – just like Bathsheba and Susanna, likewise spied upon while bathing – arouses 'forbidden' desires in

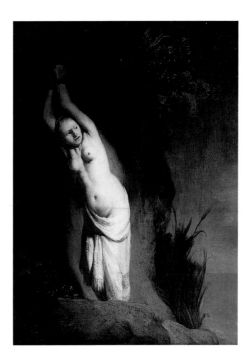

the person beholding her.[15] Thus, the most popular subjects that include female nudes are about the 'dangers' of seeing things one should not see.

At the same time, this Diana is nevertheless expressly depicted as the model the artist had posing for him. She seems to be acknowledging the viewer's gaze without reacting to it with anger or fear, as Diana would. The artist apparently wants to underscore the fact – and this is more strongly emphasised in the etching than in the drawing – that he has closely observed a specific woman's body and is showing us exactly what he saw. With the etching needle Rembrandt has suggested, just as he did with paint in the case of *Andromeda*, the texture of skin in a way not previously demonstrated. Connoisseurs would have recognised this as a direct challenge to Annibale Carracci and Willem Buytewech, who preceded him in the rendering of naked figures' skin by means of an innovative, experimental etching technique.[16]

As far as the suggestion of soft, curvaceous flesh is concerned, Rembrandt went one step further in *A Seated Female Nude* (cat.12).[17] He modelled the body with extremely subtle gradations of light and shade and faithfully recorded every crease and wrinkle in the skin. Once again, the clearly visible sleeve of an undergarment indicates that this woman is not naked by nature but has just undressed for the artist drawing her; she looks him directly in the eye, and via him the viewer of the etching. Both the immediate confrontation created by her gaze, and the strong feeling that she is not really nude but merely undressed, distinguish her from the illustrious sisters whom she emulates and with whose draughtsmen Rembrandt was engaged in a dialogue: in the first place we again recognise in

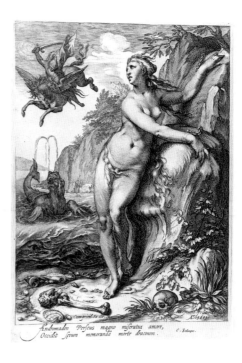

Fig.36 *left* | Rembrandt, *Andromeda*
Mauritshuis, The Hague

Fig.37 *right* | Jansz Saenredam (1597–1665) after Hendrik Goltzius (1558–1616), *Andromeda*
British Museum, London

Fig.38 | Annibale Carracci (1560–1602), *Susanna and the Elders*
British Museum, London

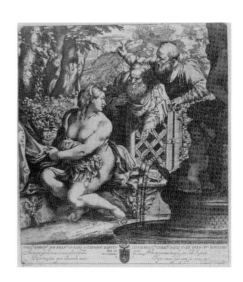

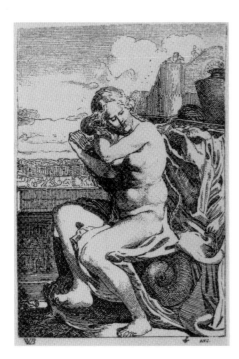

Fig.39 | Willem Buytewech (c.1591–1624),
Bathsheba
Rijksmuseum, Amsterdam

Fig.40 *left* | S. Badalocchio (1585–after 1621?) after Raphael
(1483–1520), *David Observing Bathsheba in her Bath*, in *Historia
del Testamento Vecchio*, 1607 (detail)

Fig.41 *centre* | Jacopo Caraglio (c.1500–1565) after Raphael
(1483–1520), *Alexander and Roxanne*
British Museum, London

Fig.42 *right* | Wenceslaus Hollar (1607–1677) copy after
Rembrandt, *Seated Female Nude*
British Museum, London

a number of aspects Annibale Carracci's *Susanna*,
but her attitude recalls most of all *Roxane*, the bride
of Alexander the Great, as she appears in a print by
Jacopo Caraglio after a drawing by Raphael
(fig.41).[18]

Just as in *Diana*, the mound of earth and the
cursorily indicated greenery suggest that this
woman – like Susanna, Bathsheba and Diana – is
sitting outside in an undressed state. The support
of a recognisable subject has, however, been
omitted; it is left to the viewer to see her as either
Susanna, Bathsheba or Diana (with all the accom-
panying voyeuristic implications) or simply as a
model posing. In the latter case the viewer would
have considered her to be a faithful portrayal of a
dissolute woman, presumably a prostitute.[19]

A clothed version of *A Seated Female Nude*
(cat.12) is to be seen in a painting, dated 1633, of a
woman at her toilet, dressed in a sumptuous,
fantasised costume and draped with jewels
(cat.20).[20] Her figure – the narrowness of the upper
part of her body giving way to the enormous
sprawl below – is also the same. If we imagine her
undressed, then the lower part of her body is, if
possible, even more massive than that of the nude.
We also see this silhouette in the portrait of *Oopjen
Coppit* (fig.17), the most fashionable and repre-
sentative portrait of a young woman that
Rembrandt made in this period. Anne Hollander,
commenting on the etchings discussed above, is
probably right in saying that 'the intention to make
these bodies look not only "realistic" but
specifically desirable is conveyed by their resem-
blance to the currently modish clothed look for
ladies: high waistline, plump but narrow shoulders,
huge stomach, and lots of rippling texture – in
these instances flesh not silk.'[21] Thus Rembrandt
suggests not only that the outward appearance of
these young women has been faithfully portrayed
from life, but also that their bodies, precisely where
they deviate from classical proportions, conform to
the bodily shapes that a viewer of that period found

attractive (compare for instance also cat.31 and
cat.36).

In these etched studies from a nude model
Rembrandt, competing with his illustrious
predecessors, was striving to exhibit, by means of
the etching technique, his unparalleled virtuosity
in the lifelike depiction of a female body that gives
the viewer a feeling of close proximity and
directness. Rembrandt's success in this endeavour
is apparent from the copy made by Wenceslaus
Hollar in 1635 (fig.42). Hollar, however, found it
necessary to tone down the effect of directness by
making the body's surface smoother and giving the
figure a more statuesque character by means of
sharper contours.

Several years later, in his painting of *Susanna and
the Elders* of 1636 (cat.69), Rembrandt continued
along the path he had taken with the *Andromeda*,
using all the means at his disposal to portray and
evoke powerful emotions in a narrative painting.[22]
In depicting *Susanna* he chose a subject that was the
most popular vehicle for the depiction of the
female nude and one that explicitly treated the
forbidden act of spying on a young, chaste beauty
who has taken off her clothes to bathe, thereby
unwittingly arousing the basest desires of those
spying on her, the lecherous elders who will
eventually be punished with death. The viewer,
who in fact finds himself in the same position as the
spies *in* the picture (though with a much better
view of Susanna), need fear no punishment for
enjoying this beauty, traditionally considered a
prime example of threatened chastity. That sensual
delight was the subject's greatest attraction is
corroborated by the playful identification with the
elders found in a letter from the English ambassa-
dor to The Hague, Sir Dudley Carleton, who wrote
to Rubens that he hoped the *Susanna* he was
making would be so beautiful that she could even
make old men fall in love with her.[23]

Countless great painters had portrayed this
subject before, and Rembrandt would have been

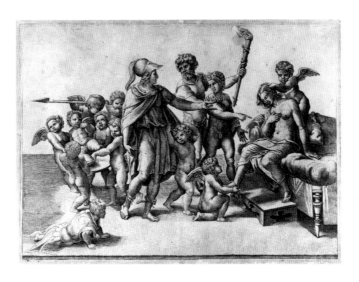

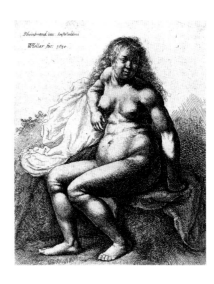

familiar with prints of various compositions by Hendrick Goltzius, Cornelis Cornelisz van Haarlem and Peter Paul Rubens, as well as the famous etching by Annibale Carracci mentioned earlier (fig.38).[24] A composition by his teacher, Pieter Lastman, was the immediate point of departure (fig.43), but it must have been the compositions by Rubens in particular – especially the invention engraved by Lucas Vorsterman – that challenged him the most (fig.44). It was Rubens he wanted to surpass in the credibility of Susanna's reaction. Rubens's attempt to involve the spectator directly by having Susanna turn towards the viewer must have been an important stimulus to Rembrandt.

More pointedly than any painter before him, Rembrandt placed the viewer in the position of a spying elder. Susanna seems suddenly to be startled by something she hears – a rustling sound, for example, or a twig snapping. She does not see the men hiding in the shrubbery behind her. Rembrandt made the elders nearly invisible,[25] so that Susanna seems to be alone. All attention is concentrated on her. Susanna tries to cover herself, turning the upper part of her body away from the viewer. Attempting to stand up, she gives an impression of wavering imbalance, which emphasises the sudden agitation of her reaction. She turns with large, startled eyes towards the spectator, whom she confronts as the intruder who has frightened her into hiding her naked body. Even more strongly than in the *Andromeda*, Susanna's vulnerable helplessness is underscored by the isolation of her brightly lit body against the dark background. She is, as it were, the terrified captive of the viewer's gaze. The moral implications are hereby heightened, but at the same time the tension created by this erotically charged moment comes more powerfully than ever to the fore.

Susanna's skin, modelled in rather impastoed paint, is – even more so than that of Andromeda – almost palpably lifelike. The fact that Rembrandt incorporated into her attitude a very classical pose stemming from antique sculpture affirms all the more strongly his conscious rejection of any idealised stylisation of the naked body.[26] The by no means classical proportions of the body, which do, however, follow the shape of the fashionable silhouette, suggest a highly lifelike quality.

The awareness that a lifelike quality increases the involvement of the viewer, especially in the case of erotically charged paintings, was powerfully expressed at this time by Jacob Cats, whose moralistic poetry enjoyed great success. When Cats warns in *Houwelyck* (Marriage), his bestseller of 1625, against the titillating effect of paintings of female nudes, he adds that the better a painter is, and the more realistic his portrayals are, the more he confuses the mind of the viewer and the more serious the consequences.[27] Such moralistic concern was obviously not shared by Joost van den

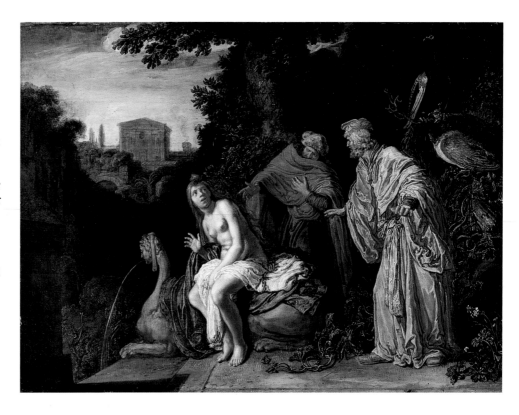

Vondel in a witty poem about a painting (unfortunately unknown) representing Susanna, in which he speaks appreciatively of the stimulating effect this highly lifelike depiction has upon the viewer. After an enraptured description of her body – one could not help wanting to kiss her on the mouth, for example – he asks whether lifeless paint is capable of kindling such love and desire in us. He answers, of course, in the affirmative, pointing to the painter as the one guilty of producing this jolting effect: it is indeed as if one beholds Susanna in the flesh. Vondel hereby humorously turns the moralist Cats's warning into a reason for praising the painter.[28]

In a related poem by Jan Vos, in which he emulates Vondel, we detect, moreover, the writer's fascination with the immoral model whom the painter observed nude and portrayed true-to-life: to depict Susanna's beauty as convincingly as possible, it was necessary to portray an unchaste woman, remarks Vos. However, he states reassuringly, the depiction is only a semblance of reality, and therefore we do not have to fear the 'poison of her heart'.[29]

The more true-to-life the nude, the stronger the suggestion that one is seeing the specific – immoral – woman who posed for the painter. While this can in fact heighten the titillating effect, it makes the portrayal more problematic.[30]

As we have observed, Rembrandt's choice of subject matter was based on a keen sense of competition with his great predecessors, whom he endeavoured to surpass in the lifelike quality of his

Fig.43 | Pieter Lastman (1583–1633),
Susanna and the Elders
Gemäldegalerie, Staatliche Museen zu Berlin, Preussischer Kulturbesitz
Photo: Jörg P.Anders

Fig.44 | Lucas Vorsterman (1595–1675) after Peter Paul Rubens (1577–1640), *Susanna and the Elders*
Rijksmuseum, Amsterdam

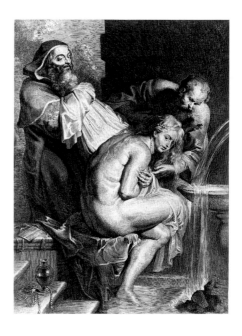

nudes, depicting subjects with a marked erotic content. In *Andromeda* and *Susanna* he used this optimal suggestion of a nude portrayed from life to express emotions in the most powerful way possible and to induce the maximum amount of involvement on the part of the viewer. That this was in fact Rembrandt's main objective is confirmed by a sentence he wrote in a letter to Constantijn Huygens, in which he expresses his desire to render the greatest possible naturalness in emotions and gestures.[31]

Houbraken's statement that Rembrandt, like Caravaggio, was an adherent of painting 'from life' – thereby referring to Van Mander's phrasing of Caravaggio's ideology – certainly has to be taken seriously. When, shortly after Rembrandt's death, Jan de Bisschop and Andries Pels were the first to give vent in writing to fierce criticism of Rembrandt's nudes, stating that Rembrandt was unshakeable in his belief that 'life' provided the painter with the best and most perfect example, there is also no reason to doubt their words.[32] A justification for this ideology was even found in anecdotes from classical antiquity, to which one often turned because of its great prestige. It is telling indeed that Van Mander closed his chapter on the portrayal of the emotions with a reference to the painter Eupompus, who, according to the biography that Van Mander adopted from Pliny, supposedly said that one ought not to follow the example of the ancients but rather the examples seen around one, pointing to the men, women and children on a market square.[33] These words resound in the intentionally controversial statement made by Caravaggio and cited by Van Mander: anything not done from nature is a mere 'bagatelle, child's play or trifle', one only has to imitate life in all its diversity. He – Caravaggio –

never took up his brushes without having 'life' before his eyes. Van Mander, who must have heard this from an artist just back from Italy, added that this was all well and good, but first one had to learn to distinguish the most beautiful in nature.[34] Van Mander is therefore very ambivalent about this extreme standpoint and finds that both methods must be combined: working from nature and choosing the most beautiful through studying antiquity and other great examples.[35]

The debate about these two methods was already underway before Caravaggio took his stand, and continued afterwards as a focus of discussion in many an artist's studio. The difference between, roughly speaking, the line as the expression of the invention originating in the mind, which selects the most beautiful and the most exalted that nature has to offer, as opposed to the achievement of the most natural and lifelike expressiveness by means of painting from life, was first clearly formulated – in writing, that is – by Vasari after he and Michelangelo had seen a painting of the naked *Danaë* by Titian (fig.45). His account of the confrontation between these two differing views was adopted in its entirety by Van Mander. Vasari wrote that Michelangelo had had high praise for Titian's manner of colouring, but afterwards said what a pity it was that Venetian painters did not learn to draw properly and did not study examples: because, he said, there would have been no better painter than Titian if he had profited as much from studying the art of drawing as he had from making studies from nature and painting from life, for his manner of painting was very lifelike and natural. Vasari himself added to this (and Van Mander repeated it) that if one does not practise drawing and make frequent studies from fine examples, both antique and modern, one can

Fig.45 *left* | Titian, *Danaë*
Museo di Capodimonte, Naples.
Photo:© Lucaiano Pedicini / Archivio dell'arte

Fig.46 *right* | Rembrandt, *Danaë*, 1636
State Hermitage Museum, St Petersburg

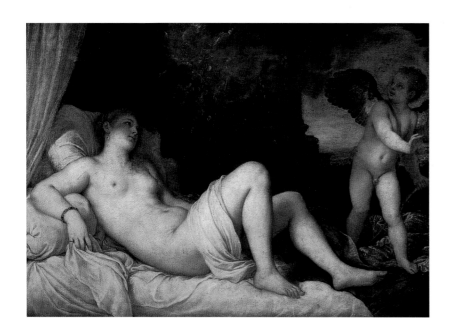

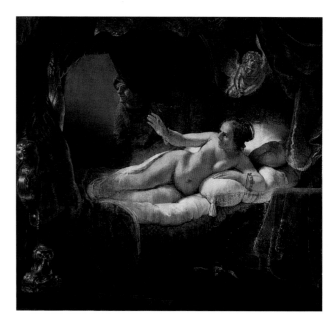

never make anything perfect. Nature, after all, is not perfect; the knowledge of art is necessary to give it beauty and grace.[36]

This, in a nutshell, articulates the controversial standpoint that from this time on will attract both supporters and detractors, Titian being the epitome of painting 'from life', whose point of departure was light and colour instead of line. In Titian's biography, Vasari had already described – and this is also to be found in Van Mander – how Titian had developed a working method in which he completely bypassed the drawing stage and straightaway started painting from life. Vasari seriously disapproved of this method, but Van Mander did not repeat his censure.[37] 'Lively', 'seems to be alive', 'naturally fleshlike' and 'like reality' are notions we often encounter in Titian's biography, which must have been a great source of inspiration for a painter like Rembrandt.

After Vasari's discussion, painters could choose sides in this dispute, and we have already seen with what vehemence Caravaggio did this, Van Mander being the first to record Caravaggio's much talked-of standpoint. The heated discussions this caused in Rome during the first decades of the seventeenth century emerge, for instance, from statements made by Giovanni Baglione, a contemporary of Caravaggio. Baglione had to admit that Caravaggio's palette was wonderful and of great naturalness. But because Caravaggio always painted everything completely from life, the result was banal, lacking in everything that is essential to great art. Caravaggio himself thought he had surpassed all other painters, Baglione writes, but others were of the opinion that he had ruined the art of painting, because many younger artists had followed in his footsteps; they had not acquired sufficient knowledge of the fundamentals of drawing and were satisfied with working from life and taking delight in their choice of palette. To his sorrow Baglione had to admit that the finest connoisseurs of that time greatly admired Caravaggio's work.[38]

This controversy would have been taken back to the Netherlands by Rembrandt's teacher Pieter Lastman and all the others who visited Rome in the first decades of the seventeenth century. Unfortunately, practically nothing was written about art during this period in the Netherlands, but we nevertheless catch a glimpse of the fierceness with which this battle was waged in a curious pamphlet written by Jacques de Ville in 1628. De Ville furiously attacks painters who work only from life, have no notion of the art of drawing and attach importance only to a special manner of painting. He addresses himself just as scathingly to art lovers who gape in admiration at such a manner of painting and are willing to pay large sums of money for it.[39] In Lastman's studio, whither the young Rembrandt went in the first half of the 1620s, such issues would have been discussed frequently, and in

the following decades the adherents of the various standpoints would only have become more set in their opinions.

An echo of this is to be found in Joachim von Sandrart (1606–1688), who was in Rome in the first half of the 1630s, subsequently living in Amsterdam from 1637 to 1645. He must have had a lot of contact, first, with the painters' community in Rome and, later, with the most prominent painters in Amsterdam, including Rembrandt. The discussions taking place at that time resound in the words of Von Sandrart, who wrote much later in life about Caravaggio and Rembrandt. Von Sandrart uses the same kind of expressions when discussing both Rembrandt and Caravaggio. Rembrandt, too, supposedly said one ought only to follow nature and should not be bound by any other rules. Without worrying about clean contours, he was nonetheless able to portray superbly the simplicity of nature through the harmonious rendering of light and the use of natural effects in his colouring. Rembrandt could 'break' the colours very subtly and artfully, depicting the true and lifelike singularity of nature as though it were life itself. He hereby opened the eyes of many who, Von Sandrart states, tended to 'colour in' rather than paint.[40]

Clearly, similar terminology is used when Titian, Caravaggio and Rembrandt are ranged against the academic 'disegno' ideal. It reveals the terms used to discuss the various manners of working, and it would have been in such terms that the painters themselves – such as Rembrandt and his school on the one hand, and the group now baptised the Dutch classicists on the other – viewed the objectives of their art.[41] Certain passages of the treatise written many years later by Rembrandt's pupil Samuel van Hoogstraten also appear to reflect discussions that took place in the period of his apprenticeship in Rembrandt's workshop during the first half of the 1640s. For example, he twice repeats Vasari's story about Michelangelo's opinion of Titian's *Danaë*, which suggests that during Van Hoogstraten's apprenticeship, at the very time Rembrandt was working on his own spectacular *Danaë*, the story was a subject of heated debate.[42] Van Hoogstraten, who, during the course of his career as a history painter converted from a Rembrandtesque style to a classicising manner, says he would prefer not to judge, for 'their methods and views were very different': some think it best to concern oneself only with things beautiful, whereas others believe that everything created by nature is worthy of attention. Both schools of thought have their merits.

The side Rembrandt chose is obvious, and his decision to take Danaë as the subject of his first life-size nude therefore acquires the character of a manifesto (fig.46).[43] Besides, during the course of the sixteenth century, the portrayal of Danaë came to be seen as the prototype of a representation

Fig.47 | Jacob van Loo (*c*.1615–1670), *Awakening Iphigenia Observed by Cymon*
Kunsthandel Hoogsteder & Hoogsteder, The Hague

whose aim was to stimulate the viewer's senses; there was, after all, a well-known story from classical antiquity in which the mere sight of a painting of Danaë excited a young man to such an extent that he raped a girl he was in love with.[44] This made it the perfect subject for painters who wished to compete with one another in the portrayal of as lifelike and sensuous a nude as possible. It is certainly no coincidence that the Danaës by Correggio, Titian and Rembrandt are among the most sensual nudes in the history of European art.[45] By painting a life-size female nude Rembrandt was placing himself in an illustrious tradition, going back to classical antiquity and revived in Italy, which, since the time of Apelles, could be seen as the loftiest ambition of every painter. By choosing this particular subject at a crucial moment in his career – he began the painting in 1636 and completed it in the first half of the 1640s – he was siding demonstratively with those convinced that a maximum of lifelikeness could be created by means of colour and light.[46] In addition, it gave him the opportunity to compete in the representation of sensual beauty with a legendary painting from classical antiquity, as well as with the famous Danaë by Titian, the greatest master in the field.[47]

More so than in Rembrandt's previous paintings, we see in his Danaë how he models the body by means of subtle nuances of colour that melt into one another and clearly visible paint texture.[48] He had now surpassed even Titian in the convincing suggestion of palpable, breathing skin.[49] Because the nude was life-size – this fact alone gives it a much greater feeling of proximity – Rembrandt depicted the bodily shapes in a more stylised manner than in his earlier paintings. But here as well we see very unclassical elements, by means of which he shows that his immediate point of departure was a living model: the squat proportions, the soft stomach sagging slightly to the side and the breast pressed upwards by the hand are all elements not found in other Danaës or recumbent Venuses. These traits underscore the naturalness and approachability of Danaë's naked body. Rembrandt banned all unnatural elements from the picture by changing the shower of gold coins (traditional since Titian) raining down on Danaë – the golden rain into which Jupiter transformed himself – into a beam of glowing light.[50] The lover whose passion and desire have been aroused by Danaë's beauty is announced only by the warm, sensual light that she welcomes with joy. Rembrandt has done everything in his power to elicit a response of sensual rapture.

In the 1620s and 1630s Dutch painters hardly ever portrayed life-size female nudes, but Rembrandt's Danaë marks a new development in this respect. Starting in the 1640s various Amsterdam painters applied themselves to this subject, and they seem to have been competing with one

another for the favour of collectors from the Amsterdam elite. One of the painters who specialised in representations of nudes was the slightly younger Jacob van Loo. When making his painting of the Awakening Iphigenia Observed by Cymon (fig.47), he took the pictorial scheme of Rembrandt's Danaë as his point of departure, and he undoubtedly did so to emulate Rembrandt in the rival working method based on drawing. Here the naked body is drawn with clear and precise contours and modelled with rather uniform illumination and smooth, invisible brushstrokes, whereby the clearly outlined forms are, as it were, 'coloured in'. In Van Loo's painting there is no accidental distortion and the bodily shapes and proportions are considerably more classical.[51] Although in our eyes Van Loo had no chance against Rembrandt, he did have more success with the subject, considering the number of nudes he painted. This was not because Rembrandt's exceptional qualities were not recognised, but because a nude in this 'classicising' style was less disturbing and therefore less problematic. Most people who wanted a life-size nude would probably have preferred one by a painter like Van Loo.

While Rembrandt's Danaë is one of the most sensual nudes in European art – something thoroughly in keeping with the nature and origin of the subject – his last painting of a female nude, the Bathsheba of 1654 in the Louvre (fig.48), is probably the most impressive. As mentioned above, the representation of Bathsheba is again a theme involving bathing and being spied upon by a man whose desire has been aroused. Ever since it was mentioned by the church father Jerome, this story has been cited as a preeminent example of the danger inherent in viewing naked beauty. Moreover, the portrayal of this subject became the Biblical prototype of a titillating representation. Since Erasmus had specifically mentioned Bathsheba as an example of a Biblical subject one ought not to paint, because seeing such paintings can only lead to sin, sixteenth- and seventeenth-century moralists often referred to it.[52]

As early as the sixteenth century Bathsheba was a much-loved subject in the Netherlands, but around the mid-seventeenth century it appears in large format in the work of such painters as Pieter de Grebber, Jacob van Loo, Jan Gerritsz and Johannes van Bronckhorst (fig.49).[53] The naked Bathsheba, more than any other subject featuring female beauty, must have been seen as the perfect challenge to painters. Unlike Venus, Diana, Danaë or Andromeda, she caused more than just pagan gods and mortals to take leave of their senses, and, unlike Susanna, it was not just foolish elders who found her beauty irresistible: it was the Biblical paragon of piety and steadfastness, the king of kings, who, upon beholding Bathsheba's beauty, could no longer control himself and fell from grace.

In Rembrandt's Bathsheba the spying king is

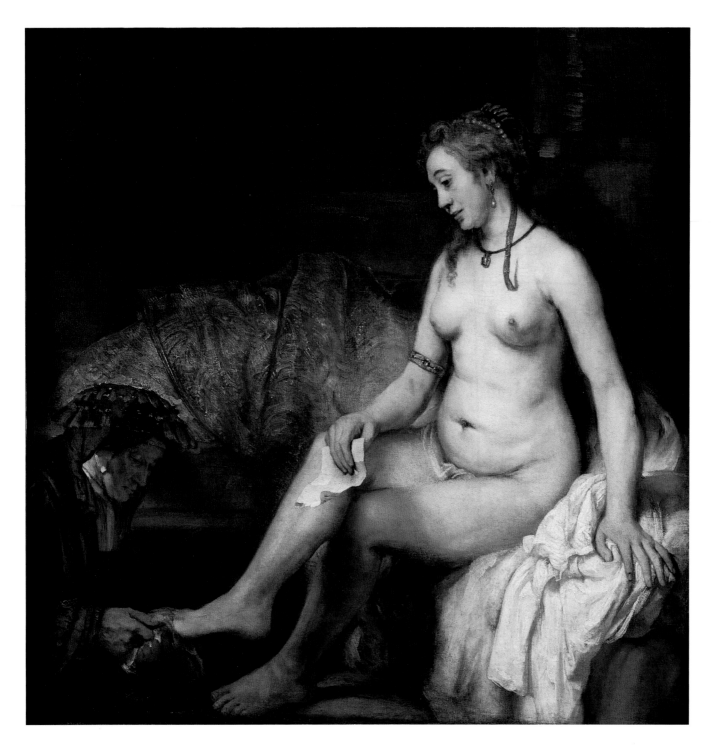

absent, causing the viewer himself to become the 'David' who beholds her.[54] Everything is aimed at producing a feeling of palpable proximity and corporeality. Bathsheba's body has been brought as 'close' as possible to the viewer: her left hand and right foot seem only centimetres from the picture plane. Never before had the naked body formed such a dominant presence. Only the shimmering gold brocade of her cloak gives the viewer's gaze the occasional chance to focus on something else. Moreover, unlike earlier Bathshebas, this depiction

lacks any indication of narrative action – there is no intimation whatever of movement or physical tension – so that there is nothing to distract the eye of the viewer from exploring her naked body.

Although Rembrandt would have been consciously striving to surpass all his predecessors in the rendering of the greatest possible lifelikeness in the portrayal of the epitome of female beauty, this was certainly not his only – and perhaps not even his most important – objective in painting this subject. Bathsheba's pensive expression and the

Fig.48 | Rembrandt,
Bathsheba with King David's Letter, 1654
Musée du Louvre, Paris
Photo: RMN-Hervé Lewandowski

Fig.49 | Johannes van Bronckhorst (1603–1677),
Bathsheba at her Toilet
Palazzo Barberini, Rome / Bridgeman Art Library

conspicuous letter in her hand compel the viewer to empathise with her. The letter, which had become a convention in depictions of this subject, is here emphasised as never before, placed as it is in the centre of the painting with the unfolded page reflecting the bright light. By this means the viewer's attention is riveted on what cannot be visualised: Bathsheba's thoughts regarding David's request. The letter indicates that Bathsheba knows she is being observed and is aware of the consequences of her beauty. The viewer is thus forced to reflect on her thoughts and the choice she must make: either she chooses to forsake her virtue (according to seventeenth-century morals, the worst thing that could befall a woman) or she decides to disobey David's command (thereby denying her destiny as the mother of Solomon). The drama of such contradictory, unportrayable emotions thus becomes the focal point for the viewer, who meanwhile contemplates the cause of it all – her irresistible beauty. Here Bathsheba is no longer the ignoble seductress she was in earlier depictions, but rather the victim of her own beauty, a beauty that no one can resist, least of all the viewer of the painting.

Through the taut contours of the body and the simple, nearly relief-like structure of the composition, Rembrandt shows that no classicist need tell him what to do: he vanquishes them on all fronts. This figure, its shoulders broader and upper body longer, is somewhat more in keeping with classical proportions. But the rendering of the soft flesh of the stomach, hips and breasts once again gives an inimitable, true-to-life impression.[55] Rembrandt's development from a marked, almost aggressive suggestion of painting 'from life' to a matter-of-course naturalness combined with an impressive monumentality has here reached its climax.

This continual striving for an optimal suggestion of lifelikeness and nearness, as well as the involvement this demanded of the viewer, could explain why Rembrandt did not often paint a female nude. Arousing feelings and emotions was Rembrandt's primary aim, but this was risky in the case of nudes. Painters such as Jacob van Loo, the Van Bronckhorsts and Caesar van Everdingen concentrated much more on painting nudes; the greater distance created by a certain degree of stylisation made their paintings more acceptable. Not surprisingly, such Rembrandt pupils as Govert Flinck and Ferdinand Bol did not apply themselves to the nude until they had laid aside their Rembrandtesque style. In his portrayals of nudes, Rembrandt seems constantly to have explored the boundaries of what was possible within society's norms and the standards prevailing among a certain group of collectors who valued his work, norms and standards that were determined by both artistic and social conventions. There appears at this time to have been a group of art lovers who accepted as the highest aim of art, even in the case

of depictions of nudes, Rembrandt's belief in a nearly uncompromising naturalness and lifelikeness that served to evoke the greatest possible empathy in the viewer, by means of depictions experienced as being 'like life itself' and expressing the 'greatest and most natural emotion'.

When, after the mid-seventeenth century, the striving for ideal beauty – with classical sculpture as the indisputable yardstick – supplanted all other approaches to art, and viewing 'life as the best and most perfect example' was seen only as a serious lapse in judgement on the part of the previous generation,[56] Rembrandt's nudes could no longer be appreciated, at least not in the written sources. This ideology was coupled with a need for purifying the visual arts, theatre and literature – banning everything that could not be considered beautiful and lofty. In particular, the naturalism of the two early etchings (cat.11 and 12), Rembrandt's most widely known nudes, so strongly evoked the presence of the naked woman who had been the model, that they were thought to be offensive and therefore encountered resistance until well into the twentieth century.[57] The specific nature of an individual body – the 'swollen stomach, hanging breasts', and, even worse, signs of having undressed, such as 'pinch marks in the legs caused by garters'[58] and 'traces of a laced-up corset in the stomach'[59] – was considered intolerable. Since Andries Pels had spoken of a 'washer woman or turf stomper' such depictions were often associated with the lower social classes. Kenneth Clark's 'disgust' and 'horrible fascination' express a sexual discomfort that could only be alleviated by nudes who did not come too close and did not demand direct involvement from the viewer.[60] But even these critics, from Pels to Clark, never denied that Rembrandt's nudes were the work of a great artist. The words of a nineteenth-century author commenting on Rembrandt's *Danaë* sum up these feelings nicely: 'horrible nature, incomparable art'.[61]

That Rembrandt wilfully followed a certain path seems indisputable, and in the case of the female nude this path must have been controversial even in his own day. Like Rembrandt himself, a section of the art-loving public would have considered his representations of nudes to be the pinnacle of a respectable tradition, and within this tradition their extraordinary effect could be held in high regard.

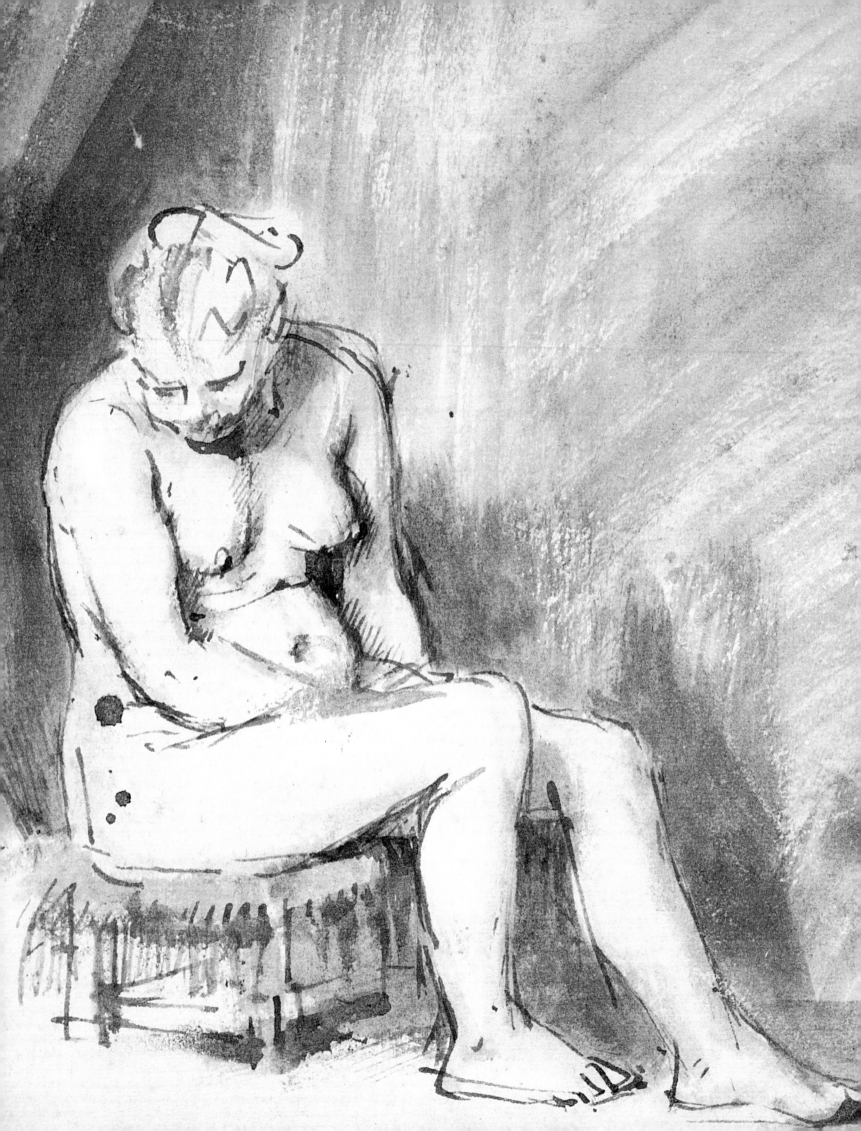

'As stark naked as one could possibly be painted …': the reputation of the nude female model in the age of Rembrandt

VOLKER MANUTH

There is hardly any other relationship that has so captured the imagination of critics, art historians and the art-loving public as that between artists and their models. The underlying reason for this fascination, and for the great interest in the stories that have come down to us from Antiquity, the Middle Ages and the Renaissance concerning this relationship, has been well formulated in a recent study by Georg W. Költzsch: 'Curiosity about everything that goes on in artists' studios, or might possibly happen, is as old as the history of art itself.'[1]

Apelles and Campaspe, Raphael and La Fornarina, Rubens and Hélène Fourment, Feuerbach and Nanna Risi, Manet and Nina Villard – these are only a few prominent examples in a long list of artist/model relationships. Furthermore, models have played a variety of roles in the lives of artists: object of desire, muse, patroness, wife, mistress and femme fatale. Naturally, it has been especially the cases in which women have posed nude for artists that have repeatedly given rise to – sometimes wild – speculation regarding the true nature of the relationship between the artist and his model.

The notion that Rembrandt was an artist whose supposed interest in the essence of things resulted in his unidealised depiction of nature, led, especially in the nineteenth century, to the attempt to identify his models as people in his immediate surroundings.[2] Clearly based on Romantic artistic ideals, this notion prompted the recognition of Saskia van Uylenburgh, Geertje Dircks, Hendrickje Stoffels, Titus, Rembrandt's father and mother, as well as his brothers and sister in a virtually endless number of portraits and other works.[3] Many of these identifications have become outdated, while others have proven more tenacious and still require clarification. Questions also remain concerning the identity of the nudes sketched and painted by Rembrandt. Can it be assumed as a matter of course that these nudes were without exception the three women with whom Rembrandt during his life had intimate relationships? An answer to this question can only be found, if at all, with reference to contemporary studio practices. By examining the extant documents it is possible to draw cautious conclusions concerning the identity of several of the nude models who posed for Rembrandt and his colleagues.

The origins of the painter/model theme can be traced back to the, at times legendary, accounts passed down from Antiquity. An example is the story of the Greek painter Zeuxis who had the five most beautiful maidens in the land pose naked for a painting of Helen, commissioned by the city of Croton. In order to improve upon nature's flaws, Zeuxis selected each model's most beautiful body part and assembled them to create his ideal portrait of Helen. According to legend, Apelles fell in love with his model, Alexander the Great's mistress

Campaspe, upon completing her nude portrait. Alexander himself was more in love with the painting than the model and rewarded Apelles by giving him his mistress. Depictions of the nude in a studio setting served for a long time to illustrate these two ancient myths concerning artists and their models. The female nude came to be studied from life more systematically by Albrecht Dürer (1471–1528).[4] A woodcut in the second edition of Dürer's *Underweysung der messung*, published in Nuremberg in 1538, shows an artist in his studio making a foreshortened representation of a female nude (fig.50). It is, however, much less the undressed woman than the correct manner of applying the rules of perspective that is the real subject of this woodcut. Unfortunately, there are no clues to the identity of the women who posed for Dürer's many studies of the female nude.

Drawing the nude *naar het leven* (from life) was practised in the Netherlands as early as the sixteenth century. It is known that Karel van Mander (1548–1606), Hendrik Goltzius (1558–1616/17) and Cornelis van Haarlem (1562–1638) 'held and formed an academy for studying from life' in Haarlem in the 1580s.[5] This so-called 'academy' was a non-official organisation in which these artists would get together for the purpose of drawing from the nude.[6] The painter Michiel Sweerts (c.1618–1664) founded a short-lived 'academy for drawing from life' in Brussels in 1656.[7] A so-called 'Academie' also existed in Utrecht, where young artists would come together to draw from live models under the guidance of a master painter.[8] In Amsterdam, around the middle of the seventeenth century, it was possible to work from the nude in *het collegie van schilders* (assembly of painters).[9] This we know from the testimony given by the painter Dirck Bleker (c.1620–after 1672) and his sisters in March 1658, concerning a commission Bleker received from a certain Bartholomeus Blijdenberch *omtrent negen à thien jaren geleden* (about nine or ten years ago) to paint a penitent Magdalen. As the patron did not indicate what model the painter should use, Bleker 'employed his usual model, a certain Maria la Mot, who ordinarily posed publicly at the assembly of painters, and was used for these ends.'[10] Whether Rembrandt took part in these sessions at the *collegie van schilders* is not known. His oeuvre, however, demonstrates that he often worked from the female (and male) nude, either alone or together with his artist colleagues and pupils.[11] Who then were these models who sat for the artist? And were all of Rembrandt's representations of the nude done from life?

Rembrandt's earliest known study of a female nude is a chalk drawing in the British Museum (cat.10).[12] This work served as the preparatory drawing for the etching *Diana at her Bath* (cat.11), which is generally dated by scholars to 1631.[13] The etching of a *A Seated Female Nude* (cat.12), which

may represent a nymph, originated around the same time as the *Diana*, and was possibly intended as a pendant to it.[14] There is, at any rate, a clear correspondence between these two unidealised representations of the female body. Nevertheless, opinions vary as to whether the same model posed for both works and whether Rembrandt even based these etchings on an actual flesh and blood woman.[15] Whichever the case may have been, the suggestion that this nude was Rembrandt's future wife Saskia van Uylenburgh has rightly been rejected.[16] That Rembrandt even knew Saskia by 1631, around the time both etchings were executed, is not certain. While it might be assumed that he could have met Saskia in the home of her relative, Hendrick Uylenburgh, the art dealer who employed Rembrandt after his move to Amsterdam from Leiden in 1631/2, the notion that Saskia would have offered to pose nude for the painter years before their wedding in 1634 is, given the moral code of the time, extremely unlikely. Such an act would have ruined the reputation of this young, unmarried daughter of a Leeuwarden burgomaster.

Public nudity – and in the eyes of Rembrandt's contemporaries posing without one's clothing before the eyes of an artist constituted public nudity – was considered an immoral and reprehensible act. With the exception of the internationally-oriented court in The Hague, even the display of cleavage in a low-cut dress was uncommon in the Northern Netherlands and would result in the immediate identification of the woman as a prostitute (fig.51).[17] Constantijn Huygens makes a comment to this effect in a poem of 1622: 'An open booby hatch, in spite of wind and winter's woes, / Is this not one's first thought when confronted with these impertinent beauties, / If the chicks ain't for sale, what are they doing out of their coop?'[18] In the Netherlands total nakedness was considered to be particularly offensive. This is indicated by the fact that prostitutes who were caught in the act stark naked were punished more severely than their colleagues who kept some of their clothes on.[19]

After their wedding, Rembrandt repeatedly captured Saskia's image in drawings, etchings and painted portraits. This occurred by way of sketches made on the spot in household situations, which can be considered genre representations (cat.77), as well as more formal sessions in which Saskia posed as mythological figures decked out in historicising costumes (cat.27). In comparison, the number of extant nude studies made by Rembrandt during his marriage to Saskia (1634–42) is remarkably small. An example of this latter category is the chalk drawing of *A Seated Woman, Naked to the Waist* (cat.70), now in Rotterdam.[20] The model is shown in profile, which de-individualises her to a certain degree. Only the figure's torso is exposed, while the breasts are mostly hidden by the left arm. The face, with its aquiline nose, does not at all resemble the

secure portraits of Saskia and might represent the features of another, unknown model.

There are a few isolated reports that painters did have their wives pose for them in the nude. But whether these reports reflect the actual state of affairs or should be consigned to the realm of artist-mythology is questionable. Thus, for example, Karel van Mander reported early on, but already with a note of doubt, that Pieter Vlerick (1539–1581) painted a Venus, 'for which, it was said, he used the nude figure of his wife.'[21] Rubens's portrait of *Hélène Fourment in a Fur Coat* depicts his second wife in the guise of the *Venus Pudica* (fig.27).[22] The identity of the sitter cannot be doubted, but the painting, it is certain, was not intended for public consumption. Significantly, it was the only work by the artist bequeathed to his wife, and, moreover, with the condition that it not be included in the final tally of her portion of the inheritance. This underlines the decidedly private and intimate nature with which the couple viewed the painting.

Just how perilous the risqué depiction of the female nude could be, especially when the model was easily recognisable, is demonstrated by a court case involving a painter and his model that took place in Amsterdam in 1676.[23] From some of the documents in this case it appears that Lodewijk van der Helst (1642–1684?), son of the more famous portrait painter Bartholomeus van der Helst (1613–1670), first promised to wed Geertruijt de Haes, but then publicly accused her of being a whore. In order to restore her good name, Geertruijt gathered accounts from witnesses against Van der Helst. In October 1676 the following account was given by Cornelia Lijntjens before a notary public at the behest of Geertruijt. She, Cornelia Lijntjens, testified to having seen in the house of the painter Lodewijk van der Helst on Herengracht a painting of Geertruijt de Haes, in which her features were clearly recognisable. The painting in question represented the woman as Venus displayed in an offensive manner. Cornelia also recognised Geertruijt's features among the figures in another painting by Lodewijk. In this work she was shown playing the double bass and accompanied by a child, who was described by the

Fig.50 | Albrecht Dürer (1471–1528), *Draughtsman and Reclining Female Nude*, from *Underweysung der Messung*, 2nd ed., published in 1538
British Museum, London

Fig.51 | Gerrit van Honthorst (1590–1656), *A Young Woman Holding a Medallion*, 1625
St Louis Art Museum

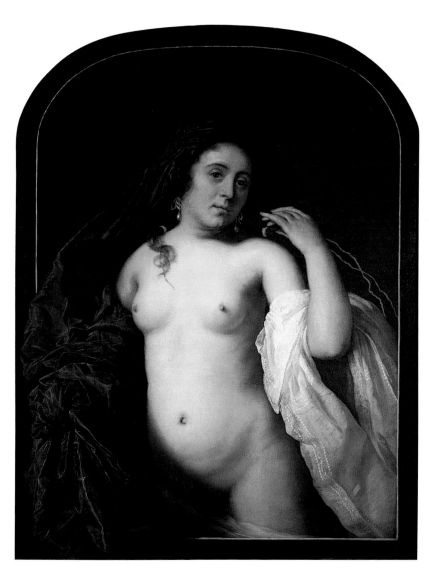

Fig.52 *above* | Bartholomeus van der Helst (1613–1670),
Female Nude with Drapery, 1658
Musée du Louvre, Paris. Photo: RMN-Arnaudet

Fig.53 *below* | Bartholomeus van der Helst (1613–1670),
Venus Holding the Apple of Paris, 1664
Musée des Beaux-Arts, Lille. Photo: RMN-Quecq d'Henripret

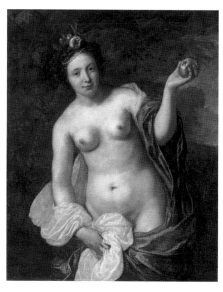

artist as Geertruijt's own progeny. The painter, according to his own testimony, had Geertruijt 'pose for the face and hands of one work, but painted the body from memory.'[24] The case was continued, and on 23 October 1676 Geertruijt, *tot reparatie van haar goed[e] eer, naem ende faam* (in order to repair her honour, good name and reputation), sought a court order to have the *contrefijtsels* (portraits) Van der Helst made of her destroyed.[25] Whether these so-called portraits were eventually destroyed is not known; the paintings described in Cornelia Lijntjens's testimony have, at any rate, never been identified. There are a number of sparsely clad half- and three-quarter-length female nudes in the oeuvre of Lodewijk's father, Bartholomeus van der Helst, such as the signed *Female Nude with Drapery* from 1658 in the Louvre (fig.52).[26] The identity of the model Bartholomeus used to paint these nudes is no longer known. It is not inconceivable that the controversial Venus painted by Lodewijk, which Geertruijt tried to have destroyed, resembled his father's painting of 1664, *Venus Holding the Apple of Paris* in Lille (fig.53).[27] The dispute between the painter and his model took an unexpected, and

noteworthy, turn in 1677: on 2 January of that year the quibbling parties married each other![28] If Lodewijk's testimony can be trusted, we can conclude from it that painters did not always have to work from flesh and blood models when creating their depictions of the nude. The naked body could also be rendered *uit de geest* (from memory).[29] Many compositions including nude figures 'from memory' were based on earlier representations.

It has been observed time and again that Rembrandt borrowed from prints for his representations of the nude in Biblical and mythological scenes.[30] Rembrandt would alter the poses of these nudes and render them in an unidealised fashion without referring to an actual living model. Often, he would combine elements from various sources, as he did, for example, with the figure of Susanna in the painting of 1636 in The Hague, *Susanna and the Elders* (cat.69).[31] A striking feature in Rembrandt's art is that he very seldom sketched from the female nude until around the middle of the 1640s. It is only from about 1646 onwards that nude studies make their appearance in his oeuvre more frequently, and it is apparent that they originated in a pedagogical context. A group of related drawings not of a female, but a male nude – most likely one of Rembrandt's pupils – can be dated to around this period.[32] The model was sketched by various pupils simultaneously and is seen from different angles in the drawings. Rembrandt, himself, used the model for the figure of a standing boy in his etching of 1646, *Nude Man Seated, Another Standing* (cat.107), known as 'The Walking Frame'.[33]

From about 1641 until 1649 Geertje Dircks lived in Rembrandt's house. She was initially employed as Titus's nursemaid, but after Saskia's death in 1642 Rembrandt began an intimate relationship with her that would end in an unpleasant manner by 1649, at the latest.[34] Judging from his extant oeuvre, there is no evidence at all to suggest that Geertje posed nude for Rembrandt. As there is no secure portrait of her, the identification of the model in Rembrandt's *A Woman in Bed* in Edinburgh (cat.100), a work from the 1640s, as Geertje also remains doubtful.[35] A copy of a drawing by an unknown Rembrandt pupil from the 1650s shows a group of artists sketching a female nude (fig.54).[36] The artist with crossed legs in the centre of this composition has on more than one occasion been identified as Rembrandt. However, given the fact that the drawing is a copy this identification should, at the very least, remain an open question. The documentary value of this drawing is limited to its role in confirming a statement made by Rembrandt's pupil Samuel van Hoogstraten (1627–1678), who advises young painters to attend *Teyckenschoolen of Academien* (drawing schools or academies) in order to draw *mans- of vrouwe-naeckten nae 't leven* (male and female nudes from life).[37]

Rembrandt's pupils, after leaving his workshop,

also organised sessions in which painters could get together to study the nude. This is at least what a document from 27 July 1658 tells us. The painters Willem Strijcker (? 1606/7–1673/7?), Nicolaes van Helt Stockade (1614–1669) and Jacob van Loo (c.1615–1670), as well as the former Rembrandt pupils Ferdinand Bol (1616–1680) and Govert Flinck (1615–1660), acknowledge in this document that a certain Catarina Jans, the daughter of a needle-maker, 'sat, stark naked, before these witnesses and other colleagues as a model, and that they, the witnesses, drew and painted her thus.'[38]

Comparatively speaking Rembrandt's engagement with the female nude in the 1650s and early 1660s was intense. The works executed in this period often show a partially or fully undressed young woman wearing a cap in an interior setting. She appears, for example, in the three etchings Rembrandt made in 1658: *A Woman Sitting with a Hat Beside her* (cat.128), *A Woman Bathing her Feet in a Brook* (cat.129), and *A Woman Sitting Half-dressed Beside a Stove* (cat.130). We do not know for certain who this woman was, but the most obvious

candidate seems to be Hendrickje Stoffels (1626–1663) who lived in Rembrandt's house from 1649 onwards and had a common-law relationship with the artist. There can be no doubt that Rembrandt's young mistress had an inspirational effect on him. He made numerous paintings of Hendrickje (cat.125, 126 and 127) and – if indeed she really did pose for the painting – made an astounding monument of his affections for her in the form of the *Bathsheba* of 1654 in the Louvre (fig.48).[39]

Rembrandt's drawings of *A Seated Female Nude* in Chicago (cat.135) and *A Woman Sitting Half-dressed Before a Stove* in Amsterdam (see cat.131, fig.156) belong to a group of studies after the female nude from the late 1650s or early 1660s. The closely related drawing of *A Female Nude Seated in Front of a Stove* in Rotterdam (fig.55), in which the same model is represented but from a different angle, has been recognised in the meantime to be the work of a pupil.[40] If we are to assume that Rembrandt at this time worked simultaneously with his pupils from the female nude, it is impossible that the model would have been Hendrickje. As

Fig.54 | School of Rembrandt (copy), *Rembrandt and His Pupils Drawing from the Nude*
Hessisches Landesmuseum, Darmstadt. Photo: W.Kumpf

is well known, Hendrickje was banned by the church authorities from participating in the Lord's Supper in 1654 because she had sexual relations with Rembrandt out of wedlock.[41] In the eyes of many contemporaries the relationship between Rembrandt and Hendrickje was scandalous. But it is not only this larger context that makes it difficult to accept the notion that Rembrandt would have had Hendrickje pose naked for his pupils. Rembrandt, like so many of his colleagues, would have availed himself of the services of women, who, it is known, posed nude in exchange for payment.

'WOMEN OF EASY VIRTUE' – PROSTITUTES AS NUDE MODELS

A number of contemporary documents inform us that seventeenth-century artists employed prostitutes in order to work from the nude. Most of these documents are written confessions or witness statements recorded during legal inquiries and proceedings for the purposes of demonstrating the morally corrupted lifestyle of the accused. Prostitution was considered a criminal offence and punishable by law.[42] Because of the type of case involved, these documents need to be analysed with caution; the piquant nature of the problem tends to obfuscate the line between fact and false accusations and defamation of character.

Unquestionably one of the most controversial personalities in the seventeenth-century Dutch art world was the Haarlem painter Johannes Torrentius, the alias of Johannes Symonsz van der Beeck (1589–1644).[43] If the innumerable preserved documents are to be trusted, Torrentius's biography resembled a *chronique scandaleuse*. Among the many things he was accused of were a dissolute lifestyle, heresy, blasphemy, and the use of magic.

In addition, he created works that were confiscated by the authorities because of their supposed obscene nature.[44] During a court case in 1628 he was tortured and sentenced to be burned at the stake on the basis of the contradictory testimonies provided by the witnesses. It took the intervention of the British king, Charles I, and the Stadholder Frederik Hendrik to have Torrentius set free. In 1648 Theodor Schrevelius wrote in his history of Haarlem, '... not the least of painters, Johannes Torrentius was however infamous: he was a second Apelles, as he could paint nude women who presented themselves to him like whores.'[45] In 1675 the painter Joachim von Sandrart (1606–1688) reported that he knew of 'a number of paintings of naked women, very inappropriate and vulgar, absolutely unworthy of praise,' by Torrentius.[46] The Haarlem artist apparently frequented brothels regularly. According to his own testimony, he did so for purely artistic reasons and not, 'to perpetrate any impure acts as was what usually went on in such places.'[47] In 1627 he justified a visit to the inn, De Casuaris (The Cassowary), a notorious brothel in The Hague, by claiming that he was a painter and in this function 'went there to see if there were persons of the female sex, beautiful of body and limb of whom, when found, the same could be obtained that they might be willing to show some of their naked parts with the purpose of being drawn so that these later could be used in paintings as the need arose'.[48] Although this justification may be a cheap excuse, it does make clear that it was not unusual for artists to look for their nude models in brothels. In 1642 the painter Jacob van Loo (1614–1670) gave evidence in a case before the Amsterdam authorities concerning the barely sixteen-year-old Sara

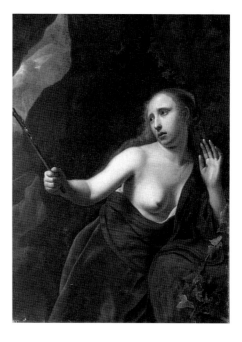

Fig.55 *left* | Attributed to Arent de Gelder (1645–1727), *Female Nude Seated in Front of a Stove*
Museum Boijmans Van Beuningen, Rotterdam

Fig.56 *right* | Dirck Bleker (c.1622–c.1670/2), *The Penitent Mary Magdalene*, 1651
Rijksmuseum, Amsterdam

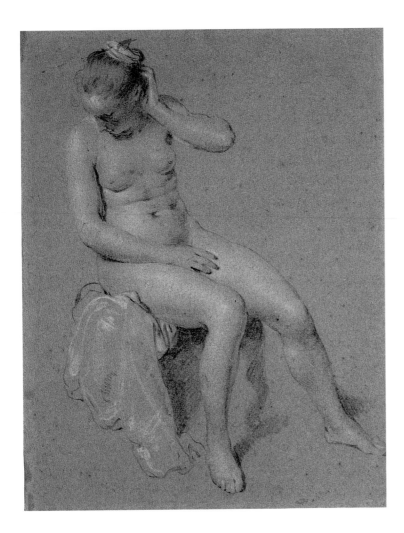

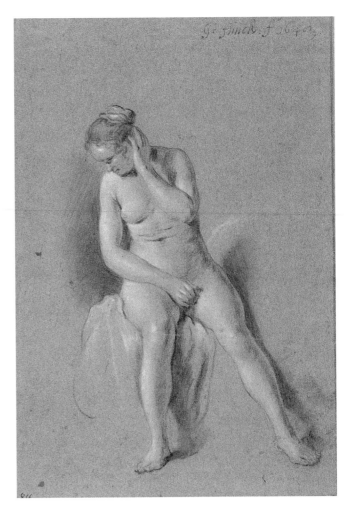

Joris, who had been accused of prostitution on more than one occasion. Apparently, Sara Joris brought up Van Loo's name during the trial. The painter was cross-examined and confessed to 'having been in an inn in the vicinity of the Lutheran church where he shared the company of a girl [Sara Joris]'. He admitted, moreover, to having 'suggested an improper act and touching her in an indecent manner, but did not speak to her about painting her.'[49] In order to exonerate herself, Sara had apparently claimed that the painter had wished to have her pose for him. Did she perhaps assume that posing without one's clothing on had less serious consequences than prostitution, a criminal offence? On the other hand, Van Loo did perhaps actually try to persuade her to model nude for him. As already mentioned, he belonged to a group of Amsterdam artists who in the 1650s frequently had models pose in the nude.

Extant works of art can only exceptionally be linked to known prostitutes. One such prostitute was the already mentioned Maria la Motte, the alias of Maria Jonas, who, according to the testimony given by the painter Dirck Bleker, posed at *het collegie van schilders* (assembly of painters) in Amsterdam and served as his model for a painting

of the Magdalen. Even if Bleker's 1651 *Magdalen* in the Rijksmuseum, Amsterdam (fig.56) is not the painting from around 1649 referred to in the above-mentioned documents, the woman who posed for this work was in all probability the same Maria la Motte, the painter's *gewoonlijck model* (usual model). In 1652 Maria was found working 'in a brothel again', for which she was sentenced to labour in a Spinning House.[50] When arrested once more in September 1659 she stated her profession to be *kaerdmutsenmaeckster* (capmaker). She was, therefore, a type of seamstress or textile worker, and it was to this group that the majority of documented prostitutes in the Northern Netherlands belonged until about 1720.[51] An added dimension of the whole affair emerges when it is noted that not only Dirck Bleker knew Maria la Motte, but that the man who commissioned Bleker's *Magdalen* was apparently also in very close contact with her. This, at any rate, was claimed by his wife's maid during the couple's divorce proceedings. In October 1657, the maid had seen how Blijdenberch together with a friend 'went to a certain whorehouse, the madams of which were Maria de la Motte and …'.[52]

Apparently, it occurred more often that several

Fig.57 *left* | Jacob Adriaensz Backer (1608–1651), *Nude Woman Seated, Glancing Downwards* Maida and George Abrams Collection, Boston

Fig.58 *right* | Govert Flinck (1615–1660), *Seated Nude Woman, 1648* Kupferstichkabinett, Staatliche Museen zu Berlin, Preussischer Kulturbesitz. Photo: Jörg P.Anders

artists would simultaneously draw from the nude and that the model would be a prostitute. A Leiden court transcript from 28 February 1678 records the case of the eighteen-year-old Cornelia (Neeltje) Jans, 'of whom it is said that she had herself painted stark naked in The Hague by seven painters at the same time'.[53] In this case as well, the model was sentenced for repeatedly prostituting herself, and not, however, because she posed without her clothing on for seven painters. The latter act only served as additional evidence of Neeltje's immoral lifestyle.

Rembrandt's one-time pupil, Govert Flinck, also sketched together with other Amsterdam painters from the nude in the 1640s and 1650s. Another member of this circle of artists was Jacob Adriaensz Backer (1608–1651). The pose of the model in his chalk drawing from around the end of the 1640s, *Nude Woman Seated, Glancing Downwards* in the Abrams Collection, Boston (fig.57) is identical to that in Flinck's drawing of a *Seated Nude Woman* in the Kupferstichkabinett in Berlin (fig.58).[54] The only slightly different angle from which both artists represented the model suggests that both sheets originated during the same session. A clue to the possible identity of Flinck and his colleagues' nude model is provided by a 1657 witness statement.[55] Margaretha (Margriet) van Wullen (1624–after 1679), the daughter of a Lutheran minister, sought a court injunction in this year to force the Amsterdam town secretary Nicolaes Heinsius (1620–1681) to make good on his promise to marry her. Heinsius for his part collected witness statements testifying to Margaretha's disreputable lifestyle. According to one such testimony, Margaretha and her sisters, Catrina and Anna were 'painted as stark naked as one could possibly be, lying asleep on a pillow in a most indecent manner,' by Flinck in 1648.[56] The

three life-size paintings, the witnesses stated, were shown to them in Flinck's studio on Lauriergracht. Although the paintings can no longer be identified, drawings by Flinck from around the end of the 1640s give an impression of what the nude studies made at the time looked like. The model who posed for the chalk drawing in the Institut Néerlandais, Paris, *Nude Woman Sleeping* (fig.59), was perhaps one of the Van Wullen sisters.[57] Other accusations that the sisters behaved indecently conclude with the statement that Catrina and Margaretha had the reputation of being *fameuse hoer[en]* (infamous whores).[58]

How much money nude models asked for their services is not known. Witnesses in Delft in 1652 testified that a petitioner 'had been accused of letting herself be painted naked and that she had earned quite a bit of money thereby'.[59] The English traveller John Farrington reported in 1710 that he saw the portrait of an influential gentleman's mistress in The Hague. He wrote that 'she had 50 guineas given to her to suffer herself to be drawn naked, which she is, only with a due regard had to modesty'.[60] The model was undoubtedly not a common prostitute, but rather a kept woman, whose living expenses would have been paid by this man from the better class in exchange for extra-marital sexual favours.[61] It would have been the express desire of her wealthy master that she present herself to the painter in a state of undress. The sum of money she received for doing so was certainly out of the reach of the common street hustler who posed nude.

In summary, it can be determined that many painters, either alone or in groups, used prostitutes as nude models. This is suggested in the first place by the preserved documents rather than an analysis of the works of art, as these usually include no clues whatsoever to the identity of the nude models. It can be assumed that the few cases that actually came before the courts only reflect the tip of the iceberg; the number of unrecorded cases may have been quite large. Given the then current attitudes to morality, the public exhibition of the undressed female body would have been considered a taboo by the majority of Rembrandt's contemporaries. Breaking this taboo resulted in an immediate association with prostitution, which was pursued, with varying vigour, by the authorities. Moreover, it is striking that the accusation of posing nude arose almost without exception in the context of other accusations, and was meant to serve as evidence of the model's morally reprehensible lifestyle. While there were legal consequences for the woman involved, these apparently did not apply to the artist.

Fig.59 | Govert Flinck (1615–1660), *Nude Woman Sleeping*
Collection Frits Lugt, Institut Neérlandais, Paris

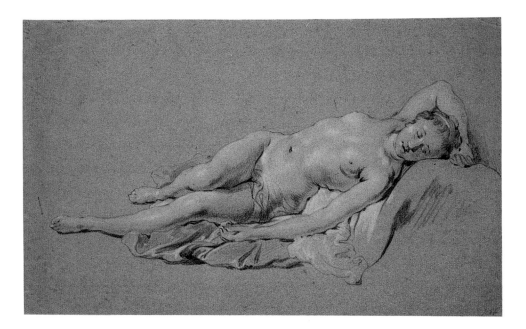

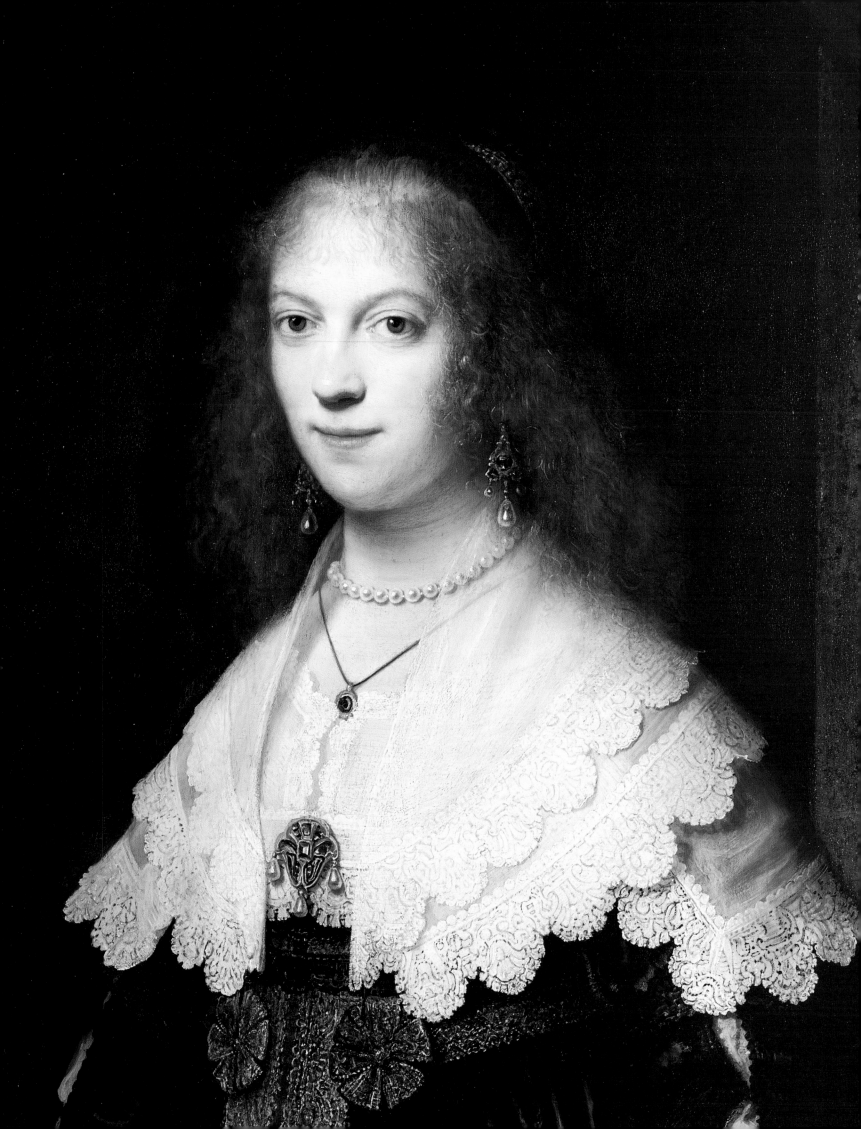

Fashion or fancy? Some interpretations of the dress of Rembrandt's women re-evaluated

MARIEKE DE WINKEL

In the past few decades various aspects of Rembrandt's work have been extensively re-searched, yielding numerous new insights into, for instance, the master's painting technique, workshop practice, iconography or his artistic milieu. In comparison, the dress in his work has received only marginal attention. Moreover, in the Rembrandt literature comments on costume are often quite speculative in character, because of an insufficient understanding of the context in which a certain garment was worn. The main problem is the question as to whether the clothing was worn in reality or was merely fancy dress. Therefore, the primary purpose of this essay is to distinguish between garments that were made up by the painter and dress that was worn in reality. To establish these differences it is first necessary to have an understanding of the normal patterns of dress current in Amsterdam during Rembrandt's lifetime, based on visual evidence as well as documentary information such as travellers' accounts or inventories. Subsequently, the possible sources for Rembrandt's fantastical costumes and the supposed role of theatrical dress are examined.

THE ALLUSIONS OF ACCESSORIES: CONVENTION, CONTEXT & CONNOTATIONS

In an article in 1993 Eddy de Jongh distinguished three aspects to be considered in the interpretation of portraits: in the first place, the sitter's facial traits, secondly, his or her gesticulation and pose, and thirdly, the additional symbols and attributes.[1] In this summing up, analysis of the sitter's dress is not mentioned. However, the important role dress plays in portraiture and the fact that often the greater part of a portrait's surface is occupied by the sitter's costume, merits an investigation of the significance of clothing. As it conveys certain messages, it can be an important means of creating a specific image of the person depicted, especially since the sitter's face is a notoriously untrustwor-thy communicator, as far as portraits are con-cerned. In the Rembrandt literature the meaning of certain accessories are often discussed without sufficient regard for the costume as a whole or the context in which it was worn. When interpreting the clothing of women in Rembrandt's portraits many different aspects have to be taken into account. The choice of a particular kind of dress or accessory is, to a large extent, determined by the social position of the sitter, his or her religious affiliation or even the location where the portrait was painted. Also, the age of the sitter has to be considered, since the older people become, the more they tend to cling to the styles of their youth. In addition, prevalent social conventions play a role. In Amsterdam, for instance, it might have been 'unsuitable' to appear in public in fashions that were current at the court of The Hague, or vice versa.

A conspicuous item of dress is the black beaver hat worn by Maria Bockenolle in her portrait by Rembrandt of 1634 (fig.60). Since hats of this kind are customarily encountered in portraits of men, Maria's dress strikes us as peculiar and slightly bold. In seventeenth-century Holland the hat was very much perceived as a sign of authority and male supremacy. In contemporary French and Dutch the word 'hat' was even used as a metaphor for man, as opposed to 'coif' denoting woman.[2] Consequently, in conservative ecclesiastical circles there was much opposition against women wearing hats, which was viewed as improper rebellion.[3] Therefore, Maria's manly headwear does not seem to accord with both her age and her position as the wife of the Dutch Reformed minister Johannes Elison. Though the leading handbook on Dutch costume cites this portrait as an example of the typical dress of the wife of a Dutch minister, Maria is not wearing Dutch dress at all.[4] Her dress closely resembles the attire of women of the English merchant and middle-classes as depicted in contemporary portraits and costume plates, as in the illustration of the wife of a London merchant by Crispijn de Passe from his book *Misbruick des houwelijkx* of 1641 (fig.61).[5] Like Maria Bockenolle, the woman in De Passe's illustration is wearing a set ruff and a man's hat over a small coif. In addition, the doublet with the neckline in a 'V' or 'U'-form (in Maria's case with a modest black fill-in) is typically English.[6] In England women started to wear these pointed doublets and beaver hats from the 1580s onwards, and though initially this use of masculine fashions was also very much criticised by contemporary moralists, by the 1630s it had become the accepted wear of respectable matrons. That Rembrandt depicted Maria in English dress is not surprising since her husband was minister of the Dutch Reformed Church in Norwich.[7] During her stay in England Maria had obviously conformed to the local style in dress, conventional for a woman of her age and class.

In Holland, however, it was very unusual to wear a hat, which is confirmed by the fact that these items are not listed in contemporary invento-ries of women's wardrobes.[8] Literary sources, on the other hand, sometimes do mention Dutch women wearing wide-brimmed hats, but only in a very specific context. For instance, Johannes van Heemskerck in his Arcadian novel *Batavische Arcadia* describes two fashionable young ladies of the highest classes in The Hague wearing black feathered hats at a seaside promenade.[9] Likewise, the 'Winter Queen', Elizabeth of Bohemia, living in The Hague at the time, is depicted in a feathered hat in the equestrian painting by Adriaen van de Venne of 1626 (fig.62).[10] In an account of a trip to North Holland one of her maids of honour in 1625 gives a very good illustration of the context in which the queen was wearing her hat:

Tuesday 26 June, we departed from The Hague to Haarlem by carriage, dressed in our usual travelling

attire with hats instead of caps, which erroneously led the common people to believe that the Queen and the Princess [of Orange] were Sir William and Sir Lodewijk [of Nassau] and us to be their pages. Like a good woman from Haarlem who came to view the Queen, but left the room dissatisfied, saying she had only seen three young men at the table with no woman in their company. Likewise, the Burgomaster of the said town visited the Princess in her chamber with her head uncovered and with her hat on the table not wanting to be covered, but since he kept insisting 'cover yourself Madam', she was forced to put on her hat back on.[11]

This account reveals that in Holland, fashionable young women occasionally donned wide brimmed feathered hats during trips in the country or as a special kind of travel or riding dress.

Compared to the portrait of Maria Bockenolle, Rembrandt's drawing of Saskia in a hat of the previous year has a much more informal air (fig.63). The dress in which Rembrandt depicted his betrothed three days after their engagement is in fact so informal that it is not comparable with commissioned portraits in which the sitters, as a rule, are depicted in their Sunday best. Saskia is wearing a straw hat over a simple coif, which seems to be tied at the back, decorated not with lace but with a little dented edge. Around her shoulders she is wearing a linen shoulder mantle which has a decorative strip and is closed at the neck. This garment called a *nachthalsdoeck* (nightrail) was very generally worn by women of all classes as a form of undress.[12] As the name indicates the garment was used in bed or while dressing, as is shown in Rembrandt's drawing of 1634 of *A Young Woman at her Toilet* (cat.30).[13] However, it was also worn during the day in combination with a linen apron as an informal house-dress to protect the woollen jacket and skirt (which were not washed) from stains (fig.64). In later years Rembrandt would also

depict his wife in bed or around the house in comparable undress.[14] For instance, in a drawing of *c*.1635 (fig.65), Saskia is leaning out of a window wearing a nightrail over a jacket and a linen night coif with a separate strip around the forehead called a *bandon* (frontlet).[15]

Margaret Loutitt in an article from 1973 has argued that Saskia's dress reflected a taste for everything pastoral during the 1630s, referring to the popularity of images of seductive shepherdesses of the Utrecht school.[16] This does not necessarily mean, however, that Saskia's hat has been modelled on the straw hats of shepherdesses in painting. It was rather the other way around: shepherdesses were depicted in straw hats because this was

Fig.60 *left* | Rembrandt, *Portrait of Maria Bockenolle (Merv. Johannes Elison)*, 1634
William K. Richardson Fund, Museum of Fine Arts, Boston

Fig.61 *above* | Crispijn de Passe (1576–1670), *Wife of a London Merchant*, 1641
University Library, Amsterdam

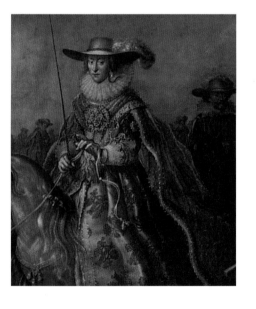

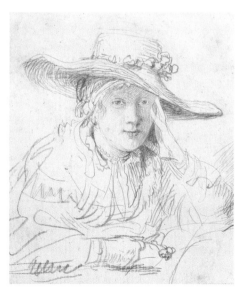

Fig.62 *left* | Adriaen van de Venne (1589–1662), *Frederick and Elizabeth of Bohemia out Riding* (detail)
Rijksmuseum, Amsterdam

Fig.63 *right* | Rembrandt, *Portrait of Saskia van Uylenburgh*, 1633 (detail)
Kupferstichkabinett, Staatliche Museen zu Berlin, Preussischer Kulturbesitz. Photo:Jörg P. Anders

Fig.64 *opposite below* | Wenceslaus Hollar (1607–1677), *Dutch Woman in her Household Dress*, illustration no. 37 from his *Theatrum Mulierum*, published in London in 1643
Lipperheidische Kostümbibliothek, Berlin

Fig.65 *opposite above* | Rembrandt, *Saskia Leaning out of a Window*, *c*.1635
Museum Boijmans Van Beuningen, Rotterdam

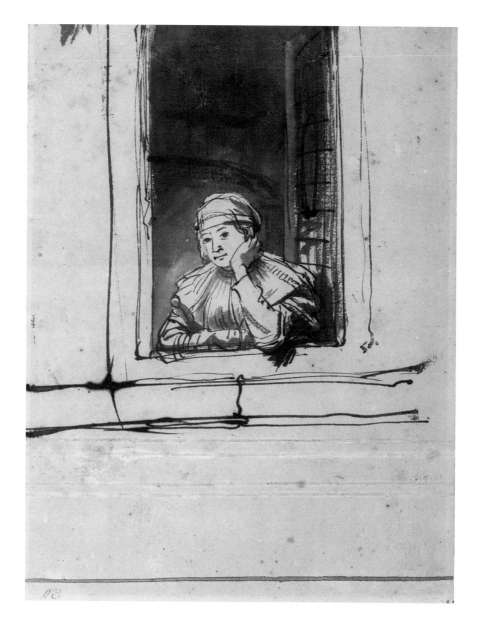

a Dutch Woman in her household Dress

Mulier Belgica in Vestitu Domestico.
37

outside a country inn: '... there the women had pleasure in putting on some straw hats, which are much worn in this country, and did become them mightily but especially my wife'.[21] Rembrandt probably shared the same sentiment when he drew his betrothed in her straw hat. At the time of their betrothal Saskia lived with her sister in the Sint-Annaparochie, a village in the rural part of Friesland.[22] It was probably here that Rembrandt drew her – outside in the country or in a garden – not in the guise of a shepherdess but just as she was, in a casual everyday dress and her straw hat.

Very different from the casual manner in which Rembrandt drew his future wife are the portraits he made of the newlyweds Maerten Soolmans and Oopjen Coppit (figs.16, 17 and 66). Both are richly dressed according to the fashionable French style. Oopjen is wearing an open gown of black silk with dots and braiding over a bodice and petticoat of the same fabric. The broad edges of Flemish bobbin lace are so large that they curl a little at the cuffs. Certain aspects of her dress have given rise to different interpretations. In 1956 Van Luttervelt interpreted Oopjen's black dress, and in particular her veil and the little gold ring on a string around her neck, as indications that she is depicted in her widow's weeds.[23] Because her portrait is undated, he supposed it must have been painted as a companion piece to the existing picture of her husband after his death in 1641. This is very unlikely, because the two portraits are so closely matched in style and composition that it is hard to believe that one was executed at a much later date. In the *Corpus*, therefore, it is posited that Oopjen might be wearing mourning for her father who died in March 1635.[24] This would imply that her portrait was completed a year after that of Soolmans, which is signed and dated 1634. An altogether different explanation has been proposed by Pieter van Thiel who explained the wearing of the ring on a string as an aspect of marriage symbolism and wondered whether the black veil was not a sign of mourning, but, rather a component of the customary seventeenth-century bridal apparel.[25]

All authors share the view that the ring on a string was a demonstration of the marital fidelity of the wearer and suppose it to be her wedding ring. However, it is more likely that one of the rings on Oopjen's fingers is her wedding ring. She has a plain gold ring and one with a black stone on the first finger of her right hand, and a ring with a table-cut stone, most probably a diamond, on the ring finger of her left hand. The plain ring on her first finger probably functioned as a wedding ring. In the seventeenth century brides were given a ring during the wedding ceremony – though this was not required – and wore this ring occasionally on holidays but not continuously.[26] Only women wore them and there appears not to have been any particular rule with regard to which finger it had to

conventional out-of-doors wear worn by women of all sorts everywhere in Europe. Wide-brimmed straw hats like Saskia's are repeatedly mentioned in women's inventories, an indication that they were quite generally worn.[17] To contemporaries, straw hats were therefore immediately associated with country life, and as a result were used in painting as well as in the theatre as the stock attribute of country girls.[18] Used by women of all classes during outings in the country as a protection against the sun, these hats functioned in much the same way as the more expensive feathered beaver hats worn by the 'Winter Queen' and her entourage.[19] This is indicated in a 1613 farce in which an Amsterdam housewife is preparing for a trip to the countryside in great haste and asks her servant to fetch her travel bags and straw hat.[20] In 1667 Samuel Pepys related that after a Sunday walk in the countryside he found the rest of his party

be worn on: they were put on the first finger, the little finger or even on the thumb.[27] The conservative Jacob Cats in his *Houwelyck* (Marriage) of 1625, expresses an old-fashioned preference for the ring finger and criticises the new habit of wearing the ring on the first finger as too sophisticated.[28] In addition, Cats had a preference for the plain gold wedding band but thought a diamond ring was also very suitable because it stood for the constancy and the fortitude of the husband.[29]

In the list of Oopjen's possessions drawn up after the death of her second husband in 1659, all the valuables she is wearing in the portrait are listed, such as the 'gilded silver handle' of the plumed fan she is holding, 'two pearl bracelets', 'two pendants of pearls with diamonds on the ear-iron' as well as 'a string of pearls of four rows around the throat'.[30] She also owned three (unspecified) rings, and a 'gold hoop with little diamonds all around'.[31] It is this last item that Oopjen is wearing on a string in her portrait by Rembrandt.

As today, in the seventeenth century rings were not only worn as wedding rings but also in memory of a certain event or of someone and as a token of affection. A good illustration of this is given in the letter Dorothea van Dorp wrote in 1624 to Constantijn Huygens in England in which she asks for a keepsake from a mutual friend:

Dear Sunny, […] can I ask you for something in addition? I would like lady Killigrew to send me a small golden ring to wear around my little finger or on a string around the neck, with her name in it, so I can wear it continuously like that of the Sun [Huygens]. Because all I have from her I take off at night.[32]

Dorothea wore her rings on a string for a sentimental reason as well as a practical one. However, rings were also simply valuable pieces of jewellery worn as a sign of wealth without a particular sentimental value.[33]

Especially during the 1630s it was fashionable to wear a ring on a string. It is also worn, for instance, by the young woman in a portrait from 1634 from Rembrandt's workshop, or by the little Elizabeth Gerbier in a family portrait of *c*.1630 by Rubens.[34] That little girls also wore rings on a string shows that this was not necessarily a demonstration of marital fidelity or a sign of widowhood. Johannes van Heemskerck in 1637 in his description of the attire of a fashionable 'shepherdess' says:

[Around] the neck … (doubtless to set off the white) she had a pleasing black silk string, on which was dangling a small golden ring with little diamonds.[35]

Heemskerck here indicates that the reason for wearing the ring in this way, was primarily an aesthetic one. The gold ring on the black string simply formed a pleasing contrast to the white of the collar.[36]

In addition, the black veil Oopjen is wearing

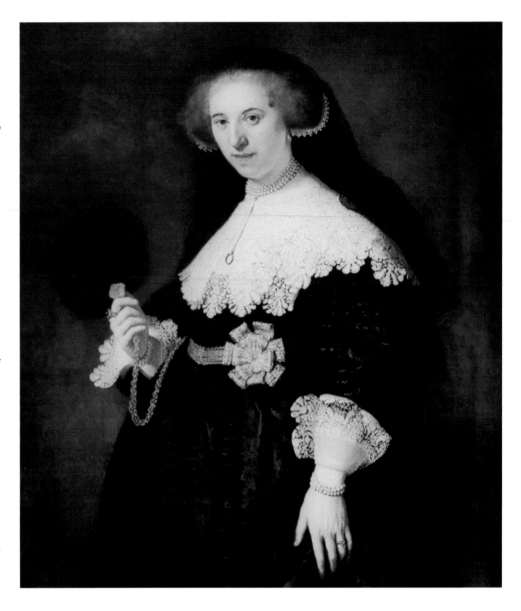

over her white coif has been interpreted as a sign of mourning. Although it is true that royal or princely widows like Amalia van Solms or Elizabeth, Queen of Bohemia are depicted wearing black veils, there is little indication that this was also usage among less noble women. Except for the court of the princes of Orange, no regulations concerning seventeenth-century mourning in Holland are known, neither for the duration of the mourning nor for the clothes themselves.[37] It seems that in the course of the century rules for mourning emerged. The mourning apparel specified in Amsterdam inventories shows there existed certain conventions concerning mourning. For instance, no shiny materials like silk or polished leather were allowed and these were replaced by special mourning garments made of a dull woollen material like black cloth in combination with chamois belts, shoes and gloves. Also, the wearing of ribbon bows and lace ceased during mourning.[38]

Fig.66 | Rembrandt, *Oopjen Coppit 1611–1689*, 1634 (detail of fig.17)
Rothschild Collection, Paris

Furthermore, it was also prohibited to wear curled hair, gold or beauty spots.[39] Only a fleeting glance at Oopjen Coppit's clothes suffices to determine that she is not in mourning: her gown is of a shiny silk material with rosettes of white ribbon at her waist and her collar as well as her cuffs are edged with luxurious lace trimmings. Moreover, her hair is curled in a fashionable fuzzy way, she is wearing gold jewellery and there is a beauty spot on her left temple. Therefore, it is evident that Rembrandt did not depict Oopjen in mourning dress.

Likewise, a black veil was not a customary element of seventeenth-century wedding dress. It was only from the early nineteenth century onwards that the white veil became the stock element of the romantic wedding dress.[40] White, or to be more precise, white cloth of silver, in the seventeenth century was traditionally worn by brides of the highest nobility only; and because black was the most formal colour, brides of Oopjen's class usually wore black on their wedding day.[41] The bride would continue to wear this gown for the next few years at more formal occasions and it is therefore possible that Rembrandt depicted Oopjen in the dress she had also worn on her wedding day a year before. However, Oopjen is not shown specifically as a bride because seventeenth-century Dutch brides typically wore a bridal crown instead of a veil.[42] Oopjen's bridal crown is still listed in her inventory of 1659 as a *bruyts kroontje* (bridal crown).[43] A rare surviving specimen shows that these crowns were made of gold and silver thread, decorated with spangles and small symbolic wax images such as flowers, fruit, doves, porridge bowls, babies and other references to the fruitfulness of the young couple.[44]

Like straw hats, ladies used black veils in the seventeenth century in summer as a protection from the sun, to prevent wrinkles and to retain their milky complexion.[45] This particular function is illustrated in an etching by Wenceslaus Hollar (1607–1677) from a series of personifications of the seasons of 1640 (fig.67). 'Summer', whose attributes are a fan and a black veil, says,

In summer when wee walke to take the ayre,
Wee thus are vayled to keepe our faces faire.[46]

That in Holland black veils had the same function is shown in a country house poem by Petrus Hondius of 1621 in which he mocks the use of fashionable accessories:

… That her pallor might be fading, a thought that causes great dismay,
And since wind and sunrays are invading, she goes veiled the entire day.[47]

Additionally, the veil protected its wearer from dust or insects. According to Constantijn Huygens in his country house poem *Hofwijck* of 1653 the ladies in The Hague used 'A black cloth before the face, against the stings of flies'.[48] The relatively large number of depictions of elegant young women wearing black veils, featured, for instance, in the album illustrations by Adriaen van de Venne from 1626 and those by the Terborch family from the 1650s and 1660s, suggests that its use was quite widespread.[49] In addition, its popularity is supported by their presence in women's inventories.[50] Therefore, black veils in seventeenth-century paintings are not automatically to be interpreted as the attribute of a widow but, depending on the context, also as a fashionable accessory functioning as a protection against the sun. That Oopjen's dress and accessories accord with the latest French fashion is shown in a comparison with Crispijn de Passe's illustration of the fashionable wife of a Parisian lawyer of 1641 (fig.68), who is wearing a fan, a black veil and rosettes at her waist in the same way as Oopjen.

Age and religious affiliation did greatly influence the dress of Rembrandt's sitters. This is evident in the double portrait of the famous Mennonite preacher Cornelis Claesz Anslo and his wife Aeltje Schouten of 1641 (fig.69). Although Anslo had amassed a substantial fortune in the cloth trade, he dressed according to the conventions of the Mennonites who lived and dressed in a conspicuously sober and restrained manner.[51] Over his simple black suit Anslo is wearing a fur lined gown, by this time a very old fashioned garment, in which the elderly, ecclesiastics and scholars preferred to be depicted, since this comfortable indoor garment denoted a dignified, time-honoured respectability.[52] The woman sitting next to Anslo was interpreted, at the beginning of this century, as a poor woman from the *hofje* (almshouse) founded by Anslo's father. Because of the handkerchief she is holding, it was assumed that she was weeping, moved to tears by Anslo's words.[53] Judged by her clothing, however, this woman cannot be considered to be poor at all.

Fig.67 *left* | Wenceslaus Hollar (1607–1677), *Summer*, 1640
University Library, Amsterdam

Fig.68 *right* | Crispijn de Passe (1576–1670), *Wife of a Paris Lawyer*, 1641
University Library, Amsterdam

Although her fur-lined three-piece so-called *vlieger* costume and set ruff are quite old-fashioned in style and without decoration, the materials used would have been of the best quality. The inventory made up after Aeltje's death in 1657 shows that sixteen years later she was still wearing the same style of dress. She owned three *vlieger* combinations like those she is wearing in her portrait, one of cloth and two of borato (a silk-wool mixture), three ruffs, six embroidered under-coifs, four over-coifs and twenty-eight handkerchiefs.[54] In spite of the widow's wealth, the inventory shows that the furnishing of the house was without any ornamentation and that there were no luxury goods to be found. It is noteworthy that materials like lace and satin, or accessories like cuffs, pearl necklaces and bracelets – usually listed in the possession of affluent merchants – are altogether absent from Mennonite inventories.[55] The only luxury accessory that seemed permissible for Mennonite ladies was the handkerchief with *akers* (tassels), conspicuously held by Aeltje as well as by another Mennonite, Catrina Hooghsaet, portrayed by Rembrandt in 1657 (cat.122).

The fact that around the mid-seventeenth century there are a number of portraits by Rembrandt and his circle depicting elderly women holding tasselled handkerchiefs (cat.137) has led Stephanie Dickey to believe that these accessories are allusions to sorrow. According to Dickey the handkerchief referred to the self-mastery of emotions and religious consolation in bereavement, and are therefore an appropriate attribute for elderly women, and widows in particular.[56] However, from the sixteenth century onwards the handkerchief has to be viewed rather as a sign of wealth than of sorrow. From the mid-sixteenth century the handkerchief functioned as a fashionable status symbol, worn by women of the upper classes to distinguish themselves from the majority of people who were still blowing their noses with their fingers.[57] By the last quarter of the century handkerchiefs were one of the costly accessories and usually carried in the hand by ladies of the highest nobility in Spanish court dress to show their wealth.[58] This use is also shown in contemporary costume plates, like those by Jean Jacques Boissard of 1581 or Cesare Vecellio of 1590.[59] Because the Spanish style, albeit in a modified version, was adopted by the urban elite in the Netherlands, around 1600 young women and little girls of this class are portrayed carrying embroidered and laced handkerchiefs.[60] When, during the 1620s, the more fashionable ladies of the court in The Hague changed to French fashion, the handkerchief was only worn by the ladies of the merchant class who adhered to the Spanish style in dress. This is nicely illustrated in the album of Adriaen van de Venne of 1626 in which different classes in Dutch society are shown in their characteristic dress.[61] In contrast to the courtiers

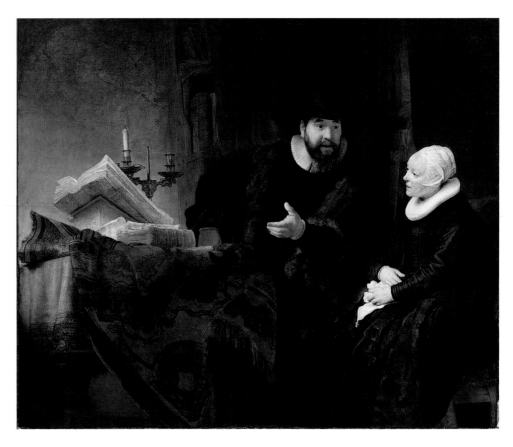

from The Hague in their colourful French garments, the affluent merchant's wife adhered to her Spanish ruff and *vlieger* costume, holding a tasselled handkerchief (fig.70).[62] Also telling is an emblematic illustration after Van de Venne in Cats's *Spiegel van de Oude ende Nieuwe Tijdt* (The Mirror of Old and New Time) of 1632 in which a young suitor ignores his old father's wishes and prefers fashionably dressed city girls to an honest, rich farmer's daughter. The latter is shown at the left dressed in the Spanish style holding a handkerchief. In both these images the handkerchief is certainly not an allusion to sorrow, but indicates a more conservative kind of chic worn by wealthy ladies from the city and the provinces. In the course of the seventeenth century the handkerchief became increasingly associated with old-fashioned (i.e. Spanish) dress styles, exclusively worn by affluent elderly matrons like the seventy-eight-year-old Margaretha de Geer (cat.137) or by Mennonites who by convention wore old-fashioned dress and accessories. That, by the mid-seventeenth century, handkerchiefs are found exclusively in portraits of elderly women in old-fashioned dress has less to do with the wearer's increasing melancholy than with the fact that younger women no longer carried this outdated fashion accessory.[63] It is therefore most unlikely that the spirited elderly woman painted by Bartholomeus Van der Helst (fig.71) was meant as an 'allegory of grief consoled by pious devotion' as stated by Dickey.[64] In this rather farcical depiction,

Fig.69 | Rembrandt, *Portrait of Cornelis Claesz Anslo 1592–1646 and Aeltje Gerritsdr Schouten 1589–1657*, 1641
Gemäldegalerie, Staatliche Museen zu Berlin, Pressischer Kulturbesitz
Photo: Jörg P. Anders

Fig.70 | Adriaen van de Venne (1589–1662), *Amsterdam Merchant and his Wife*, 1626
British Museum, London

Fig.71 | Bartholomeus van der Helst (1613–1670),
A Woman Leaning Out of a Window
Museum der Bildenden Kunste, Leipzig

the woman's handkerchief represents the out-moded fashion attribute, which had become the hallmark of her generation. Considering the setting and the rest of her dress, the woman's veil is not the sign of a grieving widow but must have functioned in the same way as Oopjen Coppit's veil.[65] In her case, however, the wearing of a veil would have been considered a silly vanity, because the woman's weathered skin is already very wrinkled, bringing to mind a poem by Cats about a vain old woman deploring her loss of youth: '… although I always wear a mask or veil, and rarely venture outside, nevertheless my youthful countenance turns into a wrinkled face'.[66] Here accessories serve to ridicule her vanity and a boisterous demeanour quite unfitting for her advanced age, of which the handkerchief had become the attribute.

Like handkerchiefs, other accessories ostenta-tiously worn in Rembrandt's portraits, like the fan and the glove, have been seen as meaningful attributes. David Smith has associated the fan worn by Agatha Bas in 1641 and the gloves carried by Oopjen Coppit's husband Marten Soolmans with love and marriage symbolism.[67] It is true that in mediaeval times gloves served as ritual objects in liturgy and as a symbol of legal authority.[68] Gloves were taken up in acceptance of a challenge and served as gifts demonstrating loyalty and service to the recipient; or they were presented as gifts to guests and provided as funeral attire.[69] Yet, by the seventeenth century they had lost most of their former significance and instead became more of a status symbol. Fans, like gloves and handkerchiefs, were costly as well as fashionable accessories whose primary function was to display their owners' wealth and status. The fact that these accessories were coveted luxury items was the reason why they were utilised as tokens of love or as gifts at weddings. As Bianca du Mortier has demonstrated, during the first decades of the century, special wedding gloves were given by the groom to his bride.[70] There was an acknowledged difference, however, between these wedding gloves, which were distinguished by their splendid embroidery, rich in love and marriage symbolism, and ordinary gloves worn as practical accessories. Although these wedding gloves are occasionally encountered in painting, it is usually the plainer glove which frequently appears in portraits.

Alternatively, gloves have often been seen as a sign of gentility or aristocracy.[71] Though this might be true in the beginning of the century, by the 1650s gloves were available in profusion and often bought by the dozen by well-to-do Amster-dam citizens.[72] When, in the course of the century, the use of gloves spread to the classes below the nobility, their charm as a status symbol began to decline. Therefore, during the second half of the century gloves gradually disappear in portraiture. This process of 'devaluation' of the glove is pointedly illustrated in a letter from The Hague

portraitist Pieter Nason (1612–1688/90) of 1662 to his patron the Frisian Stadholder Willem Frederik. With regard to a copy he had made of a portrait of the late Prince of Orange, Nason remarks: 'I have decided to omit the gloves in the copy (being in the left hand of his Highness of Orange in the original), because in my opinion such a burgher-like practice is in no way fitting for such a noble prince.'[73]

All in all it seems unlikely that accessories like gloves, handkerchiefs and fans in Rembrandt's portraits are anything more than status symbols. However, these luxury accessories did have certain associations, which over time were susceptible to change. Once fashionable status symbols like the handkerchief or glove are abandoned by the young or the trendsetting groups at court, they can become the hallmark of a more conservative chic, idiosyncratic of the bourgeoisie or the elderly. Likewise, it is of equal importance to consider the context in which particular items of dress like veils or hats are worn in order to determine their possible meaning.

FANCY DRESS

As opposed to portraiture, figures in seventeenth-century history paintings as a rule are not depicted in contemporary dress but in a fanciful costume that was labelled 'antique'. Beyond the actual meaning of this term, this did not denote classical dress but an eclectic mixture of fashionable, historic and exotic costume elements. By its nature, costume in history paintings should differ from contemporary dress, because the strange attire formed a crucial signal that the scene was set in a foreign or otherwise unknown world. In Rembrandt's work these 'antique' costumes are not only an important tool in convincingly placing the scene in a distant past or in a far-off country, but they also contribute significantly to the richness and great diversity of his history paintings. What were Rembrandt's sources for these often elaborate costumes? Were they purely the product of the master's imagination or did he draw his inspiration from existing garments, either from his own collection of studio props or from theatrical costumes?

First of all, the list of his possessions, drawn up in 1656, does not indicate that Rembrandt owned a large collection of old costumes.[74] Only a 'quantity of ancient textiles of diverse colours' is mentioned, acquired probably because of their patterns and colours and used in the studio for studying the fall of drapery.[75] Moreover, although some of the objects depicted in his work can be traced to his collection, it should be emphasised that Rembrandt's use of real objects was only incidental and bears no relation to the number of artefacts inventoried. It is telling in this respect that although a remarkably large amount of arms and armour is listed in the inventory, most weapons and armour depicted in Rembrandt's work are a

mixture of fantasy and reality.[76] The same applies to most of the other accessories depicted, such as the musical instruments and jewellery.[77] The clothing in his work forms no exception and it is therefore highly likely that the costumes to a large extent must have been imaginary rather than copied from actual garments.

For details of the clothing of the gods from classical Greece and Rome, Rembrandt may have consulted written sources. In 1604 Karel van Mander published a reference work entitled *The Depiction of Figures*, 'in which it is shown how the heathens depicted and differentiated their gods', with the assurance that it would be of 'great use to ingenious painters and poets to accoutre their protagonists'.[78] Rembrandt's depiction of *Juno* of *c*.1662–5 (cat.140) corresponds in many aspects to Van Mander's directions:

> *Juno … carries a sceptre in one hand …, and has shining beams on her head. She carries the sceptre because she is the Goddess of affluence. The peacock was her bird. Juno was very magnificent in her attire: she had a very fair gown of reddish-purple, and a blue cloak, decorated with many pearls, gems and jewels.*[79]

Instead of 'shining beams', Rembrandt depicted his Juno with a golden crown and lined her blue cloak with ermine, as is appropriate for the queen of the gods.[80] Though the prominent decoration with 'pearls, gems and jewels' seems to indicate that Rembrandt based himself directly on Van Mander's text, this is very difficult to prove with certainty. The attributes of the pagan gods, such as Minerva's owl-crested helmet or Mars' armour were well known and Rembrandt must have been familiar with them through the pictorial tradition.

On the whole, Rembrandt's fanciful costumes seem to have been largely determined by iconographic conventions and based on the pictorial tradition. Since so little was known of the appearance of women in the Near East, their costumes seem to have been based on historic or fanciful types of dress, traditionally thought to be oriental. Rembrandt in order to come to a convincing depiction of Biblical times relied heavily on his imagination and on depictions of the past by his predecessors, in particular his former master Pieter Lastman (1583–1633). The typical costume of the female protagonists in Lastman's work, consisted of a coloured gown with a fitted bodice, showing a low neckline and the very ample, finely pleated sleeves of the white shift.[81] This costume he used for heroines from classical antiquity and the Bible alike. The voluminous white shift had been the basic undergarment for centuries. The cut of this simple garment had not changed much over time and was thought to be the oldest form of dress, identical to the white drapery of classical antiquity.[82] For Rembrandt's contemporaries, only very little of the shift needed to be exposed to give a costume an antique or timeless air. Doubtless,

Lastman had taken this principle from Italian examples (e.g. Caravaggio) and dressed his female protagonists in fitted gowns of coloured and patterned fabrics revealing the sleeves of the shift, which – as an extra reference to antiquity – were usually taken up at the upper arm. Though in essence the costume of Rembrandt's heroines is identical to Lastman's, it is also much more eclectic and varied. The overgarments appear to be made of much heavier fabrics, like velvet or brocade, and are profusely decorated with jewelled chains and broad edges of golden embroidery or fur, as in his *Artemesia* of 1634 (cat.31). This dramatic, heavily ornamented costume was highly characteristic of

Fig.72 | Rembrandt, *Saskia van Uylenburgh in a Red Hat*, *c*.1633–42

Gemäldegalerie Alte Meister, Staatliche Kunstsammlungen, Kassel

Fig.73 | Hans Beham (1500–1550),
*Standing Man and Woman, c.*1530
Rijksmuseum, Amsterdam

Rembrandt's manner and he adhered to it throughout his career.

Because of their theatrical character, the costume of Rembrandt's half-length female figures of *c.*1634 and 1640 have been cited as examples of Rembrandt's use of actual theatre garments.[83] Margaret Louttit in 1973 devoted an article to the dress of his *Flora* of 1634 in St Petersburg (cat.27) and his *Flora* of 1635 (cat.36) in London.[84] She argued that the 'close observation of fashionable features and features of subsidiary theatrical and pastoral dress can only lead to the assumption that the artist was in fact painting a garment which he had actually seen', because 'there can have been no aesthetic reason behind the inclusion of details'.[85] It is true that in Rembrandt's time the pastoral vogue, originating in the popularity of classical bucolic literature, was already firmly rooted, not only in the theatre but in pictorial art as well.[86] From the beginning of the century onwards, seductive shepherdesses with deep décolletages began to feature in art, equipped with straw hats and a *houlette* (shepherd's staff). However, as a rule these shepherdesses are depicted in fashionable clothes or in exactly the same fanciful costumes found in history paintings with only a few accessories determining the pastoral character of their dress.[87] Because precisely these key elements (the *houlette* and the straw hat) are entirely lacking in the two half-lengths by Rembrandt, it is very doubtful that they were meant to be shepherdesses.[88] In fact, their wide sleeved dresses contain many oriental and sixteenth-century elements comparable to the dress of his other mythological, historical or Biblical heroines, such as his *Heroine from the Old Testament* of 1633 (cat.20) or his *Artemesia* of 1634 (cat.31).

It seems likely, therefore, that both the London and the St Petersburg pictures do not necessarily depict shepherdesses but conform to the traditional title. That Rembrandt himself applied the title *Flora* to pictures from his workshop is testified to by a note on the back of one of his drawings of *c.*1635 where prices of copies of his own work are mentioned, among them a '*floora*'.[89] In addition, after Louttit published her article, it was established that the London painting initially depicted the Old Testament heroine Judith holding the head of Holofernes.[90] The X-ray image of the painting shows that the dress for the major part was finished and that Rembrandt only changed Judith's tucked-up sleeves and added a circlet of flowers to make her into a '*Flora*'. This implies that the low neckline was not a feature specific to Arcadian dress. Moreover, in both works many inconsistent dress details occur that make the overall structure of the costumes unconvincing and rather give the impression that they must have originated from Rembrandt's imagination.[91] The fashionable line of these

fanciful gowns is probably due to his intimate acquaintance with the everyday appearance of his contemporaries.

Likewise, the high degree of detail in the costumes in Rembrandt's work of around 1640 is frequently put forward as an indication that real garments must have been used. Dudok van Heel in 1980 judged the heavy velvet dress in the half-length *Saskia van Uylenburgh in a Red Hat* in Kassel of *c.*1633–42 (fig.72) to lack elegance, originating probably from Rembrandt's chest of dressing-up clothes or from the wardrobe of Jan Krul's *Musijkkamer*. Loutitt on the contrary, characterised the dress as an 'exotic gown, observed in careful detail by the artist'.[93] However, like the London *Selfportrait* of 1640, Saskia's clothing can be dated fairly accurately to around 1530, more than a century earlier. In particular, Saskia's *tellerbarett* (broad-brimmed beret) with its very wide diameter, and her elaborately decorated *halshemd* (chemise) with smockwork and broad sleeves are both characteristic of German fashion of this period.[94] Both Saskia's costume and her pose reveal a strikingly close resemblance to depictions of women by such German masters as Albrecht Dürer, Lucas Cranach, the younger and the elder, and Hans Beham (fig.73).[95] So, in this particular case, Rembrandt's main source of inspiration was Old Master prints rather than an actual garment.

So far, it has been generally assumed that Rembrandt's interest in the contemporary theatre, together with his acquisition of bizarre and disused clothing, led to the portrayal of much dress in his history painting which was not part of current fashionable wear. However, closer examination of the use he made of his collection and the structure of the garments depicted, indicate that the master's great inventive genius on the one hand, and the pictorial tradition, especially in the form of various prints, on the other hand, were more important sources for the costumes in his history pieces.

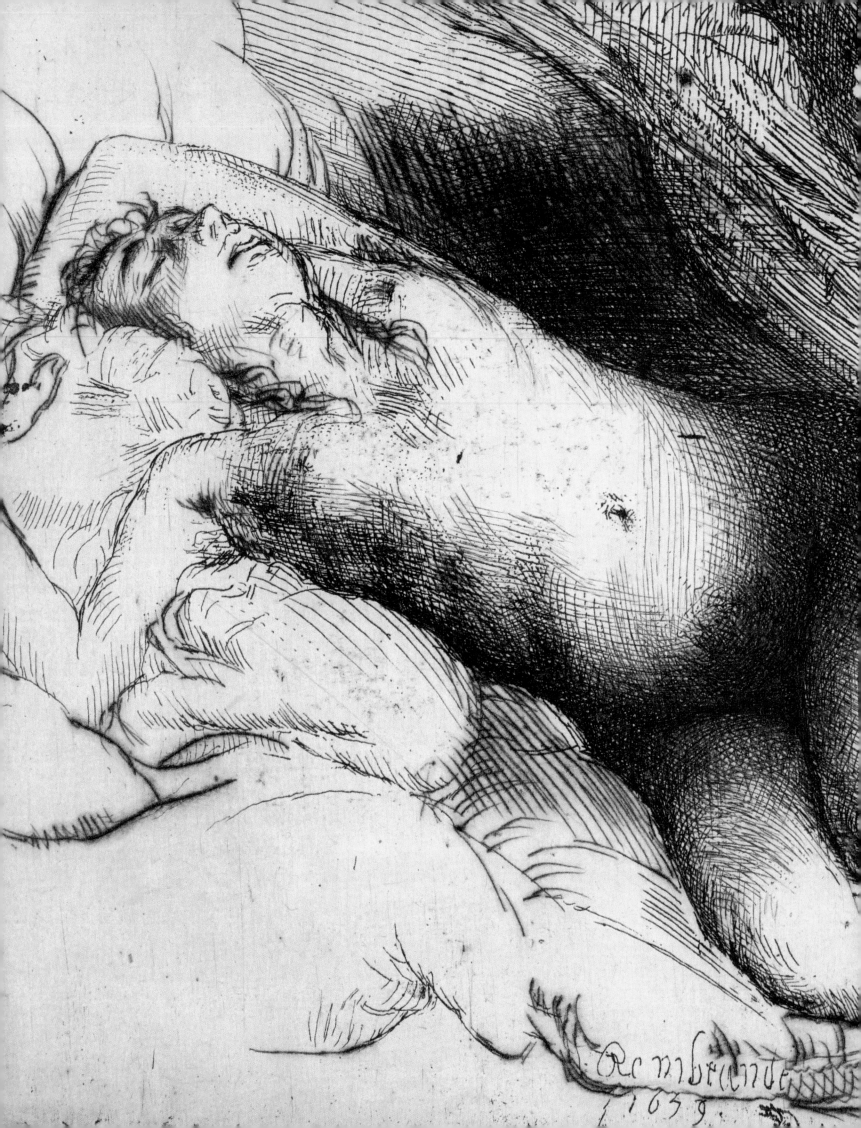

Catalogue Notes

All works are by Rembrandt van Rijn (1606–1669) unless otherwise stated.

Dimensions are in centimetres, height before width.

Information on the location of signatures and dates is given as follows: 'top' or 'bottom' is used when sited at the top or bottom edge of the work; 'upper' or 'lower' when sited somewhere else within the upper or lower half of the work. Other information on collectors' marks and inscriptions is mentioned within the catalogue text where relevant.

Works may be assumed to be exhibited at both the National Gallery of Scotland, Edinburgh and the Royal Academy of Arts, London unless marked 'Exhibited in Edinburgh only', or 'Exhibited in London only'. This occurs predominantly in the case of drawings, some of which have been deemed by their owners too fragile, rare or too frequently requested to be displayed for longer than three months.

ORDER AND NUMBERING

The works in the catalogue are arranged roughly in order of execution, but some have been grouped together slightly out of chronological order for the sake of coherence of subject matter. Catalogue numbers 26A and 137A are placed within this sequence, their loan to the exhibition having been agreed after the initial allocation of numbers.

REFERENCES

All abbreviated references may be found in the Bibliography. Exhibitions are listed under place name(s) and year, all other works under author and year. Given the huge canon of writing related to Rembrandt, it is not possible in this kind of publication to include full references to the literature on the works exhibited, nor are provenances included. However, the literature cited will direct the reader to further information of this sort.

Key references to works by Rembrandt used in this catalogue are as follows:

[I] **Paintings** executed up until 1642 appear in the three *Corpus* volumes produced by the Rembrandt Research Project and will be listed as *Corpus* plus volume and number only. (Letters appear before the *Corpus* numbers: A is considered by the Project to be authentic, B uncertain and C dubious.)

Paintings after 1642 will be given Bredius/Gerson numbers only.

[II] **Drawings** are numbered according to the catalogue raisonné by Otto Benesch (Benesch plus number only).

[III] **Etchings** are listed by Hind numbers (H. plus number only) and by references to the catalogue compiled by Karel Boon and Christopher White on the basis of the original Bartsch numbers (White/Boon B plus number only).

Detail from cat. 134

1 'The Artist's Mother', 1628

Etching, second state (of two), 6.3 × 6.4 cm
Signed (in monogram, for 'Rembrandt Harmensz Leiden') and dated, centre left: *RHL 1628* (the '2' reversed)
References: H.2; White/Boon B 352: II; Amsterdam/London 2000-1, cat.3

BRITISH MUSEUM, LONDON
(INV.NO.1973-U-737)

Rembrandt's mother was Neeltgen Willemsdr (*c*.1568-1640).[1] She was born in Noordwijk, the daughter of a baker Willem Aerntsz, and his wife Elizabeth van Tetrode, and their family was fairly well connected.[2] They later moved to the Vismarkt in Leiden. Neeltgen was married in the Reformed Pieterkerk in Leiden on 8 October 1589 to Harmen Gerritszn van Rijn. He was a prosperous fourth-generation corn miller whose name came from the site of the family's first mill on the north side of the Old Rhine, by Leiden's town gates. Neeltgen bore her husband at least ten children,[3] of whom Rembrandt was the youngest son, born on 15 July 1606.[4]

The identification of this woman as Neeltgen stems from the fact that in the 1679 inventory of the collection of the Amsterdam print and map dealer, Clement de Jonghe (1624/5-1677), the plate of an etching which appears to show the same woman was listed as 'Rembrandt's mother' (see cat.3, fig.77).[5] The assumption that the inventory identification may have been correct is reasonable in view of the fact that Clement de Jonghe probably knew the artist, who is believed to have etched De Jonghe's portrait in 1651,[6] and he certainly owned seventy-four of Rembrandt's copper etching plates. If therefore, as seems possible, Rembrandt's mother was the model for

this little etching, she would then have been about sixty years old.

Only two first states of this etching are known to exist and one of these is in the Rijksprentenkabinet, Amsterdam (fig.74).[7] Rembrandt obviously made an impression of his half-completed plate and then drew on the sheet in black chalk to plan the shape of the hood and how it draped across the old woman's shoulders. He made a pen and brush drawing (fig.75) which is extremely close in composition to the Amsterdam first state of the etching but the face is lit more from one side and more of the cap is visible under her hood.[8] The drawing may possibly be viewed as loosely preparatory for the etching, perhaps to plan out the general format, but the slight differences in composition and the fact that he drew directly onto the Amsterdam sheet of the unfinished first state imply that he was at first etching directly onto the plate from the model and not actually copying the drawing. If Rembrandt did complete the plan to etch part of her upper body, the finished effect must have disappointed him since he chopped nearly two centimetres off the height of the copper plate as well as trimming its width. The final version has something of salvage about it since the old woman's chin is left awkwardly resting on the bottom margin – a 'severed' head. However, recent research on watermarks has shown that Rembrandt continued to make prints from this plate until at least 1635.[9]

This was not the first time that Rembrandt altered the size of his copper etching plate. One of the earliest-known etchings he made, *The Flight into Egypt* of *c*.1626, was treated in a similar way when he cut out the figure of Joseph to create a separate print and then re-used the section with the head of Mary (upside-down) for a new etching of his own head.[10]

Fig.74 | Rembrandt, *'The Artist's Mother'*, 1628
Rijksmuseum, Amsterdam

Fig.75 | Rembrandt, *An Old Woman Seen from the Front*
Private Collection

2 'The Artist's Mother'

Etching, second state (of two), 6.5 × 6.3 cm
Signed (in monogram) and dated, top right:
RHL 1628 (the '2' reversed)
References: H.1; White/Boon B 354: II

BRITISH MUSEUM, LONDON
(INV.NO.1973-U-736)

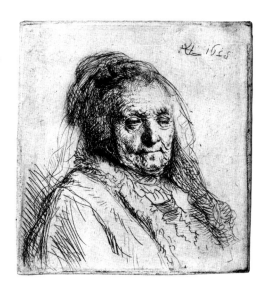

There was clearly sufficient money in Rembrandt's parents' household to ensure that he did not have to be apprenticed to a miller or baker. He was instead initially enrolled at the age of thirteen in May 1620 (having studied at the Latin school from 1616) as a student destined for Leiden University (or Academy as it was then known), perhaps with the intention of reading theology or law.[1] How-ever, since the boy 'had no desire or inclination whatsoever in this direction because by nature he was moved toward the art of painting and draw-ing',[2] in about 1620 his parents apprenticed the young Rembrandt for some three years to Jacob Isaacsz van Swanenburgh (c.1571–c.1638), a history painter who had spent twenty-five years in Italy. Around 1625, Rembrandt went to Amsterdam where he worked for about six months in the studio of 'the renowned painter' Pieter Lastman in Sint Anthoniebreestraat.[3] By the time the etchings exhibited here (cat.1 and 2) were made, Rembrandt had come back to his hometown to 'engage in and practice the art of painting entirely on his own'.[4] Leiden at the time was the centre of scholarship and religious study in the United Provinces, of which it was the second largest town. On his return Rembrandt almost certainly set up his studio in his parents' house in the Weddesteeg (a common occurrence – Lastman's studio was also in the house of his mother, to whom he paid rent).

Rembrandt set about sketching this little head in a similar way to that seen in cat.1, first printing out trial sheets of the first state which show only the old lady's face, criss-crossed in creases. Her arms and shoulders were added in the second state and the print signed only then. Rembrandt's early attempts at etching in about 1626 are clearly made by an artist unpractised in the technique.[5] How-ever, the small-scale studies of heads that Rembrandt made in the couple of years following this appear to show him actively setting about improving his skill with the etching needle. He drew what was close and available, and he drew often. His own facial features were his model in the many (often tiny) etchings he made[6] and if this is his mother, he seems to have depicted her fairly frequently,[7] and also maybe his father, though proof of identity is slight.[8]

The features shown in the etchings of the old woman seen here bear a strong resemblance to those in Rembrandt's painting of an *Old Woman at Prayer* of 1629/30 (fig.76).[9] The small format and the painstaking portrayal of the wrinkled skin are similar in both, but the direct light source in the painting means that the light falls more flatly there upon the old woman's wizened face. In the etching, however, Rembrandt gives the face more character through meticulous lines and the highlights which fall from the right, the atmospheric, oblique shadows rendering the modelling more convincing.

It is not entirely certain what led the young painter to explore etching as a medium. He is not recorded as having any master to teach him the technique, though experimentation may have been prompted through his friend and close contempo-rary Jan Lievens (1607–1674). They may have been encouraged, in turn, by the Haarlem publisher Jan Pietersz Berendrecht.[10] Lievens was also born in Leiden and had trained with Pieter Lastman from 1617 to 1619, some years before Rembrandt.[11] He had returned to Leiden after his apprenticeship, as did Rembrandt, and the two worked closely together, each influential on the artistic develop-ment of the other.

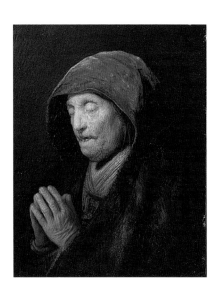

Fig.76 | Rembrandt, *An Old Woman at Prayer*, 1629/30
Residenzgalerie, Salzburg

3 'The Artist's Mother' Seated at a Table, c.1631

Etching, second state (of three), 14.9 × 13.1 cm
Signed (in monogram), lower left: *RHL f.*
References: H.52; White/Boon B 343-II

RIJKSMUSEUM, AMSTERDAM
(RP-P-OB-731)

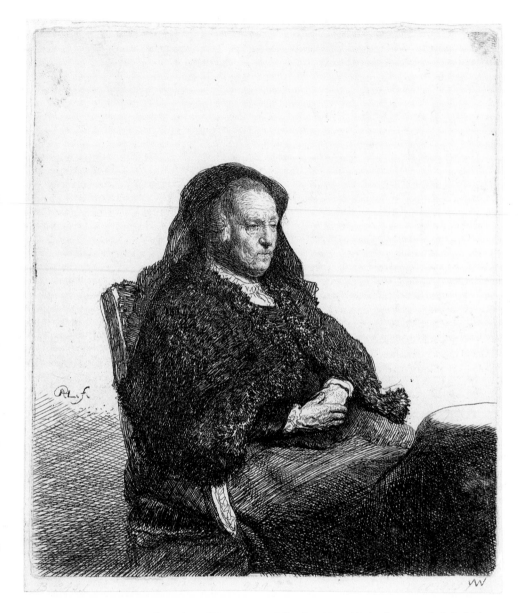

Rembrandt's skill at depicting age was recognised by the German painter and writer on art Joachim von Sandrart (1606-1688) who wrote that 'In the depiction of old people, and their skin and hair, he showed great diligence, patience and experience, so that they came close to resembling simple life.'[1] Indeed, almost half of Rembrandt's work during his period in Leiden depicts old men and women. Sandrart also noted that Rembrandt portrayed 'generally simple things that were easily understood, things that just appealed to him and were *schilderachtig* (as the Dutch say), which were nevertheless full of characteristic motifs sought directly from nature.'[2] Contemporary accounts attest that the elderly, with their grizzled heads and crepe-like folds of wrinkled skin, were regarded as being worthy of depiction, and these 'simple' subjects had a wide appeal.[3] The exact status of such works, whether they should be deemed portraits of specific people or more general studies of 'characters', either portrayed as heads or bust-length figures (known as *tronies*),[4] is extraordinarily hard to determine in Rembrandt's oeuvre, and this is certainly the case with his depictions of women.[5]

The entry in the 1679 inventory of Clement de Jonghe's estate for an etching plate entitled a 'Seated Old Woman' is likely to refer to this etching,[6] whereas what seems to be the same woman with her hand on her chest was identified as 'Rembrandt's Mother' (fig.77). That their identifications should differ, even though they might appear to be the same person, is perhaps not

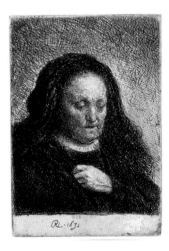

Fig.77 | Rembrandt, *'The Artist's Mother' with her Hand on her Chest*, 1631
British Museum, London

so surprising. Rembrandt made studies of his own head that cannot precisely be called self-portraits but are, rather, exploratory depictions of different emotions (presumably inspiring his pupil Samuel van Hoogstraten's advice to draw 'what you have before you, chiefly by being at the same time actor and spectator in front of a mirror').[7] In the same way, becoming familiar with the problems of drawing, etching and painting the contours of an old woman's face and figure was something that was good practise for the young artist. The results became part of the repertoire of the history painter which could be called upon when required in a composition.

Rembrandt's father was buried in April 1630 so that his mother would have been a widow when Rembrandt made this etching in 1631.[8] The notary who drew up his mother's will in Leiden on 14 June 1634, three years later, gave us the only eye-witness account we have of her when he wrote the

following: 'Considering her age, she is in fairly good health, can stand and walk, retains her memory and all her senses and faculties, and has them all under control, as far as can be judged from outward appearances.'[9] This, however, was a fairly standard legal description to guarantee that the person drawing up the will was 'of sound mind' and the same notary used almost the same formula to describe Rembrandt's sister Elisabeth when she drew up her will.[10] In later life, Neeltgen became known as Cornelia Willemsdr van Zoutbroeck, a more gentrified name which rather better became her considerable wealth: she left almost 10,000 guilders at her death in 1640,[11] at a time when this was worth approximately fifty times the annual wage of an unskilled labourer.[12]

4 'The Artist's Mother' with Oriental Headdress, 1631

Etching, first state (of three), 14.5 × 12.9 cm
Signed (in monogram) and dated, lower right:
RHL 1631
References: H.51; White/Boon B 348: I

RIJKSMUSEUM, AMSTERDAM
(INV.NO.RP-P-OB-740)

The entry for this etching in Clement de Jonghe's inventory was 'An Old Persian Woman',[1] called thus presumably on account of her striped headgear, far from normal wear for an old lady in Leiden or Amsterdam in 1631. The title given to this etching in the De Jonghe inventory makes it clear that it was perceived as a *tronie*, the generic term for 'face'. This was not a portrait as such but a 'study' of a figure which allowed the artist to show fanciful costume and different poses and expressions, sometimes elaborately conceived. They could be used as individual studies which might be assembled together in a larger composition but also enabled the artist to explore dramatic lighting effects and unusual features. Therefore, the purpose of a *tronie* was not to flatter the sitter, but to show the artist's skill and imagination, and such pieces found a ready market as works in their own right. It has been argued that studies like these would have had the additional bonus of training Rembrandt in the observation necessary for a portrait painter that he was to exploit so successfully on his arrival in Amsterdam, but they undoubtedly also taught him how to interpret real features with an inventive artist's licence which was also to prove invaluable to him as a history painter.[2]

Rembrandt had already depicted similar old women in a number of his early history and Biblical paintings, such as *Tobit and Anna*[3] and the *Musical*

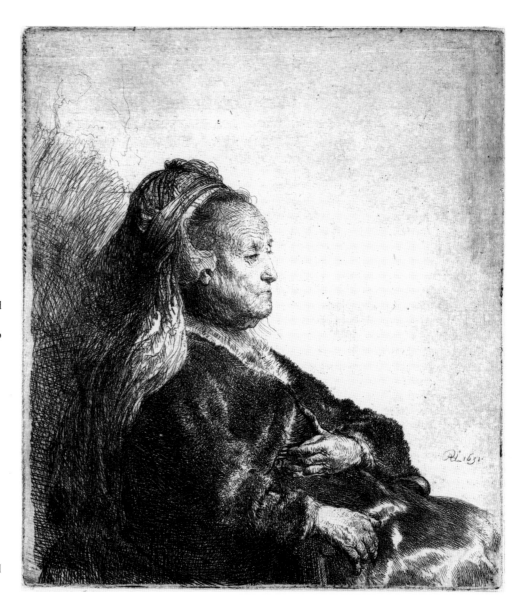

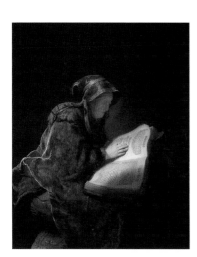

Fig.78 | Rembrandt, *An Old Woman Reading* also called '*Rembrandt's Mother*' *as the Prophetess Anna*, 1631
Rijksmuseum, Amsterdam

Allegory,[4] both painted in 1626, the *Simeon in the Temple*[5] of 1627/8 and the panel of an *Old Woman Reading (The Prophetess Anna)*, dated 1631 (fig.78).[6] Jan Lievens had painted a similar composition in c.1625 of what appears to be the same woman in profile in his *Reading Prophetess*[7] which perhaps influenced Rembrandt's choice of subject for an *Old Woman Reading* a few years later.[8] Lievens's other related compositions include *Bust of an Old Woman* (called '*Rembrandt's Mother*') of about 1629 (cat.5, fig.79)[9] and his '*Rembrandt's Mother*' painted about two years later.[10] A similar figure appears in his *Job in Misery*,[11] in the *Soothsayer*[12] and in his *Young and Old Woman (Vertumnus and Pomona)*,[13] to name but the most obvious. Rembrandt's pupil Gerrit Dou (1613–1675) used a diminutive '*Rembrandt's Mother*' figure for his panel of *Old Woman Peeling Apples* of c.1630,[14] also painting a similar model in his *Old Woman Reading* of c.1631–2.[15] Such old ladies continued to remain a stock-in-

trade subject for him throughout his career. It is not known whether or not Lievens actually worked in the same studio as Rembrandt,[16] but Dou must have done so when he was training with Rembrandt in Leiden.[17] It is quite possible that both may have known and painted the original model we see here in the years before Rembrandt's departure for Amsterdam in 1631/2, but it was presumably through the influence of etchings such as this that '*Rembrandt's Mother*' was destined to find herself reappearing as a popular motif in other artists' compositions, far beyond her own family circle.

5 A Bust of an Old Woman: 'The Artist's Mother', c.1629–31

Oil on panel, 61 × 47.3 cm
References: White 1982, cat.158, pp.101–3; *Corpus*,
vol.1, A32; *Corpus*, vol.2, Corrigenda et addenda,
pp.839–40

Along with the little picture on copper of an *Old
Woman at Prayer*[1] of *c*.1629–30 (cat.2, fig.76), and
another larger work on panel, an *Old Woman
Reading*[2] of 1631 (cat.4, fig.78), this is one of the
three paintings dating from Rembrandt's late
Leiden period (*c*.1629–31), for which Rembrandt's
mother has often been cited as model. If this panel
does indeed use her features she would have been
about sixty-two years-old when this was painted.
As discussed in the previous entry (cat.4),
Rembrandt had already used the same type of
model in other early history and Biblical works, as
had Jan Lievens and Rembrandt's pupil, Gerrit
Dou.

Jan Lievens painted what appears to be the same
woman in profile in his *Bust of an Old Woman* (fig.79)
which has been convincingly dated to about 1629.[3]
The costume is exotic in both that painting and this
picture, although Lievens's painting is consider-
ably more colourful, in the rich orange-red, bluish
green and light yellow that makes up the pattern on
the old woman's translucent scarf. The Royal
Collection *Old Woman* is similarly set against a dark
background but the palette used is more sombre,
the only bright colour being the spots of golden
yellow which highlight the design on the inside of
the old lady's deep purple velvet hood. She appears

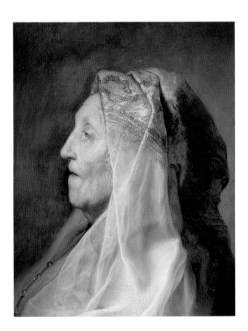

Fig.79 | Jan Lievens (1607–1674), *A Bust of an Old Woman*
Drs Isabel and Alfred Bader

to be wearing a fur coat or mantle over her dark
dress, with an embroidered and gathered white
chemise visible at the neck. The way that Lievens
paints the old woman is somewhat different from
that seen in this picture. The latter is far more
detailed in its portrayal of the woman's skin, with
delicately painted creases at the bridge of her nose;
and the same refinement occurs in the treatment of
her eyes, where a fine white line along the lower
lids and the shaded socket give a very precise sense
of modelling.

The status of this panel has been the subject of
much debate. It was published as being an authen-
tic work by Rembrandt by the Rembrandt
Research Project in the first volume of the *Corpus* in
1982, although it was stated that 'from the
viewpoint of style there is no cogent substantiation
of the attribution to Rembrandt'.[4] The picture is
indisputably the same as that mentioned in an
inventory of Charles I's collection in *c*.1639,
described by the cataloguer of the king's pictures,
the Dutchman Abraham van der Doort, as hanging
in the Long Gallery at Whitehall 'Betweene the …
ffowerteene and last wind dowes an old woeman
with a peaked falling band In a Black frame …
Done by Rembrandt and given to the kinge by my
Lo: Ankrom'.[5] On the reverse of the painting is also
a label which notes, 'Given to the King by Sir
Robert Kerr', which implies Kerr made his gift
before being created Earl of Ancram in 1633.[6]

Kerr had been sent to the Netherlands in 1629
as a personal envoy to take King Charles's condo-
lences to the King and Queen of Bohemia in The
Hague on the death of their son (Charles's
nephew).[7] On his visit to The Hague. Kerr may
well have met Constantijn Huyghens, secretary to
Frederik Hendrik, Prince of Orange, the King of
Bohemia's uncle. Huyghens had just had his
portrait painted by Lievens and may well have
introduced Kerr to the art of the young Rembrandt
as well.[8] The difficulty of determining between the
work of the two young artists was clearly a problem
for their contemporaries, even for those whom one
assumes to have been connoisseurs of their art. For
example, along with the *Old Woman* here, Kerr also
presented two other pictures to Charles I which
were also listed as by Rembrandt, the *Self-portrait*
now in the Walker Art Gallery, Liverpool,[9] and a
'*Young Scholar*', now lost, but which was then
ascribed to Lievens rather than Rembrandt in a
1649 inventory.[10] It seems that this last picture was
the same work which Rembrandt's first biogra-
pher, Jan Jansz Orlers, described in 1641 as being
by Jan Lievens, and as having been bought by the
Prince of Orange and presented to the British
ambassador (Kerr) in order to give to King
Charles.[11] It has usually been assumed that Kerr
must have taken the three pictures back with him
when he returned to England after his visit of 1629,
but this picture, and the *Self-portrait* mentioned
above, are probably slightly later than this in terms

of composition and lighting effects and fit more
closely Rembrandt's work of about 1630–1
(although neither is dated).[12] However, the 'hand-
over' of the pictures does not have to have taken
place in 1629, since they could have been shipped
after Kerr's visit, possibly through the agency of
Constantijn Huyghens.[13]

The closeness of the work of Rembrandt and
Lievens at this period in Leiden is undeniable and
the uncertainty of authorship was not just recorded
in the inventories in London, but also closer to
home at the Court at The Hague. At least four
paintings now believed to be by Rembrandt appear
to have caused confusion amongst their Dutch
cataloguers as early as 1632.[14] The Rembrandt
Research Project noted in their addenda that this
picture might be called 'a borderline case, and
whichever of the two artists painted it came very
close to the other'. It should be pointed out that
X-rays reveal the picture to be painted on top of a
portrait of a man which may have placed certain
technical constraints upon the artist and may
partially account for some such stylistic anomaly.
(Interestingly, the Rembrandt *Self-portrait* men-
tioned above is also painted on top of another
composition.)

The relationship between Rembrandt and
Lievens was extremely important for both artists.
An example of their creative sparring is given by
the way both artists dealt with the story of Lazarus,
in painting, drawing and etching, each responding
to the innovations of the other.[15] This also
happened with their versions of the story of
Samson and Delilah (see cat.9). The *Bust of an Old
Woman: 'The Artist's Mother'* is particularly fascinat-
ing because of the way it illustrates so directly how
Rembrandt and Lievens were vying with each other
at this crucial stage in Rembrandt's development,
each trying to outdo the other and spur themselves
on to greater creativity, dramatic impact and
technical mastery. In portraying the woman
believed to be Rembrandt's mother, the picture
also shows how such a model could be fruitfully
redeployed in Rembrandt's various compositions,
a practice he continued throughout his life.

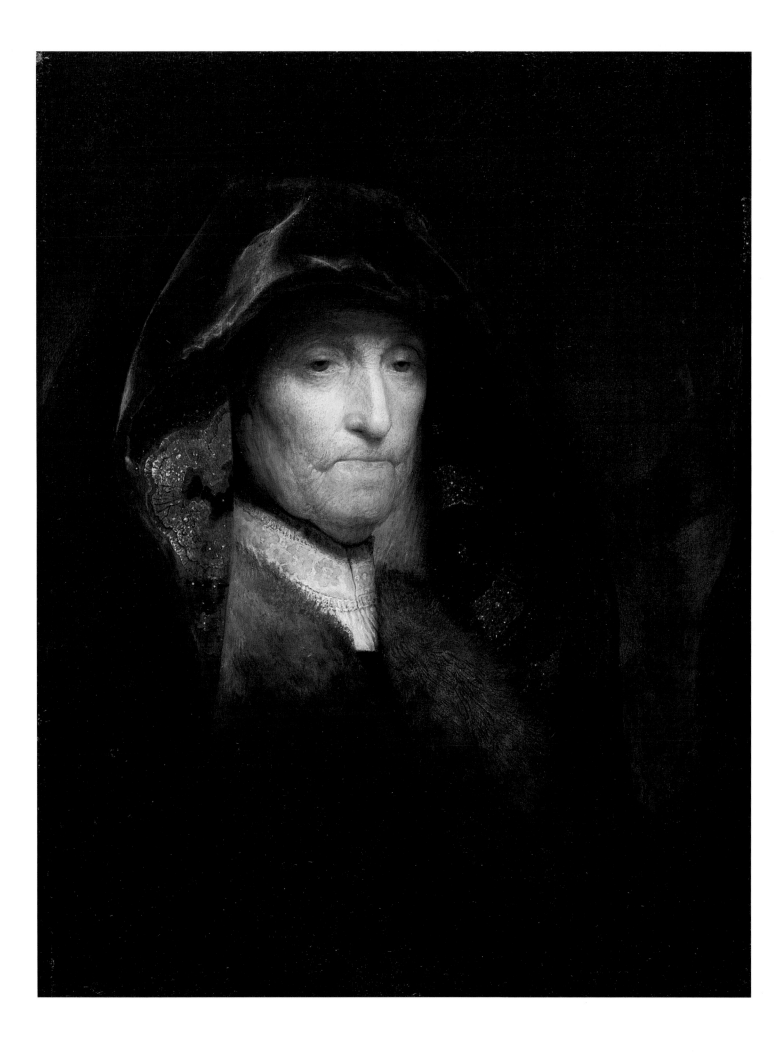

6 A Study of a Woman Asleep, c.1629–30

Drawing, black chalk (upper right portion is repaired), 25 × 22 cm
Reference: Benesch 196

KUPFERSTICHKABINETT, STAATLICHE KUNSTSAMMLUNGEN DRESDEN
(INV.NO.C1966–67)
Exhibited in Edinburgh only

This drawing, clearly made from life, shows a woman sitting on an armless high-backed chair in a thick dark dress, her head swathed in a scarf or hood, the plain white band of her collar visible at her throat. She rests one foot on the floor while the other is raised upon a rectangular block, possibly a small box containing a foot warmer (usually a clay pot with coal embers), then in common use.[1] The choice of such simple subject matter was prompted by the idea that an artist should faithfully learn to represent everything in the visible world. This type of figure study was part of that process. Drawings like this would probably have been kept by the artist for use in the studio to be consulted, adopted in other compositions or perhaps given to pupils to copy.[2]

The sheet was formerly believed to date from a couple of years later, when Rembrandt moved from Leiden to Amsterdam,[3] but the broad chalk lines with their strong parallel hatching are stylistically much closer to the end of Rembrandt's period in Leiden, found in drawings such as his *Standing Man with a Stick*, also in black chalk (fig.80). As Peter Schatborn has pointed out, a group of sheets depicting rogues and vagrants which Rembrandt made between about 1628 and 1630 were inspired

by the French artist Jacques Callot's series of prints, *Les Gueux* (The Beggars), which had been published in 1622.[4] Schatborn identified the paper Rembrandt employed for a number of these drawings as being Italian, on the basis of watermarks and tell-tale wide spacing between the wire-marks (left as a result of the paper-making process).[5] Examples of the same paper can be found in an etching by Jan van Vliet of 1631 and in documents of 1629 and 1630 in archives at Haarlem and Middelburg, providing a clear indication of the time when it was in use in the Netherlands.[6] Rembrandt used the same paper for this drawing and so it, too, can confidently be ascribed to that period.[7]

This is also one of the earliest of a number of drawings demonstrating Rembrandt's interest in the portrayal of sleep. He seems to have found the process of abandoning consciousness in sleep, as well as the curiously intimate act of watching the sleeper, artistically compelling. The Dresden drawing shows the woman's head lolling to one side with the weight of dreaming, hands heavy in her lap. Some years later, in about 1635, he drew *Two Studies of Saskia Asleep* (fig.106), in which the two sketches, presumably made moments apart, show the process of Saskia sinking into slumber, as if in two successive frames from a film.

It has been suggested that Rembrandt probably used the same model in his drawing of *A Woman Seated in Profile with Clasped Hands* (cat.22) but the Dresden woman is given virtually no identifiable features, even if the drawings were of the same date.[8] Whoever the sitter was, she seems to have been at ease in front of the artist, but whether the model was his mother, a servant or someone else we shall never know.

Fig.80 | Rembrandt, *A Standing Man with a Stick*
Rijksmuseum, Amsterdam

7 'The White Negress', c.1630

Etching, second state (of two), 9.8 × 7.7 cm
Signed (in monogram), top left: RHL (in reverse in
the first state, the plate measuring 11.2 × 8.4 cm).
The plate was cropped for the second state,
removing the original monogram
References: H.364;[1] White/Boon B 357: II

This etching, traditionally called 'The White
Negress', was described as 'A Morisco' by Daniel
Daulby in 1796, who noted, succinctly, that 'the
face of this woman is the character of a Moor,
though the complexion is fair.' One of Rembrandt's
late etched nudes (see cat.133) was also assumed to
portray a black woman but, in fact, this seems to
have been a misunderstanding of Rembrandt's
intention to explore the subtle effects of shadow
across the nude form. This etching, however, is
rather different and the features of the woman do
indeed appear African, though whether directly
observed by Rembrandt or invented from other
representations is unclear.[2] The international
nature of Dutch maritime commerce during this
period, particularly the West India Company's
trading posts in West Africa and the Caribbean,[3]
meant that, though not exactly common, black
people could certainly be seen in the Netherlands,
especially in the port cities of Amsterdam and
Rotterdam, but also elsewhere, usually as family
servants.[4] However, although Rembrandt could
presumably have seen a black woman, the likeli-
hood of the etching being a proper portrait is small.
The head shown almost in profile, with averted
gaze, is given a sketchy but rather elaborate
headdress with what appears to be a feather
fanning out behind and perhaps a veil, not
dissimilar from the fanciful headgear he was to use
in his rather more assured etching of 'The Artist's
Mother' with Oriental Headdress (cat.4) made the
following year. Such decorative adornment would
have been acceptable for tronies and it may be that
Rembrandt was again adding to his repertoire, for
use perhaps in Biblical scenes.

Rembrandt had certainly depicted black figures
before this, for example in his early Baptism of the
Eunuch of 1626,[5] partially influenced by the
compositions of the same subject by his master,
Pieter Lastman.[6] Intriguingly, given the paleness of
the woman in this etching, it seems that a clear
contrast was then made between the black skin of
the Ethiopian eunuch and the cleansed purity of his
newly baptised soul. A sonnet first published in
1630 by a Calvinist poet-preacher, Jacobus Revius
(1586–1658), refers to the baptism of the Ethiopian
who, it states, 'Received baptism … with a faithful
heart, his outer skin remained still black yet in his
soul was he whiter than the snow.'[7] Another
inscription found the following year on a Van Vliet

etching after a lost painting by Rembrandt notes
that 'Here Philip washes the black Ethiopian,
dispels the colour not of his skin but of his soul …'[8]
It is impossible to know if Rembrandt intended to
make his African woman darker, or if her skin was
left intentionally pale. The etching is lightly drawn
across part of her bust but heavily cross-hatched
along her left side with the heavy dark 'ledge'
drawn in across the bottom of the etching (cover-
ing the lines of her left sleeve and waist of her dress
which Rembrandt for some reason curtailed). This
gives the impression that Rembrandt simply
stopped working on the plate, perhaps because he
was satisfied with it or because he had experi-
mented as far as he wished.

8 *A Woman Standing with a Candle*, *c*.1631

Drawing, pen and brush and brown ink with brown
and grey wash, heightened with white; ruled framing
lines in pen and dark grey ink,
18.1 × 13.2 cm
References: Benesch 263a; London 1992, cat.6,
pp.35–6

BRITISH MUSEUM, LONDON
(INV.NO.1895–9–15–1268)

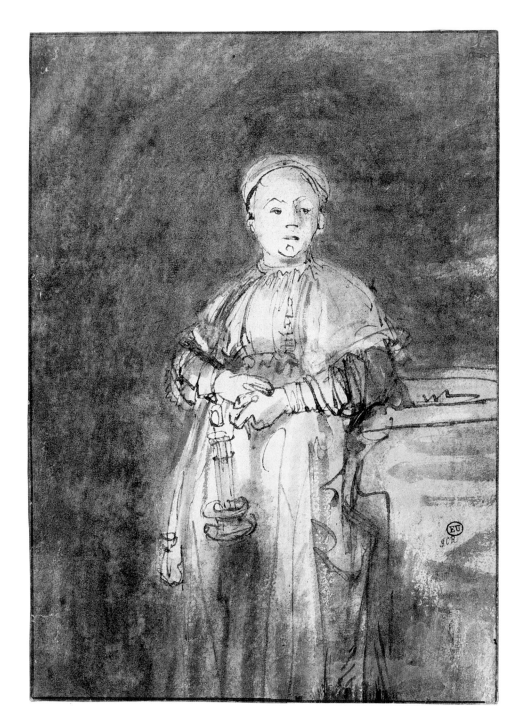

The composition of this striking drawing does not
relate to any other work known by Rembrandt
though his authorship is generally accepted.[1]
Although others have tended to place this work in
the mid-1630s, Royalton-Kisch convincingly dates it
to the end of Rembrandt's Leiden period, about
1631, on the basis of the rather angular lines that
swerve abruptly into corners and curves. The
treatment of the girl's sleeve is remarkably similar to
that seen in Rembrandt's chalk drawing dated 1631,
Old Man in an Armchair (Teylers Museum, Haarlem),
despite the difference in medium.[2]

Whether or not the artist started off with the
intention that this should stand alone as an inde-
pendent drawing is not certain, but he presumably
saw its potential as such, bringing the sheet to a high
level of finish with an especially sensitive use of
wash. He concentrates especially upon the light
which softly defines her upper body. She seems to
gather substance where the candlelight touches her
and her face and hands are relatively solid above her
summarily sketched skirts, ghostlike in the gloom.
Rembrandt's dark brown wash plunges the left
foreground into darkness and wreathes her head in a
halo of shadow. The touches of white heightening
upon her shawl and lines of wash on her dress are
deftly placed, giving the impression that the drawing
actually utilises more colours than it does, and it is
only due to the dark that they cannot be seen more
vividly.

At her right hangs a small drawstring purse, like
that seen in the Pierpont Morgan drawing of *A
Woman and Child Descending a Staircase* (cat.53). She
holds a rather unusual candlestick, a metal cage set
on a base with a handle at the top. The candle was set
into an adjustable socket, which was raised as the
stump of wax grew lower, to keep the flame at the
top (a similar one can be seen in the Boijmans Van
Beuningen Museum in Rotterdam).[3] The setting is
unclear. The woman rests her back and her left elbow
against a ledge that appears to have a flat, round lip.
The short, blunt horizontal wash lines on its side
appear to show that the outer edge is also slightly
bowed, almost like the edge of a well or curved wall.
It is difficult to know if any vague allusion to a
narrative figure was intended, such as a prudent
Biblical virgin waiting with trimmed lamp (Matthew
25: 1–13), but even if it were, Rembrandt's prime
concern was clearly the portrayal of light and dark
and how they played upon the unknown girl.

9 *A Study of a Woman's Legs, c.1628–9*

Drawing, red and white chalk, 22.6 × 17.6 cm
References: Benesch 9v; Schatborn 1985, cat.5,
pp.12–15

RIJKSMUSEUM, AMSTERDAM
(INV.NO.RP-T-1898-A-3689)
Exhibited in Edinburgh only

The artist and theorist Samuel van Hoogstraten,
once a pupil of Rembrandt, recommended using
red chalk such as this on white paper for drawing
faces, hands 'or entire nudes from life'.[1] Rembrandt
presumably taught this technique which he must
have learnt in Pieter Lastman's studio. Rembrandt
had two of Lastman's sketchbooks (one drawn in
pen and one in chalk) to hand for consultation in
the studio long afterwards, for they are listed in the
inventory of his possessions in 1656.[2] Although
Rembrandt used red and black chalks far more
rarely for drawing in his later life (favouring pen
and ink), some of his most impressive early
drawings of female nudes are in this medium, such
as *Diana at her Bath* and *A Nude Woman with a Snake*
(cat.10 and 71). In this drawing he moistened the
red chalk, presumably licking it, which provided
the density of medium required to create the darker
areas behind her knee, a process known as 'deepen-
ing'. The straight line drawn under her left foot
may indicate a raised platform used to facilitate
studio posing, such as seen in a slightly later red
chalk drawing of a *Seated Old Man*, signed and dated
1631.[3]

 This is probably the earliest figure study of a
woman by Rembrandt to have survived (although
as disembodied legs are rather hard to 'sex', this
accolade is more properly held by the *Diana at her
Bath*, cat.10). The indication of the platform

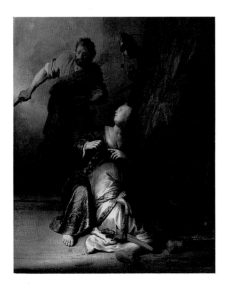

Fig.81 | Rembrandt, *Samson Betrayed by Delilah*, 1628
Gemäldegalerie, Staatliche Museen zu Berlin, Preussischer Kulturbesitz
Photo: Jörg P. Anders

mentioned above, in combination with the
carefully arranged drapery, would imply that this
sketch was made from life in the studio. As pointed
out by Volker Manuth, drawing *naer het leven* (from
the life) was something which the so-called
Haarlem Academy had practised,[4] but it is not
known whom Rembrandt might have persuaded to
model for him in this instance. The drawing has
been recognised as perhaps relating to
Rembrandt's *Samson Betrayed by Delilah* panel in
Berlin (dated 1628, but perhaps dating to 1629/30,
see fig.81).[5] On the reverse of the Amsterdam sheet
is a drawing of *Three Scribes* in pen and wash,[6]
loosely preparatory for Rembrandt's final painted

version of *Judas Repentant*, dated 1629. The
Amsterdam sheet can therefore also be dated to
about this period.[7]

 The relationship between this drawing and the
Berlin painting is far from direct: in the latter the
stance is effectively in reverse and the exposed leg
covered, but it is perhaps true that the Amsterdam
sketch may have provided a first thought for
Delilah's pose. The development of the composi-
tion of the painting marks the extraordinary
working rapport between Jan Lievens and
Rembrandt at this period, with an oil sketch by
Lievens of c.1627/8 acting as a spur for
Rembrandt's treatment of the theme.[8]

Drawing, black chalk and brush with light brown wash, 18.1 × 16.4 cm
References: Benesch 21; London 1992, cat.5, pp.33–5

BRITISH MUSEUM, LONDON
(INV.NO.1895–9–15–1266)

This is Rembrandt's first known complete figure drawing of a female nude and is a rare preparatory study for the artist's etching of *Diana at her Bath* (cat.11).[1] Rembrandt may well have known prints by Willem Buytewech and Annibale Carracci representing those other bathing beauties, Bathsheba and Susanna, or indeed Lucas Vorsterman's print after Peter Paul Rubens's *Susanna*, which may have influenced his composition (see figs.38, 39 and 44).[2] But though mindful of such precedents, it seems likely that Rembrandt probably did use a model for this drawing as well, given the apparent immediacy of his draughtsmanship. Rembrandt's drawing shows an unidealised woman, who is only identified as Diana on the basis of the sketchy quiver of arrows which hangs from a barely-defined twig behind her. Her pose was clearly rethought somewhat during drawing. The position of her left arm was raised (both upper arms were formerly parallel) and there are some areas which remain oddly tentative, such as the unresolved lower legs, heavily drawn over, and the somewhat hesitant lines of her lap.

It has sometimes been suggested that the presence of such a detailed preparatory drawing indicates that studio assistants may have collaborated with the etching of Rembrandt's *Diana*.[3] Certainly the drawing has been deeply scored along the outlines of the figure which must have been indented for transfer onto the copper plate, the reverse of the sheet having been covered in black chalk, just as we would use tracing paper.[4] However, this does not mean that Rembrandt passed his drawing to assistants to mark up the design on the copper etching plate. The alteration of the position of the arm is still not fully resolved in the drawing and would have been difficult for an assistant to copy.[5] In addition, the background of the drawing is not indented and is drawn in a far looser, more schematic style.[6] It is more likely that, whilst clearly completely confident in his ability to fill in the background when it came to making his etching, Rembrandt may have been slightly more cautious in etching one of his first female nudes straight onto the plate with no guidelines.

Rembrandt's interest in mythological subjects at the end of his period in Leiden (1630–1) may be connected with the taste of the court of the Stadholder, Frederik Hendrik, Prince of Orange, at The Hague.[7] Rembrandt was acquainted with the Prince's secretary Constantijn Huyghens (1596–1687) from about 1628–9 and Huyghens wrote his

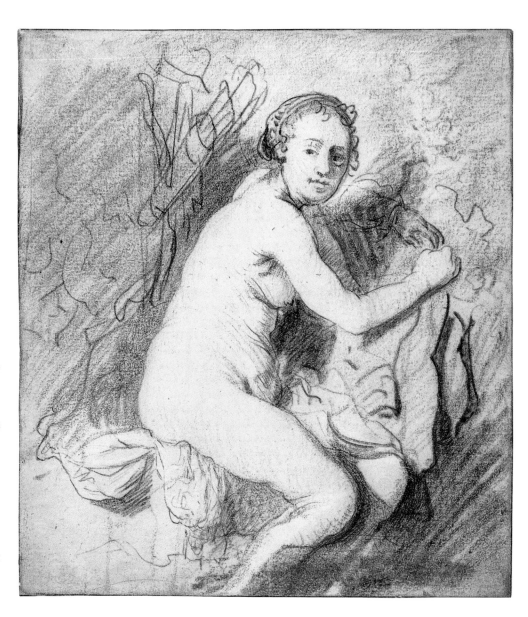

famous early critique of the work of Rembrandt and Lievens, the two famous young Leiden artists, in about 1631.[8] Huyghens had been much impressed by Rembrandt's painting of *Judas Repentant* of 1629 and it was presumably through his agency that Rembrandt's mythological paintings of *Minerva* and *The Abduction of Proserpina*, both dating to about 1630–1, were bought for the prince's collection.[9]

11 *Diana at her Bath*, c.1631

Etching, only state, 17.8 × 15.9 cm
Signed (in monogram), bottom right: *RHL.f.*
References: H.42; White/Boon B 201

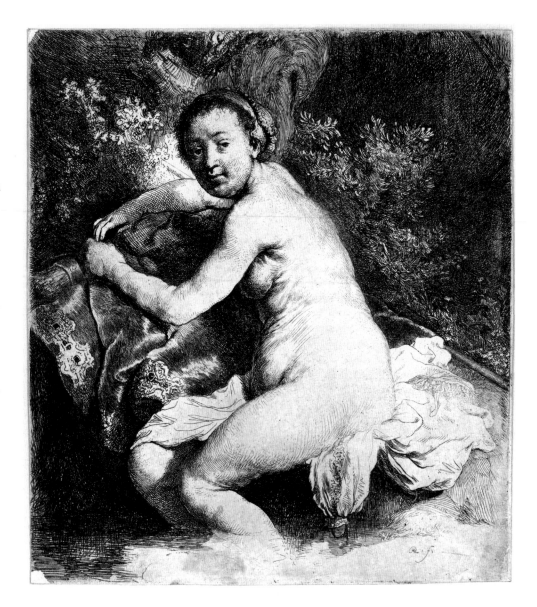

The translation of Rembrandt's female nude from chalk drawing to etching is intriguing, notably for what is altered rather than what remains the same. The slack soft belly shown in his drawing is given a rather hard-edged character by the etched line, making the folds of flesh more obvious. The process of transferring the figure of Diana onto the plate meant that some of the spontaneity found when Rembrandt worked directly onto the etching ground was inevitably lost.[1] Rembrandt avoided the awkward truncation of Diana's legs which occurred in his drawing by putting water in the foreground at the bottom of his etching, in similar fashion to another work of the same date, his first painted female nude and mythological subject, *Andromeda*[2] (fig.36), where the lower legs are painted over, hidden behind a rock.[3]

The attributes of the goddess Diana, her quiver and arrows, which though prominent in the preparatory drawing were sketchily scribbled in, are here etched in front of the figure, but in a less conspicuous position. These, together with the richly-embroidered velvety material laid on the steep bank of the pool or stream (the etched equivalent of the 'antique' costume found in paintings such as his *A Heroine from the Old Testament*, cat.20), inform the viewer that this is not meant to be a contemporary scene. Rembrandt rarely made precise identification of his Biblical, mythological or history subjects easy and much has been written about his paring down of such narrative details, frequently eliminating such pointers in order to focus upon the figure itself.[4]

This etching seems to have been conceived of as a 'pair' in some way to Rembrandt's *Seated Female Nude* (cat.12). Both plates are almost exactly the same size, in a format Rembrandt did not use again, and the pose of the women is virtually mirrored in each. Both also sit naked in a woodland setting (faint leaves are visible above the *Seated Female Nude*'s chemise at the right). There is nothing specific to enable identification of the *Seated Female Nude*, though it has been suggested that it may represent one of Diana's nymphs, perhaps even Callisto, made pregnant by Jupiter.[5] However, most depictions of Callisto show her trying to cover herself to avoid her pregnancy being discovered, in the same way that Susanna shies away when she sees she is spied upon, but Rembrandt's *Seated Female Nude* stares back without embarrassment and even *Diana*, though turned away from us, looks out with a frank gaze.

12 *A Seated Female Nude, c.1631*

Etching, second state (of two), 17.7 × 16 cm
Signed (in monogram) upper left: *RHL*
References: H.43; White/Boon B 198: II; Berlin/
Amsterdam/London 1991–2, vol.2, cat.7, pp.182–
4; Amsterdam/London 2000–1, cat.11, pp.102–5

BRITISH MUSEUM, LONDON
(INV.NO.1843–6–7–126)

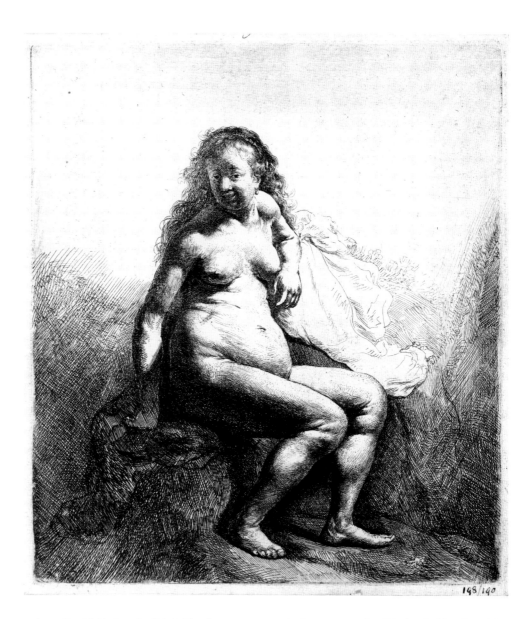

A Seated Female Nude together with the *Diana at her Bath* have prompted some of the most impassioned criticism of Rembrandt's work, most notably from Kenneth Clark who in 1956 declared them to be 'two etchings of naked women in which the pitiful inadequacy of the flesh is more unflinchingly portrayed than in any representation before or since'.[1] Partly prompted by a 'defiant honesty' to prevent compromising 'the truth of his vision', Rembrandt had clearly 'gone out of his way to find the most deplorable body imaginable and emphasise its least attractive features'. The *Diana* was seen as being slightly less monstrous, but that this 'fat, flaccid creature' should have been given the attributes of a goddess was clearly deliberate defiance of the classical portrayal of the female nude.[2]

One might think that this view was partly influenced either by Clark's Italianate bias or perhaps by different perceptions of body shape in the twentieth century, but in fact some seventeenth-century Dutchmen found the portrayal deeply disturbing too. The poet Andries Pels remarked of Rembrandt's female nudes in 1681:

> When he would paint a naked woman, as sometimes
> happened, he chose no Greek Venus as his model, but
> a washerwoman or peat-trader from a barn, naming
> his error truth to Nature, and everything else idle

decoration. Flabby breasts, distorted hands, yes even the marks of corset-lacing on the stomach and of the stockings round the legs, must all be followed, or nature was not satisfied.[3]

Pels was closely following a more general observation made ten years earlier by the artist Jan de Bisschop who wrote scathingly of the female nude as painted by Rembrandt's contemporaries, describing them as 'such monstrosity'.[4]

However, it has sometimes been argued that this body shape was considered attractive at this period and Rembrandt certainly used similar shapes for the women he painted in the early 1630s (for example cat.20, 26, 27, 31, 36).[5] It is hard to believe that he was not aware of pushing the boundaries of his representations of the female nude in prints such as this (the subject of E.J. Sluiter's essay in this catalogue). Nevertheless, he chose the medium of etching for both these nudes, implying that he thought there was a market for them amongst print collectors. In addition, an

etched copy was made of the head of Rembrandt's *Diana*, perhaps by Jan Lievens, probably shortly after it was printed, while the great printmaker Wenceslaus Hollar made a copy of the *Seated Female Nude* on his visit to Amsterdam in 1635 (see fig.82).[6] Both, then, considered the two etchings worthy of copying.[7] The two nudes were reprinted several times during Rembrandt's lifetime and afterwards (both copperplates were also used after Rembrandt's death though their whereabouts are no longer known).[8] However, by the mid-century, the neo-Platonic tenets of beauty espoused by Italian and French art were more generally in favour with prevailing Dutch taste. Though the two prints continued to be collected by some, there is little wonder that the classicist Jan de Bisschop and Andries Pels should have found so much to revile when they came to write about such 'misshapen' nudes a few years afterwards.

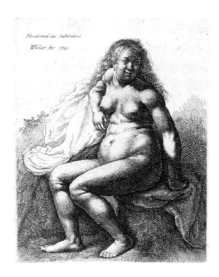

Fig.82 | Wenceslaus Hollar (1607–1677) copy after
Rembrandt, *A Seated Female Nude*
British Museum, London

13 *Jupiter and Antiope, c.1631*

Etching, first state (of two), 8.4 × 11.4 cm
Signed (in monogram), centre right: *RHL*
References: H.44; White/Boon B 204:1

BRITISH MUSEUM, LONDON
(INV.NO.1848-9-11-104)

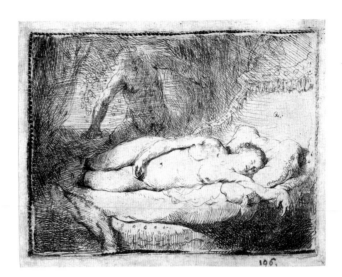

It was A.M. Hind who in 1923 described the subject of this print as Jupiter and Antiope. The story is mentioned in various classical texts and appears in Homer's *Odyssey* as well as in Ovid's *Metamorphoses*, that much-plundered source of artists' subject matter.[1] According to legend, Antiope was the daughter of the king of Thebes. Her beauty attracted the god Jupiter, who, assuming the form of a satyr, found her sleeping. He took her by force and she later gave birth to Jupiter's twin sons, Amphion and Zethus.

Earlier collectors of this print gave it different titles. Clement de Jonghe may have called it 'Venus and the Satyr' in the 1679 list of Rembrandt's work, satyrs in mythology being men with goat-like hooves, horns and hairy hind legs who were devotees of Bacchus and notoriously lecherous.[2] The 1731 inventory of the Delft collector Valerius Röver apparently lists it as 'de Danae', yet another young beauty impregnated by Jupiter, but this time in the guise of a shower of gold.[3] It is true that little coin-like circles seem to be raining down in the background of Rembrandt's print, but the iconography of Danaë would not normally require the presence of Jupiter as well, seen here as a shadowy shaggy-haired, bearded figure pushing aside the bed-hangings and pulling back the blanket.

It is possible that Rembrandt was influenced in the figure of Antiope by Werner van den Valkert's 1612 etching of *Venus Surprised by Satyrs*,[4] which in turn shows knowledge of the tradition of other sixteenth- and seventeenth-century representations of Antiope.[5] Rembrandt chose to omit the small Cupid, who also often attends Jupiter and Antiope, to concentrate primarily upon the sleeping woman.[6] The theme was overtly erotic, laden with the sexual charge of voyeurism and imminent rape, an image which artistic tradition intended to be ravishing. Rembrandt did not accentuate the folds of flesh here but instead kept his nude pale and her skin almost literally unlined.

The sleeping Antiope, her lips slightly parted and her hand dangling limply down over the edge of the mattress in relaxed oblivion, is beautifully observed and is the first of many portrayals of women in bed, both naked and clothed, which Rembrandt was to make. The most notable of these was his painting of *Danaë* begun in about 1636 (fig.46) and it is interesting that, despite the different media, the overall structure of the compositions is remarkably similar. The pose of the figures' torsos and legs, covered by the bedclothes at the same point, the way the light falls across the body from above, the tasselled pillow and ornate bed, a figure emerging from a point of light on the other side, all might suggest that this little etching was a prototype in miniature for the painting's composition.[7] Rembrandt did not portray the subject of Jupiter and Antiope again until towards the end of his life, making it the theme of one of his last and most impressive etchings in 1661 (cat.134).

14 *A Study of a Female Nude Seen from the Back, c.1630–4*

Drawing, black and white chalk, 15.9 × 11.8 cm
References: Benesch 193; Seilern 1961, p.31;
London 1983, cat.2, pp.1–2

COURTAULD INSTITUTE GALLERY, LONDON
(INV.NO.D.1978.PG.404)
Exhibited in London only

This rather foxed drawing has been likened to
another of a female nude now in Rotterdam
(cat.70), so much so that Count Seilern claimed
that it 'could well have been executed on the same
day'.[1] However, the Rotterdam sheet is consider-
ably more assured and of a later date. Seilern was
himself aware of the 'slightly irritating features' in
the drawing he owned, 'such as the restless line
beneath the figure indicating the cushion on which
she sits, or the unclear and unpleasing form under
her right elbow'.[2] The contour of the woman's
round-shouldered back is made up by rather lumpy,
broken strokes, somewhat in the 'cellulite' manner
of the thighs of *Diana at her Bath* (cat.10).
Rembrandt attempts to portray the texture of the
skin on the girl's naked back through short curved
lines fanning out to indicate the shape of her ribs
and the way the light falls across her body. But the
technique of tiny heavily-drawn lines, which
worked so well to show the wrinkles of the elderly,
gives this young torso somewhat too undulating an
effect and over-emphasises the cleft made by her
spine between her shoulders. Rembrandt's pupil
Samuel van Hoogstraten later advised his own
students against studying anatomy too thoroughly
which might risk making figures look like dried-
out codfish and skinned satyrs 'or be so knotty that
it will seem that they are filled with onions'.[3]

Hoogstraten also noted that drawings from
models should be 'proper and graceful'.[4]
Rembrandt's model, seen from the rear, preserves
some modesty: a cushion (presumably covering her
lap) provides a prop upon which to rest her elbow,
her unseen forearm across her breast. Rembrandt
uses a line to mark the edge of the drapery across
her thigh which has the purpose of defining the leg
(in the same way as he did in cat.9). Her elaborate
beribboned hairstyle (almost a precursor of those
found in cat.96) is most closely related to a drawing
in the Nationalmuseum, Stockholm, of a *Reclining
Nude* seen from behind (fig.83), possibly a prepara-
tory study for a figure in his painting of *Diana
Bathing; with the Stories of Callisto and Actaeon*,
tentatively dated 1634.[5] The pose of the girl in the
Courtauld sheet also seems loosely to relate to a
figure in the same painting.[6]

A copy of this drawing, formerly attributed to
Rembrandt is at the Boijmans Van Beuningen
Museum, Rotterdam.[7] What is unclear is who
might have made such a copy and when. Though
Rembrandt undoubtedly drew from the model
with other artists at a later date in his career (see,

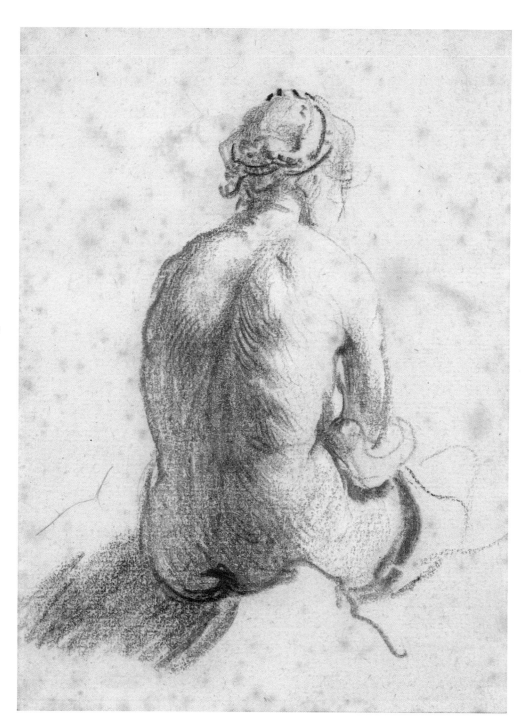

for example, cat.135), there is no evidence that he
did so at this period. While it is not impossible that
a model may have been hired to pose for a group of
artists at this time, the existence of numerous
drawn copies after drawings such as this is more
likely to indicate that Rembrandt's pupils copied
their master's earlier drawn nudes as a technical
exercise.[8]

Fig.83 | Rembrandt, *A Reclining Nude*
Nationalmuseum, Stockholm

15 *A Woman Making Water*, 1631

Etching, only state, 8.1 × 6.5 cm
Signed (in monogram) and dated, bottom left centre:
RHL 1631.
References: H.46; White/Boon B 191; Amsterdam/
London 2000-1, cat.12, pp.105-7

BRITISH MUSEUM, LONDON
(INV.NO.184-9-11)

Even in the eighteenth century, not an age renowned
for its squeamishness, this print was coyly described as
'A Woman Crouching Under a Tree', and Rembrandt's
graphic representation still has the power to shock.[1]
The squatting woman, looking over her shoulder to
make sure she is unobserved, urinates and defecates,
protected by a tree-trunk for privacy. Rembrandt
leaves a chink of light between her legs to emphasise
her action. The stream of her urine is left as a blank, a
white line through the shadow. This print was
probably intended as a pair to another of virtually the
same height and of corresponding subject matter
(fig.84). The protagonist in the *Man Making Water*,
however, shows considerably less concern about being
overlooked while relieving himself than the furtive
female (who, nevertheless, unwittingly shows us
everything).

As Ger Luijten has pointed out, these figures relate
to Rembrandt's drawings and prints of mendicants
and vagabonds of 1630-1, partially inspired by Jacques
Callot.[2] The most closely related to this print is
Callot's *A Man Making Water and Relieving Himself* of
1617, an etching from his series *Capricci di varie Figure*
dedicated to Lorenzo de' Medici.[3] Rembrandt knew
this print but there was, in any case, already a pictorial
tradition in the Low Countries of scatological human
activity developed, for example, by Pieter Bruegel and
Jan van de Velde.[4] However, focus on such subject
matter was also found in works such as Jan Miense
Molenaer's *The Sense of Smell* of 1637, where a child's
backside is wiped.[5] Though such works were regarded
as amusing rather than disgusting, there was also often
a more serious observation being made, as in, for
example, the Zeeland Calvinist Johan de Brune's
emblem where the dirty bottom of a baby is being
cleaned above the words, 'What is this life but stench
and shit?'[6] Generally, men or children were the
protagonists portrayed and Rembrandt's choice to
show a woman here is unusual. It must have been
lewdly amusing yet somewhat shocking that the fairer
sex could be seen in such a manner, just as when, a
hundred years later, Jonathan Swift wrote of the
disillusioned young man

> Strephon who heard the fuming rill
> As from a mossy Cliff distill
> Cry'd out, ye gods, what sound is this?
> Can Chloe, heavenly Chloe piss?[7]

Presumably Rembrandt's contemporaries regarded
this etching as a ribald piece which nevertheless
reminded them of the fundamental baseness to which
humanity is, of necessity, reduced.

Fig.84 | Rembrandt, *A Man Making Water*
British Museum, London

16 *The Holy Family*, c.1632

Etching, only state, 9.6 × 7 cm
Signed (in monogram), bottom right: RHL
References: H.92; White/Boon B 62

RIJKSMUSEUM, AMSTERDAM
(INV.NO.RP–P–OB–123)

The theme of a domestic Holy Family does not
appear in the Gospels, where there is no mention
of this aspect of their life. The only clue to
Joseph's trade comes when Jesus is an adult and
members of the synagogue at Nazareth are
astounded by his erudition, saying, 'Is this not
the carpenter's son?' (Matthew 13: 55).[1] Here,
however, Rembrandt sets the scene in a domestic
interior, though not specifically the carpenter's
workshop he was to portray in his large painting
of the same subject a couple of years later
(cat.26A).[2] The (perhaps false) date on that
picture was once read as 1631 and it was therefore
thought that it predated this etching. However,
there is a relationship between the two from the
point of view of the figures of Mary and the
Christ child and this print can in some ways be
seen as working towards the composition of what
was to be one of the largest subject paintings
Rembrandt had attempted.

The scene is one of calm, intimate domesticity
with Joseph reading (loosely adapted from a print
of the same subject by Annibale Carracci, 1560–
1609) while Mary suckles the baby, snug in his
wrappings, his eyes half-closed and about to fall
into sated sleep as babies do after feeding.[3] The
open work-basket and the shoe kicked off for
comfort and other such keenly observed details in
the etching, clearly partly inspired *naer het leven*,
is the key to the immediacy of the image, but
Mary's pensive gaze, looking away from her
infant, is a shadow of her foreboding for his
future. In such a way *The Holy Family* blurs the
distinction between daily life and religious
imagery, elevating the everyday to timelessness.
In so doing, Rembrandt poignantly manages to
make the sacred more humanly accessible or,
perhaps, transform every mother into a Madonna.

By the time Rembrandt made this print he was
living and working in Amsterdam, where he at
first took lodgings with Hendrick Uylenburgh in
June 1631, and worked in his 'Academy'.[4]
Somewhat surprisingly, it seems that such subject
matter did not only appeal to Catholic clients in
the city. Martin Soolmans and Oopjen Coppit
(figs.16 and 17) were members of the Dutch
Reformed Church but, nonetheless, they
apparently owned the Munich *Holy Family*,
or at any rate their son is recorded as having been
left 'a painting of Joseph and Maria done by
Rembrandt', believed to have been commissioned
from Rembrandt when he painted the couple's
portraits.[5]

17 A Portrait of a Young Woman, 1632

Oil on canvas, 92 × 71 cm
Signed (in monogram) and dated, upper right:
RHL van Rijn 1632
References: *Corpus*, vol.2, A55; Berlin/Amsterdam/
London 1991-2, vol.1, cat.10, pp.150-1; Trnek
1992, cat.104, pp.315-20

GEMÄLDEGALERIE DER AKADEMIE DER
BILDENDEN KÜNSTE, VIENNA (INV.NO.611)

Though Rembrandt was still using the 'L' for
Leiden in his signature seen here, he had almost
certainly settled in Amsterdam by the time this
picture was painted. He may already have met
Hendrick Uylenburgh, the painter and picture
dealer, when studying in Amsterdam with Pieter
Lastman in the mid-1620s. We know that he must
have been on close terms with Uylenburgh by
20 June 1631, for on that date he lent him the
enormous sum of 1000 guilders, presumably to
invest in Uylenburgh's art business.[1] The payment
may well have been in kind (works by Rembrandt)
rather than in cash and probably represents the
formal start of their working relationship which
continued for the next five years. Rembrandt is
described as a resident of Leiden at this time but he
probably settled in Amsterdam shortly afterwards
and lived in Uylenburgh's house until 1635.[2] A
Mennonite, Uylenburgh may well have encouraged
Rembrandt's portrayal of Biblical subjects, but his
connections in the city and his network of clients
also provided Rembrandt with the commissions he
had presumably been taken on to fulfil. Rembrandt
completed numerous portraits at this period of
important clergymen, wealthy merchants, and

other prosperous citizens and their wives, many of
them Mennonites.

We do not know who the sitter was in this
appealing and deceptively simple portrait. The
generally plain appearance of her dress (an open
gown or *vlieger* worn over a bodice and skirt) and
the absence of all jewellery means that she has
sometimes been thought to have been a
Mennonite, unsurprisingly perhaps in view of
Uylenburgh's own sympathies. But the lace front
peeping out from under her pleated ruff and her
transparent cuffs with their band of lace edging
militate against this interpretation. The
Mennonites forbade lace and cuffs, a ruling which
even Catrina Hooghsaet, a member of the
Waterlanders, a more liberal branch of the
Mennonite sect, observed (see cat.122).[3]

A painting now at Kassel (fig.85) was cut from
the same bolt of canvas as this picture and it has
reasonably been assumed that the two formed a
pair.[4] Pictorial convention dictated that in pendant
portraits the woman should appear to be on her
husband's left (the position of brides when they are
married in church today), so the actual painting
would have been hung on the right of that of the
man.[5] The portrait therefore shows her facing left
towards him, while he is seated with his body
facing towards his wife. Both have been slightly cut
down from their original sizes, and as a result the
young woman's head in relation to the overall
composition is set higher than is usual in
Rembrandt's portraits of women.

However, the relationship between the two
works has a dynamic all its own. In the same year as
they were painted, Rembrandt completed his
famous *Anatomy Lesson of Dr Nicolaes Tulp*, his most
elaborate portrait commission to date.[6] The
qualities of drama and immediacy that he gave to
the *Anatomy Lesson* succeed in bringing a moment
to life, more akin to the manner of history painting
than to portraiture. This was a discovery which he
also used in this portrait of an unknown woman.
The traditional formality of depiction was aban-
doned in favour of the man busying himself in
taking his penknife to sharpen the quill of his pen
while the young woman is just on the point of
raising herself up from the chair. Both actions are
remarkably well judged by the artist: here the
movement is sufficient to add animation but not to
unbalance the carefully constructed composition.
It is likely that the action is intended to show the
domestic life of the couple, involved in their daily
tasks. The lighting cast on both figures from the
left focuses upon their heads and hands and unifies
them in a way which would have seemed extremely
illusionistic when seen hanging in a Dutch interior,
where they would usually have been placed a little
apart from one another, perhaps on either side of a
chimney breast or flanking a piece of furniture.[7]

Rembrandt went on to develop this introduc-
tion of movement into such pendants, making

them lively and less formal, for example in his
impressive companion portraits of *A Fashionably
Dressed Man* and *A Young Woman with a Fan* (now in
Cincinnati and New York respectively), made the
year after this picture.[8] In that pair the man
gestures directly to the woman, a solution taken up
superbly by Frans Hals in his portraits of *Isabella
Coymans* and her husband *Stephanus Geraerdts*,
painted about 1650-2, where the two relate to each
other so intimately that it seems as if they should
really be on the same piece of canvas.[9] The natural
solution, of course, was to do exactly that, but
Rembrandt painted very few true double portraits.
His *Shipbuilder and his Wife* of 1633 and the portrait
of *Cornelis Claesz Anslo and his Wife* of 1641 (fig.69)
show how convincingly he made contemporary
couples star in their own domestic dramas, but the
fashion for more conventional pendant portraits
still continued.[10]

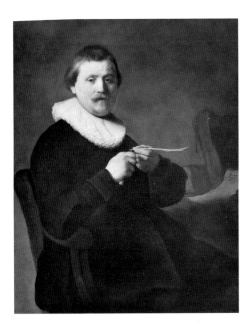

Fig.85 | Rembrandt, *A Portrait of a Man Trimming a Quill*
Gemäldegalerie Alte Meister, Staatliche Museen, Kassel

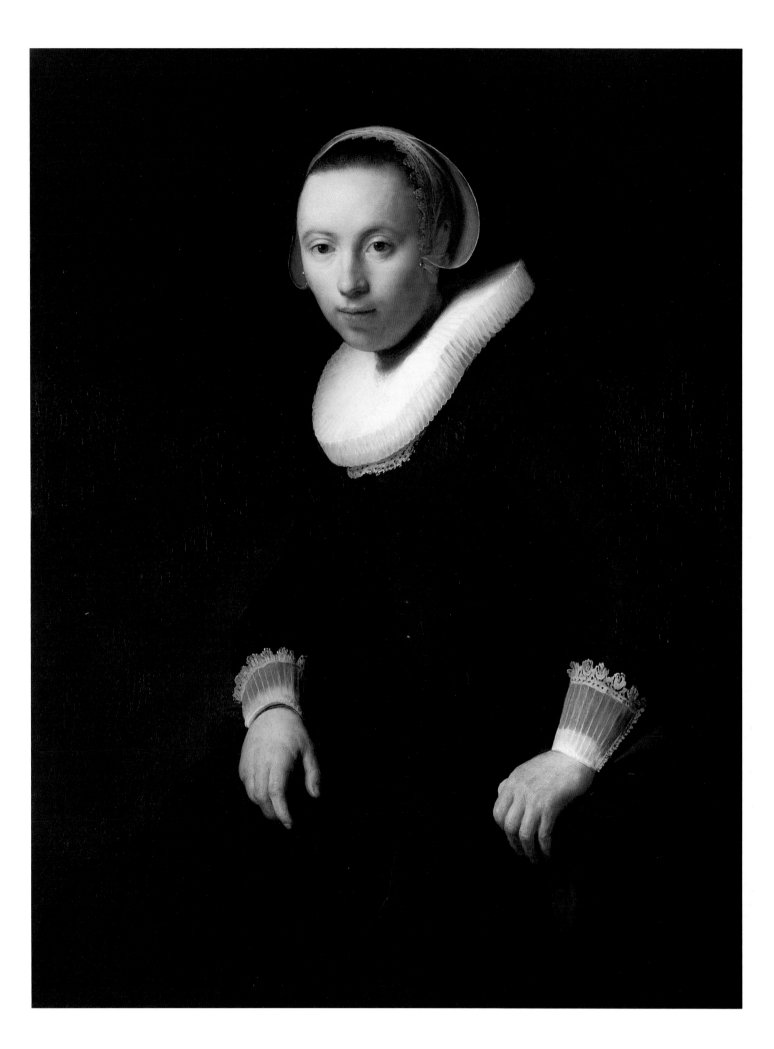

18 *A Portrait of a Lady Aged Sixty-Two, perhaps Aeltje Pietersdr Uylenburgh*, 1632

Oil on panel, oval, 73.7 × 55.8 cm
Signed (in monogram) and dated, upper right:
RHL van Ryn 1632
Inscribed at upper left: *Æ 62*
References: *Corpus*, vol.2, A63; Christie's, London,
auction catalogue, 13 December 2000, lot 52,
pp.132–7

NOORTMAN GALLERY, MAASTRICHT

It is intriguing to see the difference of approach in
how Rembrandt painted the old woman here and
the younger one in the previous entry (cat.17), both
completed in the same year. The original oval
format of this picture (confirmed by the presence of
bevelling all round the edges of the panel) did not
allow Rembrandt much space for any illusionistic
experiments, such as those in the Vienna *Portrait of
a Young Woman*. In any case, such liveliness is likely
to have been deemed inappropriate for the older
lady. The exaggerated wrinkles of old age which
Rembrandt portrayed so convincingly for 'pictur-
esque' effect in his *tronie* heads of his mother are
not in evidence here, marking out quite clearly the
boundaries between what was acceptable in *tronie*
and in 'true' portraits. Here, instead, the old
woman's glowing, soft skin is delicately creased
around the brow and mouth, her keen-eyed gaze is
given a sparkle by the fine line of white along a
lower eyelid, while her apple cheeks are smooth
above her slight smile. She takes up less room in the
composition than is usual in Rembrandt's portraits
of this period, a rather diminutive figure slightly
dwarfed by the space around her. There are traces
of some *pentimenti* showing alterations to her left
shoulder and a larger reserve was painted around
her head than was actually needed, so it may be that
Rembrandt had some difficulty in placing the
figure within the composition. Given these points,
it seems likely that the painting was perhaps
executed before the more dynamic Vienna painting
but the precise circumstances dictated by the
different commissions are not known.

Jaap van der Veen has plausibly suggested that
the woman, aged sixty-two in 1632 according to
Rembrandt's inscription, may perhaps be Aeltje
Pietersdr Uylenburgh (1571?–1644), a relative of
Hendrick Uylenburgh, who married Johannes
Cornelis Sylvius.[1] Though the precise date of her
birth is not known, she is believed to have been
born in about 1571, but could perhaps have been
born the previous year, which would be consistent
with the inscription. That Rembrandt did indeed
paint Johannes (Jan) Cornelis Sylvius (1564–1638)
and his wife is known because their son's will of
1681 lists *de twee countrefeytsels van zijn heer
testateurs vader en moeder saliger door rembrant van
Rijn geschildert* (the two portraits of the testator's
late father and mother painted by Rembrandt van
Rijn).[2] Rembrandt's portraits of the couple were

later owned by their grandson. The commission
would clearly have come through Hendrick
Uylenburgh for whom Rembrandt was working at
the 'Academy' in Amsterdam.

Aeltje was the daughter of Pieter Rommertz
Uylenburgh. One of Pieter's brothers, Gerrit, was
Hendrick Uylenburgh's father while another,
Rombertus, was Saskia van Uylenburgh's father,
making Aeltje, Hendrick and Saskia all first
cousins, though of widely differing ages. Aeltje
married her husband, the Calvinist clergyman
Johannes Cornelis Sylvius in Leeuwarden in 1595.
They settled in Amsterdam in 1610, where he first
officiated in the Gasthuiskerk and then at the Grote
Kerk after 1622.[3] Rembrandt was betrothed to
Saskia van Uylenburgh the year after this portrait
was painted, on 6 June 1633. However, we do not
know when or where Hendrick introduced the
two, as Saskia was living with her sister in
Friesland, in the north of the country. What is
known is that Rembrandt made an etching of
Aeltje's husband in 1633 and that Johannes
vouched for Saskia when her marriage to
Rembrandt was announced on 10 June 1634.[4]
Aeltje was also present at the baptism of
Rembrandt and Saskia's first child in 1635, and,
one assumes, at the second in 1638, since her
husband as Calvinist minister performed the
ceremony (Saskia was Calvinist, rather than of
Mennonite persuasion like her cousin Hendrick).
Aeltje also attended the baptism of the couple's
fourth child, Titus, attending on her own after her
husband's death at the age of seventy-four, but she
is not listed as present in the records of the baptism
of their third infant in 1640.[5]

This is not the first time that a portrait of an
unknown woman has been identified as Aeltje, in
an attempt to match a face to the will of 1681,
mentioned above. *The Portrait of a Seated Woman*
(Art Gallery of Ontario, Toronto),[6] once thought to
be by Rembrandt, was given this distinction via a
slightly circuitous route. It was sold in 1811 with a
Portrait of a Minister now in Cologne,[7] and was later
thought to be a pendant of that picture.[8] When the
identification of the man in the Cologne painting
swung round to Johannes Cornelis Sylvius, it
naturally followed that the Toronto woman was
called Aeltje Uylenburgh, though now both
portraits have been stripped of their names and
removed from Rembrandt's oeuvre – unknown
sitters once again.[9]

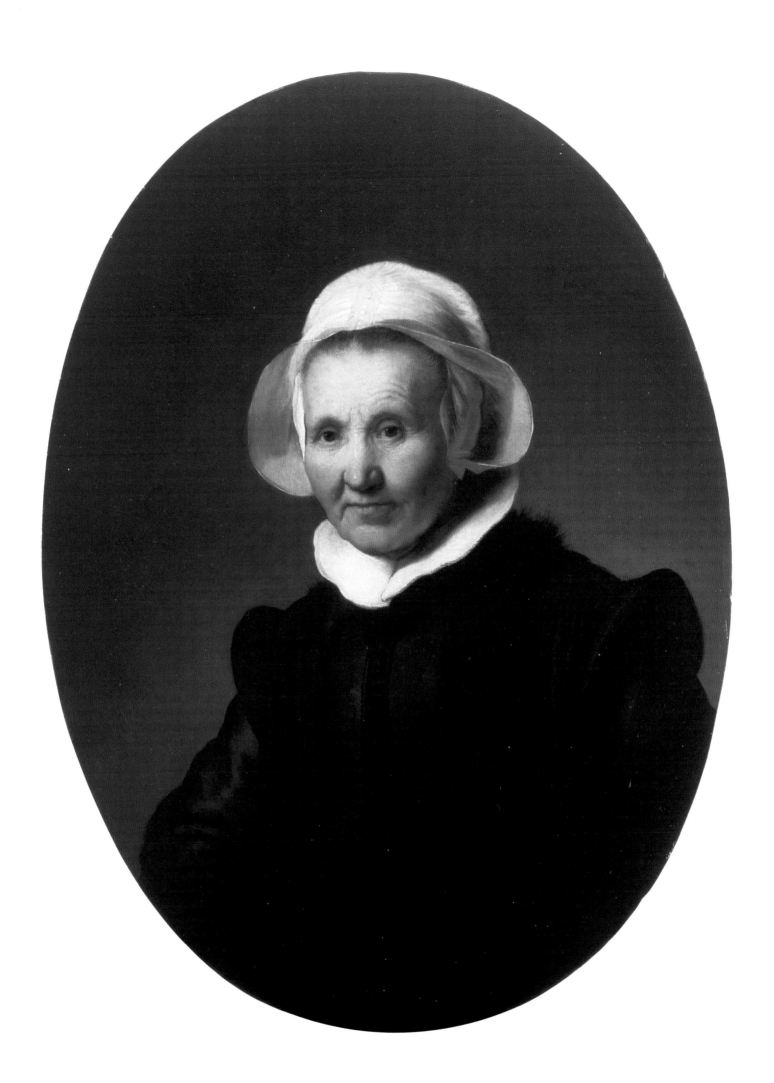

Oil on canvas, 72.5 × 54.8 cm
Signed (in monogram) and dated, centre right:
RHL van Rijn.1632:
References: *Corpus*, vol.2, A49; Stockholm 1992–3,
cat.52, pp.186–7

NATIONALMUSEUM, STOCKHOLM
(INV.NO.NM583)

Rembrandt painted two women in profile in 1632, this work and a portrait of *Amalia van Solms* (fig.86), wife of Frederik Hendrik, Prince of Orange, the Stadholder of The Netherlands.[1] Amalia is shown to the waist, though there is some evidence that the present painting may have been of slightly larger format, showing a three-quarter length figure.[2] It is impossible to know which came first, but it may be that Amalia's portrait was the catalyst for the choice of profile used in this painting. The exact circumstances behind Rembrandt's portrait of Amalia are not certain but it seems that the picture was painted to match one of Frederik Hendrik, Prince of Orange, done by Gerrit van Honthorst (1592–1656) in 1631.[3] The profile portrait was not a common type in seventeenth-century Dutch painting and Honthorst's portrait appears to be the first instance of the use of a side-view for a royal portrait in the Northern Netherlands,[4] presumably chosen in emulation of classical portrait medals and coins.[5] Quite how Rembrandt's picture came to be painted is unclear, for Honthorst completed his own pendant to the picture in 1632 (on panel) showing Amalia predominantly from the side but turned slightly towards the viewer.[6] Rembrandt's version is painted on canvas and retains a 'true' profile, arguably at the cost of flattering the sitter, but matches the Honthorst of Frederik Hendrik (also on canvas) more convincingly. Why two such portraits of Amalia should have been painted is unknown. It has been suggested that when the prince's secretary Constantijn Huyghens introduced Rembrandt to court in 1632, the young artist took it upon himself to paint the princess, perhaps at Huyghen's suggestion, in order to impress the court with his portrait painting ability.[7]

This woman, unlike Amalia, does not wear contemporary dress but a richly embroidered fanciful costume, very loosely inspired by sixteenth-century garb which Rembrandt could have used to represent an ancient, mythological or Biblical figure. She is holding the embellished handle of a fan in front of her, and a little twig of leaves with a single violet flower is tucked into the jewelled band which cinches her hair. Rembrandt's wife Saskia, as well as the artist's sister Elisabeth, have been suggested as possible models for the woman. However, there is no firm evidence that Rembrandt met Saskia until 1633 and we do not know what his sister looked like. Another suggestion is that the model was Hendrick Uylenburgh's wife, Maria van Eyck (with whom Rembrandt was lodging in Amsterdam at this time), since the inventory of Lambert Jacobsz of 1637 mentions 'a small *tronie* of an Eastern woman, the likeness of Uylenburgh's wife, after Rembrandt'.[8] This is certainly proof that some of the figures in 'eastern dress' (possibly how the costume here could have been interpreted) were then believed to be based on models from Rembrandt's own circle. It is also known that a picture painted in Rembrandt's studio in about 1633 was changed from a straightforward portrait of a woman to the figure of a sibyl, or something similar, by the addition of fanciful costume.[9] This must have been highly unusual, however, and there is little doubt that the Stockholm painting was intended as a *tronie* from the outset rather than a portrait. Rembrandt's *Bust of a Young Woman* (fig.87), also painted in 1632, is clearly closely related in figure type and costume, but we do not know if Rembrandt or his contemporaries might have linked any specific subject matter to these elaborately dressed figures.[10]

Both Rembrandt and Lievens had been using generalised versions of a facial type not dissimilar to this for some time in their history paintings. The usually blonde hair is softly curling and kept off the high rounded forehead; the nose is straight and sits above a chin which is divided into cleft curves of flesh beneath. All these are features which can be found in Rembrandt's *Andromeda*, his *Minerva* and, in miniature, in the *Abduction of Proserpina*, all of which were painted between 1630 and 1631.[11] Lievens's version of the type can be seen in his *Smiling Girl with Long Blonde Hair* of *c*.1625–9,[12] the young blonde in the lost *Young Woman and Old Woman*,[13] his profile of Delilah in his *Samson and Delilah* of about 1630[14] (who bears some of the same characteristics as a woman in profile in Pieter Lastman's *Raising of Lazarus* of *c*.1629)[15] or his *Soothsayer* of *c*.1631 in Berlin.[16] Rembrandt had used a variation of the same facial type for Mary in his *Simeon's Hymn of Praise* of *c*.1631, which was in the Prince of Orange's collection by 1632, in *A Heroine from the Old Testament* (cat.20) and in his *Rape of Europa* of 1632. Indeed, the standing woman in profile in the latter may actually be a reduced version of the Stockholm painting.[17]

The most striking example of Rembrandt's relatively rare use of such a profile can be found in his half-length portrait of *Saskia van Uylenburgh in a Red Hat*, now in Kassel, resplendent in a wonderfully ornate red velvet costume, a form of sixteenth-century dress concocted from a rich imagination (fig.88, see also fig.72).[18] The Kassel painting was probably started a year or so after the Stockholm canvas, in 1633 or 1634 (although it was not finished until 1642, the year of Saskia's death). The features in both paintings are extraordinarily similar, and the exact profile now seen in the Kassel picture is unthinkable without its predecessor here.[19]

Fig.86 | Rembrandt,
Amalia van Solms, 1632
Instutit de France – Musée Jacquemart André, Paris

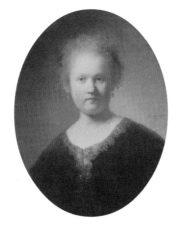

Fig.87 | Rembrandt,
A Bust of a Young Woman, 1632
Private Collection

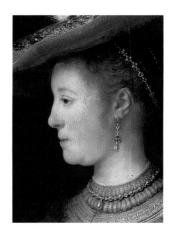

Fig.88 | Rembrandt, *A Portrait of Saskia van Uylenburgh in a Red Hat*, *c*.1633–42 (detail)
Gemäldegalerie Alte Meister, Staatliche Museen, Kassel. Photo: Ute Brunzel

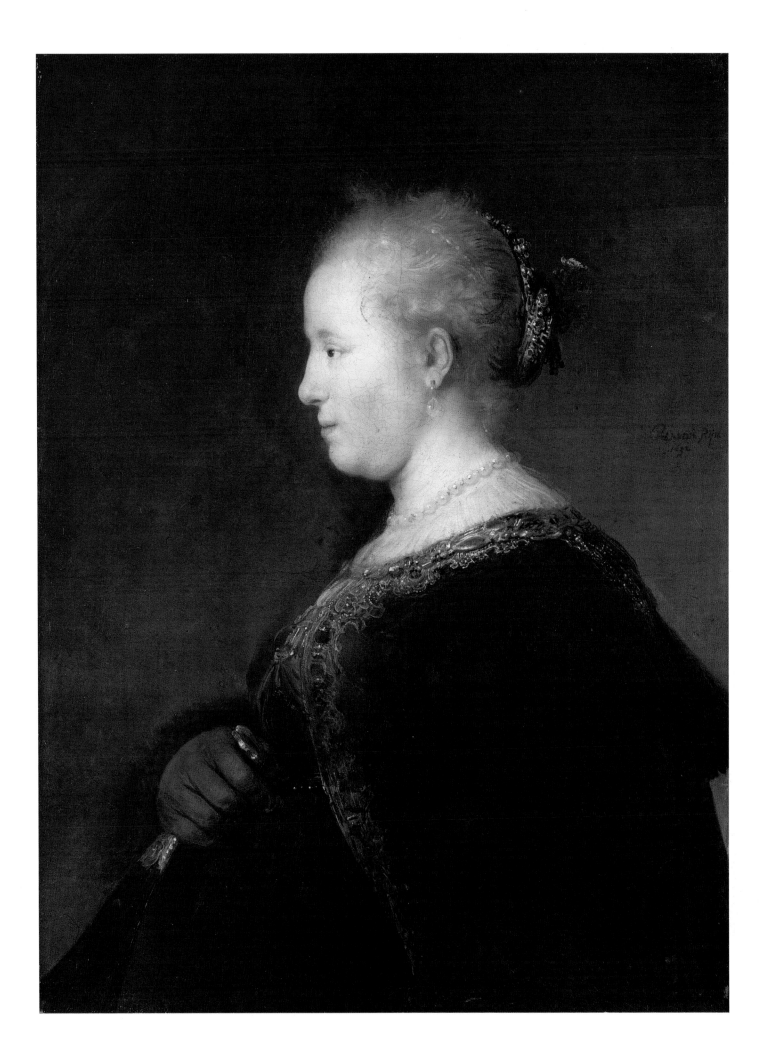

Oil on canvas, 104.2 × 94.4 cm
Signed and dated, bottom centre: *Rembrant f.*
163[2/3?]
References: Kahr 1966; *Corpus*, vol.2, A64; Laskin/
Pantazzi 1987, vol.1, pp.244–5[1]

NATIONAL GALLERY OF CANADA, OTTAWA
(INV.NO.NGC6089)

Fig.89 | Rembrandt, *The Rape of Europa*, 1632
J. Paul Getty Museum, Los Angeles

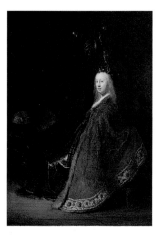

Fig.90 | Rembrandt, *Minerva*, *c.*1630–1
Gemäldegalerie, Staatliche Museen zu Berlin, Preussischer Kulturbesitz
Photo: Jörg P. Anders

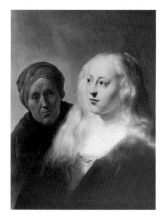

Fig.91 | Jan Lievens (1607–1674), *An Old Woman
and a Young Woman* (lost painting)
Photo: Rijksbureau voor Kunsthistorische Documentatie, The Hague

The *Young Woman in Profile with a Fan* together with the related *Bust of a Young Woman* (cat.19 and fig.87) have been seen as the general starting points for a figure in Rembrandt's *Rape of Europa* of the same year (fig.89), and also for the present painting, dating from about the same time.[2] The last digit of the date on this picture is unclear but has been read as a 2 or a 3, a dating which is completely at one with the style of the piece.

The subject of the painting has not been securely identified. A young woman sits on what appears to be a bench, mostly covered by the draping of her heavy overdress, hemmed with an intricately embroidered design which closely relates to that worn by Rembrandt's *Minerva* of *c.*1630–1 (fig.90).[3] Combing her hair is an older woman, mostly in shadow, at whose right appears to be a bowl upon the floor while behind her is a table piled with jewels, a goblet on a dish and a book, framed by what is presumably a bed curtain. In the half-lit background to the right of the young woman is a low bench, with a cushion, placed against the wall which is punctuated by shell-shaped niches and pilasters with a column at the right.

The search for the meaning of the scene has prompted reams of writing and a wide range of suggestions.[4] The juxtaposition of youthful, richly-dressed beauty and plain old age is found in a number of subjects, from Vertumnus and Pomona to elderly crones as pimps preparing young courtesans for trade, and it is possible that some form of Vanitas was intended. Jan Lievens may have inspired Rembrandt's choice of theme for he painted a (now lost) composition of an old woman with her head bound up in a cloth turban, staring from the shadows at a smooth-skinned young girl whose abundant blonde locks tumble into the shining light (fig.91).[5] No other object and no other clue is provided by the artist as to the painting's meaning but he reworked the figures slightly in his (also lost) *Bathsheba*.[6] Rembrandt could have based his Biblical heroine on such a composition and it has been suggested that the story of Bathsheba is depicted here.[7]

The Rembrandt Research Project, however, tended to favour the story of Judith from the Old Testament *Apocrypha*. There the beautiful Jewish widow Judith called her maid and 'took off her widow's garments and bathed her body with water, and anointed herself with precious ointment, and combed her hair and put on a tiara and arrayed herself in her gayest apparel … and she put sandals on her feet and put on her anklets and bracelets and rings and her earrings and all her ornaments and made herself very beautiful to entice the eyes of all men who might see her'.[8] This would appear to match the scene perfectly but the painting does not contain the wine, oil and grain that are next mentioned in the text and there is, in any case, no iconographic tradition for such a representation

(although, of course, Rembrandt was quite capable of inventing his own). Rembrandt did paint the figure of Judith but showed her with the head of Holofernes rather than this incident, and subsequently adapted it to his figure of *Flora* of 1635 (cat.36).

A less likely suggestion is that the painting shows Bocena, a young shepherdess raised by an old woman to become queen, taken from a work by Jacob Cats not published until 1637.[9] Another suggestion was that it showed the Old Testament heroine Ruth and her mother-in-law Naomi preparing for her marriage to Boaz, and that the unlit candle (if it really is this) in the shell-niche at the right referred to Ruth's descendant King David and the coming of the Messiah.[10] Madeleine Kahr likened the Ottawa picture to the etching of 'The Great Jewish Bride' (cat.35), and believed that it showed the moment at which Esther, the beautiful Jewish wife of the Persian King Ahazuerus, prepares to intercede with him.[11] The *Book of Esther* (4: 16–17; 5: 1) tells how she puts on her royal robes but, although maids are cited, there is no specific mention of an old woman dressing her. The subject was painted by Rembrandt's pupil Arent de Gelder some years later, though in a very different composition.[12] As so often, Rembrandt's source is sufficiently ambiguous to prevent the subject being pinned down convincingly. It is rather tempting to suggest that this is the painting 'by Rembrandt of Queen Hester' which was mentioned and valued at 30 guilders, in the inventory of the widow of Captain Aldert Mathijsz in Amsterdam in 1682, but it is impossible to be certain.[13]

Whoever she might represent, the *Heroine from the Old Testament* marks an important departure in Rembrandt's work.[14] Though the picture has its roots in Rembrandt's Leiden period, its conception and scale, with its half life-size figures, were unprecedented for the artist. This picture stands at the beginning of Rembrandt's production of large history paintings, ranging from single figure works to impressive grand-scale pictures with numerous figures, probably prompted by working for Hendrick Uylenburgh. Rembrandt did not use this half life-size figure type again until his *Wedding of Samson* in 1638 and it remained unusual in his paintings.[15] Instead, Rembrandt focused upon compositions with larger figures of women, such as the *Bellona* and *Flora* painted subsequently, the path he chose to follow leading on from this innovation.[16]

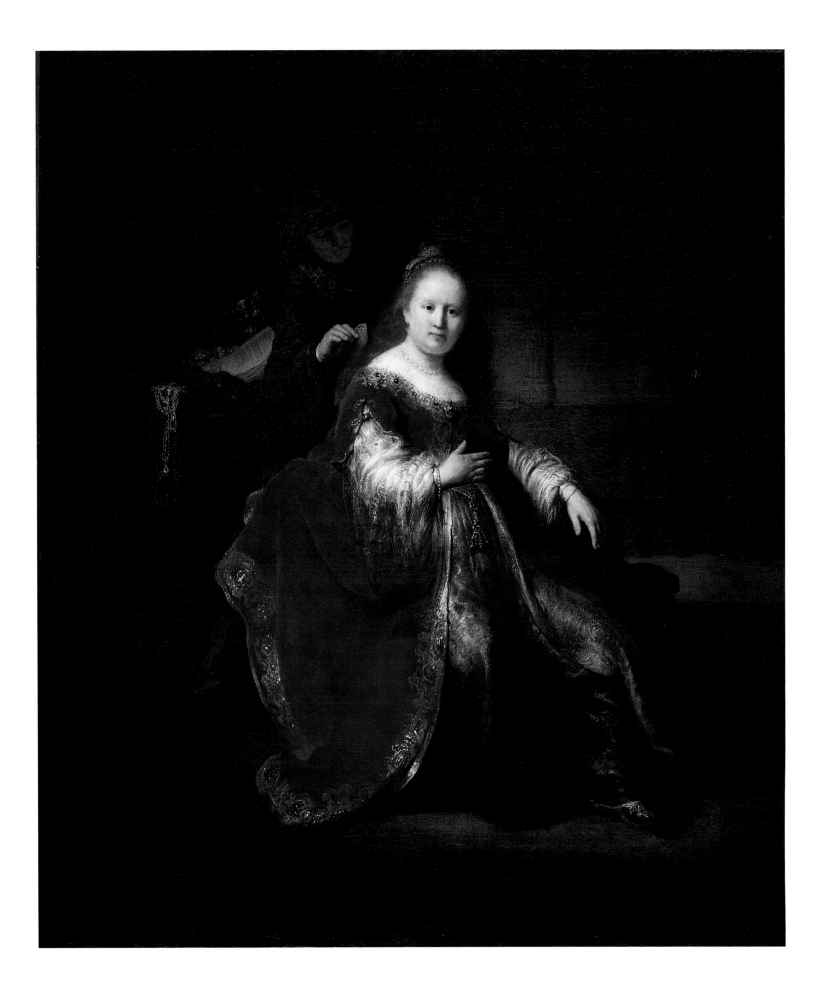

Oil on panel, 52.4 × 44 cm
Signed and dated, lower left: *Rembrandt. f[t] 1633*
Reference: *Corpus*, vol.2, A76

GEMÄLDEGALERIE ALTE MEISTER,
STAATLICHE KUNSTSAMMLUNGEN DRESDEN
(INV.NO.1556)

This painting has traditionally been identified with Saskia van Uylenburgh, the woman Rembrandt married in 1634. Rembrandt obviously met Saskia through Hendrick Uylenburgh, the picture dealer with whom he had worked since 1631. Hendrick was the son of Saskia's father's brother Gerrit. She was born in 1612,[1] the youngest daughter of Rombertus van Uylenburgh (*c.*1554–1624) who had a degree in jurisprudence. At the age of thirty, he became the Mayor of Leeuwarden,[2] the principal city in the province of Friesland, which lies to the north-east of Amsterdam. His wife, Sjukje Wieckesdr Aessinga, bore him eight children and died on 17 June 1619, when Saskia was seven years old. Rombartus died in 1624, leaving Saskia an orphan at the age of twelve. She subsequently lived in the rural Friesland village of Sint-Annaparochie with her elder sister Hiske, whose husband Gerrit van Loo became guardian on 14 June 1628 to those of his wife's siblings who were still legally minors: Titia (twenty-three), Idzart (twenty-one) and Saskia (sixteen).[3]

Rembrandt made an exquisite drawing of Saskia in 1633 (Kupferstichkabinett, Berlin, see fig.1).[4] The painstaking likeness in silverpoint on prepared vellum[5] is the basis of the identification of all (real or so-called) portraits of Saskia, and is the only annotated likeness Rembrandt made of his wife. On it he wrote: 'This is drawn after my wife, when she was 21 years old, the third day of our betrothal,

Fig.92 | Hendrick Gerritsz Pot (1585–1657), *A Woman Seated at a Table (Vanitas)*
Museum of Fine Arts, Boston. Gift of Mrs Antonie Lilienfeld in memory of Dr Leon Lilienfeld

the 8th of June, 1633.'[6] The *Bust of a Young Woman Smiling*, which shows very similar features, was painted in the same year, as was the painting now in the Rijksmuseum, Amsterdam (cat.25). Saskia wears a hat and gown in the Berlin drawing which would have been exclusively used as country attire[7] and it is likely that Rembrandt sketched her somewhere outside the city of Amsterdam, perhaps in Leeuwarden, where Rembrandt may have travelled to obtain her guardian's permission to marry. The wedding took place the following year on 22 June 1634.

The manner in which Rembrandt chose to show his subject is fascinating. The coquettish glance and open-mouthed smile appear to catch and preserve in paint a spontaneous and irrepressible spirit. However, the extent to which this should be seen as a true portrait must be questioned. A glimpse of women's teeth is comparatively rare in portraiture before the eighteenth century,[8] and earlier tradition tended to associate toothy grins less with portraiture than with comic, grotesque or bucolic characters depicted by Adriaen Brouwer, Adriaen van Ostade, or Cornelis Dusart for the amusement and moral instruction of the superior viewer. Rembrandt's painting of *The Prodigal Son* shows a widely-grinning drunk with a harlot on his knee, the faces loosely based on his own and Saskia's features (see cat.39, fig.104). Such smiles, though, did not necessarily imply moral turpitude, as Rembrandt also depicted himself grimacing and laughing in small etchings exploring different emotions.[9]

In this Rembrandt may have been influenced by the writings of the German artist and critic Karel van Mander who advised that depictions of mirth should show the eyes 'half-closed, the mouth partly open in a pleasant, cheerful smile' with a smooth unwrinkled forehead.[10] He went on to remark that when observing the model from life, smiling 'makes the mouth and cheeks wider and causes them to rise while the brow is lowered and, between the two, the eyes are slightly narrowed, creating small creases right up to the ears', almost a text-book description of what we see in the *Bust of a Young Woman Smiling*.[11] Van Mander also mentioned that a 'friendly laughing glance'[12] was appropriate for the depiction of the emotion of two lovers and that a laughing mouth was also an appropriate sign of being in love.[13] Such a grin, therefore, could be seen as entirely fitting for the portrayal of the newly betrothed Saskia.

However, there are some indications that the painting may have been intended to provoke other thoughts. Rembrandt's extremely free brushwork and the use of a similarly vivid palette to that employed in two of his history paintings of that year, *Bellona* (cat.26) and *A Heroine from the Old Testament* (cat.20), also suggest that this painting is perhaps intended less as a straightforward portrait of Saskia than as a *tronie* based upon her features.

The elaborate nature of her rich blue-green costume, more inspired by the sixteenth than the seventeenth century, with its elegant deep-red feathered hat, was chosen with considerable care. This somewhat archaic dress effectively provides an instruction to the viewer to see the painting not as a faithful rendition of contemporary life but as part of a special, partially imaginary 'historical' era.[14]

The presence of the feathered hat may have been significant. A print by Lucas van Leyden of *c.*1519 shows a young man bedecked in extravagantly plumed headgear pointing to a skull,[15] while Hendrick Goltzius's drawing of a *Young Man Holding a Skull and a Tulip*[16] of 1614 also affirms the flimsy transience of feathery frippery and quotidian concerns in the face of inevitable mortality and the solid skull. Goltzius made sure the allusion could not be misinterpreted by adding to the sheet the inscription *Quis Evadet/Nemo* (Who Escapes? Nobody). It has sometimes been suggested that Rembrandt's 1629 *Self-portrait with Plumed Beret* (Isabella Stewart Gardner Museum, Boston) may have stemmed from this pictorial convention as well, but in this case, as with the *Bust of a Young Woman Smiling*, there is no reinforcement of the message with an unambiguous skull, bubble, or hourglass.[17] The feathered hat may have simply been part of Rembrandt's partially imaginary 'dressing-up box' of historical costume, and it is difficult to know whether it would have been associated subliminally with Vanitas subjects, even in the absence of extra pointers to emphasise the interpretation.[18] A copy in reverse of the Dresden painting (admittedly scowling rather than smiling) adds all the signals the viewer might possibly need, however, as she sits amidst ropes of pearls, a snuffed candle and a prominent skull (fig.92).[19]

Whatever the extent to which the *Bust of a Young Woman Smiling* would have been regarded formally as a Vanitas by contemporary viewers, it seems likely that the direct gaze and expression of young woman in her fanciful finery may well have served to remind them of the fleeting nature of a smile, of love, of youth, and, thus, of earthly joys.

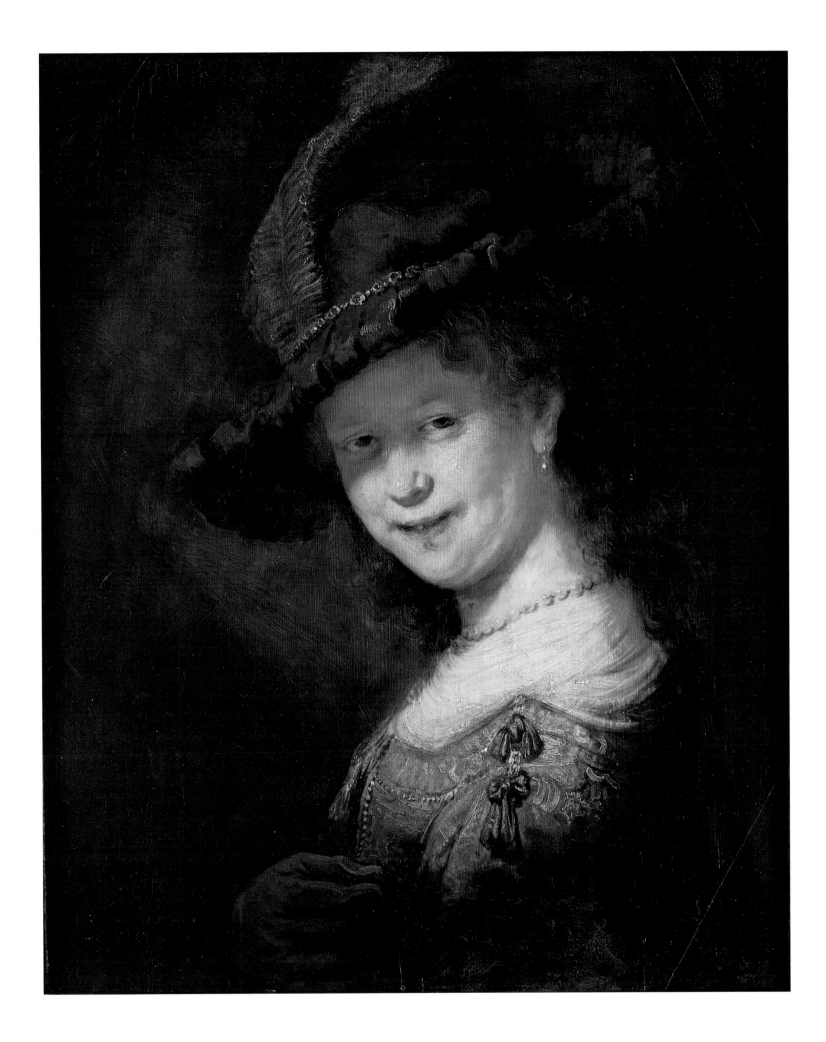

22 *A Woman Seated in Profile with Clasped Hands, c.1632–3*

Drawing, pen and brown ink, 16.6 × 13.7 cm
(Verso: *Sketches of small heads and busts*)
References: Benesch 195: Vienna 1969, cat.1

ALBERTINA, GRAPHISCHE SAMMLUNG,
VIENNA (INV.NO.8852)
Exhibited in London only

The slumped figure of the seated woman has her
left arm resting on what appears to be the arm of a
chair. If so, the chair must have had a low back for
the woman is positioned more as if propped
against a wall, upon which her head can be seen to
cast a dark shadow just behind her cap. It is only
this darkness, together with the confident parallel
lines of shading in front of her, and a couple of
lines upon her cap and collar, which give an
indication of the fall of light; and yet they are
sufficient to give volume to her form. This
economy of line can also be seen in the *Two Studies
of a Woman Reading* of *c.*1635–40 (cat.38), which
uses similarly hasty strokes to indicate the
shadows. The profile of the woman is so cursory
that it is hard to make out if she is awake or
asleep: the slightly open mouth and sharp
cheekbones give an impression of utter exhaus-
tion. On the reverse of the sheet, amongst other
quick scribbled heads, is a smaller profile of the
same woman, showing only her face, to which
Rembrandt gives a similar jagged cheekbone and
an even more sagging jowl.

 The pose almost echoes in reverse that found
in the *Study of a Woman Asleep* (cat.6) made a
couple of years earlier. But although returning to
a similar pose, Rembrandt treats it quite
differently, partly because the chalk used in the
earlier drawing gives it a different character from
that created by the more nervy lines of the pen
used here. This gives this sheet an immediacy that
one assumes to have come from drawing from life.
Rembrandt does not bother to fill in anything
that is not essential; the hands remain barely
described. The little head at the bottom of the
sheet is presumably the same woman seen from
the front and this is drawn even more
schematically. Indeed, it is so formulaic that it
seems to have sprung more from Rembrandt's
imagination of what the woman would look like
were she to turn her head towards him, rather
than being a sketch of this actually happening.
Such a distinction is an odd one, but it was
through rigorously sketching from life that the
artist could build up his mental library of images
and learn how the body was constructed as well as
feasibly be posed. In other words, direct observa-
tion of nature enabled the artist to build up a
plausible image from imagination. That this was
part of Rembrandt's practice is known from a
number of historical subjects made in the 1650s
which he drew *uit het hoofd* (from memory).[1]

23 *A Woman Seated in an Armchair*, c.1633–4

Drawing, red chalk touched with white,
14.7 × 11 cm
(Verso: *Three Studies of a Sleeve*)
References: Benesch 429; Paris 1988–9 (drawings),
cat.12, pp.24–5

MUSÉE DU LOUVRE, PARIS (INV.NO.22913)
Exhibited in Edinburgh only

The smiling young woman sits back in an armchair
whose wooden armrests have scrolled round ends,
rather like that found in Rembrandt's red chalk
drawing of *An Old Woman Seated in an Armchair* (see
cat.121, fig.147).[1] She appears to be wearing a dark
bodice with a white underblouse. Her sleeves are
full but gathered at the cuff and the material is
heightened with white on the arm nearest us, as if
the white blouse were visible there. Oddly, the
whole of the other sleeve is shaded as if all made of
dark material. (On the reverse of the sheet are three
small and rather tentative studies of a gathered
sleeve, one with a hand emerging from the cuff, all
of which show the arm hanging straight down.)[2]
The pose relates loosely to a number of works, both
drawings and paintings, which Rembrandt was
producing around 1632–5. There are some parallels
with the pose of the protagonist in *A Heroine from
the Old Testament* of c.1633 (cat.20), in the way, for
example, the further arm lies upon the edge of the
armrest; and there are rather more remote links
with figures in *A Young Woman at her Toilet* (cat.30)
and his etching of *'The Great Jewish Bride'* of 1635
(cat.35).

The woman has usually been identified as Saskia
van Uylenburgh whom Rembrandt married in
1634. There is some similarity to the features of
Saskia as seen in the 'betrothal' drawing made of
her in 1633 (see fig.1). Although they are perhaps
too generalised to state unequivocally that she was
the model here, it certainly seems possible. This
drawing is generally dated to about 1634,[3] usually
on the basis of the sitter's resemblance to Saskia).
The technique of the sheet is something of a
conundrum. Parts of this charming drawing show a
firm grasp of form and perspective and the placing
of the figure, the way she rests back in the chair, the
shape of her bodice and the bolder lines which
make up her face are impressive. However,
underlying this is a network of nervous and
indecisive lines around the contours of the figure,
more akin to the lines on the verso of the sheet. The
position of the woman's left hand is a little
unconvincing and the area around the seat of the
chair somewhat unresolved. However, fluid strokes
are superimposed to re-shape her left arm, the lines
around her cuffs and across her bodice and deft
touches mark out the folds of her neck and define
her face. It is these bolder, darker lines which
undoubtedly pull the whole composition to-
gether.[4]

It has been suggested that this is a study for
Rembrandt's etched *Self-portrait with Saskia* (cat.40)
of 1636.[5] The square-necked costume and the
wisps of veil falling from the back of the cap are
almost identical, while the white accents added to
this drawing mimic the light falling from the left in
the etching. However, both etching and drawing
are in the same direction so the drawing cannot
have been directly preparatory, as the image would
have been reversed when printed.[6]

95

Drawing, black chalk with white heightening,
26.5 × 19 cm
References: Benesch 428; *Corpus*, vol.2, A101,
p.557; Bremen 2000–1, cat.58, pp.108–9

KUPFERSTICHKABINETT, HAMBURGER
KUNSTHALLE (INV.NO.21732)
Exhibited in London only

This striking drawing is usually thought to date
from the early 1630s and has, like the *Woman Seated
in Profile with Clasped Hands* (cat.22), traditionally
been believed to represent Saskia.[1] Indeed, in both
drawings the features are remarkably close and are
drawn in a very similar way. Though insufficiently
precise to secure a certain identification, the facial
type relates to the broad brow, softly curved cheeks
and rounded chin, with its fold of flesh below,
which has plausibly been associated with
Rembrandt's wife. Probably the closest parallel for
her pose is with Rembrandt's 1635 etching of *'The
Great Jewish Bride'* (cat.35) which may represent the
Biblical story of Esther meditating on the decree to
slay the Jews.[2] However, in this drawing it is a
letter rather than a scroll which is held and the
costume appears to be contemporary rather than
fanciful or antique, putting the scene into the
present rather than a Biblical past.[3] Rembrandt
was to redraw the pose of a seated woman again
and again during his life, as a number of works in
this exhibition attest.

In fact, the black dress worn, together with
what appears to be a black veil, is a rather unusual
combination,[4] most notably found in Rembrandt's
portrait of *Oopjen Coppit* (fig.17).[5] As a result, it has
been suggested that the drawing might have been a
first thought for the composition of the portrait of
Oopjen, who appears standing in the finished work
of c.1633.[6] In the painting, Oopjen wears a
fashionable full lace collar and high lace cuffs, while
the dress shown here seems to lack lace cuffs; it
appears to have loose three-quarter length sleeves,
pulled back to reveal the voluminous gathered
white underblouse, pushed back on the forearm
rather than worn down to the wrist. If this really is
the shape intended to be portrayed, it would have
been an uncommon style in the early 1630s.
Marieke de Winkel has observed that this fashion
really only emerged somewhat later.[7] The same sort
of dress can be seen, for instance, in Gerrit van
Honthorst's *Portrait of Amalia van Solms as a Widow*
in Berlin of 1650[8] or in the *Group Portrait of Amalia
and Frederik Hendrik and Children* by the same artist
of 1647, now in the Rijksmuseum, Amsterdam.[9]

The use of bold chalk lines has its origin in
Rembrandt's drawings from his Leiden period
(see, for example, cat.6)[10] but the technique is
somewhat different. There are marked similarities
between this drawing and the Louvre's *Woman
Seated in an Armchair* (cat.23), most notably in the

way the faces and hands are drawn. In both, the
short bold dark touches marking out the eyes,
brows and bridge of the nose, define the features.
But below these defining marks in this drawing are
other faint lines that give the impression that the
whole head seems to have been shifted slightly, and
still sits a little precariously to the right. The hand
holding the letter was also altered somewhat, as
were the sleeves and skirt of the dress. The heavy
dark lines over the surface of the dress actually
change the shape of the folds in a way that does not
relate to the underlying structure, but gives the
form a solidity which it would lack without them.

Rembrandt often sketched figures in lightly
before consolidating and fixing the contours with
more definite lines,[11] but the question still hovers
as to whether the qualities discussed in this sheet
might indicate that Rembrandt was correcting a
drawing of a pupil.[12] This practice was certainly
employed by Rembrandt in his studio.[13] Samuel
van Hoogstraten, who had trained with
Rembrandt, advocated the same in his treatise *The
Introduction to the August School of the Arts of Painting*
of 1678 when he wrote: 'I recommend to masters,
when revising the Drawings of their pupils, that
they make corrections to these on the work itself.
This is an excellent exercise, and has helped many
prodigiously in the art of arrangement (composi-
tion).'[14]

25 A Bust of a Young Woman, 1633

Oil on panel, 65.6 × 49.5 cm
Signed and dated, lower right: *Rembrandt. ft. 1633*
Reference: *Corpus*, vol.2, A75

RIJKSMUSEUM, AMSTERDAM
(INV.NO.SK–A–4057)

Traces of straight bevelling on the back of the panel led the Rembrandt Research Project to believe that this composition was originally rectangular, rather than oval, but, in fact, the balance of the picture is convincing as it stands and the oval may, after all, be original.[1] The Rembrandt Research Project examined the signature during their research on this picture for the *Corpus* but their conclusions are a little difficult to reconcile since they note that its 'weak writing' and 'hesitant rhythm ... do not carry much conviction' on one page, but then call it 'confidence inspiring' on the next.[2] Recent conservation work carried out on the painting in the Rijksmuseum studios may reveal more information,[3] but the painting is authentic even if the signature is not, and 1633 is a feasible date for it in relation to Rembrandt's other dated works of that year, most notably his *Bellona* (cat.26).

Once again, Rembrandt bedecks the woman with partly fantastical costume. Over her finely pleated underblouse, she wears a dark overdress which has elaborate embroidered edging, clearly related to that found in the Stockholm *Young Woman in Profile with a Fan* and the National Gallery of Canada's *Heroine from the Old Testament* (cat.19 and 20). They seem to share a jeweller as well as a dressmaker, for the young woman here sports a necklace of pearls which circles the collar of her blouse in exactly the same way as that found in the Stockholm painting. The pearl and gilt hair ornament is topped by an ostrich feather and a filmy veil, while from her ear hangs a pearl drop. The way the veil is draped, looped up by her ear, is not dissimilar to that seen in Rembrandt's etched *Self-portrait with Saskia* of 1636 (see cat.40).

The costume gives a substantial clue that the picture should first and foremost be regarded as a a *tronie*, for it is clearly not contemporary garb. Nonetheless, the identity of the sitter has been a subject of some contention. The painting was commonly believed to portray Saskia and, though this identification was refuted by the Dutch art historian Cornelis Hofstede de Groot when he saw the painting in the collection of Lord Elgin in Scotland in 1893,[4] it was still published as 'Saskia van Uylenburgh' in the 1976 general catalogue of the Rijksmuseum.[5] However, a comparison between a picture such as Rembrandt's *Bellona* of 1633 (quite clearly a history piece) and this work, shows that the treatment of the features is almost identical in the rather rounded eyes with their heavy lids and the profile of nose, brows and full chin. The romantic idea that Saskia modelled for

every painting and drawing which portrayed a female that came out of Rembrandt's studio for eight years fails to take into account the enormous versatility and imagination of the painter. And yet he did, of course, draw, etch and probably paint her at times. The distinction between what is portraiture and what constitutes Rembrandt's idealised face of a woman at this particular period in the 1630s has tended to be blurred. It is the same problem encountered when trying to determine what can be seen as a self-portrait by Rembrandt and what should be considered a *tronie* figure based on his own features. How much variation on a theme is permissible before it no longer resembles the original closely enough to be considered a true likeness? The simplest explanation is that Saskia's face did indeed influence how Rembrandt portrayed women in his history paintings and *tronies* of the 1630s, but that on close comparison with the only documented portrait drawing we have of her (fig.1), most cannot be said to constitute real portraits. Their hair varies, their eyes are larger, the features usually take up more space within the face, their chins (often multiple) are usually more emphatic – they are 'generalisations' inspired by Saskia, and depicted, with artist's licence, broadly within the overall parameters of her face.

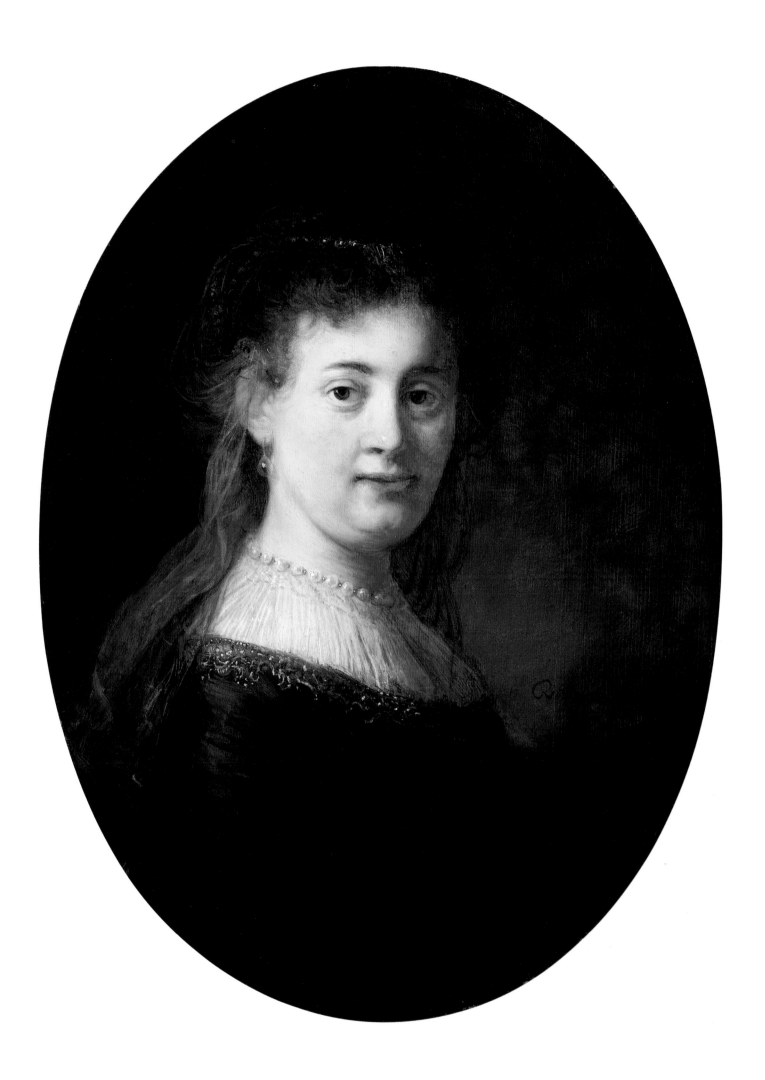

26 *Bellona*, 1633

Oil on canvas, 127 × 97.5cm
Signed and dated, lower left: *Rembrandt f. 1633*
Inscribed on bottom of shield: BELLOON[A]
References: *Corpus*, vol.2, A70; New York 1995–6,
vol.2, cat.7, pp.55–8

METROPOLITAN MUSEUM OF ART, NEW YORK
The Friedsam Collection, Bequest of Michael
Friedsam, 1931
(INV.NO.32.100.23)

This painting represents Bellona (or 'Belloona' in
the unusual Dutch spelling of the inscription), a
goddess of war (from the Latin *bellum*, meaning
war). She is mentioned in Roman mythology as the
sister, or the wife, of Mars, and is sometimes called
by the name of Duellona. Her temple at Rome was
in the Campus Martius, and it was there that the
Senate met to discuss generals' claims to triumphs
and to receive foreign ambassadors. Before it stood
the *columna bellica*, where the ceremony of declar-
ing war by priestly officials took place. Bellona
differed from the better-known Minerva, who was
goddess of war and victory, but also of the arts and
learning – her shrine was on the Aventine and
Rembrandt was to depict her two years later
(fig.93).[1] In both paintings he included a shield
decorated with the head of Medusa, the snake-
haired gorgon. From the inventory of his studio of
1656, we know that Rembrandt owned pieces of
armour as studio props, including several iron
helmets and an 'old ornamented iron shield made
by Quentin the Smith'.[2] That perhaps resembled
this one, although Rembrandt certainly embel-
lished such items in his paintings. A picture of a
Medusa's head attributed to Peter Paul Rubens and

Frans Snyders ('*Rubbens ende Snijders*') was in the
collection of Nicolaes Sohier of Amsterdam at the
beginning of the seventeenth century and was
praised by Constantijn Huyghens in his memoirs of
1629–31 as being so terrifying as to require a
curtain to cover it.[3] It is conceivable that
Huyghens and Rembrandt might have discussed
this, or even that Rembrandt may have seen the
picture. Intriguingly, Huyghens describes
Rubens's Medusa as a *pulcherrima mulier* (a very
beautiful woman).

The choice of subject and also the way it was
depicted here was a new departure for Rembrandt
and the likelihood is that he was actively trying to
emulate Rubens.[4] There does not seem to be any
direct prototype but Rembrandt certainly knew
prints after Rubens, the most successful artist of his
time in the Low Countries, with an international
reputation.[5] It is possible that he may have seen
paintings by him in the Stadholder's collection.
Amalia van Solms, whose portrait Rembrandt had
painted in 1632, is known to have had Rubens's
Roxanne Crowned by Alexander hanging over the
mantelpiece in her cabinet the same year.[6]
Rembrandt later owned works by Rubens as well:
prints after the master (and Jacob Jordaens) and
even a painting of *Hero and Leander*, purchased from
Troyanus de Magistris in Amsterdam in 1637 and
kept until 1644 (fig.7).[7] Even in the event of
Rembrandt having had no direct encounter with
Rubens's painting at this stage in his career, it has
been suggested that Jacob Adriaansz Backer may
have acted as an intermediary to the Flemish
master's art. Backer's work was greatly influenced
by Flemish painting through the Friesland painter
Lambert Jacobszoon (who also had ties with
Hendrick Uylenburgh). Backer and Govert Flinck
trained together and both arrived in Amsterdam in
1633, Flinck joining Rembrandt in Uylenburgh's
premises that year.[8] In the light of the Rubensian
style of Rembrandt's *Bellona*, it is particularly
interesting that the composition of his painting of
Flora (cat.36), which he was to complete in 1635,
was originally based on a version of Rubens's *Judith
and Holofernes*. One of these pictures was in Leiden
in the 1620s and so could have been seen by
Rembrandt there.[9] Though Rembrandt had used
elements taken from Rubens before (for example
integrating a motif from Rubens in *David before
Saul* of 1627[10]), *Bellona* marks no specific borrow-
ing but is rather Rembrandt's acknowledgement of
Rubens's approach to both style and subject matter
in the portrayal of such women.

This painting has prompted a reaction of
aesthetic repugnance from various authors, and
even the Rembrandt Research Project acknowl-
edged that it gave 'an impression of awkwardness
… and may even seem slightly risible'.[11] Bob Haak
remarked that few of Rembrandt's paintings are 'so
little attractive' and that 'the only thing that can
excite us is the fact that, underneath the present

picture, the artist originally painted his future wife
in the nude as x-ray photographs have revealed.'[12]
Actually, they have done nothing of the sort, as
confirmed by Walter Liedtke, who reasonably
pointed out that Rembrandt's wooing of Saskia
was rather unlikely to have encompassed nude
modelling sessions.[13] As mentioned in the previous
entry, this cannot be seen as a portrait of
Rembrandt's wife but is rather an idealised head
(even if others have disliked that ideal), such as
found in his *Artemesia* of 1634 in Madrid, the *Flora*
of 1635 in London and his *Minerva* of the same year
(cat.31, 36 and fig.93).[14] As has been pointed out,
these particular features, including what has been
called 'bulging goggle-eyes' were specific to
Rembrandt's women of the mid-1630s.[15]

Between 1632 and 1633, when *Bellona* was
painted, the United Provinces were busy with
military negotiations for their independence from
the Spanish Netherlands. However, these negotia-
tions came to nothing in 1633 and the war
continued. Secret meetings led by the Prince of
Orange took place with the French as possible allies
from December 1633.[16] It is possible that a Bellona
may have been commissioned in relation to these
events, either by the Prince of Orange or by a civic
client. Gary Schwartz noted that the picture was
perhaps more likely to have been painted for the
court at The Hague than an Amsterdam patron
(since Amsterdam, as a trade-centre, was keener to
sue for peace than to continue fighting). He
suggested that François van Aerssen, who had been
nominated by the Prince of Orange to negotiate
(and was also a patron of Constantijn Huyghens),
may have had something to do with the commis-
sion.[17] Whoever his client was, Rembrandt may
well have intended to portray a stolid northern
type of 'Netherlands Maid'[18] in his depiction of
this 'hefty Rubensian Bellona'.[19] The reason was
probably political, for this specifically Dutch
heroine, with the vernacular spelling of her name,
was a symbol of the country's readiness to do
battle, if necessary, to secure its hard-won
independence.

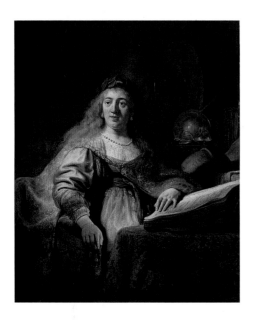

Fig.93 | Rembrandt, *Minerva*
Private Collection on loan to Bridgestone Museum of Art, Tokyo

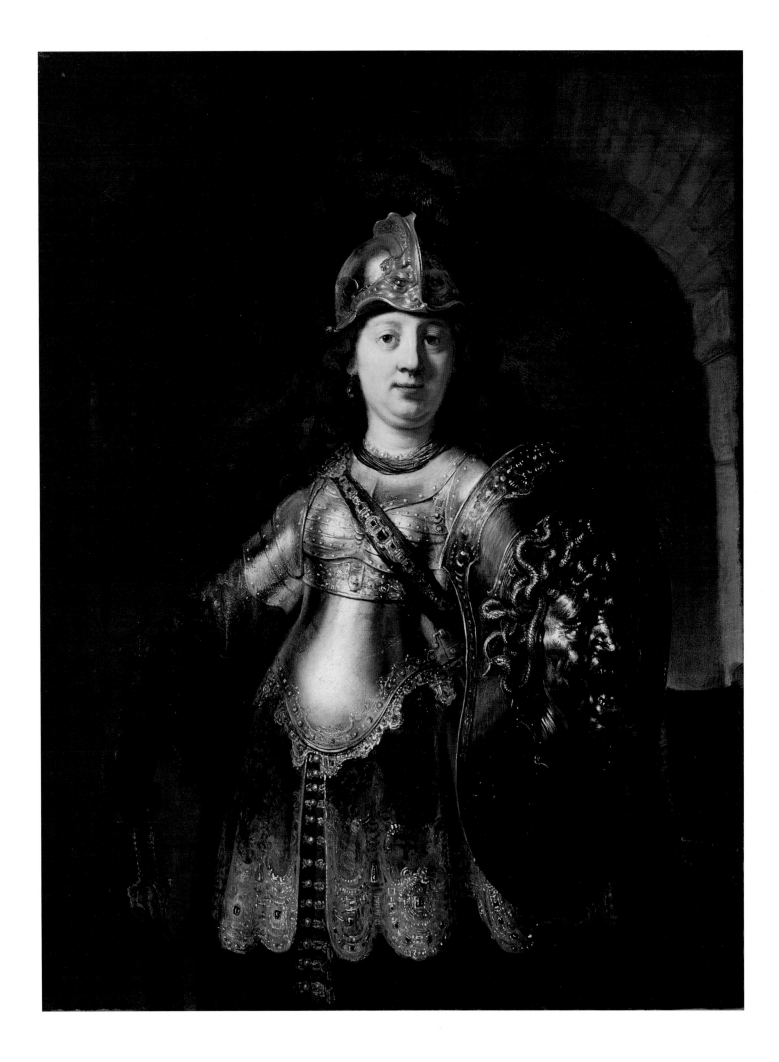

26A *The Holy Family, c.1633–5*

Oil on canvas, 183.5 × 123.5 cm
Signed and dated, bottom right: *Rembrandt. f 163[]*
References: *Corpus*, vol.2, A88; Berlin/Amsterdam/
London 1991-2, vol.1, cat.14, pp.161-3

ALTE PINAKOTHEK, BAYERISCHE
STAATSGEMÄLDESAMMLUNGEN, MUNICH
(INV.NO.1318)

Exhibited in Edinburgh only

This was the largest picture that Rembrandt had
hitherto attempted, and it was originally slightly
larger, having been trimmed in the early eighteenth
century.[1] As has been discussed in relation to his
Bellona (cat.26), Rembrandt was beginning to
demonstrate his interest in, and preoccupation
with, foreign art, perhaps in particular with
painting of the Flemish Baroque. The format of *The
Holy Family* announces the successful young artist's
ambition to move away from smaller subjects in
order to tackle a history painting on a grand scale
with nearly life-size figures. The broader treatment
of the canvas and handling which is less detailed
than in much of his previous work, appear to relate
stylistically to certain pictures by Peter Paul
Rubens (1577-1640)[2] and Anthony van Dyck
(1599-1641),[3] especially in the smooth plasticity of
the swathes of drapery seen here. Rembrandt
presumably employed this technique, in part at
least, because of the large size of the canvas and the
fact that it would be seen from a distance.

One of Rubens's most famous Holy Family
scenes, painted in about 1616, now in the Pitti
Palace, Florence, has something of a similar spirit
in showing the figures gathering around a hooded
wicker cradle, akin to that shown in Rembrandt's
version.[4] Rubens's picture was strongly affected by
Italian Renaissance examples of the theme that he

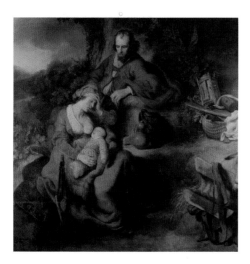

Fig.94 | Ferdinand Bol (1616-1680), *The Rest on the Flight into
Egypt*, 1644 (detail)
Gemäldegalerie Alte Meister, Staatliche Kunstsammlungen, Dresden

saw during his sojourn in Italy. It was a popular
subject there, deriving not from the Bible, but
from the Franciscan *Meditationes Vitae Christae IX*.[5]
Another Rubens *Holy Family* (now in the Wallace
Collection, London), with Jesus sitting on a fur,
was painted for the governor of the Netherlands,
seemingly for the oratory of the Archduke's palace
in Brussels.[6] This also emphasises the psychologi-
cal relation between the figures in the holy
household. It is important to stress that these are
not direct sources for Rembrandt's composition,
but there is something of the same quiet simplicity
in the pictures, with the bearded Joseph drawn
into the family circle and looking on tenderly.

Others, however, have seen more Italian
influence on Rembrandt's composition, suggesting
Titian (*c.*1485/90-1576)[7] as a possible source, or
perhaps Annibale Carracci (1560-1609), whose
print of *The Holy Family* Rembrandt had already
used in his etching of the subject a couple of years
before (cat.16).[8] It has also been noted that the
motif of Mary holding the baby Jesus's feet occurs
in images in sixteenth-century Venice and else-
where in Northern Italy, originating from Byzan-
tine *Hypsilotera* icons.[9] A section at the left of
Rembrandt's canvas was later trimmed, removing
what would have been a fire at the left-hand edge.
Thus Mary would actually have been warming her
baby's feet in front of the glowing flames.

Whether or not there was a direct pictorial
source from Flanders or Italy for Rembrandt's
composition, the picture is most definitely his
own, suffused with an atmosphere of intimate
domesticity. The Holy Family is shown in an
interior with a wooden planked floor and a stone
wall upon which one can just make out the
carpentry tools of Joseph's trade. A curtain behind
him is almost hidden in shadow at the right and the
composition is dominated by the figures of Mary
and Jesus illuminated from the left, and the
strongly-lit cradle. The baby, wrapped in fur
bunting, has fallen asleep after suckling, his face
still pressed against Mary's engorged breast, from
which milk leaks in welling bright dots of paint.
Such keenly observed detail was clearly drawn
from life and it is interesting that breastfeeding in
the Netherlands at this time was considered as one
of the main attributes of true mother love.[10]
Wherever possible, mothers were encouraged to
nurse their babies themselves instead of handing
them over to wet-nurses and the latter were only
meant to be used in cases of dire emergency due to
the incapability or death of the mother. As Jacob
Cats was to exhort in his poem on motherhood,
'*Moeder*', published in 1642,

> *Employ O young wife, your precious gifts*
> *Give the noble suck to refresh your little fruit*
> *There is nothing an upright man would rather see*
> *Than his dear wife bid the child to the teat*
> *This bosom that you carry, so swollen up with*
> *life…*[11]

That Rembrandt should have painted the Virgin's
breast so naturally was therefore both a comment
on the sense of this being a real family caught up in
normal life, and also a means of stressing the love
of the mother of Christ for her child. The quotid-
ian was, however, also mixed with the consciously
composed, for there are also formal echoes of
Lamentation or Pietà scenes in the pose of Jesus,
here a sleeping infant but later to be placed on
Mary's lap as the crucified Saviour. The composi-
tion was later used in reverse in *The Rest on the
Flight into Egypt* of 1644 by Ferdinand Bol (1616-
1680), who seems to have worked in Rembrandt's
studio from about 1635 (fig.94).[12]

The signature on *The Holy Family* may not be
authentic and the date is now missing its last
digit.[13] It was formerly thought that the picture
was painted in about 1631 but the style is clearly
later than this, and the canvas is generally thought
to date from about 1633-5.[14] The similarity of the
facial types used for the figures of Mary, the subject
in the *Bust of a Young Woman* of 1633 (cat.25) and
the artist's *Bellona* of the same year (cat.26), would
also support such a date, though the assurance of
the handling of *The Holy Family* perhaps indicates
that it was painted the following year. The
suggestion that all of these women were modelled
by Saskia van Uylenburgh who was betrothed to
Rembrandt in 1633 is unlikely, though all could be
said to be idealised heads which seem based loosely
upon her features. Despite the likelihood that
Rembrandt's observation of a lactating breast must
have been made from life, Saskia did not give birth
to their first child, Rumbartus, until the end of
1635 (he was baptised on 15 December and was
buried exactly two months later).[15]

The painting was probably in the collection of
Marten Soolmans (1613-1641) and his wife
Oopjen Coppit (1611-1689) whose pendant
portraits Rembrandt painted in 1634 (figs.16 and
17).[16] These unusually grand paintings, probably
commissioned to celebrate their marriage the
previous year, measured about 207 by 132
centimetres each.[17] Though not without prec-
edent in the Netherlands, these were the first
pendant full-length portraits which Rembrandt
was to make (and, it seems, the last).[18] Given that
the measurements of *The Holy Family* are now only
slightly less than the portraits, and that we know
the painting has been trimmed somewhat, it is
tempting to suppose that Rembrandt intended to
present the couple with a striking Biblical subject
of sufficient grandeur to match the impact of their
portraits, openly emphasising his talents as a
history painter as well as a portraitist. Though
usually thought to have been a subject reserved for
Catholic patrons, the domestic contentment of
Rembrandt's *Holy Family* might, in fact, have been
seen as a particularly apt theme in view of the
recent marriage of his clients, despite their
membership of the Reformed Church.

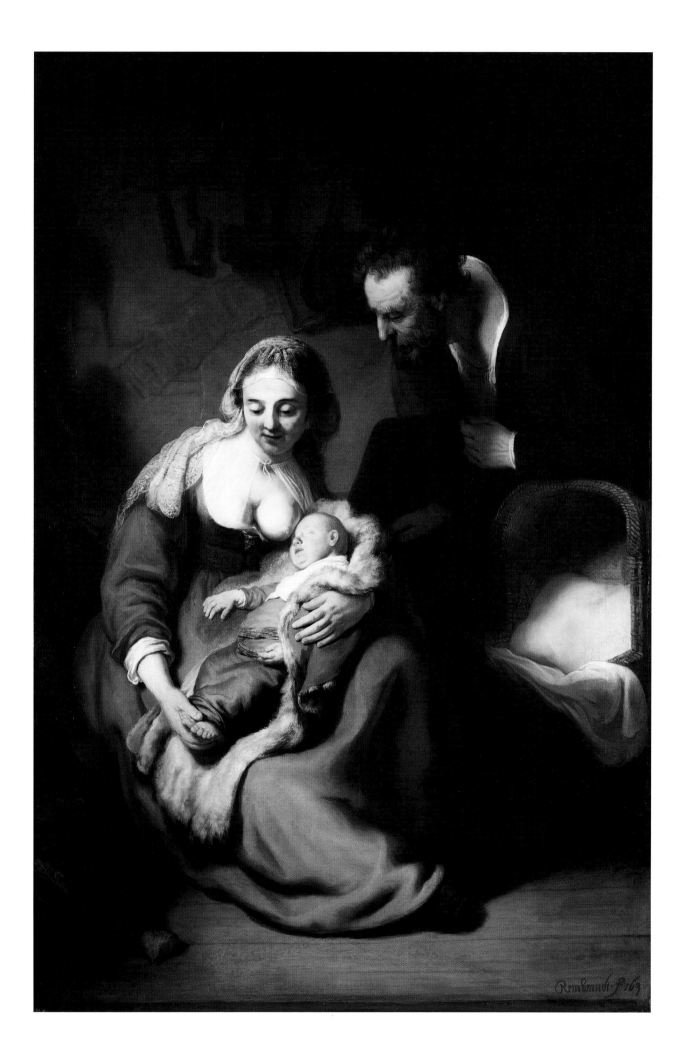

27 Flora, 1634

Oil on canvas, 124.7 × 100.4 cm
Signed and dated, lower left: Rembrandt f ... 34
Reference: Corpus, vol.2, A93

STATE HERMITAGE MUSEUM,
ST PETERSBURG (INV.NO.732)

Following on from his Bellona of the previous year, this picture continues the large three-quarter length mythological or Biblical paintings of women that Rembrandt made from 1633 to 1635. Flora, though not initially a particularly common theme in northern iconography, began to figure more frequently in various contexts later in the seventeenth century, including garden statuary and embroidery for example.[1] Her related personification of Spring, as a young woman bearing flowers, had earlier been popular in many prints of the Four Seasons, and was also utilised as the figure representing Smell with her sweet-perfumed blooms in allegories of the Five Senses.[2] It is known that Rembrandt's studio did produce works which were actually given the title 'Flora', for on the back of one of Rembrandt's drawings now in Berlin is a mention of three works from his studio bearing this name.[3] One 'floora' was done by 'fardynandus', Ferdinand Bol, and another by Leendert Cornelisz van Beyeren. These may have been copies of examples of the same subject by Rembrandt, such as this or his Flora of 1635 in London, for certainly copies of both of these pictures are known to exist.[4]

Here the goddess is adorned with a wreath of flowers containing a white rose, columbine, red marigolds, silver fir, forget-me-nots, red marigolds, red and yellow fritillary, anemones and even a red and white tulip flamboyantly unfurling just above her ear. The profusion of plants is noteworthy at a time when some of these species were less common than nowadays, and it was in about 1634 when this picture was painted that the 'futures' market of whole tulip bulbs started in the Netherlands, leading to the extraordinary speculative 'tulip mania' of 1636–7.[5] The presence of the striped or 'broken' red and white tulip would have inferred rare luxury corroborated by the richness of the figure's attire. The sheer opulence of the striped and embroidered fabric in soft colours is offset by the more broadly painted plain pale green material of her train and skirt (almost certainly chosen in relation to the subject of Flora as a young spring colour). The dress, partly inspired by sixteenth-century costume, is in the overall manner of the fantastical 'antique' dress found in previous tronies and history pictures such as the Heroine from the Old Testament (cat.20), although even more elaborate.

However, in an article about the pastoral and theatrical associations of the clothes shown here, Margaret Louttit noted that a 'pale green satin bodice very close to the colour of willow leaves'

was worn by the shepherdess Rosemond in Johan van Heemskerk's play Batavishe Arcadia of 1647. She suggested that the dress shown must have been real theatrical costume rather than imaginary and stated that the subject of Rembrandt's painting must also have represented a shepherdess, relating to the vogue of portraits historiées then popular in the Netherlands.[6] Others have seen this as a portrait of Saskia in pastoral dress.[7] The stripes on the magnificent sleeves have also been seen as a feature of this pastoral style of dress, but it should also be pointed out that Rembrandt had used such stripes in different contexts as well, such as the headdress worn by the old woman in his Musical Allegory.[8]

In 1770 this painting appeared in the sale of the collection of Herman Aarentz in Amsterdam under the description of 'A Lady Dressed like a Shepherd-ess', so it is clear that at that time it was believed to represent fashionable Arcadian costume (but it was not referred to as a portrait).[9] This vogue had been prompted by the publication of Pieter Cornelis Hooft's pastoral romance of Granida and Daifilo which had appeared in about 1605. The theme originated from classical literature such as Virgil's Eclogues and Georgics, poems celebrating 'the simple life' of farmers and shepherds, which were popular in the Netherlands and were translated by the artist and critic Karel van Mander in 1597. Contemporary Italian and Dutch writing also warmed to this subject, most particularly in Giovanni Battista Guarini's play of 1589, Il Pastor Fido (The Faithful Shepherd), to which Pieter Cornelisz Hooft's Granida and Daifilo was a tribute. Emulated in popular pastoral poems and love songs, Arcadian subjects also became fashionable in Dutch art, both as generic types and as portraits. One of the earliest known examples appears to have been a half-length Shepherdess by Paulus Moreelse of 1617 (Private Collection). Moreelse also painted A Shepherd and A Shepherdess as pendant works in 1622 (Krayer-La Roche Collection, Basel). Such gentle erudition and light-hearted amorous content also appealed to the court at The Hague, and similar works were owned by Prince Frederik Hendrik and Amalia van Solms.[10]

The representations of such shepherdesses generally showed young women, often baring their breast, crowned with large straw hats, sometimes decorated with flowers, and holding a houlette, a long thin staff with a metal tip used for herding. Marieke de Winkel has pointed out that these elements are omitted from this representation and it is unlikely that the figure here is meant to be a shepherdess.[11] It is true that no hat is shown but a crown of flowers rather similar to the wreath of blooms here is shown piled onto the head of a woman in the frontispiece of Jacob Cats's Galathee ofte Herders Klagte, published in 1627, and though Rembrandt's woman does not hold a houlette, she is carrying a staff, though admittedly one spectacu-

larly covered in flowers.[12] However, it remains unlikely that Rembrandt intended his figure to be perceived as a shepherdess; but that he should have given her a green costume with stripes and wreathed her head with flowers should not be regarded as completely incompatible elements in his portrayal of the goddess Flora.

The Rembrandt Research Project notes that neither this picture nor the Flora painted in 1635 (cat.36) should be regarded as being portraits of Saskia and it is true that, just as with the Bellona (cat.26), the idealised nature of the features here would seem to rule out the idea that this was intended as a proper likeness.[13] However, it should be mentioned that Rembrandt married Saskia in 1634, the year that this painting was made, and it seems possible that the subject may have had some special significance for the artist.[14]

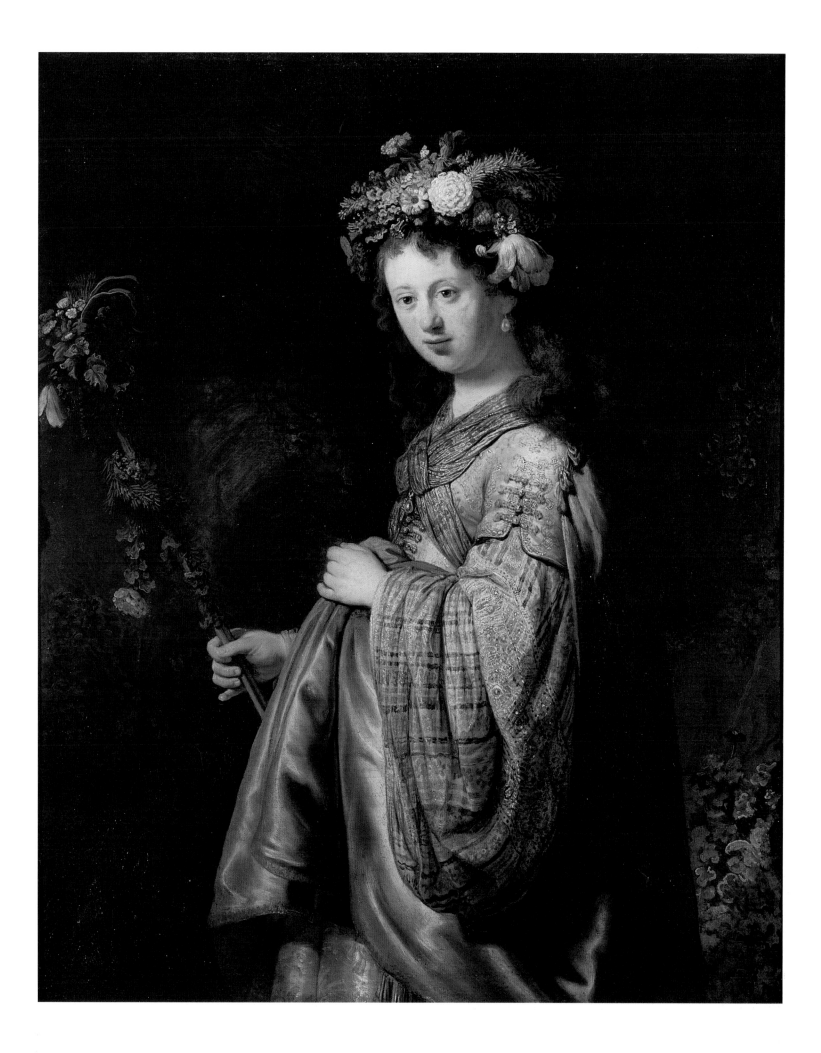

28 *Joseph and Potiphar's Wife*, 1634

Etching, first state (of two), 9 × 11.5 cm
Signed and dated, bottom left: *Rembrandt f. 1634*
References: H.118; White/Boon, B 39:1; Amsterdam/London 2000–1, cat.20, p.128

FITZWILLIAM MUSEUM, CAMBRIDGE
(INV.NO.AD.12.40–55)

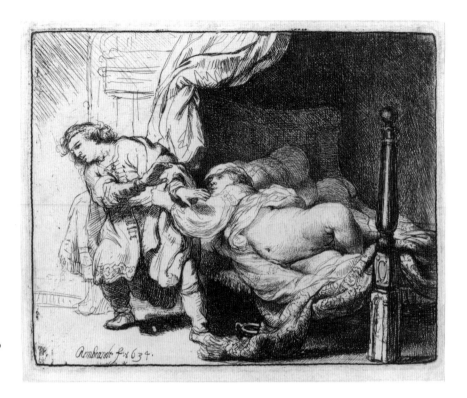

The story of Joseph and Potiphar's wife is told in the Book of Genesis 39: 6–13. Joseph was sold into slavery in Egypt by his brothers but was employed by Potiphar, captain of Pharaoh's guard, who treated him well. 'Joseph was handsome and good-looking. And after a time his master's wife cast her eyes upon Joseph, and said, "Lie with me". But he refused and said to Potiphar's wife that his master had made everything in the house available to him except her "because you are his wife: how then could I do this great wickedness and sin against God". And although she spoke to Joseph every day he would not listen to her, lie with her, or be with her. But one day when he went into the house to do his work and none of the men of the house was there, she caught him by his garment saying "Lie with me". But he left his garment in her hand and fled out of the house.' His discarded clothing was later used by the rejected woman to incriminate him.

In 1796, Daniel Daulby noted of this print: 'Rembrandt has not treated this subject with that decency which is due to the sacred source from which it was derived. The wife of Potiphar appears naked up to the waist, reclined in a lascivious posture…'[1] So indecent did it seem, indeed, that a copy of the print in reverse now in the Fitzwilliam Museum, Cambridge, shows that someone found the print so disagreeable that bedclothes were added to cover up the offending anatomy.[2] Rembrandt clearly intended to make this woman as sexually explicit as possible: her body is twisted in order to be able to grasp at Joseph's coat with her

clad upper half, while her naked, parted legs leave absolutely no doubt about her desires.

Rembrandt's depiction of Potiphar's wife is closely related to the type of nude in his earlier etching of *Jupiter and Antiope* (see cat.13) and also to the many small nudes in his painting of *Diana Bathing; with the Stories of Callisto and Actaeon*, which was painted in about 1634, the date of *Joseph and Potiphar's Wife*.[3] The starting point for the composition of his painting of *Diana Bathing* was two prints by Antonio Tempesta (1555–1630), and his etching of *Joseph and Potiphar's Wife* also appears to have been based on an engraving of the same subject by Tempesta (fig.95).[4] Rembrandt probably owned these prints, for it is known that a book of 'engraved and etched figures by Antonio Tempesta' was one of the items listed amongst his possessions in 1656.[5] However, although following the position of the foreshortened bed and the movement of the figures to the left of the composition, Rembrandt adapted his source dramatically. Tempesta's Joseph rejects his master's wife's overtures like a polite youth with a pressing engagement elsewhere, but Rembrandt's Joseph is horrified and disgusted at her advances and fends her off with moral and physical revulsion. He is etched with light lines, as is the area behind him, while the seamy sheets and surroundings of the bed (including the lurking chamberpot) are in heavy-toned sombre darkness. This chiaroscuro heightens the psychological impact of Rembrandt's composition, emphasising what Christopher White called 'a deeply felt drama of warring emotions conveyed through light and shadow'.[6]

Fig.95 | Antonio Tempesta, *Joseph and Potiphar's Wife*, c.1600
British Museum, London

29 *A Woman Having her Hair Combed, c.1634*

Drawing, pen and brush and brown ink with wash,
10.7 × 9.8 cm
References: Benesch 396; Berge-Gerbaud 1997,
cat.2, pp.4–5

COLLECTION FRITS LUGT, INSTITUT
NÉERLANDAIS, PARIS (INV.NO.805)
Exhibited in Edinburgh only

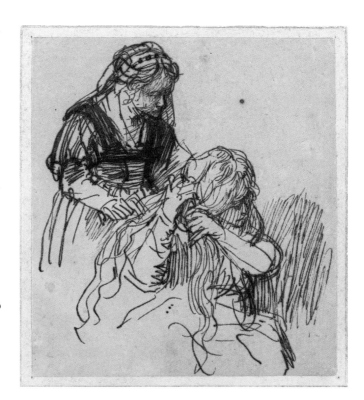

This charming sketch shows a continuation of
Rembrandt's interest in portraying women at their
toilette. He had already painted the same theme in a
historical context in his *Heroine from the Old
Testament* (cat.20). However, this sheet appears to
show a scene which could well have started as a
sketch from life, with a woman trying to rake her
fingers through her long tangled tresses before the
woman behind her starts to comb or brush them
out. The intimacy of the scene makes it tempting to
suggest that Rembrandt may have sketched Saskia
involved in such a task. The rather emphatic dark
area on the upper part of the maid's bodice, with
what appears to be lacing on the bodice under-
neath, is somewhat similar to that found on the
costume of another woman from North Holland
who was probably a maid in Rembrandt's house,
although the collar differs (see cat.80). This is not
to say that the same figure was represented,
however. If there is indeed a link to the dress of
North Holland, so explicitly drawn by Rembrandt
in his later drawing, it could be explained by the
fact that this regional costume was not uncommon
in Amsterdam where women from that area were
much sought after as maids.[1]

The neck of the standing woman initially looks
bare but a few vertical lines below her chin imply a
blouse edging of some kind, while the line of what
could be a necklace hanging down also seems to
have been drawn in. Interestingly, Rembrandt first
seems to have drawn this figure with a cap, which
would have made her look more like a maidservant,
but he then drew dots across its edge and added
loops of hair or a veil on top. This has the effect of
making her status less clear, and, just as impor-
tantly, makes the period of the drawing less clearly
contemporary. Nor did the artist only alter this
figure. The fine lines which make up the seated
woman's hair seem to have had heavier lines added
that are less close together. These snake further
down her shoulders and lengthen the hair hanging
down at the front as well, giving her the extrava-
gant locks of a heroine, such as is found in his
etching of '*The Great Jewish Bride*' (see cat.33 and
35).

All this probably happened as the drawing was
being made, but by changes as small as these it
might almost be said that Rembrandt was moving
his subject from the present into the past. This
would make sense in the light of his larger drawing
of a similar subject, *A Young Woman at her Toilet*

(cat.30). Rembrandt would often take a small,
seemingly loosely worked sketch, and reconfigure
it to create a more complex and worked up drawing
as he did with his two sketches of *A Woman
Comforting a Child Frightened by a Dog* and *A Woman
with a Child Frightened by a Dog* (see cat.54 and 55).
The exact relation of the present drawing to the
Young Woman at her Toilet is less clear and it is not
certain that this preceded the larger drawing. It is
perhaps more an example of Rembrandt turning
the subject round in his mind and exploring its
artistic possibilities.

Drawing, pen and brush and brown ink with
brown and grey wash, 23.4 × 18.0 cm
References: Benesch 395; Vienna 1969, cat.3;
Vienna/Amsterdam 1989–90, cat.39, pp.106–7

ALBERTINA, GRAPHISCHE SAMMLUNG,
VIENNA (INV.NO.8825)
Exhibited in London only

As is so often the case with Rembrandt's oeuvre,
drawings which appear related to painted composi-
tions are often not preparatory studies for those
paintings but, rather, the result of Rembrandt
continuing to mull over a particular pose, rethink-
ing it and drawing it again, sometimes some years
later. This sheet was assumed by Hofstede de Groot
to have been a preliminary study for the painting in
Ottawa of *A Heroine from the Old Testament* of *c*.1633
(cat.20).[1] Otto Benesch also noted the
compositional similarity to the Ottawa picture and
dated this drawing to 1632–4. However, the
assured penmanship and treatment of the wash as
well as the large format of the sheet must date from
the later period stylistically, as pointed out by Van
de Wetering,[2] and it seems more likely that it
represents a further stage of Rembrandt's thought
about this grouping of figures. As has been
discussed in relation to the possible meaning of the
Ottawa painting, a young woman and an older
woman could figure in many subjects for history
painting, a number of them specifically concerned
with the heroine's preparation to look her best.

Rembrandt shows the light falling from high
up, as he did in the Ottawa picture. It bathes the
dress and face of the young woman and lights the
shoulders and bowed head of the standing woman

who busies herself plaiting a long hank of hair. The
young woman who seems to have some sort of shawl
about her sits gazing forward rather dreamily, idly
twisting the end of one plait in her roughly sketched
hands. Rembrandt started off this drawing with a
pen to sketch in the figures and then added the grey
wash still seen at the top right of the sheet. Evi-
dently he decided to rework this and added a brown
wash on top which has the effect of throwing the
pair into vivid relief, brightly lit as if by a strong
shaft of sunlight against the dark background.
Rembrandt is not interested here in the faithful
recording of details, he does not bother to finish off
the skirt of either figure and he pays little attention
to the somewhat spatulate hands. The exuberance of
Rembrandt's penmanship, with his sweeping loops
of line, looks forward to the technique found in his
drawing of '*The Great Jewish Bride*' (cat.34), while the
confidence with which he lays in the wash, in broad,
dashing strokes, is masterful.

The rather sparse lines used for the young
woman's face relate to those used in the drawing
usually entitled *Saskia Leaning out of a Window* which
is of about the same date (fig.96), and both drawings
display a boldness of execution which is striking.[3] It
has been suggested that the Albertina sheet, with its
domestic scene and the figures, as far as one can tell,
in contemporary dress, may have belonged to Jan
van de Cappelle, the marine painter and contempo-
rary of Rembrandt. This album was in the list of his
estate of 1680, itemised as '*een portfolio daerin sijn
135 tekeningen sijnde het vrouwenleven met kinderen,
van Rembrant*' (a portfolio within which are 135
drawings of the lives of women with children, by
Rembrandt).[4] A number of the works believed to
have been included in this album are included in the
exhibition.

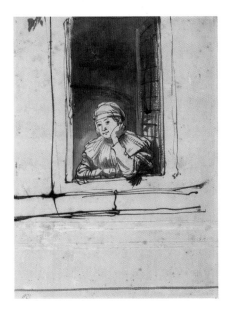

Fig.96 | Rembrandt, *Saskia Leaning out of a Window*
Museum Boijmans Van Beuningen, Rotterdam

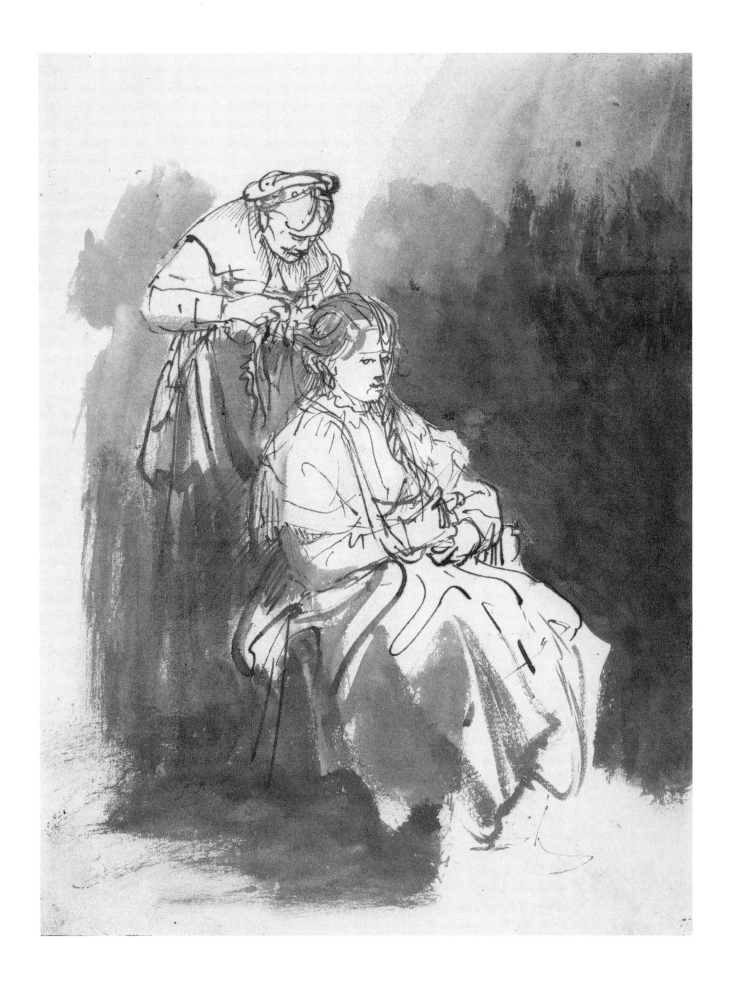

Oil on canvas, 142 × 153 cm
Inscribed, centre right: *Rembrant f 1634*[1]
References: *Corpus*, vol.2, A94, *Corpus*, vol.3,
pp.774–6

MUSEO DEL PRADO, MADRID (INV.NO.2132)

It is intriguing how many of Rembrandt's
paintings featuring women as their principal
focus are ambiguous with respect to subject
matter. Just as the Ottawa *Heroine from the Old
Testament* (cat.20) has never been convincingly
identified, the subject of the Prado picture has
also been cause for considerable debate. The
queenly figure sits clothed in magnificent
opulence. Rembrandt here renders the textures
and colours of the various materials with extraor-
dinary virtuosity. The gold and white gathered
sleeves have the flimsy softness of silken gauze,
while the sheen on the shimmering oyster satin is
so smooth that it reflects light back like a mirror,
illuminating the profile of the serving girl beside
her. Each surface and colour is considered in
relation to the way the light affects it: the girl's
wine-red velvet dress blushes more crimson where
the pile catches the light, the slatey blue-grey
plush of the covered armrests takes on a tinge of
lavender, and the golden and orange hues on the
heavy woven tablecloth turn to autumnal russets
and browns as they fall into shadow. Rembrandt
concentrates upon the details as well: the pearls
that gleam against the rippling hair that falls upon
the fur of the ermine collar, the complicated
frogging at the front of the dress and the intricate
braids that make up the coiffure of the young girl
who offers her mistress a nautilus cup full of claret
coloured liquid. At the left, barely visible, is an old
woman who holds something out in two hands, a
cloth or perhaps a bag. The central figure looks at

neither but gazes calmly off into the distance in
some reverie of her own.

Various suggestions have been made as to the
subject matter, the most usual being the stories of
of Sophonisba and of Artemesia. The story of
Sophonisba (also Sophoniba) is recounted by the
ancient Roman historian Livy, who notes that she
was the daughter of the Carthaginian general
Hasdrubal and married to King Massinissa. On her
capture by Scipio who made improper advances on
her, her husband sent a messenger with a cup of
poison for her, which she drank, preferring death
to infidelity and dishonour.[2] The pictorial iconog-
raphy of the subject often included soldiers in the
background, either Scipio's guards watching over
their prisoner, or King Massinissa's envoy with the
poisoned chalice.[3] The story of Artemesia bears
certain iconographical similarities to that of Queen
Sophonisba. She was the widow of the satrap of
Caria in Asia Minor, King Mausoleus (who was also
her brother, though this is generally tactfully
forgotten). She mourned his death so grievously
that she built him a magnificent tomb at
Halicarnassus (the *Mausoleum*) which became one
of the Seven Wonders of the Ancient World. But
she decided to honour him further by making
herself into a living reliquary, mixing some of his
ashes each day into water or wine and drinking
down the liquor.[4] In the seventeenth-century
Netherlands, Artemesia was often shown wearing a
black veil to indicate her widowhood.[5]

Two engravings by the German-born artist
George Pencz may have provided artists with the
basic elements of these two stories (figs.97 and 98),
and both subjects appeared often in sixteenth-
century prints.[6] Artemesia, plainly an appropriate
theme for high-born widows, was nonetheless not
a particularly common subject for pictures in the
Netherlands although more prevalent in Italy
where the story was depicted by artists such as

Guercino and Tintoretto.[7] However, an inventory
of the Stadholder's collection made in 1632 lists an
Artemesia by Rubens that was mistakenly itemised
as 'Sophonisba', so it is clear that there was already
a certain amount of confusion between the two
subjects.[8]

The Rembrandt Research Project interpret
Rembrandt's painting as a Sophonisba (despite the
lack of soldier-messenger) on the basis that the
figure does not wear widow's weeds and that she
does not seem to be sufficiently distressed to be
Artemesia. On the other hand, Pencz's Artemesia is
also remarkably composed. Tümpel believes the
figure is indeed the latter, and that the gesture of
the hand upon the queen's stomach indicates that
through this her body will become her husband's
memorial.[9] Technical examination of the painting
by x-ray has revealed that Rembrandt made
substantial changes to this composition, as he also
was to do with his 1635 painting of *Flora* in the
National Gallery, London (cat.36).[10] The x-rays
(fig.99) show that the figure to the left was much
larger, wore a white headdress and originally held
what seems to be a round edged container of some
kind – her fingers can clearly be seen at the left. The
light area looks as though something were being
poured from it, perhaps Mausoleus's ashes, but this
is uncertain. One might almost wonder if water was
originally being poured out of a basin, so sweeping
is the curved, whitish shape in the x-ray. The book
was added at a fairly late stage and the larger figure
at the side means that the composition would have
initially more closely resembled that of the *Heroine
from the Old Testament*, and it is just possible that
this picture also started off as another study of a
woman at her toilet.

Whatever its subject some have seen the
painting as being a 'tribute to conjugal love and
faithfulness probably dedicated to Rembrandt's
wife Saskia', though this is conjecture.[11] In facial

Fig.97 | Georg Pencz (*c.*1500–1550),
Sophonisba Taking Poison, c. 1539
British Museum, London

Fig.98 | Georg Pencz (*c.*1500–1550),
Artemesia Preparing to Drink her Husband's Ashes
British Museum, London

Fig.99 | X-ray of Rembrandt's *Artemesia*
Prado, Madrid
© Museo Nacional del Prado-Madrid

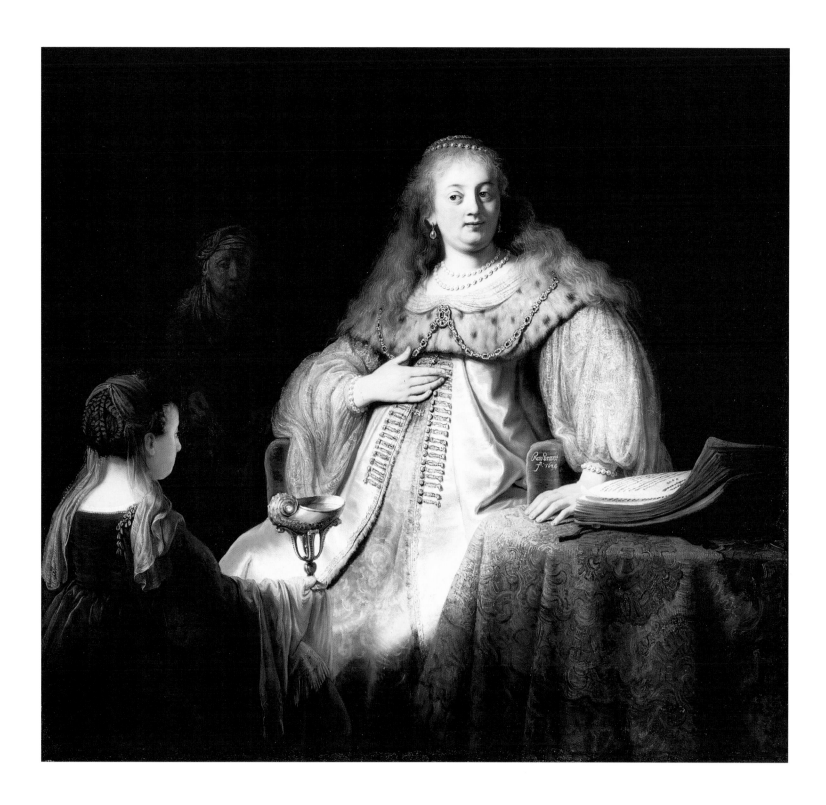

type, the heroine is physically most closely akin to Rembrandt's *Flora* of 1635 (cat.36). She has the similar plump features and heavy eyes of which the Rembrandt Research Project noted that 'the presentday viewer – used to other norms of female beauty – may perhaps find unattractive'.[12] The way in which the face is painted, with its wide forehead and curved planes of cheek and chin, is probably to be explained by the fact that the picture was not a commissioned portrait; the features therefore, which are painted in a similar way to those in Munich's *The Holy Family* of similar date (see cat.26A), are the result of Rembrandt's intention to show a generalised form of face rather than individual facial characteristics.[13] However, like *The Holy Family*, the scale of the work may also have

dictated a broader characterisation, perhaps related to the distance from which it was intended the painting should be viewed.[14]

The aloof gaze of his heroine, a restrained version of the curious sideways stare of the blonde girl in Jan Lievens's *Soothsayer*, makes her seem impervious to those around her, lost in her own private thoughts.[15] This sense of isolation in the composition was later carried to even further lengths by Rembrandt in his figure of Samson's first wife as she contemplates betraying her new husband at their marriage feast in *The Wedding of Samson* of 1638 (fig.100).[16] Though reduced in size, her pose and seeming psychological detachment from her surroundings echoes Rembrandt's heroine here.

Fig.100 | Rembrandt, *The Wedding of Samson*, 1683
Gemäldegalerie Alte Meister, Staatliche Kunstsammlungen, Dresden

32 *A Woman with Pearls in her Hair*, 1634

Etching, only state, 8.7 × 6.8 cm
Signed and dated, upper centre: *Rembrandt* f. 1634
References: H.112; White/Boon B 347; White
1999, pp.124–5

BRITISH MUSEUM, LONDON
(INV.NO.1973-U-868)

This wonderfully accomplished little study is generally thought to represent Saskia in the year of her marriage. Her dress has rather elaborate puffed sleeves gathered up with a band at her upper arm and a high, laced bodice and figured chemise. Rembrandt draws the latter in sparse, fine lines as if suffused in bright sun, as opposed to the highly-worked areas where the hatching casts deep shadows under her chin and by her jaw, where the pearl earring stands out as the one point of light. The lace edging the white *fichu* (a small triangular shawl) across her shoulders is also thrown into similar relief against the black of her dress.

Unlike the more idealised figures found in history paintings of this period, the features found here are somewhat less broadly depicted, the nose somewhat sharper and the eyes less rounded, though the soft plumpness of her throat is still in evidence. Her hair is half put up and bound at the back with strings of beads, usually believed to be pearls, which she also appears to wear about her neck. The way the shorter hair is shown springing out slightly in her fringe is similar to that in another etching made a few years later (cat.63). However, as Christopher White

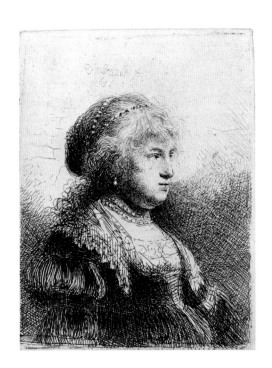

pointed out, Rembrandt was 'obviously not searching for a portrait likeness.'[1] It is, rather, an appealing study of a well-dressed woman, done with considerable charm and one that would presumably have had commercial appeal. Interestingly this was one of only two etchings of Rembrandt's that was copied by Wenceslaus Hollar (1607-1677), on his visit to Amsterdam in 1635.[2] The other was the *Seated Female Nude* (cat.12), which has prompted rather different critical response.

33 'The Great Jewish Bride', 1635

Etching with drypoint and burin, first state (of five),
21.9 × 16.8 cm
References: H.127; White/Boon B 340:1; White 1999,
pp.125–8; Amsterdam/London 2000–1, cat.25,
pp.140–4

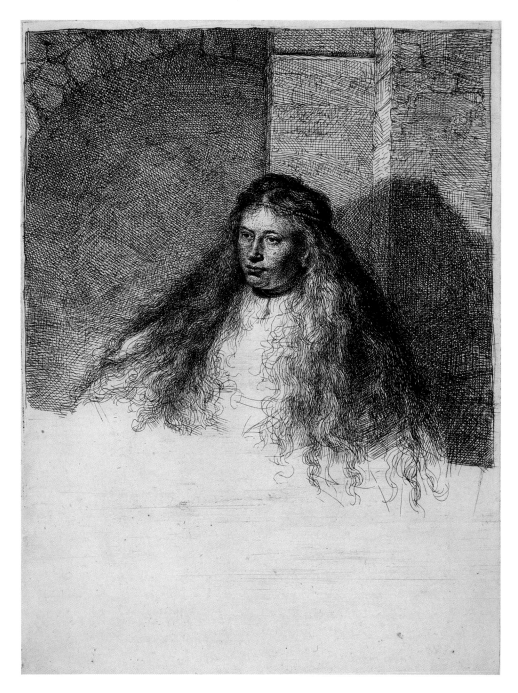

BRITISH MUSEUM, LONDON
(INV.NO.1973-U-868)

This first state of Rembrandt's etching is unfinished
and only the head with part of the background is
etched in. Rather as in his drawing of *A Woman
Having her Hair Combed* (cat.29), Rembrandt draws
the hair in loose, long curved lines, extra strokes
added on to the length and woven into the mass to
create a cloak of wavy locks about her shoulders. The
free cross-hatching of the background contrasts with
these undulating lines making the demarcation of
the head clear while tonally unifying the composi-
tion. The features are noticeably 'Saskia-like' and
many have considered it to depict her, most recently
Martin Royalton-Kisch, who stated that 'this can be
counted among Rembrandt's most directly descrip-
tive portraits of his first wife'.[1] It is interesting to
note that this resemblance was not seen by some of
the first writers on Rembrandt who gave this print
the title of the *Jewish Bride* in the belief that the figure
represented was the daughter of the Portuguese Jew,
Ephraim Buenos (1599–1665), a renowned doctor,
poet and translator whose portrait Rembrandt was
to etch in 1647.[2] The suggestion presumably arose
because of the custom that Jewish brides received
their husbands with their hair unbound, holding
their contract of marriage (Ketubah).[3] The '*Great*' in
the title was used to differentiate between this
etching and a smaller plate called the '*Little Jewish
Bride*' that Rembrandt made in 1638 (see cat.74).

Other suggestions have been put forward, such as
a Minerva[4] or a Sibyl[5] but the most plausible
interpretation was made by Madeleine Kahr who
suggested that the '*Great Jewish Bride*' relates to the
story of Esther. She was the beautiful Jewish wife of
the Persian King Ahazuerus, who interceded with
her husband to protect the Jews from the plottings
of the king's dishonest henchman Haman. The
success of her mission is celebrated in the Jewish
festival of Purim and the Book of Esther (in the third
section of the Judaic Biblical canon, known as the
Ketuvim, or 'Writings') is read on the festival as one
of the *Megillot*, five scrolls read on stated Jewish
religious holidays.[6] Kahr believed that Rembrandt
had already portrayed Esther in his earlier *Heroine
from the Old Testament* (cat.20). The subject was a
popular one in Holland in the years before peace was
signed between the United Provinces and the
Spanish in the Treaty of Munster. This was because
the Dutch saw parallels with Esther's intervention
with the King of Persia for the safety of her people,
the Jews, with their own fight for freedom against
Spanish rule.

34 *A Study for 'The Great Jewish Bride'*, *c.*1635

Drawing, pen and brush and brown ink with wash,
24 × 19 cm
References: Benesch 292; Stockholm 1992–3,
cat.138, pp.338–9; Royalton-Kisch 1993, pp.186–
8; Amsterdam/London 2000–1, pp.72–3, pp.140–4

NATIONALMUSEUM, STOCKHOLM
(INV.NO.NMH1992/1863)

Exhibited in Edinburgh only

This spirited drawing is one of the few sheets
known which is directly linked to the development
of one of Rembrandt's etchings.[1] The figure
appears in the opposite direction from the etching
because this was how Rembrandt would have
drawn onto the copper etching plate – the process
of printing reverses the image. The first and second
states of the etching were almost certainly etched
directly onto the plate but this study marks
Rembrandt's planning of the rest of the composi-
tion before continuing. The area which had already
been completed on the plate was only drawn here
in fairly light ink. The face and hair are therefore
only faintly delineated, as are the stone arch and
pilaster in the background (a similar archway to
that found in *Bellona*, cat.26). Here he adds another
pilaster in the corner which has the effect of further
emphasising the figure within the space. The rest is
completed in a much darker ink. The broad lines of
the bodice, the hand holding the scroll and the
sketchy bold lines of her dress are very much part of
Rembrandt's preliminary drawing style which does
not concentrate on precise details but forms the
overall shape of the composition.

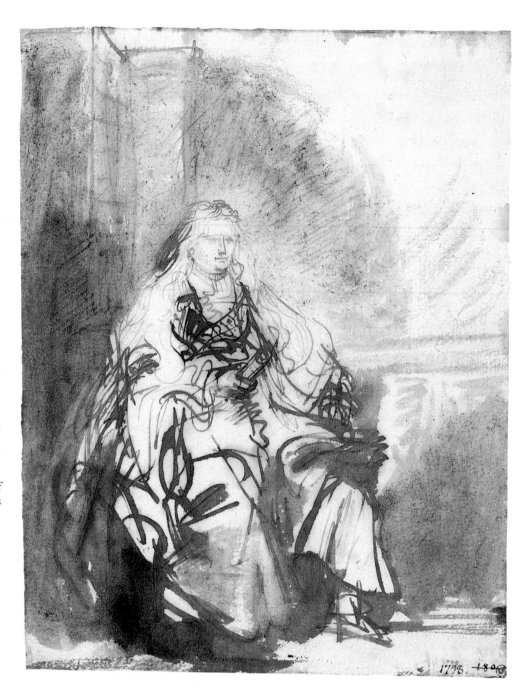

35 'The Great Jewish Bride', 1635

Etching with drypoint and burin, fifth state (of five), 21.9 × 16.8 cm
Signed and dated, lower left: *R1635* (in reverse)
References: H.127; White/Boon B 340:V; White 1999, pp.125–8; Amsterdam/London 2000–1, cat.25, pp.140–4

BRITISH MUSEUM, LONDON
(INV.NO.1973-U-866)

This is the final state of Rembrandt's etching (which some wrongly believed was completed by a pupil in the studio).[1] Examination of some of the papers upon which the different states of this etching were printed shows that the process of working on the *'The Great Jewish Bride'* actually took place within a fairly short period of time (most date it to 1635).[2] The desire to revise and improve his design can, rather, be seen to represent Rembrandt's extraordinary attention to the creative process of his etchings.

As is clear in comparison with the study he made for the third state of the etching, the form of the composition was generally followed, but Rembrandt used the drawing as a guideline only. Here he confidently fills in all the areas that were not finalised in the drawing: the pile of books resting in the background archway, the details of the fur-lining at the edge of her dark robe and the way it contrasts with the whiteness of her sleeve, her hand and the curled paper of the scroll she holds. As Christopher White has observed, there is every indication from the first state of this etching to suppose that Rembrandt worked up each separate area of the plate to a high finish, and it seems that he found it necessary to go over the whole plate again, trying to make the separate sections tie in together more convincingly from the point of view of overall tone.[3] To do this he had to darken certain parts of the plate, in particular in the shadow cast by the woman's head which had formerly been light enough for the articulation of the wall to show through. It is not certain why Rembrandt did not follow the plan of showing a full-length figure as shown in the drawing, but, intriguingly, this format brings *'The Great Jewish Bride'* even closer to the type of female heroine seen in Rembrandt's paintings of this period.

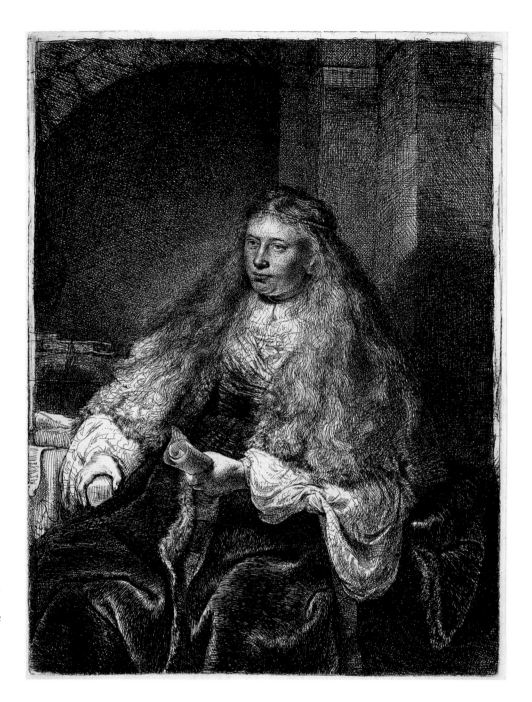

36 *Flora*, 1635

Oil on canvas, 123.5 × 97.5 cm
Inscribed, lower left: *Rem [b.] a [...] 1635*
References: *Corpus*, vol.3, A112; London 1988–9,
cat.5, pp.58–65; Berlin/Amsterdam/London
1991–2, vol.1, cat.23, pp.188–91

NATIONAL GALLERY, LONDON
Bought with the aid of the National Art
Collections Fund, 1938
(INV.NO.NG4930)

Now approximately the same size as the *Flora*
painted by Rembrandt the previous year (cat.27),
this picture may have been slightly trimmed
down.[1] The signature and date are not considered
authentic but it is thought that they may have been
copied accurately from a part of the canvas which
was cut off.[2] Technical examination of the painting
by x-ray has revealed that Flora's right hand was
originally lower on the canvas and that it did not
initially hold a staff (fig.101). Furthermore, there is
considerable confusion in the area by her left hand,

Fig.101 | X-ray of Rembrandt's, *Flora*
National Gallery, London

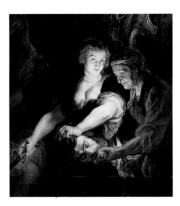

Fig.102 | Peter Paul Rubens (1577–1640),
Judith with the Head of Holofernes
Herzog Anton Ulrich-Museum, Braunschweig.
Photo: Bernd-Peter Keiser

indicating that significant changes were made
there, making it unlikely that she was originally
holding flowers. In addition, there was clearly
another figure placed at the right side of the canvas
that has been painted over on the finished canvas.
Christopher Brown convincingly suggested that
Rembrandt first intended to show the story of
Judith and Holofernes, taken from the apocryphal
Book of Judith.[3] This relates how the King of
Assyria, Nebuchadnezzar, sent his general
Holofernes to besiege the Jewish city of Bethulia.
The beautiful Jewish widow Judith managed to
leave the city to tell Holofernes that he would be
victorious. Invited into his tent, she cut off his head
as he lay in drunken sleep and brought it in a bag to
Bethulia.[4] The curving strokes at the bottom of the
x-ray probably indicate the sword she used, while
the figure at the right was presumably the old
maidservant who is often shown accompanying
Judith on her murder mission. The composition
appears to be based on a Rubensian prototype such
as his *Judith and Holofernes* now in Braunschweig
(fig.102) which may have been in Leiden in the
1620s, or his painting of the same subject now in
the Palazzo Vecchio, Florence.[5]

It is not known why Rembrandt reworked this
figure so dramatically when it seems to have been
almost complete. In doing so he also removed some
of the canvas, presumably to place Flora centrally
once the idea of including the second figure at the
right was rejected. It has been suggested that as a
Judith, the size of the painting may have started off
as wide as that of the Prado *Artemesia* (cat.31) and
may have shown the figures to knee level.[6] As with
his previous painting of *Flora*, Rembrandt concen-
trates upon the elaborate dress but it is here rather
more broadly painted. It is likely that Rembrandt
had to modify the costume slightly with his change
of subject, for Judith was traditionally shown with
her sleeves rolled up, presumably to facilitate the
act of decapitation. The overall palette is somewhat
similar, with the use of a soft green for the over-
skirt, together with the peachy orange tones in the
bodice, but here the difference of effect is substan-
tial. Her golden locks, blonde skin and the colours
in her dress seem to glow as Rembrandt shows his
subject more broadly lit than in the previous
picture, while the dark shadow cast on her dress by
her bouquet gives the sense of more convincing
plasticity. Whereas the material in the Hermitage
Flora is painted with the precision of an embroi-
derer, here Rembrandt paints the great swathes of
sleeve more freely. This is also true of her face
where the impression of three-dimensionality is
aided by softer shadows cast by her nose and the
hazier edges delineating her cheek and chin.

Though not hugely different from that of the
Hermitage *Flora*, the pose that Rembrandt chose
for this *Flora* in proffering flowers in her left hand is
rather more closely linked to the classical iconogra-
phy for the goddess. The famous statue of the

Farnese *Flora* (sketched in Rome by Maarten van
Heemskerck three times between 1532 and 1536
and engraved in Cavalleriis's celebrated book on
ancient Roman statuary of 1561) also has flowers in
her left hand.[7] Some have suggested that Titian's
Flora (see cat.119, fig.145), who incidentally holds
flowers in her right hand, may have provided a
prototype for Rembrandt's composition.[8] The
Titian was in the collection of Antonio Lopez in
Amsterdam in the 1630s where Rembrandt could
well have seen it and it seems to have been the
starting point for his *Flora* of *c*.1634, though the
parallels are rather less strong here.[9]

The debate as to whether the figure here is
intended to represent Flora or an Arcadian
shepherdess has also occurred with respect to the
Hermitage picture (see cat.27). The London *Flora* is
also decorated with a garland of flowers around her
head, but instead of a wreath, here there is a circlet
of forget-me-nots and scarlet pimpernel with a
sprig of rosemary. Not all of the blooms have been
identified but they include marigolds, cuckoo
flowers, tulips, carnation and buttercup, while her
staff is decorated with twisted tendrils of ivy. As
Marieke de Winkel has pointed out, Rembrandt
had already painted much of the costume when he
intended to portray Judith so it seems unlikely that
the low-cut dress would have been considered as
exclusively appropriate for an Arcadian shepherd-
ess.[10] This is not surprising since many of the
elements are taken from his master Lastman's
costume repertoire in his history paintings.[11]
Govert Flinck painted a pair of pictures which
show a male and female (the latter dated 1636) in
the guise of shepherd and shepherdess and
considered to be *tronie* portraits of Rembrandt and
Saskia, now in the Rembrandthuis, Amsterdam and
Braunschweig respectively (though the resem-
blance to Saskia seems distant).[12] What is intrigu-
ing about them, however, is that both carry the
'houlette' or shepherd's stick with metal scoop at
the tip (used to sling small stones), absent in both
Rembrandt's depictions of Flora and yet so
common in pastoral portraits. Indeed, Flinck's
other paintings of shepherdesses or herders all
show this implement while his painting of a *Young
Girl as Flora* contains instead a flowery staff.[13]

In 1635 Saskia gave birth to their first child. In
the same year Rembrandt and Saskia made their
will together, the custom for a couple just before
their first child was born.[14] The features here are
too generalised to be regarded as a portrait of the
artist's wife (though ultimately inspired by her
face) and the choice of Flora as a subject may well
have been commissioned. But, however much one
may objectively warn of the danger of associating
Rembrandt's private life directly with his paint-
ings, it is not unreasonable to claim that the
goddess of spring associated with new life must
have seemed an apt theme for the painter in that
particular year.

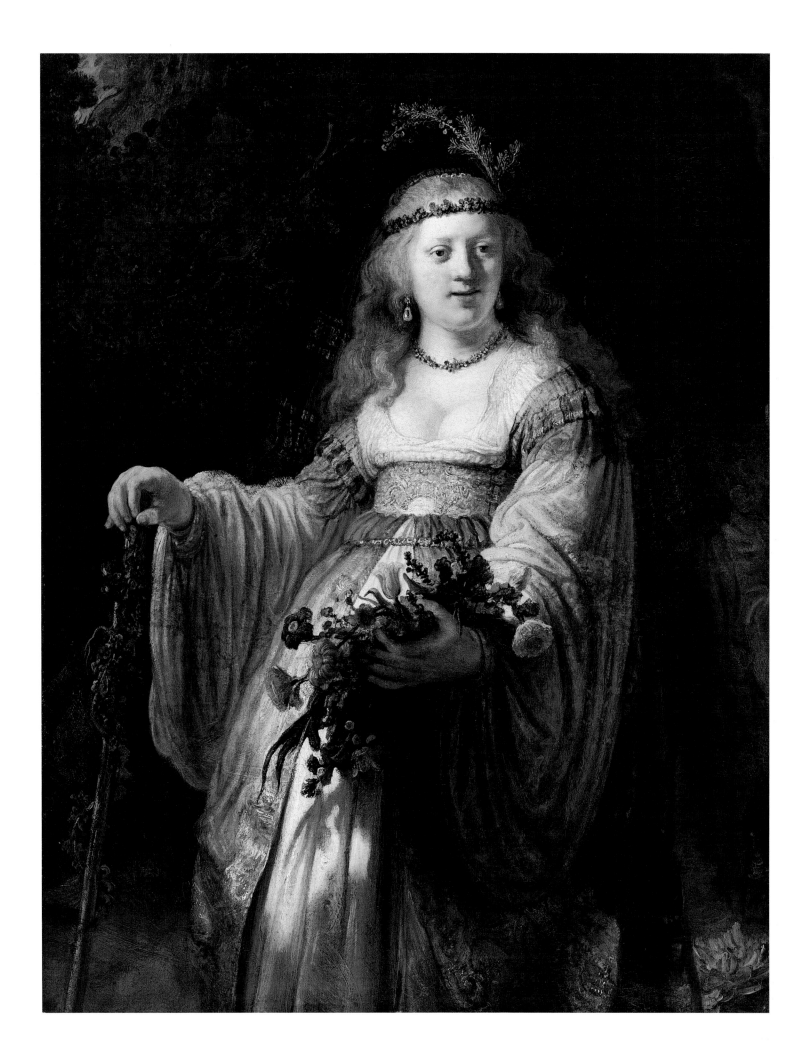

37 A Woman Reading, 1634

Etching, second state (of three), 12.3 × 10.2 cm
Signed and dated, top centre: *Rembrandt f.1634*
References: H.113; White/Boon B 345:II

RIJKSMUSEUM, AMSTERDAM (RP-P-OB-736)

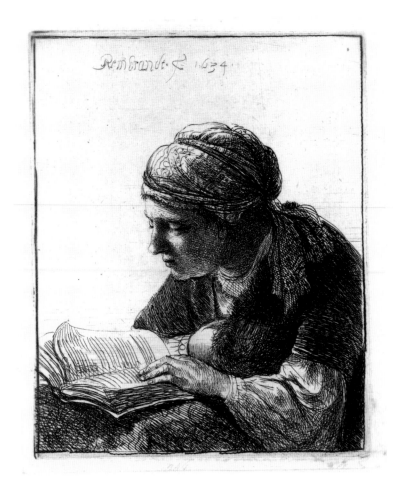

The woman, concentrating deeply upon the book in front of her, gazes intently at the words as if trying to learn them by heart, her right hand placed over her heart inside her jacket. The striped headdress together with what appears to be a fur-edged jacket worn over a full-sleeved underblouse would likely have signified that this was a *tronie* study in costume (loosely relating to the type of clothing seen in Rembrandt's etching of '*The Artist's Mother' with Oriental Headdress* (cat.4). If the costume were perceived as being oriental, as seems likely, then this may have been intended to represent a Biblical figure, perhaps devoutly reading scripture, or a seer of some kind. The form of words cannot be seen, however, so the content of the book is unknown.[1] Rembrandt shows the light from the left side reflecting off the book in order to throw light under her chin and his balance of highlight and shadow adds considerably to the contemplative nature of the scene. Such a figure could be fruitfully re-deployed in a number of different scenes as well. Rembrandt etched a woman in similar dress in his etching of 1638, *Joseph Telling his Dreams*, for which he made a related sketch.[2]

A forgery of this etching was made which replaces the head of the *Woman Reading* with that from the '*The Artist's Mother*' (cat.1). This was certainly done by 1751 since it was listed in Gersaint's catalogue raisonné of that year,[3] while

Daniel Daulby noted in 1796 that it seemed to be a companion to *Woman Reading*, 'being of the same size, of the same date, and executed in a similar taste'.[4] The effect of this amalgamation was to create a 'new' old woman reading, a clever invention given the existence of paintings such as the *Old Woman Reading* in the Rijksmuseum, Amsterdam (fig.103).[5]

It was formerly believed that this etching was made by a pupil, and that it was re-worked by Rembrandt, but subsequent scholars have seen no reason to suppose this (although it is now generally thought that the third state of the etching, where the tip of the woman's nose is strengthened by another line, is not by Rembrandt).[6]

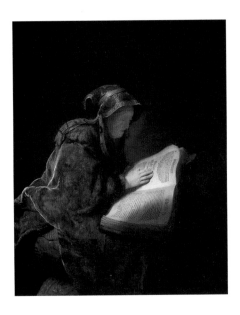

Fig.103 | Rembrandt, *An Old Woman Reading*, 1631
Rijksmuseum, Amsterdam

38 *Two Studies of a Woman Reading*, c.1635–40

Drawing, pen and brown ink, 17.4 × 23.7 cm
References: Benesch 249; New York 1995–6, vol.2,
cat.57, pp.158–60

METROPOLITAN MUSEUM OF ART, NEW YORK
H.O. Havermeyer Collection, Bequest of Mrs H.O.
Havermeyer, 1929
(INV.NO.29.100.932)

Unlike the earlier etching of *A Woman Reading*
(cat.37), these swift studies seem to have all the
spontaneity of drawing from the live model. So
much so, indeed, that Rembrandt made two
sketches on the same sheet, one after the other
(presumably showing the same woman).
Rembrandt drew quickly as his model changed her
position, invigorating the calm mood seen in the
earlier etching by giving a sense of progression of
movement. Here the woman leans back in her chair
and then hunches over to peer at the book (or vice
versa). The viewpoints are slightly different in each,
and both, slightly unusually, look down upon the
model. Rembrandt used the same approach in his
contemporaneous sketch of *Two Studies of Saskia
Asleep* (see cat.42, fig.106). There the two studies,
made presumably moments apart, are like a delayed
action film sequence, following Saskia as she sinks
into sleep. Such drawings were part of
Rembrandt's process of exploring the visible world
but they may also have been intended for studio
use. Certainly, two drawings were made after each
of the reading women here. The two copies (one
formerly with Oppenheimer, London and the other
now in the Städelsches Kunstinstitut, Frankfurt),
were previously thought to be by Rembrandt but
have since been assumed to be by his pupils,
perhaps set to copy their master's drawing as a
studio exercise.[1]

 It has occasionally been suggested that the
model for the Metropolitan sheet was Saskia.
Others believe it may have been the nurse who
looked after Saskia during her periods of bedrest
(before and after childbirth and through her later
illness), who appears in Rembrandt's drawings of *A
Woman in Bed, with a Nurse* (cat.43) and the *Interior
with a Woman in Bed* (cat.88).[2] The style of the
drawing would suggest that it dates from the mid-
1630s so it is possible that that it could relate to the
period of the birth of Saskia's first child in 1635 or
her second in 1638 – but the sketches could really
have been made after any woman, Saskia or a
servant, sometime after about 1635.

39 *Three Couples of Soldiers and Women, c.1635*

Drawing, pen and brown ink, 17.1 × 15.4 cm
(verso)
(recto: *The Lamentation- of Christ*)
References: Benesch 100; *Corpus*, vol.3, p.143

KUPFERSTICHKABINETT, STAATLICHE
MUSEEN, PREUSSISCHER KULTURBESITZ,
BERLIN (INV.NO.KDZ2312)
Exhibited in London only

This sheet has three sketches on it (the upper one
being partially trimmed) which all feature
different groupings of a man and a woman. At the
left is a man in a hat with a what appears to be a
feather, a sword swinging out from his belt, who
grapples with a woman trying to defend herself
from his hand thrust between her legs. The pose
she strikes in trying to prevent him almost
adumbrates that used for Susanna trying to
preserve her modesty in front of the Elders which
Rembrandt painted about a year later (cat.69).
The pair at the right seem less embattled and the
man's advances are dealt with more enthusiasti-
cally, his arms round the woman, one hand
cupping her breast, as he leers grinning back at us.

Otto Benesch suggested that the sheet may
have been a preparatory study to work out ideas
for a composition of 'The Prodigal Son amongst
Women'. The theme was often portrayed by early
Netherlandish artists such as Rogier van der
Weyden.[1] Taken from Luke 15: 12–23, the
parable tells of the young man who demanded his
inheritance and left his family to spend it all on
women and wine. He was forced to eat scraps
from pig troughs after losing it all and finally
returned destitute to his father who forgave him.
The Prodigal Son carousing at a brothel was
usually taken as the central motif of the story as a
warning against debauchery and excess. This was
illustrated by numerous printmakers such as
Lucas van Leyden, Cornelis Bos after Maarten van
Heemskerck, Claes Jansz Visscher after
Vinckboons, and many others.[2]

Rembrandt made another, more finished,
drawing which relates to this subject (Benesch
529) which shows a long-haired young rake, his
sword propped up against a chair, manhandling a
bare-breasted girl sitting on his knee, while
behind him a nude woman plays a lute and
another sits by. Another drawing in Orléans,
believed to be a copy after Rembrandt or work-
shop variant, also shows a similar scene (Benesch
528a).[3] Rembrandt does not appear to have
painted a brothel scene quite so explicit as those
which he sketched, but one picture in his oeuvre,
now in Dresden, has been identified as portraying
this theme, *The Prodigal Son in the Tavern*
(fig.104).[4] The prominent glass, tally slate on the
wall, extravagant peacock pie and the canoodling
all point to this subject. Dating from about 1635,
the composition was significantly re-worked
and X-rays show that it originally had an extra
woman in the background (and indeed may have
contained further figures at either side if the
canvas was cut down, as seems likely), bringing it
closer within the ambit of the Prodigal Son
iconography and Rembrandt's sketches.[5] Many
have thought that this is a double portrait of
Saskia and Rembrandt but the features are only
loosely based on theirs.[6] Gary Schwartz suggested
that the Dresden work was that listed as 'a
portrait of Rembrandt and his wife' in an
inventory of Louys Crayers (1623–1668), but one
has to ask whether Rembrandt would have
socially compromised his wife by making her a
recognisable prostitute in such a picture. It seems
more likely that it should be considered rather as a
history painting than as a portrait of life at home
with the Van Rijns.[7]

Fig.104 | Rembrandt, *The Prodigal Son in the Tavern*
Gemäldegalerie Alte Meister, Staatliche Kunstsammlungen, Dresden

40 *A Self-portrait with Saskia*, 1636

Etching, first state (of three), 10.4 × 9.5 cm
Signed and dated, top left: *Rembrandt. f.1636*
References: H.144; White/Boon B 19:I

BRITISH MUSEUM, LONDON
(INV.NO.1973-U-1358)

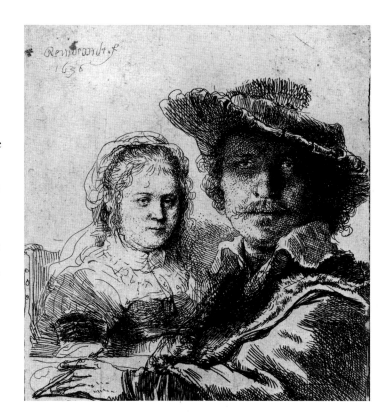

This is the only etching that Rembrandt ever made of Saskia van Uylenburgh and himself. Given the number of self-portraits he completed and the number of works that appear to have had Saskia as their starting point, if not being strictly portraits of her, it is perhaps somewhat surprising that there were not more.[1] Nor do they appear here in contemporary dress to record their daily existence together. Instead, Rembrandt is dressed in a sixteenth-century hat with slashed edges and a fur lined overgown. Saskia meanwhile is clad in a veil which resembles that found in the *tronie* in Amsterdam (cat.25). Rembrandt holds a *porte-crayon* (holder for chalk) in his left hand, presumably because he sketched himself onto the etching plate while looking into a mirror. Rembrandt must have realised this, since he does not actually show himself drawing (with what would have been the wrong hand in the print) but rests the burin across his fingers instead.[2] It is not clear what he has been sketching but there appears to be part of a circular line on the paper beneath his hand (perhaps alluding to the perfect circles which Giotto was said to produce, and thereby implying artistic genius).[3] Draughtsmanship was regarded as the most important basic skill of the artist, 'the father of art' according to Karel van Mander.[4] It has been noted that the likely meaning of the etching is not a record of Rembrandt's life but an illustration of the important effect of love upon art, a common literary theme in the sixteenth and seventeenth centuries, summed up by the saying, *Liefde baart kunst* (Love brings forth art).[5]

The setting within the composition lacks definition, due to the limited nature of the close-up view which Rembrandt uses. This means it is difficult to determine the distance between Rembrandt in the foreground and Saskia sitting behind him at the table. The space seems too narrow and they seem crammed into the scene yet are somehow unrelated to each other, as if one etching was superimposed upon another.[6] It has been suggested that Rembrandt must have drawn Saskia in the mirror as well as himself, in order to make sure that the light fell on both of them from the same direction but one would perhaps assume the etching would have created a more unified impression if this were the case.[7] Whether or not he did so in a mirror, he may have drawn Saskia first and then added himself in front – this is perhaps borne out by the lines of her dress which seem to run underneath the edge of his garment. This sense of dislocation was exploited by an eighteenth-century forger who replaced Saskia with the head of 'Rembrandt's Mother' (cat.3, fig.77) to create a new version of the composition.

(The original copper plate of this etching, showing the third state and final state, is also exhibited, on loan from Mr Robert Noortman, Maastricht.)

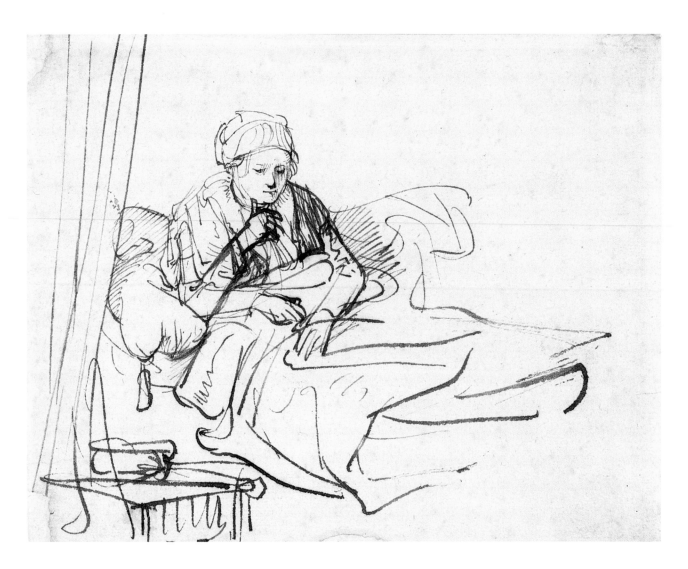

Drawing, pen and brown ink, 14.8 × 19.1 cm
References: J. Bolten 1967, cat.57; Benesch 282

GRONINGER MUSEUM, GRONINGEN
(INV.NO.1931.0205)

From the mid-1630s to the early years of the 1640s, Rembrandt drew a number of sketches showing a woman in bed: awake, asleep, propped up or lying down. It has always been assumed Rembrandt must have sketched his wife Saskia in bed in drawings such as these and this is perfectly plausible, given the intimate nature of such studies. Inevitably, therefore, they have usually been associated with the domestic life of the couple during this period and regarded in connection with Saskia's pregnancies and confinements between 1635 and 1641. The series of sketches, worked up to different degrees, offer an unusual range of variations on a theme of domesticity, perhaps the core of the type of drawings mentioned in the Van de Cappelle album as '*het vrouwenleven*' (women's lives).[1]

These sketches were part of the recording of the natural world that Rembrandt embarked upon in Leiden but they are amongst some of his most poignant drawings, partly because the viewer, rightly or wrongly, feels that Rembrandt offers a momentary glimpse of his life. However, the faces in all of these drawings are economically drawn and it is clear that in most Rembrandt was not trying to record a portrait likeness but was fascinated in the artistic possibilities of the pose and shape of the body in the bundled bedclothes. Just as he liked to place figures within doorways or windows to form a composition, Rembrandt uses the setting depicted here as a natural 'frame'. He started to draw the arms in a lowered position but drew over this, so that the head now leans upon one hand, the thumb extended to prop up the chin which foretells the same poses used in later drawings of the same subject (for example, see cat.43 and 44). The figure is closely related to *A Woman Lying in Bed c.*1634–5 (fig.105) which perhaps shows her a little while later, after being overcome by sleep.[2]

A drawing, now attributed to an unknown pupil of Rembrandt, appears to have been partially based on this sheet, showing the hands clasped in the lower position. The bold, part-angular, part-swirling, lines that Rembrandt used to show the bedclothes and propped-up pillows were interpreted by the pupil as wild calligraphic flourishes which, unlike Rembrandt's, failed to convey the form and weight of what he was trying to depict.[3]

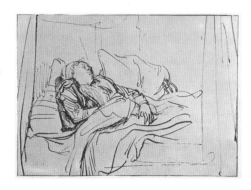

Fig.105 | Rembrandt, *A Woman Lying in Bed, c.*1634–5
J.P. Heseltine Collection, France

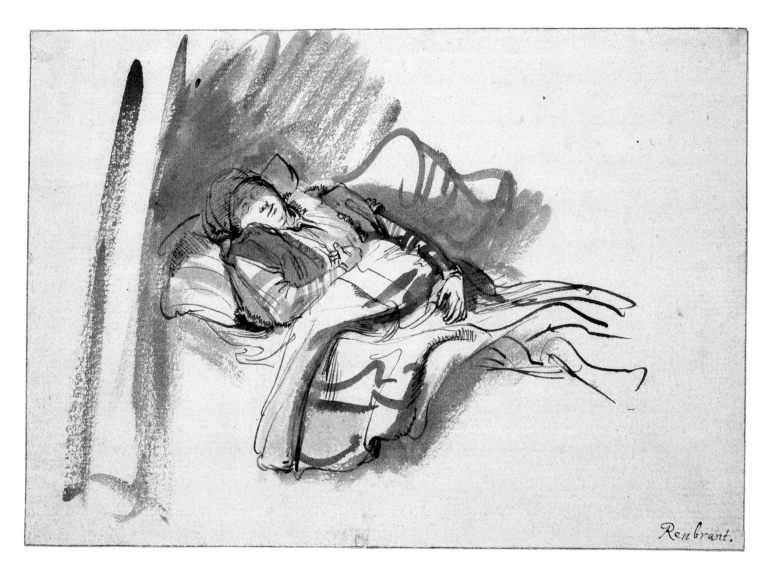

Drawing, pen and brush and brown ink with wash,
14.5 × 20.8 cm
Inscribed, bottom right: *Renbrant.*
References: Benesch 231a; Melbourne/Canberra
1997-8, cat.82, pp.348-9

VISITORS OF THE ASHMOLEAN MUSEUM,
OXFORD (INV.NO.1954.141)

The dark jerkin or shawl worn over the nightgown
and white cap is similar to that shown in *A Woman
Lying Awake in Bed* (cat.44). Benesch dated this
drawing to as early as 1635 while, more recently, it
was given a date as late as 1642, the year of Saskia's
death.[1] Rembrandt started the sketch using fine
pen lines for the figure and then added his remark-
ably fluid stripes of wash to create the setting with
its bold curtain and the strong shadow which cuts
across her face. The theme is one the artist returned
to frequently. Having earlier made drawings, such
as *A Study of a Woman Asleep* (cat.6), where the
woman's head lolls to one side, Rembrandt also

showed the actual process of falling asleep in his
extraordinary *Two Studies of Saskia Asleep* (fig.106)
in which the sketches are almost like a cartoon
sequence, made presumably moments apart.[2]
These sketches were part of the process of record-
ing the natural world that Rembrandt embarked
upon in Leiden. In fact, though most of these
drawings were undoubtedly made from life, they
also provided a vocabulary for works showing sick
or dying women in other media. Using sketches
made in a domestic setting for mythological or
Biblical scenes was, of course, not rare in
Rembrandt's work. It is hard to believe that the
drawings of women in bed of the 1630s did not in
some way inform, for example, his composition of
the etching of *The Death of the Virgin* of 1639
(cat.83), or in some manner affect the way he
envisaged this scene.

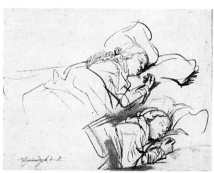

Fig.106 | Rembrandt, *Two Studies of Saskia Asleep*
Pierpont Morgan Library, New York. Photo: Schecter Lee

43 *A Woman in Bed, with a Nurse, c.1635*

Drawing, pen and brush and brown ink with grey wash, 22.7 × 16.4 cm
References: Benesch 405; Wegner 1973, cat.1099, p.156

STAATLICHE GRAPHISCHE SAMMLUNG MUNICH (INV.NO.1402)
Exhibited in Edinburgh only

This is one of the most imposing drawings of this subject that Rembrandt made, described by Benesch as 'unequalled in pictorial unity and magnificence of light and space effect'. The whole composition has obviously been carefully wrought and the impression is somewhat different from the more sketchy drawings of this type of subject matter, which appear to have been drawn straight from life. This is a considered drawing of another nature. As with the Oxford sheet (cat.42), Rembrandt started to draw this figure in fine pen. The woman's expressive face is portrayed in remarkably few lines, carefully placed. This contrasts dramatically with the sweeping brush strokes with which Rembrandt then created the nurse, or maid, in the foreground, whose form is so briefly described it almost verges on abstraction. Some have found the discrepancy so great that they considered that this figure was added afterwards.[1] But, in fact, this dark mass of line and shadow acts as a compositional *repoussoir* to put the rest of the drawing into balance and is a perfect foil to the strongly lit, more precisely drawn figure in the bed. As Martin Royalton-Kisch has pointed out, it may be that Rembrandt planned to create a similar body

in the foreground of another drawing, *A Woman Lying Awake in Bed* (cat.44), which would presumably have fulfilled the same function.[2] Rembrandt also shows a nurse or maid sitting down, placed opposite the bed head just as here, in his superb drawing made some years later of *An Interior with a Woman in Bed* (cat.88).

The woman stares out at us, under slightly frowning brows, leaning her head on her hand, the other arm lying across the sheets. Her identity has caused some debate since she has been thought to look too old to represent Saskia, one critic even stating that 'the model used certainly is not Saskia but probably Rembrandt's mother'.[3] Münz saw the figure as being linked to the elderly woman, perhaps Rachel, who leans her head upon her (barely seen) arm as she lies in bed in the background of Rembrandt's etching of *Joseph Telling his Dreams* of 1638. This, in turn, was based on a grisaille of *c.*1633,[4] probably made for the engraver and copyist Jan van Vliet,[5] which instead shows the old lady sitting leaning forward, but still in bed.[6]

The source, then, for the Munich sheet may be rather more complicated than Rembrandt simply drawing figures from life. The gloomy gaze of the woman and the pose of her chin leaning heavily upon her hand have also been regarded as allusions to melancholia, most famously depicted in one of Albrecht Dürer's best known prints, *Melencolia: I* of 1528 (fig.107).[7] Melancholy was thought to be one of the four humours that ruled all human temperaments.[8] These corresponded with four elements, and four planets; those associated with melancholy being the Earth and Saturn. Galenic philosophy believed that this dictated an earthy nature prone to pensive thought and menial occupation. However, another text argued that melancholy was the highest humour and was linked to the frenzy of genius (and also artistic endeavour).[9] Though it is highly likely that Rembrandt would have known Dürer's print (and indeed may have owned a copy of it), it is unclear if he would have been aware of the complex philosophical and religious theories which related to it. In any case, if it was indeed the artist's intention to allude to it, he did so subtly, complementing the woman's pose with the sombre stillness conveyed so expressively in this atmospheric drawing.

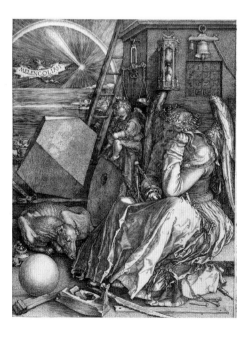

Fig.107 | Albrecht Dürer (1471–1528), *Melencolia: I*
British Museum, London

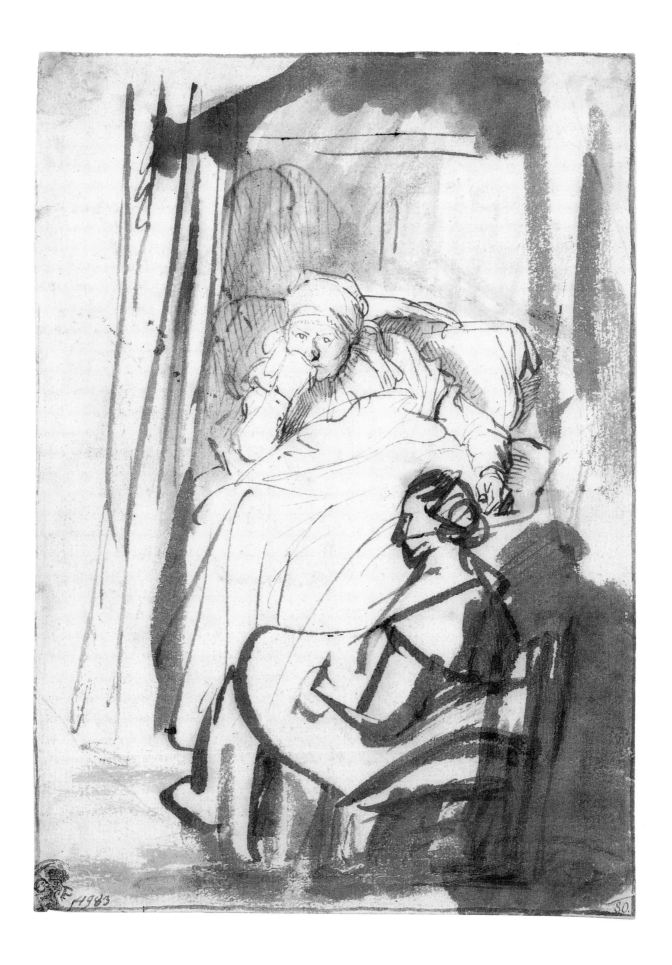

44 *A Woman Lying Awake in Bed, c.1635–40*

Drawing, pen and brown ink, 8.4 × 10.4 cm
References: Benesch 286; London 1992, cat.19,
p.69

BRITISH MUSEUM, LONDON
(INV.NO.1895-9-15-1264)

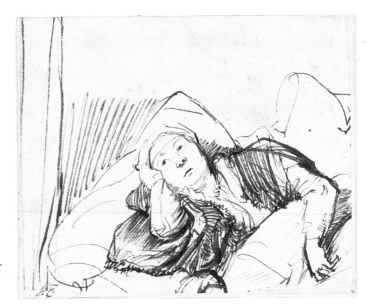

Rembrandt sketched the pillows and the bed in
fluid schematic lines and drew in the head with a
few carefully chosen strokes of the pen. He then
went back over the figure, consolidating the dark
shawl or jerkin and strengthened the shadowed
areas with fine parallel hatching. This sheet has
been trimmed but the semi-circular line which can
be made out at the bottom edge may perhaps have
been the head of another figure, perhaps a nurse
roughly drawn in, as seen in the Munich drawing of
the same theme (cat.43).[1] The drawing was later
given the title of *'A Woman in Bed, Musing'* when
listed in the sale of a former owner, William
Esdaile,[2] and the pose of the head resting upon the
chin may perhaps indicate that Rembrandt was
alluding to representations of melancholia, as also
seems possible with the Munich drawing men-
tioned above.[3] The sheet relates closely to the *Two*

Studies of a Woman shown below (cat.45), despite the
difference in media. The precise dating of both sheets
is uncertain but they clearly belong to the group of
works depicting this subject from *c.*1635–40, possibly
fitting into the latter part of this period.[4]

45 *Two Studies of a Woman, c.1635–40*

Drawing, red chalk, 15.5 × 13.7 cm
References: Benesch 280c; Seilern 1961, p.19;
London 1983, cat.9, pp.5–6

COURTAULD INSTITUTE GALLERY, LONDON
(INV.NO.D.1978.PG.184)

Exhibited in London only

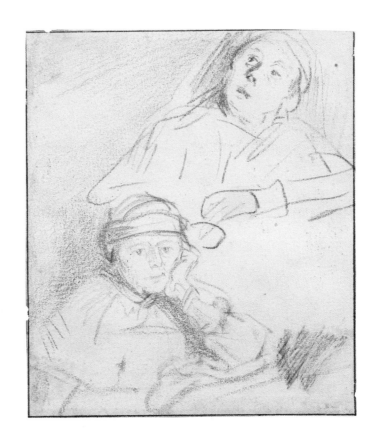

The sketch above with the head looking upwards is
drawn with great economy of line, the shoulders
and arms only barely described in confident rather
angular strokes which look forward to
Rembrandt's drawing style of the 1640s. In this
upper figure, the artist's focus was upon the face
which has an almost dumbfounded expression with
mouth hanging open slightly, while the lower
sketch relates more closely to the poses of the
figures in cat.43 and 44. The model for these sheets
has been believed to be Saskia, though the features
are rather too general to make such identification
secure. However, in the lower sketch here the
woman clearly wears a 'bandon', an informal linen
cap with a band of cloth worn across the forehead
to smooth wrinkles.[1] That this was a common part
of women's night attire might strengthen claims
that Rembrandt knew this woman well.

46 *A Sick Woman Lying in Bed, c.1635-40*

Drawing, pen and brush and brown ink touched
with white, 16.3 × 14.5 cm
Reference: Benesch 283

PETIT PALAIS, MUSÉE DES BEAUX ARTS DE
LA VILLE DE PARIS (INV.NO.DDUT01011)
Exhibited in Edinburgh only

The woman in this drawing closely resembles that
in the Munich sheet (cat.43) though, if anything,
she looks considerably more dejected. The
technique is rather similar to that seen in previous
drawings of this subject, namely finely drawn lines
for the figure and then broad wash to define the
shadows. The wash in this case is rather wilder
than seen elsewhere, although it does bear some
relation to that found in a drawing now in
Dresden, *A Woman Sitting in Bed* (fig.108), where
similar dashing strokes are made.[1] Vertical brush
lines appear on both drawings which define the
edges of the compositions, providing similar
enclosed space. White opaque paint was added to
the headcloth of the Dresden woman and here it
has also been added to the woman's cheek and the
nightdress. However, here it is not entirely certain
what purpose this was intended to serve: perhaps
it was meant to show the light falling across the
figure more vividly. Questions about the technique
of this drawing raised doubts about the attribu-
tion in the mind of one cataloguer, but Benesch
declared it to be 'one of the most vigorous studies
by Rembrandt of his wife lying sick in bed'.[2]

A drawing now in the Louvre, which was
formerly attributed to Rembrandt, but is perhaps
by Philips Koninck (1619-1688), *A Woman Resting
her Head on her Right Hand*, appears to have been
partly based on the head of the woman here,
though the hand is altered.[3] The composition also
played its part in inspiring later artists, for it was
probably seen by Camille Pissarro (1831–1903)
when it was in the collection of Eugène Dutuit
(1807–1886). The weary face, strongly lit amidst
the gathering darkness, influenced his drawing
and etching of *The Artist's Mother Lying in Bed seen
by Candlelight*.[4]

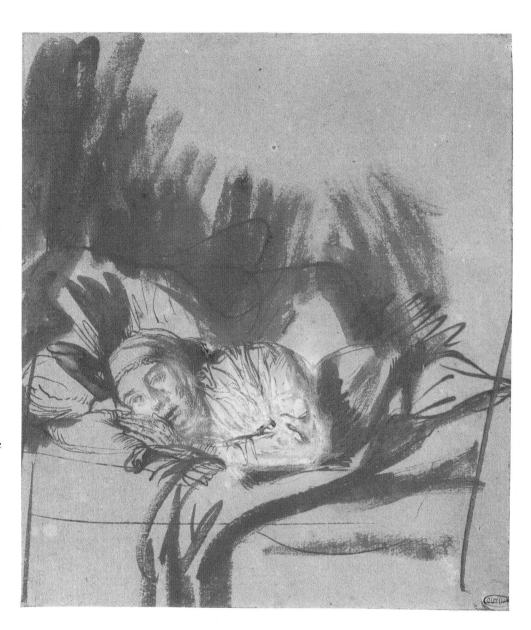

Fig.108 | Rembrandt, *A Woman Sitting in Bed*
Kupferstichkabinett, Staatliche Kunstsammlungen, Dresden
Photo: Herbert Boswank

47 *The Pancake Woman*, 1635

Etching, second state (of three), 10.9 × 7.7 cm
Signed and dated, bottom centre:
Rembrandt. f 1635
References: H.141; White/Boon B 124:II;
Amsterdam/London 2000–1, cat.28, pp.152–4

RIJKSMUSEUM, AMSTERDAM
(INV.NO.RP–P–1961–1056)

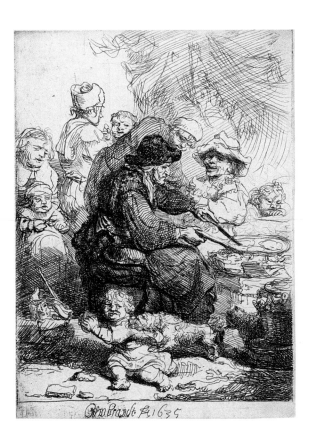

This lively scene shows an old woman cooking
batches of pancakes for a group of children of
varying ages who are crowded round her, as well as
a mother who holds an infant on her knee. In the
background one child savours a morsel of the
delicacy as another peers, head on his hand, rather
longingly at those still in the frying pan, while the
grimacing toddler in the foreground tries to
preserve his precious booty from the voracious
snuffling of the little dog who clambers over him in
enthusiasm. This latter figure was inspired by one
of the *putti* that coasts the waves in Raphael's
Triumph of Galatea (Villa Farnesina, Rome) which
was engraved by both Marcantonio Raimondi
(1480–1534) and Hendrick Goltzius (1558–1617).[1]
The pancake seller had been a popular motif in the
Netherlands from the mid-sixteenth century when
it had been depicted by Pieter Bruegel the Elder in
works such as *The Feud between Carnival and Lent*
and *The Fools' Kitchen*.[2] Pancakes, just as those still
eaten on Shrove Tuesday, were rich fare of Carnival
(from *carne-vale*, meaning 'farewell to meat'): they
were often the last feast of butterfat and milk that
was forbidden during the fast of Lent which
followed. Other artists such as Pieter van der
Heyden, Willem Buytewech, Jacob Matham, Jan
van de Velde II and Adriaen Brouwer also por-
trayed the same subject in various media.[3] Van de
Velde's print of about 1626[4] appears to have acted
as a direct influence upon Rembrandt's conception
of the subject, but Rembrandt is also recorded as
having later owned a painting by Brouwer of *A
Pancake Cook*, so this, too, may have played its part
in his choice of subject.[5]

The iconographical tradition tended to show
these women tending their skillet over a fire
indoors, but here, however, the old woman is seen
cooking out of doors: a sedentary street hawker.
The curved lines at the upper right side of the
etching may be the rough indication of some kind
of tarpaulin or awning under which she has made
her makeshift stall.[6] A drawing in the
Rijksprentenkabinet, Amsterdam (fig.109) is
related to, though not exactly preparatory for, this
etching[7] and the artist seems to have reused the
pose of the seated figure for the Sibyl in his
painting of *St John Preaching* of about 1634/5.[8]
Rembrandt's keen powers of observation and
imagination transform this stock subject into a
vividly individual study of the interaction between
children and women in this gently comedic scene.

Fig.109 | Rembrandt, *The Pancake Woman*
Rijksmuseum, Amsterdam

48 *A Woman Sitting up in Bed with a Baby, c.1635–6*

Drawing, red chalk with traces of a ruled border in
black chalk, 14 × 10.6 cm
References: Benesch 280a; London 1961, pp.17–18;
London 1983, cat.8, p.8; London 1991, cat.58, p.124

COURTAULD INSTITUTE GALLERY, LONDON
(INV.NO.D.1978.PG.183)
Exhibited in London only

The 1680 inventory made after the death of the
marine artist and friend of Rembrandt, Jan van de
Cappelle (1626–1679), mentions an album, *No 17.*
Een dito (portfolio) daerin sijn 135 tekeningen sijnde het
vrouwenleven met kinderen van Rembrandt (a portfolio
containing 135 drawings of the lives of women and
children by Rembrandt). Van de Cappelle almost
certainly acquired this during the sale of
Rembrandt's effects of 1657/8 where he also pur-
chased at least 350 other drawings by Rembrandt.[1] It
is quite likely that Rembrandt himself (rather than
Van de Cappelle) may have assembled such drawings
into albums or portfolios. Arranging them into
categories such as *het vrouwenleven met kinderen*,
would enable ease of access to subjects which could
then be used as reference material, drawings for
pupils to copy from, or as the basis for new composi-
tions.

Many of the drawings showing women with
children in Rembrandt's oeuvre have been assumed
to represent his own family. However, none of
Rembrandt's children other than Titus survived more
than a couple of months, so that pictures with large
infants and toddlers made in the mid-to-late 1630s
are unlikely to have been his own.[2] Many of the
sketches may have been prompted by Rembrandt's
own observations and by his imagination, although it
has also been pointed out that Hendrick Uylenburgh
and his wife had six children so it is possible that
Rembrandt may have sketched them too (though he
left Uylenburgh's house in 1635). Here, though, the
intimate nature of the scene and the fact that the baby
is quite little, in addition to the dating of the sheet on
stylistic grounds to the mid-1630s, have led to the
belief that it may show Saskia with her first child
Rumbartus (or Rombertus) who was born in 1635.
The infant, who was named after Saskia's father, was
baptised on 15 December and Saskia's sister Titia (see
cat.87) and her husband acted as godparents, as did
Saskia's cousin Aeltje and her husband (see cat.18).
The baby boy died only two months later and was
buried under a *cleyne steen* (small stone) between the
pillars of the nave of Amsterdam's Zuiderkerk (South
Church) on 15 February 1636.[3]

Otto Benesch believed that this drawing and
another red chalk drawing, *Two Studies of a Woman*
(cat.45), along with two other sheets, now in a private
collection, all belonged to the same sketchbook.
However, this seems unlikely since the red of the
chalks differs, as do the sorts of paper upon which the
works were drawn.[4]

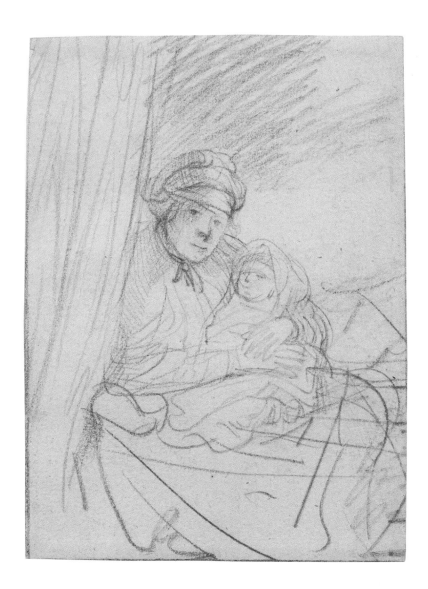

Drawing, pen and brush and brown ink with wash touched with white, 16.2 × 11.4 cm
References: Benesch 254; Paris 1988–9, cat.16, p.28

MUSÉE DU LOUVRE, PARIS
(INV.NO.RF.4678)

Exhibited in Edinburgh only

This drawing relates to that portraying a woman leaning out of a window, drawn in about 1633–4, now at the Boijmans Van Beuningen Museum, Rotterdam (fig.96). The tranquillity of the scene is partially instilled by the hidden light source at the right, presumably a window, towards which the woman looks, and which casts a strong shadow to the left of her. As in many such drawings from this period, the sitter is assumed to be Saskia, perhaps predominantly because of the relaxed and intimate atmosphere conveyed. The implication is that the woman has been briefly distracted from her other duties to sit for a moment and model for the artist. Rembrandt draws the form of the drapery with deft lines, elaborating on the basic shape of the cuff, for example, with a serpentine squiggle, while the broader strokes of wash upon her shoulders and headdress give extra depth to the material. The shadow is brushed in loosely behind her giving the whole figure a strong sense of three-dimensionality in this rapidly drawn but atmospheric sheet.

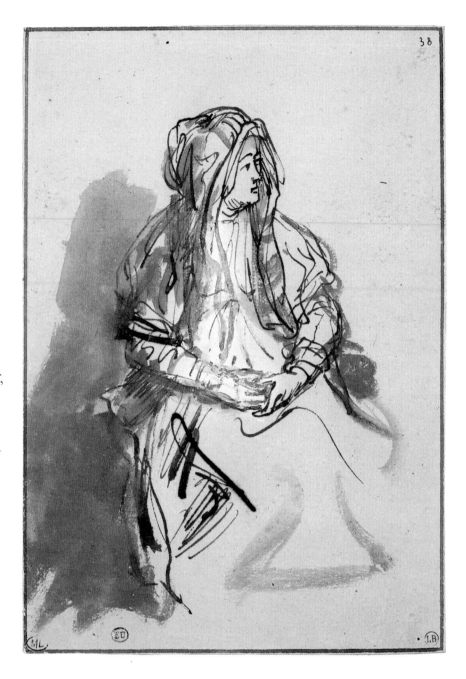

50 *A Woman with a Little Child on her Lap, c.1635*

Drawing, pen and brown ink, 16 × 13.6 cm
References: Benesch 275; Paris 1988–9

MUSÉE DU LOUVRE, PARIS
(INV.NO.RF.4677)
Exhibited in Edinburgh only

Though incorrectly once thought to show
Rembrandt's own family, such subjects were
patently based on Rembrandt's own observa-
tions.[1] However, they also often evolved in the
process of drawing and a quick sketch of a woman
holding a child could become a more worked-up
study of a Madonna that might, in turn, inspire an
etching or painting of the Holy Family. Here, the
stylistic similarity between the Louvre sheet and a
drawing of the *Virgin and Child Seated by a Window*
(fig.110) is also compounded by the clear relation
in the way the two women with their babies are
portrayed.[2] Though originally suggested as a
source for the drawing of the Virgin, it seems that
an engraving by the German artist Bertel Beham
(1502–1540) may have been the starting point for
the Louvre drawing as well.[3] The print shows a
domestic Virgin sitting in a window, looking on as
her baby suckles, her arm in an almost identical
position to that shown here, and her right foot
propped up in a roughly similar way.
(Rembrandt's drawing, in a slight anatomical
anomaly, shows his woman's right foot on the
lower step and yet her right knee is raised higher
than the left, though this area of the drawing is
not entirely clearly worked out.) However, the
close compositional links between Beham's print
and Rembrandt's drawing here indicate that even
if Rembrandt did make the drawing *naer het leven*
(from the life), he may nonetheless have had
Beham's pose in mind.

The little 'W:'-shaped inscription which
appears at the bottom right side of this sheet can
be found on other Rembrandt drawings, many of
which represent women and children. For
example, it can also be seen in the same lower
right corner of the drawing of *A Woman and Child
Descending a Staircase* of a similar date to this sheet
(cat.53). Given the general similarity of subject
matter of these drawings, it has been suggested
that this mark may indicate that they could have
been part of the portfolio entitled '*het
vrouwenleven met kinderen van Rembrandt*', later
owned by Jan van de Cappelle.

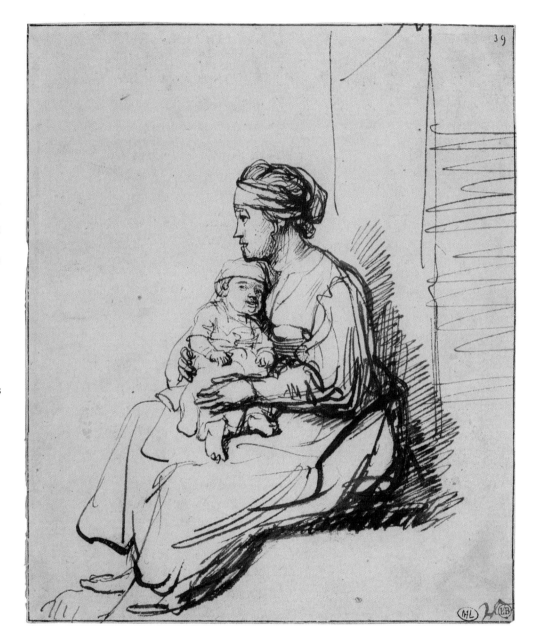

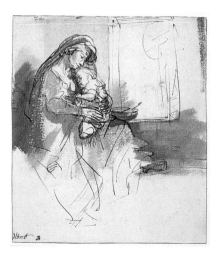

Fig.110 | Rembrandt, *The Virgin and Child Seated by a Window*
British Museum, London

51 *A Nurse and an Eating Child, c.*1635

Drawing, black chalk, 16.5 × 13 cm
References: Benesch 276; Vienna 1969, cat.6;
New York 1997, cat.51

ALBERTINA, GRAPHISCHE SAMMLUNG,
VIENNA (INV.NO.17.555)
Exhibited in London only

Though the handling of the black chalk in this
drawing was once thought to be similar to the way
Rembrandt used this medium during the time he
was in Leiden (see cat.6), both style and subject
matter point to a date in the mid-1630s when the
artist was living in Amsterdam.[1] It is almost
impossible to determine the age of the woman in
this drawing but the child is certainly too old to
have been one of Rembrandt's offspring at this
period. The elaborate loops of hair and the
beribboned cap that sits on the back of the small
head imply that she is a little girl. Engrossed in
eating, her right hand grasps the food while the
woman looks tenderly down at her. Rembrandt has
concentrated on this gaze as the centre of the
drawing and barely suggests the woman's hands, or
even arms, while the little girl's skirt is only
roughly sketched, though he did draw again round
her strange little doll-like flat-bottomed feet which
the child seems to be kicking and swinging.
Rembrandt appears to have wet the chalk to deepen
the darker areas of shadow: the very strong line
under the little girl's arm and the edge of the
woman's face. The vertical lines to the left of the
group seem to suggest some kind of curtain, while
the hatching to the right of the child appears to
show the shadow she casts against a wall.

As Benesch noticed, curious lines radiate from
the child's head, which he proposed might have
been from a hidden light source such as a candle
but which manage to give the effect of a halo. If
there were indeed a candle behind the figures then
one would not expect the shadowing shown on the
woman's left shoulder, or that the right side of her
face and the face of the girl would have been shown
so brightly lit. It is possible that some religious
scene was being alluded to, such as the childhood of
the Virgin with her mother Saint Anne, in the same
way that some of Rembrandt's drawings of a
mother and baby echo the iconography of the
Virgin and Christ child.

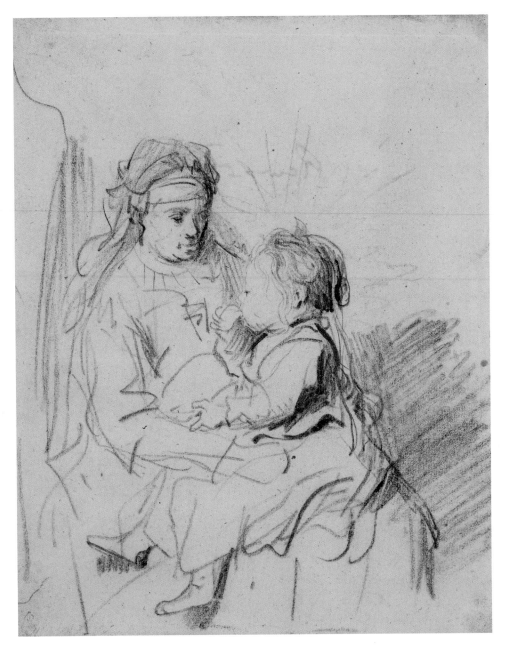

52 The Naughty Child, c.1635

Drawing, pen and brush and brown ink,
20.6 × 14.3 cm
Reference: Benesch 401

Exhibited in London only

This marvellous study would have been a perfect candidate for Rembrandt's portfolio of drawings depicting the lives of women and children. It must have been prompted by a real infant tantrum but it is too composed and carefully thought out to have been completely drawn from life. Squalling and kicking, the child is a powerhouse of fury. The expression on the woman's face is a superb study of mixed emotions in few lines, combining determination with mild distaste. The way her head inclines towards him shows tender concern, but the frowning brow betrays understandable annoyance as she grasps him round the waist in an attempt to enforce her will and avoid the flailing little limbs. We do not know what the fracas is about, but it is sufficiently serious for the wriggling toddler to have kicked his shoe off, which flies towards the floor as he thrashes about. The old woman at the left appears to be wagging her left finger in admonishment as she stands watching on, while the older children behind survey the noisy scene, perhaps with the selfish pleasure of seeing someone else behave badly when one is blameless.

The face of the infant in the Berlin drawing is a compilation of representations of a child rather

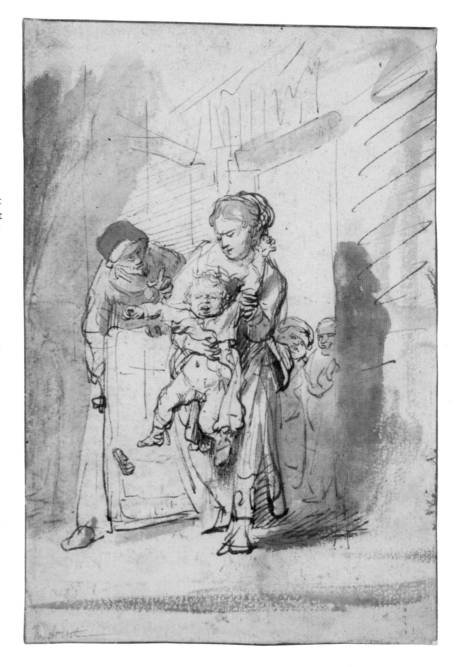

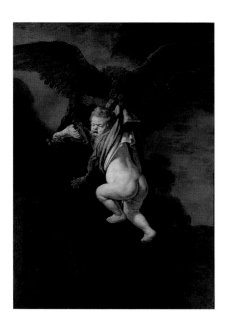

Fig.111 | Rembrandt, *The Abduction of Ganymede*, 1635
Gemäldegalerie Alte Meister, Staatliche Kunstsammlungen, Dresden

than any particular screaming toddler.[1] The head of various putti by Peter Paul Rubens showing despair at the death of Christ bear strong resemblance to the facial contortions shown here. The idea that this is not a specific child is borne out by the similarity of the features to those found in the related *Ganymede* drawing[2] and painting *The Abduction of Ganymede* (fig.111).[3] Another weeping toddler can be seen in Rembrandt's painting of *John the Baptist Preaching* which he was working on between 1634 and 1635.[4] Rembrandt may have used a carved statue of a wooden child that he bought at a sale on 22 February 1635 as a model for these infants.[5] A similar weeping putto also appears at the head of the bed in Rembrandt's *Danaë*.[6] Rembrandt was working on the latter

between 1635 and 1636, the same period as his drawings of *A Woman and Child Descending a Staircase* and *A Woman Comforting a Child Frightened by a Dog* which also show the same sort of features as the infant here (cat.53 and 54). A moral message might have been inferred by the adult curbing of an infant will. The Dutch were known for their leniency towards their children but at the same time failure to correct the follies of the young or to eradicate sheer wild wilfulness would have been frowned upon by Calvinist pedagogues. Temper tantrums were not to be encouraged if the child was to grow up a dependable and restrained citizen.[7]

A copy of the drawing is in the Hamburger Kunsthalle.[8]

53 *A Woman and Child Descending a Staircase, c.1635–6*

Drawing, pen and brush and brown ink,
18.7 × 13.2 cm
References: Benesch 313; Paris/Antwerp/London/
New York 1979–80, cat.68, pp.99–100; Berlin/
Amsterdam/London 1991–2, vol.2, cat.9, pp.46–7

PIERPONT MORGAN LIBRARY, NEW YORK
(INV.NO.I,191)
Exhibited in Edinburgh only

A young woman carries a small, clinging child down a
staircase which spirals up into the dark behind her.
The faces of woman and child are drawn with great
precision, while the child's legs and the drawstring
pouch that hangs from the woman's belt are more
schematically sketched, using a more heavily inked
line. Rembrandt also drew in a dark cap on top of the
woman's hair which has the effect of redefining the
shape of her head slightly. His use of wash is master-
ful in this drawing, perfectly modelling the figures
and the way the light plays upon the trailing skirt.

Benesch declared that Saskia and Rumbartus were
depicted here but, as has been pointed out previously,
the child is probably too old to have been
Rembrandt's first son, who was buried on 15
February 1636, only two months after his baptism.
However, it is possible that some of these drawing of
toddlers and small children of the mid-1630s may
have been based on Rembrandt's experience of living
in the house of Hendrick Uylenburgh. Hendrick had
married Maria van Eyck in 1624 and they had six
children by 1634 when Rembrandt married Saskia.
The marriage made Rembrandt a relative of the
children and he could well have drawn them.[1]
However, Rembrandt and Uylenburgh parted
company in 1635. The split may not have been
entirely without rancour and this might have ruled
out little Uylenburghs modelling for cousin
Rembrandt. In any case, in this drawing the overall
balance and rather finished manner of the drawing
make one suspect that it was a scene recalled, rather
than one drawn directly from life.[2] This method of
drawing *van onhoudt* (from memory), was a recog-
nised practice in the seventeenth century, only made
possible by having made numerous studies from life
which could inform that 'memory'.

The unidentified inscription resembling 'W:'
which appears on this sheet can be found on other
Rembrandt drawings, a number of which represent
women and children, such as those of *A Woman with a
Little Child on her Lap* (cat.50) and *A Scolding Woman*
(cat.68). It has been suggested that they were likely to
have been included in the Jan van de Cappelle album
entitled '*het vrouwenleven met kinderen van Rembrandt*'.
Such subject matter formed an important theme for
Rembrandt's work, particularly in the 1630s and
1640s.[3] The drawings were probably selected by
Rembrandt himself, assembling works related in
theme to use as a 'source book' for other
compositions.

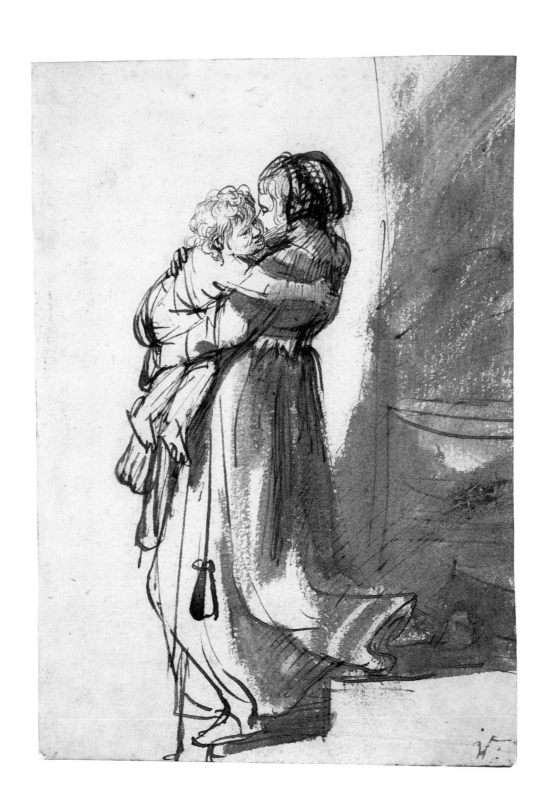

Drawing, pen and brown ink touched with white,
10.3 × 10.2 cm
References: Benesch 403a; Berge-Gerbaud 1997,
cat.3, pp.6–7

COLLECTION FRITS LUGT, INSTITUT
NÉERLANDAIS, PARIS (INV.NO.5155)

Exhibited in Edinburgh only

This beautifully conceived composition deals with
a subject which Rembrandt had already partially
explored in his etching of *The Pancake Woman*
(cat.47) where a toddler tries to protect his pancake
from being eaten. Here the infant is even younger
and is shown cowering slightly from the benign-
looking mongrel whose main focus of interest is
actually the dead duck whose neck hangs lolling
over the edge of the basket, which he sniffs
appreciatively. A cursive line gives another position
for the shape of his tail, making it appear almost
visibly wagging. The strength of the work is in the
gesture of the woman as she leans forward to
comfort and protect the bemused baby with a look
of cajoling amusement. Rembrandt then took this
motif in another drawing from Budapest (cat.55)
which intriguingly shows how he 'worked-up' the
design.

 The other side (verso) of the drawing shows two
sketches in black chalk of *Two Standing Women, Each
Holding a Child* (fig.112).[1] These little babies appear
to be even younger than the child here.

Fig.112 | Rembrandt, *Two Standing Women,
Each Holding a Child*
Collection Frits Lugt, Institut Néerlandais, Paris

55 *A Woman with a Child Frightened by a Dog, 1636*

Drawing, pen and brush and brown ink,
18.4 × 14.6 cm
Signed and dated, lower centre: *Rembrandt 1645*
Reference: Benesch 411

SZÉPMÜVÉSZETI MÚZEUM, BUDAPEST
(INV.NO.1589)

Exhibited in London only

This sheet was presumably made slightly later than
the *Woman Comforting a Child Frightened by a Dog*,
(cat.54) and illustrates perfectly how Rembrandt
was able to work from memory to embroider and
elaborate upon a scene. The previous sketch may
well have been based on direct observation but here
Rembrandt carefully creates his composition. The
relationship between the two drawings is similar to
that found between the pair of drawings showing a
woman having her hair dressed (cat.29 and 30). One
is a brief sketch while the other takes the same
subject and works it up to give it a rather different,
more finished character.

A comparison between the two sheets here
intriguingly shows how Rembrandt upgrades the
shaggy mongrel dog from the Paris drawing into an
elegant hound, which may have been taken from
the group of 'model' drawings Rembrandt appears
to have kept in the studio at this time.[1] Whereas
the mongrel in the Paris drawing is after the
shopping basket, here the dog ignores the market
goods laid on the ground. Instead, he pushes his
sharp nose at the apprehensive child whose hands
are raised in an attempt to fend him off. Again, as in
the Paris drawing, the young woman is overtly
smiling and reassuring the little one. Her gesture of
protection is still the core of the composition but
the dog is made more fully a part of the group. The
child wears the familiar padded band around its
head that would have protected it from the effect of
falls as it learnt to walk.

Unlike the earlier sketch, Rembrandt here gives
the scene a specific setting. The step in front of the
building indicates that it is the basement of a
house, and behind is a round arched doorway,
topped by a mask or decorative keystone. Above, a
woman keeps an eye on the proceedings, peering
down from the open window (a motif Rembrandt
used often).

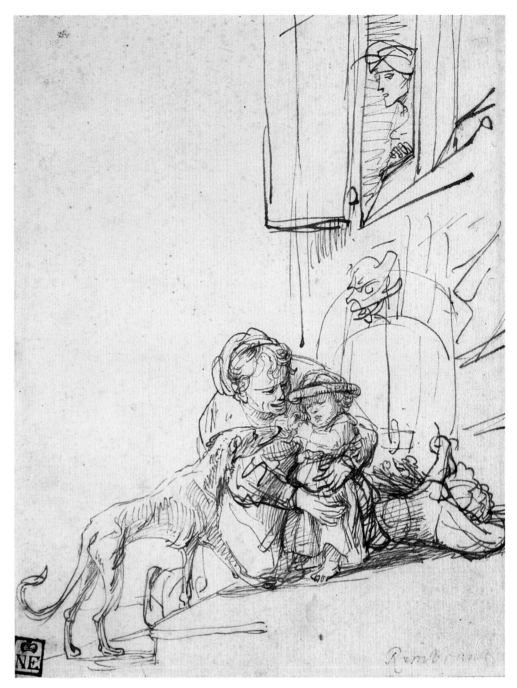

56 *Two Women Teaching a Child to Walk*, c.1635–7

Drawing, red chalk, 10.3 × 12.8 cm
References: Benesch 421; London 1992, cat.16,
pp.65–6

BRITISH MUSEUM, LONDON
(INV.NO.1910–2–12–187)

These two drawings (cat.56 and 57) were probably
once part of the same sheet but were later cut
down, a common treatment by collectors of
Rembrandt's drawings containing several
different studies of heads or figures which were
not necessarily orientated in the same direction.[1]
The two sketches here were presumably swift
studies from life. In the first, two women stoop
over to hold each hand of the sturdy little child in
its protective headgear as it totters along. One of
the women gestures forwards encouragingly while
the other looks solicitously down at the child. The
second sketch shows one woman crouched down
to keep at the child's level as she puts out both
hands to catch the infant when its balance can no
longer be sustained, for whether it falls backwards
or forwards can only be a matter of time.

 In the 1630s and 1640s Rembrandt drew a
number of works showing women teaching
children to walk or stand. The same subject is
more elaborately depicted in *Two Women Teaching a
Child to Walk* (cat.60)[2] which may date from about
the same period as the two sketches here.
Rembrandt continued his interest in this theme
when he drew *Old Woman Teaching a Child how to
Walk* and portrayed a child learning to walk in the
background of an etching of about 1646 (cat.106
and 107). His last drawing of the subject appears
to have been as late as 1656 when he again showed
a toddler taking its first tentative steps in a sheet at
the British Museum, *A Child Being Taught to Walk*.[3]
This combines elements of both sketches here, as
the toddler, seen from the back, is supported by
two figures and also encouraged by another in
front who sits on her haunches, as in cat.57.

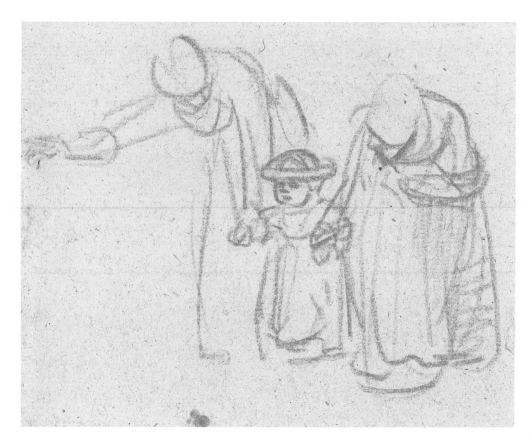

57 *A Woman Teaching a Child to Stand*, c.1635–7

Drawing, red chalk, 7.8 × 7.5 cm
References: Benesch 422; London 1992, cat.17,
p.66

BRITISH MUSEUM, LONDON
(INV.NO.1910–2–12–186)

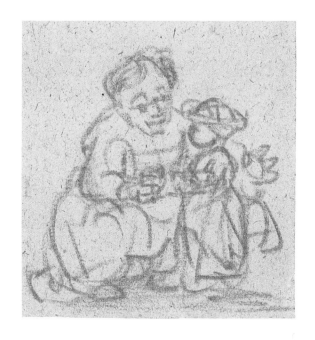

58 *Three Studies of a Woman Carrying a Child*, *c.1635–7*

Drawing, pen and brown ink, 18.7 × 15.3 cm
References: Benesch 343; Berge-Gerbaud 1997,
cat.7, pp.19–20

COLLECTION FRITS LUGT, INSTITUT
NÉERLANDAIS, PARIS (INV.NO.4904)
Exhibited in Edinburgh only

The manner in which the face of the smiling
woman in the upper part of this sheet is drawn is
reminiscent of that in the Budapest *Woman with a
Child Frightened by a Dog* (cat.55). Her expression is
similar and her cheek is marked by the same
dimpled crease, while her hair escapes into unruly
squiggles at her forehead in both drawings.

The group at the top of this sheet is delightfully
observed. The baby with its arms around the
woman's neck looks away rather disdainfully. The
woman laughs as the giggling child tries to amuse
the infant by playing 'peekaboo', emerging from
behind her skirts. Though the face of the woman
does not appear to have been altered, Rembrandt
changed the position of the baby with more
angular lines and drew the woman's arms over the
infant's legs. The other two sketches (and the false
start of a hat at the top right) are similar exercises in
trying to depict the weight and torsion of the
infant as it twists into different positions, hiding its
face over the second woman's shoulder.[1] Given the
fact that the headgear of the two lower women
differs from the bare head of the woman at the top,
one wonders whether it was perhaps the lower two
sketches that were drawn from life. The rather
more elaborate sketch at the top may have been the
next step, worked up from Rembrandt's imagina-
tion, finishing the face of the woman more
precisely and adding the hiding child as an
appealing and amusing motif.

The sheet relates to a drawing now in the
Museum het Rembrandthuis, Amsterdam, where
the pose is altered slightly so that the baby looks
out towards us.[2] Rembrandt made many other
study sketches, placing the different figures upon
the same sheet in a similar way to that seen here in
his slightly later drawing of *Three Studies of Women,
Each with a Child in her Arms and a Man in a Fur Hat*
of *c.*1639 (cat.79).

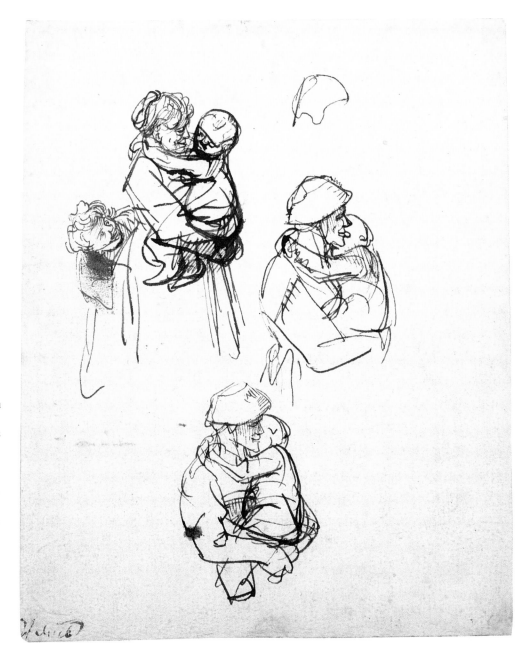

59 *Two Studies of a Beggarwoman, c.1635–8*

Drawing, pen and brown ink, 17.5 × 14 cm
References: Benesch 197; Paris 1988–9, cat.23,
p.35

MUSÉE DU LOUVRE, PARIS (INV.NO.22965)
Exhibited in London only

The Northern Netherlands were praised through-
out Europe for their charitable institutions and it
was recorded in 1662 that 'eighteen tonnes of gold'
were put towards distributing bread to the poor in
Amsterdam, 'an immense sum that is afforded by
the great riches of the city and the infinite numbers
of merchants, the great affluence of the people, and
which testifies to the charitable inclinations of the
Dutch'.[1] Nonetheless, then as now, there were
people who slipped through the social net and did
not fit neatly into the remit of the almshouses set
up by church and city. The distinction between
charity given to the deserving poor (as seen in
Rembrandt's later etching of *Beggars Receiving Alms
at the Door*, cat.111) and to wastrels and vagrants
was a sharp one, and the latter group found
themselves very much on the fringes of society.[2] It
is not clear into which category the women here
would have fitted, but the presence of children
while they begged would have presumably been an
additional appeal to pity.

 The figure with her back towards us at the top
of the sheet holds her infant in her lap, the other
child sleeps in her skirts. The heavy lines over the
bottom part of the figure below make it more
difficult to determine their poses but it seems as
though she now holds the baby in the crook of her
right arm while the older child buries its head in
her lap. A smaller sketch now in the National
Gallery of Art, Washington, shows virtually an
amalgam of the two figures on this sheet.[3] The
shape of the dress and hat resemble that in the
lower sketch, though seen from a slightly different
angle, but add the two children from the upper
one, the dark-haired child sitting up. The pose of
these seated women recalls that of the woman and
child in the dark left hand side of the painting of
the *Preaching of John the Baptist* of *c*.1634/5, so it was
already in Rembrandt's repertoire by that point.[4]
However, the style of this drawing would appear
later and it probably dates from about 1638.[5]

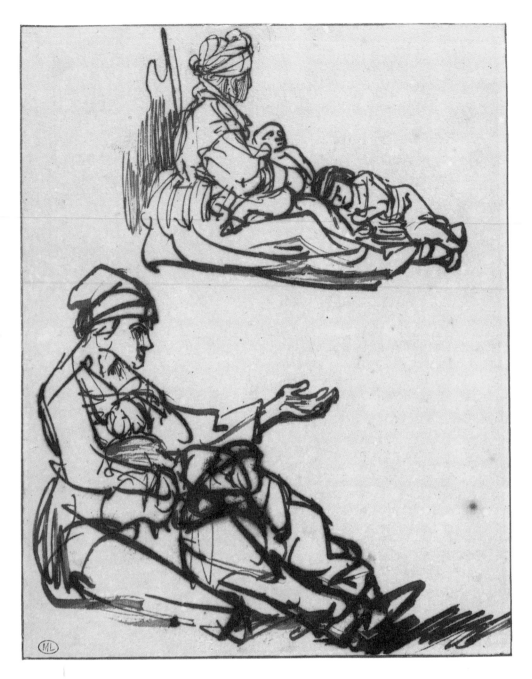

140

Drawing, pen and brush and brown ink, touched
with white, 16.2 × 14.6 cm
(verso: *Sketch of Two Faces in Profile*)
References: Benesch 391; Berge-Gerbaud 1997,
cat.5, pp.13–16

COLLECTION FRITS LUGT, INSTITUT
NÉERLANDAIS, PARIS (INV.NO.5447)
Exhibited in London only

Just as in the previous sheet, Rembrandt used a
brown wash to prepare the paper before he started
his drawing, though here the wash is considerably
more noticeable. This provided a tonal base and was
a technique which Rembrandt may have learnt from
his master Pieter Lastman.[1] Rembrandt framed his
figures in an arched doorway which is given depth
by the dramatic application of dark wash. The scene
is strongly lit from the left and the shadow cast on
the floor is applied either with a very dry brush or
smeared by Rembrandt with his fingers, as noticed
by Berge-Gerbaud.[2] The younger woman guides
the infant towards the seated old lady who urges the
child on enthusiastically. She bears some similarity
to the lower figure in the *Two Studies of a
Beggarwoman* (cat.59), both physically, and in the
manner in which she is drawn.

The idea of 'first steps' was later used by
Rembrandt in relation to the iconography of
education in an etching made in about 1646
(cat.107). However, it is not certain if any such
specific meaning is implied here. The standing
woman guiding the child was presumably drawn
before the older woman, since the latter's hands are
drawn over the lines which define the skirt of the
first figure. It may be that the seated woman was
added to provide a foreground figure to give the
composition more depth (in much the same way as
the nurse in the Munich drawing of *A Woman in Bed,
with a Nurse*, cat.43). Rembrandt was re-using his
paper for this drawing because he had already
lightly sketched in a woman, who can be seen from
the back, at the top left of the sheet. Her headdress
is sixteenth-century in style and her pose strongly
recalls the woman in the etching of *The Married
Couple and Death* which Rembrandt was to make in
1639 (cat.82).

The ink used in this drawing is quite distinctive
and is known as iron gall ink. This was made from
four basic ingredients, vitriol (iron sulphate), gum
Arabic, water and tannin (which was usually made
from oak apples, also called galls). The ink's
corrosive nature means that, over time, the edges of
the lines tend to blur, sometimes eating into the
paper.[3] Rembrandt used this ink for a number of his
drawings of this period (such as cat.78, 79 and 84).

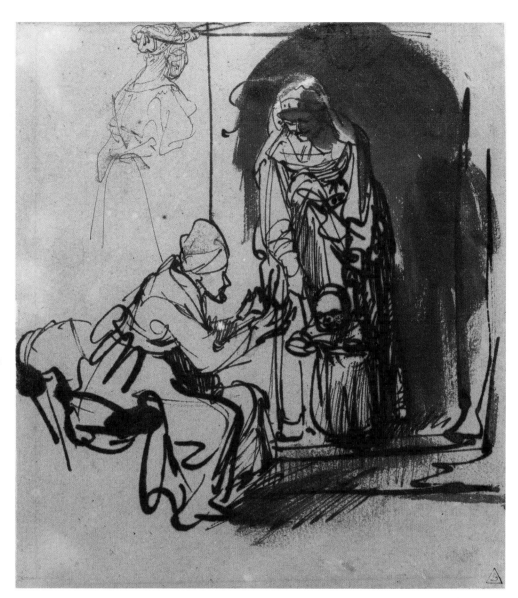

61 *A Sheet of Four Studies of Women, c.1636*

Drawing, pen and brush and brown ink, with grey
wash, touched with white, 20 × 15 cm
(verso: *Studies of Horsemen*)
References: Benesch 360; Giltaij 1988, cat.10,
pp.53–5

BOIJMANS VAN BEUNINGEN MUSEUM,
ROTTERDAM (INV.NO.R83)

The pose of the figure that appears at the top of the
sheet is related to many of the previous drawings
showing a woman's head leaning against her hand,
though here she is dozing. The sketch directly
below this is a variant on the same theme, the
woman's eyes here being slightly open. The two
heads set to the left of the sheet, one above the
other, both show a mother looking adoringly at a
small baby. Above, the faintly sketched sleeping
infant can barely be seen, wrapped up in the shawl
that covers his mother's head. In the group below,
the child's face is swathed in the shadow under the
broad-brimmed hat of his mother who lays her
cheek close to his.

The drawing has traditionally been thought to
represent Saskia and it has been stated that these
studies are all of the same woman.[1] If they do
indeed show Saskia, then the infant depicted might
be the couple's first child. However, Rembrandt
took care to vary the womens' poses and the clothes
in each and they are also drawn in slightly different
ways: one has all her hair tucked away, two wear
shawls or veils, and one is in a hat. The woman in a
cap is given a *retroussé* nose while the others have
straighter features. The tradition for such studies
of different heads, or heads in different poses, upon
the same sheet was well established in the Nether-
lands and was practised by artists such as Hendrick
Goltzius and others.[2] Though it is unlikely that
Rembrandt made this drawing as a preparatory
work, there is a very close rapport between it and
the etching that he made in 1636 (cat.62).

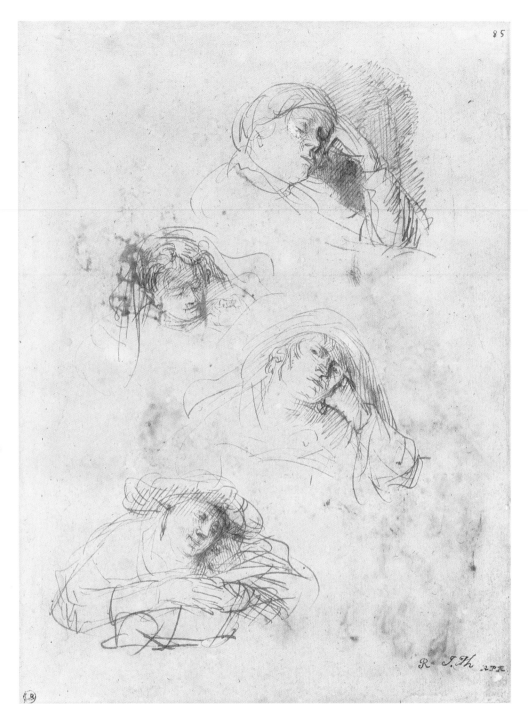

62 *A Sheet of Studies with Saskia and Others*, 1636

Etching, only state, 15.1 × 12.6 cm
Signed and dated, bottom centre: *Rembrandt f 1636*
References: H.145; White/Boon B 365

BRITISH MUSEUM, LONDON
(INV.NO.1868−8−22−702)

Rembrandt renewed his interest in making etched
'study' or *tronie* heads during 1636 and 1637.
Whereas he had previously used his own features as
the basis for these heads in his early Leiden years,
Saskia now became his most frequent model.[1]
However, yet again, like the earlier *tronies*, most of
these were not intended as straightforward
portraiture and fit, instead, into the tradition of
producing 'model sheets' of heads. Such studies
were extremely popular in printed as well as drawn
format and were produced in some number by
various artists.[2]

It seems likely that Rembrandt wished to
exploit the medium of etching here to make it
appear as if this was indeed an informally drawn
sheet from a sketch-book. The figures are posi-
tioned on the page in a way that looks appealingly
haphazard but was probably not. Rembrandt took
care to work the heads up to varying degrees. The
central figure is rather more finished than the
others while the figure behind her at the right is far
less defined. The face in profile, which is cleverly
slotted in between the two heads at the bottom of
the sheet, is drawn in very faint lines, as if an
afterthought, adding to the impression that this is
indeed an artist's study sheet. (Virtually the same
profile occurs in the lower figure on the second
state of the etching of *Three Women's Heads*, cat.64.)
Here, as in the Rotterdam drawing (cat.61),
Rembrandt also made sure to vary the poses and
the expressions. Each head is viewed from a slightly
different angle and he may have added the turbaned
figure at the top left to extend the range still more.
This person seems to be a creation of Rembrandt's
imagination and may have been the first to be
drawn on this plate since the lines at the front of
this figure seem to cut under those of the central
woman.

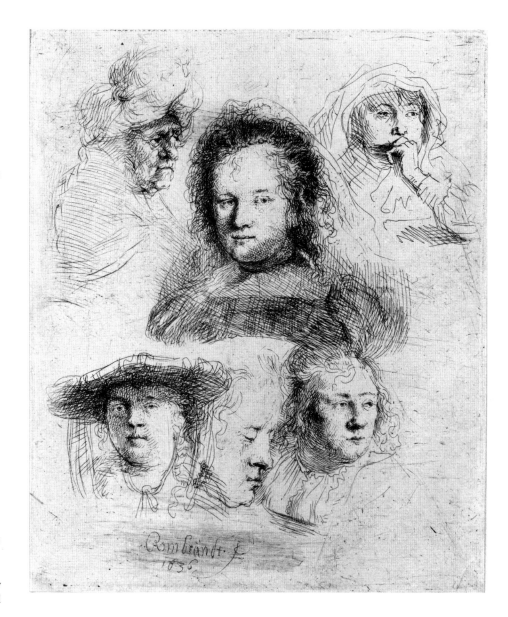

63 *Three Women's Heads, c.1637*

Etching, first state (of three), showing only one head, 12.7 × 10.3 cm
References: H.153; White/Boon B 367:I; White 1999, pp.131–2; Amsterdam/London 2000–1, cat.29, pp.154–6

BRITISH MUSEUM, LONDON
(INV.NO.1848–9–11–189)

Rembrandt started the etching with a single head that presumably must have been modelled by Saskia, given its close relation to the only known portrait drawing he made of her, just after their betrothal in 1633 (fig.1). The pose would have been drawn on the plate the same way round as it appears in that silverpoint sketch and the clear outward gaze, just off from centre, is remarkably similar. Christopher White, however, observed the tension in the fingers of the woman in the etching which push into her temple, as opposed to the more elegantly relaxed placement of the hand in the drawing. He noted that the atmosphere had changed from a 'happy carefree air' in the latter, to a tenser, more brooding mood in the etching.[1] Saskia had certainly buried one child in the interim, although perhaps, too, the novelty of sitting still while her husband drew her had waned somewhat. Nonetheless, it is a perfectly judged study in the balance of the brightness of the blank paper and the shadowing of the cheek and hand, while the sketchiness of the sleeve and cuff adds to the free character of the etching. The marks at the top of the sheet are drypoint lines which presumably remained from another image (this plate was probably a remnant from a larger one). Rembrandt could have burnished these out, but the fact that he allowed them to remain may have been intended to add to the impression of this as a spontaneous sketch.[2]

As mentioned in connection with the sheet of *Studies with Saskia and Others* (cat.62), these etchings were collected enthusiastically and recent research on watermarks of the paper shows that Rembrandt clearly made this print to sell in quantity.[3] The first state with only one head was not intended simply as a trial but as a print in its own right, since Rembrandt made a number of impressions of it, quite a few of which still exist. He then added the lower figure with downcast eyes and the faint lines of a third face at the left. Many copies were printed on paper which can be dated from 1635–40, and more again were made when many of Rembrandt's prints were re-issued in 1652. The signature that appeared on the second state of the plate did not last long, since it was burnished away during the production of later impressions.[4]

64 *Three Women's Heads, c.1637*

Etching, second state (of three), 12.7 × 10.3 cm
Signed, top left (very faintly, in the second state only): *Rembrandt*
Reference: White/Boon B 367:II

BRITISH MUSEUM, LONDON
(INV.NO.1973–U–892)

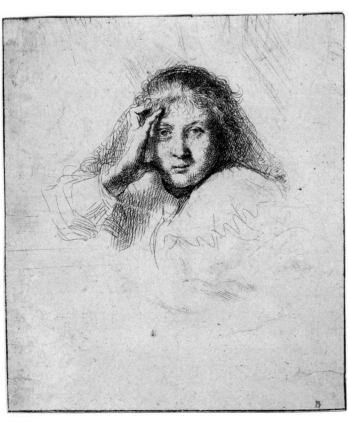

Cat.63

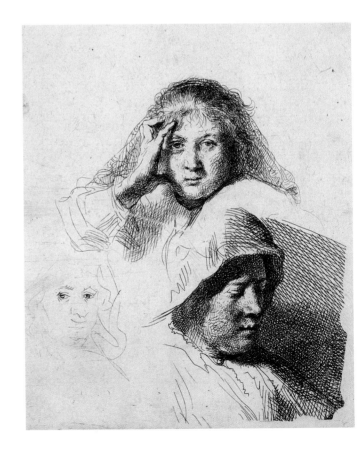

65 *Three Heads of Women, One Asleep, 1637*

Etching, only state, 14.3 × 9.7 cm
Signed and dated, top centre: *Rembrandt f 1637*
References: H.152; White/Boon B 368

BRITISH MUSEUM, LONDON
(INV.NO.11973-U-891)

A comparison between the women's heads in this
print and those in cat.62 and 64 is intriguing
because it gives an indication of how these 'model
sheets' were composed. The head at the bottom of
this etching mirrors that shown in cat.64 and,
indeed, the very finely sketched profile from
cat.62. They are not absolutely identical but they
resemble each other closely enough to suppose
that Rembrandt used this one motif three times,
reversing it here. The figure gazes down as if
reading or just about to fall asleep.

As before, Rembrandt makes sure that the
poses and headgear are sufficiently unlike each
other to maintain interest. So the white headdress
of the bottom figure is a contrast to the dark scarf
of the woman above who stares to the left with
pursed lips; this in turn differs from the rather
extraordinary fur-edged hat and patterned
'balaclava' worn by the woman asleep.

The print dealer Clement de Jonghe later
owned many of Rembrandt's copper plates,
among which was listed 'three tronie heads', but
it is not known exactly to which of Rembrandt's
etchings this referred.[1]

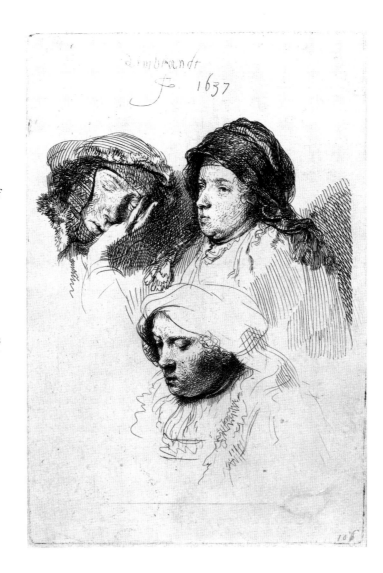

66 *A Woman in a Rich Dress with Plumed Cap, c.1636*

Drawing, pen and brush and brown ink with
wash, touched with white, additions in pen and
grey ink, 22.7 × 14 cm
References: Benesch 318; Paris/Antwerp/London/
New York 1979–80, cat.70, pp.101–3

PIERPONT MORGAN LIBRARY, NEW YORK
(INV.NO.I,177)
Exhibited in London only

Rembrandt's love of elaborate costume is found in
many of his compositions of religious, mythologi-
cal and historical subjects in the 1630s. The
extraordinary attention to the rendering of richly
embroidered fabrics, fine silks and patterned
material is most notably found in his paintings of
Flora and *Artemesia* (cat.27, 36 and 31 respectively).
This drawing was traditionally known as 'The
Jewish Bride' which, though incorrect, demon-
strates that the fanciful costume was recognised as
something out of the ordinary.

Such dramatic clothing and, indeed, the
theatrical pose struck here with the arm extended
in an expansive gesture, have suggested that this
drawing may depict a figure from the stage.
Rembrandt was a keen follower of theatre and
certainly drew actors in fanciful dress playing roles
from the *Commedia dell'Arte* such as Pantalone and
Capitano.[1] There are a number of drawings which
do not relate to these comedy figures but which
show elaborate women's dresses such as this.[2] It
has been suggested that all are related to the 1637
tragedy of *Gijsbrecht van Aemstel* by Joost van der
Vondel, which was first performed on 3 January
1638 at the Amsterdam *Schouberg* (Theatre).[3]
Although the drawings have generally been dated
somewhat earlier than this from a stylistic point of
view, it was thought that Rembrandt might have
gained access to rehearsals since he is known to
have been on good terms with the acting frater-
nity. The figure in this drawing has generally been
thought to represent Badeloch, who was the wife
of Gijsbrecht van Aemstel, Vondel's new hero for
Amsterdam and the Dutch Republic, modelled on
Virgil's Aeneas. However, this is unlikely since
Badeloch was normally shown wearing a fur cap
quite different from the plumes emerging from
this complicated confection of a headdress.[4]

One strange note is the figure's rather short left
arm (subsequently touched with what was once
more opaque white), which should be somewhat
longer in order to be in proportion to the other
one. However, Rembrandt takes much care in
depicting the rich brocade and how the pattern
was affected by the draping of the weighty skirt.
The penmanship is particularly fine in the
wonderful frippery of the veil and feathers of her
hat. The treatment of the costume has been
likened to that found in Rembrandt's drawing of
Bishop Gozewijn (another character from Vondel's

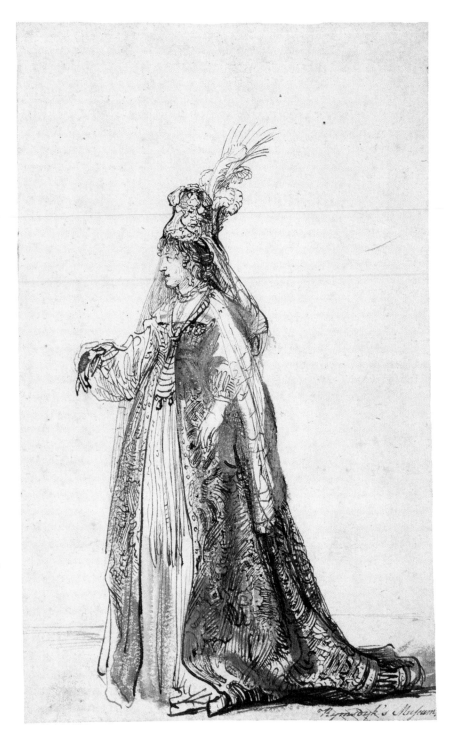

play)[5] and also to his etching of '*Preciosa*' of *c*.1642
(cat.94).[6]

If this was actually theatrical dress, it may have
been worn by a man since women did not usually
appear on stage at this period. However, there is no
obvious indication of this in the way Rembrandt
draws the face and hair which seem feminine. In
any case, the drawing is clearly a study of costume
rather than character, whether modelled by an
actor or an actress.

67 *A Woman in a Rich Dress Seen from Behind, c.1636–7*

Drawing, pen and brush and brown ink with wash,
touched with white, 19.4 × 15.5 cm
Reference: Benesch 319

KUPFERSTICHKABINETT, STAATLICHE
KUNSTSAMMLUNGEN DRESDEN
(INV.NO.C1980–494)
Exhibited in Edinburgh only

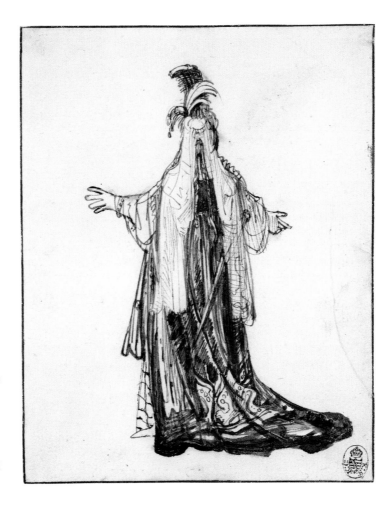

In this drawing the weight of the folds of the
figured skirt is skilfully captured, though rather
less delicately than in the *Woman in a Rich Dress with
Plumed Cap* (cat.66).[1] The veil is caught up slightly
on either shoulder and long plaits can just be made
out down the figure's back. Benesch made a
gratifyingly specific identification of the feathers
that make up these headdresses as ostrich and
heron. As has been noted, female stage roles were
taken by male actors so that, if such dresses were
seen at the theatre, they were unlikely to have been
worn by women.[2] Margaret Louttit, however, has
suggested that, though not seen regularly on the
stage of the Amsterdam Theatre, women 'certainly
took part in outdoor theatrical activities before this
and actresses were seen in travelling French
companies at least by 1645'.[3] But the fact remains
that a woman did not appear on the stage of
Amsterdam's theatre until 1655, when an actress
played the part of Potiphar's wife in a production
of Vondel's play of *Joseph in Egypten*, to great critical
acclaim (see cat.120).

68 *A Scolding Woman, c.1635*

Drawing, pen and brown ink, 13.5 × 9.8 cm
References: Benesch 279; Seilern 1961, p.15;
London 1983, cat.6, p.4

COURTAULD INSTITUTE GALLERY, LONDON
(INV.NO.D.1978.PG.181)
Exhibited in London only

Benesch compared this figure to that at the left of
Rembrandt's drawing of *The Naughty Child* (cat.52)
The sheet is generally dated to about the same
period, the mid-1630s. It was later suggested that
Rembrandt might actually have been drawing an
actor rather than a woman, since the figure may
represent a scolding harridan of a wife, a stock
theatrical figure.[1] This observation was made on
the basis that the cap which the figure wears is
'coquettish' and may even be a wreath, something
which would never have been worn by an elderly
woman in the street (though the lines of the cap are
somewhat difficult to make out).

This drawing has an unidentified 'W' shaped
mark which may relate to Jan van de Cappelle's
album of Rembrandt's drawings depicting the lives
of women and children. Other drawings which
display the same mark as that found on the
Courtauld sheet include *A Woman with a Little Child
on her Lap* and *A Woman and Child Descending a
Staircase* (cat.50 and 53).

69 *Susanna and the Elders, c.1636*

Oil on panel, 47.2 × 38.6 cm
Signed and dated, bottom right: *Rembrandt ff 163* [6].
References: *Corpus*, vol.3, A117; Berlin/Amsterdam/
London 1991–2, vol.1, cat.25, pp.196–9; Broos
1993, cat.32, pp.262–8; Melbourne/Canberra
1997–8, cat.10, pp.118–20

ROYAL CABINET OF PAINTINGS,
MAURITSHUIS, THE HAGUE (INV.NO.147)

Rembrandt had depicted some female nudes in
paintings made in the years before *Susanna*, for
example, the little naked figures that crowd his
*Diana Bathing; with the Stories of Callisto and
Actaeon*.[1] However, his painting of *Susanna* was the
largest scale single female nude he had attempted
since his *Andromeda* of 1630/1 (fig.36).[2] The
difference is remarkable and Rembrandt composed
his figure within the picture area with great
confidence. The modelling is considerably more
accomplished, as is the skilful way in which her
body in a soft glowing light is contrasted against
the darkness of the garden and architecture which
concentrates attention on the naked figure. She is
shown in a rather more idealised manner than, for
example, in Rembrandt's etching of *Diana at her
Bath*, though she was still too plain for those whose
ideas of beauty were moulded by the classical ideal,
such as Sir Joshua Reynolds. He saw this painting
in the collection of the Stadholder Willem V in The
Hague in 1781, and wrote: 'It appears very
extraordinary that Rembrandt should have taken
so much pains, and have made at last so very ugly
and ill-favoured a figure; but his attention was
principally directed to the colouring and effect, in
which it must be acknowledged he has attained the
highest degree of excellence.'[3]

The story is taken from the third apocryphal
addition to the Book of Daniel (Daniel 13: 19–23).
Susanna was the pious, beautiful wife of a wealthy
Babylonian in whose large garden she used to
bathe. Two judges, friends of her husband, spied on
her bathing and threatened to slander her if she did
not succumb to their advances. She refused as a
God-fearing wife and it was only by the interven-
tion of Daniel that she was saved. The subject was
extremely popular with artists for it provided the
possibility of justifiably painting a beautiful nude
woman as an exemplar of chastity.

Some formerly saw Rembrandt's picture as
representing a Bathsheba.[4] But the pose of the
principal figure relates closely to Rembrandt's
master Pieter Lastman's painting of this subject
(discussed below) and also to the picture which
Rembrandt made of *Susanna and the Elders* in 1647
(see cat.110, fig.140).[5] The presence of the two
elders, who can just be made out at the right of the
picture, camouflaged in the undergrowth, also
supports this interpretation (the one at the far right
is now harder to see as this part of the panel was

trimmed at some stage and only a part of his turban
is now visible).[6] Susanna is clearly shown trying to
cover her breast and lap like a *Venus Pudica*, here a
modest and protective gesture.[7] In addition to this,
she is shown with her foot covering the opening of
her slipper. The latter was used as a slang term for
female private parts in the Netherlands and
Susanna's action would have been interpreted as a
chaste one; the opening is firmly shut (unlike
paintings of brothel scenes where slippers are
strewn about the floor, implying the easy nature of
their owners).[8] This motif taken in combination
with the lewd implications of the goat's-foot
carving on the parapet all point to the subject of
Rembrandt's picture as Susanna: a virtuous woman
beset by lecherous men.[9]

Rembrandt would have known prints of various
compositions representing Susanna by Hendrick
Goltzius, Cornelis Cornelisz van Haarlem and
Annibale Carracci, and he was clearly influenced by
the outward gaze of Susanna, turning her head to
look at the viewer, found in Rubens's 1620 version
of the subject engraved by Lucas Vorsterman
(fig.44).[10] (This had been dedicated to the Dutch
poetess Anna Roemer Visscher as a *pudicitiae
exemplar* or example of chastity.)[11] However, he
also had an inspiration closer to home, for there are
marked similarities to elements of Pieter Lastman's
composition of *Susanna and the Elders* of 1614, as
mentioned above (fig.43).[12] Rembrandt certainly
knew this painting, for he drew a red chalk copy of
it, which is as interesting for what it changes as for
what it follows (fig.113).[13] Alterations were made
to the position of Susanna's hands, and Rembrandt
dispenses with Lastman's motif of her fingers
splayed in alarm and runs her right arm down the
side of her body. He also seems to have used
Lastman's *Bathsheba* as an inspiration for the way
he depicted the pile of clothes, with a sleeve
hanging down, bundled behind his Susanna.[14]

Rembrandt painted these details in a manner that is
also reminiscent of Lastman's technique.

Susanna is also interesting in relation to
Rembrandt's specific choice of subject matter. He
was demonstrably preoccupied in showing women
observed or spied upon, most notably in his
drawings and paintings of the Susanna story and
also, for example, in the etchings of *Jupiter and
Antiope* (cat.13, 134) and the painting of *Diana
Bathing; with the Stories of Callisto and Actaeon*. All, to
some extent, show intimate moments observed.
However, unlike many of his contemporaries, he
often removed many of the stock details usually
employed to place the figure firmly into its
narrative context and thus in a more 'acceptable'
state of undress.[15] Here, as with his earlier
Andromeda, the story is only implied by its barest
essentials. Both the elders in the Mauritshuis
Susanna are so thoroughly hidden that one might
almost suppose that it is the viewer who momen-
tarily plays the part of *voyeur*. This diminishing of
narrative context consequently forces the viewer
into an extraordinarily direct encounter with the
figure portrayed, an ambiguity that considerably
adds to the impact of the image.

Fig.113 | Rembrandt, copy after Pieter Lastman's *Susanna
and the Elders*
Kupferstichkabinett, Staatliche Museen zu Berlin, Preussischer
Kulturbesitz, Berlin
Photo: Jörg P. Anders

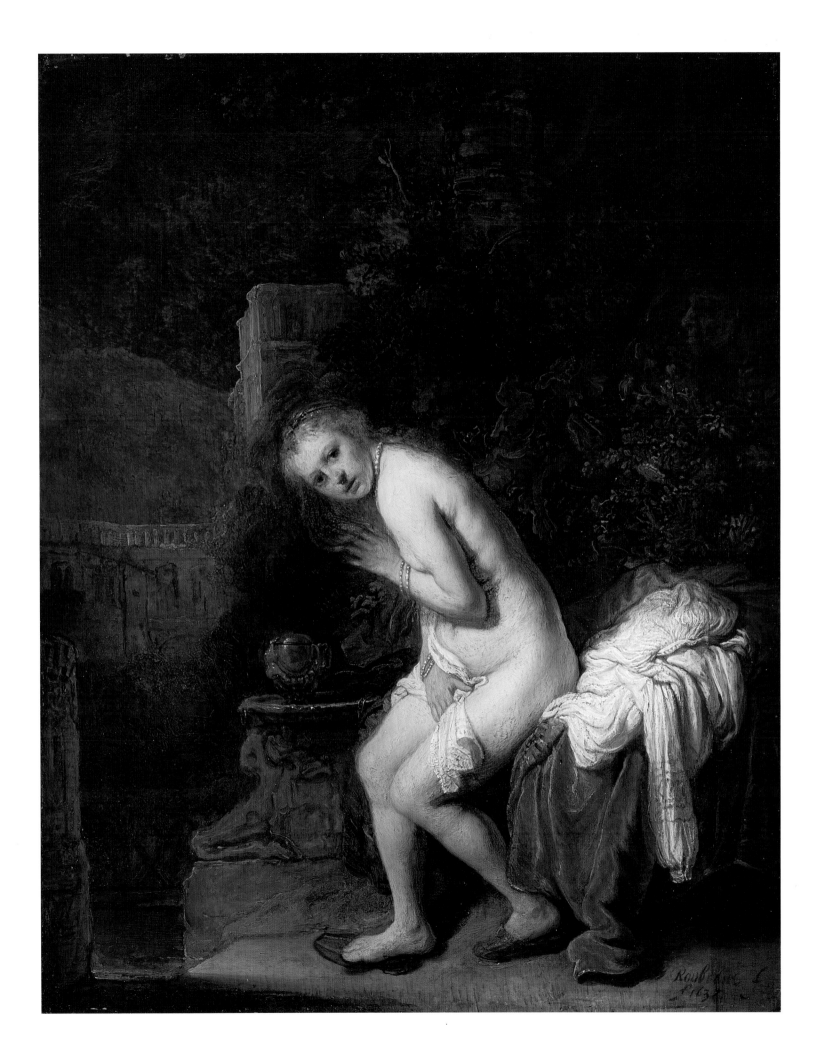

70 *A Seated Woman, Naked to the Waist, c.*1637

Drawing, black chalk, touched with white,
19.9 × 15.3 cm
(Verso: *Standing Woman*)
References: Benesch 376; Giltaij 1988, cat.14,
pp.63–5

BOIJMANS VAN BEUNINGEN MUSEUM,
ROTTERDAM (INV.NO.R81)

Rembrandt made only a few drawings of the female
nude in the latter part of the 1630s. This accom-
plished sheet was obviously drawn from a model in
the studio as the other side of the paper was also
used for a very quick sketch of what is almost
certainly the same woman, shown stripped to the
waist as here, but viewed from the back.
Rembrandt probably turned the paper over and got
the model to pose again, this time sitting down,
and this side of the sheet is worked up to a far
greater degree. The woman is shown sitting on
what may be a step or low stool, with a pillow
balanced on her lap, her forearms under it. This is
rather similar to Rembrandt's earlier drawing of *A
Study of a Female Nude Seen from the Back* (cat.14)
where the subject holds a cushion on her lap in the
same way, for comfort or for modesty, or perhaps
both.

The balance of shadow and highlight was
corrected and contours softened by the use of
white which was added to the woman's forehead
and her cheek, down her back and in the sweep of
her skirt at the edge where it would have caught the
light. Rembrandt puts in heavy shading around the
figure to give a sense of enveloping space. The
horizontal white striations in the shadow at the
right of the sheet look as if the heavy pressure with
the chalk may have picked up wood grain markings
from the surface Rembrandt was leaning on,
perhaps a wooden board or table. He certainly
marked some areas quite heavily, and the strong
lines of the hair and drapery around the figure's
waist give the drawing a momentum that enlivens a
static subject. The shading upon the pillow is
considerably softer and the modelling of the
woman's arm and breast in the half-shadow shows
subtle restraint. The technique of the drawing can
be usefully compared with that of *A Nude Woman
with a Snake* with which it must be contemporane-
ous (see cat.71). Both sheets bear similarities with
the handling of the chalk in a study of an elephant,
which is dated 1637 (Albertina, Graphische
Sammlung, Vienna).[1]

71 *A Nude Woman with a Snake, c.1637*

Drawing, red chalk touched with white,
24.7 × 13.7 cm
References: Benesch 137; Goldner/Hendrix/
Williams 1985, cat.114, pp.256–71; Turner/
Hendrix 1997, cat.62, p.78

J. PAUL GETTY MUSEUM, LOS ANGELES
(INV.NO.81.GB.27)

This is Rembrandt's only surviving red chalk
drawing of a female nude. Drawn in about 1637, it
is a tour de force in a medium which Rembrandt
had frequently used in his Leiden years but which
he employed only rarely after the 1640s.[2] Red
chalk, as mentioned in association with
Rembrandt's early *Study of a Woman's Legs*, was
commended by Rembrandt's pupil Samuel van
Hoogstraten, for drawing figures, faces, hands and
'entire nudes from life'.[3] In this sheet Rembrandt
exploits the full range of tonal variations and
chiaroscuro effects that can be wrought in this
medium. He applied white bodycolour underneath
certain areas of the figure and then drew over them
with the chalk, creating an extraordinary effect of
luminosity as the light gleams silkily on the curves
of the figure's belly, her shoulder, neck and full,
smooth thighs. The lines with which he describes
the figure vary from extremely fine strokes that
mark the silhouette of her right arm to the heavy
touches of 'deepened' (wetted) chalk for the
shadow at her navel, on her legs and the underside
of the cascading drapery. An impression of sturdy

power is imparted by the monumental solidity of
her stance.

Though Rembrandt must have made this
drawing from a model, he clearly had some
intention to portray a figure from history or
mythology since the pose was an unusual one. It
looks as if the material draped over the woman's
arm was there from the start, although its length
and bulk were perhaps increased subsequently.
What were certainly additions to the figure were
the elaborate headdress (clearly drawn over the
model's hair) and the snake which, writhing, wraps
itself once around her right thigh and then loops
round her wrist. She appears to have a firm grip on
its head. Rembrandt did not always concern
himself with providing his figures with identifying
attributes but it is likely that he did intend this
woman to 'be' somebody specific. The identifica-
tion generally deduced from the presence of the
snake, the breast displayed so prominently and the
outlandish headgear, has been Cleopatra, Queen of
Egypt. She chose to die by being bitten by an asp
after the suicide of Mark Antony following their
defeat at the battle of Actium.[4]

This sheet has been mentioned in relation to the
preparation of the composition of Rembrandt's
1638 etching of *Adam and Eve* (see cat.73).[5] There
can be little doubt that the mastery Rembrandt
demonstrates in the depiction of the figure here left
little need for improvement when it came to trying
to find a model for Eve. But though the protruding
stomach and general body shape are closely related,
the overall impression given by the two figures is
rather different. The serene vitality of the *Nude
Woman with a Snake* is at odds with the scowling
unkempt Eve. It is clear from this drawing that
Rembrandt could have depicted a lither, smoother
figure in his etching of Eve, but he chose not to do
so.

However, Lee Hendrix has suggested not only
that the woman here was the direct model for the
etching but that Rembrandt intended to portray
Eve in this drawing as well, arguing that the
presence of the snake could represent Satan rather
than the asp.[6] Her research has discovered some
convincing print sources for the form of
Rembrandt's *Nude Woman with a Snake*, the closest
of which is Hans Sebald Beham's 1523 engraving of
Eve (fig.114).[7] This shows Eve holding the apple
(placed in front of her bosom) between her fingers
in a very similar fashion to the way the woman
holds her breast in the drawing here. It may well be
that Rembrandt was aware of such prints which
may have informed his own composition, and
representations of Eve could certainly have been
the basis of his *Nude Woman with a Snake*.

There are, however, some elements of the
drawing which are hard to reconcile with the idea
that the *Nude Woman with a Snake* is meant to be
seen *as* Eve. The first, and simplest, is that shame of
the body only came after eating from the Tree of

Knowledge, and before this Eve is unclothed.
Though the drapery present does not actually cover
her nakedness, the presence of millinery in Paradise
seems unlikely, either before or after the Fall. The
second is that the motif of the woman's fingers
round her breast (and absence of an apple) is one
that would be extraordinary in the iconography of
Eve. The gesture was traditional in relation to the
depiction of the Virgin and Child, but there is no
infant here, and the woman might be proffering her
nipple to the snake. This seems more likely to relate
to the depiction of Cleopatra who offers her breast
to the serpent in order to milk its poison. The
composure of her half-smile and the firmness of her
grasp on the head of the snake might imply that she
chooses to die of her own will and is in control of
her destiny. However, other shades of meaning may
also have been intended in this enigmatic drawing.
Govert Flinck's *Venus and Cupid* of 1648 shows
Venus holding her breast in a very similar way, but
it is offered, as it were, to the beholder.[8] This
picture may have been the pendant for a portrait of
a man offered a rose by Cupid, so the pose is
presumably also linked with an allegory of love.[9] It
is possible that Cleopatra might be seen in such a
guise, committing suicide as her love for the dead
Antony and her ambitions came to naught.[10]

Fig.114 | Hans S. Beham (1500–1550), *Eve, Standing*
British Museum, London

Drawing, pen and brush and brown ink with wash,
11.5 × 11.5 cm
References: Benesch 164; Berlin/Amsterdam/
London 1991-2, vol.2, cat.11, p.196; Amsterdam/
London 2000-1, pp.69-70 and cat.30, p.159, fig.a

PRENTENKABINET VAN DE UNIVERSITEIT
LEIDEN (INV.NO.AW1097)

This is a preparatory sketch for Rembrandt's
etching of *Adam and Eve* which is dated 1638
(cat.73). The description of the Fall of Man comes
from the Book of Genesis (3: 1–19):

> *…God said 'You shall not eat of the fruit of the tree
> which is in the midst of the garden, neither shall you
> touch it lest you die.' But the serpent said to the
> woman, 'You will not die. For God knows that when
> you eat of it your eyes will be opened and you will be
> like God, knowing good and evil.' So when the
> woman saw that the tree was good for food, and that
> it was a delight to the eyes, and that the tree was to
> be desired to make one wise, she took of its fruit and
> ate, and she also gave some to her husband, and he
> ate….' God asked 'Have you eaten of the tree which
> I commanded you not to eat?' The man said 'The
> woman whom thou gavest to be with me, she gave me
> the fruit, and I ate.' God said to the woman, 'I will
> greatly multiply your pain in childbearing: in pain
> you shall bring forth children, yet your desire shall be
> for you husband and he shall rule over you.*[1]

In his etching Rembrandt did not choose the depiction of Adam and Eve as an opportunity to display the perfection of human form, the traditional preoccupation in Northern art as portrayed in works such as Hubert and Jan van Eyck's *Ghent Altarpiece*, or, indeed, Dürer's famous engraving of *Adam and Eve* of 1504 (fig.115). Rembrandt would surely have known this print but his interest lay elsewhere. He concentrates upon the psychological conflict of the moment and his preparatory sketches here show how he set about this. The crux of his composition is the apple and the drawings explore how best to show the reactions of the man and woman to it through their gestures.

In what was probably an early attempt at the theme, Rembrandt drew the couple sitting, with Adam raising both hands in horror as Eve offers the fruit (fig.116).[2] It is interesting that both are shown as rather younger and more comely than they finally appear. The Leiden sketch shows a different solution with the couple at the left of the sheet now shown standing. Eve holds out the fruit in one hand, her expression entreating. Adam, however, blocks her with both hands, his body leaning backwards as he recoils. The smaller sketch at the right is closer to Rembrandt's final resolution of the gesture in the etching (remembering that he would have drawn the composition on the etching plate in the same direction as the sketch). Here he still holds up one hand in protestation but the other links with hers around the fruit. Rembrandt maintained a teasing ambiguity in Adam's gesture in the final etching (hinted at here) which perfectly illustrates mankind's dilemma. Though one hand points upwards to warn of God's wrath, the other is placed between Eve's mouth and the apple, either to prevent her from eating it, or to grab it for himself. The future of mankind is in balance as he consciously deliberates the conflicting choice between good and evil.

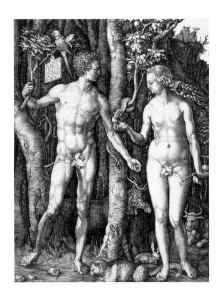

Fig.115 | Albrecht Dürer (1471–1528),
Adam and Eve, 1504
British Museum, London

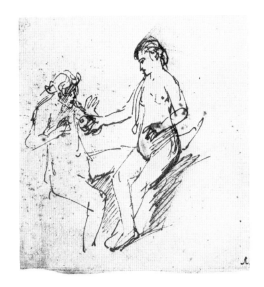

Fig.116 | Rembrandt,
A Study for Adam and Eve,c.1638
David H. Felix Collection, Philadelphia

73 *Adam and Eve*, 1638

Etching, touched in black chalk, grey wash and
pen and brown ink, 16.2 × 11.6 cm
Signed and dated, bottom centre: *Rembrandt. f.
1638*
References: H.159; White/Boon B 28:I (of II);
Berlin/Amsterdam/London 1991–2, vol.2, cat.11,
pp.195–7; Amsterdam/London 2000–1, cat.30,
pp.157–9

BRITISH MUSEUM, LONDON
(INV.NO.1852–12–11–42)

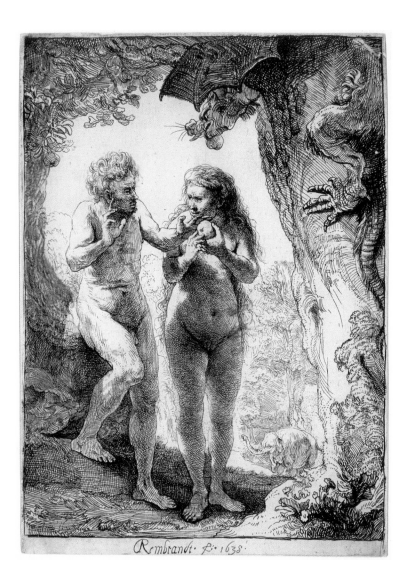

This impression of the first state of Rembrandt's
etching of *Adam and Eve* is unique, as it bears his
drawn additions.[1] As the preparatory drawing
from Leiden shows (cat.72), Rembrandt spent
time and effort on resolving the poses of the
couple for the etching, but part of the conception
for this design appears to have been inspired by a
print by Albrecht Dürer, *Christ in Purgatory*, from
his series of prints which made up the *Engraved
Passion* of 1512 (fig.117).[2] The obvious similarities
between the position and form of the dragon/
snake are clear, though Rembrandt adds bat wings
to his satanic beast. The brightness of the land-
scape behind echoes that in Dürer's print whose
stone arch is loosely followed by Rembrandt in the
dark arching shape of the foliage. Rembrandt's
additional drawing on this impression of the
etching strengthens this resemblance to Dürer's
arch even more, linking up the darker area behind
Adam with what appears to be the trunk of a tree
to support the hanging leaves above (although the

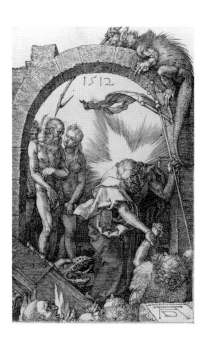

Fig.117 | Albrecht Dürer (1471–1528),
Christ in Purgatory, 1512
National Gallery of Scotland, Edinburgh

changes suggested by chalk and ink were not
actually carried out on the etching plate).

Rembrandt profoundly admired, and was
influenced by, Dürer (see for example cat.83). He
owned prints by the German master, and in 1638
(the date of this etching), he bought a considerable
number at auction, which included an unspecified
series of Dürer's *Passion*.[3] The criticism levelled
against Dürer by Karel van Mander for following
'the imitation of life in all he did, but without
carefully seeking or selecting the most beautiful of
the beautiful',[4] might just as well apply to
Rembrandt in his etching of *Adam and Eve*. Far from
flaunting their 'pre-Fall' flawless beauty, as Dürer
had attempted to portray them in his engraving of
1504, Rembrandt's Adam and Eve are here shown
'past the first flush of youth'.[5] The Austrian
engraver and authority on prints, Adam Bartsch
(1757–1821) went further, declaring that 'As
Rembrandt was completely unable to render
nudes, this print is incorrect, and the heads are
most unpleasant.'[6] But Rembrandt was not

incapable of drawing smoother-skinned beauty as
his wonderful drawing of *A Nude Woman with a
Snake* shows (cat.71).

One has to suppose that Rembrandt's less
idealised pair of figures was intentional. The idea
may have been suggested by Dürer's print as well,
where the elderly, grizzled Adam stands with Eve at
the mouth of Hell: the inevitable destination
brought upon them by the consumption of the
forbidden fruit in the Garden of Eden. Rembrandt
shows Eve and Adam scowling and squabbling,
already tainted by the brightly-lit apple that is the
focus of the etching. Its dimpled form is echoed in
the shadowed, round swell of Eve's belly. The link
may be more than one of shape alone, for the Bible
stated that it was as a result of eating this fruit, that
the fruit of the womb of all women would forever
be brought forth in pain. It seems that
Rembrandt's print told the start of the story of
humanity's fall from Grace, Dürer's its conclusion
through Christ's Redemption.[7]

Etching and touches of drypoint, only state,
11 × 7 cm
Signed and dated, top right: *Rembrandt f.1638*
(in reverse)
References: H.154; White/Boon B 342

BRITISH MUSEUM, LONDON
(INV.NO.1910-2-12-404)

This etching was originally called '*The Little Jewish Bride*' to distinguish it from '*The Great Jewish Bride*' of 1635 (cat.33). The titles arose through the custom of Jewish brides receiving their husbands with their hair loose on their shoulders. In addition, the subject of '*The Great Jewish Bride*' holds a scroll which was interpreted as the marriage contract (Ketubah).[1] Both etchings show women with their long, frizzy hair unbound, kept in place by a fine band about their heads. Both women also wear very full-sleeved gowns, in the present case ruched into tiny gathers at the neckband, rather like a cassock. Some patterning is also just visible on a bodice below this garment at the woman's breast.

While it seems likely that '*The Great Jewish Bride*' represents the Old Testament heroine Esther, this work portrays a later religious figure, Saint Catherine, who is not mentioned before the ninth century. Her attribute of a wheel can just be made out at the right of the etching. Saint Catherine of Alexandria was one of the most popular early Christian martyrs, a learned young noblewoman who protested against the persecution of Christians under the Roman emperor Maxentius. After converting his wife and several of his guards to Christianity, she then defeated the most eminent scholars summoned by the emperor to oppose her. He sentenced her to be killed by being bound to a spiked wheel (a 'Catherine wheel') but the wheel broke and she was subsequently beheaded.

The face clearly echoes that found in '*The Great Jewish Bride*' although the features are rather more pinched. The closest parallel is to be found in the figure with the dark headscarf in Rembrandt's etching of the previous year, *Three Heads of Women, One Asleep* (cat.65). Very little shading is used in the background and the white pleating of the garment and fine lines that make up the hair all combine to give an impression of light airiness. It is not known why Rembrandt wrote his name in reverse on the plate.

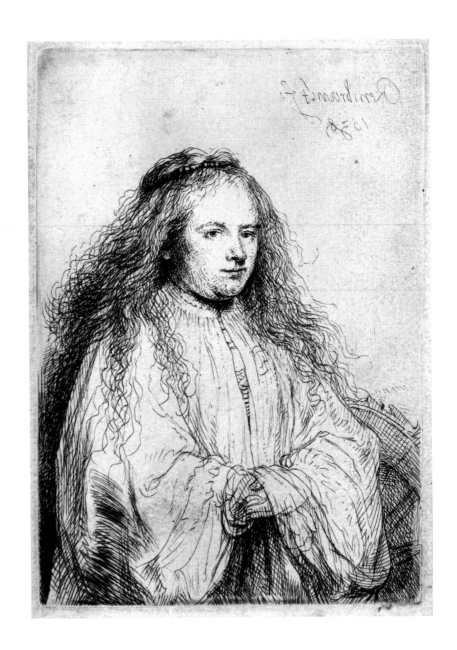

Etching, drypoint and burin, first state (of two),
23.2 × 18.4 cm
References: H.231; White/Boon B 192:1; White
1999, pp.180–2; Amsterdam/London 2000–1,
cat.36, pp.174–9

BRITISH MUSEUM, LONDON
(INV.NO.1895–12–14–111)

The meaning of this etching has been the cause of
much debate. An artist sits drawing a female nude
who models for him in a pose reminiscent of that
in *A Nude Woman with a Snake*, but seen from the
other side (cat.71).[1] Around them are various
studio accoutrements, an empty canvas on an easel
in the centre, a sculpture bust at the back, and
various studio props – a quiver, shield, sword and
a feathered cap hanging at the left. The print was
given the title of 'Pygmalion' in the eighteenth
century[2] and the pose of the model has plausibly
been linked to a print of the same name by Pieter
Feddes van Harlingen of 1615.[3] Rembrandt
probably knew this print, but, unlike Ovid's story
of Pygmalion who falls in love with an ivory statue
of his own making that expresses his ideal woman,
the artist shown here is in front of a living model
whom he draws rather than creates.[4] However,
neither in Rembrandt's etching, nor in the related
drawing, does it appear that he made use of a real
model since the pose was a borrowed one; so in
one sense Rembrandt does indeed create his figure
here by pure draughtsmanship. It seems likely
that he intended to present an allegory of the
visual arts, as the studio contains references to
drawing (the artist sketching), painting (the easel),
and sculpture (the bust). The art of drawing has
primacy here, perhaps due to the importance that
drawing held in Rembrandt's own oeuvre.[5]

A drawing in the British Museum, *The Artist
Drawing from a Model* (fig.118), was probably made

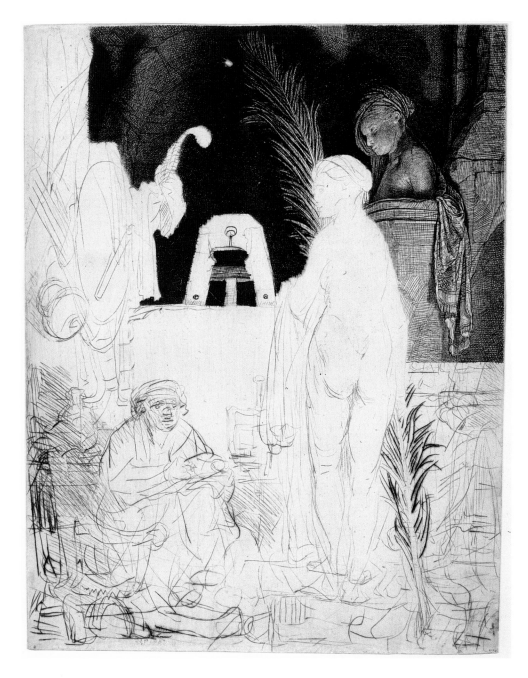

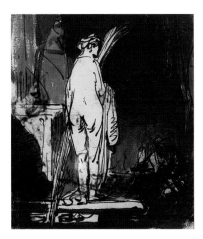

Fig.118 | Rembrandt, *The Artist Drawing from a Model, c.*1639
British Museum, London

when work on the etching had already started, in
order to determine how to complete the composi-
tion.[6] Rembrandt must have drawn this after the
second state of the etching since it resolves the
problem of the length of the model's legs by raising
the platform upon which she stands (which is
shown at a lower level in both states of the etching).
The drawing, and, by association, the etching are
generally ascribed a date of about 1639 on the basis
of the drawing's similarity to Rembrandt's
compositional study for his 1639 *Portrait of a Young
Woman, probably Maria Trip* (see cat.84).

Much has been made of the fact that the etching
was left incomplete, despite the completed
composition suggested by the drawing. The fact

that impressions were printed of both states[7]
implies that the etching was marketable in this
'unfinished' form and it has been suggested that
Rembrandt deliberately left the etching incomplete
to illustrate the actual process of his technique, for
the instruction of pupils and others.[8] However, the
two states of the etching imply that work was still
continuing on the plate, so it may be that
Rembrandt intended to complete it at some stage.
It is possible that some technical problem was the
cause of its incomplete state, such as the dark areas
being overworked (although the artist's technical
mastery over the medium of etching by this stage
would suggest that he might have found a solution
to this had he wished to).[9]

Drawing, pen and brush and brown ink, touched
with white, 17.5 × 13.4 cm
References: Benesch A3; Schatborn 1985, cat.14,
pp.32–3

RIJKSMUSEUM, AMSTERDAM
(INV.NO.RP–T–1930–51)
Exhibited in London only

Here Rembrandt shows a woman sitting, her legs
stretched out in front of her, next to a high
window whose frame is visible at the right. She is
wearing an apron and has her hair bound back in a
headscarf. She holds something in her right hand,
but it is not clear what. The side of her face and her
shoulder are so brightly lit by the sunlight as to
seem almost bleached, a foil to the deep wash used
for the wall below the window and the shadow she
casts at her left. The drawing was formerly
attributed to one of Rembrandt's pupils, Nicolaes
Maes (1634–1693), who was profoundly
influenced in his choice of subject matter by
Rembrandt's drawings of women and children.[1]
However, the style and technique of the sheet, the
use of iron gall ink and the preparation of the
paper with a light wash of ink are completely
consistent with Rembrandt's work, and the
drawing may be dated around 1638.[2]

The motif of women seen next to, or through, a
window was one that Rembrandt revisited
throughout his career, presumably partly because
of the opportunities the setting gave for 'framing'
the composition of the figure, and also because of
the lively contrasts of tone provided by the raking
light. Another drawing of similar date now in the
Collection Frits Lugt, Institut Néerlandais, Paris,
shows a similar figure, though lit from the other

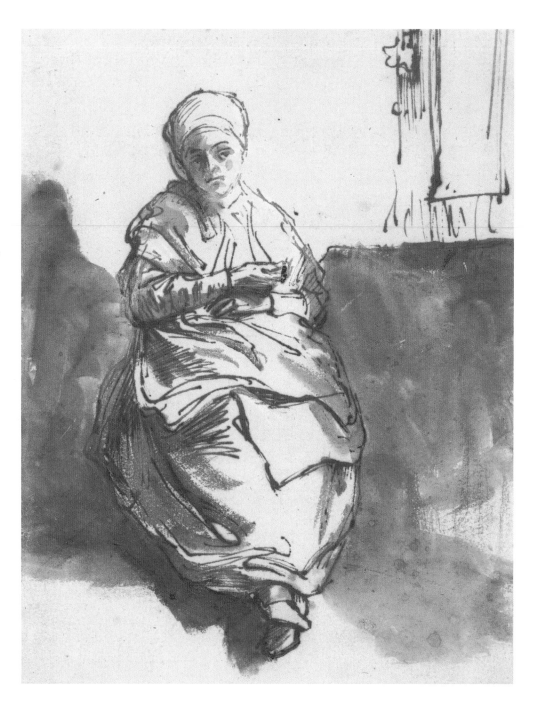

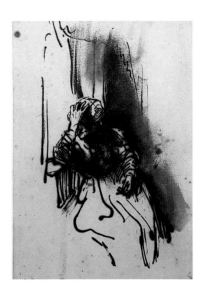

Fig.119 | Rembrandt, *A Seated Woman at a Window, c.1638*
Collection Frits Lugt,
Institut Néerlandais, Paris

side, her face mostly hidden as she leans her elbow
upon the sill (fig.119).[3] Both works seem to
summon up a mood of calm melancholy, an
impression reinforced in the Lugt drawing
through the pose of head on hand that Rembrandt
used so frequently.[4]

The features of the model have been associated
with those in earlier drawings, such as the *Young
Woman at her Toilet* (cat.30) and a drawing now in
Dresden, *A Woman Sitting in Bed* (cat.46, fig.108)
where Rembrandt's wife has also been presumed
to be the model.[5] Saskia was expecting her second
baby in 1638, two years after the death of their
first child Rumbartus.

Drawing, pen and brush and brown ink, touched
with white, 17.7 × 24 cm
References: Benesch 404; Schatborn 1985, cat.11,
pp.26–7

RIJKSMUSEUM, AMSTERDAM
(INV.NO.RP–T–1930–53)

Exhibited in Edinburgh only

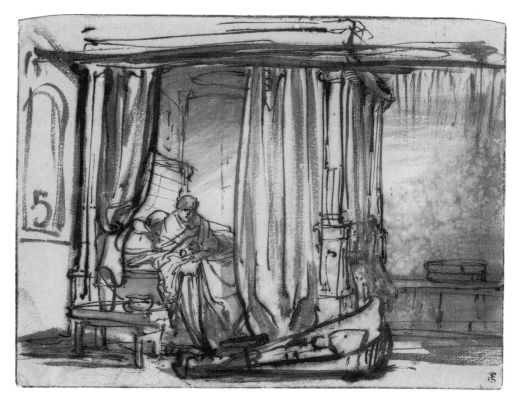

Amongst the many drawings that Rembrandt made
of women in bed from the mid-1630s to the early
1640s, this is one of only two sheets to encompass
the whole room rather than just the bed. The other,
in the Collection Frits Lugt, Institut Néerlandais,
Paris, made somewhat later, shows a different
setting (cat.88).

The chamber in this drawing has a large bed set
into the corner with carved bedposts supporting
heavy curtains. There is an arched niche or window
at the left with a pot on the sill, and a low table
beside the bed on which is placed a bowl and
another object. A long bench runs along the far
wall, on which there is an oval box or basket. In
front of the bed is a long triangular shape, difficult
to make out but which must be a nursing couch,
usually made out of wicker. It has a cushion or
pillow and perhaps blankets piled at its foot. The
same item appears in a painting of *A Delivery Room*
(fig.120), showing how this chair-bed was placed in
front of the fire, allowing the woman to lie with her
legs straight while her back was supported as she
nursed the baby. The presence of this item of
furniture with such a specific purpose, together
with the fact that no baby is included, has not
unreasonably led to the supposition that the
woman in the bed must have been Saskia in the late
stages of pregnancy, awaiting her 'lying in'.

The measured application of wash gives
substance and depth to the room without making
any area overly dense, and the assured penmanship
make the drawing unlikely to date from as early as

1635 when Saskia was pregnant with their first
child, born in a house next to that of Councillor
Boereel '*in niuwe doelstraat*'.[2] If the woman here is
indeed Saskia, the drawing would have to relate to
the imminent birth of one of her other children,
born in 1638, 1640 and 1641. Since the Lugt
drawing mentioned above can be dated later than
this sheet on the basis of style and since it shows
another room, it is thought that the
Rijksprentenkabinet sheet may have been drawn
when the couple were living in a house on the
Binnen Amstel which was called the *Suijkerbackerrij*
(Confectioner's).[3] This was where Saskia gave birth
to their little girl Cornelia in 1638. She was named

after Rembrandt's mother, and baptised on 22 July
1638, but she only survived for two weeks.[4]

A drawing in the Fogg Museum of Art, Cam-
bridge, Mass., '*Saskia Ill in Bed with a Child*', which
was formerly ascribed to Rembrandt, shows an
almost identical scene but it includes a clambering
infant, far too large to be new-born, behind its
recumbent mother.[5]

Fig.120 | Attributed to Antonie Palamedesz (1601–1673),
A Delivery Room (detail)
Private Collection

78 A Pregnant Woman Standing, c.1639

Drawing, pen and brown ink, 16.5 × 11.1 cm
(verso: *Sketch of a Young Woman Standing*)
References: Benesch 246; London 1992, cat.29,
p.85

BRITISH MUSEUM, LONDON
(INV.NO.1910–2–12–184)

It was once thought that many of the paintings of
historical or mythological heroines that
Rembrandt made in the earlier 1630s (such as *Flora*,
cat.27), showed expectant women because of their
high-waisted dress and apparently protruding
stomachs. The woman in Jan van Eyck's *Marriage of
the Arnolfini* (National Gallery, London) was also
given the same diagnosis, but it was, in fact, the
contemporary fashion in dress which gave this false
impression of pregnancy (even the resolutely
virginal Saint Catherine appears in a dress gathered
up in front in a similar way in Van Eyck's triptych
in Dresden).[1] However, in this drawing, despite the
comparative rarity of images of pregnant women,
the stance of the woman, leaning backwards
slightly to counterbalance the weight of her
stomach, and the way she rests one arm over the
bulge, make it extremely likely that she is in the
final months of carrying a child.

Pregnant women, then as now, were encouraged
to eat certain things and abstain from others
(though the nature of these dietary restrictions has
altered over the years) and instructed to refrain
from dancing, riding and other vigorous activity.[2]
There were a number of books which gave advice
on such matters for the literate mother-to-be, such
as H. Roesslin's *Den rhosegaert van de bevruchte
vrouwen* (The Rosegarden of Fruitful Women,
Amsterdam, 1616), the physician Johan van
Beverwijk's *Schat der Gezondheid* (The Treasury of
Health, Dordrecht, 1643)[3] or the anonymous *Kleyn
Vroetwyfs-boek* (The Little Book of Midwifery,
published in 1645).[4] On the day the baby was born,
a decorated notice would be posted on the door of
the house, a *kraam kloppertje* (birth announcement),
to reveal the birth and sex of the child and the
father would wear a paternity bonnet.[5] The
household was then exempt from some taxes and
duties for a short time in celebration of the birth,
perhaps reflecting a comment by the Dutchman
Bartholomew Batty who in 1581 reminded parents
that they 'begot children not only for thy selfe, but
also for thy countrie. Which should not only bee to
thy selfe a joy and pleasure, but also profitable and
commodius afterwarde unto the common wealth.'[6]

As can be seen faintly showing through on this
sheet, another woman was drawn on the verso. The
corrosive nature of the iron gall ink that
Rembrandt used here means that the lines of both
figures have 'eaten' into the opposite sides of the
paper.

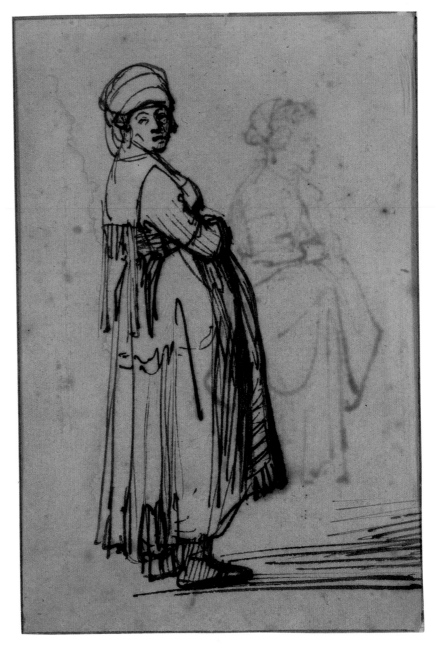

Drawing, pen and brown ink, 18.8 × 14.7 cm
References: Benesch 226; Paris/Antwerp/London/
New York 1979–80, cat.67, pp.98–9

PIERPONT MORGAN LIBRARY, NEW YORK
(INV.NO.I,190)

The arrangement of the figures on this sheet is very
similar to that in *Three Studies of a Woman Carrying a
Child* of about 1636 from the Lugt Collection
(cat.58). The Pierpont Morgan drawing was
therefore formerly thought to date to a similar or
even earlier period, as was the *Pregnant Woman
Standing* (cat.78).[1] Like the latter sheet, it is drawn
in iron gall ink upon paper which has been lightly
washed with diluted ink. The technique and style
of both sheets relate closely to a number of
drawings which Rembrandt made at the end of the
1630s.[2] Rembrandt appeared to favour the medium
of iron gall ink at this period, the dating for which
is suggested by works such as his *Study for the
Portrait of a Young Woman, probably Maria Trip*, made
for the portrait dated 1639 (cat.84), two studies
related to the etching of 1638 of *Joseph Telling his
Dreams*[3] and of his drawing dated 1639 after
Raphael's painting of *Baldassare Castiglione* which
Rembrandt made when the picture was sold in
Amsterdam that year.[4]

Not only are the *Pregnant Woman Standing* and
the drawing here extremely similar in handling, but
both have the same watermark, which also appears
on two other drawing from this period.[5] In
addition to this, the woman who is holding the
baby in the upper part of this drawing, is reminis-
cent of the figure who appears on the verso of the
Pregnant Woman Standing, both delineated with a
sharply defined jaw.[6] The babies shown here are
probably too old to be Rembrandt's own children
for his second child Cornelia only survived a couple
of weeks. The drawing should be seen more in the
light of Rembrandt's other 'study sheets', with the
figures chosen for their different poses. The lower
three groups are variants on a theme where
Rembrandt explores the interaction of the infant
and the woman who holds it: in the lower right
study the child is cradled, in the central group it
reaches out while the woman seems to nuzzle its
little capped head and in the cursory sketch at the
bottom left, it tries to hold itself upright, peering
over the woman's shoulder as she turns.

The man at the top left wearing a fur hat may
have been included to add variety to the etching, as
was the figure in the turban in cat.62. It is loosely
related to a number of other such figures in the
artist's work, for example, that at the bottom of his
Studies of Men in Fur Caps of *c*.1637.[7]

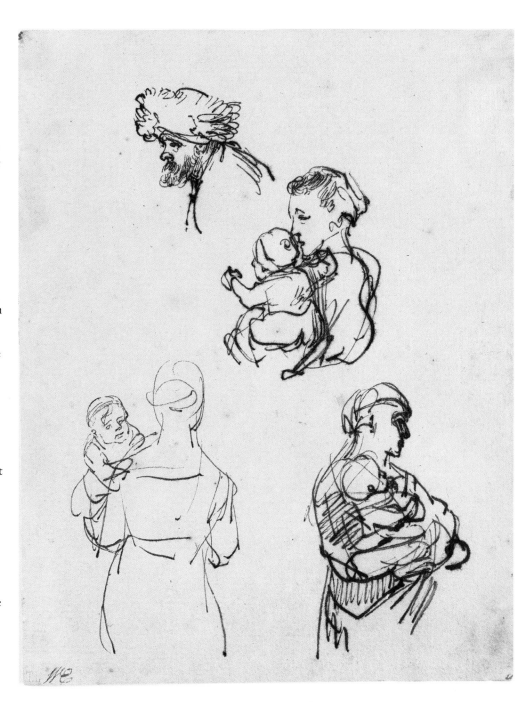

Drawing, pen and brush and brown ink with
greyish wash, 13 × 7.8 cm
References: Benesch 314; London 1992, cat.20,
pp.70–1

BRITISH MUSEUM, LONDON
(INV.NO.1895–9–15–1270)

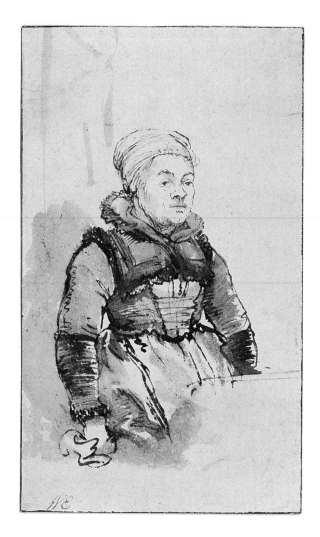

This drawing is clearly related to the following one
(cat.81), showing the same figure from the back.
The distinctive costume worn by the somewhat
thickset woman with its fur 'V' shape marking the
back of her bodice and neckline was once identified
as 'Friesland' or 'Zeeland' costume.[1] However,
there is little doubt that the bodice is characteristic
of that worn in the region of North Holland, as
noted in 1906.[2] It is notably similar to that shown
in two etchings of a farmer's wife from Edam by
Gillis van Sceyndel after Willem Buytewech which
shows the same kind of trim (figs.121 and 122).[3]
In itself this is far from extraordinary, for research
has shown that of the large number of servants in
Amsterdam (which reached some 12,000 by the end
of the eighteenth century),[4] the majority were
women and a substantial proportion came from
outside the city.[5] Though women from
Guelderland and Overijssel were favoured as
servants, women from the area round Edam were
also regarded as good servant material.[6] The fact
that this woman is shown in her regional dress,
drawn in Amsterdam, probably indicates that she
was in domestic service there.

　The London drawing was once in the collection
of Valerius Röver where it was described in his
posthumous catalogue of about 1739 as 'A peasant
woman and a sleeping woman with a child at her
breast by the same [Rembrandt]'.[7] This presumably

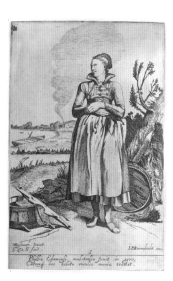

Fig.121 | Gillis van Sceyndel after Willem Buytewech
(*c*.1591–1624), *A Farmer's Wife from Edam, Seen from the Front*
Museum Boijmans Van Beuningen, Rotterdam

means that the sheet was divided at some stage
subsequently, but the presence of a woman and
baby is interesting in the light of the inscription
on the back of cat.81 which describes the woman
as Titus's nurse, though he was not born until
1641.

　Both cat.80 and 81 must have been made at the
same sitting, for unlike many drawings which
show the same model from different sides, there is
no suggestion that one of the drawings is by one of
the master's pupils. The problem is that
Rembrandt scholars have disagreed about the date
of the drawings. Benesch gave them a date of 1635
while others have attributed them to the late
1630s[8] and to the early 1640's.[9] The suggestion
that the woman is Geertje Dircks has obviously
had something to do with the later datings (see
cat.81). For the present author the most convinc-
ing stylistic analogy is to the rather precise
handling of the drawing which Rembrandt made
in 1640 for his portrait of *Cornelis Claesz Anslo*.[10]
The way that the fur around his collar is drawn is
extremely close to the fine and controlled lines in
the carefully observed depiction of the costume in
the Haarlem drawing, and the manner in which

the tightness of the bodice causes the material to
pull into strained creases, pinching at the midriff
and under the arms, is also similar.

　This does not help us with secure identification
of the model as Geertje Dircks, however. If she
started work earlier in Rembrandt's household
than previously thought (and there is no documen-
tary proof of this either way), then the inscription
on the back of cat.81 may be partially correct and
the subject therefore the woman who later looked
after Titus, though Geertje was not a wet nurse as
stated in the inscription. However, if, as research
shows, this type of costume was not infrequently
worn by servants in Amsterdam, she may have been
an earlier worker in the household from the same
region.

Drawing, pen and brush and brown ink with wash,
22.2 × 15.4 cm
References: Benesch 315; Plomp 1997, cat.327,
pp.300–1

TEYLERS MUSEUM, HAARLEM (INV.NO.O*51)

The reverse of this drawing is inscribed with the
words '*de minnemoer/van Titus soon/van Rembrand*', in
red chalk at the lower right (the wet nurse of Titus
son of Rembrandt). This inscription, together with
the characteristic North Holland costume, has led
to the supposition that the figure shown is Geertje
Dircks (Dircx) who acted as a dry nurse[1] (rather
than a wet nurse) for Rembrandt's son Titus (1641–
1668).[2] She was born in Edam between about 1600
and 1610 and had worked as a waitress in an inn in
Hoorn called 'The Moor's Head' where she had met
her husband Abraham Claesz, a ship's bugler from
Ransdorp, near Edam.[3] They married on 26
November 1634, the same year that Rembrandt
married Saskia (who was about the same age as
Geertje).[4] However, her husband died shortly
afterwards and she then kept house for a lumber
merchant, and subsequently worked for her
brother, a carpenter employed by the East India
Company. She seems to have been childless, but
presumably formed an attachment to one of the
daughters of the lumber merchant as she was made a
beneficiary of Geertje's will.[5] It is usually assumed
that Geertje joined Rembrandt's household
sometime around Saskia's death in 1642 in order to
look after his soon-to-be motherless child, but a
document of 1 November 1642 tells us that
Rembrandt probably knew her family sufficiently
well to lend money to ransom a friend of her brother
who had been captured off the Barbary coast.[6] This
might imply that Geertje was already well known to
Rembrandt, and it must be considered a possibility
that she joined the household prior to 1642, perhaps
to help Saskia in her final illness or even a couple of
years before following the birth of the short-lived
second Cornelia in 1640.[7]

When Geertje herself became ill in 1648, she
made Titus her heir, perhaps on the assumption that
Rembrandt would fulfil a promise of marriage, or at
least that they would continue to live together.
However, in 1649 they quarrelled and numerous
legal documents plot a sorry tale in which, although
Rembrandt was not actually proved guilty of
Geertje's accusation of having slept with her or
having broken a promise to marry, he was nonethe-
less ordered to pay her a sum to discharge her debts
and an annual pension in compensation. Further-
more, it appears that when she was imprisoned in
the House of Correction in Gouda from 1650 to
1655, Rembrandt seems actively to have connived at
trying to prolong her detention.[8] She returned to
her native Edam when she was finally released in the
latter year.[9]

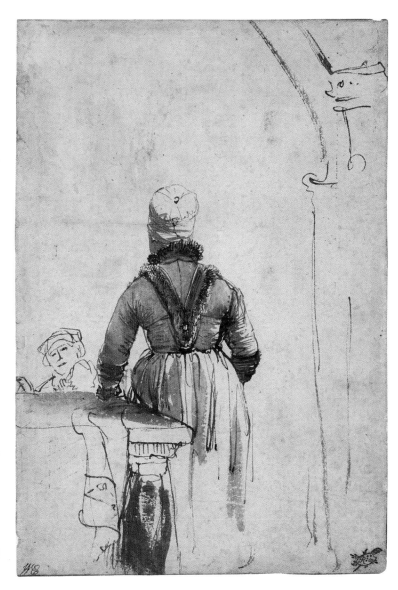

Any identification of the Teylers Museum and
British Museum drawings with Geertje Dircks must
remain speculative, however, for although Michiel
Plomp argues a date of the early 1640s for the
Haarlem sheet, Martin Royalton-Kisch believes that
the British Museum sheet dates from about 1638,
four years before the archives confirm Geertje's
presence in the Rembrandt household.[10]

The two drawings are fascinating in providing a
glimpse of the practice of drawing from a model.
The suggestion that the cursorily drawn head seen
behind the table in the Haarlem drawing may be a
student seems highly likely in view of known
practice and other examples of a model seen from
different angles (for example, see cat.135). Having
completed this drawing, Rembrandt probably
changed places with whoever was sketching in front
of the woman, and drew her from the other side.
Interestingly, a follower of Rembrandt drew an
exact copy of the Teylers drawing, now in the
Collection Frits Lugt, Institut Néerlandais, Paris.[11]

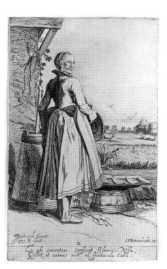

Fig.122 | Gillis van Sceyndel after Willem Buytewech (*c.*1591–
1624), *A Farmer's Wife from Edam, Seen from the Back*
Museum Boijmans Van Beuningen, Rotterdam

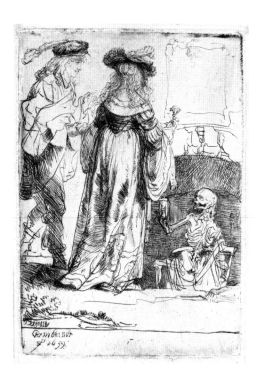

Etching and drypoint, only state, 10.9 × 7.9 cm
Signed and dated, bottom left: *Rembrandt.f. 1639*
References: H.165; White/Boon B 109; Amsterdam/
London 2000–1, cat.33, pp.164–6

RIJKSMUSEUM, AMSTERDAM
(INV.NO.RP–P–OB–191)

As has been pointed out in the entry for the drawing
of *Two Women Teaching a Child to Walk* (cat.60), the
small sketch of a woman seen from the back at the
upper left of that drawing is fairly close to that of the
elaborately dressed wife here, with the hair scraped
up into a bun under the hat and indication of a high
cut bodice. The clothes worn in the etching are
sixteenth- rather than seventeenth-century in
nature, with the apparently slashed sleeves gathered
into a tight band at the upper part of the arm,
together with the feathered hat reminiscent of that
used in Rembrandt's painting of Saskia in a red hat
in Kassel (fig.88).[1] Just as in that painting, the
woman here holds out a flower, usually symbolising
love but also the transience of life: it is offered not to
the young man at her side but towards the skeletal
Death in his dark tomb. Rembrandt etched this
plate very lightly and much of it is in drypoint
making the overall composition rather faint and
hard to make out. Death appears to carry a scythe
and holds up an hour glass.[2] Above his grave vault is
a frame of uncertain purpose that may represent a
mirror, or was perhaps intended for an inscription of
some sort.[3] The elegant couple both walk towards
Death hand in hand and the courteous young man
smiles pleasantly down at the skull below, though
their feet almost breach the grave's edge.

The historical costume shown here befits the
fact that Rembrandt based his etching upon earlier
depictions of this subject which stem from the
Dance of Death or *dance macabre*, both a pictorial
and literary theme originating in the late Middle
Ages, perhaps as a consequence of the plague. It
revolved around the ubiquity of Death the leveller
who lured everyone to him irrespective of status,
from Pope to beggar. The Dance appears to have
first taken shape in France, as a mimed sermon in
which figures from all orders of society were seized
and taken away, each by their own corpse (not, as
later, by the personification of Death). The earliest
known painting of the Dance (now destroyed) was
made in 1424 in the cemetery of the Innocents in
Paris. The first printed edition of a Dance of Death
cycle combining verses and woodcuts was issued
from the Parisian press of Guyot Marchant in 1485.
Prior to that, manuscript versions of the Dance of
Death texts had appeared in both Spain (*Dança
general de la muerte, c.*1400) and Germany (the
Lübeck *Totentanz*, 1463).

The most famous treatment of the theme was by
Hans Holbein the Younger in a series of fifty
woodcuts designed about 1523/4 and printed at
Lyons in 1538, where Death, in the form of a
skeletal musician, leads away representatives of
every class of society.[4] Rembrandt certainly owned
Holbein prints,[5] and this series seems, to have
inspired his own etching here, particularly
Holbein's *Die Edelfrau* which shows a well-dressed
couple walking in a measured pace to the beat of
Death's drum.[6] The isolation of the couple and
Death as a motif was also employed in a print by
Albrecht Dürer which Rembrandt may also have
known.[7] It has sometimes been suggested that
Rembrandt's etching depicted himself and Saskia
and that the subject in some way related to their
own marriage and her illness. However, the young
man here is certainly no Rembrandt self-portrait
and there is no proof that Saskia was ailing in 1639:
her third child was born in the summer of the
following year. A specific reference to Rembrandt's
own life, therefore, seems unlikely in this etching,
above and beyond the generality that Death was
ubiquitous for all.

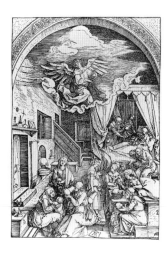

Fig.123 | Albrecht Dürer (1471–1528),
The Birth of the Virgin
National Gallery of Scotland, Edinburgh

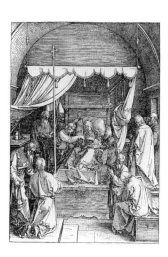

Fig.124 | Albrecht Dürer (1471–1528),
The Death of the Virgin
National Gallery of Scotland, Edinburgh

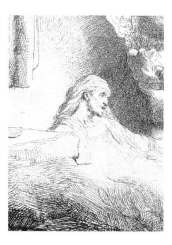

Fig.125 | Rembrandt,
The Raising of Lazarus (detail)
Rijksmuseum, Amsterdam

83 *The Death of the Virgin,* 1639

Etching and drypoint, first state (of three),
40.9 × 31.5 cm
Signed and dated, bottom left: *Rembrandt f. 1639.*
References: H.161; White/Boon B 99:I; White
1999, pp.40–3; Amsterdam/London 2000–1,
cat.32, pp.162–4

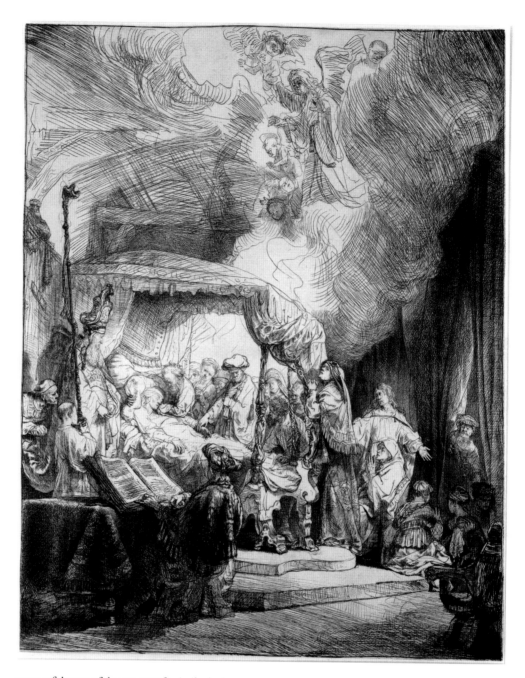

The Death of the Virgin Mary is not mentioned in
the New Testament but was described in apocry-
phal writings such as *The Golden Legend* by Jacobus
de Voraigne. Rembrandt here conflates two
moments from the story: the arrival of the angel to
warn Mary of her death, and the angel's granting
of her wish to summon all the apostles to her
deathbed from wherever they happened to be
preaching.[1] Rembrandt may have been familiar
with the literary source but he also drew upon
related pictorial ones. The composition is loosely
connected to Dürer's *The Birth of the Virgin*
(fig.123) and *The Death of the Virgin* (fig.124) from
his woodcut series of twenty prints of *The Life of
the Virgin.*[2] Rembrandt certainly knew these, as he is
listed as having purchased nine sets of the 'Life of
the Virgin' at the sale of Gommer Spranger's
collection of prints in 1638, along with a number
of other prints by that master.[3] Another close
visual reference may have been Dirck Crabeth's
design for the stained glass window of the *Death of
the Virgin* in Amsterdam's Oude Kerck (Old
Church) from which the position of the bed and
the figure reading scripture at the forefront of
Rembrandt's composition was adapted.[4]

Although Rembrandt made use of print sources
in arriving at his composition, his various studies
from life probably of his wife Saskia in bed must in
some way have informed his depiction of the dying
Virgin (see cat.41–44, 46). However, the way Mary
is drawn is also very similar to the drawing of
Lazarus in Rembrandt's etching of *The Raising of
Lazarus* of *c.*1632 (fig.125).[5] In both prints,
Rembrandt forces the focus upon the barely
conscious figures who are sketched in very softly,
bathed in bright light: one heading heavenwards,
the other summoned back to life. In surrounding
the Virgin's bed with women as well as the apostles
mentioned in *The Golden Legend*, Rembrandt makes
the deathbed scene one of human poignancy as
well as religious significance.[6]

It has often been argued that such a subject
must have been made specifically for Catholic
clients (since Protestantism discouraged devotion
to the Virgin). However, it is not known if the
etching was commissioned, though Rembrandt
certainly must have spent a considerable amount of
time and effort upon this impressive and elaborate
work. It seems that he may also have made a
smaller design for this subject at some point, for
traces of the top of the canopy of a similar bed may
just be visible in the thunderclouds which crowd
the sky in his famous etching of *The Three Trees* of
1643.[7] Though it is obvious that he re-used the
copperplate for this landscape, it is not known
whether the beginnings of the small *Death of the
Virgin* it covered might have been done a few years
earlier to coincide with the 1639 date of the larger
version here, though it may equally have been
done shortly before *The Three Trees.* (Intriguingly,
others have suggested that the dark trunks in *The
Three Trees,* with its thunderous sky, are faintly
reminiscent of the three crosses at Golgotha, and
have tentatively related this brooding composition
with Rembrandt's reaction to Saskia's death in
1642.[8])

Drawing, pen and brown ink touched with white,
16 × 12.9 cm
References: Benesch 442; London 1992, cat.26,
pp.78–9

BRITISH MUSEUM, LONDON
(INV.NO.1891–7–13–9)

This is the only existing compositional study that
Rembrandt made for a known portrait painting of
a woman. The drawing is fascinating for what it
reveals about Rembrandt's working process on the
portrait. The high degree of finish of this sheet and
its close relation to the completed painting (see
cat.85) ruled out the idea that it was a true
preparatory sketch and led to the assumption that
it must have been conceived as a *modello* for
showing the sitter the format of the planned
portrait.[1]

The drawing does present some differences
from the final picture, however, such as the
absence of the lace cuffs and rosettes, the white
shape (presumably for the fan) in the woman's left
hand and an unexplained white area by her right
elbow.[2] X-rays of the painting show that some of
the differences now present between drawing and
picture were not there in an earlier stage of the
painting's composition. For example, the drawing
has the points of the lace collar descending rather
lower than they appear in the painted version but
the X-ray of the picture reveals that they did at
first fall to where the rosettes at the woman's waist
now are. However, the X-rays also show that the
composition took a somewhat different shape
before the one that appears in the drawing and
final work. The edge of the balustrade, which is
seen at the right of both drawing and painting,
was initially more of a rail which originally
extended almost completely across the front of the
picture, stopping just short of the left edge with a
downwards sweep. The left hand, at first without
the beribboned fan handle, was placed with the
fingers resting over the edge.

It seems, therefore, that Rembrandt used this
drawing to plan the changes he intended to make
to the painting which was already well underway
and may have seemed almost complete. Interest-
ingly, the frame shown around the portrait in the
drawing may perhaps presage the artist's experi-
mentation with a slightly different format for the
painting. It is known that the picture was trimmed
(quite possibly by Rembrandt, though perhaps
later) on all but the left-hand side. The drawing is
made in iron gall ink and because of its certain link
to the 1639 portrait has been used as a guide to the
dating of a number of other works in this medium
(see, for example, cat.76, 78 and 79). The extraor-
dinarily close stylistic similarity to another iron
gall ink drawing which can also be securely dated
to this period, Rembrandt's 1639 copy of

Raphael's *Baldassare Castiglione*,[3] may also be due
to the fact that Rembrandt was making both
drawings from existing paintings, albeit in the case
of this sheet, one which was not yet totally
finished.[4]

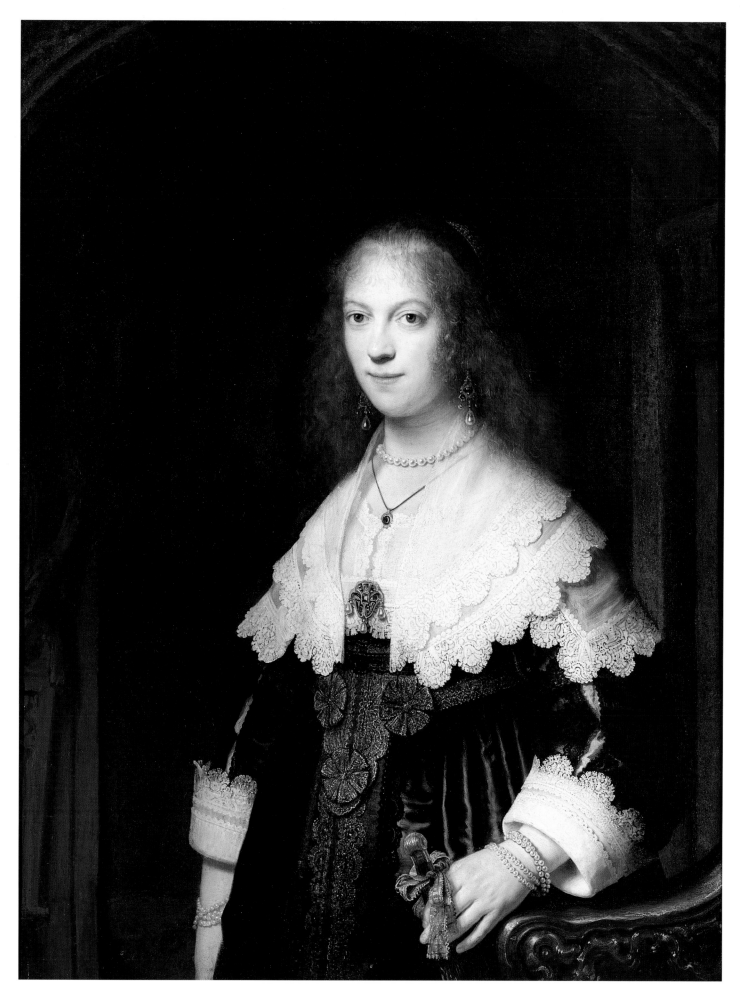

Cat.85

85 A Portrait of a Young Woman, probably Maria Trip, 1639

Oil on panel, 107 × 82 cm
Signed and dated, bottom left: *Rembrandt f 1639*
Reference: *Corpus*, vol.3, A131

RIJKSMUSEUM, AMSTERDAM
(INV.NO.SK-C-597)

This striking portrait is extraordinary in the sheer richness of its detail, the way each crisp curve of expensive lace is picked out in varying whites, the exquisite embroidery of the rosettes at the front of the black satin dress, the points of light captured in row upon row of gleaming pearls and the sumptuousness of the multicoloured woven ribbon which bedecks the handle of the subject's gilded fan. The sitter for this portrait was clearly a woman of enormous wealth and up-to-the-minute taste and elegance. However, even allowing that her high social status may have been a reason for paying special attention to her lavish costume and jewellery, this degree of detail is 'still a remarkable stylistic feature' as pointed out by the Rembrandt Research Project.[1]

The refinement with which Rembrandt modulates the light falling upon the figure gives a wonderful sense of plasticity, and the transition from the contours of the woman's dress into the darkness of the setting behind is extremely subtle, avoiding a hard-edged 'cut-out' effect in order to make her merge more convincingly with the background. As shown in relation to the study for the painting, Rembrandt was clearly experimenting with the way the woman relates to both her surroundings and also to the viewer. The hand placed upon the balustrade and the way the ribbons and the handle of her fan jut out of the picture plane towards us are both explorations of the perception of space within the picture which Rembrandt was considering at this time. One of the closest parallels is with another elaborately dressed woman whom Rembrandt painted in 1641, Agatha Bas,[2] who creates a similar *trompe l'œil* impression within the picture by leaning her hand against the edge of the painted picture frame. Rembrandt also used a related motif by placing his arm along the ledge in his own *Self-portrait* of 1640, partially inspired by Titian's so-called 'Ariosto' which was in the Amsterdam collection of Alfonso López until 1641.[3] The British Museum drawing shows that Rembrandt had initially placed his figure further away from the picture plane and more centrally. It may be that the changes displayed in the final painting, with the figure brought closer and her asymmetrical positioning within the composition the result of the panel being trimmed, may have related to Rembrandt's attempt to give the picture an immediacy of impact with the viewer.

The identification of the sitter as Maria Trip was first made by I.H. van Eeghen who looked for a relation to the first known owner of the portrait,

Hendrick Maurits van Weede of Utrecht (1737-1796), in whose descendants's hands the picture still is.[4] Maria Trip (1619-1683) was the only relative of the Van Weede family who appeared to fit the bill and if this interpretation of the genealogical evidence is correct, the painting would have come to the family through the female line.

Maria Trip would have been twenty years old when this portrait was painted, which seems feasible from the woman's appearance. She was the daughter of the hugely wealthy Elias Trip (1570-1636) and Aletta Adriansdr (1570-1656) who were also related to Margaretha de Geer (see cat.137). Maria married Balthasar Coymans in 1641 and when he died the same year she married Pieter Ruysch. Rembrandt also painted a portrait of Maria's mother Aletta, probably also in 1639, which is now on loan to the Boijmans Van Beuningen Museum, Rotterdam (fig.126).[5] Though areas of the picture are in rather poor condition, the portrait of Aletta is intriguing in comparison to that of Maria. Rembrandt experimented with the picture space in this portrait also, by placing her hand along the bottom edge of the painting, though not entirely successfully.

Aletta married Elias as his second wife in 1611 but she had been a widow for about three years by the time Rembrandt painted her portrait. There she wears a black cap and a large millstone ruff which would have been beginning to be somewhat outdated for the fashion of the time, although older women frequently continued to wear clothing which had been superseded by newer trends. Although it would have been unseemly for a widow to have been overly 'showy' in such a picture, the restraint of her portrait, both in scale and the relative simplicity of her attire, gives little clue that this was one of Amsterdam's richest and most influential women. Aletta had continued to run her husband's profitable iron and armoury business after his death, and her position in Amsterdam society was extremely high. Indeed, it was sufficiently elevated for Amalia van Solms, wife of the Stadholder Frederik Hendrik, to rely upon Aletta to provide accommodation for her in Amsterdam on the occasion of the visit of Maria de' Medici, widow of King Henri IV of France, to the city in 1638. Maria de' Medici's arrival in the city was greeted with great pomp and she made her '*joyeuse entrée*' into Amsterdam on 1 September 1638. (For some time it was believed that this was actually the direct cause of the commission of Rembrandt's *Night Watch*, and other paintings adorning the Great Hall of the Arquebusiers (*Burgerzaal in de Cloveniers Doelen*) in Amsterdam where the dowager queen dined on her visit to the city).[6]

We do not know why Aletta had her portrait painted but it is possible that celebration of the visit of Maria de' Medici may have had something to do with the commission. However, the picture of her unmarried daughter Maria may have been

prompted by different motives. Far larger than Aletta's portrait and unquestionably more glamorous, Rembrandt's magnificent portrait of this young woman, hung with pearls and fine jewels and bedecked in fine lace, cannot have helped but show her as a striking marriage prospect, her beauty matched by evident wealth.[7]

Fig.126 | Rembrandt, *A Portrait of Aletta Adriansdr*, 1639
Willem van der Vorm Foundation on loan to
Museum Boijmans Van Beuningen, Rotterdam

86 A Seated Woman, with an Open Book on her Lap, c.1639–40

Drawing, pen and brush and brown ink with wash,
12.6 × 11 cm
References: Benesch 757; Giltaij 1988, cat.15,
pp.66–7; Berlin/Amsterdam/London 1991–2,
vol.2, cat.17, pp.67–9

BOIJMANS VAN BEUNINGEN MUSEUM,
ROTTERDAM (INV.NO.R10)

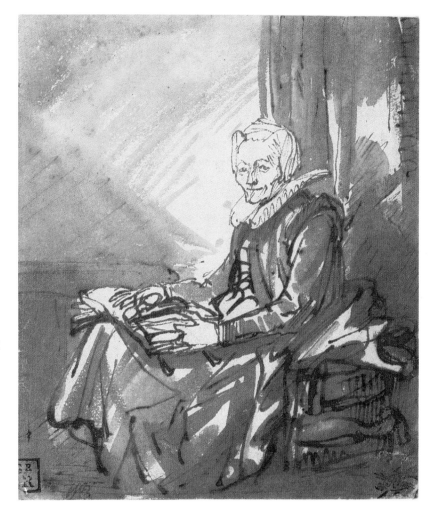

There are very few surviving drawings related to
portraits in Rembrandt's work. It is likely that this
is predominantly due to his working methods and
that he simply did not make many preparatory
drawings for portraits, most compositions
probably being set out directly onto the panel or
canvas. Certainly, a sheet such as the *Study for the
Portrait of a Young Woman, probably Maria Trip*
(cat.84), seems to have been made more to work
out the effect of changes on the portrait, rather
than as a preliminary study. Thus, apart from
drawn portraits within Rembrandt's family circle
and some preliminary sketches for etched portraits,
drawings like this are extremely scarce. The style of
the work links it closely to that of the study
mentioned above (cat.84), and can also be dated to
about the same period, c.1639–40.

It may be that the Rotterdam sheet also records
planned changes for a portrait in the same way as
cat.84. Rembrandt paid careful attention to the
setting of the composition, the fall of light upon
the wall behind the woman and the curtain
hanging behind her. She is dressed in a *vlieger*
surcoat with padded armholes known as shoulder
'wheels' (*bragoenen*) and wears a winged cap and
round ruff.[1] Though perfectly respectable, the
clothes would have begun to be a little dated by the
end of the 1630s, indicating a wealthy but not
necessarily worldly woman. The book is rather
sketchily drawn but it has clasps which can be seen
laid on her skirt just by her left hand, which keeps
her place amongst the pages, while she holds a pair
of glasses in her right hand, laid upon the right
page. The book is probably a Bible and this simply
dressed woman pausing for a moment during her
improving reading would have been perceived as
modest and god-fearing: a characterisation of quiet
piety. It is not known whether Rembrandt
completed a portrait of this woman as no related
painting is known to exist, though it was once
wrongly suggested that she represented
Margaretha de Geer (cat.137).[2]

87 *A Portrait of Titia (van) Uylenburgh*, 1639

Drawing, pen and brush and brown ink with wash,
17.4 × 14.6 cm
Inscribed and dated by the artist, bottom centre:
Tijtsija van Ulenburg 1639
References: Benesch 441;[1] Strauss/Van der Meulen
1639/13; Stockholm 1992–3, cat.142, pp.342–3

NATIONALMUSEUM, STOCKHOLM
(INV.NO.NMH2078/1863)

Exhibited in Edinburgh only

This is one of the very few annotated drawings by
Rembrandt which securely identifies the sitter as a
member of Rembrandt's wife's family. Titia was
Saskia's older sister, and was married to François
Coopal, the commissioner of Maritime Muster in
Vlissingen. Titia and her husband stood as godpar-
ents to Rembrandt and Saskia's first three children.
The first, Rumbertus, lived the longest but was
buried in 1636, some two months after his birth,
while the second, Cornelia, was baptised on 22 July
1638, but only lived for about a fortnight and was
buried in the same spot as her baby brother.[2]

This lively little study was made the following
year, though it is not known whether Titia may
have been staying with her sister when Rembrandt
drew her. Titia also attended the baptism of her
sister's third child, also christened Cornelia, on 29
July 1640,[3] but the little girl failed to thrive, dying
two weeks later and also buried in the Zuiderkerk,
on 12 August.[4] Titia herself died on 15 June 1641,
exactly one day short of a year before her sister
Saskia.[5] It is likely that Rembrandt and Saskia both
felt some affection for Titia since their next child,
Titus, born in 1641, was presumably named in her
honour. He was the only child of Rembrandt and
Saskia's marriage to survive to young adulthood. It
has also been suggested that Rembrandt's respect
for St Paul (which inspired many representations of
the saint throughout Rembrandt's life from, for
example, his *The Apostle Paul in Captivity* of 1628 to
his *Self-portrait as St Paul* of 1661) might have
prompted the choice of name of Titus, a disciple of
Paul's.[6]

Titia is shown here absorbed in her needlework,
leaning forward at a table, her pince-nez perched
perilously as she peers down in concentration at the
material in her hands. The drawing gives the
impression of a fluent sketch from life and
Rembrandt manages to convey the bright slanting
light by which she works, more by what he leaves
out of this spare scene than by what he includes,
the space left bare around her apart from the deep
shadow at her right and the hint of a table top in
front. But, this restraint may have been more
planned than it seems. It is possible that the
composition may have been influenced by a
drawing formerly ascribed to Veronese (fig.127)[7]
which shows similarities in the set of the arms
against the unseen table surface; or, probably more

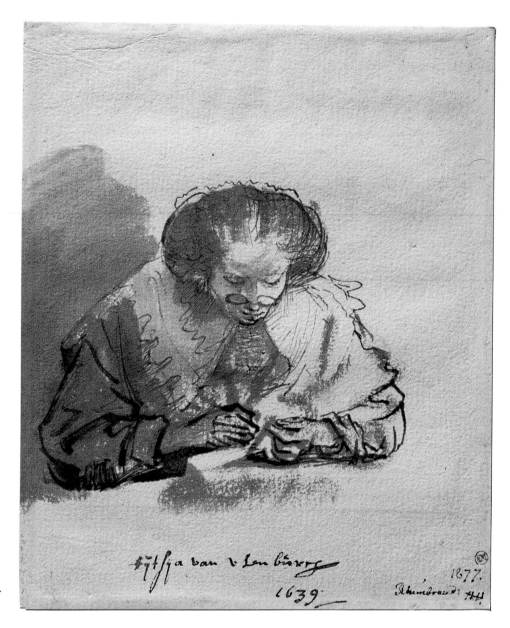

likely, by Lucas van Leyden's chalk drawing of a
Man Writing which Rembrandt may have owned
(fig.128).[8] The glasses balanced on the man's nose,
the shape made by the edge of his jacket and even
the overall form of his hat (partially followed by the
oval shape of Titia's coiffure), are all softly echoed
by the forms of Rembrandt's drawing of his sister-
in-law: a portrait sketch certainly, but one perhaps
loosely based upon the work of an artist he greatly
admired.

Fig.127 | Formerly ascribed to Veronese (1528–1588),
A Woman Sewing
Rembrandthuis, Amsterdam, on loan to the Rijksmuseum, Amsterdam

Drawing, pen and brush and brown ink, with grey
wash, 14.1 × 17.6 cm
References: Benesch 426; Berlin/Amsterdam/
London 1991–2, vol.2, cat.20, pp.78–80; Berge-
Gerbaud 1997, cat.9, pp.24–6

COLLECTION FRITS LUGT, INSTITUT
NÉERLANDAIS, PARIS (INV.NO.266)

Exhibited in London only

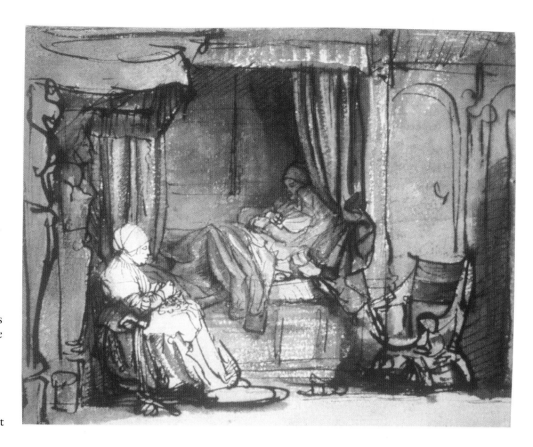

Only three drawings survive which are thought to
represent interiors of houses where Rembrandt
lived. All of them happen to feature women, two
probably showing Saskia in bed, the third possibly
showing Hendrickje Stoffels in the studio (see
cat.77 and 117). The first is believed to portray a
room in a house on the Binnen Amstel which was
called the '*Suijkerbackerij*' or 'Confectioner's'
(cat.77).[1] The fact that that drawing can be dated
rather earlier than the scene here, on the basis of its
style, has led to the reasonable supposition that the
Lugt collection sheet probably depicts a room in
the house in the Breestraat, now known as the
Museum het Rembrandthuis, which Rembrandt
bought in 1639.[2] The indications are that
Rembrandt and Saskia had been living lavishly for
some time and one of Saskia's relatives claimed that
she had 'squandered her parents' legacy on
ostentatious display and pomp'.[3] The couple
refuted this accusation soundly but admitted they
were 'quite well off and were favoured with a
superabundance of earthly possessions (for which
they can never express sufficient gratitude to the
good Lord)'.[4] Rembrandt had certainly been
acquiring expensive works for his own collection
and the move to the large house in the Breestraat
the following year must have been perceived as a
further step towards patrician status (even if the
area was becoming less fashionable amongst the
elite).

This drawing is outstanding in its complexities
of tone achieved through the precise handling of
wash and carefully judged areas left bare. The
whole is drawn with a consummate sureness of
touch: there are no corrections here. The woman
who lies propped up on pillows in the box bed,
presumably Saskia, arms folded and head bowed, is
in deep shadow, while the nurse or servant who sits
winding lace is bathed in sunlight which floods in
from an unseen window on the right. Behind the
empty chair are what appear to be two arched
doors, one perhaps a cupboard, while at the left a
fringed canopy hangs down from the large grey
mantelpiece, supported by two decorative herms.
Through the harmonious balance of the modulated
tones of grey and brown washes, the scene is
imbued with a sense of the tranquillity of a
domestic moment caught, and kept. The drawing is
generally dated to about 1640 to 1641, which
would be consistent from a stylistic point of view
and also coincides with Saskia's last two pregnan-
cies in those years.

Fig.128 | Lucas van Leyden (*c.*1489–1533),
A Man Writing
British Museum, London

89 An Old Woman with a Large Headdress, c.1640

Drawing, black chalk, 13.8 × 10.9 cm
References: Benesch 684; Seilern 1961, p.27;
London 1983, cat.19, pp.11–12

COURTAULD INSTITUTE GALLERY, LONDON
(INV.NO.D.1978.PG.191)

Exhibited in London only

This drawing was formerly thought to relate to a
painting in the State Hermitage Museum, St
Petersburg, *An Old Woman with a Book*, dated 1643.[1]
However, doubt was cast upon Rembrandt's
authorship of the painting and Abraham van Dyck is
usually cited as its likely artist. Horst Gerson also
doubted this drawing, but the assured handling and
strong sense of form in the way the figure is drawn
argue for Rembrandt's authorship nonetheless.

Rembrandt depicts the large headdress with soft
smudged chalk, giving an impression of the softly
bunched material, deepening the shadows with a
few dark, and in one case wetted, chalk lines,
making a strong contrast with the lightly drawn
white face which emerges from the folds. Severing
the link with the Hermitage painting of 1643 allows
consideration of the possibility that this drawing is
perhaps rather earlier than previously thought.
Though in red chalk rather than black, a drawing of
An Old Woman Seated in an Armchair now in the
Edmond de Rothschild collection at the Louvre
shows some similarities of handling (fig.129).[2] The
Rothschild sheet has generally been dated to the
latter part of the 1630s,[3] and although this drawing
may not be quite as early, the facial type is somewhat
related in the way the eyebrows are demarcated and
the chin defined. There is, however, no proof for the
suggestion that the woman in the Rothschild sheet
may be Rembrandt's mother who died in 1640 and
was buried in the Sint Pieterskerk in Leiden on 14
September.[4]

Fig.129 | Rembrandt, *An Old Woman Seated in an Armchair*
Musée du Louvre, Paris, Rothschild Collection. Photo: RMN-Michèle Bellot

90 *The Virgin and Child in the Clouds*, 1641

Etching with drypoint, only state, 16.9 × 10.6 cm
Signed and dated, lower centre: *Rembrandt f. 1641*
References: H.186; White/Boon B 61; Amsterdam/
London 2000–1, cat.43, pp.192–3

BRITISH MUSEUM, LONDON
(INV.NO.1973–U–929)

Rembrandt may have been inspired by a number of
sources for this composition, all from prints which
were probably in his possession. Dürer's title page
of the *Life of the Virgin* (which we know he owned),[1]
a print by Jan van de Velde after Willem Buytewech
and an etching of Federico Barocci's *Madonna and
Child* have all been suggested as having helped to
form Rembrandt's design.[2] The latter bears strong
similarities to Rembrandt's Madonna here,
particularly in the way the child is supported by the
Virgin's interlaced fingers and in the formation of
the cloud upon which she sits, so much so that
Rembrandt's etching has been described as 'a free
copy after Barocci'.[3] Given the strong similarities
between the compositions, it seems likely that the
Italian master's etching may have been amongst
those included in the book of 'copper prints by
Vanni and others including Barocci' which was
included in the inventory of Rembrandt's collec-
tion in 1656.[4]

The atmosphere in Rembrandt's etching,
however, is rather different from Barocci's version
where two *putti* look approvingly down at the
chubby Jesus and his beatifically smiling mother,
perched atop white and fluffy clouds. Rembrandt's
little Christ child is sleeping quietly, his fists
clenched, while the Virgin looks mournfully away
in another direction, dark storm clouds gathering
below. The way the baby lies across her lap,
wrapped in white cloth, is presumably a subtle
adumbration of the pose of the *Pietà* when Christ is
placed lifeless across his mother's knees. Mary
seems almost to be making a wordless appeal, in a
manner not dissimilar to Rembrandt's earlier
sketches of beggarwomen cradling their babies (for
example, cat.59). Inevitably, the way Rembrandt
drew other women with their infants subtly
affected the way he portrayed the Virgin and Child
as well. The year 1641 was also that in which Saskia
gave birth to Titus.

Rembrandt started etching this plate the other
way up but must have decided that the figure he
had begun was too small or badly placed upon the
plate, for the head is visible upside down at Mary's
left knee. The little face must have been for the
same subject, for it is suffused with an ineffable
sadness akin to that which we see on the Virgin's
face in the finished etching.

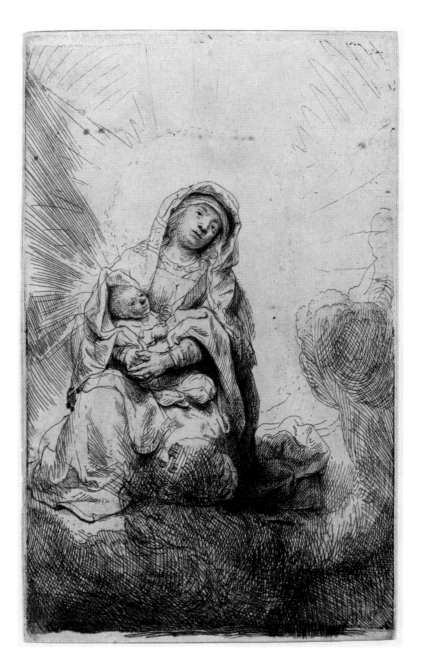

91　*A Woman Seated at a Table, c.1640*

Drawing, red chalk, 12 × 10.6 cm
References: Benesch 280e; Seilern 1961, p.20;
London 1983, cat.10, p.6

COURTAULD INSTITUTE GALLERY, LONDON
(INV.NO.D.1978.PG.185)

Exhibited in London only

This drawing was once thought to date from the
mid-1630s, partly because of the use of red chalk
which was believed to link it to sheets such as *Two
Studies of a Woman* of about 1635 (cat.45).[1] Having
once used red chalk frequently in his drawings,
particularly during his period in Leiden,
Rembrandt used this medium rarely after about
1640. The handling of this drawing, however, is
considerably more angular than in the works of the
mid-1630s and the heavily marked zig-zags of
darkened chalk on the woman's sleeve link it more
closely to Rembrandt's drawing style of the early
1640s. The viewpoint is rather unusual as
Rembrandt appears to be looking down upon the
figure. The pose of the head leaning upon the hand
is one that Rembrandt frequently drew, and its
possible links with a depiction of melancholy have
been pointed out before.[2] Here, however, the
darkly sketched-in eye and the straight, unsmiling
mouth, give an impression, rightly or wrongly, not
of mild creative musing but of a brooding bleakness
of expression.

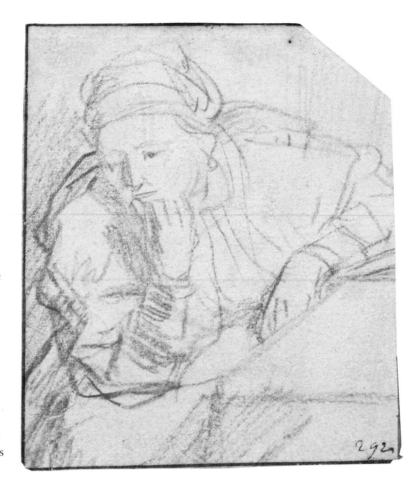

92　*A Sheet of Studies with a Woman Lying Ill in Bed, c.1641–2*

Etching, only state, 13.8 × 15 cm
References: H.163; White/Boon B 369; White
1999, pp.178–9

BRITISH MUSEUM, LONDON
(INV.NO.1973–U–904)

Having given birth in 1641 to Titus, her only child
to survive infancy, it seems that Saskia did not
recover properly from the experience. He was
baptised on 22 September 1641 and she died just
over seven months later.[1] As Dudok van Heel has
pointed out, seventeenth-century women often
gave birth more frequently than Saskia, who, for
that time, had slightly prolonged gaps between her
confinements.[2] Whether this was due to gynaeco-
logical problems or whether she was suffering from

tuberculosis as has been suggested, the many
drawings and this etching that Rembrandt made
showing a woman in bed suggest that she may
indeed have spent some time bedridden and, later,
ill.[3]

This shows Rembrandt using his etching plate
as a sketch pad, in the way he did with his *Three
Heads of Women, One Asleep* (cat.65); only here, his
placement of the groups is more extreme, turning
the plate though 90 degrees to complete the
different sketches. The etching shows the bed in
the reverse direction from those Rembrandt
depicted in most of his group of drawings of the
same subject (cat.41–4 and 46). Given the reversal
of image caused by the printing process,
Rembrandt would have drawn the bed straight
onto the plate the same way round as it appears in
those drawings. A small, quick sketch of a woman

asleep (Benesch 194, verso), which is very close to
the smaller of the studies of recumbent women on
this etching, shows the figure the other way
round.[4] The only drawing thought to depict the
property which Rembrandt bought on 5 January
1639, now the Museum het Rembrandthuis, is *An
Interior with a Woman in Bed* (cat.88). This shows the
bed in the opposite direction to the majority of
other drawings of this subject, and the bed in the
drawing of the room in the house they lived in
earlier is shown the other way round (see cat.77).
Whether this might have any implication for the
dating of this etching is difficult to tell. It is
generally linked to the period of the birth of Titus
in 1641 and Saskia's death in 1642, although it is
possible that it may have been made earlier and
thereby relate more closely to the majority of
sketches of this subject.[5]

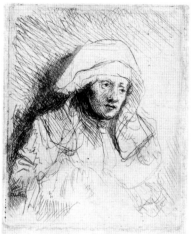

Etching, with touches of drypoint, only state, 6.1 × 5.1 cm
References: H.196; White/Boon B 359; White 1999, p.141

RIJKSMUSEUM, AMSTERDAM
(INV.NO.RP–P–OB–760)

This small etching relates to the little studies of heads which Rembrandt made in his early career (such as cat.1 and 2) but which were rarely repeated in his later work. It is possible that it represents Saskia in the last months of her life and, even if this is not the case, it is one of Rembrandt's most poignant and moving etchings. In this tiny format and with a few fine lines he sums up the pathos of this slumped, sunken-cheeked figure, looking gaunt, lacklustre and drained. Slight retouching with the drypoint needle indicates that Rembrandt regarded the etching as complete, requiring no more work despite its sketchy informality.[1]

Saskia made her will just over seven months after the baptism of her son Titus, on 5 June 1642.[2] In it she was described as 'ailing in bed' and she died only nine days later. She would have been thirty that summer. Saskia's half of the couple's goods was bequeathed to her son but the bequest was given over to Rembrandt's care with no imposition of an inventory or of any legal necessity for accountability on Rembrandt's part. She left him as sole guardian, despite the normal requirements for two to be appointed, and the Chamber of Orphans who normally oversaw such cases were excluded from this one.[3] The only restriction that was imposed was that, while Rembrandt was granted full powers over her property and any benefit that might come from it, this right was forfeited if he were to marry again. This was perfectly common where there was a child of the union, and the rest of Saskia's will shows that she trusted her husband, but it is quite possible that any future remarriage lost much of its attraction for Rembrandt as a consequence.

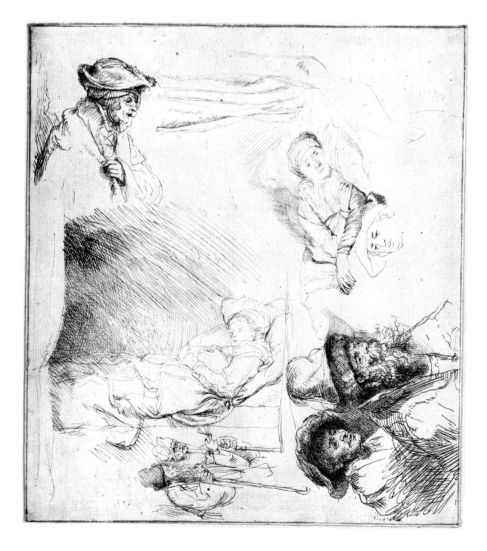

Cat. 92

94 'Preciosa' (Ruth and Naomi), c.1642

Etching, only state, 13.3 × 11.3 cm
References: H.184; White/Boon B 120

BRITISH MUSEUM, LONDON
(INV.NO.1842–8–6–142)

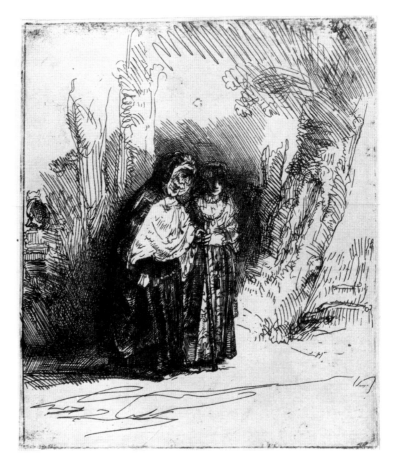

This little scene has been interpreted in numerous ways. Apart from the obvious depiction of youth and age, that was earlier discussed in relation to Rembrandt's *Heroine from the Old Testament* (cat.20), it seems that these two figures in a landscape may illustrate a particular tale. The traditional interpretation followed early print catalogues, describing the scene as 'taken from a Spanish story, which has been wrought into a Dutch tragedy.'[1] Miguel de Cervantes's *La Gitanilla* (The Little Gypsy Girl), who is also known as 'La Preciosa', describes how a young, beautiful girl is 'adopted' by a wizened gypsy who walks with her in a valley near Madrid where she is admired by (and then married to) a young nobleman, who later discovers she is of noble birth. This tale formed the basis for Jacob Cats's *Spaens Heydinnetje* (The Spanish Gypsy Girl) which was published in Dordrecht in 1637; and the story was also used by Mattheus Ganzneb Tengnagel in his play *Het Leven van Konstance … De Spaensche Heidin* (The Life of Constance … The Spanish Gypsy) which was performed in 1643.[2] However, despite the suggestion that this etching was commissioned to illustrate the play, it did not appear in Tengnagel's publication.[3] A drawing in the Musées Royaux des Beaux-Arts, Brussels, has been supposed to be a study related to the etching.[4] However, the younger woman seems to be very dark-skinned in the sketch, whereas Cervantes's heroine was notable for her fair, untanned complexion, which was all the more remarkable for a gypsy subject to the vicissitudes of sun and wind. It was this fair complexion which was taken as an indication of her high birth.

However, if one ignores the early descriptions of the print, another convincing interpretation of the scene is that it shows the young Ruth and the elderly Naomi.[5] Ruth, after her husband's death, remained loyal to her mother-in-law, travelling with her to a foreign land (Ruth 1: 16). Rembrandt's master Pieter Lastman had painted this subject in 1614 and Rembrandt's pupil Willem Drost (*fl.*1640–1680) also produced an interpretation of this theme (now in the Ashmolean Museum, Oxford) which relates to Rembrandt's etching.[6]

95 A Girl with a Basket, c.1642

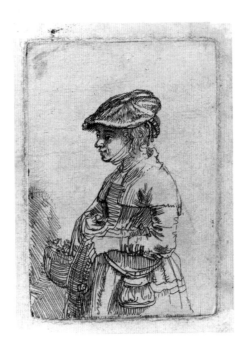

Etching, second state (of two), 8.7 × 6 cm
References: H.195; White/Boon B 356:II

RIJKSMUSEUM, AMSTERDAM
(INV.NO.RP–P–OB–753)

This small etching is an engaging study worked up with little hatching and the whole given a light and airy sense from the space left bare on the plate and the light pouring in from the right hand side. The woman carries a basket over her right arm while a purse dangles on her left hip from the belt hanging from her waist. The figure, perhaps in conjunction with the etching of *'Preciosa' (Ruth and Naomi)* cat.94, appears to have prompted a drawing, now usually attributed to Ferdinand Bol, in the Nationalmuseum, Stockholm, *An Old Woman and Young Woman in Conversation*.[1] The older woman there seems to have been adapted from the figure here, while keeping the characteristic hat and baskets.

Drawing, pen and brush and brown ink with wash, 21.4 × 16 cm
References: Benesch A10; Mongan/Sachs 1946, cat.525, p.276

FOGG ART MUSEUM, HARVARD UNIVERSITY
ART MUSEUMS, CAMBRIDGE
Gift of Meta and Paul J. Sachs
(INV.NO.1949.4)

Despite Benesch's supposition that this drawing was perhaps by Jan Lievens or Jacob Backer, his previous statement that its 'extraordinary quality … seems to leave no choice of attribution except that to Rembrandt' still holds good. It was also described by I.Q. van Regteren Altena as 'one of the most powerful studies on paper that one knows by Rembrandt'.[1] Benesch found it difficult to fit the drawing into a chronology of Rembrandt's work mainly because he would have expected the sinuosity of line to have been executed in chalks rather than pen. However, allowing for this difference in medium, the assured handling found in drawings such as the *Nude Woman with a Snake* of *c.*1637 (cat.71), the twisting intricacies of her headdress and the snake twined about her, are not unlike the serpentine coils of the coiffure of the three heads of the young girl on the Fogg sheet. The head of the young woman seen from the back who sits at the far right of the etching of the *Death of the Virgin* of *c.*1639 (cat.83) is also very close in form to the sketch of the girl at the bottom right of the drawing here. Rembrandt's evident enjoyment in tracing the form of the complicated curls with interwoven bands (not unlike the bound-up hair of Bathsheba, see fig.48) follows the tradition of earlier artists, such as Leonardo and Raphael.

The head of the old woman at the top right of the Fogg drawing has been compared to the head

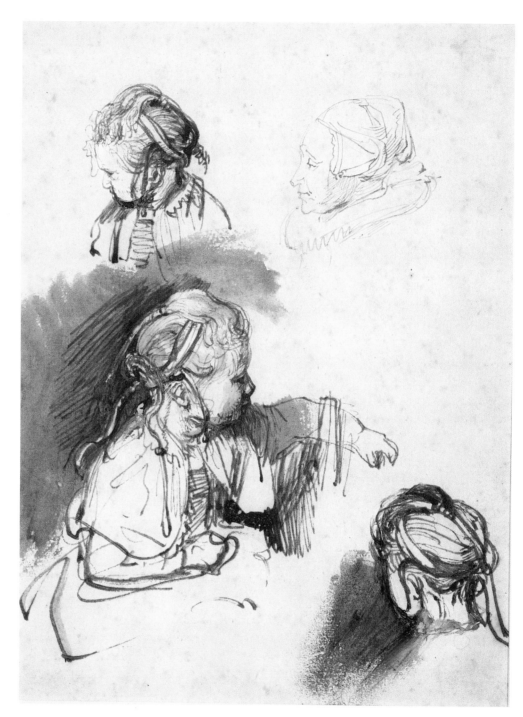

Fig.130 | Rembrandt, *Cornelis Claesz Anslo 1592–1646 and his Wife Aeltje Gerritsdr Schouten 1589–1657* (detail, see also fig.69)
Gemäldegalerie, Staatliche Museen zu Berlin, Preussischer Kulturbesitz
Photo: Jörg P. Anders

of Aeltje Gerritsdr Schouten, the wife of Cornelis Claes Anslo, in Rembrandt's double portrait of 1641 (fig.130).[2] The cap and profile are somewhat similar, although the face of Anslo's wife is turned more towards the viewer, with both eyes visible, and it seems unlikely that the sketch is directly related to the final painting.[3] Interestingly, however, Anslo's original commission appears to have been for two pendant portraits; the study for his portrait, made in 1640, is now in the Edmond de Rothschild Collection in the Musée du Louvre, Paris.[4] Given that the sketch shows Anslo animat-edly talking towards an unseen listener, it has been thought that there would have been a sketch for Aeltje's portrait, probably showing her listening to her husband as she does in the final work.[5] It is conceivable that the head of the Fogg woman might have related to such a compositional sketch in some way.[6] Though an identification of the old woman here as Aeltje cannot of course be proved (still less an implausible suggestion that she shows Margaretha de Geer),[7] the restrained pen strokes in the depiction of the old woman's face point to a date of the early 1640s for the lively Fogg drawing.

Etching, first state (of four), 11.6 × 14.3 cm
Signed and dated, bottom right centre (in the
second state): *Rembrandt. f 1642* (the '2' in reverse)
References: H.200; White/Boon B 188:1; Amster-
dam/London 2000-1, cat.46, pp.200-3

BRITISH MUSEUM, LONDON
(INV.NO.1973-U-956)

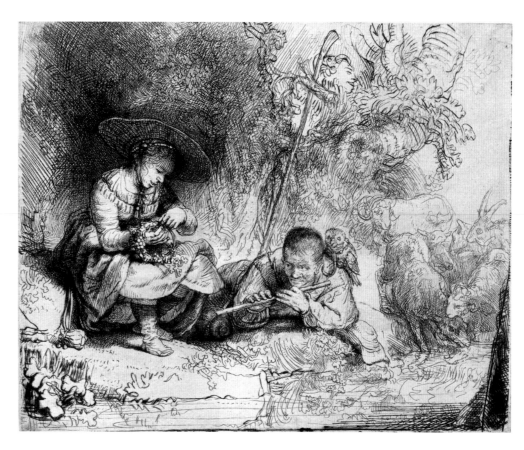

From about 1640 Rembrandt appears to have had a
growing interest in the portrayal of landscape, and
his genre scenes set outdoors begin to appear to be
predominantly rural rather than urban in location.[1]
His first landscape etching is dated 1641 and the
majority of his landscape drawings sketched from
life appear to have been made during a twelve year
period, from about 1640 to 1652, the latter date
also being that of his last landscape etching.[2] *The
Flute Player*, while not a landscape as such, echoes
this growing interest. At first sight it looks like an
ideal Arcadian scene, a pastoral idyll where the heat
of the day causes the gentle rustics to pause by a
stream to water their herd, playing music and
gathering flowers to plait into a nosegay.
Rembrandt may have seen a similar pastoral scene
during his training – Pieter Lastman's painting of
1624 of a pair of country lovers with their flock of
sheep.[3] Rembrandt was certainly aware of the
pictorial tradition for this sort of Arcadian genre, as
is probably indicated by his own earlier paintings
depicting Flora, and a picture by him described as
'A Shepherd's Path' was listed in his inventory of
1656.[4]

Closer inspection of the etching reveals that this
scene is not quite so innocent as it seems. The
shepherd, probably based on an anonymous
woodcut after Titian of *A Shepherd Playing the Flute*,
is fingering the instrument rather than playing it,
suggestively pointing it between the girl's legs as
he leers up her skirt. The harmony of love indicated
by pipe-playing, shown in, for example, Titian's
Three Ages of Man, had already hinted at erotic
meaning but here Rembrandt portrays it far more
blatantly (fig.131).[5] This is compounded by other
pictorial symbols within the composition that
would have been easily understood by a contempo-
rary viewer. The garland that the girl makes was
offered as a token of love but was also synonymous
with the offer of her body to her lover (and thence a
symbol of female sex) and the purse lying on the
ground had a similar erotic charge.[6] It may be that
Rembrandt deliberately intended to satirise the
'Little-Bo-Peep' pastoral genre by making this
etching a brazen bucolic peep show.[7]

The print was known from very early in its
history as *Eulenspiegel* (Owl-mirror), from the
traditional folk-tale of the wily fraud, Till
Eulenspiegel.[8] Rembrandt had bought a rare but
renowned print nicknamed the *Eulenspiegel* by
Lucas van Leyden for 179 guilders, a huge amount

of money, in 1642, the same year that he etched *The
Flute Player*.[9] It is possible that the motif of the owl
upon the shepherd's shoulder was inspired by his
newly acquired print. Though *The Flute Player* does
not represent the Eulenspiegel story, there are
parallels. To play 'Eulenspiegel's flute' meant to
talk untrustworthy rubbish,[10] and the collar and
bells around the owl's neck probably stand for folly
and wickedness.[11] The sheep running unchecked
with what appears to be one goat may be a refer-
ence to the Biblical 'sorting the sheep from the
goats'. Those who let them run together are failing
in their job, as is this shepherd so clearly.

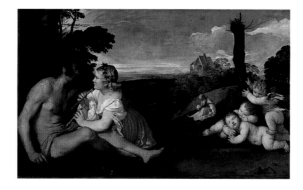

Fig.131 | Titian (*c*.1485/90-1576),
The Three Ages of Man, *c*.1514
Duke of Sutherland Loan to the National Gallery of Scotland,
Edinburgh

It is not known whether the face high in the
foliage to the right was left on the plate from a
former composition or whether it was intentionally
added as a voyeur upon the scene (partially hidden,
like Susanna's Elders). Rembrandt had not quite
finished the etching in the first state, since he did
not sign it until the second. He reworked the
shading above the woman's hat in the second and
third states of the etching, which were all done in
fairly rapid succession, and eliminated the lurking
face from the trees in the fourth state which seems
to have already been completed by about 1643.[12]

98 *The Sleeping Herdsman, c.1644*

Etching and burin, only state, 7.9 × 5.7 cm
References: H.207; White/Boon B 189

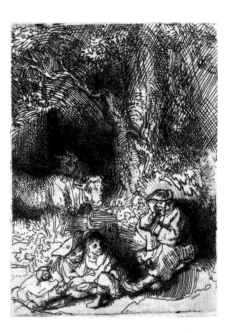

The rather earthy side of pastoral attraction was
again explored by Rembrandt in this little etching.
The scale is so small that it appears at first to be a
relatively innocuous scene. Two cows chew the cud
in the shade of the trees and an old man snoozes,
his head resting on his hand, as a couple cuddle at
the left. It is only once one ascertains whose limbs
are where amongst the lightly etched lovers that
the lewd nature of the print becomes clear. From
their smiles, the couple are obviously enjoying the
clandestine embrace tempered by the thrill of
proximity to the old man, but it is not completely
certain that he is actually sleeping, one eye
uncovered.

The Flute Player and *The Sleeping Herdsman* were
not the only etchings containing erotic incident
which Rembrandt made in the 1640s (see also
cat.108 and 109). His landscapes of *The Three Trees*
dated 1643,[1] and also *The Omval*, dated 1645,[2] both
contain entwined lovers partially hidden amongst
bushes and undergrowth. The Omval was a
recognisable area, a spit of land on a junction of the
River Amstel at the south-east of Amsterdam. To
place lovers in such a specific contemporary scene
was perhaps the most surprising, moving away
from the historically imprecise and therefore more
pastoral location seen in *The Sleeping Herdsman*. It
has been noted that Rembrandt's new interest in
erotic subject matter coincided with the aftermath
of Saskia's death in June 1642.[3]

Oil on canvas, 117 × 91 cm
Signed and dated, bottom left: *Rembrandt f.1645*
References: Bredius/Gerson 570; Toledo 1997–8

STATE HERMITAGE MUSEUM,
ST PETERSBURG (INV.NO.741)

Rembrandt's drawings of the daily lives of women and children, some made from life, some from memory, must have informed his choice of how to depict that most famous of mothers, Mary, with her baby, Jesus, and acted as a starting point for various compositions of the Holy Family in different media. Here Rembrandt emphasises the intimate domesticity of the group, placing the scene in a simple carpenter's shop, the same setting he had employed earlier in his Munich *Holy Family* (cat.26A).[1]

The observation of everyday details is remarkably controlled and precise. Rembrandt pays great attention to the shape and surface of the objects in the room, such as the wooden floorboards that run across to the tiled hearth, the woven wicker of the cradle, the foot warmer, and the little bowl with a spoon on the floor at the right, from which the baby has perhaps just been fed. The workshop behind is only partially lit but the drill hanging on the wall

Fig.132 | Rembrandt, *The Holy Family with a Curtain*
Gemäldegalerie Alte Meister, Staatliche Museen, Kassel
Photo: Ute Brunzel

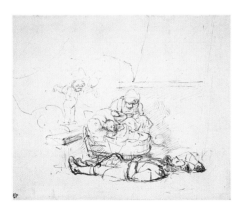

Fig.133 | Rembrandt, *The Holy Family Sleeping, with Angels Appearing to Joseph in a Dream*
Reproduced by permission of the Syndics of the Fitzwilliam Museum, Cambridge

and Joseph's workbench are just visible. The flames of a fire can be seen at the right, throwing a soft glow on the edges of the simple objects around it. (The Munich picture also originally contained a fire burning at its left side, where Mary held her baby's feet to warm them, but the fire is no longer visible since the picture was trimmed.) Here, Jesus slumbers, draughts kept out by the rich cloth that hangs over the hood of his cradle. He is snug in a fur-backed, bright red blanket to which the eye is immediately drawn, making him the visual focus of the composition. One assumes from the context of the painting that the volume that Mary holds is a book of scripture, corroborated by its size and the double columns of text upon the page.

In the Munich painting Rembrandt gave no visible indication of the sacred (no haloes, no supernatural light), but in this picture painted some ten years later, daily life and religious imagery are more obviously combined, a group of little angels hovering watchfully at the left. The foremost outstretches his arms as if to slow himself down, a charming gesture that takes on chilling implications if linked to the pose of Christ on the Cross. The angels have their antecedents in Rembrandt's *The Ascension* of 1636, one of the series painted for the Stadholder Frederik Hendrik.[2] The air of sanctity within the scene is emphasised by the diagonal flow of light from the angels to Mary, echoed in the opposing diagonals of her movements, as she leans towards the cradle. As Christian Tümpel noted, 'all the suspended, hovering elements come to rest in the focus on the sleeping child.'[3]

Joseph is only described as a carpenter once in the Gospels. However, the pictorial iconography of the Holy Family often shows him in his workshop, sometimes making items that are linked with the destiny of Jesus. Here he is seen hewing a yoke out of wood with his hand axe. This has been seen as symbolising the yoke bearing the burden of Israel which the Old Testament foretold the Messiah would break.[4] The best known Biblical passage which cites this is in the Book of Isaiah (9: 2–6): 'The people that walked in the valley of darkness have seen a great light: they that dwell in the land of the shadow of death, upon them the light hath shined … For thou hast broken the yoke of his burden … For unto us a child is born, unto us a son is given … and his name shall be called Wonderful, Counsellor, The mighty God, The everlasting Father, The Prince of Peace.' Perhaps reinforcing this Biblical allusion to light, it is notable that the little hearth fire at the right is pale in comparison to the brightness that emanates from the angels which illuminates Mary's head and the pages of the book she holds.

Although he dealt with this subject a number of times in prints and drawings, the Holy Family rarely appears in Rembrandt's paintings as a theme. Apart from the Munich painting mentioned earlier,

this picture of 1645 is the only large painting on this theme by Rembrandt that is still universally accepted as authentic. A painting at Kassel, *The Holy Family with a Curtain* of 1646, appears to derive so many of its motifs from the Hermitage picture, while at the same time presenting various stylistic anomalies, that it has now been questioned as Rembrandt's work (fig.132).[5] Rembrandt did portray the Holy Family in a different context in his *Adoration of the Shepherds*, now in the Alte Pinakothek, Munich.[6] This was one of the last of the series to be completed for the Stadholder and was paid for in November 1646.[7]

This compelling theme was clearly popular at the time amongst Rembrandt's pupils. Two paintings formerly believed to be by Rembrandt, one in the Louvre,[8] and one in the Rijksmuseum, Amsterdam,[9] both represent the Holy Family in an interior, showing just how influential Rembrandt's particularly domestic version of this topic was. The rejected Louvre painting contains a hooded cradle almost identical in type and positioning to the one in the Hermitage painting, presumably copied from Rembrandt's original. A painting of a woman's head which relates to the pose of the head of Mary in the Hermitage work is also now believed to be by a pupil.[10]

Two drawings are generally quoted in connection with the genesis of Rembrandt's *Holy Family*. One of these is usually supposed to have been a compositional sketch for the picture in the Musée Bonnat, Bayonne, although the elements of angel, Joseph, and Mary with the cradle seem rather oddly assembled – almost as separated elements rather than relating to one another.[11] The second, *The Holy Family Sleeping with the Angels Appearing to Joseph in a Dream* in the Fitzwilliam Museum, Cambridge, is not preparatory for the Hermitage work, though the rather angular angel is loosely related to one in the composition (fig.133).[12] A sheet dating to the mid-1640s in the Ecole des Beaux-Arts, Paris, which is now generally attributed to Ferdinand Bol, also has an angel who is similar to that in the Hermitage painting.[13] Bol was clearly taken with the theme, making a drawing of a *Holy Family in an Interior*, now in Darmstadt, of about the same period, which links closely to the rejected Louvre painting.[14] Rembrandt's workshop was also probably aware of other drawings the master made related to this subject, such as his *Holy Family in the Carpenter's Workshop* of c.1645, in the British Museum.[15]

It is not surprising that the Hermitage *Holy Family* should have had such an impact. Was its emotional appeal possibly augmented by nostalgia on Rembrandt's part for a life which was no longer his after Saskia's death, or was it perhaps prompted by new-found happiness with Geertje Dircks? Who can tell? As an image melding family domesticity with quiet sanctity, the painting has a subtle and poignant power that continues to weave its charm.

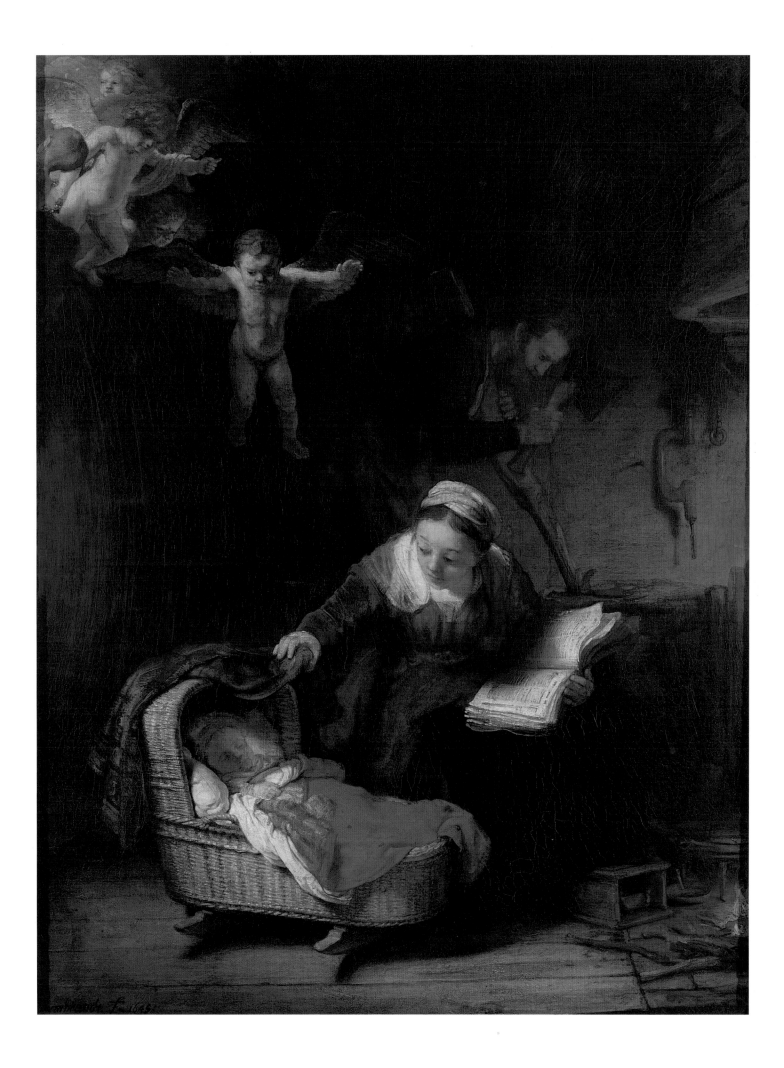

Oil on canvas (arched top), 81.1 × 67.8 cm
Signed and dated, lower left: *Rembra[…]f. 164[…]*
References: Bredius/Gerson 110; Berlin/Amsterdam/London 1991–2, cat.36, pp.230–2; Melbourne/Canberra 1997–8, cat.14, pp.130–3

NATIONAL GALLERY OF SCOTLAND,
EDINBURGH (INV.NO.NG 827)

A Woman in Bed has the peculiar honour of having been thought to represent all three women in Rembrandt's life: his wife Saskia, his son's nursemaid Geertje Dircks and the servant girl Hendrickje Stoffels. While the painting has never been doubted as an authentic work by Rembrandt, questions concerning the subject matter, the date and the model still remain. The final letters of the signature and the last figure of the date lie on the line of an old tear. The digit before the last has been read as a '3', a '4' and a '5'. The canvas appears to have once been stuck down onto boards fixed together vertically, with one more placed horizontally at the top to make up a rectangular panel (later removed). No tacking edges survive but the work seems always to have been arched at the top and it was certainly in its present format when it was included in a pastel portrait of 1757 by Jean-Etienne Liotard (1702–1789) of its then owner François Tronchin (1704–1798).[1]

The date as far as Tronchin was concerned was 1641,[2] whereas when Richard Cooper drew the painting in the collection of Lord Maynard (preparatory to his print of 1781),[3] he wrote '163 something', while Hofstede de Groot believed it to read 1657.[4] But the date is certainly '164–'. For many years the apparently intimate nature of the subject matter led to the belief that the picture showed 'Rembrandt's Mistress', as inscribed on

another drawing by Richard Cooper (fig.134).[5] The possible female candidates proposed have clearly depended on the perceived date of the painting. Trivas thought Tronchin's dating of 1641 meant that the picture must represent Saskia who died the following year.[6] She had probably been the model for a number of drawings showing a woman in bed, which, though not precisely linked to this painting, can be said to provide a background out of which the composition grew (for example, cat.41, 42, 43 and 44). However, stylistically the Edinburgh picture is unlikely to date from the early 1640s, relating more closely to the handling in, for example, the *Girl at a Window*, dated 1645 (cat.104). The *Woman in Bed* is now generally thought to have been painted between 1645 and 1647, with most opting for the earlier date.[7] If this is correct, then the often-cited identification of the model as Hendrickje Stoffels must also be called into question since the first mention of her in Rembrandt's household was in October 1649 (when she was twenty-three), though she probably started her work as a servant girl there somewhat earlier.[8] While no documented portrait of Hendrickje survives, she may have been the dark-haired, dark-eyed sitter who appears in various guises with regularity in Rembrandt's work from the 1650s, a type which does not particularly resemble the woman here.

The last proposed model is Geertje Dircks, who was certainly part of the household by 1 November 1642.[9] No firmly identifiable portrait of her is known to exist either, though it has been suggested that two drawings of a woman in regional dress may represent her (cat.80 and 81). On 28 March 1647, records of the notary Justus van der Ven state that a Martin van den Broek promised to hand over five Rembrandt paintings to Andries Ackersloot in exchange for boat supplies. The fourth listed is a

'*minnemoer van Rembrant*', which can be translated either as 'Cupid's mother by Rembrandt' (i.e., a painting of Venus) or as 'Rembrandt's children's nurse'.[10] It has been suggested that this may be Geertje, and perhaps refers to the Edinburgh picture.[11] If the model were connected with Rembrandt's household (which is not certain), then the most likely candidate would seem to be Geertje Dircks. But, though archival sources do imply that Rembrandt painted her and drew her at least once, it is simply not known what she looked like.

The subject matter of *A Woman in Bed* has remained as elusive as the identity of the sitter. A semi-naked woman with a slightly lined forehead looks out at us from behind a curtain. The bed is richly decorated, the bedlinen intricately embroidered and hung with elaborate curtains which she raises with one large hand, a curiously intimate gesture, as if beckoning. She is dressed in a plain shift and her only adornment is a gilded cap which resembles an upturned ornate metal fruit-basket, with a suspended chain handle encrusted with jewels. Research into seventeenth-century headdresses and Jewish ceremonial wear has provided no clues – it seems to be Rembrandt's invention. The bed is not dissimilar to that found in the *Danaë* (fig.46). Though started in 1636, Rembrandt considerably re-worked that composition, probably completing the alterations by 1643.[12] In the light of this, it is notable that the pose of the woman here shows similarities to Danaë, both set in lavish beds. However, the closest link as far as the pose is concerned is certainly to that of Sarah in Pieter Lastman's *The Wedding Night of Tobias and Sarah* (fig.135).[13]

This may also be the source for the iconography of Rembrandt's composition.[14] As told in the apocryphal Book of Tobit, the devil Asmodeus slew each of Sarah's seven husbands on their wedding night.[15] She was destined to be always a bride but never a wife until Tobias and the archangel Raphael put the devil to flight, as shown in Lastman's painting where all the clues to the story are intact. Rembrandt, however, seems to eliminate all details except for the opening of the bedcurtain, with Sarah waiting in hopeful anticipation to see if Tobias has survived. There is no indication that Rembrandt showed any more of the story than we see now and such a 'reduced' quotation from another picture was most unlikely to have been recognised by even the most informed of viewers (unless the picture was painted for a patron who actually owned, or knew, the Lastman). However, the coincidence with Lastman's *Tobias and Sarah* seems too overwhelming to ignore completely, and the least one can say is that Rembrandt must, at any rate, have known Lastman's picture and borne it in mind for his composition of *A Woman in Bed*.

A newspaper journalist reviewing the painting in the Wertheimer sale at Christie's in London, on 19 March 1892, noted how 'one coarse hand is putting

Fig.135 | Pieter Lastman (1583–1633), *The Wedding Night of Sarah and Tobias*, 1611
Juliana Cheney Edwards Collection. Museum of Fine Arts, Boston

Fig.134 | Richard Cooper (1730–1820), *Rembrandt's Mistress*
National Gallery of Scotland, Edinburgh

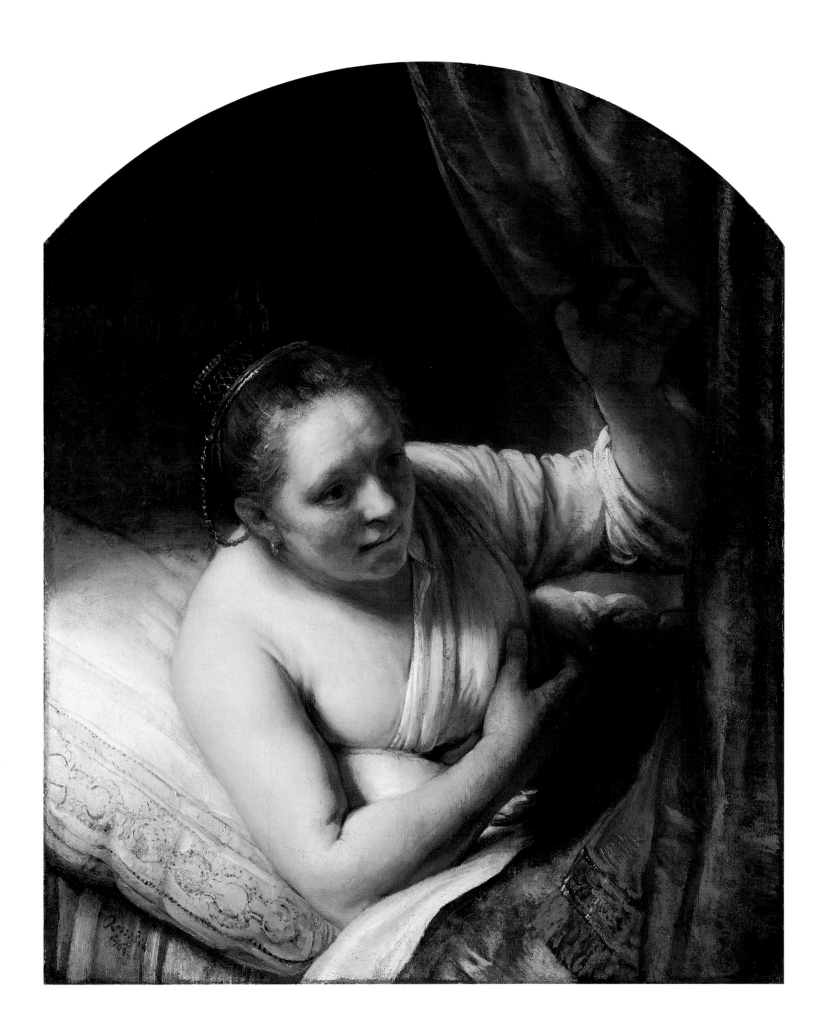

aside a heavily fringed curtain and half rising from her bed. The stereoscopic effect is marvellous.'[16]

It may be that the creation of this *trompe l'oeil* effect was the artist's primary concern and that reference to a historical subject was less important, just as may have been the case in the *Girl at a Window* (cat.104).[17] Intriguingly, a description of how to achieve such visual 'deception', as Rembrandt's pupil, the artist and theorist Samuel van Hoogstraten (1627–1678) was to call it,[18] was provided by Franciscus Junius's *De pictura veterum*, which appeared in a Dutch translation in 1641, the year before Rembrandt's completion of *The Night Watch*.[19] There it is noted that 'a girl's breasts or an outstretched hand' are given 'a distinct shadow' to make them stand out, advice which Rembrandt certainly follows in the *Woman in Bed*. While the coarseness of her hands has been noticed (at odds with the opulent surroundings), it may be that the rough manner of their painting was to emphasise the perspective in the way that Hoogstraten had recommended, namely, that 'that which is to appear in the foreground, be painted roughly and briskly, and that which is to recede be painted the more neatly and purely the further back it lies.'[20]

Nonetheless, presumably the richness of the setting, combined with the half-naked woman, would have been sufficient to suggest that the painting had some narrative context and the hint of a Biblical, mythological or historical theme was perhaps enough to render the woman's undress partially acceptable, though it is also possible that she may represent a courtesan.[21] The process is a subtle one; the erotic element of such works was presumably enhanced by the blurring of such narrative boundaries, forcing the emotional and visual focus emphatically upon the figure itself, as Rembrandt was to do so forcefully with his illusionistic effect here. Not all have seen the *Woman in Bed* as a beauty, however. Tronchin had remarked of Rembrandt's *Danäe* (fig.46) in his 1771 catalogue of the pictures from the Imperial Palace in St Petersburg, that it was a great pity that Rembrandt had not 'employed the magic of his colours on a more beautiful model', and it is interesting that the Liotard pastel markedly refines the features and form of the *Woman in Bed*. Richard Cooper was honest enough to admit on his drawing of the picture that he had '*Engraved this in mezzotint – same size as this – made this face handsomer than in the Original*'.[22]

It remains unclear whether this was meant to be seen as an openly erotic image, what the subject might have been, as well as the identity of the model, but it is Rembrandt's perfectly judged ambiguity in figure and theme that, ultimately, continues to capture the imagination.

Drawing, pen and brown ink, 23.2 × 17.8 cm
References: Benesch 407; Schatborn 1985, cat.27, pp.62–3

RIJKSMUSEUM, AMSTERDAM
(INV.NO.RP-T-1889-A-2056)
Exhibited in Edinburgh only

As is seen so often in his drawings, Rembrandt sketched in the figures first with fine strokes of the pen. These are visible, for instance, under the headdress of the woman who stands at the half door in the archway. Once the general shape had been established with these fine, pale lines, the artist then went over the sheet, defining the edges of the cap, for example, in three bold curves in dark ink. The seated old woman looking down is drawn rather precisely, with a sunken cheek and a deep crease of jowl. However, the figure which Rembrandt drew in front of her is more schematically depicted and the little child in the foreground even more so. These varying degrees of finish are used to build the drawing up into a balanced composition which Rembrandt completed with the provision of a setting, namely the hastily sketched archway. This, with the lines at the left of the drawing, indicates that the figures are sitting just inside the entrance to a house; a bench is placed nearby upon which the old woman rests her hand. Looking down in reflective mood, she is the eye of the calm in this peaceful scene.

The lower figures are given far less definition and it is not entirely certain in what occupation the woman seated on the floor is involved. She is perhaps sewing, while the child has been described as sitting on the pot, although this is equally indistinct.[1] Despite the apparent informality of this scene, the arrangement of the toddler, young adult and older woman upon the sheet has a considered quality which perhaps recalls traditional depictions of the Virgin and Child with St Anne. Though the figures are clearly partly inspired *naer het leven* (from the life), they are combined at the same time with elements that are consciously composed. Here, as in other drawings of women and children, Rembrandt perhaps subtly blurs the distinction between daily life and religious imagery.

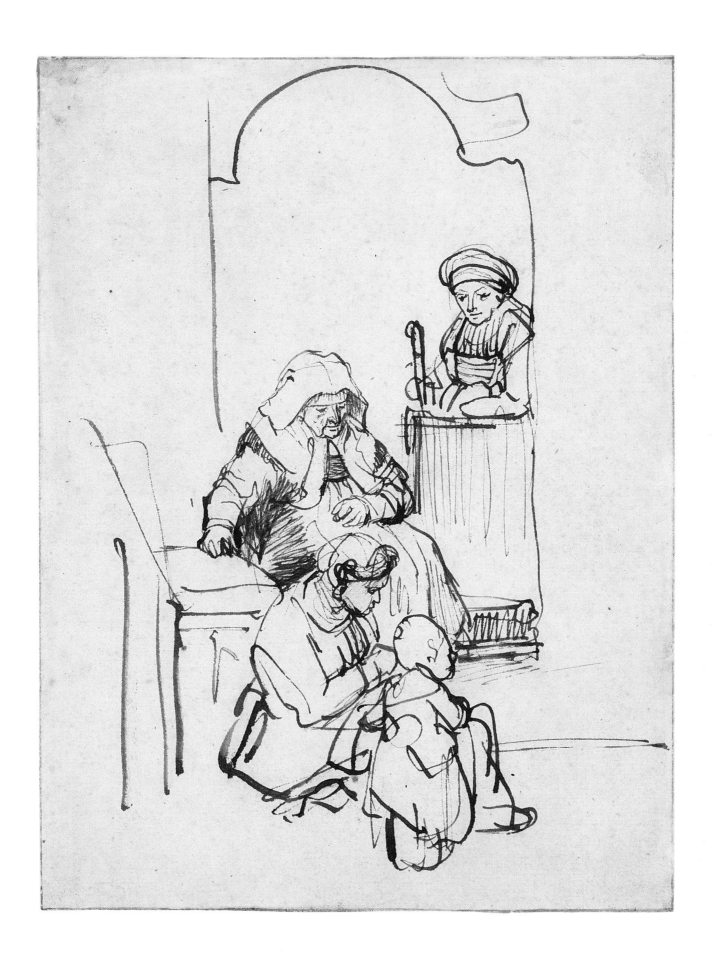

102 *The Rest on the Flight into Egypt*, 1645

Etching and touches of drypoint, only state,
13 × 11.5 cm
Signed and dated, bottom left: *Rembrandt f. 1645*
References: H.216; White/Boon B 58; White 1999,
pp.50–1

FITZWILLIAM MUSEUM, CAMBRIDGE
(INV.NO.AD.12.39–87)

This calmly contemplative little etching continues
the mood of Rembrandt's serene *Holy Family*
painted in the same year (cat.99). The couple sit on
a log, the donkey's panier lying at the right. Mary
checks on the sleeping child while Joseph looks on,
nonchalantly peeling an apple. The flight to Egypt
is mentioned only in St Matthew's Gospel (2: 13–
15): '... the angel of the Lord appeareth to Joseph in
a dream, saying, Arise, and take the young child and
his mother, and flee into Egypt, and be thou there
until I bring thee word: for Herod will seek the
young child to destroy him. When he arose, he
took the young child and his mother by night, and
departed into Egypt: And was there until the death
of Herod that it might be fulfilled which was
spoken of the Lord by the prophet, saying, Out of
Egypt have I called my son.'

Rembrandt had made an etching the previous
year which showed the Holy Family resting on
their journey to escape from Herod in all the
blackness of night that his etching needle and
inking could muster.[1] Here, however, the scene is
set in broad daylight and, as Christopher White
noted, 'it is difficult to believe that this is a flight
from persecution and not merely half an hour spent
in the garden'.[2] The scene is drawn in very lightly
etched lines that almost have the effect of
silverpoint. It seems highly unlikely that this was
due to accidental underbiting of the plate in the
acid, given Rembrandt's technical mastery of his
medium by this period. Rembrandt also made two
other prints in the same year which bear the same
characteristics, one of which was further worked
on in a second state, showing that it was not
discarded as being too pallid.[3] The fineness of line
was therefore clearly intentional on Rembrandt's
part and adds to the lightness of atmosphere in this
delicate etching.

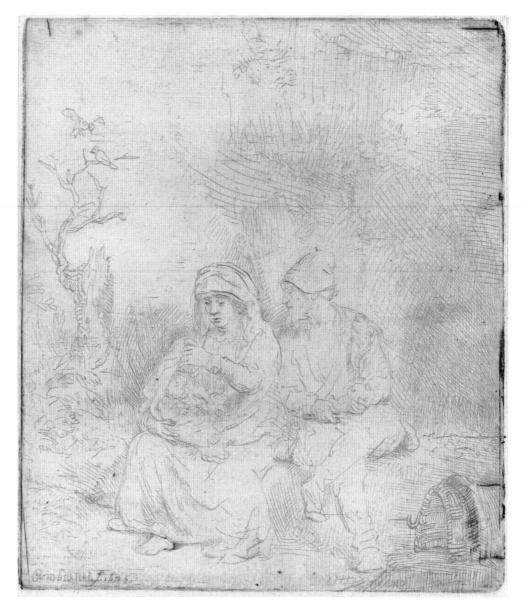

Drawing, black chalk touched with white,
8.8 × 6.6 cm
References: Benesch 700; Seilern 1961, p.28;
London 1983, cat.20, p.13; London 1993, cat.4,
pp.57–8

COURTAULD INSTITUTE GALLERY, LONDON
(INV.NO.D.1978.PG.192)

Exhibited in London only

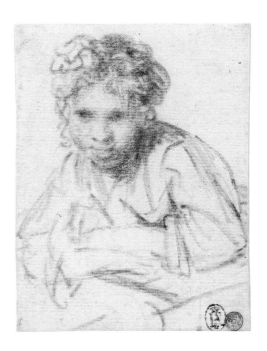

This drawing is related to the painting of *A Girl at a Window*, dated 1645, now at Dulwich Picture Gallery (cat.104). It has been linked stylistically to a study of a beggar family in Amsterdam Historisch Museum (see cat.111, fig.141).[1] Both are drawn in black chalk and both are blocked out in lines that show great variation in intensity. Some of these lines, such as those of the girl's right arm in this drawing, are drawn in very softly, while others, such as the heavy dark shading at her neck, are blacked in with far more pressure. These stylistic traits are shared by the sheet showing the beggar family which is, however, drawn on the back of a study for Rembrandt's etching of Jan Six of 1647.[2] This dating has caused doubt as to whether the sketch here may have been made after the Dulwich picture of 1645, rather than before it.

However, various features still argue for its role in the development of the composition of *A Girl at a Window*. Both arms of the girl in the drawing are placed flat against the ledge whereas in the finished picture Rembrandt placed her left arm touching her throat. Two strong parallel lines just above this arm in the drawing probably indicate where this arm was to be moved. The painting shows no signs of any changes to the positioning of the arms in the underpaint, implying that this alteration had already been worked out before Rembrandt started on the canvas. The girl's right forearm is also positioned slightly differently in the drawing and painting. In the latter, Rembrandt moves her left elbow forward, turning her body a little away from the viewer, though the outline of head and shoulder remain substantially the same as in the drawing, as does also the important direction of light and placing of shade in both works. The conclusion is that the drawing does predate the canvas and relates to the development of its final composition, though it is not a precise study for it. It is more likely that this drawing provided the inspiration for the Dulwich picture, since Rembrandt's working practice very rarely included making formal compositional drawings for paintings.

Oil on canvas (arched top), 81.6 × 66 cm
Signed and dated, lower right: *Rembrandt. f 1645*
References: Bredius/Gerson 368; Washington/Los
Angeles 1985–6, cat.26, pp.100–2; London 1993,
cat.1, p.55

DULWICH PICTURE GALLERY, LONDON
(INV.NO.163)

This picture has traditionally been called *'A Young
Girl Leaning on a Window-Sill'*, as she appears to rest
her elbows upon a stone sill. The girl's exact
location is not entirely clear, however, since the
ledge appears predominantly flat-edged where it
butts against the background wall but rounded at
the side nearest the viewer. It has been suggested
that she may be leaning upon a stone plinth or
pedestal, but this is also uncertain.[1] The final pose
in the painting departs slightly from that of the girl
in the Courtauld drawing related to this picture
(cat.103), which is closely linked in form to
Rembrandt's silverpoint sketch of the newly-
betrothed Saskia made in 1633,[2] albeit in reverse
(see fig.1).[3] Rembrandt used a similar pose in his
later *Kitchen Maid* of 1651 where the subject's left
hand props up her chin (fig.136).[4]

Just as with the *Kitchen Maid*, the Dulwich figure
is also usually assumed to represent a servant, but it
has been suggested that her gold necklaces imply
that she is no common maid. It has been proposed
that she may represent a courtesan,[5] or perhaps
some historical or Biblical figure.[6] However, the
necklaces (if real and not added by the artist) do not
rule out the possibility that the model was indeed a
domestic in Rembrandt's household. Surviving
wills of maids in the seventeenth century show that
items of jewellery, particularly of gold, were often
the only material goods such peripatetic servants
did possess, being eminently portable and maintain-
ing their value.[7]

The *Girl at a Window* closely relates in treatment
to *A Woman in Bed* (cat.100) which was probably
painted in the same year. Although the Edinburgh
woman's forehead is lined, while the Dulwich girl is
plainly younger, the facial types in both pictures are
not dissimilar, with deep-set eyes placed far apart
and in each case a broadish, slightly turned-up nose
and wide brow – features like those also found in the
Kitchen Maid. Valentiner suggested that the Dulwich
girl was Hendrickje Stoffels who would have been
nineteen in 1645.[8] One would assume the girl here
was younger, but in any case Hendrickje is not
actually documented as being in the household until
October 1649, although she must have started
working there earlier.[9] Rembrandt allowed himself
great artistic leeway with the features of those who
modelled for him for his history and genre pictures
and it is probably unlikely that these paintings were
intended as portraits of specific individuals. The girl
in his 1639 *Still-life with Dead Peacocks* in the

Rijksmuseum, Amsterdam, for example, looks like a
younger relative to the Dulwich girl but the
painting is clearly not a portrait.[10]

Rembrandt was demonstrably preoccupied with
achieving a common effect in the Edinburgh and
Dulwich pictures. In arched-top format, each shows
a female half-length figure set in darkened, indis-
tinctly defined space. Both emerge from the
shadowy background into strong light that models
their features and gives their skin luminosity. The
ledge in the Dulwich painting and the even more
striking curtain in the Edinburgh work heighten
the dramatic three-dimensionality and strong visual
impact of the compositions. The strong
brushstrokes and streaks of paint are obvious on the
canvas and Rembrandt does not attempt to make
the surfaces smoothly illusionistic. The viewer is
faced with the curious effect of a composition that
appears 'real' and yet is broadly, almost thickly
painted: a tension between technique and image sets
up a powerful dynamic in both works.

This *trompe l'œil* effect was recognised early on by
Roger de Piles, the French art theorist and painter
(1635–1709), who perhaps once owned the Dulwich
painting.[11] De Piles described how Rembrandt
propped a picture of a servant girl looking outwards
in a window of his own house in order to deceive
passers by, a successful trick until the impossible
stillness of the girl's pose was finally noticed.[12] The
tale itself may be partially apocryphal (if there had
been an attempt at deception using the present
painting would Rembrandt have painted the ledge
at such an angle?) and should perhaps be seen to
some extent as an updating of the famous *topos* of
artistic verisimilitude, such as Zeuxis's painted fruit
or Parrhasius's curtain.[13] However, the story should
not be discounted entirely as there can be no doubt
that in both this painting, the Stockholm *Kitchen
Maid* and the Edinburgh *Woman in Bed*, Rembrandt
deliberately set out to create a sense of immediacy
and contact with the viewer, through the use of

light and colour and prominent placement of the
figure on the frontal picture plane.

Rembrandt's *Girl at a Window* clearly influenced
a number of other paintings by those probably
working in his studio at the time. A painting
previously believed to be by Rembrandt but now
attributed to his workshop, perhaps by Carel
Fabritius (1622–1654), *A Young Girl Holding a Broom*,
is obviously inspired by Rembrandt's picture and
may perhaps have been based on the same model.[14]
Similarly, an anonymous *Girl at an Open Door* at
Woburn Abbey[15] and *A Girl at a Half-Door* at the Art
Institute of Chicago, now attributed to Samuel van
Hoogstraten (1627–1678), both show intimate
knowledge of the Dulwich painting.[16] When the
German artist Joachim von Sandrart visited
Amsterdam between 1637 and 1641, he noted that
Rembrandt's studio was filled 'with almost
countless distinguished children for instruction and
learning. Every single one paid him one hundred
guilders annually…'[17] In the mid-to-late-1640s
Rembrandt's students probably included Samuel
van Hoogstraten, Carel Fabritius, Abraham
Furnerius (1622–1654), Nicolaes Maes (1634–
1693), Christoph Paudiss (1630–1666), Karel van
der Pluym (1625–1672), Constantijn van Renesse
(1626–1680), Jurgen Ovens (1623–1678) and
possibly Barent Fabritius (1624–1673).[18]

However, the theme seems to have been treated
before 1645 by another presumed pupil of
Rembrandt, Jan Victors (*c.*1619–1676 or after). He
had produced a painting of *A Young Girl at a Window*
in 1640,[19] and made another version of the same
composition in 1642 (fig.137).[20] Victors is thought
to have been a member of Rembrandt's studio in the
mid-1630s and his work shows considerable formal
and thematic affinity with that of other documented
pupils in Rembrandt's workshop at that time such
as Govert Flinck (1615–1660), Ferdinand Bol
(1616–1680) and Gerbrand van den Eeckhout
(1621–1674).[21]

Fig.136 | Rembrandt, *The Kitchen Maid*, 1651
Nationalmuseum, Stockholm
Photo: Åsa Lundén

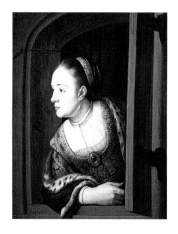

Fig.137 | Jan Victors (*c.*1619–1676 or after),
A Girl at a Window, 1642
Salomon Liliaan Gallery, Amsterdam

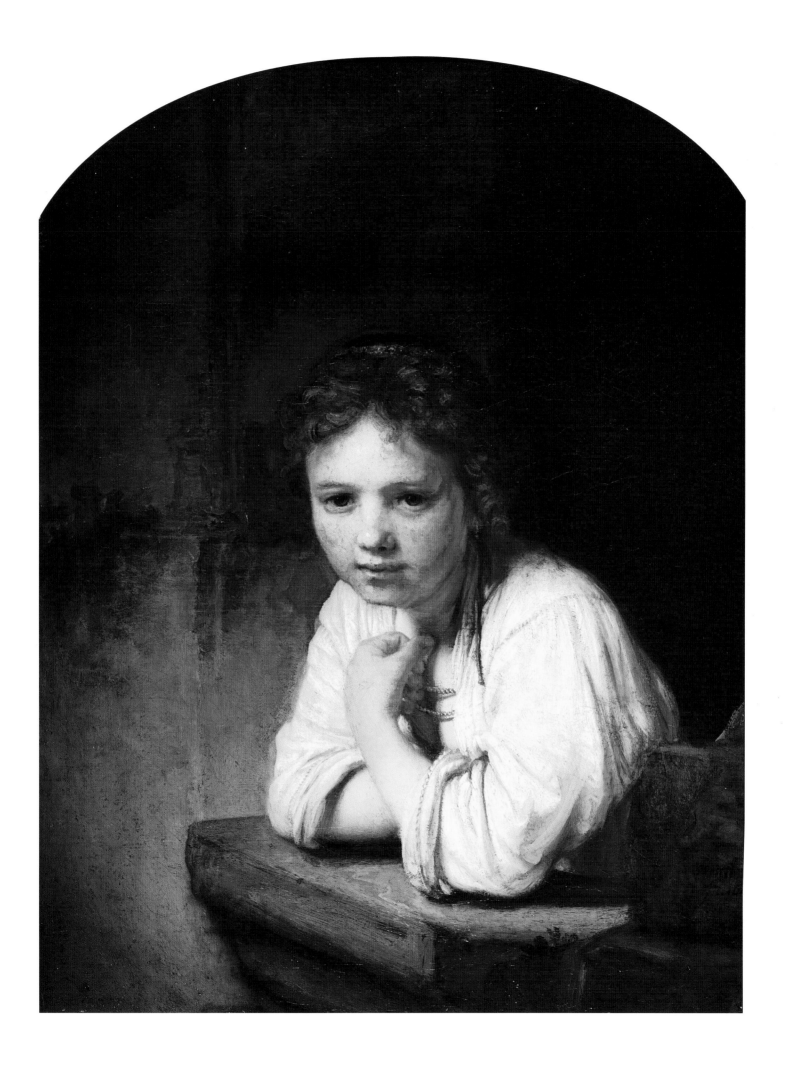

Drawing, pen and brush and brown ink with wash,
16.5 × 16.7 cm
References: Benesch 708; Stockholm 1992, cat.146,
p.347

NATIONALMUSEUM, STOCKHOLM
(INV.NO.NMH2039/1863)
Exhibited in Edinburgh only

The pose of the two women seated on the ground
recalls the drawing of *Two Studies of a Beggarwoman*,
normally dated to 1635–8 (cat.59). However, the
drawing here pays considerably more attention to
the sense of form and volume, using the atmos-
pheric wash to block in the shadows and throw the
figures into relief.[1] Rembrandt started to do this
with pen strokes. The area round the infant in the
lower group is heavily hatched and lines initially
radiated from the baby's head, almost like a nascent
nimbus or halo, but later made less obvious by the
brown wash on top. Unlike the woman below, the
mother suckling the baby above is not bare-headed.
Rembrandt may simply have added her hat,
obeying good model-sheet tradition in order to
vary each group, for it seems unlikely that there
were two different women posing.

The handling of the drawing is close in style and
subject matter to a sketch in the Lugt collection of
A Woman Holding a Child on her Knees (fig.138).[2]
This has a black chalk drawing on the reverse which
is associated with Rembrandt's commissions from
the Stadholder Frederik Hendrik. Though started
in 1632, these paintings were finally completed in
1646 and it is the latter date which has been
ascribed to both the Lugt drawing and this sheet. It
is, however, possible that the Stockholm sheet may
have been made slightly earlier as it has also been
related to a sketch in the British Museum of *An Old
Man with a Child*, ascribed to around 1640.[3]

Fig.138 | Rembrandt, *A Woman Holding a Child on her Knees*,
c.1646
Collection Frits Lugt, Institut Néerlandais, Paris

106 *An Old Woman Teaching a Child how to Walk*, *c*.1646

Drawing, pen and brown ink, 16 × 16.5 cm
References: Benesch 706; Stockholm 1992,
cat.147, p.348

NATIONALMUSEUM, STOCKHOLM
(INV.NO.NMH2074/1863)
Exhibited in Edinburgh only

Benesch suggested that this drawing and cat.105
above were once part of the same sketchbook
(along with another drawing, also in Stockholm,
of a woman suckling a child).[1] All three sheets
relate to the type of works which presumably
made up Jan van de Cappelle's portfolio of
drawings entitled 'Rembrandt's lives of women
and children'. Rembrandt made a number of other
sketches showing children taking their first steps,
such as *Two Women Teaching a Child to Walk* and *A
Woman Teaching a Child to Stand* (cat.56 and 57) and
Two Women Teaching a Child to Walk (cat.60). The
baby's padded headdress (to avoid bumping its
head when it fell over) is almost identical to that
worn by the infant in the 1643 etching of *The
Hog*,[2] whereas the pose of the child has been
related to the figures in the background of cat.107,
the etching of *A Nude Man Seated, Another Standing,
with a Woman and Baby in the Background* of *c*.1646.[3]

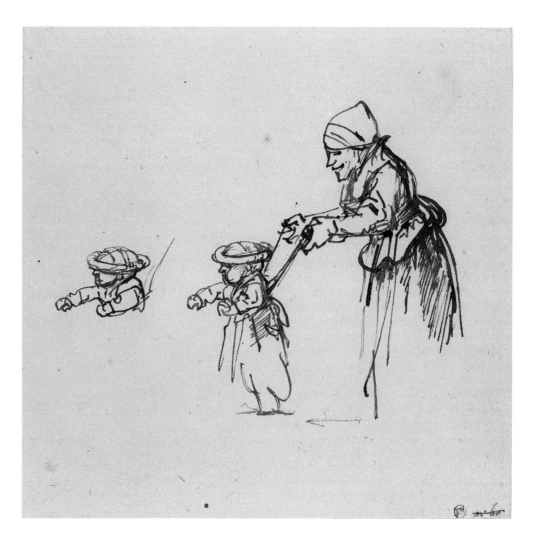

Etching and drypoint, second state (of three),
19.4 × 12.8 cm
References: H.222; White/Boon B 194:II; Berlin/
London/Amsterdam 1991–2, vol.2, cat.21, pp.224–
6; Amsterdam/London 2000–1, cat.51, pp.213–7

RIJKSMUSEUM, AMSTERDAM
(INV.NO.RP–P–OB–251)

This print was traditionally called 'The Walking
Frame' ('*Het Rolwagentje*') on account of the baby
frame in the background of the print. However, it
was only noticed later that this rather bizarre
juxtaposition of nude youths and a woman
encouraging a baby to walk, had something to do
with the subject of the etching itself. The likely
meaning is one of education and enlightenment
through practice and the baby walker was a
metaphor of this process. Just as the child learns to
toddle towards the woman protected in its baby-
walker, so a young artist would learn his craft in the
structured framework of practising to draw figures
such as those seen here. The scene in the back-
ground was almost certainly added after the nudes
had been drawn to further emphasise this point,
which was particularly apt, since this is one of the
rare occasions in which surviving works provide a
glimpse of how Rembrandt trained his assistants.

Rembrandt appears to have drawn the figures
straight onto the plate at the same time as at least
three of his pupils, including Samuel van
Hoogstraten, drew the same model from different
angles, perfectly illustrating the moral of this
etching: students must practise.[1] The French art
critic D'Argenville noted in 1745 that Rembrandt
had made a small drawing manual containing ten or
twelve pages. No copies have survived but this may
have been intended to provide instruction for his
young pupils.[2] This print, probably depicting the
same young man twice in different poses, is dated
to about 1646 on account of two other etchings of
the same youth which Rembrandt signed and dated
that year.[3]

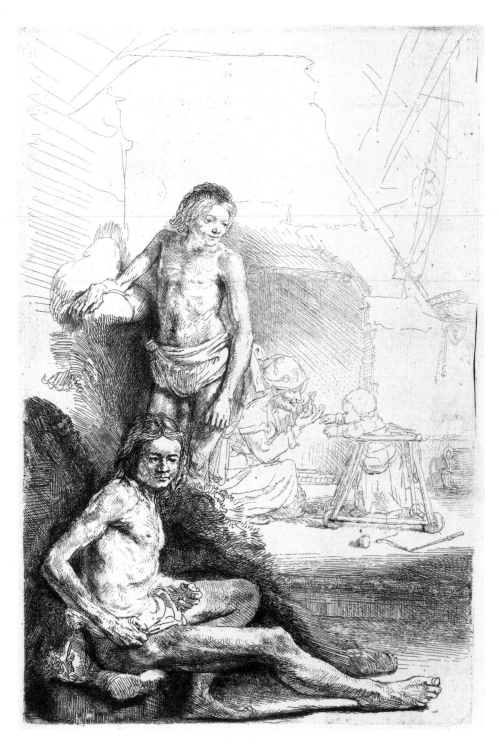

Etching and drypoint, only state, 4.7 × 6.6 cm
References: H.224; White/Boon B 187; White
1999, p.186; Amsterdam/London 2000-1, cat.53,
pp.221-3

RIJKSMUSEUM, AMSTERDAM
(INV.NO.RP-P-OB-634)

In this 'free subject', as print catalogues of
Rembrandt's work have often termed such
erotica, he was presumably inspired by an
engraving, *The Monk and the Nun*, by the German
artist, Heinrich Aldegraver (fig.139).[1] Aldegraver
lived in Soest in Westphalia which became a
Lutheran community in 1531 with the onset of
the Reformation in Germany. He clearly embraced
the new faith enthusiastically since he copied
Georg Pencz's *Monk and Nun* in 1530[2] and
engraved his own version of the composition,
mentioned above. The lechery of the Catholic
clergy illustrated by the congress of a monk and a
nun supposedly sworn to chastity was an image of
popular Protestant propaganda. The shocking
nature of such prints is set against their obvious
salacious quality: effectively pornographic scenes
proving the depravity of the Roman church,
looked at enthusiastically by disapproving
Protestants.

 The detail that Rembrandt manages to include
in such a small scene is extraordinary. The couple
lie at the edges of a field of tall corn that is being
cut into swathes by a cursorily drawn figure
swinging a sickle in his left hand (which
Rembrandt would have drawn as the right hand
on the etching plate). The woman is barefoot
while the tonsured monk has lost one of his

sandals in the excitement. We see neither face but
Rembrandt manages to convey a great deal in the
expressive hand of the woman, placed near the
friar's belt, which clasps him to her, and in his left
foot, braced against the ground for better pur-
chase.

 Unlike Aldegraver's proselytising engraving,
which includes the devil lurking above the
unchaste couple, Rembrandt's print does not
appear to be made in a spirit of obvious condemna-
tion. The woman here is no nun but a milkmaid,
judging from the jug at the left of the composition.
The linking of milkmaids with erotic pastoral
activity was well established as both a pictorial and
literary motif in the Netherlands during the
sixteenth, seventeenth and eighteenth centuries,
often with outrageously lascivious innuendo.[3] As
Ger Luijten has observed, Rembrandt also appears
to have been referring to a mediaeval tradition that
alluded to the potency of priests and monks, which
had become the subject of ribald titillation rather
than cutting satire by this time.[4] But oddly, the
couple opportunistically overcome by desire
outdoors, portrayed by Rembrandt in such a direct
way, are not made into farcical figures of fun and it
is difficult to know exactly how they would have
been perceived by a contemporary. Outrage,
laughter or excitement presumably depended,
then, as now, on the viewer's own outlook.

Fig.139 | Heinrich Aldegrever (1502-1555/61),
The Monk and the Nun
Rijksmuseum, Amsterdam

Etching, drypoint and burin, third state (of five),
12.5 × 22.4 cm[1]
Signed and dated, bottom left: *Rembrandt.f.1646*
(the '6' in reverse)
References: H.223; White/Boon 186:III;
Amsterdam 1997, cat.57, pp.281–5;
Amsterdam/London 2000–1, cat.52, pp.218–20

RIJKSMUSEUM, AMSTERDAM
(INV.NO.RP–P–OB–633)

Also known as the *'Ledikant'* or *'Le Lit à la Française'*,
this print was described by Daniel Daulby in 1796
thus: 'A young couple are discovered on a bed …
This piece is executed in a masterly stile, and it is
much to be regretted that Rembrandt should spend
his time and his abilities upon subjects so indecent,
and unworthy of his genius, as this.'[2] He was not
the only one to think so, while some believed that
Rembrandt was too great an artist to have made
such a work and that his signature had been added
to this plate as a fraudulent joke in poor taste.[3] In
1906 when a canon of Rembrandt's prints was
published, this etching, along with five more, was
omitted as being unsuitable for the general public.[4]
The other etchings were, not surprisingly, *Joseph
and Potiphar's Wife*, *A Woman Making Water* and its
companion piece, *A Man Making Water*, *The Flute
Player*, and *The Sleeping Herdsman* (cat.28, 15 and
fig.84, cat.97 and 98 respectively). However, they
were all printed on a separate sheet and could be
obtained on application, with an extra twenty
pfennigs in stamps, to the publisher, who for-
warded them, no doubt in an unmarked envelope.[5]

One might assume that the morals of the
seventeenth century would have provoked an even
more prudish reaction to such imagery. However,
in 1647, only a year after this etching was finished,
a deposition was made by twenty-two artists in
Antwerp, including Jacob Jordaens, which gives a
rather different picture. It testified that 'volumes of
prints by Carracci, Rosso and De Jode' were 'traded
every day showing the fornication of gods and
suchlike' and 'similar picture books' by Raphael,
Marco da Ferrara and 'still more scandalous' ones
by Peter van Mol were being sold to artists and
print enthusiasts alike and were considered as
standard items in a general collection.[6] There is no
reason to think that the situation was any different
in Amsterdam and we know that Rembrandt
owned a folder full of such erotic images by
Carracci, Raphael, Girolamo Rosso and Giulio
Bonasone.[7]

In comparison with much of the pornographi-
cally explicit Italian erotica mentioned above,
Rembrandt is relatively restrained in this etching.
Apart from their naked lower legs, both bodies are
covered up, although it is possible that Rembrandt
originally considered showing the man's shirt
ending higher up to reveal more buttock, judging

from the dark vertical line by the woman's right
hand. He shows the lovers in a similar position to
that seen in the *Monk in the Cornfield*, where the man
also leans his weight upon the knuckles of his right
hand and the woman's right leg lies inside his limbs
in the same way, her right hand embracing his back.
But in this etching Rembrandt moves the couple to
enable their faces partly to be seen, a glimpse of
rapt intimacy. He clearly could not decide on the
exact pose, for he gave the woman two left arms,
one lying at her side (as in the woman in the *Monk
and the Cornfield*) and the other about her lover's
waist. This changing of pose is seen in his drawing
of *A Woman Sitting up in Bed* (cat.41) but unlike
there, Rembrandt could have burnished out the
extra arm he had he chosen to do so, since he
produced five states of this etching. It may be that
he regarded *The French Bed* as in some way experi-
mental, leaving the left side of the composition
largely incomplete but scratching straight onto the
plate to create the subtle deep shadows in the soft
pleating of the bedhangings.[8] The presence of the
glass on the table and the prominent feathered
beret placed jauntily on the bedpost has led to the
suggestion that the scene may illustrate the
excesses of the Prodigal Son.[9] The plumed cap was
a recognised symbol of love, vanity and frivolity
(depending on context) and was certainly a
common motif in depictions of this parable, but
would be a unique instance in the iconography of
this Biblical subject to show him thus, so graphi-
cally engaged.[10]

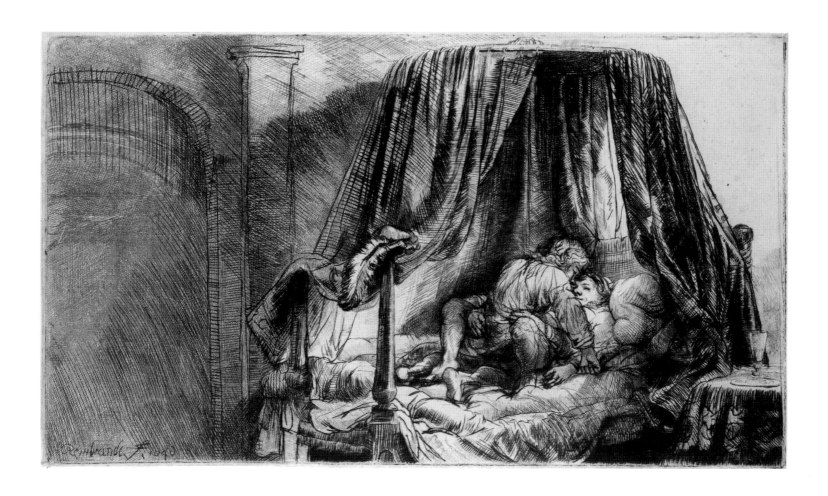

Drawing, black chalk, touched with white,
20.3 × 16.4 cm
References: Benesch 590; Berlin/Amsterdam/
London 1991–2, vol.2, cat.24, pp.90–92

KUPFERSTICHKABINETT, STAATLICHE
MUSEEN, PREUSSISCHER KULTURBESITZ,
BERLIN (INV.NO.KDZ5264)
Exhibited in London only

Rembrandt did not abandon the subject of *Susanna and the Elders* after he had completed his painting of the subject *c*.1636 (cat.69). This drawing shows how he continued to refine and rethink his approach to the way the story was depicted. He completed another version of the subject in 1647 (fig.140).[1] This shows the scene in somewhat more orthodox fashion in the sense that, rather than focusing only upon the figure of Susanna, Rembrandt includes far more of the narrative element by showing the elders approaching Susanna. It is the dynamic of the group upon which Rembrandt concentrates. Susanna still looks out appealingly (in both senses) towards the viewer but her assailants are already in evidence, one even tugging her wrap away from her back. The whole scene is opened out and the dark expanse of the pool at the left acts as the foil for the brightness of the naked body and pile of blood-red clothes which are cast off to the side.

By incorporating more details relating to the story, the painting of 1647 follows the model of Pieter Lastman's painting of *Susanna* more closely than Rembrandt's version of the subject of *c*.1636 (see fig.43 and cat.69). He also re-introduces the splayed fingers which were previously rejected in his version of Lastman's painting, albeit in a slightly different form. The drawing here is related to the development of Rembrandt's composition for the 1647 painting which appears to have had an extraordinarily complicated genesis.[2] It seems that

there may have been three separate stages in the evolution of the composition, which shows a number of *pentimenti* or alterations. The first stage of the painting may have been started in about 1638 on the basis of a preparatory drawing of the 'grasping' elder (with the lewd action of pushing his thumb up from his fist) made in iron gall ink, a medium which Rembrandt used often at that period.[3] The second stage (known to us through a copy attributed to Barent Fabritius in the Budapest National Museum) showed the elder closest to Susanna actually grasping her from behind to reach around to her breast.[4] This would have been a considerably more violent gesture than his lecherous tweaking of her wrap as shown in the final state of the painting.

In changing the pose of the elder, Rembrandt also had to alter the posture of Susanna. He lowered her left arm, and also showed slightly more of her right shoulder, as appears in the final composition. It seems that the present drawing was made in order to work out these changes upon the pose, which was effectively a subtle variation of the one he had first used for his earlier *Susanna*.[5] On close inspection, some parts of the outlines seem deeply grooved, almost as if incised for transfer to the painting support in, for example, an area at the back of the head, down the back, under the chin, around the elbow and at the top of the hand) although it is perhaps possible that this was caused by a hard fragment within the chalk.

The *Seated Female Nude as Susanna* was almost certainly modelled from life in the studio. As Peter Schatborn has pointed out, the model's right arm is resting upon a table top in the studio and one can see the low back of the chair upon which she sits.[6] She presumably kept her lower half covered for modesty's sake and we can see the white material of her chemise that she has simply let fall around her waist above the darker skirt. The use of black chalk is particularly subtle and Rembrandt draws in wonderfully fine shading upon her torso, with an awareness of tone that is more controlled and less broad than his technique of the 1630s. It is also interesting that the facial type has altered from the earlier period. This model is marked by the angular jut of her jaw, a well-defined cheekbone and a straight, sharper nose that are a far cry from the plump roundness and curvaceous chins found in works of the previous decade.

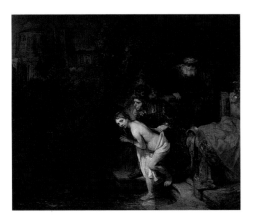

Fig.140 | Rembrandt, *Susanna and the Elders*, 1647
Gemäldegalerie, Staatliche Museen zu Berlin, Preussischer Kulturbesitz
Photo: Jörg P. Anders

Etching, drypoint and burin, second state (of three), 16.3 × 12.9 cm
Signed and dated, bottom right: *Rembrandt.f.1648*.
References: H.233, White/Boon B 176:II;
Amsterdam 1997A, cat.56, pp.276–80;
Amsterdam/London 2000–1, cat.60, pp.250–3

HUNTERIAN ART GALLERY, UNIVERSITY OF
GLASGOW (INV.NO.GLAHA: 44490)

Rembrandt drew and etched many studies of
beggars, in groups and as single figures, both male
and female, and returned to this subject well into
the 1650s. A little family group is shown begging
at the door of a wealthy household with its fine
carved stone doorway and large iron grilles at the
windows. They are part of the *rechte armen*
(deserving poor) whose humble supplication
required alms from devout and charitable citizens
as part of their social duty.[1] The threadbare skirt
the woman wears is obviously old but patched
neatly, while the man holds a hurdy-gurdy, his
right hand turning its handle. His eyes are lowered
blankly, perhaps meekly downcast, but probably
because of blindness. The pictorial tradition of the
blind hurdy gurdy player whose wife collects alms
dates back to the sixteenth century (and was
popularised by David Vinckboons in Amsterdam
in the seventeenth century).[2] The woman puts
forward her hand to receive the coin, with the
baby on her back to add extra poignancy to her
plight. The social distinction between those
whose poverty was inescapable and those mendi-
cants whose downfall was their own doing was
keenly delineated in the Netherlands at the time:
to give to the former was charity which would be

Fig.141 | Rembrandt, *The Hurdy Gurdy Player and his Family*
Fodor Collection, Amsterdams Historisch Museum, Amsterdam

repaid to the donor in heaven, whilst beneficence
to the latter was pointless and wasteful.[3]

A drawing in the Fodor collection shows a
similar group and may perhaps be a study for the
etching (fig.141),[4] but Rembrandt's inspiration for
the composition was also probably the rare print of
1520 by Lucas van Leyden of a family of beggars,
Eulenspiegel, an impression of which he had bought
at great expense for his collection in 1642.[5] The
basket-laden beggarwoman in Rembrandt's print
here was later copied by Jan Steen (1626–1679) as
the older woman begging in his painting of *The
Burgher of Delft and his Daughter* of 1655.[6] He
omitted the male beggar and infant and made the
woman into a widow seeking alms with a young
boy.

Etching, drypoint and burin, first state (of six),
12.7 × 11 cm
Signed and dated, bottom right: *Rembrandt f.1651*
(the '6' in reverse)
References: H.253; White/Boon B 53:I; White
1999, pp.71–4, 75

RIJKSMUSEUM, AMSTERDAM
(INV.NO.RP–P–OB–104)

Unlike the airy *Rest on the Flight into Egypt* (cat.102),
this dark scene shows the moment when Joseph
leaves with Mary and the infant Jesus in the dead of
night to travel to safety in Egypt, after his dream of
an angel warning of danger.[1] The overall composi-
tion is similar to that of one of Rembrandt's earliest
etchings of about 1627, showing Joseph walking
with Mary riding her donkey, heading off to the
left.[2] However, the preoccupation in the present
etching, made more than twenty years later, is
predominantly the depiction of the dark. The
figures of Joseph and Mary (the baby, unseen, is
snuggled inside her mantle) are lit brightly against
the gloomy foliage by the brilliance shining from
the lantern which casts a pattern of white pools of
light on the earth below.

It is possible that the well-known engraving of
1613 by Hendrick Goudt (1573–1648) of a painting
of *The Holy Family* by Adam Elsheimer (1578–1610)
may have inspired Rembrandt's etching.[3] In
Goudt's print Joseph holds a pinewood torch
which lights the little group of the Holy Family in
the foreground, set against light to the right from
the moon and to the left from a fire lit by shepherds
outside.[4] Rembrandt also provides another source
of light from the lighter patch of sky above at the
right. The likelihood that Rembrandt knew the
composition is demonstrated by his painting of
1647 of the *Rest on the Flight into Egypt* (National
Gallery of Ireland, Dublin) which echoes the
general layout and atmosphere of Elsheimer's
original.[5] However, it has also been suggested that
Rembrandt borrowed elements from his master
Pieter Lastman's 1608 composition of the same
subject, which, though set in daylight, configures
the Holy Family in a similar way. Lastman had just
returned from Rome at the time this was painted,
where he was certainly influenced by the work of
Elsheimer (who lived and died in that city).[6]

This is the first and brightest state of this
etching which Rembrandt proceeded to work on,
inking different surface tones on the plate, wiping
selected areas clean and darkening the scene
progressively with more hatching.[7] In this
experimental nocturnal scene, some of the
impressions Rembrandt produced are so tenebrous
that one can barely make out the shapes of the
figures in the overpowering gloom which has such
density that even the shafts of lantern light fail to
penetrate it.

113 *The Virgin with the Instruments of the Passion, c.1652*

Etching and drypoint, only state, 11 × 8.9 cm
References: H.193; White/Boon B 85

BRITISH MUSEUM, LONDON
(INV.NO.1973-U-951)

This etching shows Mary with the faintly drawn symbols of Jesus' passion in front of her, the nails from the cross, and the crown of thorns. Though sketchily executed, the etching was early recognised for the qualities of its moving depiction of the mother of Christ. Daniel Daulby noted in 1796 that Mary 'seems to muse over these memorials of our Lord's passion, with a fixed attention, and silent sorrow.'[1] Rembrandt had drawn the grieving Virgin in a drawing now in the Fodor collection[2] which seems to have been based on fifteenth-century iconography of the Lamentation, such as that found in Rogier van de Weyden's painting of the same subject in the Mauritshuis.[3] This sketch may have been made in connection with Rembrandt's painting of *The Entombment of Christ*, which he worked upon between 1636 and 1639, for his series of the Passion painted for the Stadholder Frederik Hendrik.[4] Another drawing which was certainly connected with *The Entombment of Christ* shares certain characteristics with this etching, namely its isolation of the figures of grieving women draped in their mantles[5] and the mood which anticipates that of the painting of 1661, '*The Virgin of Sorrows*' (cat.137A).

Works depicting the Virgin Mary are usually thought to have been made for the Catholic market but the fact that Martin Soulmans and his wife appear to have owned Rembrandt's *Holy Family* (cat.26A) shows that this was not exclusively so.[6] However, it is hard to envisage that this staunchly Catholic image of the Sorrow of Mary would have had wide appeal to those outside the Roman church.

Etching, second state (of two), 9.5 × 14.5 cm
Signed and dated, bottom centre: *Rembrandt.f.1654*
References: H.275; White/Boon B 63:II; Berlin/
Amsterdam/London 1991-2, vol.2, cat.36,
pp.269-71; White 1999, pp.88-90

RIJKSMUSEUM, AMSTERDAM
(INV.NO.RP-P-1962-33)

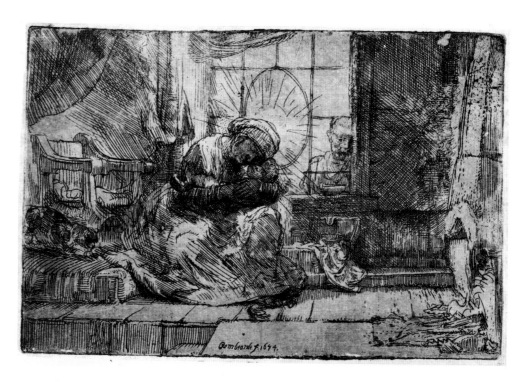

This belongs to a number of etchings Rembrandt
made in 1654 depicting the childhood of Christ
(cat.115). Whilst the other five scenes depict
incidents which are described in the Bible, the
actual narrative of this etching is Rembrandt's own
invention.

Though the pose of the Virgin is similar to the
woman at the bottom of the sheet of Rembrandt's
Sheet of Four Studies of a Woman, of *c*.1636 (cat.61), it
was taken more or less directly from Andrea
Mantegna's engraving, *The Virgin and Child*
(fig.142).[1] The resemblance is so close that one
assumes the print was in Rembrandt's possession,
and it is known that he owned a 'costly book of
Andrea de Mantegna'[2] (though this may have been
a set of illuminated woodcuts after Mantegna's
Triumph of Caesar).[3] Rembrandt does not follow
Mantegna's technique, however, and the shading
here is more diverse, the shapes of the drapery less
angular and the treatment of light more atmos-
pheric. In the traditional iconography of a
Madonna of Humility (*Madonna dell'umilità*),
Mantegna's Mary sits upon the floor, while
Rembrandt's Virgin is settled upon a low 'L' shaped
dais, cradling her baby tenderly, her cheek against
his. Sun streams through a window with circular

Fig.142 | Andrea Mantegna (*c*.1431-1506), *The Virgin and
Child, c*.1500
British Museum, London

leading in the centre, emphasising Mary's halo
which Rembrandt has drawn in straight lines
radiating outwards from her head.[4]

At first sight, the scene seems thoroughly
domestic: a cat plays with the hem of Mary's dress,
a bowl rests on the window sill while a sewing-
basket lies open beneath, household chores
momentarily interrupted. However, beneath the
Virgin's right foot is a black snake. Rembrandt, in
showing Mary as the New Eve, recalls the mediae-
val tradition where Old Testament characters had
their counterparts in the New Testament texts. In
the Book of Genesis, after reprimanding Eve, God
says to the serpent: 'I will put enmity between thee
and the woman, and between thy seed and her seed:
it shall bruise thy head and thou shalt bruise his
heel.'[5] Here, Mary's act of trampling the snake
underfoot signified that her child would conquer
Satan, at last redeeming Eve's sin of listening to the
serpent in the Garden of Eden. It is likely that the
cat also symbolises evil in this context as well, while
popular tradition had it that Satan dwelt in the
chimney, warm with hell fire, which could also be
significant here.[6]

Joseph is outdoors, looking through the
window, though changes on the plate show that he
may originally have been placed near the chimney.[7]
His exclusion from the room may also be symbolic
of Mary's virginity to which the window itself was
an accepted reference: her purity was like the glass
through which light could pass, its substance still
intact. But though such references were undoubt-
edly present, Rembrandt does not overload the
quiet intimacy of this little scene with doctrinal
symbols but instead combines the domestic and
sacred with an assured touch.[8]

115 *The Flight into Egypt*, 1654

Etching and drypoint, only state, 9.3 × 14.4 cm
Signed and dated, bottom left: *Rembrandt f. 1654*
References: H.276; White/Boon B 55

RIJKSMUSEUM, AMSTERDAM
(INV.NO.RP−P−OB−113)

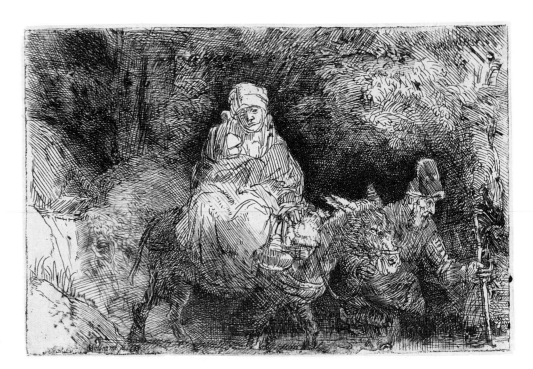

This is one of a number of plates made in 1654 depicting the childhood of Christ which included *The Adoration of the Shepherds*, *The Circumcision in the Stable*, *Christ Disputing with the Doctors* and *Christ between his Parents Returning from the Temple*.[1] The *Virgin and Child with the Cat and the Snake* (cat.114) also appears to have belonged to this series though it is in fact supplementary to the Biblical text. There has been some debate as to whether Rembrandt intended them to be perceived as a 'set' in any formal sense, for it has been pointed out that the etchings all function as works of art in their own right.[2] However, five of the six plates have almost exactly the same measurements (9.5 × 14.4 cm) to within a couple of millimetres of each other while *The Adoration of the Shepherds* measures 10.6 × 12.9 cm.[3] It may be that Rembrandt did conceive these plates as part of a thematic series, perhaps in emulation of artists he demonstrably admired, such as Albrecht Dürer and Lucas van Leyden.[4]

Unlike the technical experimentation which formed the impetus for his earlier depiction of *The Flight into Egypt* of 1651 (cat.112), here the focus is more upon the human significance of the story. The grizzled Joseph leads the donkey forward with a look of weary determination while Mary, her eyes downcast, is lost in a world of her own solemn contemplation. Rembrandt took pains to emphasise the humble nature of Christ's early life in these small etchings, whose format is chosen perfectly to complement the intimacy of these scenes.[5] This was in significant contrast to four larger scale etchings he made in the same year, all measuring approximately 21 × 16 cm. One of these shows the *Presentation in the Temple* while the other three depict Christ's Passion and the events that followed: *The Descent from the Cross*, *The Entombment* and *The Supper at Emmaus*.[6] That Rembrandt intended some of his etchings to be seen as part of a series is strongly suggested by a document of 1671 which states that Rembrandt had 'some polished plates on which to carry out the passion'.[7]

These etchings of the childhood of Christ were made in the year that Rembrandt and Hendrickje's daughter was born. She was christened Cornelia after Rembrandt's mother (the third child of the artist's to bear that name) in the Oude Kerk on 30 October 1654.[8]

116 *Susanna and the Two Elders*, early 1650s

Drawing, pen and brush and brown ink with grey wash, touched with white, 20.1 × 18.8 cm
References: Benesch 592; Schatborn 1985, cat.36, pp.80–1

RIJKSMUSEUM, AMSTERDAM
(INV.NO.A3689)
Exhibited in Edinburgh only

This drawing attests to Rembrandt's continued interest in the theme of Susanna and the two Elders. Having completed his paintings of *Susanna* in *c*.1636 and 1647 (see cat.69 and 110), Rembrandt here reworked the group again. In this case, he reverses the figures and swaps the man with the tall hat and the other elder, so that this time it is the turbaned man who touches Susanna. The man in the tall hat, however, now reaches out towards her, making him more active than previously (the second figure in the 1647 painting was shown slightly further away, passive except for his leer). Rembrandt drew his outstretched arm twice and painted white over the upper one, but this has now discoloured because of oxidisation.

Instead of trying to grab her wrap from her, the turbaned man reaches forward to place a hand upon her shoulder while holding up a threatening finger warning what will happen if she fails to accommodate them. Susanna is shown turned more to the front than before, though her arms still try to cover her nakedness. Unlike in the two paintings, Rembrandt does not show her head turned towards the viewer; instead, all her attention is focused on the danger behind her. The fine lines of this controlled work and the careful hatching have led to a dating of the early 1650s.[1] Another sheet in Berlin, also depicting the same characters but in a more vertical format, was probably made a couple of years later than this drawing, showing that Rembrandt still wished to revise his artistic conception of the subject of Susanna – a process that had continued for some twenty years.[2]

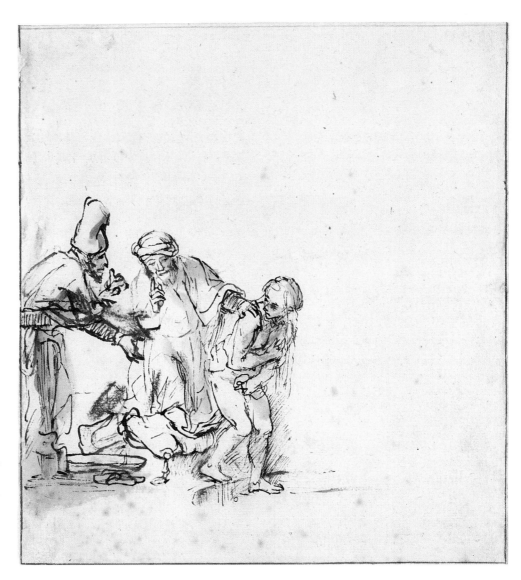

Drawing, pen and brush and brown ink and wash, with white wash, 20.6 × 19.1 cm
References: Benesch 1161; Berlin/Amsterdam/London 1991–2, vol.2, cat.33, pp.116–7; Melbourne/Canberra 1997–8, cat.96, pp.376–7

VISITORS OF THE ASHMOLEAN MUSEUM, OXFORD (INV.NO.PI 192)

The Austrian authority on prints, Adam Bartsch (1757–1821), wrote of Rembrandt in 1797 that 'He loved great contrasts of lights and darks, and he pushed them far beyond intelligence. His studio, though quite sombre, was arranged in such a way that it did not receive much light except through a hole, like a dark-room; this lively ray hit, at the will of the artist, the place he wanted to brighten. When he wanted clear backgrounds, he put behind his model a dropcloth of the colour of the background which he found suitable, and this canvas receiving the same ray of light that falls on the head, indicated the sensitive gradation, which the painter augmented according to his principles.'[1] This drawing of Rembrandt's studio appears to show something of what Bartsch described, with the light focused and reflected by the tented blind suspended over the window whose lower shutters are closed.

Rembrandt uses the window to provide the source of light, as in his etching of *The Virgin and Child with the Cat and the Snake* (cat.114) or his drawing of *Minerva* dated 1652.[2] An easel stands at the left side while books and boxes are piled up on a low table under which is a small stool. The 'lively ray' mentioned by Bartsch spotlights a woman, naked to the waist, who sits upon a strutted chair in front of the edge of an elaborate chimneypiece (similar to that seen in cat.88). To the right, indistinctly drawn, is what has been interpreted as a cradle with a folded coverlet.[3] Studio accoutrements had already been depicted by Rembrandt in his etching of *The Artist Drawing from a Model* (cat.75), but this drawing gives the impression of having been sketched from the life. The likely date of the sheet in the mid 1650s is suggested by the style of the drawing and it is probable that the studio depicted was that in Rembrandt's house on the Breestraat, now the Museum het Rembrandthuis.[4] (The only other two drawings depicting interior views of Rembrandt's houses are cat.77 and 88.)

It has been suggested that the model may have been Hendrickje, with the cradle of the baby Cornelia (baptised 30 October 1654) placed in front of her. However, the identification of the object as a cradle is not certain and even if we could see the woman's face, we have no documented portrait of Hendrickje with which to compare it. There appears to have been a virtual dearth of drawn nudes amongst Rembrandt's work from about the middle of the 1640s and lasting for nearly a decade. However, works such as this demonstrate that his interest in portraying the female nude began to resurface strongly at this period. His paintings of *Bathsheba* (Musée du Louvre, Paris, fig.48) and *A Woman Bathing* (National Gallery, London, fig.143) are both dated 1654 and are generally acclaimed to be amongst the artist's finest paintings to depict the naked female form.[5] It appears that, from about the period of the Oxford sheet, Rembrandt frequently drew from the nude model with a group of his students, each sketching the pose from slightly different angles. A study survives in a private collection (perhaps drawn by Abraham van Dyck), showing a woman in identical undress in almost exactly the same pose as the woman in this drawing, implying that the artist was sitting to Rembrandt's left as he made his drawing.[6]

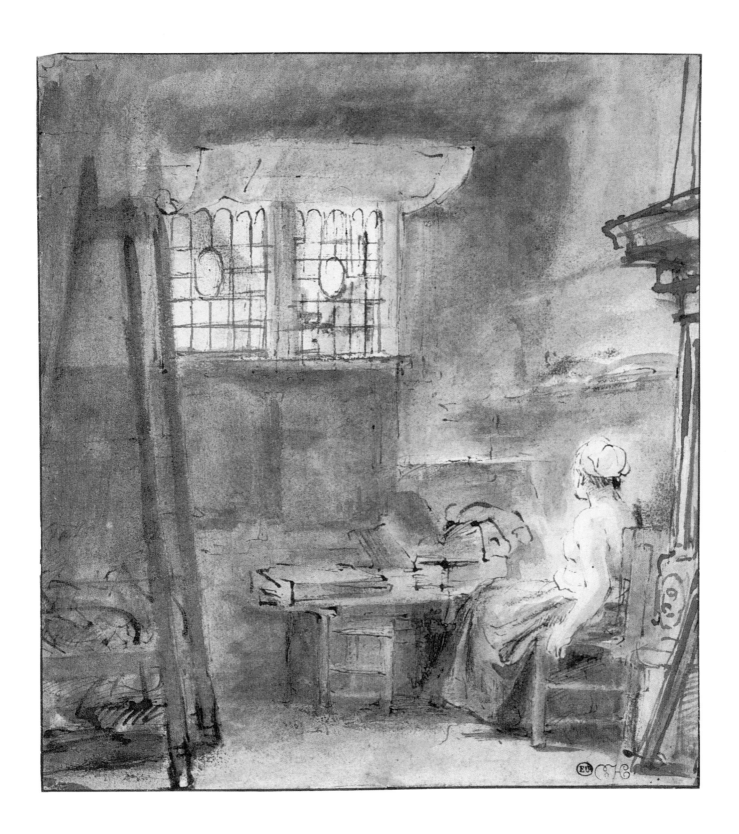

Drawing, brush and brown wash, some white mixed into some parts of the wash, 24.6 × 20.3 cm
References: Benesch 1103; London 1992, cat.58, pp.134–5

BRITISH MUSEUM, LONDON
(INV.NO.1895–9–15–1279)

Exhibited in Edinburgh only

This wonderfully fluent drawing, executed entirely in brush, is something of a conundrum. The technique is extremely rare for Rembrandt and cannot be firmly linked to any securely authenticated or dated drawing. However, it does relate to a landscape drawing in the Louvre which was also made with a brush in the same hue of ink.[1] Though that drawing is unsigned and undated, the association with Rembrandt's authorship is strengthened by the presence of his writing on the reverse of that sheet.[2] The *Young Woman Sleeping* also bears similarities to *A Woman Seated at a Window*, and *A Young Woman Seated in an Armchair* (cat.123 and 124) from the point of view of style and probably belongs to a similar period, although they, too, are neither signed nor dated.

The matter of technique aside, the dating and the identification of the model of this drawing have always been considered together, any conclusion about the former resting largely upon the possibility of the latter being Hendrickje Stoffels. Hendrickje was the youngest of four children of Sergeant Stoffel Jegers of Bredevoort near Arnhem.[3] It is not known exactly when Hendrickje started working in Rembrandt's household but it seems that she may first have been employed to

help out when Titus's nursemaid, Geertje Dircks, became sick. Geertje was described by the notary Laurens Lamberti when she made her will on 24 January 1648 as being 'infirm but able to walk and stand and in possession and full capacity of her mind, memory and speech.'[4] Whether Hendrickje's presence was instrumental in the cooling-off in the relationship between Rembrandt and Geertje we are never likely to know, but she was certainly on Rembrandt's side when she testified on his behalf against Geertje the following year in the convoluted court case that unfolded when the painter was sued for breach of promise.[5] In her deposition on 1 October 1649, which confirms that she must have been in the household by 15 June that year when Rembrandt and Geertje had drawn up arrangements to part, Hendrickje was described as being unmarried and aged twenty-three, making her younger than her employer by some twenty years.[6] She stayed with him until her death aged thirty-seven in 1663.

The resemblance has been observed between the girl sleeping here and Rembrandt's *A Woman Bathing* (fig.143)[7] of 1654 whose hairstyle and facial features appear similar, and the dating of the British Museum drawing has generally been given to the same period on this basis.[8] Though, as mentioned previously, there is no authenticated portrait known of Hendrickje, a certain physical type begins to emerge more frequently in Rembrandt's work from this period that is quite unlike the largely blond, rather frizzy-haired 'Saskia-like' figures which had featured earlier. Though we do not see her face clearly here, this woman's characteristics appear to match those increasingly found in Rembrandt's drawings and paintings from the mid-1650s into the 1660s – namely a woman with darkish hair drawn off her forehead, large dark eyes, almond-shaped rather than round, and an oval face with defined cheekbones. However, it should be mentioned that within these parameters, there is a wide amount of variation, just as with Rembrandt's earlier works purporting to represent Saskia.

The young woman is shown gracefully posed, her cheek against her right arm which is propped up, perhaps upon pillows, while the rest of her body appears draped in a sheet or wrap of some kind. The portrayal of women asleep is a theme which had recurred frequently in Rembrandt's work from the late 1620s and was one that he continued to depict until the end of his life.[9] As a subject in Netherlandish art before the seventeenth century, the sleeping figure was depicted relatively rarely but prior to this was generally connected with the deadly sin of Sloth.[10] Sleep also tended to have associations with lust and drunkenness.[11] In this drawing, though, it would be hard to envisage that Rembrandt intended to evoke such moralising elements and the beauty of the pose seems as important as the fact that the woman is shown

sleeping. Despite the anomalies mentioned concerning technique, dating and identification of the model, Rembrandt's authorship of this drawing has never been questioned. Executed with a sparse, fluid elegance reminiscent of eastern calligraphy, *A Young Woman Sleeping* has a quality of immediacy and yet timelessness, making it one of Rembrandt's most impressive and justly famous drawings.

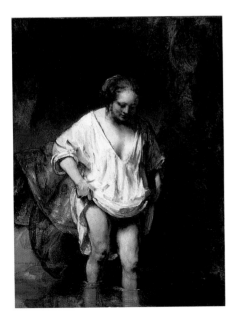

Fig.143 | Rembrandt, *A Woman Bathing*, 1654
National Gallery, London

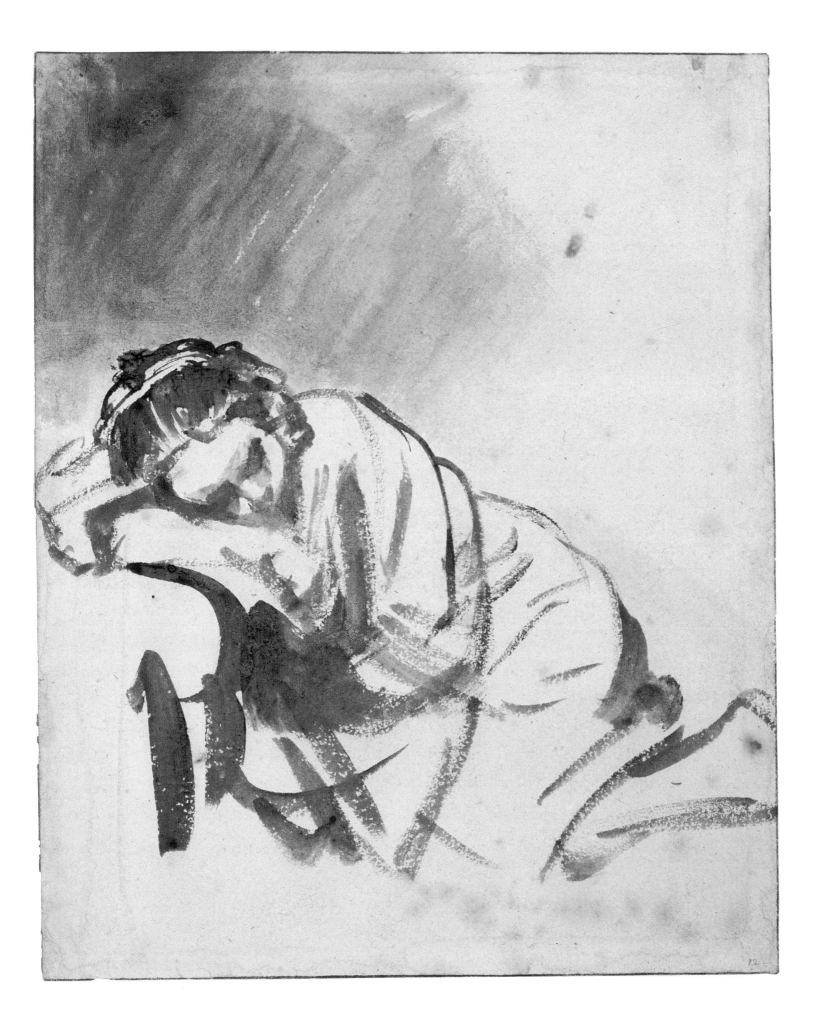

Oil on canvas, 100 × 91.8 cm
References: Bredius/Gerson 114; Berlin/Amsterdam/London 1991-2, vol.1, cat.41, pp.250-3; New York 1995-6, vol.2, cat.12, pp.69-71

METROPOLITAN MUSEUM OF ART, NEW YORK
Gift of Archer M. Huntington, in memory of his father, Collis Potter Huntington, 1926
(INV.NO.26.101.10)

Rembrandt showed a sustained interest in the depiction of Flora, a theme which he re-visited at different stages of his life. The 'betrothal' drawing that Rembrandt made of Saskia in 1633 (Benesch 427) has also been mentioned in relation to this theme since she, too, holds a flower, perhaps a rose. Although fundamentally part of the context of the drawing, given that Saskia is wearing country garb, it also probably stood for love and marriage, an allusion often found in art and literature.[1] (For example, Jacob Cat's *Houwelyck* (Marriage) of 1625 has an engraving of a woman handing out a rose to smell.)[2] Rembrandt's earlier paintings of the subject were the *Flora* of 1634 from the Hermitage (cat.27), the *Flora* of 1635 from the National Gallery, London (cat.36) and a painting called *Saskia as Flora* of 1641, now at the Gemäldegalerie Alte Meister, Dresden (fig.144).[3]

The classical mythology of Flora has two different yet interwoven strands which affected the iconography of the way in which she was depicted.[4] According to the third-century Christian author Lactanius, a Roman courtesan left all her ill-gotten gains to found a floral games for the people of Rome and the embarrassed Senate were forced to honour this ex-prostitute as a goddess.[5] This 'Flora meretrix' was linked to courtesans, but her elevation to goddess of flowers made her 'Flora mater', who, together with her husband Zephyrus (the west wind), brought spring to the world.

A painting of *Flora* by Titian (fig.145) which was in the collection of Antonio López in Amsterdam in the 1630s has, at various times, been suggested as a source for all of Rembrandt's pictures of this subject, including the Metropolitan *Flora*.[6] Interestingly, in the light of the fact that all Rembrandt's pictures of Flora have generally been associated with his wife or mistress, Joachim von Sandrart's engraving of Titian's *Flora*, made in Amsterdam in about 1640, is inscribed with a quatrain which implies that the work was then thought to portray Titian's lover:

> *In Springtime, warmed and nourished by soft showers,*
> *When Zephyr's gentle breeze brings forth sweet flowers,*
> *Then Flora, in the mantle of the Spring,*
> *Enamours Titian, and tempts others' hearts to sing.*[7]

The way in which Titian portrays his *Flora* proffering flowers in her chemise has been taken to indicate she may have been a courtesan, offering her body as well as blooms. However, Titian was also influenced by classical sculpture in his portrayal: the shift was seen as 'antique' dress as well as 'undress' by Titian and the bared breast was a common feature of goddesses in classical sculpture, such as the *Venus Genetrix*, now in the Louvre, Paris.[8] Titian's composition does appear to have partially inspired the Dresden *Flora* which shows a similar pose and where the loosened bodice has a similar profile to the décolletage in the Titian.[9] The Metropolitan *Flora* also suggests a knowledge of the Titian in its treatment of the white shift, painted almost as an exercise in the virtuoso depiction of drapery, as seen in Rembrandt's even more masterful *Aristotle* of 1653.[10] The broad fall of soft white material collects into deep gathers which Rembrandt sculpts with shadow, making almost abstract patterns. (In this context it is interesting to note that the well-known antique statue, the *Farnese Flora*, was most renowned for the beauty of the carving of her delicate drapery.)[11]

Rembrandt shows his Flora holding towards us her golden-yellow apron filled with flowers, but her face is turned almost into pure profile, recalling the same feature in his earlier *Saskia van Uylenburgh in a Red Hat* in Kassel (fig.72), while another studio version of this painting now in Antwerp comes even closer to the same contours.[12] Rembrandt altered the hat quite dramatically, traces of which can be seen on the canvas, and crowned this Flora with the most flamboyant wreath yet, a branch of cherry blossom, its leaves catching the light with their glossy edges. The tone of this composition, however, is more sombre and contemplative than the previous versions of the subject: she appears more chaste than a courtesan, despite her offering of flowers.

Her features seem to correspond to a general facial type Rembrandt started to use in his history pictures from the end of the 1640s. They also relate, though they are not identical, to those found in his *Bathsheba* of 1654.[13] Both these paintings have been believed to represent Rembrandt's servantmaid and mistress, Hendrickje Stoffels, though unfortunately, as has been stressed before, there is no authenticated portrait of her known. It should also be stressed that the similarity of the forms of the facial features in this *Flora* to Rembrandt's earlier portrayal of Saskia in *Saskia in a Red Hat* should make one careful of suggesting that this (and, indeed, the *Bathsheba*) is meant to be seen as a true portrait of Rembrandt's lover. However, it does seem as though the 'ideal' head of the women used in Rembrandt's history pictures had changed, and the blonde, round-eyed women of the 1630s are found no more, being replaced by a figure with darker, straighter hair and a sharper chin, as seen here. Interestingly, Rembrandt had already depicted a face akin to this in his *Susanna and the Elders* of 1647 (see cat.110, fig.140), before Hendrickje is recorded as being in Rembrandt's household. This could partly be due to a change in fashion in the intervening years, but the *Bathsheba* and the *Flora* show, if nothing else, that Rembrandt's conception of the female 'ideal' head in his history paintings had altered significantly over the years.

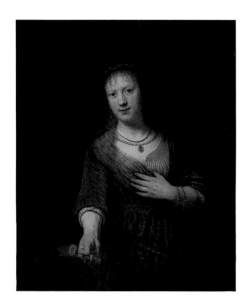

Fig.144 | Rembrandt, *Saskia as Flora*, 1641
Gemäldegalerie Alte Meister
Staatliche Kunstsammlungen, Dresden

Fig.145 | Titian (*c*.1485/90-1576), *Flora*
Galleria degli Uffizi, Florence / Bridgeman Art Library

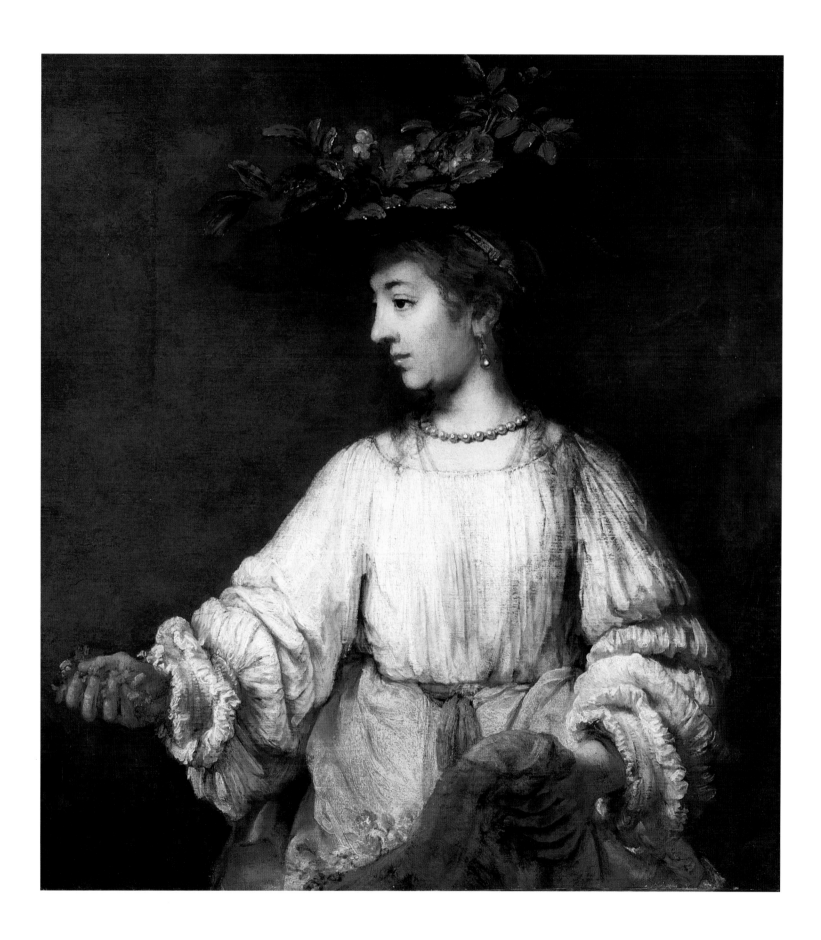

Oil on canvas, 113.5 × 90 cm
Signed and dated, lower centre: *Rembrandt f. 1655*
References: Bredius/Gerson 524; Tümpel 1993,
cat.25, p.392

GEMÄLDEGALERIE, STAATLICHE MUSEEN,
PREUSSISCHER KULTURBESITZ, BERLIN
(INV.NO.828H)

Rembrandt had already portrayed a slightly earlier
episode of this story in his etching of 1634 (cat.28),
taken from the Book of Genesis (39: 6–13). In the
etching, the attempted seduction is shown, with
Iempsar, Potiphar's wife, in less dignified mode,
naked and needy. In his attempt to escape her
unwanted advances, Joseph 'left his garment in her
hand and fled out of the house'. This discarded
garment is presumably the rich coat which lies at
the rejected woman's feet in the painting, and
which she is just about to use to incriminate him
falsely.

Potiphar's wife is literally and metaphorically at
the centre of this composition, placed strategically
by the prominent bed. Her mouth is open as she
utters her accusation, gesturing at Joseph rather
crudely with her thumb. Her legs are almost
crossed as if to emphasise to her husband that she
has rejected Joseph's impropriety, while her left
hand clutches at her open chemise to cover her
breast in what we know to be a display of modesty.
Joseph is shown raising his eyes and hand plead-
ingly towards heaven, God alone his witness,
although X-rays show that Rembrandt originally
portrayed him in an even more theatrical pose with
his head in his hands.[1] Slight alterations were also
made to the position of Iempsar's foot. The drama
of the moment is achieved through these expressive

poses, the placing of the figures and also through
the rich but broken brushstrokes that make the
opulent hangings, gilded bedpost and brocaded
gown glint against the shadows. Christian Tümpel
proposed that Rembrandt's decision to place the
action around the bed was inspired by Flavius
Josephus (although Rembrandt had already used
this setting for his etching of the subject).[2]
Josephus's account of the incident in his book *Of
the Antiquities of the Jews*, does describe Iempsar as
urging her husband to take revenge upon 'the
wicked slave, who has desired to defile thy bed',[3]
and it is known from the inventory of Rembrandt's
goods made in 1656 that he owned a German copy
of this publication, extensively illustrated by
Tobias Stimmer.[4]

Neither the Biblical account nor Josephus's
version, however, specifically describes all three of
the protagonists as being present when Iempsar lies
to her husband about Joseph, and it may be that the
idea of showing them all together was inspired by a
painting of 1629 by Jan Pynas (*c.*1585–after 1650),
although the compositions themselves are not
particularly similar.[5] It is perhaps more likely that
the idea came from a play, *Joseph in Egypten* of 1639–
40 by Joost van den Vondel (1587–1679).[6] In this
dramatisation, Joseph, Iempsar and Potiphar were
all on stage for the false accusation.[7] A critically
acclaimed production of this play in 1655 had
unusually featured an actress (Adriana van den
Bergh) performing the role of Potiphar's wife, as
Gary Schwartz has pointed out.[8] It is interesting in
this context that the figures in Rembrandt's
painting, dramatically lit in the dark setting, are
carefully positioned across the picture plane and
the rhetorical gestures made by Iempsar and Joseph
certainly give the impression of a staged scene. This
effect is further added to by the step which runs
across the front of the composition and across
which the end of the bed appears to be perched
precariously like a theatrical prop, there for effect
rather than use. Whether or not the play was the
inspiration for Rembrandt's painting, the popular-
ity of the play that year must have created a more
receptive market for the subject amongst his
clientele, further suggested by the presence of
another version of the composition produced by
the artist's workshop, now in the National Gallery
of Art, Washington (fig.146).[9]

It has been suggested that Rembrandt's reason
for choosing to paint this subject was considerably
more personal, and related to Geertje Dirck's
accusation against him for breach of promise in
1649.[10] It is true that 1655 was the year when
Geertje was finally released from the house of
correction in Gouda (a detention which
Rembrandt had attempted to prolong) and that the
debt he owed her made her one of his most
significant creditors.[11] But one could just as well
cite what Rembrandt must have seen as an unfair
accusation by the Church against Hendrickje in

1654 if looking for a cause in Rembrandt's own
life. But this is an uncertain route to travel and
perhaps it is salutary to remember that, though
Rembrandt made his etching of the story of *Joseph
and Potiphar's Wife* in the year of his marriage to
Saskia, nobody has, understandably, ever suggested
that his blatant and, to many, distasteful depiction
of female nudity there had anything whatsoever to
do with his first experiences of marital relations.

Rembrandt here reveals his admiration for
Titian and Venetian painting of the sixteenth
century in his choice of palette. The glowing
creamy white of the unsullied sheets, deep red on
the velvet chair, soft rose-pinks of the folds of
Iempsar's robe and the tones of gold-yellow of her
slipper and in the highlights upon Potiphar's
eastern garb and the carved golden bedpost, are
thrown into brilliance by being set against the dark
background. But while this 'Venetian' colouring
conveys Rembrandt's conception of the sumptuous
Biblical setting perfectly, he uses it with restraint,
placing small accents carefully where they will
most count but will not disturb the overall balance
of the composition. The dark-haired Iempsar with
her coiffure swept back from her high forehead,
dark eyes and straight nose is from the same
'family' as Rembrandt's drawings of *A Young
Woman Sleeping* or *A Young Woman Seated in an
Armchair* (cat.118 and 124), although, interestingly,
a link to Hendrickje has not been suggested in this
case, though it has in so many others.

It is possible that either this, or perhaps the
Washington painting, was owned by Harmen
Becker, a wealthy merchant collector for whom
Rembrandt may have painted his picture of *Juno*
(cat.140).[12]

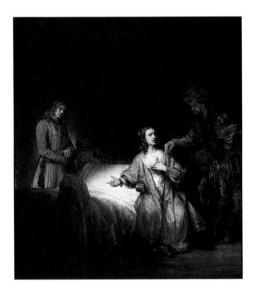

Fig.146 | Rembrandt's Workshop, *Joseph and Potiphar's Wife*
Andrew W. Mellon Collection
National Gallery of Art, Washington DC

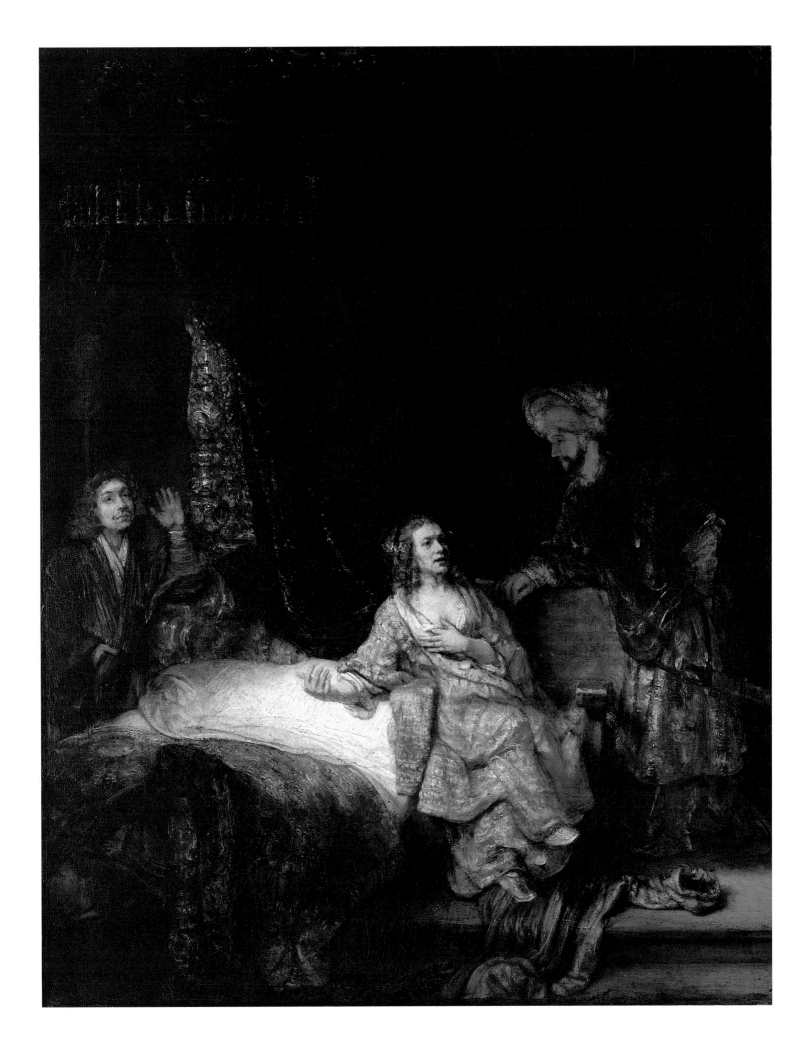

Oil on canvas, 83 × 69.5 cm
Signed and dated, centre left: *Rembrandt f.1655*
References: Bredius/Gerson 385; London 1976,
cat.90, p.73; Washington 1985, cat.292, pp.363–4

COLLECTION OF THE DUKE OF BUCCLEUCH
AND QUEENSBERRY KT, DRUMLANRIG
CASTLE (INV.NO.144)
Exhibited in Edinburgh only

The strong impact of the atmospheric use of light
and shadow in this picture and the striking
simplicity of its composition make it one of
Rembrandt's most impressive single figure
paintings of the 1650s. Rembrandt's contempo-
rary, Joachim von Sandrart, wrote of the artist in
Teutsche Akademie, published in 1675, that 'In the
depiction of old people, particularly their skin and
hair, he showed great diligence, patience and
practice ... he indeed excels, not only grandly
rendering the simplicity of nature but using natural
forces to colour, heighten and embellish it,
particularly in his half-length pictures of old
heads.'[1]

It has been suggested that this portrait might be
a posthumous *portrait historié* of Anna Wijmer
(1584–1654), the mother of Rembrandt's patron
Jan Six.[2] The existence of a portrait of her is
recorded in a quatrain by the poet and playwright
Joost van den Vondel (though the artist of the
picture Vondel writes of was unspecified). A female
portrait formerly ascribed to Rembrandt still in the
Six collection is unlikely to be this sitter on the

Fig.147 | Rembrandt, *An Old Woman Seated in an Armchair*
(detail, see also fig.129)
Musée du Louvre, Paris, Rothschild Collection
Photo: RMN-Michèle Bello

grounds of age[3] and, though Rembrandt did make
a pen and ink drawing of *Minerva in her Study* in
about 1652 (Six Collection, Amsterdam) in an
album amicorum owned by Jan Six, the claim that it
represents Jan Six's mother as Minerva is un-
founded.[4]

Similarly seeking a sitter, old catalogues of the
Buccleuch collection have tended to identify the
woman as Rembrandt's own mother, Neeltgen
Willemsdr van Zuytbrouck, who was born in
Noordwijk in 1568, married to Rembrandt's
father in Leiden on 8 October 1589 and died on
14 September 1640 (see cat.1–5). Again, the
identification is unlikely since this painting was
made fifteen years after her death. Rembrandt drew
a study in the latter half of the 1630s, perhaps using
his mother as a model, which clearly demonstrates
his skill at depicting the curves and contours of the
elderly face (fig.147).[5] The frontal pose and the way
the face is constructed are somewhat similar to this
painting but here the planes of the face are shown
through chromatic changes. Rembrandt paints the
dark shadowing defining the soft pouches under
the woman's eyes, the streak of rosy pink next to an
area of brownish underpainting by her nose which
defines the deep crease of her cheek and the smears
of bruise-coloured paint which are placed at the
inner corners of her eyes in order to show where
the thin papery skin hangs loose by her eye sockets
and where it is stretched tight over the bony bridge
of her nose. While the foundations for
Rembrandt's ability to depict old women had long
been laid, this painting has nothing of a stock
figure about it and his response has a vivid imme-
diacy that would suggest the work was made from
the life.

The woman is wearing a warm brown velvet
cloak edged with white fur, under which appears to
be a snowy white collar tied with a long white
string. However, the garment seems also to have
white sleeves, rather like a habit. On her head is a
dark hood, reminiscent of that which Rembrandt
had painted some twenty-five years before in his
composition of *Bust of an Old Woman* now in the
Royal Collection (cat.5). Like that garment, this
hood is also lined with golden brocade, a feature
that one would not usually expect to find in a
straightforward contemporary portrait. However,
a painting of 1651 in the Hermitage of a woman
with a book upon her knee, dressed in a large black
hood, by Rembrandt's pupil Ferdinand Bol (1616–
1680), shows her wearing a cloak with a bejewelled
golden clasp which one would normally associate
with a *tronie* or history picture.[6] But that painting
is inscribed with the information that the sitter was
eighty-one years old, thus making it plain that Bol
was painting the portrait of a real lady, in the guise
of a Biblical figure.

The iconographic tradition in the Netherlands
would almost certainly have prompted the
interpretation of Rembrandt's *An Old Woman*

Reading as portraying a character from the Bible.[7]
This is partly because of the size of the book, but is
further emphasised by the obvious concentration
of the woman, who is completely absorbed in the
text. Her expression has an extraordinary quality of
contented contemplation, an impression which
Rembrandt enhances by the treatment of light
which seems to emanate from the unseen pages of
the book, reflecting onto her white garment. The
light from the pages shines softly upon her face
beneath the dark hood, illuminating her face, while
the text itself, perhaps, enlightens her soul.
Rembrandt had made a painting of a similar subject
in 1631 (see cat.4, fig.78),[8] which is generally
interpreted as representing the prophetess Anna
reading psalms because the text seems to resemble
Hebrew. Other such figures have been interpreted
as embodiments of Religion or Sibyls. Though
there are too few clues to indicate such a precise
interpretation here, such figures, often widows,
were seen as representing a life of piety and
simplicity.[9] Indeed, the poet Jacob Cats in his
writings on marriage in 1625 (*Houwelyck*) described
the characteristics of the exemplary widow as 'A
heart that is uplifted by reading in God's book, /An
eye that enjoys being wet with tears, /A quiet soul
that is ashamed of the world.'[10]

These single figures of old women, originally
intended as *tronies* or studies for larger history
paintings, had become genre subjects in their own
right by this period. Judging by the many works
which seem to have come out of Rembrandt's
workshop depicting such figures,[11] and also the
number painted by his pupils (for example,
Abraham van Dijck, 1635–1672[12] or Nicolaes
Maes, 1634–1693),[13] these studies were extremely
popular with his clientele. It is intriguing that,
having made a number of such female half-lengths
in the early 1630s, Rembrandt should, after nearly
three decades, have revisited such subject matter in
An Old Woman Reading. In his assessment of
Rembrandt's work referred to above, Joachim von
Sandrart went on to comment that these 'simple
subjects' did not lead to 'profound reflections'.[14]
However, modern viewers of this painting might
find it hard to agree with such an observation, for,
as Christian Tümpel has observed, many other
seventeenth-century Dutch artists may have shown
old age as miserly, decrepit and foolish, but
Rembrandt, in such works as this, portrayed the
elderly as 'waiting, hoping, meditating, and
reading, taking on a profound human dignity
through their faith and hope.'[15]

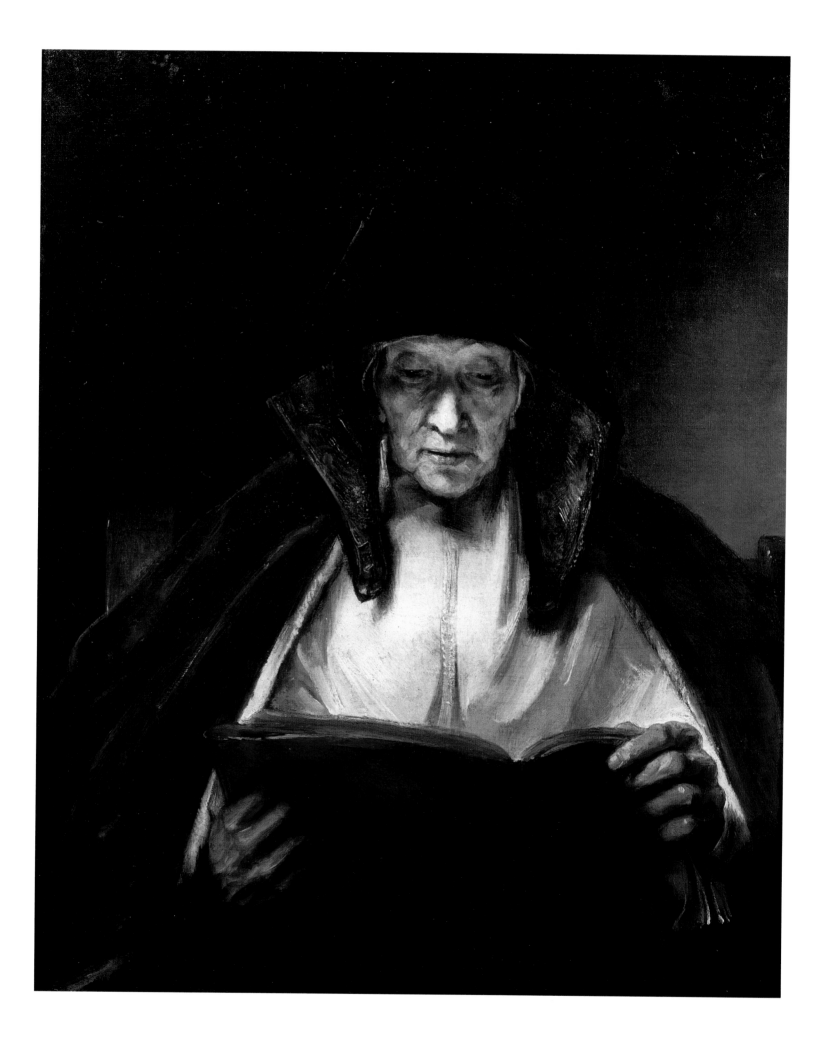

Oil on canvas, 126 × 98.5 cm
Inscribed on shield, upper left: *CATRINA HOOGH-SAET. OUT 50 Jaer Rembrandt f.1657.*
References: Bredius/Gerson 391; London 1995, cat.52, pp.140–2

PENRHYN CASTLE, GWYNEDD
Exhibited in London only

In most of his portraiture of women, Rembrandt generally followed the Netherlandish portrait convention of showing them as wives, looking across to (our) left, designed to be placed to the right of a pendant work of their husband. The pose of the sitter here appears perfectly to fulfil this rule. This is not to say that Rembrandt never tested the limits of such convention, as in his portrait of Agatha Bas (1611–1658) of 1641, where the sitter looks straight out at the viewer instead of at her husband (as, also, does Margaretha de Geer, cat.137).[1] Indeed, Rembrandt showed Agatha Bas so centrally positioned that her portrait could be hung on the left or right of her husband's with no detriment to the balance of the picture, and a drawing by C. Andriessen of 1805, showing the pendants together in the art gallery of L.B. Coclers, intriguingly reveals that they placed Agatha on the left of her husband, rather than on the customary right side.[2]

Though the pose of the sitter here, facing to the left, would suggest that the portrait was intended as a pendant to that of a man, its pair has not been identified. Catrina, also called Catharina or, more commonly, Trijn Jans (1607–1685), was a Mennonite and the daughter of the compass-maker, Jan Dircksz Hooghsaet. The Mennonites were followers of Menno Simons (1496–1561) and believed in the literal observance of the Bible and the authority of the congregation, rejecting weapons and state and civic institutions, but often thriving as businessmen. One might have assumed that the pendant picture would have been of Catrina's second husband, Hendrick Jacobsz Rooleeuw, a dyer by trade and a Mennonite preacher whom she had married in 1637.[3] (Her first husband Pieter Claesz had died in 1628 a year after their marriage.)[4] However, it is very unlikely that he would have figured in this 'missing' pendant since the marriage was not a success and Catrina apparently lived separately from her husband for some years before her portrait was painted.[5] This was most unusual in seventeenth-century Amsterdam and implies that Catrina must have been independent to some considerable degree, not only in wealth but also in spirit.

That Catrina should have had herself painted is also unusual, for such a commission by a woman was not common. As we have seen, the widowed mother of Maria Trip appears to have commissioned Rembrandt to paint both her and her single daughter, but it is interesting that the widow was painted directly facing the viewer and that the as-yet-unmarried Maria is positioned turning only very slightly to the left (cat.85). Why then, when she, too, could have been portrayed like this, should Catrina Hooghsaet have had herself painted as if for a pendant when she and her husband had been separated for some years? Perhaps the most likely suggestion is that the picture had been commissioned as a pendant to a documented portrait of Catrina's late brother. This is certainly possible, as both pictures were bequeathed to her young nephew (though whether as a pair is unspecified).[6]

Catrina is shown wearing a black gown with wide sleeves edged with a simple band of white, allowing the gathered edges of her white underblouse to show underneath. Her collar is wide and plain, tied with tasselled strings, both at the neck and at both points of the collar. Her white cap is of complicated construction, held in place by decorated golden metal grips which were known as 'head-irons' (*hoofdijsertgen*). The rounded end of one of these is shown pushing into her flesh just under the cheekbone, an effect that was noticed a few years earlier by Owen Feltham on his visit to the Low Countries. He remarked of the females victim to this fashion that 'Their Ear Wyres have so nipt in their Cheeks, that you would think some Faery, to do them a mischief, had pinched them behind with Tongs'.[7] It is known Catrina bequeathed her golden 'ear-wyres' to her relative Marritje Dircksdr Hooghsaet.[8] The wearing of such headgear indicates that Catrina was a member of the more tolerant Waterland congregation of Mennonites. Catrina did, however, observe the proscription on the wearing of lace and elaborate cuffs upheld by the more orthodox amongst the sect. The handkerchief decorated with tassels ('*akers*') that she holds would have been considered acceptable too, since these seem to have been one of the very few luxury accessories that the soberly dressed Mennonite women did allow themselves.[9]

Catrina may have heard about Rembrandt through her second husband's brother, Lambert Jacobsz (1592–1637), who was a great admirer of the artist's work. Another family connection was provided via her aunt who was married to the teacher and calligrapher Lieven Willemsz van Coppenol (1598–after 1667)[10] of whom Rembrandt made at least two portraits in about 1658.[11] However, her commission could equally have been influenced by the fact that Rembrandt had portrayed many Mennonites during his career (such as his painting of the Mennonite preacher Claes Anslo and his wife – see fig.69[12]). Given the fact that her estranged husband was a preacher for this sect, to which she also belonged, she may well have met some of those whom Rembrandt had painted, and it is not inconceivable that she may have seen some of these portraits. Though not a Mennonite himself, Rembrandt had close contacts with the Mennonites, due presumably to his contact at the beginning of his career in Amsterdam with Saskia's cousin Hendrick Uylenburgh, who was one of their number.

The picture was reputedly altered in a number of different ways and it has been stated that 'one of the hands was in her lap, the parrot was on the table and there was a curtain on the left'.[13] However, Alastair Laing notes that 'there is no real evidence of this' but that some paint has sunk into the canvas and become less legible.[14] What does seem to have been altered, though, is the (now almost invisible) parrot and the inscriptions hanging from the support for the ring upon which it sits. It is known that Catrina was kept companion by a parakeet or parrot, for it is mentioned in the will she made in 1657, the year this portrait was painted, as 'her little parakeet with its cage' (*Haer perkietye met syn kouw*).[15] This would certainly have been frowned upon by the Mennonites as a symbol of luxurious and indulgent frippery and, indeed, in 1655 a sermon had been preached criticising women who lavished care upon parrots but ignored the poor.[16] However, Catrina's pet must have been remembered with pleasure by someone, for the painted parrot placed so prominently in the background was almost certainly added on later instructions to provide further identification of the sitter, along with the inscription.

Catrina chose to have her portrait painted in 1657, the year she made a will determining what would happen to her possessions after her death. This was perhaps prompted by some atavistic instinct, given her own childlessness and the fact that she intended to leave the picture to her nephew, who was only three years old. He might never have remembered, or known, the face of his feisty Mennonite, parrot-owning aunt without Rembrandt's portrait, so full of character and dignity.

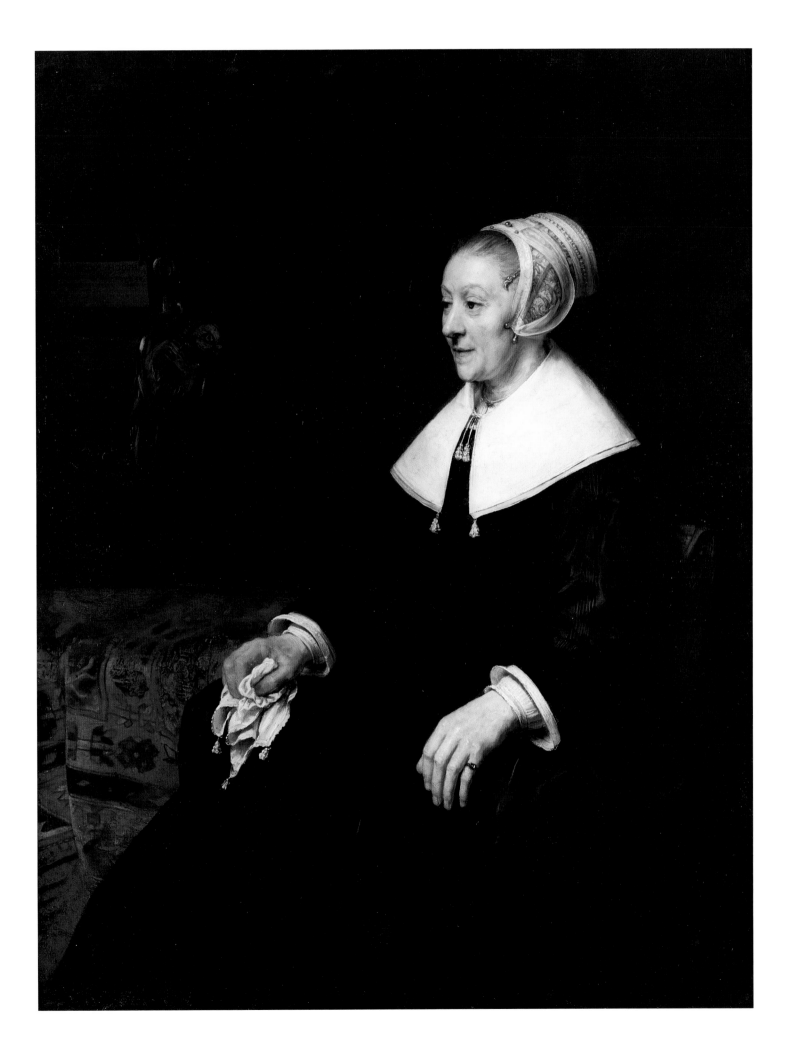

Drawing, pen and brush and brown ink with wash, and white wash, 16.3 × 17.5 cm
References: Benesch 1101; Berlin/Amsterdam/London 1991–2, vol.2, cat.35, pp.120–1; Stockholm 1992–3, cat.157, p.358

NATIONALMUSEUM, STOCKHOLM
(INV.NO.NMH2084/1863)

Exhibited in Edinburgh only

This drawing was clearly made within a very short time of another of almost identical dimensions which is also in the collection of the Nationalmuseum, Stockholm (fig.148).[1] It can be assumed that the first was probably the one showing the woman awake, leaning her head upon her hand, deep in thought. Such a pose is reminiscent of a number of Rembrandt's compositions, such as that of *A Study for a Girl at a Window* (cat.103). Whether overcome by melancholy or weariness, the woman in the drawing here seems to embody the natural progression from the first pose as she leans back against the window frame, allowing herself to give in to sleep and to the warmth of the sun. For, above all, in this most painterly of drawings, the impression is one of heat and stillness, the dark brown wash in the background showing the deep shadows indoors while the woman sits by the open window bathed in light.

Rembrandt seems to have found the abandoning of consciousness into sleep compelling and returned again and again to this theme. Here he combines it with another of his favourite motifs, that of a woman framed by a window. Images of women sitting at windows were not without moral significance in the Netherlands in the seventeenth century, as is still the case in Amsterdam's red light

district. Though prostitution was not necessarily implied, a woman who had time to lounge at a window in full view of the outside world was by implication not busy with her household, neglectful of her duties and waiting for the devil to find work for her idle hands. (One wonders whether the mirrors still to be seen attached to the windows of upper storeys in the Netherlands today are not a reflection of this idea, allowing those inside to see what is going on outside without the ignominy of being seen to peer out.) However, it is unlikely that Rembrandt wished to infer any such meaning in his drawing of this woman basking in the sun. It is more probable that he favoured such a setting for its compositional possibilities of portraying a strongly lit figure within geometric confines, as demonstrated by another sheet now in the Musée du Louvre, also dating to the mid-1650s, where a woman leans on the window sill seen from the other side (fig.149).[2]

Both of the Stockholm studies are made in reed pen, with great economy of line, the wash then drawn in by brush. The freedom of the handling in the broad brushstrokes he uses here relates closely to the British Museum's *Young Woman Sleeping* of *c*.1654 (cat.118) and also to the study of *A Young*

Woman Seated in an Armchair of *c*.1654–60 (cat.124), both of which have also been thought to represent Hendrickje Stoffels.

Fig.148 | Rembrandt, *A Woman with her Eyes Open*
Nationalmuseum, Stockholm

Fig.149 | Rembrandt, *A Woman Looking Out of a Window*
Musée du Louvre, Paris, Rothschild Collection. Photo: RMN-Gérard Blot

Drawing, pen and brush and brown ink with wash, 16.3 × 14.3 cm
References: Benesch 1174; London 1992, cat.59, pp.135–6

BRITISH MUSEUM, LONDON
(INV.NO.1948–7–10–7)

This drawing is executed in reed pen, the same technique that Rembrandt used in *A Woman Seated at a Window, Eyes Shut* (cat.123) and was presumably made at about the same time. With her dark hair brushed back from her forehead with a few curls escaping at the side, the woman has, not unreasonably, been associated with Hendrickje Stoffels, on the basis of the recurrence of these features in Rembrandt's work at this period. She sits slightly forward, tensely, in her high-backed chair, her elbows resting on its arms, a forceful brooding presence. Her dark brows are created by one straight line across, matched by a horizontal stroke for her mouth, bleak and serious.

It is unlikely that this was a simple study from life. The square neckline of the dress, its tight bodice and huge gathered sleeves suggest a Renaissance style, almost certainly indicating that the subject matter was in some way connected with a history picture. It has been suggested that the drawing may have been made as preparatory for the painting believed to represent Hendrickje now at the National Gallery, London (see cat.125). But though the way the arms were originally shown in the painting seems to correspond more closely with this drawing, the dress remains very different, as does the expression of the sitter.[1]

In this drawing, the hands initially appear to have been clasped together in the woman's lap, although the shapes at this point are extremely hard to make out and it is conceivable that she is actually holding something in her left hand. Martin Royalton-Kisch suggested that this might be a scroll and that the figure in her regal robes might have been intended as a study for Queen Esther meditating on the decree to slay the Jews.[2] Taken from the Book of Esther (4: 8), this incident marked Esther's decision to risk her life by opposing Haman's perfidious plot against her people, the Jews. Rembrandt probably intended to depict this moment in his etching of '*The Great Jewish Bride*' (see cat.33–5) and Esther may also have been portrayed in the painting of *A Heroine from the Old Testament* (cat.20), both finished some thirty years earlier. Certainly the serious gaze of the woman here summons up the impression of deep thought, perhaps illustrating Esther's dilemma, determining at last to intervene on behalf of the Jews, stating 'Then I will go to the king, though it is against the law: and if I perish, I perish.'[3]

Oil on canvas, 101.9 × 83.7 cm
Inscribed, lower left: *Rembrandt 16[5?]9*
References: Bredius/Gerson 113; London 1988–9,
cat.13, pp.106–11; McLaren/Brown 1991, vol.1,
pp.364–7

NATIONAL GALLERY, LONDON
(INV.NO.NG6432)

The evidence provided by X-rays of this painting
seems to reveal that both of the woman's arms were
originally folded across her body, before her right
arm was altered to lean upon the gilded and turned
post, presumably the upright of a chair (fig.150).
The sitter's left hand was initially visible (rather
than hidden inside her robe) and this first pose has
been seen as relating more closely to the British
Museum drawing of *A Young Woman Seated in an
Armchair* (cat.124).[1] However, although the two
works were probably made at about the same time,
the exact position of the sitter's right hand is not at
all certain and the marked differences between the
dress and the facial expressions point more to
variations on similar poses, rather than to a direct
relationship between the two compositions.[2]

The date of the painting has been debated to the
extent that few scholars have agreed upon the same
year of execution. The third digit of the date
inscribed upon the canvas itself is unclear but is
either a '5' or a '6'. The latter figure is impossible
since the style of this picture is not compatible with
those paintings Rembrandt produced in the last
year of his life. However, technical examination of
the canvas has suggested that the signature is not
by Rembrandt and seems to have been added to the
picture slightly later, also making the date of 1659
potentially suspect as well.[3] Stylistically, the
composition relates to other three-quarter length
portraits which Rembrandt made in the early
1650s such as his 1651 etching of Clement de
Jonghe[4] or the painting of Nicolas Bruyningh of
1652 now in Kassel.[5] In both these works
Rembrandt was exploring the compositional
opportunities and challenges presented by a seated
figure, which was also a consideration in his etched
portraits of Jan Lutma of 1656,[6] and of Arnold
Tholinx, made at about the same time.[7]

If the compositional structure suggests a date of
the mid to late 1650s, another factor has also
contributed to this dating. When compared with a
formal portrait of the same period such as that of
Catrina Hooghsaet (cat.122), it is clear that the
sitter's informal pose, frank gaze and revealing
dress create a very different mood. It is the
atmosphere of intimacy in this painting, together
with the similar features of dark hair and brown
eyes which recur in Rembrandt's work from the
early 1650s, that have led to the identification of
the sitter as Rembrandt's mistress, Hendrickje
Stoffels. There are perhaps five paintings by

Rembrandt which are generally accepted as
portraying her, namely this picture, *A Woman at an
Open Door* in Berlin (cat.126), a painting of her made
in *c*.1654–60 in the Metropolitan Museum (cat.127),
another in the Louvre of *c*.1654 (fig.153) and *A
Woman Bathing* of 1654 in the National Gallery,
London (fig.143).[8] None of these, however, can be
considered a formal portrait, especially the latter as
it shows a half-naked woman paddling in the water.
In the *Woman Bathing*, the rich robe which lies on
the pool's bank behind her suggests that some
historical subject was implied, such as, perhaps,
Bathsheba.[9] The paint there is applied in a remark-
ably fluid manner, almost sketchy in the thick
strokes of cream and soft brown that make up her
shift. It had been suggested that the panel was left
unfinished; however, despite its extremely loose
handling, Rembrandt obviously thought it
sufficiently complete to sign and date it.

However, the present painting believed to
represent Hendrickje Stoffels seated does actually
appear to have been left incomplete.[10] Her wrap,
woollen or furred, is left undefined, as are areas of
the loosely brushed-in background and the line of
red for the tablecloth or bedspread in the fore-
ground. Nevertheless, given the deep décolletage
and the relaxed pose of his mistress, it is possible
that Rembrandt saw no need to complete these
areas, given the apparently informal, intimate
nature of the work.[11] As Arnold Houbraken's
famous critique of the artist stated, Rembrandt
worked some things up 'in great detail, while the
remainder was smeared as if by a coarse tar brush,
without consideration for drawing. He was not to
be dissuaded from this practice, saying in
justification that a work is finished when a master
has achieved his intention in it.'[12]

This picture was exhibited at the Royal Academy
of Arts in London in 1882 and the German art
historian Wilhelm Bode published his perspicacious
assessment of it the following year:

> … *the presentation of the subject indicates she must
> have stood in some close relationship to Rembrandt.
> She sits in an armchair resting her right arm on its
> arm. The manner in which the precious white fur is
> thrown about her form, suggests (as in Rubens's
> famous painting of his second wife in the Belvedere) it
> veils a very incomplete toilette: where because of the
> right arm which rests in the fur, it has fallen open, the
> chemise and the bare bosom is seen on which falls a
> golden chain, hanging round the neck at the throat …
> In opulence and luminosity close to the Berlin
> picture,*[13] *this portrait can be ranked with the Louvre
> picture*[14] *as regards the magic of chiaroscuro, the
> mastery of execution and through the indescribable
> expression of feminine charm.*[15]

In the second half of the 1630s Rubens painted the
famous portrait of his second wife, Hélène
Fourment, *Hélène Fourment in a Fur Coat* ('*Het
Pelsken*'), 'in the Belvedere' when Bode described it,
now in the Kunsthistorisches Museum, Vienna

(fig.27).[16] This was a *portrait historié* in the sense that
it showed his young wife as Venus, the classical
goddess of Love, inspired by the pose of the classical
sculptures of the *Venus Pudica* (Chaste Venus).[17]
Evidently Rubens did regard the picture as of some
personal significance, for it was not sold but kept in
his private collection. Rubens bequeathed it to
Hélène at his death, specifically noting that she
owned it exclusively and did not have to reimburse
any of the other heirs for their share in it.[18] Bode
astutely noted a certain similarity of theme and
mood between Rubens's and Rembrandt's pictures,
though it is not known if Rembrandt would have
been aware of the Flemish master's composition.
Rubens was influenced in his depiction by the *Lady
in a Fur Wrap* by Titian, a painting which Rubens
had copied when it was in the collection of Charles I
in England (and is now also in the Kunsthistorisches
Museum, Vienna, fig.151).[19] Again, it is difficult to
be certain if Rembrandt would have known this
composition through copies or prints, but his own
picture has much of the same atmosphere – the
juxtaposition of creamy skin against the texture of
fur or wool and the frank, sensual gaze of the
models.[20] Whether or not Rembrandt also intended
to allude to a particular historical or mythological
figure in this painting unfortunately remains
unknown, although her elaborately braided hair and
golden ornaments might perhaps indicate this.

Fig.150 | X-ray
of Rembrandt's
Hendrickje Stoffels (?),
1659
National Gallery,
London

Fig.151 | Titian
(*c*.1485/90–1576),
A Lady in a Fur Wrap,
c.1535
Kunsthistorisches
Museum, Vienna

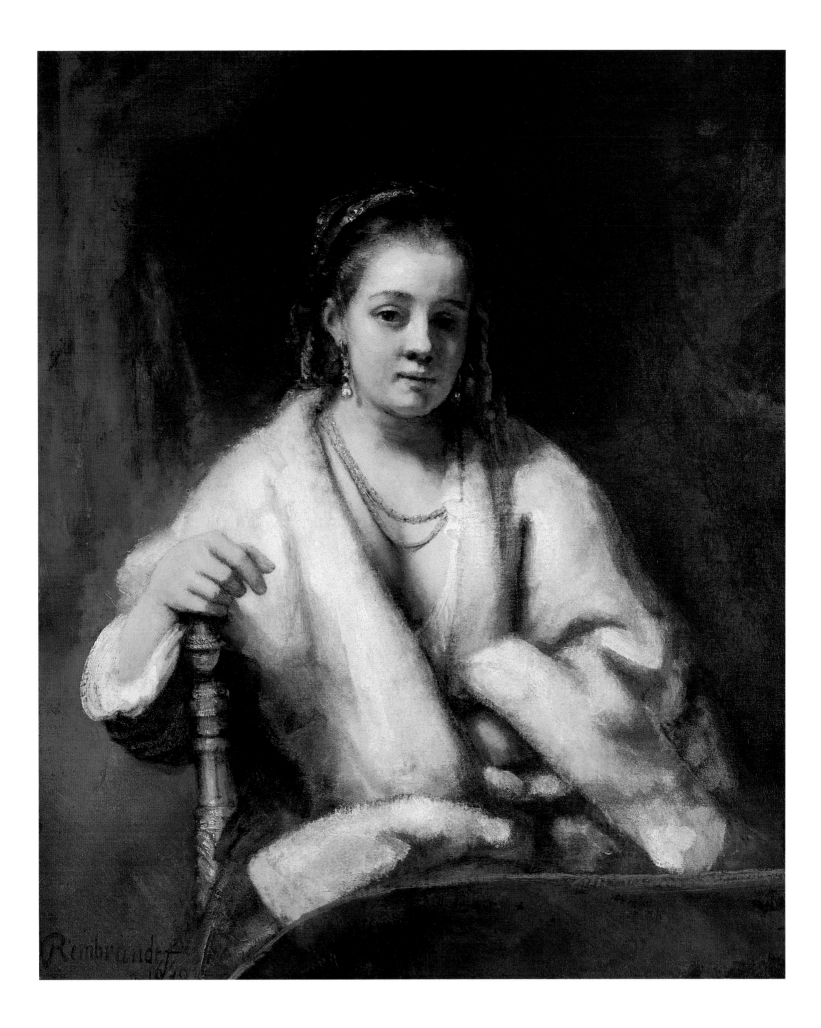

Oil on canvas, 88.5 × 67 cm
References: Bredius/Gerson 116; Berlin/Amsterdam/London, vol.1, cat.45, pp.267–71

GEMÄLDEGALERIE, STAATLICHE MUSEEN,
PREUSSISCHER KULTURBESITZ, BERLIN
(INV.NO.828B)

Rembrandt was demonstrably preoccupied by trying to create a sense of immediacy and contact with the viewer in this painting, somewhat in the same manner as in his portrait of Agatha Bas in 1641.[1] In that picture Agatha's left hand was placed at the outer edge of the canvas to give the impression of her posing at a window, and shown as if 'breaking out' of the picture, with her left thumb hooked round the edge of the moulding and her fan thrust forward into the viewer's space beyond the 'two dimensional' plane. Here the richer palette of colours and softer light gives a more subtle, but nonetheless striking effect, achieved through the dramatic pose and prominent placement of the figure in the composition. The woman stands at an open door rather than a window, resting her left arm along the top of the closed lower half of the door and nonchalantly leaning her other arm up against the door-frame.

The clothes in this painting are far from the formal magnificence of Agatha's fashionable dress, however. The loose deep-red gown, thrown into relief by the creamy white of the low-cut chemise, which also falls into soft folds at the wrists, is tantamount to a state of *déshabille* that appears to have little to do with contemporary fashion. The painting is dominated by that same informality of mood that is so prevalent in Rembrandt's probably slightly earlier portrait of *Hendrickje Stoffels (?)* (cat.125). This, together with the facial similarities

Fig.152 | Jacopo Palma (Palma Vecchio 1480–1528),
A Woman at an Open Door, 1516–18
Gemäldegalerie, Staatliche Museen zu Berlin, Preussischer Kulturbesitz
Photo: Jörg P. Anders

to those found in that painting and to those in the Metropolitan Museum of Art's *Hendrickje Stoffels (?)* (cat.127), have led to an identification of the sitter as Rembrandt's mistress. However, as is probably the case with both those pictures also, it seems unlikely that Rembrandt conceived them as straightforward portraits.

In this case he appears to have based his composition upon a sixteenth-century Venetian prototype of a half-length figure of a courtesan by Palma Vecchio (c.1480–1528), an artist much influenced by Titian. A similar painting to that which seems to have formed the basis for Rembrandt's composition is now in Berlin (fig.152),[2] Rembrandt's source may have been taken from another version of the same composition in the collection of Andrea Vendramin which came to Amsterdam in the 1640s, where it was sold by Gerrit Uylenburgh.[3] A drawing in the manuscript catalogue for this sale (now in the British Museum) anticipates the pose of Rembrandt's woman here.[4] Kenneth Clark was the first to observe this, noting that 'The Vendramin collection contained several of those pictures representing ample, uncorsetted ladies, who are, perhaps, not sufficiently athletic for modern taste, but who obviously appealed to Venetian amateurs in the mid-sixteenth century … Rembrandt has not been interested in the subject, but he has been delighted with the circular movement of the pose, and has seen how it could give a new character to the window-frame device, which he had already used several times. Thus from a cloying and artificial formula he has made one of the most fresh and natural of all his portraits, the picture of Hendrickje in Berlin.'[5] Rembrandt even emulates the colours of the sixteenth-century Venetians in this picture with his wonderful claret-reds and warm browns, the flesh tints glowing against the darkness of the setting, all rendered in generously thick strokes of paint.

Whether Kenneth Clark was right about Rembrandt not being interested in the subject is not so certain. Rembrandt had made a painting depicting such a theme before, since his 'Courtesan Combing her Hair' was listed as hanging in the antechamber of his house in the inventory of his possessions made on 25–26 July 1656 in relation to his application for a *cessio bonorum*, or declaration of insolvency, which was granted on 8 August that year.[6]

The X-rays and other scientific investigations of this painting show that Rembrandt made a number of changes to the composition before he reached this solution.[7] The woman's raised arm at first flexed back at the elbow to touch her head while strange brushstrokes apparently unrelated to the figure seem to indicate that there was another composition entirely underneath at one stage. Technical examination of a number of Rembrandt's self-portraits has revealed that quite a significant number appear to have been painted on top of other

pictures, the first compositions being abandoned for some reason.[8] Since patrons were unlikely to accept already-used canvases or panels for commissioned works, it made sense to re-use such supports for painting non-commissioned pictures, such as self-portraits or other works made for the open market in the studio. This canvas, painted when Rembrandt's finances were at a low ebb, might have been considered in a similar category. The urge to 'matchmake' for paintings of single figures has prompted the suggestion that the picture was the pendant to Rembrandt's now lost *Self-portrait with a Sketchbook*,[9] but it remains doubtful if Rembrandt would have flaunted convention to paint pendant portraits of himself and his mistress. In fact, there is no reason to suppose that this composition could not have stood on its own as an independent work, just as did the Palma Vecchio originals.

Another alteration in the composition revealed by X-rays shows that Rembrandt changed the cord around the woman's neck. At first, this hung straight down but then he looped it up to make the ring more prominent, tucked just inside the edge of the woman's chemise over her heart.[10] In the absence of any wedding ring, Hendrickje had been summoned in front the Church Council to admit that she had 'committed acts of whoredom with Rembrandt the painter' and was punished by being excluded from the Lord's Supper.[11] Rembrandt was called before them once (before they realised he was not a member of the congregation) but he did not turn up; Hendrickje finally appeared before them in July 1654 on her fourth summons. Since she was unmarried and about five months pregnant at the time, the accusation was somewhat difficult to deny. The child that was born, Cornelia, was christened after Rembrandt's mother and he admitted to paternity at the baptism. Perhaps orthodox married status was not particularly important to Rembrandt at this stage and, even if it had been, the terms of Saskia's will would likely have proved a deterrent. But Hendrickje stood by the painter, bore his child, withstood the Church's disapproval and stayed with him until her death. She became known as his wife, though they never married.

Though it seems more than possible that Rembrandt based his figure here on Hendrickje, as an available model at the time of his financial ruin, it is unthinkable that he would have been publicly trying to imply that she herself was a courtesan. In any case, her features had been adapted to fit the Italianate model, made broader and more monumental. Rembrandt here shows us a generalised ideal rather than a portrait of an individual. But perhaps the subject matter of a courtesan wearing a ring around her neck did have a personal significance for both artist and sitter. All that can be certain is that Rembrandt decided to focus more attention on the gold band in the final version than originally shown in his first conception of the composition.

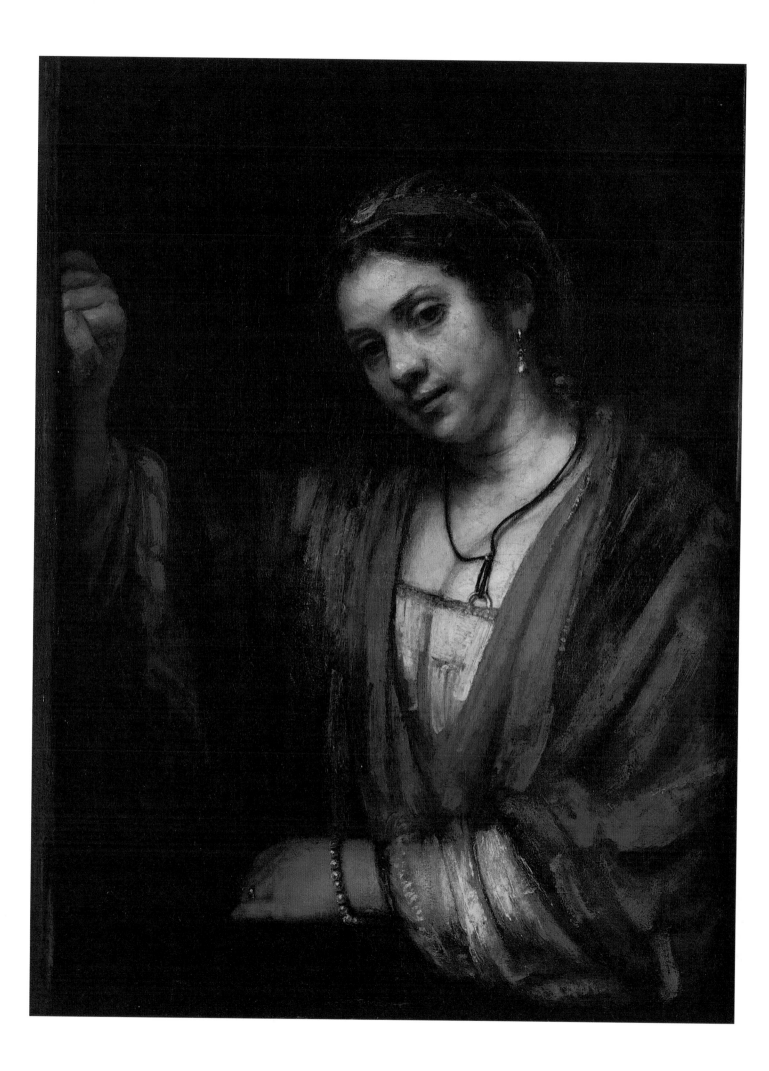

Oil on canvas, 78.4 × 68.9 cm
Signed and dated, centre right: *Rembrandt f 1660*
References: Bredius/Gerson 118; New York 1995–6, vol.2, cat.16, pp.78–80

METROPOLITAN MUSEUM OF ART, NEW YORK
Gift of Archer M. Huntington, in memory of his father, Collis Potter Huntington, 1926
(INV.NO.26.101.9)

The German art historian Wilhelm Bode first made the suggestion that this picture might represent Hendrickje Stoffels, a view which has remained generally accepted.[1] The picture was also inevitably ascribed a pendant, in this case the *Self-portrait* in the Altman collection.[2] Apart from the questionable assumption that Rembrandt would have made pendant pictures of himself and his mistress, this partnership is unlikely since the figures differ in scale, as does the execution of the works (though the poor condition of this picture makes the latter rather harder to determine).[3]

With its date of 1660, it was believed that this was the last known picture of Rembrandt's mistress to survive. On 15 December 1660 Hendrickje and Rembrandt's son Titus legally took on the responsibility for running Rembrandt's 'company and trade in paintings, graphic art, engravings and woodcuts', removing the artist completely from the financial side of the business, presumably to prevent further claims on Rembrandt from creditors.[4] The sales of Rembrandt's goods that had taken place from the end of 1655 had been insufficient to protect the house in the Breestraat, which was sold on 1 February 1658,[5] and the family subsequently

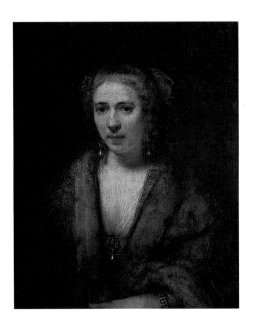

moved to a rented house in the Rozengracht in the artisan Jordaan district of Amsterdam.

In his emotive description of the painting in 1911, Sir C.J. Holmes noted that Hendrickje had 'lost the bloom of youth' and that, though 'the eyes still retain their lustre … the face shows unmistakably the advance of age and ill-health, and the contrast between the cheeks, still flushed but no longer firm, and the febrile brilliancy of the eyes, gives the portrait an indescribable pathos – a premonition of the death which was to overtake the sitter some two years later … Here, with the waning of her physical health, she begins to be withdrawn from us, and to be already enveloped in the dim air of another world.'[6]

It is true that a comparison of this picture and, say, that of *Hendrickje Stoffels (?)* in the National Gallery (cat.125), or the painting in the Louvre of about 1652–4 (fig.153), does imply that the woman in the New York picture might be somewhat older. But this is only relevant if they should be considered as actual portraits, which may well not be the case. In addition, the date and signature on the Metropolitan picture is no longer believed genuine, and it is possible that Rembrandt may have painted it a few years earlier.[7] Holmes's moving account, then, relies predominantly upon the identification of the woman as Hendrickje and on the date of 1660 being correct, as well as his knowledge that she died in 1663.

Much has been made of the suggestion that Hendrickje was suffering from breast cancer in her later years, on the rather dubious grounds that she was the model for the nude in *Bathsheba*, who appears to have an enlarged axillary lymph node, a common feature of the disease, visible at the join of the edge of her breast and her left arm pit (fig.48). This diagnosis has even prompted medical articles, and the Australian health service used the painting in the last decade to raise awareness of breast cancer amongst Antipodean women.[8] But what has been seen as a lump is in fact an area of misleading abrasion in the paint surface which has allowed the brown underpaint to show through. Hendrickje was buried in July 1663 and it is now generally thought that she succumbed to the plague, which had broken out in Amsterdam that year, killing 1752 people in Amsterdam alone.[9]

This was the epidemic which spread to Britain and led to the horror described by Daniel Defoe in his *Journal of the Plague Year*. That account starts: 'It was about the beginning of September, 1664, that I, among the rest of my neighbours, heard in ordinary discourse that the plague was returned again in Holland; for it had been very violent there, and particularly at Amsterdam and Rotterdam, in the year 1663, whither, they say, it was brought, some said from Italy, others from the Levant, among some goods which were brought home by their Turkey fleet; others said it was brought from Candia; others from Cyprus. It mattered not from

whence it came; but all agreed it was come into Holland again.'[10]

It seems that this painting may have been inspired by a sixteenth-century Venetian model, as was *The Woman at an Open Door*, the *Flora* in the Metropolitan, and, perhaps, the *Hendrickje* in the National Gallery, London (see cat.126, 119, 125 respectively). At first sight, the picture bears similarities of composition to the latter, and it is interesting that X-rays perhaps indicate that the costume in the New York painting was also originally more revealing, with the open bodice exposing more of the breast, a left hand placed upon the chest and the right hand originally in a lower position.[11] Was this perhaps based upon another depiction of a Venetian courtesan, such as that which seems to have inspired the *Woman at an Open Door*? Intriguingly, in this earlier configuration the composition more closely resembles a painting by Willem Drost (1633–1663 or after) of *A Young Woman*[12] in the Wallace Collection, London, which in turn appears to have been strongly influenced by Venetian art, in particular Palma Vecchio.[13] Whether Drost came to this through Rembrandt (whose pupil he was from c.1649–50 to c.1652–3) or vice versa, from the mid-1650s both artists clearly demonstrate an admiration of the work of Titian and his contemporaries, in both colour and composition.[14]

In his completed picture here, Rembrandt makes the woman's right hand touch her breast, almost in a gesture of devotion, and draws her wrap about her modestly. Walter Liedtke has convincingly suggested that a close compositional parallel is provided by a now lost Titian of *The Repentant Magdalene*,[15] which Rubens had copied twice, and of which Cornelis Cort had also made an engraving in 1599 in the same direction as the figure here.[16] The atmosphere of the Metropolitan picture, with its air of quiet sadness, would not have been out of place in relation to such subject matter and some of Rembrandt's pupils also painted half-length Magdalenes which relate to this work, with similarly downcast eyes.[17] One has to conclude that the 'indescribable pathos', noticed by Sir C.J. Holmes, was entirely intentional on Rembrandt's part, and may well have been chosen to better convey his theme. It is possible that the picture, quite probably modelled by Hendrickje, should be read in this light rather than as a straightforward portrait of Rembrandt's long-suffering mistress.

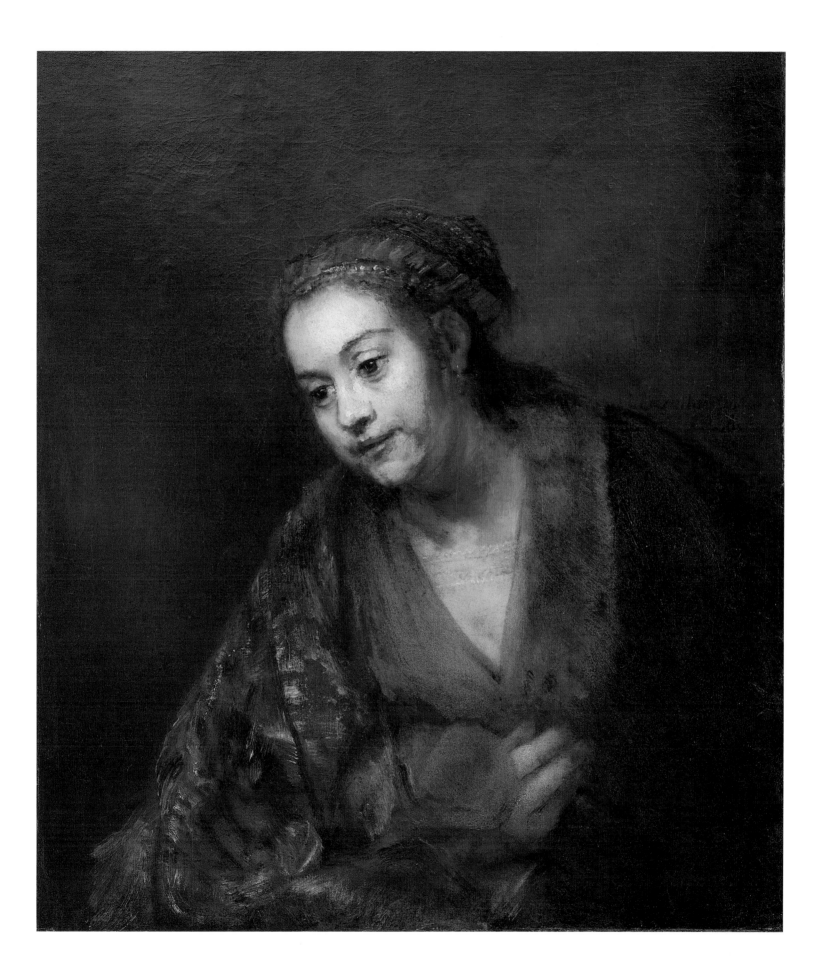

128 *A Woman Sitting, with a Hat Beside her*, 1658

Etching, drypoint and burin, first state (of two),
15.6 × 12.9 cm
Signed and dated, top left: *Rembrandt. f. 1658.*
References: H.297; White/Boon B 199:I; Cambridge 1996–7, cat.38, pp.17–18; White 1999, p.204

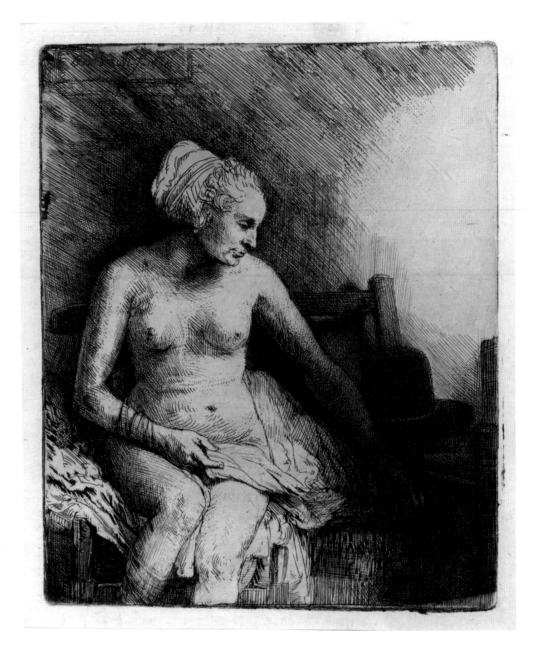

In the last decade of his life, Rembrandt turned again to making etchings of the female nude. They are an extraordinary group, inventive and technically superb, showing his lifetime of experience and innovation in the medium. He had made no etchings of nude women since his print of *The Artist Drawing from a Model* of about 1639 (cat.75), although he produced etched studies of male figures in the mid-1640s (cat.107) and another in 1651.[1] Rembrandt made six etchings depicting nude women in the space of four years, four of these prints being dated 1658. It seems likely that his interest in portraying the female nude had been rekindled with works such as his painting of *Bathsheba* of 1654,[2] but these later etchings should also be seen in conjunction with a number of drawn studies he made dating from the late 1650s and early 1660s (for example cat.132 and 135).

It is not known who modelled for these etchings, though the woman here also appears to be the same as that seen again in cat.130. Various suggestions have been made over the years as to her identity, such as 'Rembrandt's concubine' in Clement de Jonghe's 1679 inventory, De Burghy's rather extraordinary title of 'The Jewish fiancée' while Valerius Röver identified the print in 1731 as one of 'two naked seated women from life'.[3] Another suggestion was prompted by an inscription on the reverse of an impression of the second state of this print in the National Gallery of Art, Washington, which cites '*Voor 't Chirurg*' (For the Surgeon). This has been thought to indicate that Rembrandt gave this print to the surgeons' guild in gratitude for their provision of facilities to draw from the nude, but there is no proof that this was the case.[4] The drawing of Rembrandt's studio in the Ashmolean Museum (cat.117) shows a seated woman modelling and there is no reason to suppose that Rembrandt had changed his practice in the intervening period, even though he may have moved into smaller premises in the year this print was made.[5] He could also perhaps have joined in with others to draw from the nude, possibly with his former pupils Ferdinand Bol and Govert Flinck, who together drew nude studies of a shared model in 1658.[6]

The etching is printed with surface tone on thick oriental paper which is probably Japanese, as was used for many impressions of the first state of this piece.[7] Another impression of the first state now in the British Museum, also on Japanese paper, is annotated on the reverse in brown ink: 'John Barnard./This impression with a high cap is extremely scarce.'[8] Rembrandt reduced the height of the woman's headgear in the second state to resemble something more akin to a turban. The meaning of the hat on the chair is unclear. Women very rarely wore hats like this in the Netherlands, as Marieke de Winkel has shown.[9] If one presumes it to be male attire then, given the state of undress of the woman, it may conceivably hint at improper proceedings, though Daniel Daulby defended the print in 1776, stating that 'the subject of this piece does not appear by any means to be as disgusting as Gersaint has represented'.[10]

129 *A Woman Bathing her Feet in a Brook*, 1658

Etching, only state, 16 × 8 cm
Signed and dated, top left: *Rembrandt f. 1658*
References: H.298; White/Boon B 200; Cambridge
1996–7, cat.40, p.18; Amsterdam/London 2000–1,
cat.88, pp.352–4

FITZWILLIAM MUSEUM, CAMBRIDGE
(INV.NO.AD.12.39–162)

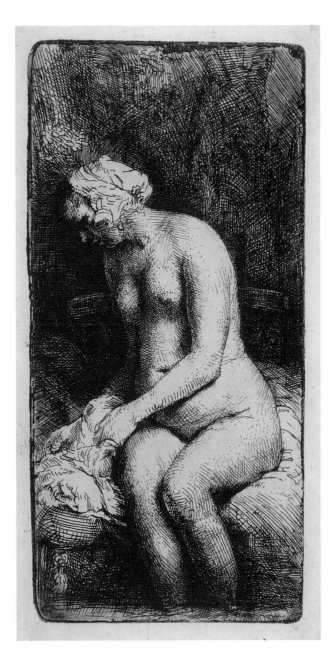

The setting of this print is somewhat ambiguous.
The woman at first glance would appear to be
shown outdoors with a small flourish of foliage
above her head and her feet apparently submerged
beneath the water-level, a motif Rembrandt had
used in his drawing of *Diana at her Bath* of *c.*1631
(cat.10) and his painting of *A Woman Bathing* of
1654.¹ The inventory of De Jonghe's collection
probably refers to the composition as '*Vroutgen
aan de put*' (A Woman by the Well).² However, the
tussock upon which she sits is made of soft
pillows, a tasselled cushion is at her right, and just
visible behind her is the back of a bench or chair.³
Rembrandt clearly did not think it necessary to
eliminate studio elements entirely from his scene:
they are also present in cat.128.

Unlike the latter, Rembrandt did not use
drypoint or the burin on this print, but made
similar stipples and short hatched and parallel
lines to show the play of light across the woman's
body. Turning her face away to make it almost
invisible draws the viewer's attention to the soft
curves of her form: the long arc of her shoulder,
pale against the surrounding darkness of the
background. The balance between light and
shadow was paramount in Rembrandt's late
etchings of nudes. Less interest is shown in the
fastidious exploration of each fold of flesh and
bump of fat that is found in his earlier work. In
that sense the women of these last etchings seem
to be more idealised; they fill their skin more
smoothly (despite Kenneth Clark's description of
the figure in this etching as an 'old woman').⁴
Although clearly prompted by the model in a
studio, one wonders whether Rembrandt needed
the model once the general composition had been
determined, for it is the general shape which he
explores, and how to integrate the forms into the
background and avoid eye-jolting contrasts
between lit body and dark setting.

The carefully judged use of surface tone with
which Rembrandt printed many of these figures
also contributed to this subtle effect, as did his
choice of paper. This is printed with surface tone
upon a thick oriental paper, which is probably
Japanese, the origin of the paper used for cat.128.
Rembrandt was one of the first Western
printmakers to use Japanese paper, which appears
to have been imported to the Netherlands on two
west bound Dutch East India ships in 1643 and
1644 (the Dutch had exclusive trading rights with

Japan from 1639 to 1854). Japanese paper was
made from the gampi plant and came in a range
of colours from white to dark buff and varying
thicknesses. The fine, smooth fibres were
extremely receptive to printer's ink and were
ideal for registering different nuances of tone.
The softness of the paper meant that minimum
pressure was needed on the plate to transfer the
ink, so drypoint burr did not wear off so quickly,
while some of the paper broadened and softened
both etched and drypoint lines. Though it would
be incorrect to suggest that Rembrandt used this
expensive paper specifically for his late etchings
of nudes, he cannot have been unaware of the
remarkable subtlety of effect which it was able to
impart to them.

130 *A Woman Sitting Half-dressed before a Stove*, 1658

Etching, drypoint and burin, third state (of seven), 22.8 × 18.7 cm
Signed and dated, upper right: *Rembrandt f. 1658.*
References: H.296; White/Boon B 197:III; Cambridge 1996–7, cat.33, p.16; Melbourne/Canberra 1997–8, cat.121, pp.438–9

FITZWILLIAM MUSEUM, CAMBRIDGE
(INV.NO.AD.12.39–74)

Of the six prints that Rembrandt made depicting the female nude from 1658 to 1661, this is the only one that does not show her completely naked. Christopher White has pointed out that the line of her leg is visible beneath her skirt and that Rembrandt may have actually depicted her nude at first, but these 'structural' lines may simply have been to give an indication of volume to the material.[1] In any case, she is here shown stripped to the waist, with her white chemise hanging down over the waistband of her long, thick, dark skirt, similar to the way women had modelled for other studies from the life for Rembrandt (such as cat.14, 70, 110 and 117). The dark niche behind her emphasises the silhouette of the woman's profile, seated in a way which has been likened to a classical relief,[2] but the closest similarity is to the pose of Rembrandt's Bathsheba.[3] The upper part of the woman's torso with her extended left arm, the hand resting in crumpled drapery, and the lowered profile of her face, would have resembled the painting when Rembrandt drew his design on the plate (in reverse direction to the final print).

This impression, printed on thick, slightly pinkish paper which is probably Japanese, was inked with only a little tone on the plate. This enables one to make out the relief on the cast iron stove depicting Mary Magdalene at the foot of the Cross, a detail which is only clear in a few impressions that have not been printed with heavy surface tone, such as this. In relation to the religious image of the iron relief, one wonders if there was any significance in the woman's gesture of placing her foot across her slipper or patten, the same motif which the artist used in his painting of *Susanna and the Elders* now in the Mauritshuis (cat.69). However, rather than indicating the spiritual reform of the Magdalene (who left prostitution to follow Christ), this might just as well indicate that the model was trying to keep her feet off the cold floor, especially given the small charcoal burner at the left.

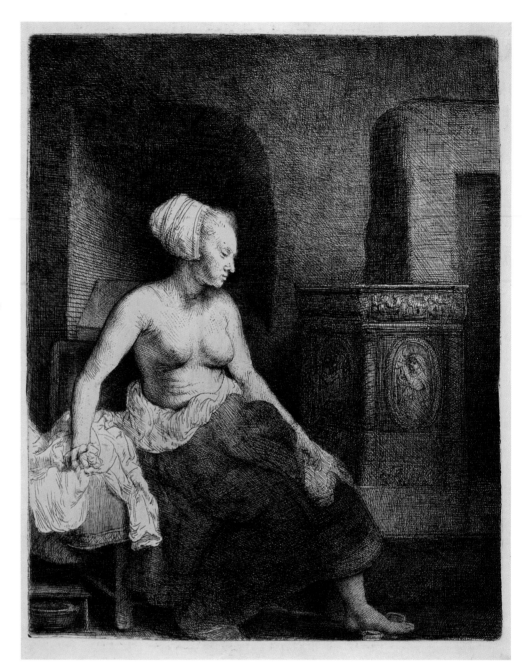

131 *A Woman Sitting Half-dressed before a Stove*, 1658

Etching, drypoint and burin, sixth state (of seven),
22.8 × 18.7 cm
Signed and dated, upper right: *Rembrandt f. 1658.*
References: H.296; White/Boon B 197:VI; Amsterdam/London 2000–1, cat.87, pp.347–52

RIJKSMUSEUM, AMSTERDAM
(INV.NO.RP–P–OB–258)

Rembrandt worked on seven different states of
this etching.[1] He had added a damper key to the
massive stove flue in the fourth state, presumably
to interrupt the strong vertical emphasis that it
provided, perhaps thought too dominant. The
most notable change made in this, the sixth state
of the print, was the burnishing out of the white
cap that the woman previously wore, showing her
instead with her hair drawn back into a bun. The
critic Arnold Houbraken suggested that
Rembrandt made such alterations expressly to
increase the marketability of his prints: 'Thanks to
his method of putting in small changes or small
additions so that his prints could be sold as new …
no true connoisseur could be without … the
woman by the stove, albeit one of his lesser works,
each must have it with and without the white cap,
and with and without the stove key.'[2] There may
well be an element of truth in this, for Rembrandt
was often prompted to go back to rework a plate
because it was worn, but it is hard to see all such
changes as commercial ploys alone. Rembrandt's
alterations and the fact that he produced seven
states of this plate must have been partly due to
the necessity of upgrading a plate that had suffered
wear but also (for some of the states) to improve
his conception of the composition.

Rembrandt combines an extraordinary range of
different techniques within this print, from the
sketchy drawn lines which make up the discarded
garments to the closely etched hatching of the
woman's skirt, given more depth by the extra
work of the burin and the burr of drypoint lines
scratched into the surface of the plate. The
background becomes less and less clear in the
successive states of the plate and the final removal
of the woman's white cap takes away the one focus
of light of the print. However, this may have been
precisely the reason for its removal. Rembrandt
may have felt that it created too much contrast
with the atmospheric, brooding darkness out of
which the woman's body emerges, softly lustrous
in the pallid light. This impression is also printed
on Japanese paper, the colour of which further
emphasises Rembrandt's tonal control in the
print.

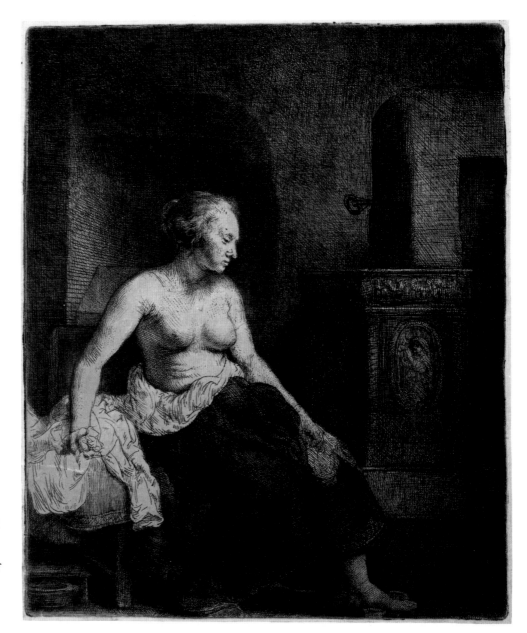

Drawing, pen and brush and brown ink with wash, touched with white, 13.5 × 28.3 cm
References: Benesch 1137; Schatborn 1985, cat.52, pp.114–15

RIJKSMUSEUM, AMSTERDAM
(INV.NO.RP-T-1917-1)
Exhibited in Edinburgh only

Rembrandt's renewed interest in portraying the female nude in the latter part of his life is demonstrated by six etchings, but also by a number of drawings, of which this sheet and cat.135 are prime examples. Though not preparatory for the etchings, both relate closely to poses that he used in the prints. The relaxed pose here can be compared both to his etching of *A Reclining Female Nude* (cat.133) of 1658 (the probable date of this drawing), and also, particularly, to the figure of Antiope in his print of *Jupiter and Antiope* made the following year (cat.134).

This drawing was made with a reed pen which Rembrandt used to draw broad lines in the thick curves of the pillows upon which the model lies, the undulations of her lower leg and the sweeping arch of her heel. Rembrandt uses thinner lines to show the outline of the body where the light falls, reserving the full pressure of the thick nib for the shadowed areas, such as the line of her nose and the underside of her belly. In addition to this, he then used an extremely dilute wash to fill in the subtle shadows that give such delicacy of form to the nude, marking the swell of her breast and the soft shading on her brow and cheek.

Rembrandt attempted to correct an overly dark line on the woman's stomach by covering it with white paint, but this is now unfortunately again prominent, due to the oxidisation of the pigment the artist used. Though the sheet was trimmed rather brutally, chopping off the woman's toes, the whole drawing still has a remarkable sense of balance and control. The critic Claude-Roger Marx noted this poise when he remarked in 1960, 'Everywhere in a whole series of drawings of nudes made *c.*1654–58, there is a charm and a lightness which contrasts with the heaviness of the female body in many other paintings. Do not [they] seem to foreshadow the French painters of the female form of the eighteenth century, perhaps a Fragonard or Watteau?'[1]

133 *A Reclining Female Nude*, 1658

Etching, drypoint and burin, second state (of two),
8.1 × 15.8 cm
Signed and dated, bottom left: *Rembrandt f. 1658*
References: H.299; White/Boon B 205:II; Cambridge
1996–7, cat.42, pp.18–19; White 1999, pp.204–7

FITZWILLIAM MUSEUM, CAMBRIDGE
(INV.NO.AD.12.39–163)

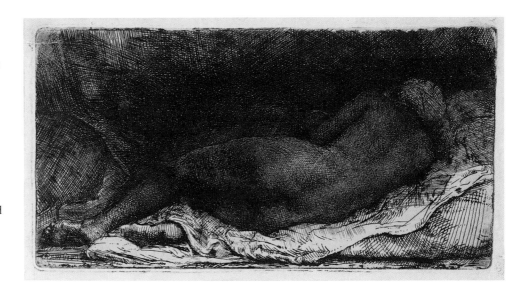

When it was catalogued in 1797 by the Austrian
engraver and authority on prints, Adam Bartsch
(1757–1821),[1] this etching was given the title of
'*Négresse Couchée*' (Negress Lying Down). Others had
simply called the figure a 'naked sleeping woman',[2]
while Daniel Daulby, the year before Bartsch's
catalogue appeared, described her as 'a Naked
woman seen from behind' in 'Rembrandt's dark
manner'.[3] She lies with her right leg flexed under-
neath her, the underside of her foot emerging from a
sheet. Rembrandt limits the space to dark curtaining
and a mound of bedclothes, which he left mainly
unshaded in the foreground, but defined them in
drypoint lines with deep velvety burr. The simple
setting, in conjunction with the fact that we do not
see the woman's face, means that the focus is upon
the volume and shape of her body, and the pattern it
makes against the bright sheets. The pose may have
been inspired by a figure in Hans Sebald Beham's
engraving of *St John Chrysostom* or Agostino
Veneziano's print of *A Nude Woman on a Fur*.[4]

 A unique impression of the first state of the print
in the Bibliothèque Nationale, Paris,[5] makes it clear
that the woman was not black, but that Rembrandt
made the etching far darker in the second state,
partly to enhance the shadows but also perhaps for
practical reasons. The first state actually shows a
pale-skinned figure, with a ghostly double image
above her body, and what appears to be another head
placed further up the pillow to the right. It seems
that Rembrandt rethought the placing of the body
on the plate and moved the whole figure down and to
the left, to the position we see now. In order to mask
these changes, it was necessary to etch heavily round
the upper edge of the woman's body, and in this
heavily-inked version of the second state it is no
longer possible to make out the earlier figure. It is
likely that once the background had been made
darker, the paleness of the woman's buttocks and
back stood out too much, disturbing the tonal
balance of the overall composition. The subsequent
fine cross-hatching across the woman's supine body
corrected this, but the fine network of lines de-
manded extreme care in inking, and in some
impressions the subtlety of the dark contours,
intentionally half lost in shadow, became so black as
to be indecipherable.[6] Nonetheless, this remains one
of Rembrandt's most atmospheric etchings of female
nudes, as she lies languorous as any Odalisque,
stretched out in the intimate dark of her curtained
bed.

Etching, drypoint and burin, first state (of two),
13.8 × 20.5 cm
Signed and dated, bottom centre: *Rembrandt f 1659*.
References: H.302; White/Boon B 203:I; Amsterdam/London 2000–1, cat.90, pp.361–4

FITZWILLIAM MUSEUM, CAMBRIDGE
(INV.NO.AD.12.39–159)

Rembrandt etched this subject nearly thirty years
before (see cat.13), and although he had not
depicted precisely the same story since, his
numerous drawings of women asleep could not but
have helped him in forming this extraordinarily
striking image. The contrast between this and his
earlier etching is dramatic, both from the point of
view of style and also of technique. Here he is a
complete master of his medium. Lines etched, and
drawn with the burin, mark out the contours of the
figures, half-tones are stippled, tresses of hair are
given velvety texture by the ink caught in the burr
of drypoint strokes, while the intensity of the
cross-hatched shadows heightens the impact of the
image.

This beautiful sheet, printed with subtle
surface tone, is on thick oriental paper, possibly
Japanese, which gives the impression of vellum in
its creamy grey tones. Prints on oriental paper
were much sought after by collectors, according
to the French art historian and theorist, Roger de
Piles (1635–1709), in 1699, but Rembrandt must
have also been attracted by the wonderful quality
the paper gives to the printed line, and also for
the beautiful tone it gave to the areas he left free
of ink for effect – here the luminous highlights on
Antiope's flesh and the pale softness of the snowy
sheets.

Rembrandt's starting point was Annibale
Carracci's etching of 1592 of *Jupiter and Antiope*
(also sometimes called *Venus and a Satyr*, fig.154)[1]
which in turn shows knowledge of the tradition
of other sixteenth- and seventeenth-century
representations of Antiope or Venus – for
example Correggio's *Venus, Cupid and a Satyr*, and
Titian's *Jupiter and Antiope* ('The Pardo Venus'),
now both in the Louvre, Paris.[2] Many of these
were ultimately modelled on the classical
sculpture known as the *Sleeping Ariadne* (or
Cleopatra) in the Papal collection at the Vatican,

Rome.[3] Whether or not this specific source would
have been noticed by contemporary collectors, it is
interesting that Valerius Röver, referring to this
print in 1731, described it as a 'Nymph [and] Satyr
etched in the Italian manner', prompted perhaps as
much by Rembrandt's technique as his Italian
borrowing.[4] However, the finished work is far
from being a copy and, though no preparatory
drawing is known, it seems likely that Rembrandt
would have drawn from the model in the search for
the perfection of his composition, in studies such as
his *Nude Woman Lying on a Pillow* (cat.132),
probably made shortly before.

There exists some ambiguity about the subject
(in the same way as in Rembrandt's previous
version) and the male figure, his horns wreathed in
Bacchic vine-leaves could again be either Jupiter or
a satyr. However, someone decided to clear up
Rembrandt's ambiguity by adding a couplet to the
second state of the etching: 'Jupiter, when he opens
the woman's lock, Becomes either devil, or beast or
an idiot.'[5] Picasso made two prints inspired by the
erotic power of this image, which are, however,
both entitled *A Faun Unveiling a Sleeping Woman*
(fig.155).[6]

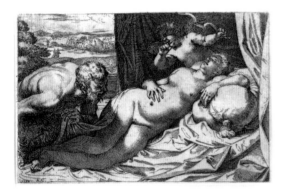

Fig.154 | Annibale Carracci (1560–1609), *Jupiter and Antiope*
(also called *Venus and a Satyr*), 1592
Rijksmuseum, Amsterdam

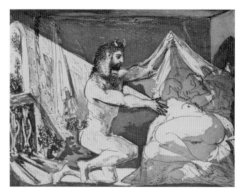

Fig.155 | Pablo Picasso (1881–1973),
A Faun Unveiling a Sleeping Woman, 1936
National Gallery of Australia, Canberra © DACS 2001

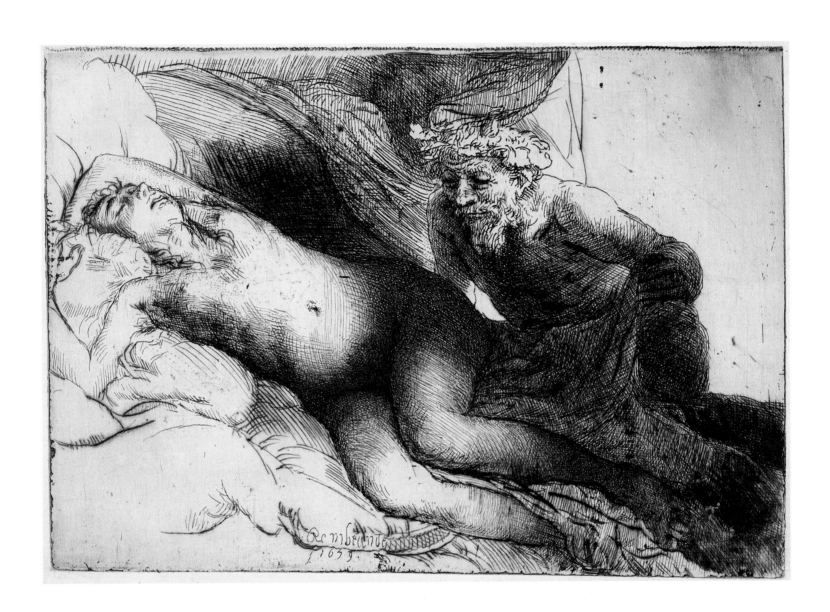

135 A Seated Female Nude, c.1660

Drawing, pen and brush and brown ink with wash, and white wash, 21.1 × 17.4 cm
References: Benesch 1122; Berlin/Amsterdam/London, vol.2, cat.38, pp.126–7

ART INSTITUTE OF CHICAGO
Clarence Buckingham Collection
(INV.NO.1953,38)
Exhibited in London only

This is one of the most beautiful of Rembrandt's surviving late drawings of a female nude, of similar quality to the *Nude Woman Lying on a Pillow* (cat.132) and his *Female Nude in Front of a Stove* of about 1661 (fig.156).[1] The date of the latter is suggested by the fact that it was drawn upon a lined cashbook which was also used for a study for Rembrandt's painting of the *Staalmeesters* (or Syndics), dated 1662.[2] The same ruled vertical lines are clearly visible on a related drawing in the British Museum of a seated female nude which is now ascribed to a pupil of Rembrandt, perhaps Johannes Raven the Younger (1634–1662).[3] This implies that the account book was ripped up and the paper shared around amongst the different artists at the modelling session.

Many such drawings of the female nude were originally believed to be by Rembrandt himself. The confusion arose because Rembrandt drew from the same nude model in the company of other artists who were attempting to emulate his style.[4] The Chicago drawing appears to have been made at the same session as a sheet now in the Boijmans Van Beuningen Museum, Rotterdam, which was also once thought to be by Rembrandt. This is now generally attributed to Arent de Gelder (1645–1727) who was Rembrandt's pupil probably in the early 1660s (fig.55).[5] A comparison between the two drawings shows how the pupil, sitting on the other side of the model from his master, concentrates upon the details: the specific construction of the stool (similar to that under the table in the drawing of Rembrandt's studio, cat.117) and the stove behind the woman.

Rembrandt, on the contrary, takes the simplification seen in the background of an etching such as the *Reclining Female Nude* (cat.133) to an even bolder conclusion here. The darkness of the draped material at the left and the shadows cast by the figure upon the uneven wall behind, are implied with a few deft strokes of a brush and washes with varying saturations of ink. He drew some of the contours of the figure in remarkably straight lines, almost as a form of artistic short-hand, such as the two bold parallels that delineate her left calf, the sharp 'L' shape that marks her right hip on the stool and the horizonal lines that cut across the soles of her feet. These create what amounts to a general structural armature which Rembrandt fills in with the specific curves of the

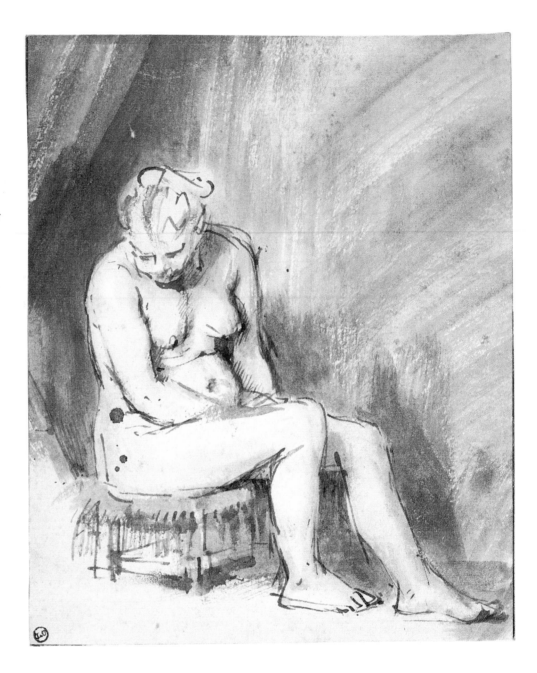

woman's shape. While his pupil's sheet describes details, Rembrandt's drawing, in a deceptively simple manner, tells far more about the way the light plays upon the woman's form and her relationship to the space about her.

Fig.156 | Rembrandt, *A Female Nude in Front of a Stove*, c.1661
Rijksmuseum, Amsterdam

Etching, drypoint and burin, second state (of three), 20.5 × 12.3 cm
Signed and dated, lower left: *Rembrndt f. 1661*
References: H.303; White/Boon 202:II; White 1999, pp.209–10

BRITISH MUSEUM, LONDON
(INV.NO.1973-U-1139)

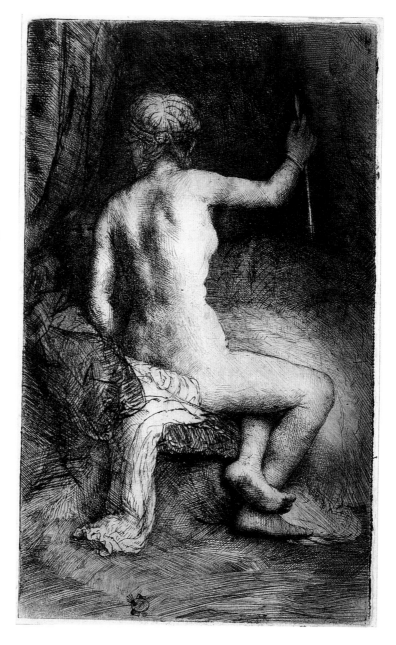

This is the last known etching Rembrandt made of a woman, and was probably the penultimate etching of his life (his last was a commissioned portrait made in 1665).[1]

The pose was modelled from life, corroborated by the existence of two drawings, formerly believed to be by Rembrandt but now attributed to Johannes Raven, which both depict the same pose from different angles. In the first, the model is shown from the same side as Rembrandt must have drawn her (since the pose in the print appears reversed due to the printing process), though from slightly further to the left (fig.157).[2] The second shows a more distant viewpoint from further behind the model, and more of the setting with the corner of a large curtained bed visible at the left (fig.158).[3] In both drawings it is clear that the model is clinging onto a rope or sling which may have been strung to the top of the bedpost in order to support the otherwise exhausting pose that required her right arm to be raised. This was, and remained, common practice, and can be seen in a number of academic studies of nudes.

Though Rembrandt probably started his etching at the same time as these drawings were made, he then elaborated upon the scene to include the head of a boy or man, just visible in the dark at the left. The woman's raised arm now holds an arrow rather than a support rope (a suggestion that this is a slit of light in the curtains does not seem to tally with the spatial organisation of the bed in relation to the figure).[4] He also gave his nude an intricate headdress or coiffure (which, it has been suggested, was inspired by a drawing attributed to Correggio in the British Museum).[5] Rembrandt had made precisely the same kind of embellishment to his drawing of *A Nude Woman with a Snake* more than two decades before, changing his figure from a contemporary model to a historical figure by drawing a piece of richly elaborate headgear on top of the model's original hair (see cat.71). It seems likely that Rembrandt did intend to give the scene some historical or Biblical meaning by these careful additions. The print was interpreted as Antony and Cleopatra (on the basis that Clement de Jonghe may have referred to it in his inventory of 1671 as 'Naked Cleopatra')[6] and also as King Candaules showing his bodyguard Gyges the beauty of his wife.[7] However, the most probable subject is Venus with Cupid, either arming him with his arrow of love, or wresting it from him in punishment.[8] However, as so often with such themes, Rembrandt hints at, rather than underlines, his meaning. His preoccupation here is with his last variation on the theme of the nude where, as Christopher White observed, 'his perfect representation of soft light breaking into a dark space represents the final mastery of all that he had searched for in his last group of studies.'[9]

Fig.157 *left* | Johannes Raven (1634–1662),
A Seated Female Nude
Rijksmuseum, Amsterdam

Fig.158 *right* | Johannes Raven (1634–1662),
A Seated Female Nude Surrounded by Drapery
British Museum, London

Oil on canvas, 130.5 × 97.5 cm
References: Bredius/Gerson 394; London 1988–9,
cat.17, pp.126–9; Maclaren/Brown 1991, vol.1,
pp.352–3

NATIONAL GALLERY, LONDON
(INV.NO.NG1675)

Painted as a pendant to the portrait of Jacob
Jacobsz Trip (fig.159),[1] this is an impressive
depiction of a matriarch who bore her husband at
least twelve children. Margaretha was born in
Liège, on 10 November 1583, the daughter of
Louis de Geer who moved his family to Holland,
first to Aachen and then to Dordrecht. Margaretha
was married in 1603 to Jacob, one of the great
industrialist merchants of the seventeenth century.
He was born in Zaltbommel in Gelderland, settling
in Dordrecht in his youth. Jacob's brother Elias
founded an iron business and they went into
partnership with Louis de Geer the younger,
Margaretha's brother. The Trip family fortunes
were consolidated by this union which combined
their iron business with the De Geer's enormously
profitable trade in armaments, the latter providing
their own supply of raw materials from Swedish
copper mines. The partnership also ran fleets and
shipyards. Jacob was involved in the iron and
weaponry manufacture to a great extent after 1626,
but also dealt as a merchant in textiles, comestibles,
charcoal and lime, and ran a lucrative saltworks in
Zwijndrecht, across the river from Dordrecht.[2]

Jacob and Magaretha spent their lives in
Dordrecht, though Margaretha presumably
travelled to Amsterdam for Rembrandt to paint
her. The Trip family had already had dealings with
Rembrandt, long before he painted the couple. In
1639 Margaretha's sister-in-law who lived in
Amsterdam, Aletta Adriaensdr (widow of Jacob's
brother Elias), had commissioned Rembrandt to
paint her portrait and that of her daughter Maria
Trip (cat.85). It is not known why the portraits of
Jacob and Margaretha were commissioned, but it
has been suggested they may perhaps have been
intended to hang in the Trippenhuis in Amsterdam
which was built for two of their sons, Louys (1605–
1684) and Hendrick (1607–1666), who successfully
carried on the family businesses.[3] The Trippenhuis
on the Kloveniersburgwal was designed by the
architect Justus Vingboons (1620/21–1698) whose
work on Stockholm's 'Riddarhuset' (1653–6) the
brothers may have seen in their youth when they
both spent some time in Sweden in connection
with their family's interests. Built between 1660
and 1662 in the fashionable classical style with a
grand pediment and eight Corinthian pilasters, the
Trippenhuis was the most opulent private house in
Amsterdam, and it may be that Rembrandt's large-
scale formal portraits of the brothers' parents were
designed to hang in such a setting.[4]

Jacob Trip and Margaretha de Geer were no
strangers to having their portraits painted. The
Dordrecht artist Nicolaes Maes (1634–1693), who
trained with Rembrandt sometime between 1646
and 1653, painted the couple no less than eight
times (including replicas) between 1657 and 1669.[5]
Two other famous Dordrecht artists also painted
the couple, Jacob Gerritz Cuyp (1594–1651/2)[6] and
his son Albert Cuyp (1620–1691).[7] Intriguingly,
Margaretha seems to have had her husband's image
painted after his death, as may be witnessed by
Maes's portrait of Jacob now in the Mauritshuis,
The Hague.[8] Though inscribed with his age as '84',
it seems that the portrait could have been made as a
posthumous pendant for one of his wife (now lost)
which was dated 1665, and thus painted four years
after his burial on 8 May 1661. The last time
Margaretha had her portrait painted seems to have
been in 1669 at the age of eighty-five.[9]

This has some bearing on Rembrandt's powerful
frontal image of Margaretha in the present picture,
for it has been observed that her pose is somewhat
unconventional in the context of traditional
Netherlandish female portraiture (called by
Stephanie Dickey 'the time-honoured heraldic half-
turn' towards the husband).[10] Although Rembrandt
had flouted this convention many years earlier with
pictures such as his *Woman with a Fan* of 1633[11] or
the *Agatha Bas* of 1641,[12] to great dramatic effect,
this 'centrality' is, if anything, more marked in the
portrait of Margaretha de Geer.[13] Her gnarled but
capable left hand rests upon the arm of a chair
(which is turned to face the viewer far more than
that on which her husband sits) and her steady
outward gaze has something of the enthroned ruler.
The right hand clutches a large tasselled handker-
chief similar to the one held by Catrina Hooghsaet
in the portrait of 1657 (cat.122). The costume she
wears, with its wide millstone ruff, was of a kind
fashionable more than thirty years before, but often
retained by the older generation.

Interestingly, Rembrandt's depictions of elderly
women whom we know, or assume, to be widows,

such as Margaretha's sister-in-law Aletta Adriansdr
(fig.126), or the eighty-three-year-old woman
painted in 1634,[14] share the same frontal place-
ment, the subject looking straight out at the viewer.
The possibility remains that Rembrandt's portrait
of Margaretha was made (or, at least, finished) after
her husband had died in 1661, the probable date of
the paintings, and Rembrandt may have had to base
his portrait of the dead man on another of the many
paintings of him, as Nicolaes Maes was later to
do.[15]

This supposition is arguably corroborated by
technical analysis of both of Rembrandt's portraits
of the couple.[16] That of Jacob shows few changes,
and has a certain fixed uniformity about it, while
the painting of Margaretha bears all the marks of a
work altered and added to in the process of its
creation. The relative simplicity of construction of
Jacob's portrait and the complex, painstaking
technique used in that of his wife are understand-
able if one supposes that Rembrandt may have been
copying the former, but reacting to a living model
in front of him in the case of Margaretha. The
existence of another problematic study of the head
of Margaretha, seen slightly more from the side and
dated 1661 (fig.160) further complicates matters.[17]
Clearly of the same woman, such studies are
extremely rare in Rembrandt's oeuvre. It is painted
in a rather finicky technique that is somewhat
anomalous in Rembrandt's work and shows fewer
alterations than the larger picture. Yet, although
doubted by many, it is hard to disassociate it
completely from Rembrandt's three-quarter length
portrait, and it may perhaps have been made as a
smaller version for the Dordrecht house.[18]

It cannot be proved that Margaretha de Geer was
portrayed after the death of her husband, but even if
she was not yet a widow when this work was
painted, Rembrandt leaves us in no doubt of the
high status of this matriarch in one of the Nether-
lands' most influential families. Though her sober
expression is frank rather than haughty, she is
unquestionably a power with which to be reckoned.

Fig.159 | Rembrandt,
Jacob Trip 1575–1661
National Gallery, London

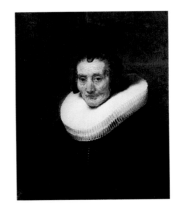

Fig.160 | Attributed to Rembrandt,
A Portrait of Margaretha de Geer, 1661
National Gallery, London

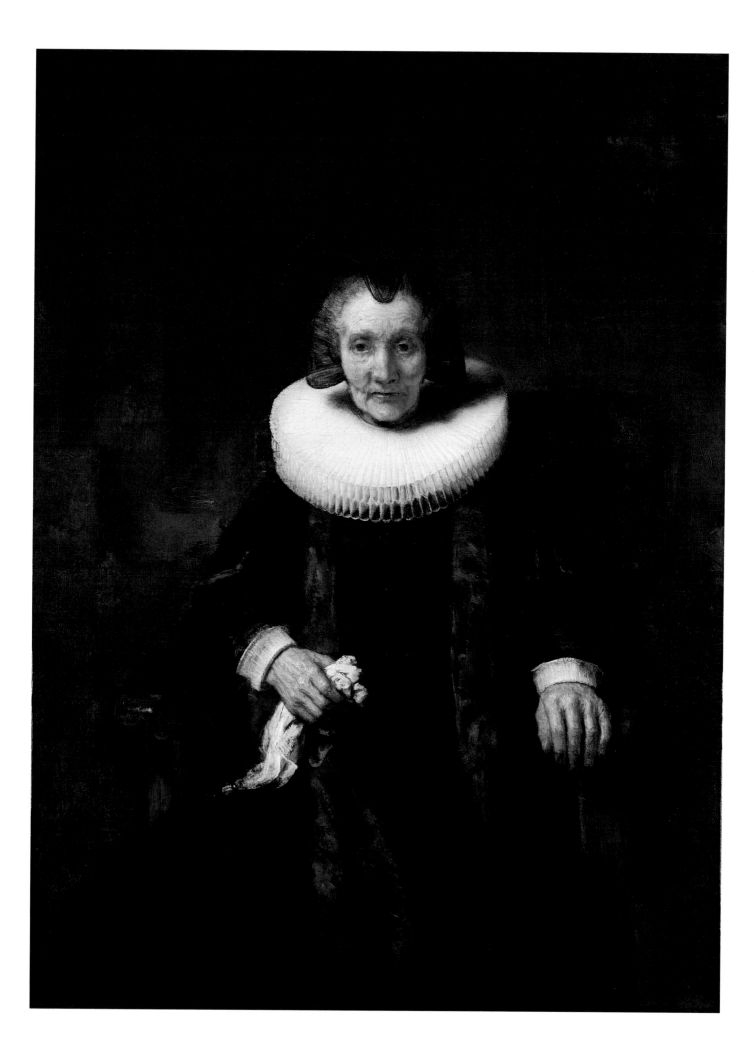

Oil on canvas, 110.5 × 80.5 cm
Signed and dated, centre right: *Rembrandt f.1661*
References: Bredius/Gerson 397; Tümpel 1993,
cat.85, p.402; B. Huin, *La collection des Princes de
Salm*, Museé départmental d'art ancien et
contemporain, Epinal, 1993–4, cat.28, pp.80–1;
Slatkes 1992, cat.67, p.130

MUSEÉ DÉPARTMENTAL D'ART ANCIEN ET
CONTEMPORAIN, EPINAL
Collection de Princes de Salm
(INV.NO.1828.37)

The atmospheric use of light and shadow in this
picture, allied to the striking simplicity of the
composition, contribute to making it a singularly
moving one, despite the problems that arise from
its poor condition. The painting was formerly in
the collection of the Princes of Salm (which family
still owns Rembrandt's *Diana Bathing; with the
Stories of Actaeon and Callisto*),[1] but was appropri-
ated for the Préfecture at Epinal when the previ-
ously independent principality of Salm was re-
turned to France in 1793. It entered the Museum
collection on 3 April 1829.[2] Although the picture
was not burnt in the fire which destroyed other
works on 21 February 1808, it has suffered badly
over the years, and the abraded, cracked surface and
areas of raised pigment inevitably make it rather
difficult to assess. Nonetheless, it has always been
published as a work by Rembrandt.[3]

The subject was listed as 'a woman with a
chaplet', and an 'old devotée' in the earliest known
inventories, those of 1778 and 1793,[4] and she has
subsequently been seen as an aged nun, on the basis

Fig.161 | Lucas van Leyden (*c*.1489–1533),
The Virgin with the Rosary, *c*.1520
Rijksmuseum, Amsterdam

of costume which has been interpreted as a white
habit, covered with a brown headdress and mantle,
and the beads of a rosary which she holds in her
right hand.[5] The rosary had certainly been used by
some Roman Catholics in the Low Countries since
the first Dominican Confraternity of the Rosary
was founded in Haarlem in 1478, and Rembrandt
had depicted Catholic subject matter before – for
example, in his paintings of *The Holy Family* (cat.26A
and 99) and etchings of the Virgin Mary (cat.83, 90,
114). However, it is not certain that the rosary was
originally part of this composition. The woman's
right hand with the beads looped over it and the
folds of the white robe at the bottom of the picture
are very flatly painted. A horizontal line is visible
across the entire bottom of the picture and
technical investigation has shown that this is the
edge of a strip that was added onto the original
canvas.[6] The rosary is largely painted on this
section of the picture and it seems that this
attribute may have been added when this strip of
canvas was attached, perhaps in the nineteenth
century.

What also becomes apparent on close inspection
is that the costume worn by the woman is some-
what more elaborate than initially appears, and
certainly not that of a seventeenth-century nun.
The lining of the dark headdress, that seems to
hang over the woman's shoulders to become a
cloak, is made up of more colours than simply
brown, and is painted with broken brushstrokes
that imply a rich gold-encrusted pattern rather
than plain material. Though achieved in a different
way, the effect is somewhat similar to that found in
the gold lining of the hood worn by the earlier *An
Old Woman Reading* (cat.121). More ornate
patterning and bright dots of paint also decorate a
neckband which is just visible under the heavy
white pleats that cover her breast. This area is
effectively the focal point of the composition,
catching the light that falls softly from the left. The
broad way that the material is painted, with the
deep grooves of shadow streaked into the creamy
folds is reminiscent of the white chemise soaked in
blood which Rembrandt was later to paint in 1666
in his dying Lucretia in the Minneapolis Institute
of Arts (cat.141, fig.165).[7]

The isolation of the figure in the Epinal painting
and the lack of any indication as to the setting recall
Rembrandt's *An Old Woman Reading* of 1655
(cat.121), although there the large book gives some
indication that the picture might be interpreted as
an embodiment of piety, a Biblical character or a
Sibyl, following the iconographic tradition of the
period. These single figures of old women were
clearly not intended as portraits but their costume
almost certainly marks them out as *tronies* (figure
studies). Unlike the *Old Woman Reading*, however,
which appears to have been painted from the life,
the Epinal picture was not necessarily painted from
a model. The closest parallel for the composition in

Rembrandt's work is in his etching of *The Virgin
with the Instruments of the Passion* (cat.113), made
about a decade before. The downcast gaze and
dress bear close comparison. The heavy mantles are
both dark-coloured, while the underdresses and
wimples are white. The painting does not repeat
the etched Virgin's raised hand but, instead, relates
more closely to the pose found in the New York
Hendrickje (cat.127), where the subject's hand on
her breast has been interpreted as a gesture with
possible religious significance.

It seems feasible that this painting does
represent a Mater Dolorosa (Virgin of Sorrows),
the summation of Simeon's prediction to Mary at
the presentation of her son in the temple that 'a
sword shall pierce thy heart'.[8] If the Virgin is
indeed shown here, then the possibility that a
rosary might have been included in the original
composition should again be considered.[9] A
woodcut by Lucas van Leyden depicts the grieving
Virgin with a rosary in front of her, her hands
placed upon her breast in the way we see here
(fig.161).[10] Though not particularly common in
representations of this theme, the rosary would
have been an acceptable part of the religious
iconography of the subject, for it was associated
with the 'Mysteries' of the Virgin's life, Sorrowful,
Joyful and Glorious. Prayers to meditate upon each
were counted on the string of rosary beads. It is
possible, then, that the strip of canvas which was
later added to the bottom of the painting may have
replicated a section that had originally been part of
the composition, perhaps including a rosary, but
which had for some reason been damaged.

It has been suggested that this painting may
have been linked with other single figures with a
religious theme which Rembrandt painted at about
this time, such as the *Titus as a Monk* of 1660
(Rijksmuseum, Amsterdam)[11] and a number of
other apostles or evangelists which appear to have
been produced by Rembrandt and his studio from
the late 1650s and the early 1660s.[12] It seems
unlikely that '*The Virgin of Sorrows*' was part of a
group including the four Evangelists as Valentiner
proposed,[13] but may have been related to a group
of the Apostles, perhaps including Christ.[14]
Another possibility is that it may have been a
pendant to an Ecce Homo, for which there is an
iconographic precedent, for example, in the work
of Titian.[15] Valentiner's ingenious solution as to
why such subjects by Rembrandt did not often
appear in Dutch inventories of the period was that
that they were painted for export, but, in any case,
one would assume that most of these pictures,
many of whose status has been queried, would have
appealed primarily to members of the Church of
Rome.[16]

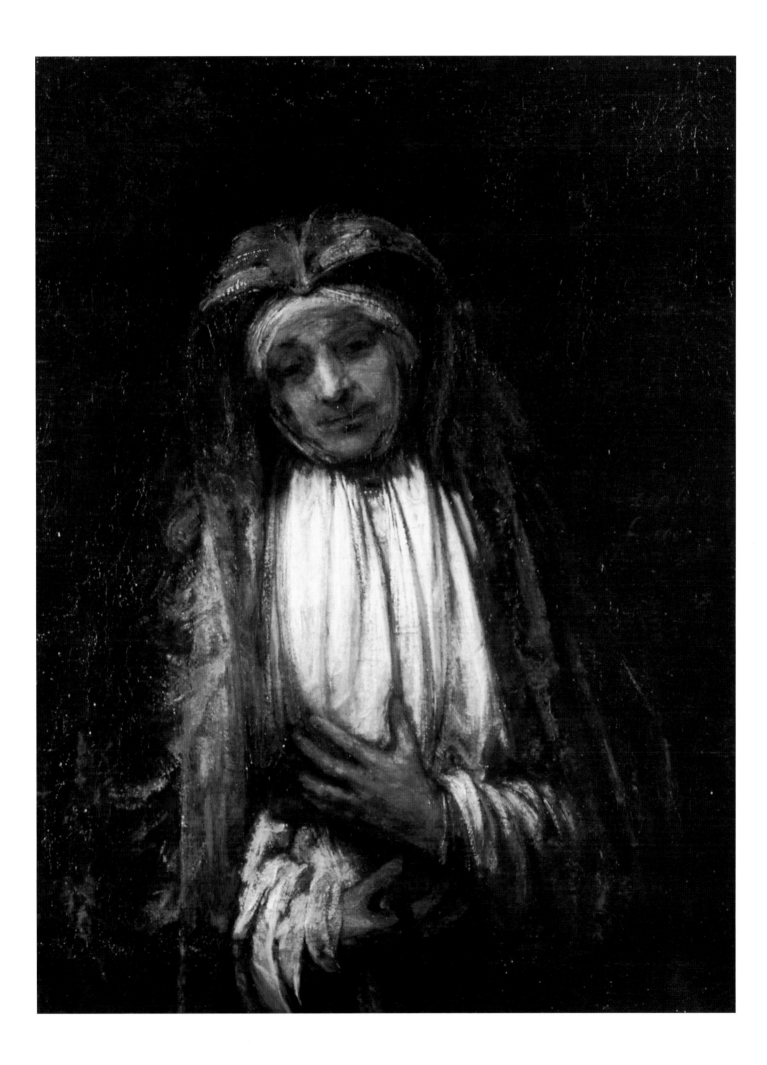

Drawing, pen and brown ink with brown wash,
17.2 × 9 cm
References: Benesch 1105; New York 1995–6,
vol.2, cat.65, pp.170–2

METROPOLITAN MUSEUM OF ART, NEW YORK
H.O. Havermeyer Collection, Bequest of Mrs H.O.
Havermeyer, 1929
(INV.NO.29.100.937)

Exhibited in London only

This remarkable drawing and the related sheet in
the Robert Lehman collection (cat.139) are two of
the very few drawings which Rembrandt sketched
to record a particular event. The subject of both
sheets was proposed by I.H. van Eeghen in 1969,
who identified the hanging figure as Else
Christiaens, born in Jutland, who arrived in
Amsterdam in April 1664 to find work.[1] On the
twenty-seventh of that month, her landlady beat
her with a broom for non-payment of rent and Else
retaliated by killing the woman with an axe.[2] The
Amsterdam court sentenced her to be executed for
murder on 1 May 1664 and it was stated that the
executioner was to strike her on the head 'several
times with the same axe with which she killed the
woman'. It was ordered that her body then be
'brought to Volwyck and fastened to a pole with an
axe above her head, to decay in the air and to be
devoured by birds'.[3] This drawing must have been
made very shortly afterwards. The weapon she
used to kill her victim was tied up in front of her
face as the badge of her crime. She is on public
display '*pour encourager les autres*'. Her body has
been trussed up to the post, the skirts tied tightly
around her to avoid needless extra spectacle.

The public execution field was on the headland
of Volewijck, north of Amsterdam across the IJ.
The headland, west of the village of Nieuwendam,
has been joined to the northern shore for at least
one hundred and fifty years but a ferry was for
centuries the only connection to what is now
Amsterdam-Noord. Rembrandt had certainly
been to the surrounding area before, as witnessed
by his landscape drawing of the *Bend in the
Diemerdijk looking towards Nieuwendam* made in
about 1649–50.[4] Another drawing of the gallows
(fig.162) was made by the Amsterdam artist
Anthonie van Borssum (1630/1–1677) who was
formerly thought to have been a pupil of
Rembrandt, and whose style was influenced by
him.[5] Van Borssum was predominantly a land-
scape artist and his conception of what was clearly
the same scene (given the little figure with her axe
at the right of the sheet) is fascinating in contrast
with Rembrandt's drawings here. Van Borssum
shows the windmills across the water, a boat
sailing by, and a few visitors who have come to
observe the guilty on the gibbet as part of a good
day out.

Fig.162 | Anthonie van Borssum (1630/1–1677), *Site of the
Execution in the Volewijck near Amsterdam*, 1644
Rijksmuseum, Amsterdam

139 *A Woman Hanging on a Gibbet*, 1664

Drawing, pen and brush and brown ink with
brown wash, 15.8 × 8.1 cm
References: Benesch 1106; New York 1995–6,
vol.2, cat.66, pp.170–2

<small>METROPOLITAN MUSEUM OF ART, NEW YORK</small>
Robert Lehman Collection, 1975
(INV.NO.1975.1.803)

Exhibited in Edinburgh only

On the basis of style alone, this drawing, and the
previous one (cat.138) might have been thought to
date from earlier in Rembrandt's career. The rather
curtailed fine, and somewhat scratchy, parallel lines
that he uses to shade the shoulder of the dead
woman here can be found in Rembrandt's copies
after Mughal miniatures and in his full-length self-
portrait drawing (now in the Rembrandthuis,
Amsterdam) which date from the previous decade.[1]
Intriguingly, it is only the link to Else Christiaens's
execution in 1664 which provides such a late date
for both drawings.

It is difficult to tell if Rembrandt rarely felt
inspired to draw contemporary incidents, or
whether he did in fact make a number of such
sketches which for some reason have not survived.
However, the balance of evidence provided by the
drawings which have come down to us would
suggest that he made such drawings rarely. Both
this drawing and cat.138 are on expensive Japanese
paper. The figure of the executed woman domi-
nates the sheet, with what appears to be a strange
poignancy. It cannot be known if he intended to
convey compassion, but both drawings have a
compelling immediacy borne of their matter-of-
fact attention to detail. Unlike in Anthonie van
Borssum's panoramic and distanced scene of the
killing field at Volewijck,[2] Rembrandt focused
solely upon the lifeless woman, and in a few brief
strokes of the pen, delineated the dead weight of
her dangling limbs, her helpless and isolated body.

Oil on canvas, 127 × 123.8 cm
References: Bredius/Gerson 639; J.S. Held,
'Rembrandt's *Juno*', Apollo, vol.105, no.184, June
1977, pp.479–85; Tümpel 1993, cat.113

ARMAND HAMMER COLLECTION, UCLA
HAMMER MUSEUM, LOS ANGELES
(INV.NO.AH.90.58)

Rembrandt's *Juno* stands in majesty before us,
dressed in a gown of very dark brownish-red, with
a fur cloak draped across her shoulders. This is
fastened by a wide band of pearls and a golden
ornament, in the middle of which is a large clasp
brooch bedecked with an enormous jewel. On her
head is a crown and her heavy hair is loosely held
back in a snood, netted with strings of pearls. Her
left hand rests by a table covered in red cloth, her
right holds a golden sceptre, while at her side, a
peacock, symbol of Juno, can just be made out. As
Marieke de Winkel has pointed out, Juno's dress
largely follows the artist and theorist Karel van
Mander's instructions on how to depict the
goddess. He had noted that she should carry a
sceptre in one hand, 'because she is the Goddess of
affluence. The peacock was her bird. Juno was very
magnificent in her attire: she had a very fair gown
of reddish-purple, and a blue cloak, decorated with
many pearls, gems and jewels.'[1]

Though Rembrandt chose to give her a cloak of
regal ermine rather than cerulean blue, he
festooned her with strings of jewels, perhaps to
emphasise her nature as a 'Goddess of affluence'.
Juno was the principal Roman goddess, the wife of
Jupiter. She was concerned with all aspects of
women's life, especially marriage and childbirth,

and is usually portrayed as a matronly figure. Her
association with wealth was because her temple
served as a mint in ancient Rome and one of her
names, '*moneta*', is the origin of the word money.[2]
The peacock was 'her bird' because, in commemo-
ration of the death of her hundred-eyed servant
Argus, Juno placed his eyes on the peacock's tail.
Rembrandt had depicted a Juno before, as a statue
seen from the back in his etching of 1648 to
illustrate the tragedy of *Medea*, written by his
patron Jan Six (1618–1700).[3] The critic Arnold
Houbraken rather scathingly observed that 'no
true connoisseur could be without the Juno with or
without the crown' (Rembrandt had added Juno's
diadem in the second state of this etching).[4]

While the etched Juno was shown sitting in a
temple that looks like a Dutch church interior, this
Juno is unquestionably Italianate in inspiration and
is, as Julius Held noted, 'one of the most striking
manifestations of the interest the ageing
Rembrandt took in Venetian portraiture'.[5] He went
on to suggest that the frontal pose of the figure
echoed that found in the work of Titian, such as his
'*La Schiavona*' in the National Gallery, London[6]
(whose square neckline is very similar) and that it
also related strongly to a *Portrait of a Lady* attrib-
uted to Bonifazio de' Pitati (called Bonifazio
Veronese, 1487–1553).[7] While these particular
paintings were probably unknown to Rembrandt
('*La Schiavona*' was in Italy during his lifetime), this
three-quarter-length frontal pose was a feature of
sixteenth-century Venetian portraiture, as wit-
nessed by a number of works by Paris Bordon
(1500–1571) showing women in a similar stance.[8]
Rembrandt's composition was initially closer to
such poses, as he first painted Juno with two hands
resting on a table or ledge at the lower edge of the

picture.[9] An X-ray mosaic of the painting (fig.163)
shows that her right arm was not originally raised
to her sceptre, the broad white lines circling the
elbow-length sleeves implying that her arms were
both placed at the same level.

It is not only the composition of this picture
that strikes the viewer as Venetian, but also the
manner of its painting, most specifically relating to
the style of the late Titian. The Italian painter and
writer Giorgio Vasari (1511–1574) in his *Life* of
Titian, described Titian's manner of painting in old
age as 'executed with bold strokes and dashed off
with a broad and even coarse sweep of the brush,
insomuch that from close quarters little can be
made out, but from a distance they appear per-
fect'.[10] While this effect has been attributed to
decrepitude and failing eyesight, the prime reason
was probably that Titian tended to work without
preparatory drawings, making alterations directly
on the canvas, believing this to be the 'true and best
method of working and the true design',[11] exactly
as witnessed in so much of Rembrandt's own work.
Ernst van de Wetering has convincingly argued
that Rembrandt's emulation of this manner was
not necessarily reliant upon direct experience of
Titian's late paintings, but, given the Italian artist's
legendary status, could have been inspired by Karel
van Mander's writings or even derived through
information supplied by Rembrandt's masters,
Swanenburgh and Lastman, who had both studied
in Italy.[12]

Some have seen the face of Hendrickje in
Rembrandt's Juno and it was proposed that the
picture was a pendant to the *Self-portrait* of 1658 in
the Frick collection, New York, showing
Rembrandt richly dressed in golden-yellow.[13] The
suggestion that he was represented as Jupiter,
however, seems unfounded, and his costume may
have been intended to invoke a famous painter
from the past.[14] Though the Juno certainly has the
dark hair and eyes that we assume Hendrickje to
have had, there is no doubt that Rembrandt
intended to portray an idealised face and figure
here, complying with the concept of Juno 'in
classical antiquity as the ideal of ripe womanly
beauty'.[15]

It has been suggested that a number of
Rembrandt's large single-figure compositions from
the latter part of his life were commissioned, and
that their subjects were often dictated by patrons,
such as Don Antonio Ruffo's choice of *Aristotle
Contemplating the Bust of Homer* and an *Alexander the
Great*.[16] This may perhaps also be true in the case of
Rembrandt's painting of *Juno*, which seems to have
been in the collection of Harman Becker (*c.*1617–
1678).[17] An immigrant to Amsterdam from Riga
and a merchant in marble floor tiles, textiles and
jewels, Becker's profitable business funded his fine
art collection. He bought a claim note upon
Rembrandt from another creditor (to whom
Rembrandt owed 1082 guilders) on 31 December

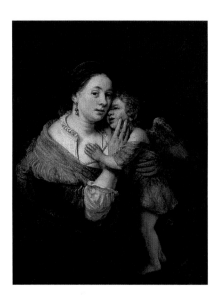

Fig.163 | X-ray of Rembrandt's, *Juno, c.1662–5*
Armand Hammer Collection, UCLA at the Armand Hammer Museum of
Art and Cultural Center, Los Angeles

Fig.164 | Rembrandt, *Venus and Cupid*
Musée du Louvre, Paris
Photo: RMN-Hervé Lewandowski

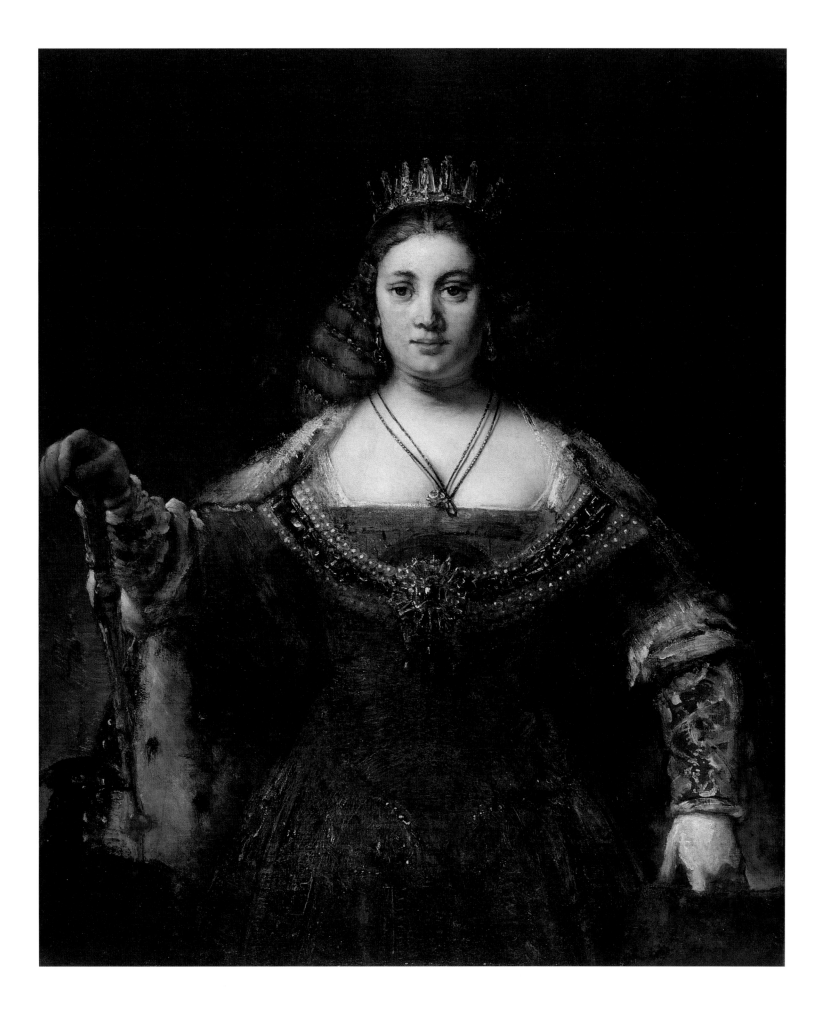

1664[18] and Rembrandt surrendered nine paintings and two albums of prints and drawings to Becker as collateral. When he offered to pay to get them back on 29 August 1665, Becker said 'Let Rembrandt first complete the "Juno"', before he would accept the money and return Rembrandt's works; the affair was finally resolved on 6 October that year, by which stage one assumes the *Juno*, goddess of wealth, had become a particularly apt addition to the usurer's collection.[19] But it may be that Rembrandt never did complete the painting, since areas of the left arm and hand appear to be unfinished and one wonders at what stage, and by whom, the right hand was altered. Perhaps the

Juno had remained in the studio awaiting completion for some time and had then been worked on quickly between August and October 1665, in order to release the painting to fulfil Becker's stipulation.[20]

Becker's posthumous inventory lists '*A Juno by Rembrandt van Rijn; a Venus and Cupid by the same*'.[21] A copy after Rembrandt's *Venus and Cupid* was also mentioned[22] and it is possible that this was the same picture now in the Louvre (fig.164).[23] Given to 'Rembrandt's school' in current Louvre documentation (though also attributed to Ferdinand Bol),[24] this may well be a contemporary copy of Rembrandt's lost composition. Apart from

these, Becker owned another thirteen paintings listed as by Rembrandt, including two *tronies* of women and a 'Pallas' which hung in the back parlour.[25] Pallas Athena was the goddess of wisdom and the arts and war, and was often depicted with a helmet, shield and spear, just as shown in Rembrandt's *Bellona* (cat.26) and *Minerva* (see cat.26, fig.93). Though it is not known exactly which works are listed, Becker clearly owned a 'classical trio' of Rembrandt deities, the goddesses of love, the arts and war, and Juno, the Queen of Heaven herself.[26]

141 *Lucretia*, 1664

Oil on canvas, 120 × 101 cm
Signed and dated, centre left: *Rembrandt 1664*
References: Bredius/Gerson 484; Wheelock 1995, pp.280–7

NATIONAL GALLERY OF ART, WASHINGTON
Andrew Mellon Collection
(INV.NO.1937.1.76)

The main source for the story of Lucretia, a heroine of ancient Rome, came from Livy's *History of Rome* (Book 1, chap.58). She was the virtuous and beautiful wife of the nobleman Lucius Tarquinius Collatinus. She was raped by her husband's relative Sextus Tarquinius, son of Lucius Tarquinius Superbus, the tyrannical Etruscan king of Rome. She had wished to commit suicide rather than submit to Sextus Tarquinius, but he threatened to

kill her and a male slave, place both corpses on the bed, and then claim that he had slain them for adultery. She preferred to give up her body rather than disgrace her name. After admitting the rape to her husband and father, she exacted from them an oath of vengeance against the Tarquins. She then stabbed herself to death and became legendary as the embodiment of the honour and chastity of Roman women. She was also a political symbol of the revolt against tyranny, since Lucius Junius Brutus then led the enraged populace in a rebellion that drove the Tarquin kings from Rome. The event (traditionally dated 509 BC) marked the foundation of the republic of ancient Rome.

Rembrandt had already painted 'A large painting of Lucretia' which is now lost but was listed in the inventory of the bankrupt Abraham Wijs and Sara de Potter on 1 March 1658.[1] His other representation of the subject was made in 1666, *The Suicide of Lucretia*, now in the Minneapolis Institute of Arts (fig.165).[2] While the Washington picture, painted two years earlier, shows the moment just before Lucretia stabs herself, the Minneapolis picture depicts the moment after the knife-thrust, as the red wound seeps into her white chemise, the fine fabric sticking to her body where it is soaked wet with her blood. The strange rope to which Lucretia clings in the Minneapolis picture has been interpreted as a curtain rope, and even a bell-pull, but may have originated as the sort of cord to which the model clung for support while posing (as seen in cat.136, figs.157–8). The idea of the rope opening a curtain has also been linked to the perceived theatrical nature of both pictures. The poses in both are highly dramatic. The Washington Lucretia opens her mouth, as if to deliver her final soliloquy, while the other Lucretia has been described as pulling on the cord to close the curtain on the last act.[3]

However, the inspiration for the poses and types in both the paintings of Lucretia was not necessarily the theatre, for there was a long

tradition of images of the subject. The portrayal of Lucretia divided effectively into three main types: Lucretia struggling with Sextus Tarquin, a nude Lucretia stabbing herself and a partially clothed Lucretia with the dagger.[4] The representations of Lucretia as a single figure may originally have been prompted by an antique statue believed to be Lucretia which was found in Trastevere in Rome and eulogised in a poem by Pope Leo X. This probably formed the basis for Raphael's *Death of Lucretia* and Marcantonio Raimondi's print after it made in *c*.1511–12 (which Rembrandt may have known).[5] Obviously the subject of Lucretia had also been popular in the north, with artists such as Albrecht Dürer (1471–1528)[6] and Lucas Cranach (1472–1553),[7] but Rembrandt's portrayal of Lucretia seems to have little to do with these. It is with the half-length Lucretias shown with the heroine partially dressed, painted by sixteenth-century Venetian artists such as Titian (*c*.1485/90–1576), Palma Vecchio (*c*.1480–1528) and Veronese (1528–88), that Rembrandt's heroine shows the closest links.[8] It has been pointed out that some similar pictures were in the collection of the Archduke Leopold Wilhelm in Brussels in the 1650s, but it is not known if Rembrandt was aware of them.[9]

Rembrandt's depiction of Lucretia, unlike those paintings which showed the heroine nude, does not focus upon her physical attributes but rather on her emotional reaction and her gaze upon the dagger. Shakespeare's narrative poem, *The Rape of Lucrece*, first published in 1594 and much reprinted in the following century, puts her predicament succinctly:

Poor hand, why quiver'st thou in this decree?
Honour thyself to rid me in this shame;
For if I die, my honour lives in thee,
But if I live, thou livest in my defame.[10]

However difficult to carry out, the classical world had seen her suicide as an honourable act, but the Christian ethic saw 'self-murder' (as the Dutch

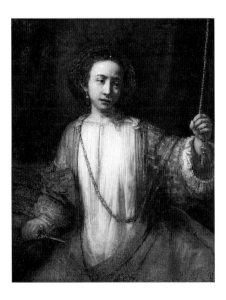

Fig.165 | Rembrandt, *The Suicide of Lucretia*, 1666
Minneapolis Institute of Arts, Minneapolis

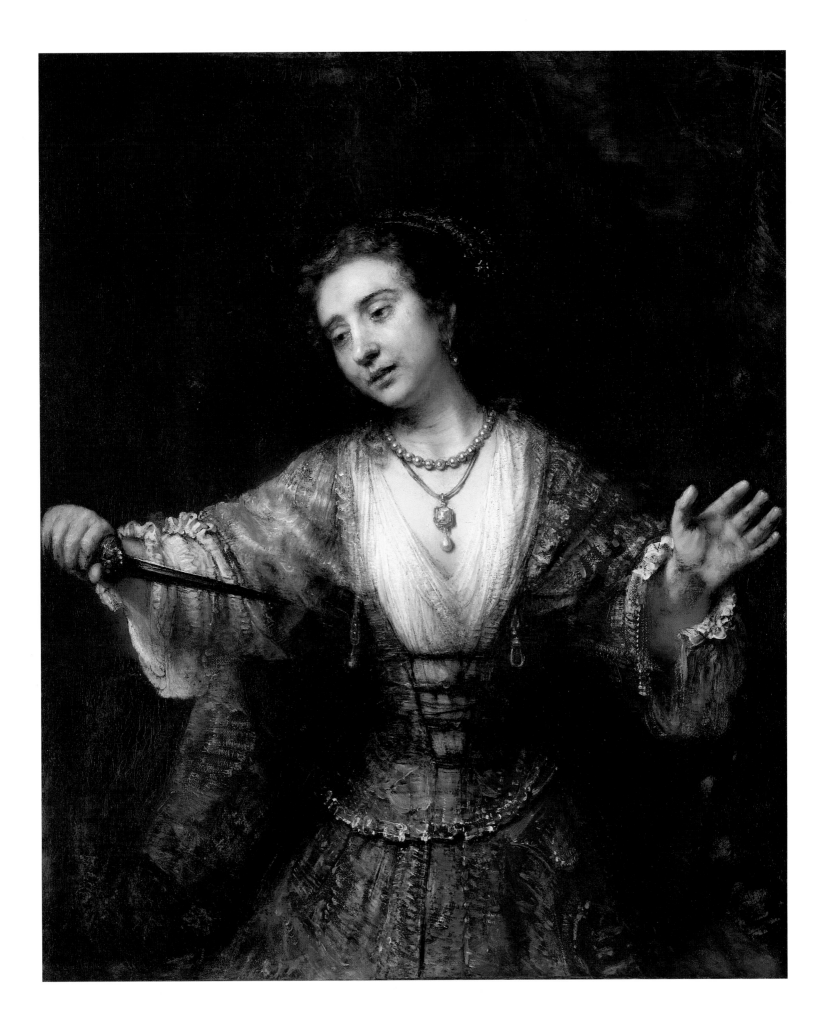

called it) as a crime against God. The deep pathos of Rembrandt's portrayal appears to carry this extra burden of moral dilemma, increasing the agonising decision Lucretia faces.

Rembrandt shows her head tilted slightly, her eyes red through crying (while tears shine on the lower eyelids of the Minneapolis *Lucretia*). Her earring does not hang straight down but sways out to the right, implying her movement as she holds the dagger towards her, the blade of which was shortened slightly by the artist.

The broad sweeps of the palette knife used in this picture have been likened to the technique used in '*The Jewish Bride*' (fig.6).[11] The blade sculpts the textures of the paint to give the dress an extraordinary encrusted quality, as if it has been hewn out of pigment, rather than rich material sewn together. In the costume found in his early history paintings, such as the two early *Floras* (cat.27, 36), Rembrandt had used his imagination in rendering richly detailed dress. Here, however, there is no interest in portraying details of the physical construction of the garment. Instead, the planes of the shape are created as a pattern of textures and colours rather than as a description of real garments. The chemise is shown falling into a deep 'v', matched by the shape of her open bodice with its laces unloosened. The sleeve of her left arm also appears undone as the underside of her forearm is visible, another sign of the indignity to which she has just been subjected.

It is not known why or for whom the picture was painted. Given the story's references to the founding of the Roman republic, Gary Schwartz proposed that the subject of Lucretia may have been commissioned in relation to political events of the time.[12] The parallels between the foundation of the Roman and the Dutch republic had been drawn upon in Rembrandt's painting, *The Conspiracy of Claudius Civilis* of *c*.1662, a fragment of which is now in the Nationalmuseum, Stockholm.[13] But if Lucretia was seen as having written the definition of Liberty in her lifeblood, it is conspicuously absent in this painting. (Interestingly, the blood on the Minneapolis *Lucretia* was overpainted by the squeamish at some stage, and was not revealed until restoration in 1953.)

Others have seen this painting not as a commission but as a posthumous portrait of Hendrickje who had died in 1663, the year before it was painted. The idea that Rembrandt's depiction of the self-sacrificing Lucretia was inspired by his loss of Hendrickje is appealing. She had certainly given her loyalty to the artist, even in the face of being publicly humiliated by the Church on account of living in sin. She had also borne him a child out of wedlock, coped with his bankruptcy and even helped to run his business, but to say that this was Rembrandt's tribute to her memory cannot be substantiated. What is perhaps as interesting, however, is that similar, though not identical,

features to those seen in the tilted head in the Lucretia here, figure elsewhere in Rembrandt's late work, such as his depiction of Asenath in his painting of *Jacob Blessing the Sons of Joseph* (fig.4)[14] and the head of the woman in the Braunschweig *Family Portrait* (fig.5).[15] It is striking that these, as well as his '*Jewish Bride*' are all dark-haired, dark-eyed women. It does not seem overly-sentimental to suggest that, even though they are not actual portraits of Hendrickje, perhaps for the elderly Rembrandt all women came a little to resemble her.

Notes and References

An introduction to
Rembrandt's Women
JULIA LLOYD WILLIAMS

1 See cat.100.

2 Quoted by an anonymous author in the entry on Rembrandt in the 1892 edition of *Encyclopaedia Britannica* (clipping in National Gallery of Scotland files).

3 For example see Bredius/Gerson 73–82, 129–31.

4 Dr A.P. Laurie, 'Hendrickje. A Famous Rembrandt', *The Scotsman*, 5 August 1929 (clipping in National Gallery of Scotland files).

5 See cat.1, note 5.

6 See Bredius/Gerson 83–91.

7 Benesch 427. See also, cat.21.

8 Rembrandt's etching *Self-portrait with Saskia* (cat.40) is discussed later in this introduction.

9 See cat.100, note 10 and Melbourne/Canberra 1997–8, p.133.

10 For more information about the dire financial implications of these proceedings see S.A.C Dudok van Heel's essay. The relationship between Geertje and Rembrandt is described in lively detail in Schama 1999, pp.542–9.

11 Strauss/Van der Meulen, 1660/12.

12 Strauss/Van der Meulen, 1654/4.

13 Gerson 1968, p.263.

14 For some examples of the wide range of ways in which women were portrayed, see Haarlem 1986.

15 London 1988–9, p.124.

16 See M.W. Ainsworth in *Art and Autoradiography: Insights into the Genesis of Paintings by Rembrandt, Van Dyck and Vermeer*, The Metropolitan Museum of Art, New York, 1982, p. 29. This comment is made specifically in relation to the Metropolitan Museum of Art, New York's 'Van Beresteyn' portraits of 1632 which she considers authentic, as does W. Liedtke in New York 1995–6, vol.2, cat.3, 4, pp.46–50 (refuting the rejection of the pair in the *Corpus*, vol.2, c68, c69) and that museum's *Portrait of a Lady with a Fan* (*Corpus*, vol.2, A79 – as *Portrait of a Woman in an Armchair*) but to state that this difference is always present in Rembrandt's female portraits would be too great a generalisation. I am grateful to Dr Ainsworth for sending me information in relation to this.

17 Ibid.

18 'The Jewish Bride' (Bredius/Gerson 416) is considered here as in the terms of history painting rather than portraiture.

19 Strauss/Van der Meulen, 1659/18.

20 *Corpus*, vol.2, A77.

21 *Corpus*, vol.3, A143. For the tradition of joint portraits of married couples, see p.414.

22 Schama 1999, p.379.

23 *Corpus*, vol.2, A58.

24 *Corpus*, vol.3, p.146.

25 Strauss/Van der Meulen, 1648/7, from the inventory of Abraham Bartjes a teacher of French living on Bethaniendwarsstraat, Amsterdam.

26 *Corpus*, vol.3, A111. See, too, cat.39.

27 Letter of 1937 from Herbert Read to Sir James Caw, Director of the National Gallery of Scotland, in Gallery files.

28 For further discussion on *tronies* see cat.3, note 4 and cat.4, note 2.

29 Strauss/Van der Meulen, p.269, and note 2.

30 N. Salomon, *Jacob Duck and the Gentrification of Dutch Genre Painting*, (*Ars Picturae* 4) Doornspijk, 1998, p.27.

31 Ibid., p.47 and note 55 and 56.

32 Schwartz 1984, p.293.

33 Bredius/Gerson 437.

34 See cat.125, note 19.

35 Bredius/Gerson 417.

36 Bredius/Gerson 416.

37 See cat.12, note 3.

38 E. George, *The Life and Death of Benjamin Robert Haydon*, London, 1948, p.223, quoted in White 1999, p.193 and by Craig Hartley in Cambridge 1996, p.2.

39 See Boston 2000–1, p.136.

40 Strauss/Van der Meulen, 1656/12: the inventory of Rembrandt's possesions made on 26 to 27 July 1656. See, for example, nos.195, 196, 200, 205, 206, 207, 209, 210, 214, 230, 232, which included work by Raphael, Tempesta, the Carracci, Barocci, Guido Reni and Spagnoletto.

41 Strauss/Van der Meulen, 1637/6, 1659/20.

42 Strauss/Van der Meulen, 1656/12, no.273, ''t proportie boeck van Albert Dürer, houtsnee'. See, too, cat.73 and 82–3.

43 Clark 1960, pp.325–30.

44 See cat.48, note 1.

45 See cat.42–4, 46, 77, 88 and 92.

46 Benesch 1169; London 1992, cat.60, pp.137–8.

47 See White 1999, p.184; I. Zdanowicz in Melbourne/Canberra 1997–8, p.406; Schama 1999, p.544.

48 See cat.109, note 7.

49 *Corpus*, vol.2, A92.

50 Benesch 1210.

51 See Berlin/Amsterdam/London 1991–2, vol.1, pp.168–9.

52 Bal 1991, especially pp.138–76.

53 Strauss/Van der Meulen, 1656/12, no.193 or perhaps 198.

54 Hollstein, x, nos.B1, 6, 8, 10, 12, 16 and B.2, 5, 7, 9, 11, 13. See E.S. Jacobowitz and S.L. Stepanek, *The Prints of Lucas van Leyden and His Contemporaries*, National Gallery of Art, Washington 1983, pp.102–5. For a further bibliography on the subject of the Power of Women theme, see p.105 note 1, including S.L. Smith, *'To Women's Wiles I Fell', The Power of Women 'Topos' and the Development of Medieval Secular Art*, Ph.D. diss, University of Pennsylvania, 1963.

55 E.S. Jacobowitz and S.L. Stepanek, *The Prints of Lucas van Leyden and His Contemporaries*, National Gallery of Art, Washington 1983, p.102.

56 *Corpus* vol.1, A24 and cat.73.

57 Quoted by Gerson 1968, p.466. Faure was originally trained in medicine and brought his scientific knowledge to bear in his study of the history of art, relating it to the progress of human culture. The best known of his many art historical and critical works is his *History of Art* (5 vols., 1909–21; tr. by Walter Pach, 1937).

58 *The Complete Letters of Vincent Van Gogh*, London 1958 (1978 edition), vol.3, p.187.

Rembrandt: his life, his wife, the nursemaid and the servant
S.A.C. DUDOK VAN HEEL

This biography incorporates the latest insights and findings. Lack of space prevents repetition of everything from my previous publication, S.A.C. Dudok van Heel, 'Rembrandt van Rijn (1606–1669): a Changing Portrait of the Artist', in Berlin/Amsterdam/London, vol.1, 1991–2, pp.50–67.

With thanks to Dr Marten Jan Bok, Prof. Dr E.O.G. Haitsma Mulier and Sylvie Matton.

1 Houbraken 1718–21, 2nd edition, 1753, p.272: 'Hij had ten huisvrouw een boerinnetje van Raarep of Randsdorp in Waterland, wat klein van persoon maar welgemaakt van wezen, en poezel van lichaam. Haar portret ziet men nevens het zijne in een van zijne prentjes'.

2 P. Moustiers, *Saskia*, Paris, 1999.

3 S. Matton, *Moi, la putain de Rembrandt*, Paris, 1998.

4 For the research for, and interpretation of, the Rembrandt documents see S.A.C. Dudok van Heel, 'Archival investigations and the figure of Rembrandt', in Amsterdam 1987–8, pp.11–15.

5 H.F. Wijnman, notes in C. White, *Rembrandt*, The Hague, 1964, pp.139–55, no.40.

6 Alexander Korda, *Rembrandt*, with Charles Laughton as the painter, U.K., 1936. Hans Steinhoff, *Rembrandt*, Germany, 1942. Charles Matton, *Rembrandt*, Ognon Pictures, France, 1999.

7 V. Veen and M. Jonker, *Het Rembrandtbeeld. Hoe een kunstenaar in de 19de-eeuw een nationale held werd*, Amsterdam, 1977. In this connection see J. Tollebeek and T. Verschoffel, '"A Profitable Company". Het pantheon als historisch genre in het negentiende-eeuwse België', in *Bijdragen en mededelingen betreffende de geschiedenis der Nederlanden*, 115, 2000, pp.223–43.

8 P.J.M. de Baar, *De Leidse verwanten van Rembrandt van Rijn en hun Leidse afstammelingen tot heden*, Leiden, 1992, p.2.

9 Strauss/Van der Meulen, 1641/8.

10 For the other possibilities see Berlin/ Amsterdam/London 1991–2, vol.1, p.53.

11 On the persecutions see S.A.C. Dudok van Heel, 'De remonstrantse wereld van Rembrandts opdrachtgever Abraham Anthoniszn Recht', in *Bulletin van het Rijksmuseum*, 42, 1994, pp.334–46, and A.G. van der Steur, 'Aantekeningen betreffende de remonstrantse gemeente te Warmond', in *Rijnland, tijdschrift voor sociale genealogie en streekgeschiedenis voor Leiden en omstreken*, 9/10, 1966, pp.265–90.

12 A.F. de Graaf, 'Remonstranten uit Leiden en omgeving', in *Rijnland, tijdschrift voor sociale genealogie en streekgeschiedenis voor Leiden en omstreken*, 9/10, 1966, pp.246–62; membership roll for 1656: no.198, Lysbet Simons, widow of Arien Hermans van Rijn, with her daughter: no.199, Cornelia Ariens van Rijn, a miller's wife. Also listed are: no.61, Jan Molijn, painter, and his wife Neeltje Cornelis in Vrouwesteeg; no.65, François Mieris, painter, and his wife Cniertje Cornelis; and among the Rijnsburg members: no.236, master-surgeon Herman Homan, later Spinoza's landlord.

13 De Baar 1992, pp.3ff: Cornelia Adriaensdr van Rijn married a Catholic, Flemish immigrant on 3 April 1655 before the court at Leiden and, presumably after her conversion, in the Roman Catholic mission station on the Appelmarkt on 13 March 1668.

14 R.E.O. Ekkart, *Isaac Claesz. van Swanenburg 1537–1614, Leids schildere en Burgemeester*, Zwolle, 1998, pp.126–8. S.A.C. Dudok van Heel, 'Pieter Lastman (1583–1633). Een schilder in de Sint Anthonisbreestraat', in *Kroniek van het Rembrandthuis*, 91/2, 1991, pp.2–15.

15 B. Broos, 'Rembrandts eerste Amsterdamse periode', *Oud Holland*, 114, 2000, pp.1–6. Lastman's mother died in December 1624 and her possessions were sold in April 1625. His sister married in April 1625 and his brother died at the beginning of May. From May 1625 Lastman therefore lived alone in the St Antonisbreestraat (no.59). See S.A.C. Dudok van Heel, 'Waar woonde en werkte Pieter Lastman (1583–1633)?', *Maandblad Amstelodamum*, 62, 1975, pp.31–6. Did Rembrandt perhaps come to Amsterdam after May 1625?

16 C. Tümpel, 'Pieter Lastman and Rembrandt', in Amsterdam 1991, pp.54–84.

17 The latter held the view that the state was above the church.

18 Amsterdam 1991, cat.no.111.

19 B. Broos, 'Hippocrates bezoekt Democritus" door Jan Pynas, Lastman, Moeyaert en Berchem', in *Kroniek van het Rembrandthuis*, 91/2, 1991, pp.16–23. The subject was also painted by Jan Pynas (1581–1631) in 1614, Claes Moeyaert (1591–1655) in 1636 and Nicolaes Berchem (1620–1683) in the 1640s – all before the signing of the Treaty of Münster in 1648, which brought the Eighty Years War to a close.

20 See my remarks about Vondel's play *Palamedes* of 1625 in Dudok van Heel 1994 (see note 11), pp.339–40 and 421. P. Tuyman, 'Een oud Rembrandt – raadsel opgelorst', in *Kroniek van het Rembrandthuis*, 99/1–2, pp.2–7, and J. Stumpel, 'A Twelfth attempt: the subject of Rembrandt's History Piece in Leiden', *Simiolus*, 28, 2000–1, pp.44–50.

Both authors place the history in pre-Republican Rome on the basis of the wolf on the column, a symbol of the kings of ancient Rome. The creature on the column is actually a seventeenth-century sheep with a long tail (*Meesterlijk vee. Nederlandse Veeschilders 1600–1900*, Dordrechts Museum, 1988, cat.nos.6, 7, 25, 32 and *passim*). This is a symbol of Christendom and the painting must represent a scene from Christian history. It is remarkable that the prince seems to wear trousers, which would have been considered barbarian clothes.

21 C.L. Heesakkers, *Constantijn Huygens. 'Mijn jeugd'*, Amsterdam, 1987, pp.84–9. The translation is from Schwartz 1985, p.76.

22 R. Baer in Washington/London/The Hague 2000–1.

23 For the tuition fees paid by pupils see M.J. Bok, 'The life of Abraham Bloemaert', in M.G. Roethlisberger, *Abraham Bloemaert and his Sons. Paintings and Prints*, Ghent, 1993, pp.551–87, especially pp.572–3.

24 B. Broos, 'Rembrandts eerste Amsterdamse periode', *Oud Holland*, 114, 2000, p.4; Schwartz 1984, p.4.

25 S.A.C. Dudok van Heel, 'De schilder Nicolaes Eliaszn Pickenoy (1588–1650/56) en zijn familie. Een geslacht van wapensteensnijders, goud- en zilversmeden te Amsterdam', in *Liber Amicorum Jhr. Mr. C.C. van Valkenburg*, The Hague, 1985, pp.152–60, note 6.

26 There are a few reports of portraits; see Wijnman 1959, p.14.

27 E. van de Wetering, 'Isaac Jouderville a pupil of Rembrandt', in A. Blanket et al., *The Impact of a Genius. Rembrandt, his Pupils and Followers in the Seventeenth Century. Paintings from Museums and Private Collections*, Amsterdam, 1983, pp.59–69.

28 E. van de Wetering, 'Problems of apprenticeship and studio collaboration', in *Studies in the Workshop Practice of the Early Rembrandt*, Amsterdam, 1986, pp.45–90, especially pp.60–76. Several Amsterdam ladies wear two layers of lace (see fig. 12), and Amalia van Solms, in her portrait as Princess of Orange, even has three, which is unique in Dutch portraiture.

29 M. Bijl et al., 'Rembrandts portret van Johannes Wtenbogaert, verwerving en restauratie, in *Bulletin van het Rijksmuseum*, 42, 1994, pp.327–33, especially p.331.

30 Schwartz 1985, pp.143–66. S.A.C. Dudok van Heel, 'Enkele observaties bij het portret van 83-jarige dame uit 1634 door Rembrandt', in *Maandblad Amstelodamum*, 79, 1992, pp.6–15.

31 Berlin/Amsterdam/London 1991–2, vol.1, p.54. E. Hinterding, 'Rembrandt and Van Vliet: the Watermarks', in C. Schuckman et al. (eds.), *A Collaboration on Copper. Rembrandt & Van Vliet*, Amsterdam, 1996, pp.24–6, especially p.25.

32 J. Bolten (ed.), *Rembrandt and the Incredulity of Thomas*, Leiden, 1981. For discussion on the workshops, based on H. Miedema, *De Archiefbescheiden van het St. Lukas gilde te Haarlem 1497–1798*, Alphen a/d Rijn, 1980, see M.E.W. Goossens, *Schilders en de Markt, Haarlem 1605–1635* (Leiden University PhD diss.), The Hague, 2001.

33 E. van de Wetering, 'Remarks on Rembrandt's oil-sketches for etchings', in Amsterdam/London 2000–1, pp.36–63, and pp.52–5.

34 Houbraken 1718–21, second edition 1753, vol.2, p.18.

35 P. Huys Janssen, 'Rembrandt's Academy', in *The Hoogsteder Exhibition of Rembrandt's Academy*, Zwolle, 1992, pp.20–35.

36 Amsterdam/London 2000–1, pp.50–1.

37 J.C. Kutsch Lojenga, 'De oudste generaties Ulenburch te Leeuwarden', in *Jaarboek van het Centraal Bureau voor Genealogie*, 36, 1982, pp.51–73, especially p.73. For Saskia's relationship to Hendrick Uylenburgh, see F. Bontekoe and J.C. Kutsch Lojenga, 'De van Loo's in de omgeving van Rembrandt', in *Jaarboek van het Centraal Bureau voor Genealogie*, 35, 1981, pp.137–74, especially p.168. Saskia was the only member of the Uylenburgh family to adopt the form 'van Uylenburgh'; see Strauss/Van der Meulen, 1642/2.

38 Strauss/Van der Meulen, 1647/6.

39 Strauss/Van der Meulen, 1655/6, and S.A.C. Dudok van Heel, 'Schrijfoefeningen van Titus van Rijn (1641–1668)', in *Maandblad Amstelodamum*, 67, 1980, pp.3–7.

40 S.A.C. Dudok van Heel, 'De galerij en schilderloods van Rembrandt, of waar schilderde Rembrandt de "Nachtwacht"', in *Maandblad Amstelodamum*, 74, 1987, pp.102–6. *Idem*, 'Frans Banninck Cocq (1605–1655), de kapitein van "de Nachtwacht"', in *Maandblad Amstelodamum*, 79, 1992, pp.28–33.

41 S.A.C. Dudok van Heel, 'Rembrandt doet in 1639 een miskoop. De geschiedenis van Rembrandts huis', in *Kroniek van het Rembrandthuis*, 1997, pp.2–13.

42 Strauss/Van der Meulen, 1653/9.

43 S.A.C. Dudok van Heel, '"Gestommel" in het huis van Rembrandt van Rijn. Bij twee nieuwe Rembrandt-akten over het opvijzelen van het huis van zijn buurman Daniel Pinto in 1653', in *Kroniek van het Rembrandthuis*, 1991, pp.2–13. This was the house in which Hendrick Uylenburgh had his workshop. See also Strauss/Van der Meulen, 1653/6. The repairs to the foundations of the smaller neighbouring house at the back cost 3,802 guilders in 1659.

44 Strauss/Van der Meulen, 1649/6.

45 Strauss/Van der Meulen, 1648/2.

46 Vis 1965, figs. on p.127, where she signed with a swastika, and on p.130, where she made a different mark.

47 Vis 1965, *passim*. S. Slive, in *Frans Hals*, vol.3, London, 1974, nos. 186 and 187, dated the Frans Hals portraits on which Vis's reconstruction was based to the early 1650s, when Geertje Dircks had already left Rembrandt's house. Columns and a vista were added in the backgrounds of both portraits at different dates.

48 Hendrickje Stoffels had a linen chest of this kind; see Strauss/Van der Meulen, 1658/9.

49 H. Roodenburg, *Onder censuur. De kerkelijke tucht in de gereformeerde gemeente van Amsterdam, 1578–1700*, Hilversum, 1990, pp.230–3.

50 I.H. van Eeghen, 'De familie Six en Rembrandts portretten', in *Maandblad Amstelodamum*, 58, 1971, pp.112–16.

51 I.H. van Eeghen, 'Anna Wijmer en Jan Six', in *Jaarboek Amstelodamum*, 76, 1984, pp.38–68, especially pp.56–60.

52 S.A.C. Dudok van Heel, 'Dr. Nicolaes Tulp alias Claes Pieterszn. Dignity between Simplicity and Splendour', in *Nicolaes Tulp. The Life and Work of an Amsterdam Physician and Magistrate in the 17th Century*, Amsterdam, 1998, pp.41–116, especially p.98.

53 I.H. van Eeghen, 'De Keizerskroon, een optisch bedrog', in *Maandblad Amstelodamum*, 56, 1969, pp.162–8.

54 Strauss/Van der Meulen, 1656/6, 17 May 1656.

55 O. Vlessing, 'Waarom Spinoza in de ban werd gedaan', in *Nieuw Israelitisch Weekblad*, 11 August 2000, pp.10–11. Spinoza was not excommunicated for his heretical beliefs but for trying to withdraw property from his father's estate. It was only later that he became a famous philosopher. H. Noordkerk, *Handvesten ofte privilegien ende octroyen: mitsgaders willekeuren, costuimen, ordonnantien en handelingen der stad Amsterdam*, Amsterdam, 1748, p.644.

56 Strauss/Van der Meulen, 1656/10, 14 July 1656.

57 Berlin/Amsterdam/London 1991–2, vol.1, pp.60–1.

58 S.A.C. Dudok van Heel, 'Het "Schilderhuis" van Govert Flinck en de kunsthandel van Uylenburgh aan de Lauriergracht te Amsterdam', in *Jaarboek Amstelodamum*, 74, 1982, pp.70–90.

59 Wijnman 1959, p.16.

60 I.H. van Eeghen, 'Wat veroverde Rembrandt met zijn Claudius Civilis?', in *Maandblad Amstelodamum*, 56, 1969, pp.145–9.

61 Strauss/Van der Meulen, 1660/20, 15 December 1660.

62 I.H. van Eeghen, 'Handboogstraat 5', in *Maandblad Amstelodamum*, 56, 1969, pp.169–76, especially p.172. J. van der Veen, 'Het netwerk van verzamelaars rondom Rembrandt', in B. van den Boogert (ed.), Amsterdam 1999–2000, p.143.

63 Strauss/Van der Meulen, 1662/9 and 1669/5.

64 Y.M. Prins, 'Het testament van Titus van Rhijn', in *Genealogie, kwartaalblad van het Centraal Bureau voor Genealogie*, 3, 1997, pp.8–9.

65 This is in direct contrast to Rubens whose descendants number some 15,000, amongst whom are the heirs of the last Emperor of Austria and the head of the House of Bourbon. See H. Duchamps (ed.), 'Rubens et son descendants', *Le Parchemin*, vol.25, 1977, and six other volumes.

66 See note 46 and H.F. Wijnman, 'Een episode uit leven van Rembrandt: de geschiedenis van Geertje Dircks', *Jaarboek Amstelodamum*, 60, 1968, pp.103–17.

67 P. Mousteers, *Saskia*, Paris, 1999.

68 R. van Oven, *Hendrikje Stoffels, roman uit het leven*, Amsterdam, 1936; H. Krosenbrink, *Hendrikje Stoffels, Gelderse roman*, Naarden, 1973; S. Matton, *Moi, la putain de Rembrandt*, Paris, 1998.

The model woman and women of flesh and blood

E. DE JONGH

With thanks to Marten Jan Bok, Bas Dudok van Heel, Ger Luijten and Peter Schatborn for their critical comments and information.

1 Kloek 1995, p.256.

2 Much has been published about women in the Netherlands in the seventeenth century in the past few decades, or about women in their relationship to men and children. Among the most important publications are Haks 1982; Schama 1987; Van Deursen 1991; Dekker 1992; Dixon 1995; and Kloek 1995. On the role of women in the realms of literature and the visual arts see Spies 1993; Schenkeveld-van der Dussen 1997; and Kloek et al. 1991.

3 One thinks primarily of works by Erasmus, Vives, Coornhert and Cats. See also Veldman 1986; and Franits 1993.

4 See Maclean 1980, pp.17–20; Haarlem 1986, p.28.

5 Maclean 1980, pp.5–27; and Orbán 1985. Bleyerveld 2000, discusses anti-feminism and the subject of 'women's wiles' in great detail.

6 Maclean 1980, pp.12–13; and Haarlem 1986, p.28.

7 Ibid.

8 De Groot 1939, I, p.7: 'Alzoo doorgaens der wijven geslacht als kouder ende vochtiger, minder bequaemheid heeft tot zaken, verstand vereisschende, als 't geslacht der mannen, zoo is het mannelick gheslacht genoegzaem aengeboren eenige opperheid over de wijven.' The English translation (slightly emended) is from Grotius 1926–36, I, pp.15–17. See also Kooijmans 1997, p.220. On the theory of the humours and the supposed implications for women in the seventeenth century, see Dixon 1995, pp.93, 101–3, 169–70 and 221. See also Kloek 1995, pp.251–2.

9 For example, see Cats 1661, pp.80–7, especially (on p.83) for his advice to men: 'Dus, als ghy nu en dan een vrouwe straffen moet, /So maeckt dat ghy het werck ter rechter uren doet' ('So if you have to chastise a woman now and then, choose a fitting moment'). Also Haks 1982, p.150; and Schama 1987, pp.398–400.

10 Haks 1982, pp.70–3. See also Franits 1993, *passim*, on the model woman. On chastity and honour see Leuker/Roodenburg 1988; Roodenburg 1990, pp.244–54 ('Eer en schande'); Van de Pol 1996, pp.67–83; and Roodenburg 1996. The poem accompanying Cats's emblem (Cats [1640], p.27), contains the following crucial lines: 'Is erghens yet, of broos, of teer, /Ghewis het is der maeghden eer' (If there is anything that is fragile or delicate it is, for sure, the honour of maidens).

11 On domesticity see Franits 1993, pp.29, 68–76, 87–9, 95–100; and Corbeau 1993, pp.370–74. On the sexually insatiable woman see Orbán 1985, p.132.

12 Cats 1661, p.111: 'Want raeckt haer weligh hert eens buyten sin gebot, /Soo wort haer teere schoot een deure sonder slot'.

13 Haarlem 1986, pp.20–1.

14 Houbraken 1718–21, II, pp.276–7: 'Zekere Mevrouw (wier naam ik niet melden wil) die op veere na de schoonste niet was, liet haar pourtret van hem schilderen, 't welk hy zoo even, als het was met al de pokputten en naden had nagebootst. Zy opgestaan zag zoo vies als zy wel mocht, zeggende tegens hem: *Wat Duivel, Maas, hebje daar voor een monstereuze troony naar my gemaalt! ik begeer t zoo niet gemaakt te hebben, de honden zouden 't wel nabassen, zoo 't over de straat gedragen wierd*. Maas, die toen haast bemerkte wat 'er voor hem te doen stondt, zeide: *Mevrouw, 't en is noch niet voltooit*, en verzocht haar andermaal te zitten: nam een Vispenceel en verdreef al die pokputten, zette een blos op de wangen en zeide, *Mevrouw nu is het gedaan, u believe het nu eens te zien*. Zy het gezien hebbende zeide: *Ja, zoo moest het wezen*. Zy nam daar genoegen in toen 't 'er niet geleek'. Although it is difficult to prove, it seems that Maes's teacher, Rembrandt, was not one of the portraitists who was prepared to employ visual euphemisms. Thanks to a notarial document it is known that he refused to make the changes to a portrait of a young woman demanded by the patron, who claimed that it bore no resemblance to the sitter; see Strauss/Van der Meulen, 1654/4, p.310.

15 Sweerts 1678, p.152; Van Gelder 1993; Rutten 1997, pp.23–4, 189–92, 194–5.

16 De Jongh 1993; Reznicek 1977, pp.91–9.

17 Frisch 1988; Bedaux 1999, p.121.

18 Van Beverwijck/Van Gemert 1992, p.149.

19 See Cats 1632, p.1: 'Spreucken ende Spreeck-woorden, Rakende de onderlinge plichten tusschen man en wijf': 'Een vette hin, /Dat wort geoordeelt wel te staen'; Cats 1632, p.49: 'Liefdes Kort-sprake': 'Geen beter blanket, Als gesont en vet'; and Cats 1632, p.123: '… een fluxe meyt van ses-en-twintig jaren … vet, lijvigh, wel geborst'. See also Van Deursen 1991, p.81.

20 Hellinga 1941, p.107: 'Onse dochter neemt vast toe en wort vast groot en vet'.

21 The Hague 1987, p.147: '… vettjens ende blozende van aensicht'.

22 Houbraken 1718–21, I, p.272: '… welgemaakt van wezen, en poezel van lichaam'; he was referring to the etching of 1636 (see cat.40), in which the woman clearly has a round face. WNT, XII, cols. 3015–16.

23 Vondel 1927, p.453.

24 Cats 1661, p.162. De Jongh 2000, pp.53–4; Sluijter 1998, pp.78–9, 81; and Sluijter 2000, p.121.

25 Clark 1960, p.327. Bruyn 1970, p.28, objected to Clark's opinion, shared by several writers, 'that Rembrandt here expressed a rebellious, anti-classical attitude'. See also Albert Blankert in Melbourne/Canberra 1997–8, pp.34–6, 118–20; and Martin Royalton-Kisch in Amsterdam/London 2000–1, pp.98–105.

26 Hollander 1980, pp.108–10, 159–60; Sluijter 1998, pp.69, 93–4, note 34. Compare, also, the figures of Eve in the etching *Adam and Eve* (cat.73), and the so-called '*Cleopatra*' drawing (cat.71), both of whom have well-rounded bellies, as does the female nude in a later drawing: Berlin/Amsterdam/London 1991–2, vol.2, p.127.

27 Pels 1681, pp.35–6.

28 Houbraken, who had equally harsh things to say about Rembrandt's nudes, calling them 'te droevig om 'er van te zingen, of te spelen' (too sad to sing about or make music), was another who failed to remark on their corpulence; see Houbraken 1718–21, I, pp.261–2. The artist and theoretician Jan de Bisschop, in 1669–70, did refer explicitly to corpulence when speaking in disdainful terms about a nude Leda or Danaë rendered 'with a fat and swollen belly, pendulous breasts, impressions of garters on the legs, and much more of such monstrosity', but, in contrast to Pels and Houbraken, he does not mention Rembrandt in this context; see Emmens 1968, pp.58–9.

29 Cf. Emmens 1979, pp.77–114; Sluijter 1998, *passim*; Albert Blankert in Melbourne/Canberra 1997–8, pp.32–8.

30 On the *Woman in Bed* see Albert Blankert in Melbourne/Canberra 1997–8, pp.130–3. See also Hollander 1980, pp.108, 160; and Reznicek 1977, pp.91–9. Van Deursen 1991, p.82, suggests that 'a man of quality might have preferred a lighter step and slender waist'.

31 Moryson, quoted by Van Deursen 1991, p.83. See also Haks 1982, pp.155–56; and Dixon 1995, p.216.

32 Van Stipriaan 1996, pp.198–229.

33 Schama 1987, pp.375–97.

34 E. de Jongh, in Amsterdam 1997A, pp.337–40. Noordegraaf/Valk 1996, pp.71–2, are fairly sceptical about the standards of hygiene in seventeenth-century Holland, saying that 'travellers can write what they like, we would have no trouble in sketching a picture that would horrify people living in the twentieth century of the filthiness of the streets, in the canals and in the houses, and even of people themselves in early modern times'. ('Reizigers mogen schrijven wat ze willen, het zou ons niet moeilijk vallen een voor de twintigste-eeuwer onthutsend beeld te schetsen van de vervuiling langs de straten, in de grachten en in de huizen, en van de mensen zelf in de vroegmoderne tijd'.) See also Vis 1996, pp.23–34, on bye-laws on rubbish in several towns, and p.71 ('De mythe van de schone stad').

35 Vis 1996, pp.19–20: '… crengen van dode honden, verkens off ander vullens'; and Amsterdam 1997A, p.338.

36 Amsterdam 1997A, p.337. Rembrandt made two small etchings of a man and a woman urinating outdoors, although not in the presence of other people. See Ger Luijten in Amsterdam/London 2000–1, pp.105–7, and the present catalogue, no.15 (A Woman Making Water).

37 Van Deursen 1991, pp.81–3; Kloek 1995, pp.247–50.

38 Van Deursen 1991, p.9; Kloek 1995, pp.270–6.

39 See Schama 1987, pp.404–7; and Kloek 1995, pp.271–2.

40 Van Deursen 1988; Van de Pol 1996, passim.

41 Van Deursen 1991, p.10.

42 One such was Sophia Trip who, after her husband died, took over the running of the Coymans trading company, which had a staggering turnover of four million guilders a year; see Kooijmans 1997, pp.122–3.

43 On the churches and the various religious denominations in the Netherlands see especially Van Deursen 1991, pp.260–318. See also Kloek 1995, pp.268–9.

44 See Van Deursen 1991, pp.283–5, for klopjes. Judith Pollmann, in Pollmann 2000, draws attention to the relatively large number of women who were members of the Reformed Church in the seventeenth century. It seems that women were also in the majority in other congregations. According to Pollmann, women saw church membership as a way to enhance their 'eerlijkheid' (honour). Female religiousness practised outside confessional boundaries easily roused suspicion and was liable to condemnation.

45 The French School took advanced pupils from the wealthier families, the lessons probably being conducted in French. The Latin School was for boys who planned to go to university. On these and other forms of education, as well as the question of illiteracy, see De Booy 1980, pp.27–8; and Van Deursen 1991, pp.122–4. Spufford 1995, pp.248–63, concludes that, compared to other European countries, literacy was quite high in the Republic.

46 See Dekker 1995, p.45, on the education of Susanna Huygens.

47 Spies 1986. See also Rang 1988.

48 See Schenkeveld-van der Dussen 1979–80, on Anna Roemer Visscher; Smits-Veldt 1994, on Tesselschade; Van der Stighelen 1987, and De Baar et al. 1992, on Schurman.

49 The best-known of such works is Van de wtnementheyt des vrouwelicken geslachts (On the excellence of the female sex), Dordrecht, 1639, by Johan van Beverwijck, the author of De schat der gesontheit. On the place of Van de wtnementheyt within the tradition of propagandist writings of this kind, which were not always free of ambivalence, see Moore 1994. See also De Brune de Jonge 1681, pp.111–19.

50 Haarlem 1993; and Kloek et al. 1991. For women in literature see Spies 1993; and Schenkeveld-van der Dussen 1997.

51 See the biographical sketch by S.A.C. Dudok van Heel in Berlin/Amsterdam/London 1991–2, vol.1, pp.50–67, and his essay in the present catalogue.

52 Vis 1965; Wijnman 1968; Strauss/Van der Meulen, pp.267, 270, 274, 276. Schwartz 1984, pp.240–8, regards Rembrandt as the evil genius in the conflict, although he does not exonerate Geertje. See also S.A.C. Dudok van Heel's essay in the present catalogue.

53 See Ruessink 1989; Schwartz 1984, pp.297–8; and Dudok van Heel's essay in the present catalogue.

54 Haks 1982, pp.105–19, 128–40; Van Boheemen 1989–91, passim; Hokke 1987. In general, unmarried women were not held in very high regard, certainly not when they grew old; see De Wildt 1995.

55 See, for example, Haks 1982, p.118; Haarlem 1986, pp.165–6; and Kooijmans 2000.

56 Noordam 1987; Broos/Stoffers 1991, p.49; Dekker 1995, pp.200–1; De Jongh 2000A, pp.79–90.

57 Knappert 1909, pp.31–2.

58 On midwives see Van Beverwijck 1637, II, pp.54–68; M.J. van Lieburg in Schrader 1984, pp.1–46; and G.J. Kloosterman in ibid., pp.47–79. See also Schama 1987, pp.524–35; Van der Waals 1987, pp.14–15, 21–2; and Damstra-Wijmenga 1995, p.135.

59 See Dixon 1995, pp.38–58, on gynaecological theories in the Renaissance and the seventeenth century.

60 Haks 1982, pp.143–50.

61 Van Eeghen 1956.

62 Cornelia died before 8 December 1685 at Batavia (now Jakarta) in the Dutch East Indies. She had married at the age of sixteen or seventeen; see Schwartz 1984, pp.298, 300; and De Baar 1992, p.4.

63 See Kloek et al. 1991A.

64 Kloek et al. 1991A; and Broos/Stoffers 1991.

65 Benesch 1973, 707 recto, 708, 707A and 1073, although the attribution of the last two drawings does appear open to criticism. See also Giltaij 1988, p.53. The painter and collector Jan van de Cappelle owned '135 tekeningen sijnde het vrouwenleven met kinderen van Rembrandt' (135 drawings of the life of women with children by Rembrandt); see Giltaij 1988, p.52.

66 Cats 1661, p.167: 'Een die haer kinders baert, is moeder voor een deel;/Maer die haer kinders sooght, is moeder in 't geheel'; Van Beverwijck 1637, II, pp.75–84.

67 Cats 1661, pp.167–70: '… dickmael ongesint gestoorde borsten geeft'; Van Beverwijck 1637, II, pp.75: 'Dat elcke Moeder haer eyghen Kinderen, soo het moghelijck is, behoort te suygen: ofte anders, wat Minne sy sal verkiesen' (That every mother should suckle her own children if possible, and if not which nurse she shall choose). The nurse had to meet all sorts of requirements. See also Kloek et al. 1991A, p.24; and Roberts 1998, p.84.

68 De Jongh 2000A, p.79.

69 Badinter 1980.

70 Dekker 1995, pp.200–22; Kooijmans 1997, pp.79–80, 103, 153–4, 220; and Roberts 1998, pp.148–53.

71 As Gerard ter Borch the Elder did in the case of a small daughter who had died; see McNeil Kettering 1983, II, p.700; Alpers 1988, p.30.

72 Schatborn 1985, pp.26 and 32.

73 Giltaij 1988, pp.53 and 55.

74 On Flora see Held 1961. Flora had long been associated with several faculties: she could represent prostitution (Flora meretrix), but equally springtime or fertility; see Pauly 1979, cols.579–80.

75 For years there has been a difference of opinion about the answers to these two questions. Some

of the figures are seen as shepherdesses (the view taken by McNeil Kettering 1983, pp.58–62). In general it is worth taking to heart what Peter Schatborn wrote about a drawing of Saskia: 'It was customary for artists to use members of their household as models, and Saskia is no exception'; see Schatborn 1985, p.32. Ger Luijten reads a Vanitas meaning into the portrait of Saskia with flowers in Kassel (1634, completed in 1642); see Amsterdam/London 2000–1, pp.165–6. Interestingly, Saskia was being adorned with flowers as early as the betrothal portrait of 1633. They decorate the brim of her hat, and she is holding one in her hand; see Berlin/Amsterdam/London 1991–2, vol.2, pp.29–31.

76 Benesch 1973, 448; Pieter van Thiel in Berlin/Amsterdam/London 1991–2, vol.1, pp.188–91.

77 See London 1988–9, pp.58–65.

78 An interesting connection between flowers and pregnancy was made in a gynaecological study of 1724 by the Flemish surgeon and anatomist Jan Palfijn (1650–1730). Speaking of menstrual blood he says: 'Men noemtse ook der Vrouwen bloemen, om dat na 't voorbeeld der Bomen, welke dat gene Vrugten dragen, indien dat 'er geen bloemen voorafgaan, de Vrouw in 't gemeen niet zwanger werd, voor datse hare Bloemen heeft gehad' (It is also called ladies' flowers, for analogous to trees which bear no fruit unless they have flowers first, a woman does not usually fall pregnant before she has had her flowers.); see Palfijn 1724, p.115.

'Horrible nature, incomparable art': Rembrandt and the depiction of the female nude

ERIC JAN SLUIJTER

This essay was written in the context of the research programme, 'Pictorial Traditions and Meaning in Dutch Art of the Sixteenth and Seventeenth Centuries', funded by the Netherlands Organisation of Scientific Research.

1 Houbraken 1718–21, pp.261–2.

2 Especially since Emmens's pioneering study (Emmens 1968 and Emmens 1979).

3 For a detailed treatment of this painting, see Sluijter 1993A, pp.31–7 and Grohé 1996, pp.165–93. For technical information and dating, see De Vries/Tóth-Ubbens/Froentjes 1978, pp.63–71 and Corpus, vol.1, pp.309–14.

4 For the four prints after Goltzius, the prints by Jacques de Gheyn II after Karel van Mander and by Willem van Swanenburgh after Jan Saenredam, see Sluijter 2000, pp.48–61.

5 Van Mander 1604, Leven, fol.176 verso (Titian) and fol.74 verso (Nicias); the Andromeda by Giulio Fontana (B. 56) of 1562 is freely engraved after Titian. Regarding the above-mentioned Andromeda by Rubens, see Muller 1981–2.

6 See note 4 above.

7 Sluijter 1993, p.36.

8 Rembrandt hereby eliminated any possibility of interpreting the Andromeda allegorically, for this would necessitate the presence of Perseus. (Various art historians have nevertheless offered allegorical interpretations.) For diverse readings of the story and the representation, see Sluijter 2000, pp.52–9.

9 The only non-idealised Andromeda that Rembrandt knew – from the evidence of a number of his motifs – was the book illustration by Pieter van der Borcht (P. Ovidii Nasonis Metamorphoses, Antwerp, 1591, p.119). This clumsily drawn figure, however, is of a completely different nature.

10 Even the nudes in the prints of Lucas van Leyden, as well as a few nude figures portrayed by Pieter Lastman (who seldom attempted such

depictions; see fig.43) – all of which were important sources of inspiration for Rembrandt at this time – are statuesque and idealised in comparison, and display entirely different proportions.

11 See London 1992, pp.33–4 and Holm Bevers, Berlin/Amsterdam/London 1991–2, vol.2, pp.182–4.

12 Engravings after Raphael's Loggie, partly by Sisto Badalocchio and partly by Giovanni Lanfranco, were published in 1607 (Historia del Testamento Vecchio). In 1615 there likewise appeared a series of etchings (in reverse) by Orazio Borgiani (Raffaello Loggie del Vaticano). Rembrandt certainly knew one or other of these series (see Tümpel 1969, pp.163–4 and Sluijter 1998, p.59).

13 In the drawing, the quiver hangs in the tree behind her, whereas in the etching it lies beneath her hands.

14 For this subject in Netherlandish art and Rembrandt's painting of Diana with Actaeon and Callisto (Museum Wasserburg Anholt), which will not be discussed in this article, see Sluijter 2000A, pp.26–8, 50–2, 59–61 (Rembrandt), 81–2, 103–12, 117–18 (Rembrandt).

15 Concerning this subject matter see, especially, Sluijter 1998, pp.76–81. Regarding the unfortunate Actaeon, he is portrayed as a lecherous voyeur, not in Ovid's story, but in all the explications and commentaries dating from that time.

16 For Buytewech's experiments with the etching technique, inspired by the Carracci, see Haverkamp Begemann 1959, p.10; for Annibale Carracci's technique in this print, which is a combination of etching and engraving, see De Grazia Bohlin 1979, p.444.

17 For this dating see Melbourne/Canberra 1997–8, pp.390–1, no.99, where the authors remark, on the basis of the watermark (this information supplied by Erik Hinterding), that the etching was probably printed in 1631.

18 See Golahny 1983, pp.673–4. Amy Golahny correctly links this print to Rembrandt's Bathsheba composition of 1643, but it would have been a source of inspiration for the earlier etching as well.

19 For documents from Rembrandt's immediate circle in Amsterdam, which clearly show that these women were considered immoral and were frequently prostitutes, see Dudok van Heel 1981 and Dudok van Heel 1982.

20 She may be seen as a Bathsheba, Esther or Judith, making herself beautiful for a David, Ahasuerus or Holofernes (and the painting has borne all of these names at one time or another), but one may also place her in the tradition of the courtesan with her procuress. See Sluijter 1998, pp.62–5.

21 Hollander 1993, p.160; see also p.108: 'The fashionable silhouette was masterfully reflected in the nude images of the early Rembrandt, whose ladies have the modest breasts, fair shoulders, huge bellies and general massiveness below the waist that was then so much admired in female bodies.'

22 For a detailed treatment of this subject, see Sluijter 1993, pp.37–46. For an overview of data and interpretations, see De Vries/Tóth-Ubbens/Froentjes 1978, Corpus, vol.2, pp.121–31, 198–201 and Van Thiel in Berlin/Amsterdam/London 1991–2, vol.1, pp.196–9. Excellent observations on Rembrandt's nudes are to be found in Schama 1985 and Schama 1999, pp.383–401.

23 See McGrath 1984, p.84: 'La Susanna hà da esser bella per innamorar anco li Vecchij …' (letter dating from 1618).

24 For these prints see Sluijter 1993A, notes 39 and 40.

25 Regarding these nearly invisible figures see Corpus, vol.2, p.189 and Berlin/Amsterdam/London 1991–2, vol.1, p.196.

26 See Sluijter 1993, p.41 and note 45; it concerns the *Venus Doidalsas* (or *Crouching Venus*), via a print made by Albrecht Altdorfer, and not the usual Venus Pudica type as previously thought.

27 Cats 1625 (edition *Alle de Wercken*, Amsterdam, 1712), p.387. See also Sluijter 1998, pp.79–81.

28 Concerning this poem see Porteman 1986 and Sluijter 1993, pp.44–6.

29 This poem is also printed in Porteman 1986, pp.314–15.

30 Dudok van Heel 1981 even describes a divorce case in which a painting of Mary Magdalene was used as evidence of a relationship that the owner supposedly had with the model who had posed for the painting, the prostitute Marie de la Motte. See also note 57 below. For *topoi* of that time concerning the 'erotic' relationship of the painter to his model and the various consequences thereof, see Sluijter 2000, pp.138–44.

31 Strauss/Van der Meulen, p.161. See also Huygens's enthusiastic words about the young Rembrandt: Huygens (ed. Heesakkers 1987), pp.85–6. In connection with *Andromeda* and *Susanna*, see Sluijter 1993, p.36.

32 De Bisschop admittedly makes no mention of Rembrandt's name, but it is clear that he had Rembrandt in mind when passing such harsh judgement on nudes painted from life. For the passage in question see De Bisschop (De Bisschop 1671) and Pels (Pels 1681, also cited in Houbraken 1718–21, vol.1, pp.116–17): Emmens 1979, pp.71–6 and 88–93. See also note 40 below for my interpretation of the criticism voiced by these authors, which does not concur with that of Emmens.

33 Van Mander 1604, *Grondt*, fol.29 recto and Van Mander 1604, *Leven*, fol.70 recto/verso (Pliny, *Nat. Hist.*, xxiv, p.61).

34 Van Mander 1604, *Leven*, fol.191 recto (an English translation of this text, the earliest on Caravaggio, is to be found in Friedländer 1955, p.260).

35 Cf. note 46 below.

36 Van Mander 1604, *Leven*, fol.176 verso (Vasari, *Lives of the Artists*, 1568, London edition 1878–85, vol.3, pp.574–5).

37 Van Mander 1604, *Leven*, fol.174 verso. For a discussion of the relationship between Van Mander's text on Titian and that of Vasari, see Golahny 1984, pp.30–45. Van Mander attributes these innovations completely to Titian instead of to Giorgione, as Vasari does.

38 For Baglione's text (in *Le Vite de' Pittori, Scultori et Architetti*, Rome, 1642), as well as an English translation, see Friedländer 1955, pp.231–6.

39 De Ville 1628, pp.3, 7, 11, 12, 14 (De Ville argues for the painting of architectural pieces, but this makes his criticism of certain practices no less interesting). Jan de Brune the Younger also distinguishes between two kinds of painters; see Emmens 1979, p.166.

40 Von Sandrart 1675 (ed. 1925), pp.202–3. I disagree with Emmens when he says that Von Sandrart – proceeding from a new, classicist understanding that supposedly did not arise until after Rembrandt's death – now projects the classicist criticism of Caravaggio on to Rembrandt as well, and that this does not tell us anything about the notions of Rembrandt's own time. Although Von Sandrart would have embroidered upon his recollections over the years and his information is not always reliable, he does, in my opinion, give viewpoints that must have been under discussion for decades. Unlike Emmens, I am likewise convinced that the criticism voiced by De Bisschop, Pels and Van Hoogstraten did not arise only from theoretical ideas that developed later. As argued here, many aspects reflect discussions that had been going on for a long time.

41 For the 'Dutch classicists' see Rotterdam/ Frankfurt 1999–2000. Strangely enough, the authors of this catalogue speak only in 'Wölfflinian' terms about the differences in style

between these painters and, for example, Rembrandt and his school, without considering in what terms Rembrandt and his contemporaries might have thought about such stylistic distinctions.

42 Van Hoogstraten 1678, pp.36 and 288.

43 See Sluijter 1999, pp.40–2. Amy Golahny pointed out that Vasari's account of Titian's work must have been of great importance for Rembrandt: see Golahny 1984, pp.137–42. See also Grohé 1996, p.241.

44 This concerns a passage from Terence's *Eunuch*, which became widely known because it was cited by Augustine. See Sluijter 1999, pp.14–16 and 19 with further references to the literature (Carlo Ginzburg pointed this out much earlier).

45 The only known written reaction from a contemporary concerning these nudes – Giovanni della Casa's letter to Alessandro Farnese, in which he wrote, among other things, that Titian's *Venus of Urbino* seemed like a chaste nun compared to this *Danaë* – therefore states the case quite plainly (see Sluijter 1999, pp.21–24, with further references to the literature).

46 Goltzius also chose Danaë as the subject of his first life-size nude, in the hope of demonstrating his ability to combine both schools of thought (see Sluijter 1999, pp.25–8).

47 He was probably not familiar with Titian's composition; various prints with representations of Danaë, as well as Goltzius's painting of 1603, would have played a role in the genesis of Rembrandt's composition. See Sluijter 1999, p.42, note 158, with further references to the literature.

48 Rembrandt's *Danaë* originated in two phases between 1636 and the mid-1640s, so that a clear difference in style is discernible. For a technical description and a discussion of the changes Rembrandt made in the painting during the second phase, see *Corpus*, vol.3, pp.209–23.

49 That the sensual experience of seemingly breathing skin is a crucial part of Titian's objectives emerges from various utterances of such versifying supporters as Dolce and Aretino; see Sluijter 1999, pp.23–4. With regard to various aspects of Rembrandt's striving to rival Titian, see Van de Wetering 1997, ch.6, especially pp.162–9. It must also be noted that the painting, owing to the tragic attack with knife and sulphuric on 15 June 1985, is only a shadow of what it once was. See Sokolowa 1998. Schama suggests – in my opinion correctly – that this painting was singled out for attack precisely because of the great sensuality it exudes (Schama 1999, pp.383–8).

50 Moreover, this banished all direct associations with venal love. See Sluijter 1999, pp.15–16 and 28–30.

51 For the story of Cymon and Iphigenia and regarding Van Loo's painting, see Nicole Spaans in Utrecht 1999, pp.211–15. In painting an Iphigenia observed by Cymon instead of a Danaë, Van Loo seems to have taken a stand against Rembrandt. This story from Boccaccio's *Decameron* involves not the arousal of desire through the viewing of a nude but the very opposite: Cymon was a rather backward (but ravishing) youth who, inspired by the sight of perfect beauty – the beautiful Iphigenia – was transformed from a coarse country bumpkin into a cultured man and a judge of beauty. The opinion that the ideal beauty of true art speaks not to the senses but rather to the intellect seems to have been cleverly underscored by this choice of subject matter. Van Loo, for that matter, also painted representations of Danaë; see Sluijter 1999, fig.42, for a version that also reveals knowledge of the composition by Rembrandt.

52 Ibid., pp.76–81.

53 See Sluijter 1998, pp.70–1, with further references. For an overview of the many previous Bathsheba representations, see Kunoth-Leifels 1962.

54 Regarding the relationship of Rembrandt's painting to the pictorial tradition, see Sluijter 1998, pp.49–76.

55 She has nearly always been identified, not surprisingly, as Hendrickje Stoffels. See, among others, the essays by Svetlana Alpers and Margaret Carroll in Adams 1998, whose interpretations are based entirely on this identification. Considering the vision of the nude model prevailing at that time, it seems to me unthinkable that Hendrickje would have been recognisably portrayed here. However, the rather elongated face with high eyebrows curving down, heavy eyelids, the rather long nose, somewhat protruding upper lip and long, narrow jawline all combine to form an ideal type that we frequently encounter in Rembrandt with some variations – from the *Susanna* of 1647 to the *Lucretia* of the 1660s – and has very little in common with the round face, full cheeks and completely different chin and jawline in the paintings which are more correctly referred to as portraying Hendrickje Stoffels (for this type, for instance, London 1988–9, pp.106–8).

56 De Bisschop 1671, dedication to Jan Six (unpaginated), cited in Emmens 1979, p.72.

57 An apt expression of this attitude was prompted by the first experiments in nude photography, where the problem became even more acute: '... those sad nudities which display with a desperate truth all the physical and moral ugliness of the model paid by the session' (Disdéri, 1862, cited in Freedberg 1989, p.113).

58 De Bisschop 1671, dedication to Jan Six (unpaginated), cited in Emmens 1979, p.71.

59 Pels 1681, cited in Houbraken 1718–21, vol.1, pp.116–17.

60 It is revealing that the terms in which Manet's *Olympia* was severely judged by contemporary critics are often very similar. See especially Clark 1984, pp.79–146.

61 L. Viardot, *Les Musées d'Angleterre, de Belgique, de Hollande et de Russie*, Paris, 1860, p.319, cited in Schama 1999, pp.385–6. Viardot also wrote of the *Danaë* that it was 'an indecent subject painted in a still more indecent manner'.

'As stark naked as one could possibly be painted…': the reputation of the nude female model in the age of Rembrandt

VOLKER MANUTH

1 Költzsch 2000, p.6. 'Die Neugier nach all dem, was sich in den Ateliers der Künstler ereignet oder ereignen könnte, ist wohl so alt wie die Geschichte der Kunst selbst.' For the relationship between artists and their models see also Nottingham/Kenwood 1991; Borel 1990; Borzello 1982; Baden-Baden 1969. For a discussion of the complex art theoretical implications in allegorical depictions of the artist and his model in Dutch art of the seventeenth century, see most recently Sluijter 2000, chapter IV.

2 For the early reception of Rembrandt in general, and in nineteenth-century Dutch art history in particular, see Slive 1953, J. Boomgaard and R. Scheller; see also 'In wankel evenwicht: de Rembrandt-waardering in vogelvlucht,' in Berlin/ Amsterdam/London 1991–2, vol.2, pp.106–23, and, especially, Boomgaard 1995, *passim*.

3 This is still reflected in Abraham Bredius's 1935 catalogue of Rembrandt's paintings (*Rembrandt: Schilderijen*, Utrecht, 1935; English edition Vienna, 1937). The section 'II. Portraits 2: Rembrandt's Family' is divided into portraits of (a) Rembrandt's mother (b) Rembrandt's father (c) Rembrandt's sister (d) Saskia (e) Hendrickje Stoffels (f) Titus (g) Rembrandt's brother.

4 For a discussion of Dürer's studies of female nudes see Költzsch 2000, pp.136–43.

5 The quotation is taken from the anonymous biography of Karel van Mander, published in the second edition of his Schilder-Boeck, Amsterdam, 1616–1618, fol.s2 recto: 'hielden en maeckten onder haer dryen een Academie, om nae 't leven te studeeren…'. The English translation is taken from Van Mander/Miedema 1994–9, vol.1, p.26.

6 For a discussion of the nature of the so-called Haarlem Academy see Hirschmann 1918, *passim*; Miedema 1987, pp.15–16, and most recently Van Thiel 1999, pp.59–73.

7 Miedema 1987, p.16: 'academie van die teeckeninge naer het leven'.

8 See Bok 1990, *passim*, and Bruyn in Berlin/ Amsterdam/London 1991–1992, vol.1, p.80.

9 For the term 'collegie van schilders' see also the document concerning the painter Dirck Bleker and his model Maria la Motte discussed below. Willem Goeree recommended that young artists form a 'Kollegie' in order to draw from the nude once or twice a week under the supervision of an experienced master: see Goeree 1670, pp.72–3; see also Schatborn 1981–2, pp.21 and 31.

10 'daer toe genomen sijn gewoonlijck model naer de persoon van een Maria la Mot, de welcke ordinaris int collegie van schilders opentlijck sat ende daer toe gebruyckt wiert': quoted in Dudok van Heel 1981, p.214. For the case of Maria de la Motte see Dudok van Heel 1981; Schatborn 1981–2, pp.21–2; Bruyn in Berlin/ Amsterdam/London 1991–2, vol.1, p.88, note 74, and Van de Pol 1996, fig.14.

11 See, among others, Schatborn 1981–2, pp.20–3; Amsterdam 1984–5, and Bruyn in Berlin/ Amsterdam/London 1991–2, vol.1, pp.80–1.

12 Benesch 21. For a recent discussion of the drawing see Royalton-Kisch in London 1992, pp.33–5, no.5.

13 The most recent discussion of this etching is Royalton-Kisch in Amsterdam/London 2000–1, pp.98–101, no.10.

14 For the identification of the figure as a nymph see Welzel in Berlin/Amsterdam/London 1991–2, vol.2, pp.182–4, no.6, and most recently Royalton-Kisch in Amsterdam/London 2000–1, p.103. For this etching and Rembrandt's *Diana* see also Hollander 1993, pp.159–60.

15 Regarding Rembrandt's etching of a *Seated Female Nude* (cat.12), Schatborn 1993, p.164, argues that 'There is a possibility that Rembrandt has etched her directly from life'. For Mariet Westermann in Boston 2000–1, p.45, it is more likely that 'she is no model in the studio either, for the mound on which she sits and the lightly drawn shrubbery to her right suggest a sylvan setting'.

16 For this rejected identification see Royalton-Kisch in Amsterdam/London 2000–1, p.105, note 4, who responds to the suggestion made by Wurzbach 1876, p.287, that the nude figure was modelled after Saskia.

17 Gerrit van Honthorst's 1625 *Smiling Girl, Holding an Obscene Image* (City Art Museum, St. Louis, Missouri, inv.no.63.1954) shows a young courtesan wearing a costume that would have been associated with prostitution in the seventeenth century. For the dress of prostitutes in the Netherlands during the seventeenth and eighteenth centuries see Van de Pol 1996, pp.307–17. The inscription on the small image of the nude woman in Honthorst's painting reads 'Wie kent mijn naers van afteren' (who recognises my ass from behind); see Judson/ Ekkart 1999, pp.173–4, no.215. Other examples of this type of image are discussed by Slive 1970–4, vol.1, pp.92–4.

18 Constantijn Huygens, *Kerkuraia Mastix. Dat is 't costelijck mall*, Middelburgh, 1622, verses 40–5: 'Een open memmen-hol, trots windt en winter's wonden, Treft eener niet te recht dit onbeschaemde moy, Zyn d'hoenders niet te coop, wat doen sij uyt de koy?'

19 For this see Van de Pol 1996, pp.334–5.

20 Benesch 376. Rotterdam, Museum Boijmans Van Beuningen (inv.no.R81); for this drawing see Giltaij 1988, p.65, no.14.

21 Van Mander 1604, fol.252v: 'daer men seght, dat hy met het naeckt zijner Huysvrouwen hem hadde geholpen.' The English translation is taken from Van Mander/Miedema 1994-9, vol.1, p.269.

22 Kunsthistorisches Museum, Vienna (inv.no.688). For Rubens's portrait of Hélène Fourment see Held 1967 and Vlieghe 1987, pp.91-3.

23 For this case see Bredius 1915-21, vol.2, pp.415-17.

24 Bredius 1915-21, vol.2, pp.415-16: 'voor het eene stuk geseten hadde en hy haar trony ende handen nae 't leven had geschildert, dog dat hy het lichaem uyt de geest daarby had gevoegt'.

25 Gemeentelijke Archiefdienst, Amsterdam (Municipal Archive, Amsterdam), NA (Notarial Archives), (Notary Jacob Matham), 4492, dd. 23 October 1676, pp.557-8: 'tot reparatie van haar goed[e] eer, naem ende faam'; see also Bredius 1915-21, vol.2, pp.415-17.

26 For this painting, Louvre, Paris (inv.no.R.F.1984-8) see Foucart 1987, pp.80-4, with colour illustration.

27 Musée des Beaux-Arts (inv.no.P.252); for this painting see De Gelder 1921, pp.120-1, 159, no.8, and, most recently, De Lavergnée/Scottez-De Wambrechies 1999, p.76, no.253.

28 See Bredius 1915-21, vol.2, p.417.

29 For the terms 'naar het leven' (from life) and 'uit de geest' (from memory) see Schatborn 1993. This author gives the following definition: 'Works *uit de geest* are in a way partially memorised visual impressions, which have been moulded finally by the mind according to certain artistic standards, rules, and ideals, including a kind of selectivity' (p.156); see also Swann 1995.

30 For this see, among others, Sluijter 1993A, where Rembrandt's paintings of *Andromeda* (Mauritshuis, The Hague, *Corpus*, vol.1, pp.309-14, A 31) and *Susanna and the Elders* (Mauritshuis, The Hague, *Corpus*, vol.3, pp.198-201, A 117) are compared with the pictorial conventions in earlier images of the same subjects.

31 For this painting in The Hague see *Corpus*, vol.3, pp.198-201, A 117; Van Thiel in Berlin/Amsterdam/London 1991-2, vol.1, pp.196-9, no.25, and Sluijter 1993, pp.38-46.

32 For a discussion of this group of studies after the young male nude which are today in Vienna, Graphische Sammlung Albertina (Benesch 709), London, British Museum (Benesch 710), Paris, Musée du Louvre (Benesch A55), see Bruyn in Berlin/Amsterdam/London 1991-2, vol.1, pp.80-1, figs.95-7, and Hinterding in Amsterdam/London 2000-1, pp.213-17; for the drawing in the British Museum see Royalton-Kisch in London 1992, pp.180-2, no.82.

33 Bartsch 194. For the most recent discussion of Rembrandt's etching see Hinterding in Amsterdam/London 2000-1, pp.213-17.

34 For Geertje Dircks's relationship with Rembrandt see Dudok van Heel in Berlin/Amsterdam/London 1991-2, vol.1, p.57, and his essay in this catalogue.

35 For a discussion of the painting in Edinburgh see Kelch in Berlin/Amsterdam/London 1991-2, vol.1, pp.230-2, no.36, and cat.100 in the present catalogue.

36 Hessisches Landesmuseum, Darmstadt. For a discussion of this and related drawings see Amsterdam 1984-5, 6/11 and 7; Miedema 1987, pp.17-21; Bruyn in Berlin/Amsterdam/London 1991-2, vol.1, p.81, fig.90, and, most recently, Költzsch 2000, pp.231-3.

37 Van Hoogstraten 1678, p.294. Willem Goeree, in his *Inleydinge tot de Al-ghemeene Teyckenkonst* (Middelburg, 1668, pp.72-3) had recommended that artists draw after nude models twice a week under the supervision of an experienced master: see Schatborn 1981-2, p.21.

38 For the document see Bredius 1915-21, vol.4, p.1255: 'voor haar getuygen als andere collegialiter moeder naeckt als model geseten heeft, en dat sy getuygen daernaer geteeckend en geschildert hebben'. See also Schatborn 1981-2, p.88, Blankert 1982, pp.54, 73-4, Bruyn in Berlin/Amsterdam/London 1991-2, vol.1, p.89, note 74, and Van Berge-Gerbaud in Paris/Haarlem 1997-8, p.72, note 3.

39 For the many different aspects of the history, reception and interpretation of Rembrandt's painting in Paris, see the contributions to the volume edited by A. Adams 1998. For a discussion of the identification of the model as Hendrickje Stoffels, see especially S. Alpers, 'I. The painter and the model', ibid., pp.148-59, and M.D. Carroll, 'Uriah's Gaze', ibid., pp.160-75.

40 Benesch 1121. Schatborn was the first scholar to propose an attribution of the drawing in Rotterdam to Rembrandt's pupil Arent de Gelder (1645-1727) who studied with Rembrandt during the first half of the 1660s. See Schatborn 1985, p.148, fig.67a; *idem* 1987, pp.307-8, 310 with fig.5; *idem* in Berlin/Amsterdam/London, vol.2, pp.152-3, no.49; and, most recently, in Dordrecht/Cologne 1999, p.258, no.64. This attribution has been questioned by Giltaij 1988, pp.316-17, no.185.

41 For the charges against Hendrijckje Stoffels see Strauss/Van der Meulen, 1654/11, 1654/12, 1654/14, 1654/15; see also Dudok van Heel in Berlin/Amsterdam/London 1991-2, vol.1, pp.57-60 (with older literature), and the same author in his essay in this catalogue.

42 The most comprehensive study of prostitution in the Northern Netherlands during the seventeenth and eighteenth centuries is Van de Pol 1996. See also Van de Pol 1988. Böse 1985, *passim*, discusses prostitution as a topic in seventeenth-century Dutch literature. For the prosecution of prostitution see Van de Pol 1996, pp.203-25, and Roodenburg 1990, pp.230-320.

43 For Torrentius see Bredius 1909, and, recently, Brown 1997.

44 For a list of the paintings by Torrentius which were confiscated in September 1627 see Bredius 1909, p.8.

45 Schrevelius 1648, p.445, here quoted from Sluijter 2000, p.320, note 211: 'Johannes Torrentius is ook onder de Schilders de minste niet geweest, maar infaem: hy was een twede Apelles, als hy naakt Vrouwen mogt schilderen die haar ten toon stelden als Hoeren.'

46 Sandrart/Peltzer 1925, p.176: 'wol etliche nackende Weibsbilder, sehr ungeschickt und liderlich, anfolglich unwürdig zu loben'.

47 For this quotation see Bredius 1909, p.37.

48 Quoted from Bredius 1909, p.37: 'aldaer gegaen om te vernemen, off daer vroupersoonen waeren, schoon van leeden en lichaem om sulcx, alsoo bevindende, deselve daertoe te vercrijgen dat se eenige van haer naecte leden souden willen verthoonen om nageteyckent te worden omme deselve daernaer in schilderijen naer gelegentheyt te passe te brengen'; see also Van de Pol 1988, p.122-3.

49 Gemeentelijke Archiefdienst, Amsterdam (Amsterdam Municipal Archives), Rechterlijke Archieven (Juridical Archives) no.5061, inv.no.305 (confession books), dd. 15 April 1642, fol.30: 'in een herberg te zijn geweest bij de Lutherse kerk aldaer hij in gezelschap met een meisje [Sara Joris] was,' and 'van eene lichtvaerdicheijt gesproocken ende oock haer oneerlijck aengetast te hebben, dan [doch] met haer niet gesprocken van haer te schilderen.' For the Amsterdam confession books as an archival source for prostitution see Van de Pol 1996, pp.41-3. I am grateful to Jaap van der Veen who kindly drew my attention to this document.

50 Dudok van Heel 1981, p.217: 'wederom in een hoerhuys gevonden.'

51 For a profile of the prostitutes arrested in the Northern Netherlands in the seventeenth and eighteenth centuries see Van de Pol 1996, pp.102-6, especially p.104.

52 Quoted from Dudok van Heel 1981, p.214: 'in zeker infaem hoerhuys is gegaen, daer hospitaas van waaren Maria de la Motte ende…'.

53 Quoted from Miedema 1989, p.111, note 81: 'die geseyt wert haer inden Haghe te hebben laten moedernaeckt laten uijtschilderen van seven Schilders te gelijck.' Miedema refers to Ivan Gaskell as having provided the information concerning this document.

54 For Backer's drawing (black and white chalk on blue paper, 28.5 × 22.6 cm) see Sumowski 1979-92, vol.1, no.54x; for Flinck's drawing (black and white chalk on blue paper, 36.3 × 24.9 cm) see Sumowski 1979-92, vol.4, no.899. See also Schatborn 1981-2, p.90, figs.4 and 5.

55 For this statement see Dudok van Heel 1982, pp.73-5.

56 The quotation is taken from Dudok van Heel 1982, p.74: 'uytgheschildert so moedernaeckt als iemant uytgheschildert soude konnen werden, so legghende op het alderoneerlijkste op een kussen te slapen.'

57 For Flinck's drawing (black chalk, heightened with white and beige chalk, on blue paper, 24.9 × 41.2 cm) see Sumowski 1979-92, vol.4, no.939, and Van Berge-Gerbaud in Paris/Haarlem 1997-8, pp.148-9, no.66.

58 Dudok van Heel 1982, p.75.

59 Records of the notary Frans Boogert, no.1999, dd. 16 February 1652: 'sy haer naect hadde laten uijtschilderen ende dat sy gelts genoeg darmede wist te winnen', quoted from Montias 1982, p.176. Montias (ibid., p.176, note hh) also refers to another document from Delft, according to which in 1670 a woman was accused of being a whore who 'had let her mother be painted naked outside The Hague.'

60 For Farrington's comment see Van Strien 1989, p.96.

61 For the different types of prostitute in the Northern Netherlands in the seventeenth and eighteenth centuries see Van de Pol 1996, pp.114-24.

Fashion or fancy? Some interpretations of the dress of Rembrandt's women re-evaluated

MARIEKE DE WINKEL

This essay is based on ideas first developed in three chapters of my University of Amsterdam M.A. thesis, *Het kostuum bij Rembrandt*, of 1993 (De Winkel): 'The dress of Maria Bockenolle'; 'The dress of Oopjen Coppit'; and 'The dress of Mennonites'. It also draws on the chapter called '*Vol van veranderingen* […] *in den toestel der kleedingen*', Costume in Rembrandt's history paintings', in my forthcoming dissertation.

1 De Jongh 1993.

2 See WNT, under 'Hoed': 'Waar hoeden zijn, betalen geene mutsen' (where there are hats, coifs do not count). This is comparable to the explanation of the French lexicographer Furetière 1690, under 'Chapeau': '1. Habillement, ou couverture de teste dont se servent les hommes par toute l'Europe Occidentale. 2. Signifie quelquefois un homme. Il y avoit plusieurs femmes à cette assemblée, mais il n'y avoit pas un chapeau' (Hat: 1. Signifies item of dress or head-covering worn by men throughout Western Europe. 2. Occasionally also denotes a man. There were numerous women at that gathering, but there was not a single 'hat').

3 The German chaplain Johann Ellinger, for instance, fulminates: 'Vorzeiten war der Hut ein zeichen der Freiheit, heutiges tages wollen die Weiber mit dem Hut auffsteken, zugleich auch den Männer ihre Herrschafft und Freyheit nehmen' (the hat used to be a sign of freedom; nowadays women by donning the hat thereby rob men of their authority and freedom): Ellinger 1629, p.22.

4 Der Kinderen-Besier 1950, p.115. A similar case is the portrait of Anna Boudaen Courten of 1619 by Salomon Mesdach (?-1628) in the Rijksmuseum, Amsterdam. Like Maria, Anna is portrayed wearing a hat in an indoor setting and she was always assumed to be wearing Dutch dress: Der Kinderen-Besier 1950, pp.56, 62 and Van Thienen 1930, fig.22. However, at the time Anna was portrayed she was living in London where she died only two years later.

5 The supposition that Maria might be wearing English dress was first posited in the *Corpus*, vol.2, A 99. Compare for instance the portraits of an unknown English couple painted by an anonymous painter in 1628 in the Victoria and Albert Museum in London and John de Critz's, *Portrait of Hester Tradescant and her stepson* of 1645 in the Ashmolean Museum in Oxford (illustrated in Cumming 1984, pp.47 and 79). English women with hats also feature prominently in the famous costume book of Cesare Vecellio of 1590 and in the costume plates of Wenceslaus Hollar of 1649 (illustrated in Cumming 1984, pp.81 and 82).

6 John Chamberlain relates that James I in 1620 called on the Bishop of London to tell his clergy 'to inveigh vehemently and bitterly in theyre sermons against the insolencie of our women, and theyre wearing of brode brimd hats, [and] pointed doublets'. See Ribeiro 1986, p.72. By the end of the century it was established as a characteristic style for old women, and the members of sects such as the Quakers. It is still worn in Wales as Welsh national dress and as the typical witch's outfit.

7 See *Corpus*, vol.2, A 98.

8 This conclusion is made on the basis of the more than 300 wardrobe inventories from 1600 to 1700 gathered from the Amsterdam Municipal Archive.

9 Van Heemskerck 1647, pp.48-9. This passage does not occur in the earlier edition of the book of 1637. The dress of the women is normal fashionable dress as would have been worn by young ladies (*juffrouwen*) of the highest classes in The Hague. In a painting by Adam Willarts of 1633, some fashionably dressed young women are taking a stroll along a riverbank wearing black hats with white feathers: Adam Willarts, *The Meuse river by Den Briel*, 1633, Museum Boijmans Van Beuningen, Rotterdam.

10 Adriaen van de Venne, *Equestrian portrait of the King and Queen of Bohemia*, 1626, Rijksmuseum, Amsterdam. See also Royalton-Kisch 1988, pp.15, 167.

11 Published in Royalton-Kisch 1988, p.348.

12 Sewel 1691, under 'Night-Rail': 'een Nachthalsdoek'. Randle Holme in 1688 defines the item as follows: 'A Night Rail is a Ladies Undress, being made after the fashion of the Whisk [falling collar], but with a larger compass, reaching from the Neck, round about the person down to the middle or wast; it is made of Plain or Laced, or Wrought with Needle Work, according to the Wearers Nobility': Holme 1688, p.15. In genre painting this accessory is often encountered - for instance in the work of Jan Miense Molenaer, Gabriel Metsu or Johannes Vermeer. See De Winkel 1998, p.329 and illustrations on p.330.

13 See also his *c.*1631 drawing of *A Woman Standing with a Candle*, cat.8 (Benesch 263A).

14 See for instance *A Woman Seated at a Table* of *c.*1640, cat.91 (Benesch 280e).

15 For the frontlet, see also Rembrandt's drawings of *c*.1635, cat.43, 48 and 50. Hexham 1647, under 'the Frontlet': *'Het bandeken daer men het hoofd mede bindt'*. Cotgrave 1610, under 'Frontal': *'A frontlet; or a forehead-band'*. Plain frontlets (or crosscloths) were bound round the forehead and worn in illness or confinement. They were thought to prevent wrinkles and were therefore sometimes smeared with cream. This particular use is described in a poem by Petrus Hondius: 'En om't voorhooft van de ployen/Te bewaren/in het toyen. Eermen't hooft gaet neder leggen/Langtmen uyt het nacht packet/ Smalle schrookens/diese seggen/Nu te zijn alom de Wet/En't gebruyck om in den slaep/Dienst te doen/van trouwe knaep/Om het voorhooft tot den haren/Van de fronsen te bewaren.' (And to guard her brow from wrinkles, while dressing, before the head is laid to rest, she desires from her dressing table, narrow bands, which are as they say in use everywhere, to use while sleeping as a loyal servant to prevent the forehead from wrinkling.) Hondius 1621, p.13. Rubens also painted Hélène Fourment, in his painting known as *'Het Pelsken'* of 1638 (see fig.27, p.31), in a fur-lined nightgown and with a frontlet.

16 Louttit 1973, especially p.318. For these images see also McNeil Kettering 1983.

17 Straw hats are often encountered in seven-teenth-century inventories of women of all classes: in Dordrecht in 1649 the Mennonite Heyltgen Lucas owned '1 stroo hoet' (one straw hat), as does Magteltje Weda in 1697. The burgomaster's wife, Catharina den Hulck, in 1688 bequethes to her sister '1 thuijnhoet becleet' (one lined garden hat); GAD (Municipal Archives, Dordrecht) (dd.13 December 1649) ONA 592, notary A. van Nievelt, fol.7–18v., dd.2 January 1697; GAD 262, not. A. Meynaert, fols.1–44v., dd.13 December 1688. In Amsterdam the 16-year-old daughter of a goldsmith Margriet Wolff owned 'twee stroo hoeden *f* 1:-:-' (two straw hats, 1 guilder), while Trijntje Claes in 1635 owned '1 stroo hoett' (one straw hat). GAA. notary Laurens Lamberti, NA. 568, dd.16–19 August 1632, pp.616–28, p.625; GAA. 5073,969, dd.23 November 1635, fols.1v.-16v., fol.14. The wealthy Leiden professor's wife Catharina Thijs in 1649 owned '1 strooijen hoet met witte pluymen' (one straw hat with white plumes). Leiden University Library, Bibliotheca Thysiana, no.164, fol.p.87.

18 See for instance the many genre depictions of milk-maids delivering their wares to the city by Nicolaes Maes (Sumowski 1983-95, vol.3, nos.1361-2; 1376; 1378-80). In 1667 Samuel Pepys sees an an actress 'dressed like a country-maid with a straw hat on': 24 January 1667, Pepys/Latham 1970-94, vol.8, p.28.

19 For instance, when Rubens depicts women in wide brimmed hats, as in his self-portrait with Isabella Brandt or Hélène Fourment or her sister Susanna, it is always in an out of doors setting. See Vlieghe 1987, *passim*.

20 'Och/waer blijft dit paert? Dit loopt immer te laeng aen. Gaet ghy rasch/en haelt my die twee boesjetten/Met mijn stroo'n hoet/om op het hooft te setten'. (Oh, where is that paert? This is taking too long a time. Hurry, fetch me two travel bags and that straw hat of mine.) Coster 1613, act 5.

21 Sunday 11 August 1667: Pepys/Latham 1970-94, vol.8, p.382.

22 In the document in which the marriage is registered Saskia is said to be from 'St. Annakerke'. In this village the marriage was solemnised in 1634: Strauss/Van der Meulen, 1634/5. That Rembrandt drew Saskia's portrait outside is also argued (on other grounds) in Van de Wetering 1997, pp.70-2.

23 Van Luttervelt 1956, p.93.

24 *Corpus*, vol.2, p.557.

25 Berlin/Amsterdam/London, 1991-2, vol.1, p.175.

26 Voskuil 1975. Johan Huydecoper in 1621 provided his bride with four diamond rings in addition to a wedding ring, which in comparison was far less valuable. 'Een diamant tafel rinc *f* 1360:-:-; 1 roos rinc met 7 diamanten 428:-:-; Een rinc met 22 diamanten 280:14:-; Een trou rinc 12:-:-; Een tafelrinc 330:-:-' (1 table-cut diamond ring, 1360 guilders; 1 rose ring with 7 diamonds, 428 guilders; a ring with 22 diamonds, 280 guilders; a wedding ring, 12 guilders; a table-cut [diamond] ring, 330 guilders). Rijksarchief Utrecht, Huydecoper Archive, R 67, no.30.

27 See for instance Rembrandt's drawing of *A Woman Seated in an Armchair, c.*1633-5, cat.24 (Benesch 428).

28 Cats 1625, *Bruyt*, fol.9: 'Maer waerom desen ring niet daer het dient gehsteken, En van een goet ghebruyck moet-willens afgheweken? Het was, gelijck het blijckt, de vinger naest de pinck, Aen wien het trou-juweel in ouden tijden hinck; Die heeft een hooger macht, op wel-gegronde reden.' Fol. 9v.: 'Te draegn dit kleynoot, een pant van ons ghemoet, Dat nu daer enckel pracht de voorste vinger doet, Wel, sooje niet is nieuw, off niet te los en zijt, Soo draeght het trou-gemerck ghelijck in ouden tijt.

29 Cats 1625, *Bruyt*, fol.17v.: 'Het weerde trou-verbont, dat niet en is te breken, Wort metten diamant te rechte vergeleken, De rijcke diamant, een prince vande ringen, Het puyck, en hooft-juweel van alle schoone dinghen, Wert inden ouden tijt, en heden by ghebracht, Tot leere van gedult, en rechte manne-kracht, Ghy prince van het huys moet daer steen steen ghelijcken'.

30 'Twee braseletten van parell; een toer parrels van vier om de hals; twee parrelen met diamanties en hangerties aen 't ijser; 1 silver vergulde steel van een wayer'. GAA, notary B. Coornhart, NA 2864, fols.260v.-273, dd.3 November 1659, Inventory of Marten Pietersz Day and Oopjen Coppit, fols.265, 271.

31 '3 ringen; een hoep met diamanten'. Ibid., fols.270, 271.

32 24 March 1624: 'Songetgen, … Nogh wou ick wel wat meer hebben. Ick wou wel, dat mevrou Killegrew mijn wou seijnde een clijn gouwe rincksken, om voor aen den pinck te dragen, of aen een cordeken om den hals, met haer naem daerin, dat ick mocht altoos continueel draeghen, gelijck dat van de song. Want al dat ick van haer heb, dat leg ick snachts af'. 'Songetgen' (Sunny) was the pet-name Dorothea and Constantijn gave each other. Worp 1911, vol.1, p.154. See also Bille 1958.

33 The English traveller Owen Feltham found that a Dutch woman's hands 'shews her for a Labourer; which you shall ever find as it were in recompence loaden with rings to the cracking of her fingers'. Feltham 1652, pp.52-3.

34 Peter Paul Rubens, *Deborah Kip, Wife of Balthasar Gerbier, and her Children*, 1629/30, National Gallery of Art, Washington.

35 'De hals … waer datse (onghetwijffelt om het wit te meer te doen af-steecken) een aerdigh swert zyde snoertje om had, daer een kleyn goud ringetjen aen hingh, in-gheset met Diamantjes; daelende even tot daer het kleet aenden boesem uyt-ghesneden zijnde.' Van Heemskerck 1637, pp.292-3.

36 In comparison with English portraits of the time it appears that in England the ring was worn in this manner from the end of the sixteenth century onwards. In England black strings were also worn around the wrists and sometimes attached to one of the rings on the finger. See Scarisbrick 1993, p.89 and Scarisbrick 1995, pp.93-5.

37 Groeneweg 1991, p.90. The wife of the Hague schoolmaster David Beck died in childbed on 10 December 1623. On 18 February he, for the first time, wore his new French mourning suit made of black cloth. He is still wearing it on 8 December 1624. Probably the mourning worn for spouses was for one year. Beck 1993.

38 An important indication for this is the note Constantijn Huygens the Younger made in his diary. On 25 March 1696 he remarks: 'the mourning affecting the linen ended today and we began to wear lace again'. It concerned the mourning over Mary II who died on 7 January of the previous year. The mourning period officially started on 16 January 1695, so throughout the entire period of mourning no lace was worn. Huygens 1876, vol.1, pp.445, 580. See also Groeneweg 1991, p.90. In 1644 Stadholder Willem Frederik of Frisia in his diary notes that Princess Louise Henriette of Orange removes all her ribbon bows when she goes into mourning. Visser and Van der Plaat 1995, p.44.

39 Taylor 1983, pp.92-105. Samuel Pepys on 21 April 1666 wrote: '... I was sorry to see my Lady Castlemaine, for the mourning forcing all the ladies to go in black, with their hair plain and without spots. I find her to be a much more ordinary woman than ever I durst have thought she was.' Pepys/Latham 1970-94, vol.7, p.106.

40 The white bridal gown with a train and a veil originated at the beginning of the nineteenth century and was originally the attire in which débutantes were presented at Court. Mansfield 1980, pp.114-15; Cunnington and Lucas 1972, pp.62-79. Only Jewish brides wore veils in the seventeenth century during the marriage ceremony. This tradition referred to the veil with which Rebecca, the ideal bride from the Bible, covered herself before marrying Isaac (Genesis 24:65).

41 Groeneweg 1991, p.81.

42 Compare the depictions of brides in, for instance, Cats's *Houwelyck* from 1625 and the illustration in Zacharias Heyns's costume book, *Dracht-tooneel*, of 1601. The bride in this series wears 'op 't hooft een schoon vercierde kroone, Want soo wort sy recht na de kerck geleyt' (a beautifully ornamented crown on her head, and so she is led to church). Heyns 1601, no.15. For women of the lower classes these crowns were made from more ephemeral materials like paper or real flowers. Noblewomen, however, had crowns made of pearls and gems. See Anonymus 1638, p.1. Constantijn Huygens in 1660 paid a substantial 91 guilders for the 'bruyts-croon' of his daughter Susanna. Schinkel 1851, p.29.

43 'Een juweel koffertjen daerin: … een bruyts kroontje' (A jewellery casket, in it: … a bridal crown). GAA, notary B. Coornhart, NA 2864, fols.260v.-273, dd.3 November 1659, Inventory of Marten Pietersz Day and Oopjen Coppit, fol.263.

44 Museum Willet-Holthuysen in Amsterdam. It was worn by a certain Brigitta Stuyling in 1667.

45 For the use of black veils as a fashionable accessory in the genre paintings of Gerard Terborch, see Bringemeier 1974.

46 The text in Latin: 'Lenes astivi ZEPHYRI dum carpimus auras, Velamen nigrum lumina nostra tegit'. Here a black veil is explicitly mentioned.

47 'En haer claerheyt te verteeren, Daerse niet wel teghen mach; Wint en Sonne soud'haer deeren/ Gaet gesleuyert al den dach'. Hondius 1621, p.12.

48 'E[e]n swarte lapp voor 't hoofd, voor 'steke vande vliege', Huygens 1653, p.70.

49 See Royalton-Kisch 1988, pp.185, 209, 271 and McNeil Kettering 1988, vol.2, p.403, 406, 518, 523, 559, 688, 736, 738. For other portraits of women and little girls wearing veils see also Haarlem 1986, illustrations on pp.39, 55, 282.

50 The inventory of the Hague noblewoman Maria van Voorst van Doorwerth from 1610 lists: 'Een swart gebeelt gasen flours met een gitten cant, Een zijde lampers flours met gitte kanten' (a black figured gauze veil edged with garnets and a silk transparent veil edged with garnets). Van der Klooster 1980. Also in Amsterdam black veils are listed, such as 'een swarte sijde sluyer' (a black silk veil) in the inventory of Hester Ergas in 1653 (GAA, notary A. Lock, NA 2261, fols.477-83, dd.16 May 1653); and 'een swart sijde sluyer' (a black silk veil) in the trousseau of Johanna Homma (GAA, notary Jacob de Winter, NA 2410, cat.21, fols.20-39, dd.8 November 1674).

51 See Groeneweg 1995, pp.206-8.

52 De Winkel 1995.

53 See Berlin/Amsterdam/London 1991-2, vol.1, p.225.

54 '1 lakense rock, 1 lakense vlieger, 2 borsies, 1 doos met 2 kragen daar in, 1 kraegh, 28 sack neusdoecken, 1 gesteecke muts, 1 bouratte vliger met sijn lyf en borsje, Noch 1 bouratte vlieger met een borsje, 5 gesteecke mutsen; 4 boven mutsen, 2 silvere oor ijsers'. GAA, notary Jacob van Loosdrecht, NA 1995, pp.766-97, dd.25-31 December 1658.

55 This conclusion is based on the examination of some 56 probate inventories of Mennonites from the period 1600 to 1700 at the Amsterdam and Dordrecht archives.

56 Dickey 1995.

57 See Braun-Ronsdorf 1967, pp.20-2 and Haarlem 1986, p.112 referring to Erasmus's *De civilitate morum puerilium*. The handkerchief functioned in the same way as the decorated gold toothpicks displayed on belts in portraits of men: see for example Haarlem 1986, p.117.

58 Documented in the portraits of, for instance, Alonso Coello or Juan Pantoja de la Cruz. See illustrations in Braun-Ronsdorf 1967, figs.23, 24, 34-38, 41, 42. See also Hearn 1995, nos.17, 124, 136, 141.

59 Vecellio 1590: for instance his *Nobile Ornata Gentildonne a Feste Pubbliche* (Venetian gentlewoman at a public festival); and Boissard 1581 plates 6, 17, 18, 20, 21, 24, 25b.

60 See the portrait by the Enkhuizen painter Jan Claesz of Reynu Semeyns of 1595 and his portraits of a six-year-old girl and of an eight-year-old girl, both of 1594. See Ekkart 1990, pp.46-7, 70-2.

61 See Royalton-Kisch 1988.

62 According to the text he is more interested in girls dressed according to the court fashion (i.e. French). Cats 1632, p.94.

63 In Spain the little princesses also wear large handkerchiefs with their (equally archaic) Spanish court dress in their portraits by Diego Velázquez (1599-1660) of the 1650s in the Prado in Madrid and the Kunsthistorisches Museum, Vienna.

64 Dickey 1995, p.354.

65 The woman is leaning on a windowsill from the outside. In addition, her vivid red jacket indicates she is not in mourning dress.

66 'Want of ick schoon al even staag, een sluijer of een maske draag, en dat ick selden buyten koom, Mijn jeugdig wesen evenwel, verandert in gerimpelt vel'. Cats 1660, p.472.

67 Smith 1982, pp.56, 79-80, 85. Rembrandt, *Portrait of Agatha Bas*, 1641, Royal Collection, Buckingham Palace, London.

68 Smith 1982, p.75.

69 Cumming 1982, p.21, Linthicum 1936, p.267. For instance, in 1627 Carel Martens provided 114 pairs of gloves for the professors coming to his promotion at Leiden University. In his account book he listed: 'Ontfangen van monfrère Guiliuem van der Helst den 2 July 1627 in Amsterdam tot betalinghe van 9½ dosijn handschoenen de somme van *f* 60:-:-' (received from Guiliaem van der Helst, 2 July 1627 in Amsterdam, for paying 9½ dosen of gloves the sum of 60 guilders). Martens 1970, p.164.

70 Du Mortier 1984, p.189. Wedding fans also existed, but there were special fans for church or funerals.

71 Haarlem 1986, p.131. Smith 1988, pp.45-6. For instance, in Rembrandt's *Portrait of Jan Six* of 1654, Collection Six, Amsterdam.

72 The inventory of the Amsterdam bachelor Matthias van Gherwen, for instance, lists: 'negen paer oude handtschoenen ƒ 1:10:-; acht paer nieuwe handtschoenen ƒ 2:10:-; een paer geborduurde handtschoenen met een paer witte gebraijde handtschoenen met eenige blaeuwe sijde franje ƒ 2:-:-' (nine pairs of old gloves 1:10:-; eight pairs of new gloves 2:10:-; a pair of embroidered gloves and a pair of white knitted gloves with some blue fringe 2) GAA, notary Jacob de Winter, NA 2408, cat.6, January 1653, fols.2-30.

73 'Hoogh geboorne … Vorst en heer, Ick hebbe goet gevonden, de hantschoenen (sijnde in 't principael inde linckerhandt van sijn hooght d'Orange) uit copy niet te maecken, omdat myns ordeels geen doorluchtig prins en voeght, soodanigh borgerluchtige actie'. Royal House Archive, The Hague, Archive Willem Frederik A 25 VII C-214. Letter of Pieter Nason to Willem Frederik, dd.23 December 1662. I am indebted to Alexandra Bauer for this interesting reference.

74 Strauss/Van der Meulen, 1656/12.

75 'Een pertije antiekse lappen van diverse coleuren'. Strauss/Van der Meulen, 1656/12.

76 See Scheller 1969 and Van Gelder/Van der Veen 1999, pp.71 and 75.

77 The jewellery has been systematically analysed, together with the silver by the jewellery expert, Karel Citroen, in 1992-3. The conclusion of this investigation was that most of the gold chains and jewels in Rembrandt's work are purely fantastical and have little resemblance to surviving pieces of jewellery. The same is true for the musical instruments in Rembrandt's work: see Van Gelder/Van der Veen 1999, pp.52-3.

78 *Uitbeeldinge der Figueren: waer in te sien is hoe d'Heydene hun Goden uytghebeeldt en onderscheyden hebben, Alles seer nut den vernuftighen Schilders en oock Dichters hun Personnagien in vertooninghen oft anders toe te maken*, Alkmaar, 1604: added to his 'Explanation of the Methamorphosis', part of Van Mander 1604.

79 Van Mander 1604, fol.26v.: 'Juno … houdende in d'een handt eenen Coningh-staf…, hebbende op 't hooft schijnende strale. Den scepter soude sy hebben, om datse Godinne des Rijckdoms is. Den Pauw was haer Vogel … Juno was seer prachtigh in haer dracht: sy hadde een seer schoon bloeyende root purpur cleet, en eenen blaeuwe mantel, over al vol Peerlen, Gesteenten en Juweelen'.

80 It was traditional to depict Juno with a crown. In the second state of his *Medea* etching (White/ Boon B 112), Rembrandt added a crown to the statue of Juno, seen from the back. Later Van Hoogstraeten, in directions very similar to Van Mander, also gives her a crown. Van Hoogstraten 1678, First book, p.100: 'Juno Koninginne der Goden, zult gy met kroon en scepter vereeren, haer kleet moet van schoon root purper zijn, en haer Azuren mantel zult gy met Paerlen en gesteenten borduren. Haer gelaet moet trots en belgzuchtig gestelt zijn, en twee Pauewen zullen haren wagen trekken' (Juno, queen of the gods, you should present with a crown and a sceptre, her gown should be of fair red-purple, and her blue cloak should be embroidered with pearls and gems. Her face should be proud and belligerent, and two peacocks should draw her chariot).

81 Examples are, for instance, Iphigenia in his *Orestes and Pylades Disputing at the Altar* of 1614, Rijksmuseum, Amsterdam; and Nausicaä in *Odysseus and Nausicaä*, in the Herzog Anton Ulrich-Museum, Braunschweig.

82 See Newton 1975, *passim*, and Hollander 1975, p.159.

83 Louttit 1973; Dudok van Heel 1980; Schwartz 1984, p.127; Gordenker 1995, pp.26-8. Most authors supposed that Rembrandt dressed Saskia in theatre costumes from Jan Harmensz Krul's *Musijk-kamer*. This notion, however, is not supported by any factual evidence.

84 Louttit 1973.

85 Louttit 1973, p.318.

86 See for the origins and all the other aspects of the pastoral genre in Holland: McNeil Kettering 1983 and Utrecht 1993.

87 See the illustrations in McNeil Kettering 1983 and Utrecht 1993.

88 The current title of the London painting is '*Saskia van Uylenburch in Arcadian Costume*', called *Flora* in this catalogue (cat.36).

89 Benesch 448 and *Corpus*, vol.2, A 83. The copies were made by an anonymous pupil, Leendert van Beyeren, and Ferdinand Bol.

90 *Corpus*, vol.2, A 112.

91 The dress of Rembrandt's *Artemesia* for instance, also shows much detail as well as a fashionable high waistline. In the St Petersburg *Flora*, for example, the attachment of the mantle [?] with bows and its continuance into the skirt is very odd. In the London painting the strange transition of the thick fabric of the shoulder-wings into the much lighter fabric of the white sleeves is very unconvincing, especially at the right arm.

92 Dudok van Heel 1980.

93 Louttit 1973, p.322.

94 See Zander-Seidel 1990, pp.73, 131. Judging by contemporary painting, the colour red also seems to have been typical of women's dress in the German-speaking region.

95 Gudlaugsson first remarked on a certain similarity between this painting and the work of Aldegrever. Gudlaugsson 1938, p.15. On Rembrandt's use of prints by Hans Sebald Beham and Heinrich Aldegrever see White 1969, p.166 and Tümpel 1973, p.165, on Rembrandt's etching (White/Boon B 179) of the *Monk in the Cornfield* which is derived from Aldegrever. Rembrandt's two etchings of peasants of 1634 (White/Boon B 177 and 178) are also based on works by Beham of 1542; see Van Rijckevorsel 1932, p.120. See also Broos 1977.

Notes to the Catalogue Entries

1

1 *Corpus*, vol.1, p.274.

2 Strauss/Van der Meulen, 1561/1, 1581/2 and Berlin/Amsterdam/London 1991-2, vol.1, p.51, note 5.

3 Strauss/Van der Meulen, 1622/1.

4 Ibid., 1641/8.

5 *Corpus*, vol.1, p.274, 'Rembrandt's Moeder'. For more information on Clement de Jonghe's inventory see D. de Hoop Scheffer and K.G. Boon, 'De inventarieslijst van Clement de Jonghe en Rembrandts etsplaten', *Kroniek van het Rembrandthuis*, 25 (1971), pp.1-17 and D. de Hoop Scheffer, 'Nogmaals de inventarieslijst van Clement de Jonghe', *Kroniek van het Rembrandthuis*, 26 (1972), pp.126-34.

6 White/Boon B 272 and Amsterdam/London 2000-1, cat.66, pp.272-7: for doubts about the traditional identification of the sitter as De Jonghe, see p.276.

7 *The Artist's Mother*, head only, full face, etching with additions in black chalk, 8.5 × 7.2 cm (RP-P-OB-747).

8 Benesch 55, *Old Woman seen from the Front*, c.1628, pen and brush, 12.2 × 10.5 cm, Private Collection. See Amsterdam 1988-9, cat.10, pp.34-5; Leiden 1991-2, p.65; *Seventeenth Century Dutch Drawings. A Selection from the Maida and George Abrams Collection*, exhibition catalogue, Rijksprentenkabinet, Amsterdam/Albertina, Vienna/Pierpont Morgan Library, New York/Fogg Art Museum, Cambridge 1991-2, cat.43, pp.104-5.

9 Amsterdam/London 2000-1, cat.3, p.87.

10 Ibid., cat.2, pp.85-6.

2

1 Berlin/Amsterdam/London 1991-2, vol.1, pp.52-3, where Dudok van Heel argues that theology was a likely option, while Mariet Westermann argues that Orlers' (see note 2 below) statement that Rembrandt 'might serve the town and the common good with his learning' implies a career in politics or administration was more likely (Boston 2000-1, p.25).

2 Strauss/Van der Meulen, 1641/8. This was according to Rembrandt's first biographer, Jan Jansz Orlers, Burgomaster of Leiden, writing on famous citizens.

3 Strauss/Van der Meulen, 1641/8 and Berlin/ Amsterdam/London 1991-2, vol.1, pp.52-3 and Dudok van Heel, in present catalogue. For further information about Lastman, see Amsterdam 1991.

4 Strauss/Van der Meulen, 1641/8.

5 Amsterdam/London 2000-1, pp.13-14.

6 For example up until about 1631: White/Boon B nos.1, 4, 5, 8, 9, 10, 12, 13, 15, 16, 24, 27, 316, 320, 338. For further information on these, see catalogue entries in London/The Hague 1999.

7 White/Boon B nos.343, 348, 349, 351, 352, 354.

8 Possibly White/Boon B 292 and B 294, though there is no firm identification. See too Amsterdam/London 2000-1, cat.9, p.96 and note 1, p.98. An etching plate entitled 'Rembrandt's father' was in De Jonghe's inventory (see cat.1, note 5) while a drawing in the Ashmolean Museum, Oxford, in red and black chalk (Benesch 56) has 'HARMAN. GERRITS. van de Rhijn' inscribed upon it, though not perhaps written by the artist (see Boston 2000-1, p.118, note 1). There is also mention of a painted 'tronie of an old man, being a portrait of Mr Rembrandt's father' (Een out mans tronie, sijnde 't conterfeytsel van de vader van Mr. Rembrant), Strauss/Van der

Meulen, 1644/1. A painting of Rembrandt's father was also mentioned in the estate of Jan van de Cappelle, Hofstede de Groot 1906, no.360.

9 *Corpus*, vol.1, A27.

10 Amsterdam/London 2000-1, p.13, and note 10. See too Boston 2000-1, pp.56-8.

11 For further information on Lievens see Braunschweig 1979, Amsterdam 1988-9, and Leiden 1991-2.

3

1 Von Sandrart 1675, A. Pelzer (ed.), Munich, 1925, p.203: 'In Ausbildung alter Leute, und derselven Haut und Haar, zeigte er einen groszen Fleisz, Gedult und Erfarenheit, so dasz sie dem einfältigen Leben ganz nahe kamen'.

2 Ibid.: '…quoted by B. Bakker, '*Schilderachtig*: discussions of a seventeenth-century term and concept', *Simiolus*, 23 (1995), p.155, note 27.

3 Boston 2000-1, p.45, suggests that these subjects could be appreciated by the less educated members of the public who were also beginning to buy pictures. See also Schama 1987, pp.430-1.

4 For a definition of *tronies* see Melbourne/ Canberra 1997-8, J. van der Veen, 'Faces from Life: *Tronies* and Portraits in Rembrandt's painted oeuvre', pp.69-80, especially pp.71-3, and L. de Vries, 'Tronies and Other Single-figured Netherlandish Painting', *Leids kunsthistorisch jaarboek*, 8 (1990), pp.185-202. See too Washington/London/The Hague 2000-1, p.47, note 85 and p.48, note 86, for further references.

5 London/The Hague 1999, E. van der Wetering, 'The Multiple Functions of Rembrandt's Self-portraits', pp.10-36, in particular p.36.

6 'Sittende oude vrouw', *Corpus*, vol.1, p.274.

7 Van Hoogstraten 1678, p.110, '…die gy voorhebt, bevinden, voornaemelijk voor een spiegel om tegelijk vertooner en aenschouwer te zijn.'

8 Strauss/Van der Meulen, 1630/1.

9 Ibid., 1634/4.

10 Ibid., 1641/3.

11 Ibid., 1640/9 and 1640/11. The estate was left to the four surviving children, Rembrandt, his brothers Adriaen and Willem and sister, Elisabeth (Lysbeth). Rembrandt's inheritance portion was a mortgage of 3565 guilders on property payable to him by Adriaen in yearly tranches of 300 guilders from 1 November 1641.

12 I am grateful to Michael Hoyle and Professor Leo Noordergraaf, who proposed that in about 1650 an unskilled worker in the Dutch Republic would have earned between 150 and 200 guilders per annum (depending on seasonal fluctuations).

4

1 *Corpus*, vol.1, p.274, 'een oude persiansche vrouw'. See also cat.1, note 2.

2 Blankert 1982, pp.26-7, believes that *tronies* were more highly regarded than portraiture since they came closer to the more prestigious genre of history painting in incorporating more imaginative elements than required for portraits. See Washington/London/The Hague 2000-1, p.48, note 88.

3 *Corpus*, vol.1, A3.

4 *Corpus*, vol.1, A7.

5 *Corpus*, vol.1, A12.

6 *Corpus*, vol.1, A37.

7 Sumowski 1983-95, vol.3, 1222. Intriguingly, his composition of this subject painted c.1625, now in the Johnson Collection, Philadelphia Museum of Art, shows a very different model: Sumowski 1983-95, vol.3, 1214.

8 Lievens, who trained with the portrait painter Joris van Schooten (c.1587–1652/3) may have introduced this subject matter to Rembrandt.

9 Braunschweig 1979, cat.18, pp.70–1, Sumowski 1983–95, vol.3, 1261, and Boston 2000–1, cat.8, pp.100–1.

10 Sumowski 1983–95, vol.3, 1268.

11 Braunschweig 1979, cat.25, pp.84–6; Sumowski 1983–95, vol.3, 1191.

12 Sumowski 1983–95, vol.3, 1187.

13 Sumowski 1983–95, vol.3, 1188, and Melbourne/Canberra 1997–8, p.218.

14 Washington/London/The Hague 2000–1, p.33, fig.6.

15 Washington/London/The Hague 2000–1, cat.2, pp.66–7.

16 Though the artists obviously knew and responded to each other's work at this period, there is no known documentary evidence to support a shared studio.

17 For further information about the training of Gerrit Dou in Rembrandt's studio see R. Baer in Washington/London/The Hague 2000–1, pp.28–9.

5

1 Corpus, vol.1, A27.

2 Corpus, vol.1, A37.

3 Braunschweig 1979, cat.18, pp.70–1; Sumowski 1983–95, vol. 3, 1261; Melbourne/Canberra 1997–8, cat.35, pp.220–1; Boston 2000–1, cat.8, pp.100–1.

4 Corpus, vol.1, p.321.

5 The inventory is a manuscript in the Bodleian Library, Oxford (MS. Ashmole 1514); see O. Millar, 'Abraham van der Doort's Catalogue of the Collections of Charles I', Walpole Society, vol.37, 1960, no.101, p.60.

6 White 1982, p.101.

7 For a discussion of the Kerr family collections, see Edinburgh 1992; The Earls and Marquesses of Lothian; p.167 and cat.29, 30, 46.

8 See R.E.O. Ekkart, 'Rembrandt, Lievens and Constantin Huyghens', in Leiden 1991–2, pp.48–59.

9 Corpus, vol.1, A33.

10 O. Millar, 'Abraham van der Doort's Catalogue of the Collections of Charles I', Walpole Society, vol.37, 1960, no.57, p.84 and O. Millar, 'The Inventories and Valuations of the King's Goods 1649–51', Walpole Society, vol.43, 1972, no.97, p.304'.

11 J.J. Orlers, Beschrijvinge der Stadt Leyden, Leiden, 1641; see Corpus, vol.2, p.839.

12 Corpus, vol.1, pp.321 and 330.

13 White 1982, p.103.

14 Corpus, vol.2, p.839. The four paintings are Corpus, vol.1, A12, 24, 38, 39.

15 For discussions on the relationship of the two artists' representations of The Raising of Lazarus, see Corpus, vol.1, A30; Leiden 1991–2, pp.110–13; H. Gutbrod, 'Lievens und Rembrandt: Studien zum Verhältnis ihrer Kunst', Ars Faciendi, vol.6, Frankfurt am Main, 1996, pp.235–66.

6

1 Or else a studio block, used to position models.

2 J. Bruyn, 'On Rembrandt's Use of Studio Props and Model Drawings during the 1630s', Essays in Northern European Art presented to Egbert Haverkamp-Begemann, Doornspijk, 1983, p.54, note 9, who suggests that such drawings in the 1630s may have been employed somewhat in the manner of mediaeval model books. For the different uses made of Rembrandt's drawings by his pupils see too Amsterdam 1984–5.

3 Benesch 196.

4 Schatborn 1985, pp.4–11 and note 1.

5 Ibid., note 6.

6 Ibid., notes 7, 8, 9.

7 I am most grateful to Peter Schatborn for pointing this out. Other drawings on the same paper are Benesch 12, 22, 31, 32, 45, 46.

8 Benesch 196.

7

1 Hind wrongly rejects Rembrandt's authorship. An accepted Rembrandt print of 1630 (White/ Boon B 192) can be found on the other side of an impression of the first state of this print: Amsterdam/London 2000–1, cat.9, p.98.

2 Apart from Lastman's compositions mentioned in note 6 below, Rembrandt was presumably aware of other works depicting black figures, such as traditional representations in the depiction of The Adoration of the Kings, but the portrayal of black women is far more unusual.

3 J.I. Israel, The Dutch Republic. Its Rise, Greatness, and Fall 1477–1806, Oxford, 1995, pp.313–14, 408–9, 935–6.

4 For examples, see I. Gaskell, The Thyssen-Bornemisza Collection. Seventeenth-century Dutch and Flemish painting, cat.27, Frans Hals's Family Group in a Landscape, pp.144–7, and, also, R.E.O. Ekkart, Nederlandse portretten uit de 17de eeuw. Eigen collectie Museum Boymans-van Beuningen Rotterdam, Singapore, 1995, cat.67, Abraham Lambertsz van den Tempel, Portrait of Jan van Amstel and Anna Boxhoorn, pp.188–190.

5 Rijksmuseum het Catharijneconvent, Utrecht, Corpus, vol.1, A5.

6 Amsterdam 1991, pp.57–60. The scene is taken from Acts 8: 38.Lastman's picture in the Staatliche Kunsthalle, Karlsruhe, dated 1623, bears the closest links to Rembrandt's composition but Lastman had also depicted the same subject three times before. See Corpus, vol.1, p.101.

7 'Ontfinck van hem den doop met een gelovich hert, Sijn wterlijcke huyt bleef wel swert Maer witter als de sneeuw wiert hy aen syner sielen', J. Revius, Over-Ysselsche Dangen en Dichten, Deventer, 1630, p.228: see Corpus, vol.1, p.102.

8 'Hic lavat Aethiopem nigrum pellitque colorem, Non cutis est animae, post pansa oracla Philippus': see Corpus, vol.1, pp.102–3.

8

1 See London 1992, p.36 for detailed listing of literature relating to the drawing.

2 Benesch 40. See Plomp 1997, p.291.

3 Pre-industriële Gebruiksvoorwerpen/Pre-industrial Utensils 1150–1800 (collection catalogue of Afdeling Kunstnijverheid en Vormgeving/ Department of Applied Arts and Design, Boijmans Van Beuningen Museum, Rotterdam), Rotterdam, 1991, p.215, repr., inv.F8476, iron candlestick, 21 cm high. I am very grateful to Norbert Middelkoop for tracking this down for me.

9

1 Van Hoogstraten 1678, p.31: 'Maer tot het teykenen van tronien, handen, of geheele naekten na 't leven, moogt gy gesmijdich root krijt op wit papier gebruiken.'

2 Boston 2000–1, p.51 and note 4.

3 Benesch 20; Berlin/Amsterdam/London 1991–2, vol.2, cat.2, pp.26–8.

4 V. Manuth, 'As stark naked as one could possibly be painted', the reputation of the nude female model in the age of Rembrandt', essay in this catalogue, p.47, note 5.

5 Corpus, vol.1, A24. The Corpus authors suggest that the style of the work implies a slightly later date than 1628, a date which is also thrown into doubt by the uncharacteristic signature.

6 Benesch 9r.

7 Corpus, vol.1. A15.

8 See Braunschweig 1979, Samson and Delilah: cat.15 (Lievens pp.64–5), 16 (Lievens pp.66–8) and U4 (Rembrandt pp.232–3); H. Gutbrod, 'Lievens und Rembrandt: Studien zum Verhältnis ihrer Kunst', Ars Faciendi, vol.6, Frankfurt am Main, 1996, pp.143–70; Leiden 1991–2, pp.106–9; Boston 2000–1, p.71.

10

1 Amsterdam/London 2000–1: see M. Royalton-Kisch, 'The role of drawings in Rembrandt's printmaking', pp.64–81.

2 White 1969, vol.1, pp.172 ff, and E.J. Sluiter's essay in this catalogue.

3 Berlin/Amsterdam/London 1991–2, vol.2, cat.7, p.184, note 10. The only pupils known to have been working with Rembrandt in Leiden between 1630 and 1631 were Isaac de Jouderville (see Strauss/Van der Meulen, 1630/2, 1630/4, 1631/3, 1631/9, 1631/10) and Gerrit Dou (see Washington/London/The Hague 2000–1, p.29).

4 See London 1992, fig.5a verso, p.34.

5 Amsterdam/London 2000–1, p.101.

6 Amsterdam/London 2000–1, p.64.

7 For a survey of the artistic taste at the court of Stadholder Frederik Hendrik of Orange and his wife Amalia van Solms see The Hague 1997–8, vol.1.

8 For a description of Huyghens's relationship with Rembrandt see Boston 2000–1, pp.31–5, and a new translation of Huyghens's writing on Rembrandt, pp.134–6; for further literature see p.134, notes 1, 2 and 4.

9 Corpus, vol.1, A38, p.363; A39, p.370.

11

1 See Amsterdam/London 2000–1, pp.64–81 and pp.100–1.

2 Corpus, vol.1, A31.

3 Corpus, vol.1, p.313.

4 Written about by Tümpel 1969 as the concept of 'Herauslösung' in his investigation of the pictorial iconography used by Rembrandt in his history subjects: see C. Tümpel, Jahrbuch der Hamburger Kunstsammlungen, 13, 1968, pp.95–128.

5 Berlin/Amsterdam/London 1991–2, vol.2, p.184 and Amsterdam/London 2000–1, p.103.

12

1 Clark 1956, p.325. (For a discussion of Rembrandt's portrayal of the female nude, see E.J. Sluiter's essay in this catalogue.)

2 Ibid., p.326.

3 Pels 1681, pp.35–6:
'Als hij een' naakte vrouw, gelijk 't somtijds gebeurde,
Zou schild'ren, tot modél geen Griekse Venus keurde:
Maer eer een' waschter, of turftreedster uit een' schuur,
Zijn dwaaling noemende navolging van Natuur,
Al 't ander ydele verziering. Slappe borsten' Verwrongen handen, ja de neepen vans de worsten
Des rijglifs in de buik, des kousebands om 't been,
't Moest al gevolgd zijn, of natuur was niet tevreen.'

4 J. de Bisschop, Paradigmata graphices variorum artificum, The Hague, 1671, unpaginated dedication to Jan Six: 'een vrouwe-naeckt met een dicken en gheswollen buyck, hangende borsten, kneepen van kousse-banden in de beenen en veel meer sulcke wanschaepenheyt' (a naked woman with a thick and swollen belly, pendulous breasts, the pinchmarks of the stocking garters on the legs and much more such monstrosity).

5 Hollander 1975, pp.108, 160.

6 Hollstein 91. Pennington 1982, no.603.

7 Martin Royalton-Kisch tentatively proposes that this might have been done in order to get work as a reproductive engraver of Rembrandt's work, rivalling Jan van Vliet: see Amsterdam/ London 2000–1, p.105. However, even if Hollar was trying to impress Rembrandt as an ulterior motive, there were certainly other Rembrandt etchings he could have copied.

8 I am most grateful to Erik Hinterding for confirming this. His research on the two prints is as follows: the second state of a Seated Female Nude was printed in c.1632–34 (Doubleheaded Eagle, variant A.a. [Ash/Fletcher 1998, 15, A.a.]), and reprinted c.1648 (Strasbourg Lily, variant D'.a. [Ash/Fletcher 1998, 36, D'.a.]). It is known with several other watermarks that are difficult to date, but the impression with the Arms of Amsterdam watermark [Ash/Fletcher 1998, 1, D.d.] is probably a posthumous impression. The etching of Diana at her Bath was reprinted in c.1634–5 [Ash/Fletcher 1998, 11, A.a.], in c.1638 [Ash/Fletcher 1998, 36, E'.c.], 1639–40 [Ash/Fletcher 1998, 19, E.a.], and somewhat later, as an impression of the print occurs with an unidentified Arms of Amsterdam watermark. This last watermark-type was not introduced until c.1653, and was very common in the late seventeenth and early eighteenth century. As with White/Boon B 198, a few other watermarks have been found in impressions of this print, but so far it has not been possible to date them.

13

1 Book XI, 260 and Book VI, 110–11. It is possible that Constantijn Huyghens's influence continued in causing Rembrandt to select mythological themes at this time: see cat.10.

2 White/Boon B 204.

3 Ibid. There may be a confusion with Rembrandt's later etching of what is probably the same subject, see cat.134. It is possible that what is so clearly described as a 'crown' in White/Boon may have been misread by De Jonghe as a satyr's bacchanalian wreath.

4 White 1969, vol.1, p.175, note 4 and vol.2, fig.264.

5 For a discussion of the tradition of the representation of the subject of Jupiter and Antiope see Wethey 1975, vol.1, pp.54–6.

6 Amsterdam/London 2000–1, p.363.

7 Corpus, vol.3, A119.

14

1 Seilern 1961, p.31.

2 Ibid.

3 Van Hoogstraten 1678, p.53. Quoted by P. Schatborn in Amsterdam/Washington 1981–2, p.15.

4 Van Hoogstraten 1678, pp.292ff, Amsterdam/ Washington 1981–2, p.12.

5 Benesch 193A (Benesch addenda 6), giving a late date of 1635. Diana Bathing; with the stories of Callisto and Actaeon, Corpus, vol.2, A92. The authors felt the signature and date of 1634 are unconvincing and one still has to wonder whether both drawings and perhaps the painting may be of a slightly earlier date.

6 Intriguingly, a reproductive engraving, attributed to the workshop of C. de Passe the elder, after the painting shows this figure as more closely resembling the Courtauld sheet, with her right arm bent at the elbow rather than straight: see Corpus, vol.2, p.494, fig.8.

7 Giltaij 1988, cat.182, p.312. A copy of this drawing exists which has been attributed to Flinck: see Giltaij, note 4.

8 The inventory of 1656 describes 'Een boeck, vol teeckeninge van Rembrant gedaen, bestaende in mans en vrouwe; naeckt sijnde' (a book full of drawings by Rembrandt of men and women; they being nude) from which pupils could have drawn. Strauss/Van der Meulen, 1656/12, no.239. For pupils' copies see also Amsterdam 1985–6, pp.22–37.

15

1 Daulby 1796, p.122.

2 Amsterdam/London 2000–1, p.106 and note 1.

3 Ibid., fig.e: Ger Luijten rightly makes the point that such low-life scenes were considered acceptable by even the highest society.

4 Ibid., p.106 and note 7.

5 Mauritshuis, The Hague. See Schama 1985, pp.481–3.

6 'Dit lijf, wat ist, als stanck en mist', Johan de Brune, *Emblemata of zinne-werck*, Amsterdam, 1624, no.17.

7 'Strephon and Chloe', *c*.1731, from *Poems 1698–1737*. I am grateful to M.J. Moore for this reference.

16

1 See Berlin/Amsterdam/London 1991–2, vol.1, p.162.

2 *Corpus*, vol.2, A88.

3 Bartsch 11.

4 See S.A.C. Dudok van Heel's essay in this catalogue, p.22, note 35.

5 Ibid., p.458: 'een schilderij van Joseph en Maria, gedaen door Rembrandt'.

17

1 Strauss/Van der Meulen, 1631/4.

2 See S.A.C. Dudok van Heel's essay in this catalogue, p.22.

3 De Winkel 1993, on Mennonite costume, pp.105–11.

4 *Corpus*, vol.2, p.210 and p.216.

5 For an overview of the pictorial tradition of portraying couples in Dutch art see Haarlem 1986.

6 *Corpus*, vol.2, A51.

7 W. Liedtke in New York 1995–6, vol.2, p.54.

8 *Corpus*, vol.2, A78 and A79. In New York 1995–6, vol.2, p.54, Liedtke points out the similarity of the pose of these two portraits to figures in *The Anatomy Lesson of Dr Nicolaes Tulp*.

9 Washington/London/Haarlem 1989–90, cat.nos.68, 69, pp.322–5.

10 *Corpus*, vol.2, A77 and *Corpus*, vol.3, A143. See too D.R. Smith, 'Rembrandt's Early Double Portraits and the Dutch Conversation Piece', *Art Bulletin*, LXIV, no.2 (June 1982), pp.260–88.

18

1 Christie's, London, auction catalogue, 13 December 2000, p.134.

2 Ibid. See also *Corpus*, vol.3, p.722.

3 White/Boon B 266, p.121.

4 Strauss/Van der Meulen, 1634/2.

5 Strauss/Van der Meulen, 1635/6; 1638/8; 1641/4; 1640/5.

6 *Corpus*, vol.3, C114, p.722.

7 Bredius/Gerson 272. Smith 1829–42, vol.v, nos.349 and 557. He believed them to represent Justus Lipsius and his wife. Though the portraits were sold together in 1811, it is far from certain that they were actually intended as pendants.

8 C. Vosmaer, *Rembrandt. Sa vie et ses oeuvres*, The Hague, 1877, pp.261–2.

9 *Corpus*, vol.3, C114, p.722, suggests that they may have been painted by Carel Fabritius.

19

1 *Corpus*, vol.2, A61.

2 *Corpus*, vol.2, A49, p.163 and note 1.

3 The Hague 1997–8, vol.1, cat.9, pp.132–141.

4 Ibid., p.135.

5 Ibid., p.135, note 4, and The Hague 1997–8, vol.2, p.180 and note 92. It is possible that this commission was related to the 1631 *Act of Survivance* (which made the position of Stadholder hereditary), which was commemorated by several medals struck that year showing Frederik Hendrik in profile *à l'antique*.

6 The Hague 1997–8, vol.1, cat.9c, p.137.

7 The Hague 1997–8, vol.2, p.180 and note 95.

8 Strauss/Van der Meulen, 1637/4: 'cleine oostersche vrouwen troni, het conterfeisel van H. Ulenburg's huijsvrouwe nae Rembrant'.

9 *Corpus*, vol.3, C115.

10 *Corpus*, vol.2, A50.

11 *Corpus*, vol.1, A31, A38, A39.

12 Sumowski 1983–95, vol.3, no.1275 and Melbourne/Canberra 1997–8, cat.34, pp.216–9.

13 Sumowski 1983–95, vol.3, no.1188 and Melbourne/Canberra 1997–8, fig.34a, p.218.

14 Oil on canvas, 129 × 110 cm: Rijksmuseum, Amsterdam; Leiden1991–2, p.108 repr.

15 Amsterdam 1991, cat.22, pp.130–1.

16 Oil on canvas, 151.2 × 142.3 cm: Gemäldegalerie, Staatliche Museen, Berlin; Leiden1991–2, p.119 repr.

17 *Corpus*, vol.1, A34; vol.2, A64, A47.

18 *Corpus*, vol.2, A85.

19 Ibid., p.435. The head originally turned to face the front slightly more, showing a glimpse of the other eye.

Rembrandt adapted almost the same silhouette as used in the Kassel picture in 1642 in his depiction of Lieutenant Willem van Ruytenburgh in the *Night Watch*. See *Corpus*, vol.3, pp.468–9, where the effect of the feather in Van Ruytenburgh's hat and his embossed and fringed gorget are likened to Saskia's velvet hat and embroidered bejewelled collar.

20

1 The measurements of the painting are here given as 109.2 × 94.4 cm.

2 *Corpus*, vol.2, p.272. See, also, p.147 (A47).

3 *Corpus*, vol.1, A38.

4 *Corpus*, vol.2, pp.273–4 for a detailed evaluation of these suggestions.

5 Sumowski 1983–95, vol.3, no.1188 and Melbourne/Canberra 1997–8, fig.34a, p.218.

6 'Bathsheba receiving David's letter': Sumowski 1983–95, vol.3, no.1189; see too *Corpus*, vol.2, p.273, fig.7, the mezzotint of Lievens's composition by J.G. Haid.

7 For example, Slatkes 1992, cat.11, pp.34–5.

8 Judith: 10: 1–4.

9 Jacob Cats, *Werelts Begin, Midden, Eynde, besloten in den Trouringh*, Dordrecht, 1637. There is no good reason to suppose Rembrandt would have known the text before its publication.

10 Letter in National Gallery of Canada files, Dr Alfred Bader, 25 January 1971.

11 M. Kahr, 'Rembrandt's Esther: A Painting and an Etching Newly Interpreted and Dated', *Oud Holland*, LXXXI (1966), pp.228–44. The *Corpus*, vol.2, p.276, rejects this idea, stating that Mordecai would not have sent so many papers to Esther. In any case, the sheets are clearly bound together and therefore constitute a book (scripture?) rather than the edicts.

12 Dordrecht/Cologne 1998–9, cat.20, pp.168–9.

13 *Corpus*, vol.2, p.275.

14 *Corpus*, vol.3, p.8. Rembrandt's *Old Woman Reading* (Rijksmuseum, Amsterdam, *Corpus*, vol.1, A37) comes closest to the scale of figure but is only shown as a three-quarter length in a smaller composition.

15 *Corpus*, vol.3, A123 and p.11.

16 See cat.26 and 27.

21

1 Strauss/Van der Meulen, 1612/1, p.47. Saskia was baptised on 2 August of this year. See also note 6 below.

2 Ibid.

3 Strauss/Van der Meulen, 1628/3, unnumbered pages of addenda and corrigenda (p.671). For some unknown reason, a new guardian, Suffridus Rodehuijs, replaced Gerrit van Loo on 20 July 1633 who remained Saskia's guardian until her marriage to Rembrandt the following year.

4 Benesch 427. See also Berlin/Amsterdam/London 1991–2, vol.2, cat.no.3, pp.29–31.

5 For the discussion of the significance of his choice of this medium, see Van de Wetering 1997, 'Lost Drawings and the Use of Erasable Drawing Boards and "Tafeletten"', pp.47–74.

6 Inscribed 'dit is naer mijn huijsvrou geconterfeit/so sij 21 jaer oud was den derden/dach als wij getroudt waeren/den 8 junijus/ 1633'. However, Strauss/Van der Meulen, 1633/3, p.100, notes that Saskia was only twenty on 8 June 1633, deduced from the document assigning Saskia's guardianship to Rodehuijs (1633/4, in the unnumbered pages of addenda and corrigenda, p.672), which states that Saskia was twenty on 20 July 1633.

7 See the essay by Marieke de Winkel, p.56.

8 This has been arguably linked with the development of improved dental hygiene. For example, see C. Jones, 'Pulling Teeth in Eighteenth-Century France', *Past and Present*, reviewed *The Times*, 19 July 2000, which states that the first portraits to show an open smile date from the late eighteenth-century. However, obviously not all teeth can have been so decayed as to mar beauty before this, since a contemporary of Rembrandt's, Robert Herrick (1591–1674), wrote in *The Rock of Rubies, and the Quarrie of Pearls*: 'Some asked how pearls did grow, and where?/Then spoke I to my girl/To part her lips,/and showed them there/The quarelets of pearl.'

9 See London/The Hague 1999–2000, cat.nos.20–3, and also Amsterdam/London 2000–1, cat.nos.7 and 8.

10 Van Mander 1604A, fol.25 recto, line 28; Miedema 1973, vol.1, pp.166–7: 'We moeten de ogen aardig half dicht maken, de mond wat open, aangenaam en vrolijk lachend … een blij voorhoofd, dat glad en oprecht is, en niet betrokken met veel rimpels.'

11 Van Mander 1604A, fol.25 recto, line 36; Miedema 1973, vol.1, pp.168–9: '…door het lachen mond en wangen breder worden en omhoog komen, het voorhoofd daalt, en tussen beide zijn de ogen half dichtgeknepen en gedrukt, zodat ze naar de oren toe kleine rimpels maken.'

12 Van Mander 1604A, fol.23 recto, line 7; Miedema 1973, vol.1, pp.158–9: '…de uitbeelding van het affect van de liefde tussen mannen en vrouwen … met vriendlijk [elkaar] toelachend aankijken…'

13 Van Mander 1604A, fol.24 verso, line 25; Miedema 1973, vol.1, pp.164–6: '…een lachende mond op verliefheid…'

14 Rembrandt also later showed himself in sixteenth-century dress along with a feathered hat in his *Self-portrait* etching of 1638, White/Boon B 20; London/The Hague 1999–2000, cat.49, p.166.

15 Lucas van Leyden (active 1508–died 1533), *Youth with Plumed Cap and Skull*, engraving: Bartsch 174.

16 Pierpont Morgan Library, New York, Acc.no.111, 145. Frans Hals also used the motif of a plumed cap in his *Vanitas* picture of about 1626–8, *A Young Man with a Skull* (National Gallery, London, inv.no.6458). See *Frans Hals*, exhibition catalogue, Royal Academy of Arts, London, 1989, exh. cat.29, pp.208–11.

17 *Corpus*, vol.1, A20; London/The Hague 1999–2000, cat.no.10, pp.104–6.

18 See, too, cat.82 and cat.109; in the latter a plumed hat hangs upon the bedpost.

19 Boston Museum of Fine Arts, inv.no.48.1165, attributed to Hendrick Gerritsz Pot: see *Corpus*, vol.2, A76, p.365, fig.4.

22

1 Amsterdam 1984–5, p.8, p.13 and note 13.

23

1 Benesch 310. See, too, Paris 1988–9, drawings, p.26, and Paris 2000, cat.93, pp.140–1. The drawing is dated 1635–7 in both publications, along with the suggestion that it portrays Rembrandt's mother.

2 Reproduced Paris 1988–9, drawings, p.24, fig.12.

3 By Benesch 429, and originally proposed by Saxl in 1908.

4 See, too, cat.24 for a dicussion of similar technique.

5 Hofstede de Groot 1906, no.623. E. Starky remarked in Paris 1988–9, loc.cit., that the idea 'remained seductive' despite Benesch's earlier dating of the work.

6 For a discussion of the few drawings Rembrandt made in connection with prints, see M. Royalton-Kisch in Amsterdam/London 2000–1, pp.64–81 and note 1.

24

1 Bremen 2000–1, cat.58, pp.108–9, where the drawing is given the title of *Saskia Seated, with a Letter in her Left Hand*.

2 *Esther* 4: 8 and 5: 1.

3 The composition faintly recalls the lost *Bathsheba* by Jan Lievens, known through a mezzotint by J.G. Haid: *Corpus*, vol.2, p.273, fig.7.

4 De Winkel's essay in this catalogue, pp.58–9, points out that the black veil did not necessarily indicate a death in the family, nor yet was usual for a bridal veil, but might be worn simply as a decorative protection for the face.

5 See *Corpus*, vol.2, p.557.

6 Ibid., fig.5.

7 I am grateful for this verbal communication from Marieke de Winkel.

8 The Hague 1997–8, vol.2, p.197, repr.

9 Ibid., p.183, repr.

10 Bremen 2000–1, loc. cit.

11 For example, Giltaij 1988, cat.9, p.52.

12 This is by no means certain but might perhaps explain some of the points mentioned above. I am grateful to Peter Schatborn for discussing this problem with me.

13 The drawings of Constantijn van Renesse are most often cited as examples demonstrating such corrections though it seems that he then also adopted the style of Rembrandt's corrections – bold lines over more tentative ones – in his own work without intervention from the master.

14 Van Hoogstraten 1678, p.192: 'De meesters raed ik, alsze Teykeningen haerer discipelen oversien, datze de zelve voorwerp maken, verbeeteren.

Dit oefent ongemeen en heeft veelen geweldich in de schikkunst [het componeren] geholpen'. The translation is taken from Amsterdam 1984-5, p.10.

25

1 *Corpus*, vol.2, pp.359-60.

2 Ibid., p.359 and p.360. The Rembrandt Research Project suggest that the current signature and date accurately record the original signature and date which may have been written on part of the panel which was cut off when the panel was trimmed down to an oval shape.

3 Not yet available at the time of going to press.

4 C. Hofstede de Groot, 'Hollandsche Kunst in Schotland II: Broom Hall bij Edinburgh', *Oud Holland*, 11, 1893, p.223.

5 P.J.J. van Thiel et al., *All the Paintings in the Rijksmuseum of Amsterdam*, Amsterdam/ Maarssen, 1976.

26

1 *Corpus*, vol.3, A114.

2 Strauss/Van der Meulen, 1656:12, no.182: 'een raer gefigureert Iser schilt van Quintijn de Smith.' Other items of armour were listed as nos.157, 158, 159, 167, 186, 320.

3 See S.A. Worp, 'Constantijn Huyghens over de schilders van zijn tijd', *Oud Holland*, 9, 1891, p.119. This was probably a copy of the *Head of Medusa* by Rubens and Snyders now in the Kunsthistorisches Museum, Vienna, inv.no.3834: see P. Sutton et al., *Rubens in America*, Museum of Fine Arts, Boston/Toledo Museum of Art, 1993-4, cat.12, pp.245-7.

4 *Corpus*, vol.2, p.330.

5 Strauss/Van der Meulen, 1656:12, nos.228, 245.

6 The Hague 1997-8, vol.1, p.37.

7 Strauss/Van der Meulen, 1637/6.

8 *Corpus*, vol.2, A70, p.330.

9 London 1988-9, pp.62-3.

10 *Corpus*, vol.1, A9.

11 *Corpus*, vol.2, p.328.

12 Haak 1969, p.101.

13 New York 1995-6, vol.II, p.56, note 3. Saskia, however, was not Mennonite and nor was her father, although her first cousin Hendrick was.

14 A. van Grevenstein, K. Groen, E. van de Wetering, 'Esther Before Haman, attributed to Rembrandt', *Bulletin van het Rijksmuseum*, vol.39, 1991, special issue, p.66.

15 Ibid., p.67.

16 See The Hague 1997-8, vol.1, pp.24-5 for a brief resumé of these events.

17 Schwartz 1984, pp.124-5.

18 For example, see Schama 1987, p.69, fig.23, an engraving of a coin of 1573 showing a similar figure type in a female allegory of the Dutch Nation brandishing a sword, with the inscription LIBERTAS PATRIAE, taken from G. van Loon, *Beschryvinge der Nederlandsche Historiepenningen*, 's Gravenhage, 1723-8.

19 Chapman 1990, p.37, quoted by W. Liedtke in New York 1995-6, vol.2, pp.57-8, note 18.

26A

1 *Corpus*, vol.2, 452.

2 J. Rosenberg, *Rembrandt*, Cambridge Mass., 1948, vol.1, p.121.

3 Slatkes 1992, suggests that the head of Joseph relates to the types of heads which Anthony van Dyck used for various saints and apostles in his early work, quoting exhibition catalogue *Anthony van Dyck*, National Gallery of Art, Washington, 1999, cat.19. However, a much closer example is cat.15 in that exhibition, *Moses and the Brazen Serpent* of c.1620-1 (Museo del

Prado, Madrid). The figure of the bearded man who supports the blonde woman on her knees is remarkably similar in face and pose to Rembrandt's Joseph, both leaning forward and seen in profile.

4 M. Jaffé, *Rubens Catalogo Completo*, Milan, 1989, no.284. Dated by Jaffé to c.1616.

5 E. Mâle, *L'art religieux de la fin du moyen âge*, Paris, 1908, p.10.

6 M. Jaffé, *Rubens Catalogo Completo*, Milan, 1989, no.368; J. Ingamells, *The Wallace Collection Catalogue of Pictures: Dutch and Flemish*, vol.4, London, 1992, cat.P81, pp.314-15, there dated to c.1614-15.

7 Van Rijckevorsel 1932, pp.87-91; W. Sumowski, 'Eininge frühe Entlehnungen Rembrandts', *Oud Holland*, 1956, no.71, pp.109-13.

8 *Corpus*, vol.2, p.456.

9 J. Bruyn, 'Rembrandt and the Italian Baroque', *Simiolus*, 1970, no.4, p.36.

10 Schama 1987, p.538.

11 Quoted by Schama 1987, p.538, from J. Cats, *Houwelyck, In Alle de Werken. De Deughdelijke Vrou*, Amsterdam, 1642, p.361.

12 Sumowski 1983-95, vol.1, no.81.

13 *Corpus*, vol.2, p.455.

14 *Corpus*, vol.2, p.456.

15 Strauss/Van der Meulen, 1635/6 and 1636/3.

16 *Corpus*, vol.2, p.458: their son Jan Soolmans is recorded as having been left 'een schilderij van Joseph en Maria, gedaen door Rembrandt' (a painting of Joseph and Maria done by Rembrandt) believed to have been commissioned from Rembrandt when he painted the couple's portraits.

17 *Corpus*, vol.2, A100, A101; see figs.16, 17.

18 Berlin/Amsterdam/London 1991-2, vol.1, p.171.

27

1 New York 1995-6, vol.2, p.91 and note 4.

2 Berlin/Amsterdam/London 1991-2, vol.1, p.191 and Sluijter 1986, p.254. However, a number of works of this subject dating from the sixteenth and seventeenth centuries are listed in inventories: see *Corpus*, vol.2, A93, p.501.

3 Benesch 448.

4 See under section 7, Copies, in *Corpus*, vol.2, A93, fig.6 and A112, figs 7-8.

5 Schama 1987, pp.350-35. See also fig.162, p.364, P. Nolpe's print of *Flora's Cap of Fools* ('Floraes Geks-kap') of 1637 which was a satire upon the tulip 'fever'.

6 M. Louttit, 'The romantic dress of Saskia van Ulenborch: its pastoral and theatrical associations', *The Burlington Magazine*, 115, 1973, pp.46-7: 'Zijnde een bleeck-groen Satyne hongherlijn, de verw van 't wilghe-bladt seer na komende…'. The first edition was published under another name in 1637.

7 *Corpus*, vol.2, p.499.

8 *Corpus*, vol.1, A7.

9 See *Corpus*, vol.2, p.502, section 8. The sale is Lugt 1831: 'De dame is levensgroot verbeeld in de gedaante van een Herderin…. Het hoofd, so wel als de Herdersstaf dewelke sij in haare rechterhand heeft, is rykelyk versierd met Bloemen en groente.' (The lady is shown lifesize in the guise of a shepherdess…. Her head, as well as the shepherd's crook, which she holds in her right hand, is richly adorned with flowers and greenery.)

10 The Hague 1997-8, vol.1, cat.18, pp.174-7.

11 See Marieke de Winkel's essay in this catalogue, p.63.

12 Louttit, op.cit., fig.83.

13 Slatkes 1992, p.436, however, is adamant that this does indeed represent Saskia and claims that

the London *Flora* does as well, while noting that Saskia's features are sufficiently altered in the other mythological figures of this time so as to avoid identification.

14 *Corpus*, vol.2, pp.499-500 suggested that the pose of Flora may be related to that of the woman in Jan van Eyck's *Marriage of the Arnolfini* (National Gallery, London). Though that painting was in Spain during Rembrandt's lifetime, it seems that the composition was known to a number of sixteenth- and seventeenth-century artists: L. Campbell, *The Fifteenth Century Netherlandish Schools*, National Gallery catalogues, London, 1998, pp.178-81. However, that such a pose might have been chosen to celebrate the marriage is probably unlikely (Campbell discusses and rejects the theory that the Arnolfini painting represents a marriage, pp.198-201).

28

1 Daulby 1796, p.21.

2 Inv.no.AD.12-39-168: first mentioned in White 1969, p.36. C. Hartley in Cambridge 1996, cat.7, p.9, notes that the name of the famous Parisian print dealer P. Mariette may not be original but could have been added such as to make the print more saleable.

3 *Corpus*, vol.2, A92. See White 1999, p.177.

4 Bartsch 71. Reproduced in Amsterdam/London 2000-1, p.128, fig.a.

5 Strauss/Van der Meulen, 1656/12, no.210: 'een dito met gesneeden en geeste figuren van Antonij Tempeest'.

6 White 1999, p.32.

29

1 Verbal information supplied by Marieke de Winkel, who states that a number of contemporary plays and documents refer to the popularity of maids from the area around Edam in North Holland. They were apparently commonly seen in their regional dress, as shown in figs.121, 122.

30

1 HdG 311. See too Kahr 1966, p.241.

2 *Corpus*, vol.2, p.273.

3 Benesch 250; Giltaij 1988, cat.8, pp.50-1.

4 Suggested by P. Schatborn in Vienna/ Amsterdam 1989-90, p.106.

31

1 *Corpus*, vol.2, p.505 notes that Rembrandt signed his name without a 'd' in a number of etchings in 1632 and 1633 (B 38, B 81:I, B 101) and some paintings such as cat.20. See also *Corpus*, A40, A67 and A68.

2 Livy XXX, 12, 15.

3 For example, G. van den Eeckhout's painting of 1664 in the Herzog Anton Ulrich-Museum, Braunschweig (inv.no.260): repr. as fig.6 in *Corpus*, vol.3, p.510.

4 Aulus Gellius, *Noctes Atticae* x, 18, 3. Valerius Maximus made this story famous in his *Memorabilia*, 4. 4 Ext.1.

5 Though this does not always signify a widow: see Marieke de Winkel's essay in this catalogue, pp.58-9.

6 Tümpel 1993, p.182. For Tümpel's analysis of the iconography of the two subjects see pp.182-5.

7 The Hague 1997-8, vol.1, p.152.

8 Bildersgalerie Potsdam-Sanssouci, inv.no.7596: see The Hague 1997-8, vol.1, cat.24, pp.198-9, and also cat.12 (G. van Honthorst, *Artemisia*), pp.150-4.

9 Tümpel 1993, p.185. However, the dark figure in the background holding the cloth or sack

from which Tümpel believes the ashes are poured now appears to have been a later addition, though perhaps dating from the seventeenth century: see *Corpus*, vol.3, p.776.

10 The restoration of the painting was carried out by the Prado conservator Clara Quintanilla.

11 C. Luca de Tena/M.Mena, *Guide to the Prado*, Madrid, 1993, p.290.

12 *Corpus*, vol.2, p.507.

13 *Corpus*, vol.2, A88.

14 *Corpus*, vol.2, A88, p.456.

15 Sumowski 1983-95, vol.3, no.1187. For a colour reproduction see The Hague 1997-8, vol.1, cat.17. The general facial types for these figures are loosely related as discussed in cat.19.

16 *Corpus*, vol.3, A123.

32

1 White 1999, p.125.

2 Pennington 1982, no.1650.

33

1 Amsterdam/London 2000-1, p.140.

2 White/Boon B 278. He was also known by his Latin name Bonus, and was in the publishing house of Samuel Menasseh Ben Israel. He may have introduced Rembrandt to the Rabbi Menasseh who lived in the Breestraat; Jan Lievens also made a portrait of Buenos (Hollstein, XI, no.20, p.18).

3 White/Boon, vol.1, p.152, quote this from Landesberger, *Rembrandt, the Jews and the Bible*, Philadelphia, 1946, p.74.

4 Valentiner 1924-35, no.572.

5 Benesch 292.

6 M. Kahr, 'Rembrandt's Esther: A Painting and an Etching Newly Interpreted and Dated', *Oud Holland*, LXXXI, 1966, pp.228-44.

34

1 For a discussion of this group of drawings see Royalton-Kisch 1993 and also M. Royalton-Kisch, 'The role of drawings in Rembrandt's printmaking' in Amsterdam/London 2000-1, pp.64-81.

35

1 London 1992, p.192, note 17, for summary of opinions on the belief that this was finished by a pupil.

2 Amsterdam/London 2000-1, p.144.

3 White 1999, p.127.

36

1 London 1988-9, pp.58-9. The Rembrandt Research Project note that Rembrandt first trimmed the width of the painting but that some further 20 cm was later removed from the work's height and width (*Corpus*, vol.3, p.160).

2 *Corpus*, vol.3, A112, p.155.

3 C. Brown, 'Rembrandt's "Saskia as Flora" X-rayed', *Essays in Northern European Art presented to Egbert Haverkamp-Begemann on his sixtieth birthday*, Doornspijk, 1983, pp.48-51.

4 Judith 13: 1-15.

5 London 1988-9, pp.62-3, and Berlin/ Amsterdam/London 1991-2, vol.1, cat.23, fig.23b.

6 *Corpus*, loc.cit.

7 Haskell/Penny 1981, cat.4, pp.217-18, and note 1.See also Cavalleriis, *Antiquae Statuae Urbis Romae, Liber Primus* (58 plates published before 1561), Plate 11.

8 For example J. Kelch in Berlin/Amsterdam/ London 1991-2, vol.1, p.252.

9 Some have also believed that Rembrandt was influenced by the Titian in his Hermitage *Flora*: first suggested by Voss 1905, pp.156–62 and supported by I. Linnik in *Dutch and Flemish Paintings from the Hermitage*, Metropolitan Museum of Art, New York/Art Institute of Chicago, 1988, cat.22, p.48, although the *Corpus* is more dismissive of this idea.

10 Marieke de Winkel's essay in this catalogue, p.63.

11 Slatkes 1992, p.438. See, for example, figures with similar bodice shapes, elaborate skirts and sleeves in Amsterdam 1991, cat.1, 7, 8, 9.

12 Sumowski 1983–95, vol.2, nos.655 and 656; see too London 1988–9, figs.44, 45.

13 Ibid., nos.635, 665, 673. The *Young Girl as Flora*, no.1077, is an allegorical portrait, since the girl is shown in more contemporary dress, with flowers.

14 Strauss/Van der Meulen, 1635/5. In the event of no child surviving, Rembrandt appointed his mother as legatee, while Saskia appointed her sister Titia (see cat.87) amongst others from her family.

37

1 *Corpus*, vol.1, A37, pp.354–5 for a discussion of the prophetess Anna. There, however, the first lines of the book appear to be Hebrew, although they cannot be read.

2 White/Boon B 37. See Amsterdam/London 2000–1, cat.31, pp.139–62; the drawing is reproduced as fig.d, p.161.

3 Gersaint 1751, no.315.

4 Daulby 1796, p.207.

5 *Corpus*, vol.1, A37.

6 Münz 1952, no.89, rejected by White/Boon, p.153.

38

1 Benesch 194 and 252; see New York 1995–6, vol.2, p.159 and note 3.

2 W.R. Valentiner, 'Aus Rembrandts Hauslichkeit', *Jahrbuch für Kunstwissenschaft*, 1923, p.279.

39

1 For more information Benesch cites his article 'Rembrandt and the Gothic Tradition', *Gazette des Beaux-Arts*, 6th series, vol.XXVI, 1944, p.296, fig.9.

2 See Amsterdam 1997, cat.19, pp.118–123. It is suggested that Rembrandt may have based his *Prodigal Son* on a print after an anonymous master depicting 'Sijn Ryck Afbeeldinge Vanden Verlooren Soon': see p.121, fig.9.

3 *Corpus*, vol.3, pp.142–3, and fig.6.

4 *Corpus*, vol.3, A111.

5 Suggested by A. Mayer-Meinschel, 'Rembrandt und Saskia im Gleichnis vom Verloren Sohn', *Staatliche Kunstsammlungen Dresden Jahrbuch*, 1970/1, pp.39–57.

6 See *Corpus*, vol.3, p.146 for a discussion of this point.

7 'conterfeytsel van Rembrandt van Rijn en sijn huysvrouw', Schwartz 1984, pp.192–3. This could refer to another, lost painting that might have been a proper double portrait.

40

1 Some have seen the *Prodigal Son at the Tavern* (*Corpus*, vol.3, A111) as a double portrait and an inventory refers to a portrait of Rembrandt van Rijn and his wife which may, however, be another painting: see *Corpus*, vol.3, p.146.

2 London/The Hague 1999–2000, cat.46, pp.162–3.

3 Rembrandt also perhaps alludes to this in his

Self-portrait now at Kenwood House, London, Bredius/Gerson 52, p.551.

4 London/The Hague 1999–2000, p.162, note 156.

5 Ibid., note 154.

6 D.R. Smith, 'Rembrandt's Early Double Portraits and the Dutch Conversation Piece', *Art Bulletin*, LXIV, no.2 (June 1982), p.283.

7 London/The Hague 1999–2000, p.162, and note 153.

41

1 See cat.47 for a further discussion of Jan van der Cappelle's portfolio of Rembrandt drawings.

2 Benesch 281.

3 Benesch 256: to be included in T. Vignau-Wilberg's forthcoming exhibition, *Rembrandt auf Papier; Werk und Wirkung*, Neue Pinakothek, Munich, 2001–2.

42

1 Melbourne/Canberra 1997–8, p.348.

2 Benesch 289.

43

1 The opinion of C. Neumann, rejected by Benesch 405, p.96.

2 London 1992, p.69.

3 See Münz 1952, no.175, p.86.

4 *Corpus*, vol.2, A66.

5 For Van Vliet's work with Rembrandt, see Amsterdam 1996.

6 Tümpel suggested in *Rembrandt legt die Bibel aus*, Berlin, 1970, cat.14, that the figure may originally have been inspired by an engraving made by Aldegraver in 1532 (Illustrated Bartsch, vol.16, no.18, p.143), though the figure there is actually tucked up in bed to the neck; see *Corpus*, vol.2, p.296 and note 4.

7 Bartsch 74. See A. Ozaki, 'Some Observations on the Motif of Saskia's drooping Head in the Drawings by Rembrandt during the 1630s', *Art History*, Tohuku University, Kawauchi, Japan, VI, 1984, pp.73–90.

8 For an account of the iconography of Dürer's print see F. Yates, *The Occult Philosophy in the Elizabethan Age*, London/Boston, 1979, pp.49–59.

9 This originated in a pseudo-Aristotelian text disseminated by the Italian Renaissance writer Marsilio Ficino in 'De Triplicita Vita': for more information on this subject see note 8 above.

44

1 London 1992, p.69.

2 Christie's, London, 17 June 1840, lot 16.

3 London 1992, loc.cit., quoting A. Ozaki, 'Some Observations on the Motif of Saskia's drooping Head in the Drawings by Rembrandt during the 1630s', *Art History*, Tohuku University, Kawauchi, Japan, VI, 1984, pp.73–90.

4 London 1992, loc.cit.

45

1 See Marieke de Winkel's essay in this catalogue, p.56 and note 15. The bandon is probably also depicted in cat.43, 48, 50.

46

1 Benesch 255.

2 E. Michel, 'La collection Dutuit, *Gazette de Beaux Arts*, 1903, I, p.239: 'la lourdeur de l'exécution nous rend un peu douteuse l'attribution de ce dessin, et aussi de la *Femme au Lit*.'

3 Benesch 284.

4 See B.S. Schapiro's review, 'R. Bretell and C. Lloyd's *Catalogue of Drawings by Camille Pissarro in the Ashmolean Museum, Oxford*' in *Master Drawings*, vol.XX, Number 4, Winter 1982, pp.394–5, and figs.2, 3.

47

1 White 1999, p.177 and note 14.

2 See Berlin/Amsterdam/London 1991–2, vol.2, cat.10, note 1.

3 Schatborn 1985, p.16, and note 1.

4 Amsterdam/London 2000–1, cat.28, fig.a.

5 Strauss/Van der Meulen, 1656/12, no.1: 'een stuckie van Ad. Brouwer, sijnde een koekebacker'. This has also been interpreted as a pastry cook but an etching by Theodoor Matham after A. Brouwer shows that Brouwer certainly painted this subject: see Amsterdam/London 2000–1, cat.28, fig.b.

6 Convincingly suggested by Ger Luijten in Amsterdam/London 2000–1, pp.153–4, who likens it to a drawing now attributed to Arent de Gelder: see fig.d.

7 Benesch 409; see Schatborn 1985, cat.6, pp.16–17.

8 *Corpus*, vol.3, A106, p.83.

48

1 Hofstede de Groot 1906A, 412, no.17; Schatborn 1981A, pp.10–12. See too A. Bredius, 'De Schilder Johannes van de Cappelle', *Oud Holland*, vol.X, 1892, p.37 and M. Russsell, *Jan van de Cappelle*, Leigh-on-Sea, 1975, p.55.

2 Van Eeghen 1956, p.144.

3 Strauss/Van der Meulen, 1635/6 and 1636/3.

4 London 1983, p.6, on this proposal made in the entry for Benesch 280c.

50

1 See cat.48, note 2.

2 Benesch 113.

3 Bartsch 8. Suggested by Benesch, reproduced in London 1992, cat.11, p.51, fig.11a.

51

1 See Benesch 276, which refutes the suggestion made originally by Bauch that the drawing dated from the Leiden period.

52

1 See P. Schatborn, 'Over Rembrandt en Kinderen', *Het Kroniek van het Rembrandthuis*, 27, 1975, pp.8–19.

2 Benesch 92. See too Berlin/Amsterdam/London 1991–2, vol.2, cat.10, pp.48–50.

3 *Corpus*, vol.3, A113. See too Berlin/Amsterdam/London 1991–2, vol.1, cat.24, pp.192–5.

4 *Corpus*, vol.3, A106: for a detail showing this figure see p.77.

5 *Corpus*, vol.3, p.166: see Strauss/Van der Meulen, 1635/1.

6 *Corpus*, vol.3, A119. See too J. Bruyn, 'On Rembrandt's use of Studio-Props and Model drawings during the 1630s', *Essays in Northern European Art presented to Egbert Haverkamp-Begemann on his sixtieth birthday*, Doornspijk, 1983, pp.52–60.

7 See Schama 1987, 'In the republic of Children', pp.481–516, and also J. Dekker, 'Trotse Opvoeders van Kwetsbare Kinderen. De pedagogische ruimte in de Nederlanden', essay in Haarlem/Antwerp 2000–1, pp.43–60.

8 Inv.no.22085: see Bremen 2000–1, cat.72, pp.132–3.

53

1 Berlin/Amsterdam/London 1991–2, vol.2, p.46.

2 Ibid., and note 4.

3 Stampfle lists all the drawings identified with this mark in his entry on this drawing in Paris/Antwerp/London 1979–80, pp.99–100. He notes that Jeroen Giltaij saw the mark as an 'R', standing for Rembrandt, while others have suggested that it was simply a collector's mark.

54

1 Benesch 403.

55

1 See *Corpus*, vol.3, p.83.

56 & 57

1 London 1992, p.65. For an example see Benesch 219.

2 The two British Museum sketches are generally thought to date from the 1630s but Benesch dated them to as late as 1645–50: see London 1992, p.66, note 3.

3 Benesch 1169; London 1992, cat.60, pp.137–8.

58

1 As convincingly suggested in Berge-Gerbaud 1997, p.19.

2 Benesch 342.

59

1 Parival, *Les Délices de la Hollande*, Leiden, 1662, p.98, quoted by Schama 1987, p.576.

2 See Schama 1987, pp.570–9.

3 Benesch 198.

4 *Corpus*, vol.3, A106. This was first suggested by Benesch, who accordingly gave this sheet a similar date.

5 Paris 1988–9, cat.23, p.35. A link is suggested with the seated figures at the right of the etching of the *Death of the Virgin* of 1639 (Paris 1988–9, cat.84) but the parallel does not seem particularly close to this author.

60

1 Berge-Gerbaud 1997, cat.5, p.14, note 6.

2 Ibid., p.14.

3 For a comprehensive and updated review of recent research on this subject see http://www.knaw.nl/ecpa/ink/

61

1 Giltaij 1988, p.55.

2 See Amsterdam/London 2000–1, p.156, fig.c and note 4.

62

1 White 1999, p.131.

2 Amsterdam/London 2000–1, p.156, and note 3; J. Bolten, *Dutch and Flemish Drawing Books. Method & Practice 1600–1750*, Landau, 1985.

63 & 64

1 White 1999, p.131.

2 Berlin/Amsterdam/London 1991–2, vol.2, p.198.

3 Amsterdam/London 2000–1, p.155 and note 5.

4 Ibid., p.156.

65

1 Amsterdam/London 2000-1, p.156, note 6.

66

1 First recognised by W.R. Valentiner, 'Komödiantendarstellungen Rembrandt's', *Zeitschrift für bildende Kunst*, vol.50, 1925-6, pp.265-77. For an example see too Berlin/Amsterdam/London 1991-2, vol.2, cat.12, pp.54-6.

2 See Benesch 316, 316a, 317, 319, 320, 321, 322. Not all of these, however, are still thought to have been drawn by Rembrandt.

3 H. van de Waal, 'Rembrandt at Vondel's Tragedy Gijsbreght van Aemstel', *Miscellanea I.Q. van Regteren Altena*, Amsterdam, 1969, pp.145-9.

4 B. Albach, 'Een tekening van het Amsterdamse toneel in 1638', *De Kroniek van het Rembrandthuis*, 1972, pp.111-25.

5 Benesch 122.

6 Paris/Antwerp/London/New York 1979-80, p.102.

67

1 Valentiner doubted the drawing and it was elsewhere ascribed to Philips Koninck, see Benesch 319. A number of similar studies have since been attributed to pupils, such as Benesch 320, now given to Govert Flinck: see Giltaij 1988, cat.77, p.167.

2 C. N. Wybrands, *Het Amsterdamse toneel van 1617-1772*, Utrecht, 1873, p.85.

3 M. Louttit, 'The romantic dress of Saskia van Ulenborch: its pastoral and theatrical associations', *The Burlington Magazine*, 115, 1973, pp.317-26, p.326, note 41.

68

1 I.Q. van Regeren Altena, review of Seilern 1961 in *Oud Holland*, LXXIX, 1964, p.184.

69

1 *Corpus*, vol.2, A92.

2 *Corpus*, vol.1, A31.

3 E. Malone (ed.), *The Works of Sir Joshua Reynolds*, 4th edn, London, 1809, vol.3, pp.344-5.

4 *Corpus*, vol.3, p.200 and note 1: suggested by the authors, De Vries/Tóth-Ubbens/Froentjes 1978.

5 As stated by A. Wheelock Jr, in his review of De Vries/Tóth-Ubbens/Froentjes 1978, *Art Bulletin*, 63, 1981, pp.164-8.

6 Berlin/Amsterdam/London 1991-2, vol.1, p.198.

7 Suggested by Broos 1987, p.290, fig.3. Many classical statues of Venus (though not necessarily those called Venus Pudica) showed her hands trying to cover these areas: for example, Haskell/Penny 1981, cat.84, 85, 86, 88.

8 Amsterdam 1976, cat.68. Jan Steen's *A Woman at her Toilet* of 1663 (Buckingham Palace, London) shows this motif and there are many other such examples in his work: see Washington/Amsterdam 1996-7.

9 *Corpus*, vol.3, p.200.

10 E.J. Sluiter's essay in this catalogue.

11 E. McGrath, 'Rubens's "Susanna and the Elders" and moralising inscriptions on Prints', in H. Vekeman and J. Muller Höfstede (eds.), *Wort und Bild in der niederländischen Kunst und Literatur des 16. Und 17. Jahrhunderts*, Erftstadt, 1984, pp.81-5.

12 Pieter Lastman, *Susanna at the Bath*, 1614: oil on panel, 42 × 58 cm, Gemäldegalerie Staatliche Museen, Berlin.

13 Benesch 448.

14 The State Hermitage, St Petersburg, inv.no.1958.

15 The concept of 'Herauslösung' as suggested by C. Tümpel, *Jahrbuch der Hamburger Kunstsammlungen*, 13, 1968, pp.95-128.

70

1 Benesch 457. The comparison was suggested by Benesch in his entry for Benesch 137. The elephant, with related studies Benesch 458-60, was used as in the background of Rembrandt's 1638 etching of *Adam and Eve* (see cat.72).

71

1 See, too, the bibliographical addenda to that catalogue in G. Goldner, L. Hendrix, with the assistance of K. Pask, *European Drawings-2, Catalogue of the Collections. The J. Paul Getty Museum*, Malibu, 1992, p.357.

2 For the dating of this sheet, see cat.70, note 1.

3 Van Hoogstraten 1678, p.31: Maer tot het teykenen van tronien, handen, of geheele naekten na't leven, moogt gy gesmijdich root krijt op wit papier gebruiken. See too cat.9.

4 First suggested by J. Byam Shaw, *Old Master Drawings*, 3, no.10, September 1928, pp.31-2.

5 White 1999, p.39.

6 In a forthcoming paper, 'Rembrandt and Eve: from Drawing to Print'. I am most grateful to Lee Hendrix of the J. Paul Getty Museum, Los Angeles, for making her research on this topic available to me.

7 Illustrated Bartsch, vol.15, p.40, 4/II (115) [Pauli 4]: engraving, 8.1 × 5.4 cm.

8 Oil on canvas, 87 × 71.2 cm, Israel Museum, Jerusalem: reproduced Broos 1981, p.129, fig.b.

9 Broos 1981, p.129, note 10.

10 Apart from works depicting nursing mothers, it is nonetheless rather unusual for a woman to be shown in such a pose alone. A later example can be seen in a drawing attributed to Girodet (Christie's London, 7 July 1988, lot 258: later in *Master Drawings*, Colnaghi's, New York/London, 1999, cat.43).

72

1 As E. de Jongh has pointed out in his essay in this catalogue, women were 'still tainted by the dubious reputation of the first woman': see p.29.

2 Benesch 163.

73

1 M. Royalton-Kisch points out that the only other known impression of the first state which is in Vienna is not touched: Amsterdam/London 2000-1, p.158.

2 *Christ in Purgatory*, engraving, monogrammed and dated 1512, 11.7 × 7.5 cm, Bartsch 16, from the 1512 *Engraved Passion*.

3 Strauss/Van der Meulen, 1638/2. Rembrandt spent 224 guilders on various prints at this auction in the late collector Gommer Spranger's house on the Fluwelburgwal in Amsterdam. See also Amsterdam 1999-2000, p.106.

4 Van Mander/Miedema 1994-6, I, pp.90-1.

5 Amsterdam/London 2000-1, p.158.

6 Bartsch 1797, no.28, quoted by A. Blankert in Melbourne/Canberra 1997-8, p.38. Bartsch was influenced in this observation by Gersaint 1751, pp.18-19, no.29. Bartsch was custodian of the Imperial Library in Vienna. From 1803 to 1821 he published in twenty volumes *Le peintre graveur*, the pioneering work in the systematic study of Dutch, Flemish, German, and Italian painter-engravers from the fifteenth to the seventeenth century. This still remains of great importance to art historians and the numbering system he adopted has been referred to by most subsequent works in this field.

7 Tümpel 1970, no.1, and H. Bevers in Berlin/Amsterdam/London 1991-2, vol.2, cat.11, pp.195-7.

74

1 White/Boon, p.152, quote this from Landesberger, *Rembrandt, the Jews and the Bible*, Philadelphia, 1946, p.74.

75

1 London 1992, p.83, note 10, with reference to the *Venus Felix* in the Vatican.

2 White 1999, p.180, and note 22, notes that Pierre Yver calls it this in his 1756 supplement to Gersaint's catalogue of Rembrandt's etchings.

3 Hollstein, 21, repr. This was suggested by F. Saxl, 'Zur Herleitung der Kunst Rembrandts', *Mitteilungen der Gesellschaft für vervielfältigende Kunst*, II-III, 1910, pp.42-3. Saxl also stated that the large palm frond which the model holds relates to a print of *Fame and Victory* by Jacopo de' Barbari, Bartsch 18.

4 Ovid, *Metamorphoses*, Book X, 243-97.

5 As shown in cat.40.

6 Benesch 423. See too London 1992, cat.27, pp.81-3.

7 Amsterdam/London 2000-1, p.179. Erik Hinterding notes that the second state was printed several times around 1640, though it was left aside until used for printing again in around 1652.

8 See P. Schatborn, 'Tekeningen van Rembrandt in verband met zijn etsen', *Kroniek van het Rembrandthuis*, 38, 1985, pp.93-109.

9 White 1999, p.182. Rembrandt started off with a drypoint sketch and then worked up the darkest areas first.

76

1 See for example, W.W. Robinson, 'Nicolaes Maes a Draughtsman', *Master Drawings*, XXVII, 1989, pp.146-62, especially fig.21, p.154, for its compositional (though not stylistic) similarity to the drawing here.

2 Schatborn 1985, p.32, and notes 6 and 7.

3 Benesch 253.

4 Benesch 282, 360, 405, 427, and other works already mentioned in this catalogue.

5 Schatborn 1985, p.26.

77

1 Oil on panel, 58.4 × 89.5 cm, Sotheby's, New York, 14 October 1999, lot 84 (version of a composition by Palamedesz in the Goldstein Brinkmann Collection). For another version of this subject see also Sotheby's, London, 16 December 1999, lot 134.

2 'naest den pensijonaris Boereel niuwe doelstraat', the address Rembrandt gave on a letter to Constantijn Huyghens written in February 1636, the month of Rumbartus's death: see Strauss/Van der Meulen, 1636/1 and Schatborn 1985, note 2.

3 'op die binnen emster, thuis is genaemt die suijkerbackerrij', the address which Rembrandt listed as his own in 17 December 1637 and 12 January 1639: see Strauss/Van der Meulen, 1637/7 and 1639/2.

4 Strauss/Van der Meulen, 1638/8 and 1638/9.

5 Benesch 413: see Mongan/Sachs 1946, cat.522, pp.275-6 (inv.no.1961.151). The drawing was worked up in another hand which adds to the difficulty in determining its precise status.

78

1 National Gallery, London, inv. no.186: see L. Campbell, *The Fifteenth Century Netherlandish Schools, National Gallery, London*, London, 1998, p.191 and note 110.

2 Schama 1987, pp.524-5.

3 For a discussion of J. van Beverwijck's writings, see L.van Gemert, 'The power of the weaker vessels: Simon Schama and Johan van Beverwijck on women', in Kloek/Teeuwen/Huisman 1994, pp.39-50 and for M. Spies's critique, pp.51-3.

4 For a list of contemporary literature on this subject see Schama 1987, p.669.

5 Schama 1987, p.521 and note 34 and 35.

6 B. Batty, *The Christian Man's Closet*, translated from the Dutch by W. Louth, London, 1581, sig.31, quoted by Franits 1993, p.112, note 10.

79

1 See Benesch 226.

2 London 1992, p.84.

3 Benesch 168 and Benesch 161 verso (studies for White/Boon B 37).

4 Benesch 451.

5 See London 1992, p.85. Both drawings are in the Rijksprentenkabinet, Amsterdam: *Boy walking with a Stick* (not in Benesch but see Schatborn 1985, no.13) and *Cow in a Shed* (Benesch 393, Schatborn 1985, no.15).

6 Noticed by Benesch.

7 Benesch 370. Roughly similar types were often used in Rembrandt's work of the early 1630s, such as White/Boon B 119, B 151.

80

1 Benesch 314, where it is called Friesian or Zeeland costume.

2 Hofstede de Groot 1906, no.1327, as *c*.1635. M. Royalton-Kisch remarks in London 1992, p.71, that the same form of costume appears in an illustration of women from Leiden too, as seen in *Rembrandt tentoonstelling. Tekeningen*, Boijmans Van Beuningen Museum, Rotterdam; Rijksprentenkabinet, Amsterdam 1956, p.94.

3 Plomp 1997, p.301.

4 H. Diederiks, *Een stad in verval. Amsterdam omstreeks 1800*, Amsterdam, 1982, pp.349-50.

5 See L.C. van de Pol, 'The lure of the big city. Female migration to Amsterdam', in Kloek/Teeuwen/Huisman 1994, pp.73-81.

6 See cat.29, note 1.

7 'Een boerin en een slapend vrouwtje met een Kindtje aan de borst van Deselve [Rembrandt]', quoted in Plomp 1997, p.301 and note 1.

8 London 1992, on the basis of the similarity of the London sheet to Benesch 168 datable to *c*.1638 and the cursively drawn figure in the Haarlem sheet to the group at the right hand of Benesch 164, the study for *Adam and Eve* (see cat.72).

9 Plomp 1997, p.301, who notes that Haverkamp-Begemann, Rosenberg, White and Slive range from 1642 to 1645 in their dating of the drawing.

10 Plomp 1997, p.301.

81

1 Strauss/Van der Meulen, 1649/6, states specifically a dry nurse rather than a wet nurse.

2 For an alternative reading of this inscription as a Venus by Rembrandt, see cat.100, note 10 and Melbourne/Canberra 1997-8, p.133 and notes 18, 19.

3 Wijnman 1968, pp.103-5.

4 Strauss/Van der Meulen, 1634/9.

5 Strauss/Van der Meulen, 1648/2. Trijntje Beets, child of Pieter Lambertsz Beets of Hoorn was left the sum of 100 carolus guilders.

6 Strauss/Van der Meulen, 1642/8.

7 Strauss/Van der Meulen, 1640/5.

8 See S.A.C. Dudok van Heel's essay in this catalogue, p.24.

9 Wijnman 1968, p.114.

10 London 1992, cat.20, pp.70-1.

11 Amsterdam 1984-5, cat.14, p.25.

82

1 *Corpus*, vol.2, A85.

2 Ger Luijten in Amsterdam/London 2000-1, p.165, notes that this was an original conception but may have been based on Hans Holbein's figure of Death playing a trumpet in his 1538 woodcut, *Gebeyn aller Menschen*, repr. fig.b.

3 Amsterdam/London 2000-1, p.165.

4 See K. Hoffmann, 'Holbeins Todesbilder', *Ikonographia. Anleitung zum Lesen von Bildern. Festschrift Donat de Chapeaurouge*, Munich, 1990, pp.97-110.

5 Strauss/Van der Meulen, 1656/12, no.237.

6 Amsterdam/London 2000-1, p.165.

7 Bartsch 94.

83

1 Amsterdam/London 2000-1, p.162.

2 Albrecht Dürer, *The Birth of the Virgin*, 1511, woodcut, 29.7 × 21 cm, Bartsch 80. *The Death of the Virgin* from this series also seems to have been influential in its relation to the depiction of the bed and the figure seen from behind, kneeling and holding the long cross, relating to a similar figure in Rembrandt's print: see White 1999, p.42.

3 Strauss/Van der Meulen, 1638/2.

4 White 1999, p.43, fig.50. The *vidimus* design for this is in the Rijksprentenkabinet, Amsterdam, pen and ink with wash, 29.8 × 23.1 cm.

5 White/Boon B 73.

6 Philip Galle after Pieter Bruegel the Elder also crowded his version of the scene with both men and women (Hollstein 106): see Amsterdam/London 2000-1, p.164, note 6.

7 White/Boon B 212: see C. Campbell, 'Rembrandt's etsen "Het Sterfbed van Maria en De drie bomen"', *Kroniek van het Rembrandthuis*, 32, 1980, nr.2, pp.2-33, and Hinterding 1995, pp.10-11.

8 Amsterdam/London 2000-1, pp.207-8, and notes 5 and 9.

84

1 London 1992, p.78 and note 4: originally suggested in Haak 1969.

2 London 1992, p.78.

3 Benesch 451.

4 Suggested by M. Royalton-Kisch in London 1992, p.78.

85

1 *Corpus*, vol.3, p.318.

2 *Corpus*, vol.3, A145.

3 *Corpus*, vol.3, A139.

4 I.H. van Eeghen, 'Maria Trip of een anoniem vrouwsportret van Rembrandt', *Maandblad Amstelodamum*, 43, 1956, pp.166-9.

5 *Corpus*, vol.3, A132. She was also known by the name of Aeltje, Alitea, Aeltken and, wrongly, Alotta.

6 *Corpus*, vol.3, p.452 and note 15. It is noted that although this is unlikely to have been the direct cause (especially given the fact that most of the militia group portraits there did not appear until 1640-2), the visit may nonetheless have provided the 'more general reason for decorating the hall fully'.

7 Rather scandalously, three suitors, Coymans, Boreel and Fabry, were mentioned in connection with Maria: see Schwartz 1984, pp.207-8.

86

1 Giltaij 1988, p.66, note 5.

2 Gerson 1968, no.385, pp.130, 503. Both J. Giltaij and P. Schatborn argue against this, on the basis that Jacob Cuyp's portrait of Margaretha of 1651 does not show any close resemblance.

87

1 Benesch believed the portrait in the Royal Collection, Buckingham Palace, London (*Corpus*, vol.3, A145), depicted Titia as well, rather than Agatha Bas.

2 Strauss/Van der Meulen, 1638/8 and 1638/9.

3 Ibid., 1640/5.

4 Ibid., 1640/6.

5 Ibid., 1642/3. The document gives the dates of death as 5 June 1641 for Titia and 4 June 1642 for Saskia, but this was according to the Julian calendar in use in Friesland until 1700.

6 Ibid., 1641/4. See also London/The Hague 1999-2000, pp.213-14.

7 J. Schmidt-Degener, 'Portraits peints par Rembrandt', *L'Art Flamand et Hollandais*, 19, 1913, pp.180-1. He then owned the drawing and pointed it out as a possible source for Rembrandt's composition. Its attribution is rejected by R. Cocke, *Veronese Drawings. A Catalogue Raisonné*, London, 1984, p.331, no.154v (who confuses Saskia with Titia in the title of the Stockholm drawing).

8 Strauss/Van der Meulen, 1668/5. The drawing is in an album bound in black morocco with the words 'Lucas Teeckeninge 1637': British Museum, London, inv.no.1892.8.4.8-23.

88

1 'op die binnen emster, thuis is genaemt die suijkerbackerrij', the address which Rembrandt listed as his own in 17 December 1637 and 12 January 1639: Strauss/Van der Meulen, 1637/7 and 1639/2.

2 See S.A.C. Dudok van Heel's essay in this catalogue, pp.23-4.

3 Strauss/Van der Meulen, 1638/7: 'dat d'Impetrants voorsz. Huysfrouwe met pronken en de praelen haer ouders erffenisse hadde verquist...'

4 Ibid., 'hij Impetrant ende sijn huysfrouwe voorsz. rijckelyck ende ex superabundanti sijn begoediget (waervan sij den Almachtigen nummermeer genochsaem connen dancken)...'

89

1 Bredius/Gerson 361, p.578.

2 Benesch 310.

3 Paris 2000, cat.93, p.140.

4 Strauss/Van der Meulen, 1640/8.

90

1 See cat.83, note 3.

2 Broos 1977, pp.75-6.

3 Bartsch 2; see M. Schapelhouman in Amsterdam/London 2000-1, p.193, fig.a.

4 Strauss/Van der Meulen, 1656/12, no.195:'een dito met kopere printen van Vani en anderen als meede barotius'.

91

1 Benesch 280e.

2 See, for example, cat.43 and 44.

92

1 Strauss/Van der Meulen, 1641/4.

2 S.A.C. Dudok van Heel's essay in this catalogue, p.27.

3 Bijtelaar 1953, pp.50-2.

4 National Gallery of Victoria, Melbourne: see Melbourne/Canberra 1997-8, cat.75, fig.75a, p.334.

5 Hind dated the etching to about 1639 while Münz 1952, no.96, and White/Boon B 369 ascribe it to about 1641-2. See too London 1992, cat.19, p.69, note 2, where M. Royalton-Kisch suggests that the earlier date is still possible.

93

1 White 1999, p.141.

2 Strauss/Van der Meulen, 1642/2.

3 Had the Chamber of Orphans not been excluded, a list of Titus's possessions would have had to have been made separately at this time. These would then have been excluded from Rembrandt's bankruptcy sale of 1656: see Tümpel 1993, p.233.

94

1 Daulby 1776, pp.85-6.

2 See M.P.A.M. Kerkhof, 'Cervantes in de Nederlanden tot 1746', *Mededelingen van de Stichting Jacob Campo Weyerman*, 18, 1995, 1, pp.3-10.

3 J. Six, *Oud Holland*, 1909, vol.27, p.90.

4 Benesch 737.

5 A drawing inspired by this etching has been supposed to represent Ruth and Naomi. See Giltaij 1988, cat.121, p.121, perhaps by N. Maes.

6 See Berlin/Amsterdam/London, vol.1, cat.83, pp.388-90, for a discussion of the depiction of this subject in the Netherlands and the interpretation of Rembrandt's etching here.

95

1 Benesch 738; Sumowski 1979-92, vol.1, cat.207, p.438.

96

1 See S. Slive, 'Rembrandt at Harvard', *Apollo*, CVII, June 1978, p.455.

2 *Corpus*, vol.3, A143.

3 First suggested by L.C.J. Freirichs, 'De schetsbladen van Rembrandt voor het schilderij van echtpaar Anslo', *Maandblad Amstelodamum*, 56, 1969, pp.206-11; see *Corpus*, vol.3, p.412.

4 Benesch 759.

5 See Berlin/Amsterdam/London 1991-2, vol.1, cat.33, p.224.

6 Both this and the link to Margaretha de Geer are rejected by Slive, op.cit., p.457: 'neither identification would seem to be acceptable'.

7 H.R. Hoetink, 'Nog een portret van Margaretha de Geer', *Miscellanea I.Q. van Regteren Altena*, Amsterdam, 1969, pp.150-1, p.341, fig.1.

97

1 White 1999, p.184.

2 B. Bakker et al., *Landscapes of Rembrandt - his favourite walks around Amsterdam*, Gemeentearchief, Amsterdam; Institut Néerlandais, Paris, 1998-9, pp.26-9.

3 Amsterdam/London 2000-1, p.202, fig.a: *Shepherd and Shepherdess*, 1624, oil on panel, 53 × 47 cm, Museum Naradowe, Gdansk.

4 'Een hardersdriffie', Strauss/Van der Meulen, 1656/12, no.60, quoted in Amsterdam/London 2000-1, p.200.

5 Wethey 1975, vol.3, cat.36, pp.182-4. The Titian was, incidentally, copied by Jan de Bisschop in about 1650: see Wethey p.184.

6 A. McNeil Kettering, 'Rembrandt's Flute Player: a unique treatment of pastoral', *Simiolus*, 7, 1977, 1, p.37 and note 72.

7 Berlin/Amsterdam/London 1991-2, vol.2, p.212 and note 6.

8 Known from an inscription on the back of one of Rembrandt's self-portrait etchings: see Amsterdam/London 2000-1, cat.4, p.88; see too p.201 and note.6.

9 B. Cornelis and J.P. Filedt Kok, 'The taste for Lucas van Leyden prints', *Simiolus*, 26, 1998, pp.43-4.

10 Amsterdam/London 2000-1, p.201.

11 Berlin/Amsterdam/London 1991-2, vol.2, p.212 and Amsterdam/London 2000-1, p.203, note 7.

12 Amsterdam/London 2000-1, p.203, note 9.

98

1 White/Boon B 212. The lovers, barely visible in some impressions but hidden in the den of bushes in the right foreground, have been interpreted in various ways. See M. Royalton-Kisch in Amsterdam/London 2000-1, cat.48, pp.207-9, especially note 7.

2 White/Boon B 209. The lovers appear in the shadow at the left of the gnarled tree.

3 Tentatively suggested by White 1999, p.184; by I. Zdanowicz in Melbourne/Canberra 1997-8, p.406.

99

1 *Corpus*, vol.2, A88.

2 *Corpus*, vol.3, A118. The treatment is there likened to Rembrandt's *Ganymede* (*Corpus*, vol.3, A113), albeit on a larger scale: see p.206. See too Gerson 1961 for the Stadholder's commission.

3 Gerson 1968, p.94.

4 Tümpel 1986, p.245 and Berlin/Amsterdam/London 1991-2, vol.1, p.162.

5 Bredius/Gerson 572, p.608. This was suggested by Bernhard Schnackenburg, of Schloss Wilhelmshöhe, Staatliche Museen, Kassel, in a paper on the picture given at the Rijksmuseum, Amsterdam, 6 December 1999.

6 Bredius/Gerson 574, p.608.

7 Strauss/Van der Meulen, 1646/6. A smaller related version of this subject is in the National Gallery, London, dated 1646, Bredius/Gerson 575, p.608; McLaren/Brown 1991, cat.53, pp.330-2 (as Rembrandt), but is believed by Tümpel 1993, p.250, to be painted by a member of Rembrandt's studio.

8 *Corpus*, vol.3, C87: 'an attribution to Ferdinand Bol is worth considering', p.557. See note 14.

9 Bredius/Gerson 568, p.608, undated: rejected by Rembrandt Research Project as Rembrandt studio (the conclusion of a conference on the picture held at the Rijksmuseum, Amsterdam, 6 December 1999).

10 See Bredius/Gerson 570, p.608.

11 Benesch 567. One wonders if the drawing was not made after the Hermitage painting rather than preparatory for it.

12 Benesch 596; D. Scrase, *The Golden Century; Dutch Master Drawings from the Fitzwilliam Museum, Cambridge*, Munich/Heidelberg/Braunschweig/Cambridge, 1995-6, cat.107, p.107.

13 Benesch 555 and Sumowski 1979-92, vol.1, no.248. Attributions of drawings to Bol have been complicated because they were usually based upon a drawing of *Joseph Interpreting Dreams* (Sumowski 1979-92, vol.1, no.101) related to a painting in Schwerin. However, the painting is now no longer thought to be by Bol: see Bruyn 1988 in which the oil is given to Kneller (no.970).

14 Sumowski 1979-92, vol.1, no.195, see note 8.

15 Benesch 516; London 1992, cat.43, pp.111-12.

100

1 A. Chong, *European and American Painting in the Cleveland Museum of Art*, Cleveland Ohio, 1993, p.133, inv.no.78.54.

2 N.S. Trivas, 'New Light on Rembrandt's so-called "Hendrickje" at Edinburgh', *The Burlington Magazine*, no.70, 1937, p.252.

3 For Cooper's print of 1781 see Melbourne/ Canberra 1997–8, p.133, note 15 and fig.14d. The presence of the inscription 'Lord Maynard' on one of the three preparatory drawings for this print now in the National Gallery of Scotland (D 4820/59 verso) has implications for the provenance of the *Woman in Bed* since it must have been in the collection of Lord Maynard by 1781 when Cooper copied it (it was previously believed to have been acquired by him in *c.*1790).

4 HdG 305.

5 National Gallery of Scotland, Edinburgh, D 48201/59 verso – detail of head and hand. Inscription: 'Rembrand's Mistriss – Lord Maynard'.

6 N.S. Trivas, 'New Light on Rembrandt's so-called "Hendrickje" at Edinburgh', *The Burlington Magazine*, no.70, 1937, p.252.

7 Gerson 1968, cat.227, p.497, as dated '164–': 'must date from the late 1640s'; Berlin/ Amsterdam/London 1991–2, vol.1, cat.36, p.230 as 164[5]; Tümpel 1993, cat.23, p.392, 'around 1649/50'.

8 Gerson 1968, cat.227, p.497, notes that this is Hendrickje though her identity 'is not beyond dispute'; Slatkes 1992, cat.292, p.442, still keeps the Hendrickje title though with reservations.

9 Schwartz 1984, p.240, though he interprets the date on the Liotard miniature copy of the Rembrandt in Tronchin's portrait as 1647 (rather than 1641, as stated by Trivas).

10 Strauss/Van der Meulen, 1647/1.

11 Melbourne/Canberra 1997–8, p.133.

12 *Corpus*, vol.3, A119.

13 Museum of Fine Arts, Boston. We know that Rembrandt copied his master's work, and corrected it, as shown in the drawing of *Susanna and the Elders*, Berlin, see fig.113.

14 Tümpel 1993, cat.23, p.392.

15 Book of Tobit 6–8.

16 Clipping from *The Saturday Review*, 26 March 1892, in Gallery files.

17 Professor van de Wetering suggested at a lecture in Melbourne 1997 that this painting was actively intended to deceive the eye, in the same way as Roger de Piles mentions the Dulwich *Girl at a Window* as being placed at the window of Rembrandt's house to deceive passers-by: see cat.104.

18 'bedrog', quoted by Van de Wetering 1997, p.186.

19 *Corpus*, vol.3, A146.

20 Quoted from Hoogstraten's *Inleyding tot de hooge schoole der schilderkonst* by Van de Wetering 1997, p.184.

21 A. Blankert in Melbourne/Canberra 1997–8, cat.14, p.133 and note 17.

22 National Gallery of Scotland, Edinburgh, inv.no.D 48201/18 verso.

101

1 See *Dutch Genre Drawings of the Seventeenth Century. A Loan exhibition from Dutch Museums, Foundations and Private Collections*, exhibition catalogue, Pierpont Morgan Library, New York/ Museum of Fine Arts, Boston/Art Institute of Chicago, 1972–3, cat.89, p.56.

102

1 White/Boon B 57.

2 White 1999, p.50.

3 White/Boon B 96 and B 147; see White 1999, p.50.

103

1 Benesch 749. Suggested by M. Royalton-Kisch in London 1992, p.57.

2 White/Boon B 285.

104

1 C. White in Washington/Los Angeles 1985–6, p.100.

2 Benesch 427.

3 London 1992, p.58.

4 Bredius/Gerson 377, p.580.

5 As noted by G. Cavalli-Björkman in London 1992, p.15, who suggests that this is unlikely.

6 C. Brown in Berlin/Amsterdam/London 1991–2, vol.1, p.352.

7 M. Carlson, 'A Trojan Horse of Worldliness? Maidservants in the burgher household in Rotterdam at the end of the seventeenth century' in Kloek/Teeuwen/Huisman 1994, p.95 and note 31.

8 Valentiner 1905, p.41, 44.

9 Strauss/Van der Meulen, 1649/4, 1 October.

10 *Corpus*, vol.3, A134.

11 M. Roscam Abbing in London 1993, pp.19–24 and Roscam Abbing 1999, pp.89–128.

12 London 1993, p.19.

13 The book cover of Roscam Abbing 1999 shows the Dulwich picture set into a window of the Rembrandthuis, but a figure such as the Stockholm *Kitchen Maid* placed frontally with her arms lying flat upon a ledge would have made a far more convincing figure, relating to the planes of the real structure of the window.

14 Bredius/Gerson 378, p.580. See too Wheelock 1995, pp.287–96.

15 London 1993, cat.3, pp.56–7, attributed to a pupil of Rembrandt.

16 Berlin/Amsterdam/London 1991–2, vol.1, cat.72, pp.350–3.

17 Sandrart/Peltzer 1925, p.203. See too London 1993, p.13, note 2 for references to Rembrandt as a teacher.

18 London 1993, p.12 and Wheelock 1995, p.292. For the work of these artists see Sumowski 1983–95.

19 Sumowski 1983–95, vol.4, no.1785, signed and dated 1640, Musée du Louvre, Paris, inv.no.1194.

20 Salomon Liliaan Gallery, Amsterdam.

21 For the work of these artists see Sumowski 1983–95. Bol also painted elaborate composi- tions depicting a woman at a window (more akin to Victors's woman shown here than to the Dulwich girl): see Sumowski 1983–95, vol.1 nos 122 and 123, the former dated '164…'.

105

1 The placement of the figures and the line drawing is close to Benesch 658, although without the use of wash. This was dated by Benesch to about 1640–2 and linked to Benesch 659 in the British Museum which M. Royalton Kisch dates to *c.*1639–40: see note 3 below.

2 Benesch 382.

3 Benesch 659: see London 1992, p.87.

106

1 Benesch 707.

2 White/Boon B 157.

3 See Benesch 706.

107

1 See Amsterdam/London 2000–1, p.213, p.215, fig.a and p.217, figs.c and d. The pose of Rembrandt's standing figure is in reverse from those of the three pupils' drawings, implying that he was drawing straight onto the copper, they onto the paper.

2 Berlin/Amsterdam/London 1991–2, vol.2, p.224, note 5, quoted by Emmens 1968, p.157.

3 White/Boon B 193 and B 196.

108

1 Bartsch 179, 11.7 × 7.4 cm.

2 Bartsch 178.

3 Amsterdam 1997, cat.52, pp.260–3. For example, Ger Luijten quotes a seventeenth- century riddle which makes this link clear (p.261 and note 6) and cites lines from the poem 'The Milkmaid', *c.*1767, where the milkmaid desires to 'play with a young man's milk when I go out milking again' (p.263, note 10).

4 Amsterdam/London 2000–1, p.221 and notes 3 and 4.

109

1 The first state of the plate measures 15 × 22.4 cm; the second, third and fourth states measure 12.5 × 22.4 cm; the fifth measures 12.5 × 17.6 cm.

2 Daulby 1796, p.119.

3 M. Muller, for example, thought so; see E. de Jongh in Amsterdam 1997, p.282 and note 4.

4 Amsterdam 1997, p.281 and note 3. The publication was H.W. Singer's contribution to the *Klassiker der Kunst* series. The prints omitted were White/Boon B 39, B 186, B 188, B 189, B 190, B 191.

5 Ibid., note 3. For institutional reaction to some of the Italian pornography mentioned below see B. Talvacchia, 'Fragments of "I modi" in the British Museum: Material Remains, Traces and Locked Cases', *Quaderni di Palazzo Te*, Milan, vol.8, 2000, pp.46–55.

6 Quoted by Ger Luijten in Amsterdam/London 2000–1, pp.218–19, and note 1: from E. Duverger, *Antwerpse kunstinventarissen uit de zeventiende eeuw* (Fontes Historiae Artis Neerlandicae 1), Brussels, 1984 (10 vols to date), vol.5, pp.399–400.

7 Strauss/Van der Meulen, 1656/12, no.232, and note: 'een dito met de bouleringe van Raefel, Roest, Hanibal Crats en Julio Bonasoni'.

8 Amsterdam 1997, p.283.

9 Amsterdam/London 2000–1, p.220.

10 Ibid., p.220 and Amsterdam 1997, pp.283–4, where the iconography of the feathered hat is examined. See too the entry in this catalogue for *Bust of a Young Woman Smiling*, cat.21, which discusses this motif.

110

1 Bredius/Gerson 516, p.600.

2 See Berlin/Amsterdam/London 1991–2, vol.1, cat.37, pp.233–7.

3 Ibid., p.236, fig.37d; Benesch 157.

4 Ibid., p.234, fig.37a.

5 Berlin/Amsterdam/London 1991–2, vol.2, p.90. It is here suggested that there were only two stages to the painting but that the Berlin drawing does represent the transitional stage between the painting as recorded in the Barent Fabritius drawing, and the final version of the painting in Berlin.

6 Berlin/Amsterdam/London 1991–2, vol.2, p.92.

111

1 Washington/Amsterdam 1996–7, p.121 and note 10.

2 Berlin/Amsterdam/London 1991–2, vol.2, p.239 and note 4.

3 See Amsterdam/London 2000–1, p.252 and Schama 1987, pp.570–9.

4 Benesch 749, recto.

5 New Hollstein no.159. Amsterdam/London 2000–1, p.253, notes 6 and 7.

6 Washington/Amsterdam 1996–7, cat.7, pp.119–121.

112

1 Matthew 2:13–15.

2 White/Boon B 54.

3 Hollstein 3; White 1999, p.71.

4 The painting of 1609 is in the Alte Pinakothek, Munich: see Keith Andrews, *Adam Elsheimer*, Oxford, 1977, cat.26, pp.154–5.

5 Bredius/Gerson 576, p.609. This was the only example of an outdoor nocturnal scene, and the sole incidence of a landscape connected with a Biblical story which Rembrandt painted.

6 W. Stechow, 'Some observations on Rembrandt and Lastman', *Oud Holland*, 84, 1969, p.152. The Lastman picture is in the Boijmans Van Beuningen Museum, Rotterdam.

7 For a description of this process see White 1999, pp.72–4, figs.86–91.

113

1 Daulby 1796, p.65.

2 Benesch 153. The figure could also represent Mary Magdalene.

3 *Mauritshuis Illustrated General Catalogue*, Amsterdam, 1993, inv.no.264, pp.158–9.

4 *Corpus*, vol.3, A126.

5 Benesch 152. The heavily draped figure there, with arms across her chest, appears to have been borrowed from a woodcut of the *Lamentation* by Lucas Cranach the Elder (Hollstein 21); see *Corpus*, vol.3, p.276 and notes 5 and 6.

6 *Corpus*, vol.2, A88, p.458.

114

1 Bartsch 8.

2 Strauss/Van der Meulen, 1656/12, no.200, listed amongst the art books in the inventory made of Rembrandt's possessions in 1656.

3 For the influence of Mantegna upon Rembrandt, see Clark 1966, pp.147–53, and London 1992, cat.53, pp.123–5.

4 The effect is somewhat reminiscent of the window in Rembrandt's mysterious etching 'Faust' of *c.*1652: White/Boon B 270.

5 Genesis 3:15.

6 Slatkes 1973, pp.257–8.

7 H. Bevers in Berlin/Amsterdam/London 1991–2, vol.2, p.269.

8 Berlin/Amsterdam/London 1991–2, vol.2, p.270 and note 8, links this combination of domestic scene and religious imagery to earlier Netherlandish prototypes.

115

1 White/Boon B 45, B 47, B 64, B 60.

2 H. Bevers in Berlin/Amsterdam/London 1991–2, vol.2, p.269, who describes there being 'only a loose connection between the individual scenes'.

3 E. van de Wetering in Amsterdam/London 2000–1, p.44.

4 Ibid.

5 White 1999, p.88.

6 White/Boon B 50, B 83, B 86, B 87.

7 Mentioned in a testament by Cornelis van Everdingen quoted in Amsterdam/London 2000–1, p.45 and note 21.

8 Strauss/Van der Meulen, 1654/18.

116

1 Schatborn 1985, p.8, listing Benesch 890 and 924 as stylistic comparisons.

2 Benesch 977.

117

1 Quoted by Gerson 1968, p.476. For more information on Bartsch, see cat.73, note 6.

2 Benesch 914.

3 Melbourne/Canberra 1997-8, p.376.

4 P. Schatborn in Berlin/Amsterdam/London 1991-2, vol.2, p.116, suggests a date of *c.*1654-5, while that of *c.*1658 (given by B. Broos in Melbourne/Canberra 1997-8, p.376), seems somewhat too late.

5 The date of the London painting has sometimes been read as '1655' but is corroborated as 1654 in London 1988-9, p.96.

6 Benesch 1161a; see Berlin/Amsterdam/London 1991-2, vol.2, p.116 and note 1, repr. fig.33a.

118

1 Benesch 1351.

2 As M. Royalton-Kisch notes in London 1992, p.134, though with the cautionary observation that the subject matter of the drawings is obviously unrelated.

3 Strauss/Van der Meulen, p.269, and note 2.

4 Strauss/Van der Meulen, 1648/2.

5 Strauss/Van der Meulen, 1649/3.

6 Strauss/Van der Meulen, 1649/4.

7 Bredius/Gerson 437, p.589; Berlin/Amsterdam/London 1991-2, vol.1, cat.40, pp.246-9.

8 London 1992, p.134.

9 For example, cat.6, 13, 42, 65, 123, 132 and 134 in this catalogue.

10 For a discussion of sleep as portrayed in the Netherlands in the seventeenth century and before see N. Salomon, *Jacob Duck and the Gentrification of Dutch Genre Painting* (*Ars Picturae* 4), Doornspijk, 1998, pp.28-30 and 83-7.

11 See, for example, Jan Steen's *Wine is a Mocker*, Washington/Amsterdam 1996-7, cat.38, pp.221-4.

119

1 Haarlem 1986, cat.33, pp.171-4, for an example of seventeenth-century portraiture containing this motif.

2 Ibid., p.128, fig.20e.

3 *Corpus*, vol.3, A142.

4 For a discussion of this, see J.S. Held, 'Flora, Goddess and Courtesan', *De artibus opuscula, Essays in Honor of Erwin Panofsky*, New York, 1961, pp.201-8.

5 Haskell/Penny 1981, cat.4, p.218.

6 E.M. Bloch, *Gazette des Beaux-Arts*, 6th series, 29, 1946, pp.175-86. See too cat.36, note 9.

7 See Hollstein: *German*, vol.XL (1995), cat.1, p.15, repr. and Wethey loc.cit.: 'Vere viret placido perfusa liquore/A Zephyro, et blando turgida flore viget/Flora modis veris, Titiani pecti amore/Implet, et huic similes illaqueare parat.' I am grateful to G. Hubbuck for providing the translation.

8 Wethey 1975, vol.3, p.26 and p.154.

9 Stechow 1942, p.141.

10 Metropolitan Museum of Art, New York: see New York 1995-6, vol.2, cat.11. See too p.69: W. Liedtke also notes that the quality of the *Flora* was never comparable to the *Aristotle* and is, in any case, less well preserved.

11 Haskell/Penny 1981, cat.4, p.218.

12 New York 1995-6, vol.2, p.70, fig.61: after Rembrandt, *Saskia*, oil on canvas, 112 × 89 cm, Museum voor Schone Kunsten, Antwerp.

13 Musée du Louvre, Paris; Bredius/Gerson 521, p.601.

120

1 Tümpel 1993, p.392: the X-rays are reproduced in W. Sumowski, *Wissenschaftliche Zeitschrift der Humboldt-Universität Berlin:Gesellschafts und sprachwissenschaftliche Reihe* 7, 1957/8, p.237.

2 Tümpel 1993, p.392.

3 Quoted by Wheelock 1995, p.316, from *The Genuine Works of Flavius Josephus*, trans. W. Whiston, London, 1755, vol.1, pp.82-3.

4 'een hoogduitsche Flavio Fevus gestoffeert met figuren van Tobias Timmerman': Strauss/Van der Meulen, 1656/12, no.284.

5 Alfred Bader Collection, Milwaukee. Wheelock 1995, p.316, note 7, states that Pynas's picture was first mentioned in connection with this composition by Bauch 1960, p.258, note 96.

6 See too cat.66 and 67 in this catalogue.

7 Suggested by H. Kauffmann, 'Anmerkungen zu Rembrandts Potipharbildern', in O. von Simson and J. Kelch (eds.), *Neue Beiträge zur Rembrandt-Forschung*, Berlin, 1973, pp.50-7.

8 Schwartz 1984, pp.274-5.

9 Bredius/Gerson 523, p.601; Wheelock 1995, inv.no.1937.1.79, pp.314-21. Two drawings have been quoted in the production of these compositions: Benesch 958, which appears to relate to the pose of Potiphar in the Berlin painting, and Benesch 623, a compositional sketch half-way between the Berlin and Washington picture which Gerson described as 'unconvincing' (Gerson 1968, cat.275, p.499).

10 Wheelock 1995, p.316.

11 Wijnman 1968, p.114.

12 A. Bredius, 'Rembrandtiana', *Oud Holland*, 28, 1910, p.200. Becker's full inventory runs from p.200: 'een beschuldiginge Josephs door Potiphars huysvrouw'. Bredius observed, 'hierbij is geen schilder vermeld maar 't ligt voor de hand aan Rembrandt's schilderijen met dit onderwerp te Berlijn en St Petersburg [now Washington] te denken.'

121

1 Sandrart/Pelzer 1925, p.203.

2 Schwartz 1984, p.262.

3 Bredius/Gerson 358. Gerson suggested that the picture may be by Ferdinand Bol.

4 Benesch 914: see Berlin/Amsterdam/London 1991-2, vol.2, cat.31B, pp.109-13.

5 Benesch 310: see Paris 2000, cat.93, pp.140-1.

6 Berlin/Amsterdam/London 1991-2, vol.1, cat.64, pp.328-9.

7 For a discussion of this see *Corpus*, vol.1, pp.355-6. There were, of course, secular interpretations of some images of women reading: for example, see Amsterdam 1997, cat.62, pp.303-6.

8 *Corpus*, vol.1, A37.

9 See the chapter on widowhood ('Weduwe') in Frantis 1993, pp.161-94, and especially pp.172-9.

10 Cats 1625, chapter 6, p.55: 'Een hert, dat sich verquickt in Godes bouck te lesen, /Een oog, dat sich vermaeckt met tranen nat te wesen, /Een siel van stillen aert, die sich der werelt schaemt.'

11 For example, Bredius/Gerson 381, 383, 384 (C. Brown has suggested nos.381 and 383 may have been modelled by the same sitter as in the Buccleuch painting: London 1976, p.73.)

12 For examples, see Sumowski 1983-95, vol.1, nos.367, 370, 372, 375, 377.

13 For examples, see Sumowski 1983-95, vol.3, nos 1366, 1367, 1368, 1369. A look through the volumes of Sumowski shows that many other artists also depicted such figures, too numerous to mention here.

14 See Tümpel 1993, p.299.

15 Ibid.

122

1 *Corpus*, vol.3, A145.

2 Reproduced in Berlin/Amsterdam/London 1991-2, cat.35, p.227, fig.34-5b.

3 Suggested by H. Wijnman, *Jaarboek Amstelodamum*, 31, 1934, pp.81-96, especially p.81.

4 Strauss/Van der Meulen, 1657/9.

5 S.A.C. Dudok van Heel, *Doopsgezinde bijdragen*, new series 6, 1980, pp.105-23, especially p.115. She married again, aged sixty-six, to the Amsterdam surgeon Jan Schildt with whom she lived until her death: see Wijnman 1959, p.35

6 Strauss/Van der Meulen 1657/9, a will of 7 June 1657 in which she left 'ijtem de conterfeijtsels van haer comparant ende haer overleden broeder' to her nephew Jonge Jans Hoogsaet, son of her brother Cornelis Claesz. See too H. Wijnman, *Uit de kring van Rembrandt en Vondel: Verzamelde studies over hun leven en omgeving*, Amsterdam, 1959 for the provisions of Catrina's will. She made three wills in all.

7 Quoted in London 1995, p.140, from O. Feltham *A Brief Character of the Low Countries*, 1652, p.50.

8 London 1995, p.140, note 6, based on De Winkel 1993, pp.105-11.

9 See Marieke de Winkel's essay in this catalogue, p.59.

10 Schwartz 1984, p.333.

11 Rembrandt etched two portraits of Coppenol: White/Boon B 282, B 283. He may perhaps also have painted the little panel now in the Metropolitan Museum of Art, New York (see New York 1995-6, vol.2, cat.34, pp.120-2, where it is ascribed to 'Style of Rembrandt') which was cited as authentic by E. van de Wetering in Amsterdam/London 2000-1, pp.59-61.

12 *Corpus*, vol.3, A143.

13 Bauch 1966, cat.519.

14 London 1995, p.142.

15 H. Wijnman, *Uit de kring van Rembrandt en Vondel: Verzamelde studies over hun leven en omgeving*, Amsterdam, 1959, p.33.

16 London 1995, p.142, note 13.

123

1 Benesch 1102; see, too, Melbourne/Canberra 1997-8, cat.95, pp.374-5.

2 Benesch 1099; see, too, Paris 2000, cat.105, pp.160-1.

124

1 Suggested, for example, in London 1988-9, p.108, but questioned by M. Royalton-Kisch in 'Rembrandt's Sketches for his Paintings', *Old Master Drawings*, 27, 1989, pp.137-9.

2 London 1992, p.135.

3 Book of Esther: 4: 16.

125

1 London 1988-9, p.108.

2 As stated by M. Royalton-Kisch in 'Rembrandt's Sketches for his Paintings', *Old Master Drawings*, 27, 1989, pp.137-8.

3 C. Brown and J. Plester, 'Rembrandt's Portrait of Hendrickje Stoffels', *Apollo*, vol.106, October 1977, pp.288-9. It is there noted that the date, though not added by Rembrandt, may, however, have some basis in fact.

4 White/Boon B 272. This etching, oddly, shows De Jonghe's cloak draped over the right arm of the chair, but there appears to be no corresponding left arm.

5 Bredius/Gerson 268.

6 White/Boon B 276.

7 White/Boon B 284.

8 Bredius/Gerson 116, 118, 111, respectively.

9 See Berlin/Amsterdam/London, 1991-2, vol.1, cat.40, pp.146-9.

10 This was interpreted as inferior quality by Tümpel 1986, cat.A77 who rejected the work as from Rembrandt's circle. Schwartz did not include it in his catalogue raisonné of 1984.

11 C. Brown in 'Rembrandt's Portrait of Hendrickje Stoffels', *Apollo*, vol.106, October 1977, p.289.

12 Houbraken 1718-21, vol.1, p.259.

13 Bredius/Gerson 116: see cat.126.

14 Bredius/Gerson 111: see cat.127, fig.153.

15 Quoted by C. Brown in 'Rembrandt's Portrait of Hendrickje Stoffels', *Apollo*, vol.106, October 1977, pp.287-8, from W. Bode, *Studien zur Geschichte der Holländischen Malerei*, Braunschweig, 1882, pp.551-2. Bode at first thought that the picture could not represent Hendrickje because of the date which he saw as being 1665. He later altered his opinions in Bode/Hofstede de Groot 1897-1906, vol.5, pp.16-19 and vol.6, pp.14-17.

16 H. Vlieghe, *Corpus Rubenianum Ludwig Burchard, Part XIX, Portraits*, vol.2: Antwerp Identified Sitters, New York, 1987, cat.97, pp.91-3.

17 For example, see Haskell/Penny 1981, cat.84, pp.318-20.

18 Ibid., p.92, note 2.

19 Wethey 1975, vol.2, cat.48, pp.106-7.

20 Though Rembrandt would not have known it, another painting which makes use of some of these elements is El Greco's *Lady in a Fur Wrap*, Pollok House, Glasgow Museums, see H. Wethey, *El Greco and His School*, Princeton, 1962, cat.148 – generally believed to be a portrait of El Greco's mistress.

126

1 *Corpus*, vol.3, A145.

2 J. Kelch, *Katalog der Gemäldegalerie der Staatlichen Museen Preussischer Kultutbesitz*, Berlin-Dahlem, 1975, p.346, no.828B. See too P. Rylands, *Palma Vecchio*, Cambridge, 1992, cat.35, pp.177-8.

3 Clark 1966, p.132.

4 British Museum, London, Vendramin catalogue, Sloane MSS, no.4004, fol.51.

5 Clark 1966, p.132.

6 Strauss/Van der Meulen, 1656/12, no.39: 'Een Cortisana haer pallerende vanden selven'. It is there suggested that this may refer to the picture now in the Hermitage, St Petersburg: Bredius/Gerson 387.

7 See Berlin/Amsterdam/London 1991-2, vol.1, p.271, figs.45d and e.

8 See London/The Hague 1999-2000.

9 Bredius/Gerson 46; see Berlin/Amsterdam/London 1991-2, vol.1, p.268 and note 3.

10 For the wearing of rings in this way see Marieke de Winkel's essay in this catalogue, pp.57-8. Of course, rings did not necessarily signify marriage but could also be construed as tokens of affection or friendship.

11 Strauss/Van der Meulen 1654/15: 'Hendrickje Jaghers voer de vergadering verschenen zijnde, bekent dat se met Rembrant de schilder Hoererije heeft geplecht, is daerover ernstelijck bestraft, tot boetvardicheijt vermaent en van den taffel des Heeren afgehouden.' She had been called before the Council three times before but had not turned up: see Strauss/Van der Meulen, 1654/11, 12, 14.

127

1 Bode/Hofstede de Groot 1897-1906, vol.6, cat.438.
2 Bredius/Gerson 54.
3 W. Liedtke argues strongly against this suggestion in New York 1995-6, vol.2, p.78.
4 Strauss/Van der Meulen, 1660/20.
5 Strauss/Van der Meulen, 1658/3.
6 C.J. Holmes, *Notes on the Art of Rembrandt*, New York, 1911, pp.154-5.
7 New York 1995-6, vol.2, p.78.
8 For example, R.G. Bourne, 'Did Rembrandt's *Bathsheba* really have Breast Cancer?', *Australian and New Zealand Journal of Surgery*, vol.70, March 2000, no.3, pp.231-2. Dr Bourne states that she displays an abnormality of the left breast and axilla but the conclusion drawn is that there should be an alternative diagnosis such as tuberculous mastitis or, less likely, a chronic lactational breast abscess.
9 She was buried in the Westerkerk, Amsterdam, in a rented grave, in July that year: Strauss/Van der Meulen, 1663/4.
10 Daniel Defoe, *A Journal of the Plague Year being observations or memorials of the most remarkable occurrences, as well public as private, which happened in London during the last great visitation in 1665*, first published 1773, London 1908 ed., p.1.
11 M.W. Ainsworth et al., *Art and Autoradiography, Insights into the Genesis of Paintings by Rembrandt, Van Dyke, and Vermeer*, Metropolitan Museum of Art, New York, 1982, pp.72-6. However, W. Liedtke notes that these findings remain conjectural, in New York 1995-6, vol.2, p.80, note 6.
12 J. Ingamells, *The Wallace Collection Catalogue of Pictures*, vol.4 (Dutch and Flemish), London, 1992, cat.p61, pp.87-9. The picture is undated and was ascribed to c.1654 by Sumowski on the basis of comparison with Drost's *Bathsheba*, dated 1654, in the Louvre.
13 New York 1995-6, vol.2, p.78, repr.fig.62.
14 For a discussion of the influence of Venetian art upon Drost and Rembrandt by J. Kelch, see Berlin/Amsterdam/London 1991-2, vol.1, cat.45, p.270.
15 New York 1995-6, vol.2, p.80; see Wethey 1975, vol.1, cat.127, pp.148-9.
16 See Wethey 1975, vol.1, p.150 and fig.191.
17 For example, Sumowski 1983-95, vol.2, nos.1322, 1383: there attributed to Nicolaes Maes.

128

1 White/Boon B 195.
2 Bredius/Gerson 521.
3 White/Boon, p.97.
4 Ibid.
5 Strauss/Van der Meulen, 1658/3. The house on the Breestraat was sold on 1 February 1658 and, although the final payment was not settled until 1660, it is usually thought that the family moved out before the latter date.
6 Bredius 1915-22, vol.4, p.1255. For a further discussion of the practice of drawing from the model, see Volker Manuth's essay in this catalogue.
7 White/Boon, p.97.
8 Inv.no.1835-6-13-7.
9 See Marieke de Winkel's essay in this catalogue, p.55.
10 Daulby 1776, p.126.

129

1 Bredius/Gerson 437: see cat.118, fig.143.
2 White/Boon B 200, p.97.
3 Daulby 1776, p.127, rather ingeniously calls this 'a garden chair'.
4 Clark 1956, p.330.

130

1 White 1999, p.204.
2 White 1999, p.203 and note 21: François Perrier's engraving is reproduced in Berlin/Amsterdam/London 1991-2, p.245, fig.39e (though J. Foucart is adamant that Rembrandt's composition of *Bathsheba* did not depend on knowledge of this print).
3 Bredius/Gerson 521. See Berlin/Amsterdam/London 1991-2, vol.1, p.245, fig.39g for a reproduction of this print in reverse to compare the relative poses of the two works.

131

1 White 1999, p.204, suggested that there may have been states prior to this since a line of the woman's leg can be made out under the skirt, which he has interpreted to mean that Rembrandt originally drew this figure nude.
2 Houbraken 1718-21, vol.1, p.271, quoted by C. Hartley in Cambridge 1996-7, p.17.

132

1 Quoted in Gerson 1968, p.466.

133

1 See cat.73, note 6 for information on Bartsch.
2 Valerius Röver and Clement de Jonghe (White/Boon, p.100).
3 Daulby 1796, cat.197, p.129.
4 Suggested by C. Hartley in Cambridge 1996-7, p.19: see Hans Sebald Beham (Bartsch 215) and Agostino Veneziano (Bartsch 410).
5 Reproduced in White 1999, p.205, fig.280.
6 White 1999, pp.206-7 notes that the only impression he considered to be entirely successful in inking and printing of the plate to achieve the balance Rembrandt sought is of the second state of the print in the British Museum, London, reproduced p.205, fig.281.

134

1 Bartsch 17, etching and burin, 15.4 × 22.3 cm. For a discussion of the iconography of the subject, see cat.13, note 5.
2 C. Gould, *The Paintings of Correggio*, London, 1976, pp.238-9; Wethey 1975, vol.3, pp.53-6, no.21, 161-2.
3 Haskell/Penny 1981, no.24, pp.184-7.
4 Amsterdam/London 2000-1, p.364 and note 2. The open style of hatching could have been likened to Annibale Carracci's technique.
5 'Jupin, als hij ontsluit het Vrouwelijk slot, Word Droes of beest of vleugeldier of zot. Jupin, en ouvrant la serrure feminine, Fait Satirique ou autre enorme mine.'
6 See Amsterdam 2000, pp.86-92.

135

1 Benesch 1142.
2 Benesch 1179 and 1180, studies for Bredius/Gerson 415: see Melbourne/Canberra 1997-8, p.380.
3 Benesch 1143. See, too, London 1992, cat.107, pp.215-8.
4 A sizeable group of these is at the Staatliche Graphische Sammlung, Munich and will be reassessed in an exhibition on the holdings of Rembrandt drawings in the collection later this year: see cat.41, note 3.
5 Benesch 1121. See Berlin/Amsterdam/London 1991-2, vol.2, cat.49, pp.152-4. For a discussion of De Gelder's draughtsmanship see P. Schatborn, 'Tekeningen van Arent de Gelder', in Dordrecht/Cologne 1998-9, pp.111-21.

136

1 White/Boon B 264.
2 Benesch 1146. See Berlin/Amsterdam/London 1991-2, vol.2, cat.51, pp.156-8.
3 Benesch 1147. See London 1992, cat.106, pp.214-5.
4 White/Boon, p.98, citing George Swarzenski, *Rembrandt Austellung*, Frankfurt, 1906, no.94.
5 White/Boon, p.98, citing *Meesterwerken der Europese Prentkunst*, Amsterdam 1966, cat.122: see too A.E. Popham, *Italian Drawings in the British Museum. Artists working in Parma in the sixteenth century*, London 1967, no.17*, reproduced pl.15.
6 White/Boon, p.98: 'Naekte Cleopatra'.
7 See C.S. Ackley, *Printmaking in the Age of Rembrandt*, Museum of Fine Arts, Boston/Saint Louis Museum of Art; 1981, cat.172, p.251, note 2.
8 Ibid., p.251, and note 3 for a reference to the pictorial tradition of this subject.
9 White 1999, p.210.

137

1 Bredius/Gerson 314. See, too, London 1988-9, cat.16, pp.120-5, under cat.67 and 68, which lists Jacob's date of birth as 1575; W. Robinson in Melbourne/Canberra 1997-8, p.309, suggests a date of c.1576.
2 For Trip's business activities, see S.A.C. Dudok van Heel, 'Het maecenaat Trip, opdrachten aan Ferdinand Bol en Rembrandt van Rijn', *Kroniek van het Rembrandthuis*, 31, 1979, pp.14-15. See also I.H. van Eeghen in R. Meischke and H.E. Reeser, (eds.), *Het Trippenhuis te Amsterdam*, Amsterdam, 1983, pp.72-3.
3 Dudok van Heel 1979, p.22; London 1988-9, cat.16, p.120.
4 Hendrick Trip and his wife Johanna de Geer lived in the north part of the Trippenhuis while Louys and his wife Emerentia Hoefslager took up residence in the south 'house'. The Trippenhuis was of sufficient size to house the Rijksmuseum's collection from 1817 to 1885.
5 For an assessment of these paintings see Melbourne/Canberra 1997-8, under cat.67 and 68, pp.309-11. The paintings are a half-length of Jacob Trip of 1657 in the Burrell Collection, Glasgow; two pendant portraits in the Szépművészeti Múzeum, Budapest; two replicas of the latter, formerly in Kasteel Nederhemert, Gelderland, now destroyed; one lost portrait of Margaretha aged 81, dated 1661, also formerly in the Kasteel Nederhemert; a portrait of Jacob Trip, now in the Mauritshuis (believed to be a posthumous pendant to the lost portrait of Margaretha aged 81); and, finally, one portrait of Margaretha aged 85, dated 1669, in the Dordrechts Museum, Dordrecht. See too Sumowski 1983-95, vol.3, under nos.1396 and 1397, p.2028.
6 Maclaren/Brown 1991, vol.1, p.351, note 4 and p.353, note 4. The paintings are two pendants of 1649 of Jacob, aged 74, in E. Haverkamp-Begemann's collection, New York, and Margaretha, aged 65, in Aix Museum; two pendants of 1651 of Jacob aged 71 in Denver Art Museum, and Margaretha, aged 66 in the Rijksmuseum, Amsterdam; a lost replica of the latter reproduced in *Oud Holland*, 1928, p.257.
7 W.J. Russell Collection, Amsterdam: a 1651 bust length of Jacob aged 74.
8 See I. Németh and R. van Leeuwen, 'Onthullingen over onze Jacob Trip', *Mauritshuis Nieuwsbrief*, vol.5, nos.3-4, 1992, pp.8-9.
9 See note 5.
10 Dickey 1995, p.354.
11 *Corpus*, vol.2. A79.
12 *Corpus*, vol.3, A145.

13 Gerson 1968, p.130, notes that it omits any reference to the male pendant and is 'in keeping with Flemish portrait convention', citing a comparison of Jacob Jordaens's *Portrait of a Woman* of 1641 in the Musées Royaux des Beaux-Arts, Brussels.
14 *Corpus*, vol.2, A104.
15 The likely candidate is Maes's portrait of 1647.
16 See London 1988-9, cat.15, p.124.
17 Bredius/Gerson 395.
18 London 1988-9, cat.18, pp.130-3.

137A

1 *Corpus*, vol.2, A92.
2 B. Huin, *La collection des Princes de Salm*, Musée départemental d'art ancien et contemporain, Epinal, 1993-4, and, for the foundation of the Epinal Museum, see G. Guery, *Hommage au Duc de Choiseul-Stainville (1760-1838), Fondateur du Musée Départmental des Vosges*, Musée départemental d'art ancien et contemporain, Epinal, 1995.
3 For example Hofstede de Groot 1908-27, vol.6, cat.189; Bauch 1966, cat.283; Gerson 1968, cat.367; Schwartz 1984, cat.360; Slatkes 1992, cat.67; Tümpel 1993, cat.85.
4 B. Huin, *La collection des Princes de Salm*, Musée départemental d'art ancien et contemporain, Epinal, 1993-4, cat.28, p.80.
5 Hofstede de Groot 1908-27, vol.6, cat.189.
6 Investigative photography took place on 26 October 1970 in the CNRS, Musées Nationaux de France (CL nos: 18564; 18565, 18566, 18567; 18568). A letter from M. Hours, Conservateur des Musées Nationaux de France, of 13 November 1970 in Gallery files notes that 'La partie inférieure a été ajoutée vraisemblement au debut du XIX ème siècle. Il s'agit d'une toile encollée au céruse qui de ce fait ne peut être traversée par les rayons X. Les rayons infra-rouges soulignent cette différence de matière et la lumière rasante confirme l'addition. Mon sentiment est que le chapelet a été ajouté dans la main droite de la Vièrge est a l'origine de cet aggrandissement.'
7 Bredius/Gerson 485.
8 Luke 2: 35.
9 The suggestion that the painting might represent the Mater Dolorosa was first suggested by W.R. Valentiner in 'Die vier Evangelisten Rembrandts', *Kunstchronik und Kunstmarkt*, New Series 32, 1920/1, pp.219-22.
10 Tümpel 1993, cat.85, p.402; New Hollstein, *Lucas van Leyden*, 1996, cat.198, p.181.
11 Bredius/Gerson 306. See, too, Bredius/Gerson 307 and 308.
12 See for example Bredius/Gerson 285, 297, 612, 613, 615, 616, 616A, 617.
13 W.R. Valentiner, 'Die vier Evangelisten Rembrandts', *Kunstchronik und Kunstmarkt*, New Series 32, 1920/1, p.221.
14 Tümpel 1993, cat.83, p.402, who notes that he believes that the present picture was in a group with Bredius/Gerson 59, 615, 616, 616A, 617, 629, as part of the Apostle series.
15 Wethey 1969, vol.1, cat.32, 77, plates 214, 215.
16 W.R. Valentiner, 'Die vier Evangelisten Rembrandts', *Kunstchronik und Kunstmarkt*, New Series 32, 1920/1, pp.219-22.

138

1 I.H. van Eeghen 'Else Christiaens en de kunsthistorici', *Maandblad Amstelodamum*, 58, April 1969, pp.73-8.
2 Strauss/Van der Meulen, 1664/1.
3 Strauss/Van der Meulen, 1664/1.
4 Benesch 1358. See B. Bakker et al., *Landscapes of Rembrandt. His Favourite Walks*, Gemeentearchief, Amsterdam; Institut Néerlandais, Paris, 1998-9, p.229 and colour plate p.144.
5 Sumowski 1979-92, vol.2, no.291, p.626.

139

1 For example Benesch 1187 and 1205; the self-portrait is Benesch 1171. The comparisons were suggested by C. Logan in New York 1995-6, p.172.

2 Sumowski 1979-92, vol.2, no.291, p.626.

140

1 Marieke de Winkel's essay in this catalogue, see p.62 and notes 78, 79, 80. More generally on this subject, see E.J. Sluijter, 'Depiction of Mythological Themes', in Washington/Detroit/Amsterdam 1980-1, pp.55-64.

2 J.S. Held, 'Rembrandt's *Juno*', *Apollo*, vol.105, no.184, June 1977, pp.484-5.

3 White/Boon B 112.

4 Houbraken 1718-21, vol.1, p.271.

5 J.S. Held, 'Rembrandt's *Juno*', *Apollo*, vol.105, no.184, June 1977, p.483.

6 C. Gould, *The Sixteenth-Century Venetian School. National Gallery, London*, London, 1959, NG 5385, pp.120-3.

7 J.S. Held, 'Rembrandt's *Juno*', *Apollo*, vol.105, no.184, June 1977, p.483, fig.5 (as collection of the late J. Paul Getty).

8 For example, see *Paris Bordon e il suo Tempo, Atti del convegno internazionale di studi, Treviso 28-30 October 1985*, Treviso, 1987, pp.250-2, figs.5, 6, 7, 9, 10, 11.

9 First mentioned by J.S. Held, *Rembrandt's 'Aristotle' and Other Rembrandt Studies*, Princeton, N.J., 1969, pp.85-103. There is also a faint indication of an arched line painted at the top of the work, while a strip of about 18cm was trimmed from the right side of the canvas, probably when it was relined at some stage.

10 Vasari 1568 (1996 ed.), vol.2, p.794.

11 Vasari 1568 (1996 ed.), vol.2, p.781.

12 Van de Wetering 1997, p.163. For a detailed discussion of Rembrandt's 'rough manner', see ch.7, particularly pp.160-9.

13 Bredius/Gerson 50. For the suggestion that the *Juno* and this portrait are related, see Slatkes 1992, cat.272, 273, pp.410-2.

14 London/The Hague 1999-2000, cat.71, p.198.

15 J.L.A.A.M. van Ryckevorsel, 'De teruggevonden schilderij van Rembrandt: De Juno', *Oud Holland*, 33, 1936, p.272, '... hier, evenals in de klassieke oudheid, wordt Juno voorgesteld als het ideaal der gerijpte vrouwelijke schoonheid'.

16 Adams 1998, p.5.

17 Van Ryckevorsel, op.cit., pp.271-4, and N. de Roever, 'Herman Becker, koopman en kunstkenner', *Uit onze oude Amstelstad*, III, Amsterdam, 1891, pp.110ff.

18 Strauss/Van der Meulen, 1664/6.

19 Strauss/Van der Meulen, 1665/17, 1665/20, 1665/19.

20 The concept of 'unfinished' late works by Rembrandt is discussed by Van de Wetering 1997, pp.210-11: where Houbraken's criticism of Rembrandt regretted that 'he was so quick to change and move on to other things that many of his works were left only half-way finished'. Many pictures remained unfinished ('onopgemaeckt') at Rembrandt's death: see Strauss/Van der Meulen, 1669/5, the inventory of Rembrandt's goods at his death.

21 A. Bredius, 'Rembrandtiana', *Oud Holland*, 28, 1910, p.200; 'Op de Voorcamer: een Juno van Rembrandt van Rijn; een Venus en Cupido van deselve'. The inventory runs from pp.195-201. Becker also owned another picture of Juno by an anonymous artist, painted lifesize ('levensgroot').

22 Ibid., p.107: 'een Venus en Cupido na Rembrandt' which hung 'Int achterportael'.

23 Bredius/Gerson 117. Also entitled *Hendrickje Stoffels en Vénus*.

24 Bredius 117 and Bauch 1966, cat.107: both believed it to be by Rembrandt.

25 *Oud Holland*, 28, 1910, p.200, 'een Pallas van Rembrandt van Ryn', listed as 'In de Agter-camer'.

26 Bredius/Gerson, p.557.

141

1 Strauss/Van de Meulen, 1658/8: 'In 't Voorhuis/Een groot stuck schilderij van Lucretia/van R: Van Rijn', in the house on the Keizersgracht.

2 Bredius/Gerson 485.

3 W. Stechow, 'Lucretiae statua', *Beiträge für George Swarzenski*, Berlin, 1951, pp.114-24; J.S. Held, 'Das gesprochene Wort bei Rembrandt', *Neue Beiträge zur Rembrandt-Forschung*, Berlin, 1973, p.123; Wheelock 1995, p.284; Slatkes 1992, p.188. However, the Minneapolis *Lucretia*'s pose has also been likened to that of David in Caravaggio's *David and Goliath* (Galleria Borghese, Rome) by M. Hirst, 'Rembrandt and Italy', *The Burlington Magazine*, 110, 1968, p.221.

4 For a further discussion of both pictorial and literary representations of Lucretia, see I. Donaldson, *The Rapes of Lucretia, Myth and its Transformations*, Oxford, 1982.

5 Wheelock 1995, p.282 and note 8. See, too, G. Keyes and A. Wheelock, *Rembrandt's Lucretias*, National Gallery of Art, Washington; Minneapolis Institute of Arts, Minneapolis, exhibition brochure, 1991-2, pp.3-6.

6 L.C. Hults, 'Dürer's Lucretia: Speaking the Silence of Women', *Signs: Journal of Women in Culture and Society*, 16, 1991, pp.205 and 237.

7 M.J. Friedländer and J. Rosenburg, *The Paintings of Lucas Cranach*, Ithaca, N.Y., 1978.

8 For example, see Wethey 1975, vol.3, cat.x-33, pp.219-20, Palma Vecchio, formerly given to Titian; cat.x-24, p.215, Venetian school, formerly given to Titian. For Veronese's *Lucretia* see S. Ferino-Pagden, W. Prohasa and K. Schütz, *Die Gemäldegalerie des Kunsthistorischen Museums in Wien*, Vienna, 1991, p.73, no.1561.

9 Wheelock 1995, pp.282-3, see Wethey 1975, vol.3, figs.202 and 210 for David Teniers's the Younger's paintings depicting the collection of Leopold Wilhelm at Brussels painted *c*.1651 (now in the Museo del Prado and the Musées Royaux des Beaux-Arts, Brussels).

10 Quoted by Wheelock 1995, p.284, and note 17. First associated with Rembrandt's *Lucretia* of 1664 by J. Veth, 'Rembrandt's Lucretia', *Beelden en Groepen*, Amsterdam, 1914, p.25.

11 Bredius/Gerson 416, suggested by Wheelock 1995, p.285 and note 19. E. Haverkamp-Begemann found the technique in this painting somewhat anomalous in relation to Rembrandt's work of this period and suggested a similarity to the technique of Arent de Gelder.

12 Schwartz 1984, no.382, p.330.

13 Bredius/Gerson 482. See too H. van de Waal, *Drie eeuwen Vaderlandsche Geschiedenis-uitbeeldingen*, 1952, vol.1, p.233, for the parallels drawn between the Roman and Dutch republics in the seventeenth century.

14 Bredius/Gerson 525.

15 Bredius/Gerson 417.

Bibliography and Abbreviated References

ADAMS 1998
A. Jensen Adams (ed.), *Rembrandt's Bathsheba Reading King David's Letter*, Cambridge/New York/ Melbourne, 1998

ALPERS 1988
S. Alpers, *Rembrandt's Enterprise: The Studio and the Market*, London, 1988

AMSTERDAM 1976
E. de Jongh et al., *Tot lering en vermaak: Betekenissen van Hollandse genrevoorstellingen uit de zeventiende eeuw*, Rijksmuseum, Amsterdam, 1976

AMSTERDAM 1984–5
P. Schatborn and E. Ornstein-van Slooten, *Bij Rembrandt in de leer/Rembrandt as Teacher*, Museum het Rembrandthuis, Amsterdam, 1984–5

AMSTERDAM 1985–6
B.P.J. Broos, *Rembrandt en zijn voorbeelden/ Rembrandt and his sources*, Museum het Rembrandthuis, Amsterdam, 1985–6

AMSTERDAM 1986
W. Kloek, J.P. Filedt Kok and W. Halsema, *Kunst voor de beeldenstorm: Noordnederlandse kunst 1525– 1580*, Rijksmuseum, Amsterdam, 1986

AMSTERDAM 1986–7
R.E.O. Ekkart and E. Ornstein-van Slooten, *Oog in oog met de modellen van Rembrandts portret-etsen/ Face to Face with the Sitters for Rembrandt's Etched Portraits*, Museum het Rembrandthuis, Amsterdam, 1986

AMSTERDAM 1987–8
S.A.C. Dudok van Heel, P. Schatborn and E. Ornstein-van Slooten, *Dossier Rembrandt: Documenten, tekeningen en prenten/The Rembrandt Papers: Documents, Drawings and Prints*, Museum het Rembrandthuis, Amsterdam, 1987

AMSTERDAM 1988–9
Jan Lievens 1607-74: Prenten en Tekeningen, Museum het Rembrandthuis, Amsterdam, 1988–9

AMSTERDAM 1989–90
P. Hecht, *De Hollandse fijnschilders: Van Gerard Dou tot Adriaen van der Werff*, Rijksmuseum, Amsterdam, 1989–90

AMSTERDAM 1991
A. Tümpel and P. Schatborn, *Pieter Lastman: Leermeester van Rembrandt/The Man Who Taught Rembrandt*, Museum het Rembrandthuis, Amsterdam, 1991

AMSTERDAM 1996
C. Schuckman, M. Royalton-Kisch and E. Hinterding, *Rembrandt & Van Vliet: A Collaboration on Copper*, Museum het Rembrandthuis, Amsterdam, 1996

AMSTERDAM 1997
E. de Jongh and G. Luijten, *Spiegel van alledag: Nederlandse genreprenten 1550-1700*, Rijksmuseum, Amsterdam, 1997. See also AMSTERDAM 1997A

AMSTERDAM 1997A
E. de Jongh and G. Luijten, *Mirror of Everyday Life: Genreprints in the Netherlands 1550-1700*, Rijksmuseum, Amsterdam, 1997. See also AMSTERDAM 1997

AMSTERDAM 1999–2000
Rembrandt's Treasures (Rembrandts Schatkamer), Museum het Rembrandthuis, Amsterdam, 1999– 2000

AMSTERDAM 2000
Etched on the Memory. The presence of Rembrandt in the prints of Goya and Picasso, Museum het Rembrandthuis, Amsterdam, 2000

AMSTERDAM/GRONINGEN 1983
A. Blankert et al., *The Impact of a Genius: Rembrandt, his Pupils and Followers in the Seventeenth Century. Paintings from Museums and Private Collections*, Waterman Gallery, Amsterdam; Groninger Museum, Groningen, 1983

AMSTERDAM/JERUSALEM 1991–2
C. Tümpel et al., *Het Oude Testament in de schilderkunst van de Gouden Eeuw*, Joods Historisch Museum, Amsterdam; Israel Museum, Jerusalem, 1991

AMSTERDAM/JERUSALEM/MÜNSTER 1994
C. Tümpel (ed.), *Im Lichte Rembrandts: Das Alte Testament im Goldenen Zeitalter der niederländischen Kunst*, Joods Historisch Museum, Amsterdam; Israel Museum, Jerusalem; Westfälisches Landesmuseum für Kunst und Kulturgeschichte, Münster, 1994. See also AMSTERDAM/JERUSALEM 1991–2 of which the 1994 catalogue is the expanded edition

AMSTERDAM/LONDON 2000–1
E. Hinterding, G. Luijten and M. Royalton-Kisch, *Rembrandt the Printmaker*, Rijksprentenkabinet, Rijksmuseum, Amsterdam; British Museum, London, 2000–1

AMSTERDAM/ROTTERDAM 1956
Rembrandt tentoonstelling ter herdenking van de geboorte van Rembrandt op 15 juli 1606: Schilderijen, Rijksmuseum, Amsterdam; Museum Boijmans van Beuningen, Rotterdam, 1956

AMSTERDAM/WASHINGTON 1981–2
P. Schatborn, *Figuurstudies. Nederlandse tekeningen uit de 17de eeuw/Dutch Figure Drawings from the seventeenth century*, Rijksprentenkabinet, Rijksmuseum, Amsterdam; National Gallery of Art, Washington, 1981–2

ANGEL 1642
P. Angel, *Lof der schilder-konst*, Leiden, 1642. See also HOYLE/MIEDEMA 1996

ANONYMUS 1638
Anonymus, *Relation de ce qui s'est paßé a la Haye au mois de Fevrier l'an 1638 … au mariage de monsieur de Brederode et de Madamoyselle de Solms*, The Hague, 1638

ANTWERP/ARNHEM 1999–2000
K. Van der Stighelen and M. Westen, *Elck zijn waerom. Vrouwelijke kunstenaars in België en Nederland 1500-1950*, Koninklijk Museum voor Schone Kunsten, Antwerpen; Museum voor Moderne Kunst, Arnhem, 1999–2000

ASH/FLETCHER 1998
N. Ash and S. Fletcher, *Watermarks in Rembrandt's Prints*, Washington, 1998

ASSELIJN 1683
T. Asselijn, *Kraambed of kandeelmaal van Zaartje Jans*, Amsterdam, 1683

DE BAAR 1992
P.J.M. de Baar, *De Leidse verwanten van Rembrandt van Rijn en hun Leidse afstammelingen tot heden*, Leiden, 1992

DE BAAR ET AL. 1992
P.J.M. de Baar et al. (eds.), *Anna Maria van Schurman (1607-1678). Een uitzonderlijk geleerde vrouw*, Zutphen, 1992

BADEN-BADEN 1969
Maler und Modell, Staatliche Kunsthalle Baden-Baden, Baden-Baden, 1969

BADINTER 1980
E. Badinter, *L'Amour en plus. Histoire de l'amour maternel XVIIe-XXe siècle*, Paris, 1980

BAER 1990
R. Baer, *The Paintings of Gerrit Dou (1613-1675)*, PhD diss., Institute of Fine Arts, New York University, 1990

BAL 1991
M. Bal, *Reading 'Rembrandt': Beyond the World-Image Opposition*, Cambridge, Mass., 1991

BALDINUCCI 1681–1728
F. Baldinucci, *Notizie de' professori del disegno da Cimabue in qua, per le quali si dimostra come, e per chi le bell'arti di pittura, scultura, e architettura lasciata la rozzezza delle maniere greca, e gotica, si siano in questi secoli ridotte all'antica loro perfezione*, 6 vols., Florence, 1681–1728

BALDINUCCI 1686
F. Baldinucci, *Cominciamento e progresso dell'arte dell'intagliare in rame, colle vite di molti de' più eccelenti Maestri della stessa Professione*, Florence, 1686

BARTSCH 1797
A. von Bartsch, *Catalogue raisonné de toutes les estampes qui forment l'oeuvre de Rembrandt, et ceux de ses principaux imitateurs*, 2 vols., Vienna, 1797

BARTSCH (+ NO.)
A. Bartsch, *Le Peintre graveur*, 21 vols., Vienna, 1803–21

BAUCH 1960
K. Bauch, *Der frühe Rembrandt und seine Zeit: Studien zur geschichtlichen Bedeutung seines Frühstils*, Berlin, 1960

BAUCH 1966
K. Bauch, *Rembrandt: Gemälde*, Berlin, 1966

BECK 1993
D. Beck, *Spiegel van mijn leven; een Haags dagboek uit 1624*, Hilversum, 1993

BEDAUX 1999
J.B. Bedaux, 'From Normal to Supranormal: Observations on Realism and Idealism from a Biological Perspective', in *Sociobiology and the Arts*, J.B. Bedaux and B. Cooke (eds.), Amsterdam/ Atlanta, Georgia, 1999, pp.99-128

BENESCH (+ NO.)
O. Benesch, enlarged and edited by E. Benesch, *The Drawings of Rembrandt*, 6 vols., London/New York, 1973

BERGE-GERBAUD 1997
M. van Berge-Gerbaud, *Rembrandt et son école. Dessins de la Collection Frits Lugt*, Paris, 1997

BERGSTRÖM 1966
I. Bergström, 'Rembrandt's double-portrait of himself and Saskia at the Dresden Gallery', *Nederlands Kunsthistorisch Jaarboek* 17, 1966, pp.143-69

BERLIN/AMSTERDAM/LONDON 1991–2
Rembrandt: The Master & His Workshop, vol.1: *Paintings*, C. Brown, J. Kelch and P.J.J. van Thiel (eds.); vol.2: *Drawings & Etchings*, H. Bevers, P. Schatborn and B. Welzel (eds.), Altes Museum, Berlin; Rijksmuseum, Amsterdam; National Gallery, London, 1991–2

VAN BEVERWIJCK 1637
J. van Beverwijck, *Schat der gesontheyt*. Met verssen verciert door Heer Iacob Cats, Dordrecht, 1637

VAN BEVERWIJCK/VAN GEMERT 1992
J. van Beverwijck, *De schat der gezondheid*, L. van Gemert (ed.), Amsterdam, 1992

DE BIE 1661
C. de Bie, *Het gulden cabinet van de edel vrij schilderconst*, Antwerp, 1661

BIJTELAAR 1953
B. Bijtelaar, 'Het graf van Saskia', *Amstelodamum*, vol.40, 1953, pp.50-2

BILLE 1958
C. Bille, 'Oopen Coppit en haar ring', *Maandblad Amstelodamum*, 45, 1958, pp.186-7

DE BISSCHOP 1671
J. de Bisschop, *Paradigmata, Graphices Variorum Artificum*, Amsterdam, 1671

BLANKERT 1973
A. Blankert, 'Rembrandt, Zeuxis and Ideal Beauty', in BRUYN ET AL. 1973, pp.32-9

BLANKERT 1982
A. Blankert, *Ferdinand Bol 1616-1680: Rembrandt's Pupil*, Doornspijk, 1982

BLEYERVELD 2000
Y. Bleyerveld, *'Hoe bedriechlijck dat die vrouwen zijn'. Vrouwenlisten in de beeldende kunst in de Nederlanden circa 1350-1650*, Leiden, 2000

BODE/HOFSTEDE DE GROOT 1897–1906
W. Bode and C. Hofstede de Groot, *The Complete Work of Rembrandt: History, Description, and Heliographic Reproduction of All the Master's Pictures, with a Study of His Life and His Art*, 8 vols., Paris, 1897–1906

VAN BOHEEMEN 1989–91
P. van Boheemen et al. (eds.), *Kent, en versint, Eer datje mint. Vrijen en trouwen 1500-1800*, Zwolle, 1989-91

BOISSARD 1581
J.J. Boissard, *Habitus Variarum Orbis Gentium*, Malines, 1581

BOK 1990
M.J. Bok, '"Nulla dies sine linie" – De opleiding van schilders in Utrecht in de eesrte helft van de seventiende eeuw', De zeventiende eeuw, vol.6, 1990, pp.58-68

BOLTEN 1967
J. Bolten, *Dutch Drawings from the Collection of Dr C. Hofstede de Groot: An Introduction and Critical Catalogue*, Utrecht, 1967

BOMFORD/BROWN/ROY 1988
D. Bomford, C. Brown and A. Roy, *Rembrandt. Art in the Making*, National Gallery, London, 1988

BOOMGAARD 1995
J. Boomgaard, *De verloren zoon. Rembrandt en de Nederlandse kunstgeschiedschrijving*, Amsterdam, 1995

BOON 1963
K.G. Boon, *Rembrandt de etser*, Amsterdam, 1963

DE BOOY 1977
E.P. de Booy, *De weldaet der scholen. Het plattelandsonderwijs in de provincie Utrecht van 1580 tot het begin der 19de eeuw*, Utrecht, 1977

DE BOOY 1980
E.P. de Booy, *Kweekhoven der wijsheid. Basis en vervolgonderwijs in de steden van de provincie Utrecht van 1580 tot het begin der 19e eeuw*, Zutphen, 1980

BOREL 1990
F. Borel, *Le modèle ou l'artiste séduit*, Geneva, 1990

BORZELLO 1982
F. Borzello, *The artist's model*, London, 1982

BÖSE 1985
J.H. Böse, 'Had de mensch met één vrou niet connen leven…' Prostitutie in de literatuur van de zeventiende eeuw, Zutphen, 1985

BOSTON 1981
C.S. Ackley, *Printmaking in the Age of Rembrandt*, Museum of Fine Arts, Boston, 1981

BOSTON 2000–1
A. Chong (ed.) et al., *Rembrandt Creates Rembrandt. Art and Ambition in Leiden, 1629–1631*, Isabella Stewart Gardner Museum, Boston, 2000–1

BOSTON/NEW YORK 1969–70
Rembrandt: Experimental Etcher, Museum of Fine Arts, Boston; Pierpont Morgan Library, New York, 1969

BRAUN-RONSDORF 1967
M. Braun-Ronsdorf, *History of the Handkerchief*, Leigh on Sea, 1967

BRAUNSCHWEIG 1979
R. Klessmann, J. Bialostocki, R.E.O. Ekkart and S. Jacob, *Jan Lievens: Ein Maler im Schatten Rembrandts*, Herzog Anton Ulrich-Museum, Braunschweig, 1979

BRAUNSCHWEIG 1983
R. Klessmann et al., *Die holländischen Gemälde*, Herzog Anton Ulrich-Museum, Braunschweig, 1983

BREDIUS (+ NO.)
See BREDIUS 1935

BREDIUS 1909
A. Bredius, *Johannes Torrentius. Schilder. 1589-1644*, The Hague, 1909

BREDIUS 1915
A. Bredius, 'Rembrandtiana', *Oud-Holland*, vol.33, 1915, pp.126-8

BREDIUS 1915–22
A. Bredius, *Künstler-Inventare: Urkunden zur Geschichte der holländischen Kunst des XVIten, XVIIten und XVIIIten Jahrhunderts*, 8 vols., The Hague, 1915-22

BREDIUS 1935
A. Bredius, *Rembrandts Schilderijen*, Utrecht, 1935; German edition, Vienna, 1935; English edition, London, 1937

BREDIUS/GERSON
A. Bredius, revised by H. Gerson, *Rembrandt: The Complete Edition of the Paintings*, London, 1969

BREMEN 2000–1
A. Röver-Kann, *Rembrandt, oder nicht? Zeichnungen von Rembrandt und seinem Kreis aus den Hamburger und Bremer Kupferstichkabinetten*, Kunsthalle Bremen, 2000–1

BRINGEMEIER 1974
M. Bringemeier, 'Volkskundliches zu zwei Gemälden von Gerard Ter Borch', *Rheinisch-Westfälische Zeitschrift für Volkskunde* 21, 1974, Heft 1-4, pp.5-13

BROOS 1977
B.P.J. Broos, *Index to the Formal Sources of Rembrandt's Art*, Maarssen, 1977

BROOS 1981
B.P.J. Broos, *Rembrandt en tekenaars uit zijn omgeving. Oude tekeningen in het bezit van de Gemeentemusea van Amsterdam waaronder de collectie Fodor*, vol.3, Amsterdam, 1981

BROOS 1981-2
B.P.J. Broos, review of STRAUSS/VAN DER MEULEN, *Simiolus*, vol.12, no.4, 1981-2, pp.245-62

BROOS 1984
B.P.J. Broos, review of SUMOWSKI 1979-92, vols.1-4, *Oud Holland*, vol.98, no.3, 1984, pp.162-86

BROOS 1987
B.P.J. Broos, *Meesterwerken in het Mauritshuis*, The Hague, 1987

BROOS 1993
B.P.J. Broos, *Liefde, list en lijden: Historiestukken in het Mauritshuis*, Ghent, 1993; English edition, *Intimacies and Intrigue, History Painting in the Mauritshuis*, The Hague, 1993

BROOS/STOFFERS 1991
I. Broos and E. Stoffers, 'Elite en de min in de zeventiende en achtiende-eeuwse Republiek', *Moederschap en de min. Volkscultuur* 8, no.3, 1991, pp.47-64

BROWN 1981
C. Brown, *Carel Fabritius: Complete Edition with a Catalogue Raisonné*, Oxford, 1981

BROWN 1997
C. Brown, 'The strange case of Jan Torrentius: art, sex, and heresy in seventeenth-century Haarlem', R.E. Fleischer, S.C. Scott (eds.), *Rembrandt, Rubens, and the art of their time: recent perspectives*, Department of Art History, Pennsylvania State University, 1997, pp.224-33

DE BRUNE DE JONGE 1681
J. de Brune de Jonge, *Wetsteen der vernuften* (1644), in *Alle volgeestige werken*, Amsterdam, 1681

BRUSATI 1995
C. Brusati, *Artifice and Illusion: The Art and Writing of Samuel van Hoogstraten*, Chicago/London, 1995

BRUYN 1970-1
J. Bruyn, 'Rembrandt and the Italian Baroque', *Simiolus*, vol.4, no.1, 1970-1, pp.28-48

BRUYN 1984
J. Bruyn, review of SUMOWSKI 1983-95, vol.1, *Oud Holland*, vol.98, no.3, 1984, pp.146-62

BRUYN 1988
J. Bruyn, review of SUMOWSKI 1983-95, vol.3, *Oud Holland*, vol.102, no.4, 1988, pp.322-3

BRUYN 1996
J. Bruyn, review of SUMOWSKI 1983-95, vol.6, *Oud Holland*, vol.110, nos.3-4, 1996, pp.165-73

BRUYN ET AL. 1973
J. Bruyn, J.A. Emmens, E. de Jongh and D.P. Snoep (eds.), *Album Amicorum J.G. van Gelder*, The Hague, 1973

BÜRGER 1858-60
W. Bürger (E.J.T. Thoré), *Musées de la Hollande*, 2 vols., Paris, 1858-60

CAMBRIDGE 1996
C. Hartley, *Rembrandt and the Nude*, Fitzwilliam Museum, Cambridge, 1996

CAMPBELL 1971
C.G. Campbell, *Studies in the Formal Sources of Rembrandt's Figure Compositions*, PhD diss., London, 1971

CAMPBELL 1980
C. Campbell, 'Rembrandts etsen *Het sterfbed van Maria* en *De drie bomen*', *Kroniek van het Rembrandthuis*, vol.32, no.2, 1980, pp.2-33

CASTIGLIONE 1528
B. Castiglione, *Il libro del cortegiano* (1528), trans. A. Haakman, Amsterdam, 1981

CATS 1625
J. Cats, *Houwelyck, dat is de gantsche gelegentheyt des echten-staets*, Middelburg, 1625

CATS 1632
J. Cats, *Spiegel van den Ouden ende Nieuwen Tijdt, Bestaende uyt Spreeck-woorden ende Sin-spreucken…*, The Hague, 1632

CATS [1640]
J. Cats, *Maechden-plicht, ofte ampt der ionck-vrouwen, in eerbaer liefde aenghewesen door sinne-beelden*, Gouda [1640]

CATS 1660
J. Cats, *Dootkiste voor de levendige*, Amsterdam, 1660

CATS 1661
J. Cats, *Houwelyck* (1625), in *Alle de wercken*, Amsterdam, 1661

CAVALLI-BJÖRKMAN 1993
G. Cavalli-Björkman (ed.), *Rembrandt and His Pupils: Papers Given at a Symposium in Nationalmuseum Stockholm, 2-3 October 1992*, Stockholm, 1993

CHAPMAN 1990
H.P. Chapman, *Rembrandt's Self-Portraits. A Study in Seventeenth-Century Identity*, Princeton, N.J., 1990

CHICAGO 1969
E. Haverkamp Begemann et al., *Rembrandt after Three Hundred Years*, The Art Institute of Chicago, 1969

CLARK 1956
K. Clark, *The Nude. A Study of Ideal Art*, London, 1956 (reprinted Harmondsworth, 1960)

CLARK 1960
See CLARK 1956

CLARK 1966
K. Clark, *Rembrandt and the Italian Renaissance*, London, 1966

CLARK 1978
K. Clark, *An Introduction to Rembrandt*, London, 1978

CLARK 1984
T.J. Clark, *The Painting of Modern Life. Paris in the Art of Manet and his Followers*, Princeton, N.J., 1984

COPPIER 1917
A.-C. Coppier, *Les Eaux-Fortes de Rembrandt*, Paris, 1917

CORBEAU 1993
M. Corbeau, 'Pronken en koken. Beeld en realiteit van keukens in het vroegmoderne Hollandse binnenhuis', *Volkskundig Bulletin* 19, 1993, pp.354-79

CORPUS
J. Bruyn, B. Haak, S.H. Levie, P.J.J. van Thiel and E. van de Wetering, *A Corpus of Rembrandt Paintings*, Stichting Foundation Rembrandt Research Project, 3 vols. to date, The Hague/Dordrecht/Boston/London, 1982-

COSTER 1613
S. Coster, *Spel van Tijsken van der Schilden*, Amsterdam, 1613

CUMMING 1982
V. Cumming, *Gloves*, London, 1982

CUMMING 1984
V. Cumming, *A Visual History of Costume. The Seventeenth Century*, London, 1984

CUNNINGTON AND LUCAS 1972
P. Cunnington and C. Lucas, *Costumes for Births, Marriages and Deaths*, London, 1972

DAMSTRA-WIJMENGA 1995
S. Damstra-Wijmenga, *In smart zult gij uw kinderen baren. Opmerkelijke opvattingen over voortplanting*, Amsterdam/Overveen, 1995

DAULBY 1796
D. Daulby, *A Descriptive Catalogue of the Works of Rembrandt, and of his Scholars Bol, Livens, and Van Vliet, complied from the original etchings and from the catalogues of De Burgy, Gersaint, Helle and Glomy, Marcus, and Yver*, Liverpool, 1796

DEGRAZIA BOHLIN 1979
D. DeGrazia Bohlin, *Prints and Related Drawings by the Carracci Family. A Catalogue Raisonné*, Washington, 1979

DEKKER 1992
R. Dekker, 'Vrouwen in middeleeuws en vroegmodern Nederland', in *Geschiedenis van de vrouw, III. Van renaissance tot de moderne tijd*, A. Farge and N. Zemon Davis (eds.), Amsterdam, 1992, pp.415-45

DEKKER 1995
R. Dekker, *Uit de schaduw in 't grote licht. Kinderen in egodocumenten van de Gouden Eeuw tot de Romantiek*, Amsterdam, 1995

VAN DEURSEN 1974
A.Th. van Deursen, *Bavianen en slijkgeuzen: kerk en kerkvolk ten tijde van Maurits en Oldebarnevelt*, Assen, 1974

VAN DEURSEN 1988
A.Th. van Deursen, 'Werkende vrouwen in een Hollands dorp', *De zeventiende eeuw*, vol.4, 1988, pp.3-16

VAN DEURSEN 1991
A.Th. van Deursen, *Plain Lives in a Golden Age. Popular culture, religion and society in seventeenth-century Holland*, Cambridge, 1991

DEZALLIER D'ARGENVILLE 1745-52
J.A. Dezallier d'Argenville, *Abrégé de la vie des plus fameux peintres*, 3 vols., Paris, 1745-52

DICKEY 1994
S.S. Dickey, *Prints, Portraits and Patronage in Rembrandt's Work around 1640*, PhD diss., New York University, New York, 1994

DICKEY 1995
S.S. Dickey, '"Met een wenende ziel … doch droge ogen": Women Holding Handkerchiefs in Seventeenth-Century Dutch Portraits', *Nederlands Kunsthistorisch Jaarboek*, vol.46, 1995, pp.333-67

DIXON 1995
L.S. Dixon, *Perilous Chastity. Women and Illness in Pre-Enlightenment Art and Medicine*, Ithaca/London, 1995

DORDRECHT/COLOGNE 1999
Arent de Gelder (1645-1727): Rembrandts laatste leerling, Dordrechts Museum, Dordrecht; Wallraf-Richartz-Museum, Cologne, 1999

DUDOK VAN HEEL 1978
S.A.C. Dudok van Heel, 'Mr Joannes Wtenbogaert: Een man uit remonstrants milieu en Rembrandt van Rijn', *Jaarboek Amstelodamum*, vol.70, 1978, pp.146-69

DUDOK VAN HEEL 1979
S.A.C. Dudok van Heel, 'Het maecenaat Trip: Opdrachten aan Ferdinand Bol en Rembrandt van Rijn', *Kroniek van het Rembrandthuis*, vol.31, no.1, 1979, pp.14-26

DUDOK VAN HEEL 1980
S.A.C. Dudok van Heel, 'Enkele portretten "à l'antique" door Rembrandt, Bol, Flinck en Backer', *Kroniek van het Rembrandthuis*, vol.32, 1980, pp.2-9

DUDOK VAN HEEL 1981
S.A.C. Dudok van Heel, 'Het "gewoonlyck model" van de schilder Dirck Bleker', *Bulletin van het Rijksmuseum*, vol.29, 1981, pp.214-20

DUDOK VAN HEEL 1982
S.A.C. Dudok van Heel, 'Het "schilderhuis" van Govert Flinck en de kunsthandel van Uylenburgh aan de Lauriergracht te Amsterdam', *Jaarboek Amstelodamum*, vol.74, 1982, pp.70-90

DUTUIT 1885
E. Dutuit, *Tableaux et dessins de Rembrandt: Catalogue historique et descriptif* (supplement to *L'Oeuvre complet de Rembrandt*), Paris, 1885

EDINBURGH 1950
Rembrandt, National Gallery of Scotland, Edinburgh, 1950

EDINBURGH 1992
J. Lloyd Williams et al., *Dutch Art and Scotland: A Reflection of Taste*, National Gallery of Scotland, Edinburgh, 1992

VAN EEGHEN 1956
I.H. van Eeghen, 'De Kinderen van Rembrandt en Saskia', *Jaarboek Amstelodamum*, vol.43, 1956, pp.144-6

VAN EEGHEN 1983
I.H. van Eeghen, 'De familie Trip en het Trippenhuis', in *Het Trippenhuis te Amsterdam*, R. Meischke and H.E. Reeser (eds.), Amsterdam, 1983, pp.27-125

EKKART 1990
Rudolf E.O. Ekkart, *Portret van Enkhuizen in de Gouden Eeuw*, Zuiderzeemuseum, Enkhuizen, 1990

ELLINGER 1629
J. Ellinger, *Allmodischer Kleyder Teuffel; das ist, Schimpf und Ernstlicher Discurs, über den heuttigen oder A-la-modischen Kleyder Teuffel, & etc.*, Frankfurt, 1629

EMMENS 1968
J.A. Emmens, *Rembrandt en de regels van de kunst*, Utrecht, 1968

EMMENS 1979
J.A. Emmens, *Rembrandt en de regels van de kunst* (with English summary), revised edition, Amsterdam, 1979

FELTHAM 1652
O. Feltham, *A brief character of the Low-countries under the States*, London, 1652

FILEDT KOK 1972
J.P. Filedt Kok, *Rembrandt Etchings and Drawings in the Rembrandt House: A Catalogue*, Amsterdam, 1972

FOUCART 1982
J. Foucart, *Les Peintures de Rembrandt au Louvre*, Musée du Louvre, Paris, 1982

FOUCART 1987
J. Foucart, *Nouvelles acquisitions du Départment des Peintures (1983-1986)*, Musée du Louvre, Paris, 1987, pp.81-4

FRANITS 1993
W.E. Franits, *Paragons of Virtue. Women and Domesticity in Seventeenth-Century Dutch Art*, Cambridge, 1993

FREEDBERG 1989
D. Freedberg, *The Power of Images. Studies in the History and Theory of Response*, Chicago/London, 1989

FRIEDLAENDER 1955
W. Friedlaender, *Caravaggio Studies*, Princeton, N.J., 1955

FRISCH 1988
R.E. Frisch, 'Fatness and Fertility', *Scientific American* 258, 1988, no.3, pp.70-7

FROENTJES 1969
W. Froentjes, 'Schilderde Rembrandt op goud', *Oud Holland*, vol.84, 1969, pp.233-7

FURETIÈRE 1690
A. Furetière, *Dictionaire Universel*, The Hague/Rotterdam, 1690

DE GELDER 1921
J.J. de Gelder, *Bartholomeus van der Helst*, Rotterdam, 1921

VAN GELDER 1993
R. van Gelder, 'Heerlijke conterfeitsels en monstereuze tronies. Ideaal en werkelijkheid in de portretkunst van de renaissance', *Nederlands tijdschrift voor tandheelkunde* 100, 1993, pp.567-71

VAN GELDER/CAN DER VEEN 1999
R. van Gelder, J. van der Veen, '"A collector's cabinet in the Breestraat", Rembrandt as a lover of art and curiosities' in *Amsterdam 1999-2000*, pp.33-89

GERSAINT 1751
E.-F. Gersaint, *Catalogue raisonné de toutes les pièces qui forment l'oeuvre de Rembrandt*, Paris, 1751

GERSON 1961
H. Gerson, *Seven Letters by Rembrandt*, The Hague, 1961

GERSON 1968
H. Gerson, *Rembrandt Paintings*, Amsterdam, 1968

GILTAIJ 1988
J. Giltaij, *The Drawings by Rembrandt and His School in the Museum Boijmans-van Beuningen, De tekeningen van Rembrandt en zijn school in het Museum Boijmans-van Beuningen*, Rotterdam, 1988

GOEREE 1668
W. Goeree, *Inleydinge tot de Algemeene Teeken-Konst[...]*, Middelburg, 1668

GOEREE 1670
W. Goeree, *Inleydinge tot practyck der Al-gemeene Schilder-Konst*, Middelburg, 1670

GOEREE 1682
W. Goeree, *Natuurlyk en schilderkonstig ontwerp der menschkunde*, Amsterdam, 1682

GOLAHNY 1983
A. Golahny, 'Rembrandt's Early Bathsheba: The Raphael Connection', *The Art Bulletin*, vol.45, 1983, pp.671-5

GOLAHNY 1984
A. Golahny, *Rembrandt's Paintings and the Venetian tradition*, PhD diss., New York, 1984

GOLDNER/HENDRIX/WILLIAMS 1985
G. Goldner, L. Hendrix, G. Williams, *European Drawings-1. Catalogue of the Collections. The J. Paul Getty Museum*, Malibu, 1985

GOLDSCHEIDER 1960
L. Goldscheider, *Rembrandt: Paintings, Drawings and Etchings*, London, 1960

GONNET 1920
C.J. Gonnet, 'Rembrandt en Geertje Dircx', *Oud-Holland*, vol.38, 1920, pp.80-2

VAN GOOL 1750-1
J. van Gool, *De nieuwe schouburg der Nederlantsche kunstschilders en schilderessen*, 2 vols., The Hague, 1750-1

GORDENKER 1995
E.E.S. Gordenker, '"En rafelkragen, die hy schilderachtig vond" Was Rembrandt een voddenraper?' in *Kostuum, verzamelingen in beweging*, Zwolle, 1995, pp.21-32

GROENEWEG 1991
I. Groeneweg, 'Enkele aspecten van mode en kleedgedrag in Nederland naar aanleiding van de brieven van Van Hogendorp uit de late achttiende eeuw', *Textielhistorische Bijdragen* 31, 1991, pp.60-98

GROENEWEG 1995
I. Groeneweg, 'Regenten in het zwart: vroom en deftig?', *Nederlands Kunsthistorisch Jaarboek*, vol.46, 1995, pp.199-251

GROHÉ 1996
S. Grohé, *Rembrandts mythologische Historien*, Cologne, 1996

DE GROOT 1939
H. de Groot, *Inleidinge tot de Hollandsche Rechts-geleerdheid. Met aanteekeningen van S.J. Fockema Andreae. Vierde uitgave*, L.J. van Apeldoorn (ed.), 2 vols., Arnhem, 1939

GROTIUS 1926-36
H. Grotius, *The Jurisprudence of Holland*, trans. and annot. R.W. Lee, 2 vols., Oxford, 1926-36

GUDLAUGSSON 1938
S.J. Gudlaugsson, *Ikonographische Studien über die holländische Malerei und das Theater des 17. Jahrhunderts*, PhD diss., Würzburg, 1938

HAAK 1969
B. Haak, *Rembrandt: His Life, His Work, His Time*, New York, 1969

HAAK 1976
B. Haak, *Rembrandt Drawings*, London, 1976

HAAK 1984
B. Haak, *The Golden Age: Dutch Painters of the Seventeenth Century*, New York, 1984

HAARLEM 1986
E. de Jongh, *Portretten van echt en trouw: Huwelijk en gezin in de Nederlandse kunst van de zeventiende eeuw*, Frans Halsmuseum, Haarlem, 1986

HAARLEM 1993
P. Biesboer et al., *Judith Leyster. Schilderes in een mannenwereld*, Frans Halsmuseum, Haarlem, 1993

HAARLEM/ANTWERP 2000-1
J.B. Bedaux and R. Ekkart et al., *Kinderen op hun mooist. Het Kinderportret in de Nederlanden 1500-1700*, Frans Halsmuseum, Haarlem; Koninklijk Museum voor Schone Kunsten, Antwerp, 2000-1

THE HAGUE 1987
Huygens herdacht, A. Eyffinger (ed.), Koninklijke Bibliotheek, The Hague, 1987

THE HAGUE 1992
P. Huys Janssen and W. Sumowski, *Rembrandt's Academy*, Hoogsteder & Hoogsteder Gallery, The Hague, 1992

THE HAGUE 1997-8 (vol.1)
P. van der Ploeg, C. Vermeeren et al., *Princely Patrons. The Collection of Frederick Henry of Orange and Amalia of Solms*, Mauritshuis, The Hague, 1997-8

THE HAGUE 1997-8 (vol.2)
M. Keblusek and J. Zilmans, *Princely Display, The Court of Frederik Hendrik of Orange and Amalia van Solms*, Historical Museum, The Hague, 1997-8

THE HAGUE/SAN FRANCISCO 1990-1
B. Broos et al., *Great Dutch Paintings from America*, Mauritshuis, The Hague; The Fine Arts Museums of San Francisco, 1990

HAKS 1982
D. Haks, *Huwelijk en gezin in Holland in de 17de en 18de eeuw. Processtukken en moralisten over aspecten van het laat 17de- en 18de-eeuwse gezinsleven*, Assen, 1982

HASKELL/PENNY 1981
F. Haskell and N. Penny, *Taste and the Antique*, New Haven/London 1981

HAVERKAMP BEGEMANN 1959
E. Haverkamp Begemann, *Willem Buytewech*, Amsterdam, 1959

HAVERKAMP BEGEMANN 1961
E. Haverkamp Begemann, review of O. Benesch, *The Drawings of Rembrandt*, 6 vols., Oxford/London 1954-7, *Kunstchronik* 14, 1961, pp.10-28, 50-7, 85-91

HEARN 1995
K. Hearn (ed.), *Dynasties. Painting in Tudor and Jacobean England 1530-1630*, Tate Gallery, London, 1995

VAN HEEMSKERCK 1637
J. van Heemskerck, *Inleydinghe tot het ontwerp van een Batavische Arcadia*, Amsterdam 1637

VAN HEEMSKERCK 1647
J. van Heemskerck, *Batavische Arcadia*, Amsterdam, 1647 (expanded version of the 1637 edition)

HELD 1961
J. Held, 'Flora, Goddess and Courtesan', *De Artibus Opuscula XL: Essays in Honor of Erwin Panofsky*, M. Meiss (ed.), vol.2, New York, 1961, pp.201-18

HELD 1967
J. Held, 'Rubens' "Het Pelsken"', in *Essays in the History of Art Presented to Rudolf Wittkower*, London, 1967, pp.188-92

HELLINGA 1941
W.G. Hellinga (ed.), *Het hart op de tong*, The Hague, 1941

HEXHAM 1647
H. Hexham, *Het Groot woorden-boek gestelt in 't Engelsch ende Nederduytsch*, Rotterdam, 1647

HEYNS 1601
Z. Heyns, *Dracht-Thoneel*, Amsterdam, 1601

HdG. (+NO)
See HOFSTEDE DE GROOT 1908-27

H. (+NO.)
A.M. Hind, *A Catalogue of Rembrandt's Etchings: Chronologically Arranged and Completely Illustrated*, 2 vols., second edition, London, 1923

HINTERDING 1995
E. Hinterding, *The History of Rembrandt's Copperplates, with a Catalogue of Those That Survive*, Zwolle, 1995

HIRSCHMANN 1918
O. Hirschmann, 'Karel van Manders Haarlemer Akademie', *Monatshefte für Kunstwissenschaft* II, 1918, pp.213-31

HOFSTEDE DE GROOT 1894
C. Hofstede de Groot, 'Entlehnungen Rembrandts', *Jahrbuch der Königlich Preussischen Kunstsammlungen*, vol.15, 1894, pp.175-81

HOFSTEDE DE GROOT 1906
C. Hofstede de Groot, *Die Handzeichnungen Rembrandts: Versuch eines beschreibenden und kritischen Katalogs*, Haarlem, 1906

HOFSTEDE DE GROOT 1906A
C. Hofstede de Groot, *Die Urkunden über Rembrandt (1575-1721)*, The Hague, 1906

HOFSTEDE DE GROOT 1908-27
C. Hofstede de Groot, *A Catalogue Raisonné of the Works of the Most Eminent Dutch Painters of the Seventeenth Century, Based on the Work of John Smith*, 8 vols., London, 1908-27

HOFSTEDE DE GROOT 1928
C. Hofstede de Groot, 'De portretten van het echtpaar Jacob Trip en Margaretha de Geer door de Cuyp's, N. Maes en Rembrandt', *Oud-Holland*, vol.45, 1928, pp.255-64

HOKKE 1987
J. Hokke, '"Mijn alderliefste Jantielief". Vrouw en gezin in de Republiek: regentenvrouwen en hun relaties', *Vrouwenlevens 1500-1850. Achtste Jaarboek voor vrouwengeschiedenis*, U. Jansz et al. (eds.), Nijmegen, 1987, pp.45-73

HOLLANDER 1975
A. Hollander, *Looking through clothes*, New York/London, 1975

HOLLSTEIN
F.W.H. Hollstein et al., *Dutch and Flemish Etchings, Engravings and Woodcuts, c.1450-1700*, 46 vols. to date, Amsterdam/Roosendaal/Rotterdam, 1949- (for the vols. on Rembrandt, see WHITE/BOON)

HOLME 1688
R. Holme, *The Academy of Armory and Blazon*, Chester, 1688

HONDIUS 1621
P. Hondius, *Dapes inemptae, of de Moufe-schans, dat is, de soetigheydt des buyten-levens, vergheselschapt met de boucken. Afghedeelt in X gangen*, Leiden, 1621

HOOGEWERFF 1919
G.J. Hoogewerff, *De twee reizen van Cosimo de'Medici, Prins van Toscane, door de Nederlanden (1667-1669): Journalen en documenten*, Amsterdam, 1919

VAN HOOGSTRATEN 1678
S. van Hoogstraten, *Inleyding tot de hooge schoole der schilderkonst: anders te zichtbaere werelt*, Rotterdam, 1678

HOUBRAKEN 1718-21
A. Houbraken, *De groote schouburgh der Nederlantsche konstschilders en schilderessen*, 3 vols., Amsterdam, 1718-21 (second edition The Hague, 1753)

HOYLE/MIEDEMA 1996
M. Hoyle (trans.), H. Miedema (introduction and commentary), 'Philips Angel, *Praise of painting*', *Simiolus*, vol.24, 1996, nos.2-3, pp.227-58

HUYGENS 1653
C. Huygens, *Vitaulium. Hofwyck. Hofstede vanden Heere van Zuylichem onder Voorburgh*, The Hague, 1653 [1651]

HUYGENS 1876
Journaal van Constantijn Huygens, den zoon, Werken uitgegeven door het Historisch Genootschap, nieuwe reeks 23, 3 vols., Utrecht, 1876

HUYGENS (ED. HEESAKKERS 1987)
Constantijn Huygens. Mijn jeugd, trans. and comm. by C.L. Heesakkers, Amsterdam, 1987

ILLUSTRATED BARTSCH
W.L. Strauss et al. (eds.), *The Illustrated Bartsch*, New York, 1978-

DE JONGH 1969
E. de Jongh, 'The Spur of Wit: Rembrandt's Response to an Italian Challenge', *Delta: A Review of Arts, Life and Thought in the Netherlands* 12, no.2, 1969, pp.49-67

DE JONGH 1993
E. de Jongh, 'Reticent informants: seventeenth-century portraits and the limits of intelligibility', in K.-L. Selig (ed.), *Polyanthea. Essays on art and literature in honor of William Sebastian Heckscher*, The Hague, 1993, pp.57-73

DE JONGH 1993A
E. de Jongh, 'Dikte en voorspoed. Jacob Jordaens-tentoonstelling in Antwerpen', *Cultureel Supplement NRC Handelsblad*, 16 April 1993, p.7

DE JONGH 2000
E. de Jongh, *Questions of meaning. Theme and motif in Dutch seventeenth-century painting*, Leiden, 2000

DE JONGH 2000A
E. de Jongh, *Dankzij de tiende muze. 33 Opstellen uit Kunstschrift*, Leiden, 2000

JUDSON/EKKART 1999
J.R. Judson, R.E.O. Ekkart, *Gerrit van Honthorst, 1592-1656*, Doornspijk, 1999

KAHR 1966
M. Kahr, 'Rembrandt's *Esther*. A Painting and an Etching, newly dated', *Oud Holland*, vol.81, 1966, pp.228-44

KAHR 1973
M. Kahr, 'Rembrandt and Delilah', *Art Bulletin*, vol.55, no.2, June 1973, pp.240-59

KEISER 1941-2
E. Keiser, 'Über Rembrandts Verhältnis zur Antike', *Zeitschrift für Kunstgeschichte* 10, 1941-2, pp.129-62

DER KINDEREN-BESIER 1950
J.H. der Kinderen-Besier, *Spelevaart der mode, de kledij onzer voorouders in de 17de eeuw*, Amsterdam, 1950

KLIBANSKY/PANOFSKY/SAXL 1964
R. Klibansky, E. Panofsky and F. Saxl, *Saturn and Melancholy: Studies in the History of Natural Philosophy, Religion and Art*, London, 1964

KLOEK 1995
E.M. Kloek, 'De vrouw', in *Gestalten van de Gouden Eeuw. Een Hollands groepsportret*, H.M. Beliën, A.Th. van Deursen and G.J. van Setten (eds.), Amsterdam, 1995

KLOEK ET AL. 1991
E. Kloek, C. Peters Sengers and E. Tobé (eds.), *Vrouwen en kunst in de Republiek. Een overzicht*, Hilversum, 1998

KLOEK ET AL. 1991A
E. Kloek, G. Van Oostveen and N. Teeuwen, 'Nederlandse medici en moralisten over moederschap en min (1600-1900)', *Moederschap en de min. Volkscultuur* 8, 1991, no.3, pp.20-39

KLOEK/TEEUWEN/HUISMAN 1994
E. Kloek, N. Teeuwen, M. Huisman (eds.), *Women of the Golden Age. An International debate on women in seventeenth-century Holland, England and Italy*, Hilversum, 1994

VAN DER KLOOSTER 1980
L.J. van der Klooster, 'De juwelen en de kleding van Maria van Voorst van Doorwerth', *Nederlands Kunsthistorisch Jaarboek*, vol.31, 1980, pp.50-64

KNAPPERT 1909
L. Knappert, *Van sterven en begraven*, in *Uit onzen bloeitijd. Schetsen van het leven onzer vaderen in de XVIIe eeuw*, S.D. van Veen (ed.), Baarn, 1909, pp.3-47

KNUTTEL 1914
W.P.C. Knuttel, *Nieuw Nederlandsch biografisch woordenboek*, vol.3, Leiden, 1914

KÖLTZSCH 2000
G.-W. Költzsch, *Der Maler und sein Modell*, Köln, 2000

KOOIJMANS 1997
L. Kooijmans, *Vriendschap en de kunst van het overleven in de zeventiende en achttiende eeuw*, Amsterdam, 1997

KOOIJMANS 2000
L. Kooijmans, *Liefde in opdracht. Het hofleven van Willem Frederik van Nassau*, Amsterdam, 2000

KUNOTH-LEIFELS 1962
E. Kunoth-Leifels, *Über die Darstellungen der 'Bathseba in Bade': Studien zur Geschichte des Bildthemas: 4. bis 17. Jahrhundert*, Essen, 1962

DE LAIRESSE 1707
G. de Lairesse, *Het Groot Schilderboek*, 2 vols., Amsterdam, 1707 (second edition 1740)

LANDSBERGER 1962
F. Landsberger, *Rembrandt, the Jews and the Bible*, Philadelphia, 1962

LASKIN/PANTAZZI 1987
A.M. Laskin and M. Pantazzi, *European and American Painting, Sculpture and Decorative Arts*, National Gallery of Canada, Ottawa, 1987

LAURENTIUS 1996
T. Laurentius, *Etchings by Rembrandt: Reflections of the Golden Age – An Investigation into the Paper Used by Rembrandt*, Amsterdam, 1996

LAURENTIUS ET AL. 1992
T. Laurentius, H. van Hugten, E. Hinterding and J.P. Filedt Kok, 'Het Amsterdamse onderzoek naar Rembrandts papier: Radiographie van de watermerken in de etsen van Rembrandt', *Bulletin van het Rijksmuseum*, vol.40, 1992, pp.353–84

DE LAVERGNÉE/SCOTTEZ-DE WAMBRECHIES 1999
A. Brejon de Lavergnée, A. Scottez-De Wambrechies, *Musée des Beaux-Arts de Lille. Catalogue sommaire illustré des peintures, I (Écoles étrangères: Pays-Bas du Nord et du Sud, Allemagne, Angleterre, Espagne, Italie et autres)*, Paris, 1999

LEIDEN 1976–7
'Geschildert tot Leyden Anno 1626', Stedelijk Museum de Lakenhal, Leiden, 1976

LEIDEN 1988
E.J. Sluijter, M. Enklaar, P. Nieuwenhuizen et al., *Leidse fijnschilders: Van Gerrit Dou tot Frans van Mieris de Jonge, 1630–1760*, Stedelijk Museum de Lakenhal, Leiden, 1988

LEIDEN 1991–2
C. Vogelaar et al., *Rembrandt & Lievens in Leiden*, Stedelijk Museum de Lakenhal, Leiden, 1991–2

LEJA 1996
J. Leja, 'Rembrandt's "Woman Bathing in a Stream"', *Simiolus*, vol.24, no.4, 1996, pp.320–7

LEUKER 1992
M.-T. Leuker, *'De last van 't huys, de wil des mans…' Frauenbilder und Ehekonzepte im niederländischen Lustspiel des 17. Jahrhunderts*, Münster, 1992

LEUKER/ROODENBURG 1988
M.-T. Leuker and H. Roodenburg, ' "Die dan hare wyven laten afweyen". Overspel, eer en schande in de zeventiende eeuw', in *Soete minne en helsche boosheit. Seksuele voorstellingen in Nederland 1300–1850*, G. Hekma and H. Roodenburg (eds.), Nijmegen, 1988, pp.61–84

LINTHICUM 1936
M.C. Linthicum, *Costume in the drama of Shakespeare and his contemporaries*, Oxford, 1936

LONDON 1899
Winter Exhibition: Works by Rembrandt, Royal Academy, London, 1899

LONDON 1938
Catalogue of the Exhibition of 17th Century Art in Europe, Royal Academy, London, 1938

LONDON 1952–3
Dutch Pictures 1450–1750, Royal Academy, London, 1952

LONDON 1976
Art in Seventeenth-Century Holland, National Gallery, London, 1976

LONDON 1983
H. Braham, *Drawings by Rembrandt, Princes Gate Collection, University of London*, Courtauld Institute Gallery, London, 1983

LONDON 1988–9
D. Bomford, C. Brown and A. Roy et al., *Art in the Making: Rembrandt*, National Gallery, London, 1988–9

LONDON 1991
W. Bradford and H. Braham, *Master Drawings from the Courtauld Collections*, Courtauld Institute Gallery, London, 1991

LONDON 1992
M. Royalton-Kisch, *Drawings by Rembrandt and his Circle in the British Museum*, British Museum, London, 1992

LONDON 1993
C. Brown et. al., *Paintings and their Context IV: Rembrandt's 'Girl at a Window'*, Dulwich Picture Gallery, London, 1993

LONDON 1995
A. Laing, *In Trust for the Nation. Paintings from National Trust Houses*, National Gallery, London, 1995

LONDON/THE HAGUE 1999–2000
C. White and Q. Buvelot (eds.), *Rembrandt by Himself*, National Gallery, London; The Mauritshuis, The Hague, 1999–2000

LOUTTIT 1973
M. Louttit, 'The Romantic Dress of Saskia van Ulenborch: Its Pastoral and Theatrical Associations', *The Burlington Magazine* 115, May 1973, pp.317–26

LUGT 1915
F. Lugt, *Wandelingen met Rembrandt in en om Amsterdam*, second edition, Amsterdam, 1915

LUGT 1921, 1956
F. Lugt, *Les marques de collections de dessins & d'estampes*, Amsterdam, 1921; *Supplément*, The Hague, 1956

LUGT 1938, 1953, 1964
F. Lugt, *Répertoire des Catalogues de Ventes Publiques*, 3 vols., The Hague, 1938, 1953, 1964

VAN LUTTERVELT 1956
R. van Luttervelt, 'Bij het portret van Oopje Coppit', *Maandblad Amstelodamum* 43, June 1956, p.93ff.

MCGRATH 1984
E. McGrath, 'Rubens's Susanna and the Elders and Moralizing Inscriptions on Prints', in J. Müller Hofstede and H. Vekeman (eds.), *Wort und Bild in der niederländischen Kunst und Literatur des 16. und 17. Jahrhunderts*, Erftstadt, 1984, pp.73–90

MACGREGOR 1989
A. MacGregor (ed.), *The Late King's Goods: Collections, Possessions and Patronage of Charles I in the Light of the Commonwealth Sale Inventories*, London/Oxford, 1989

MACLAREN 1960
N. MacLaren, *The Dutch School*, National Gallery, London, 1960

MACLAREN/BROWN 1991
N. MacLaren, revised and expanded by C. Brown, *The Dutch School, 1600–1900*, 2 vols., National Gallery, London, 1991

MACLEAN 1980
I. Maclean, *The Renaissance Notion of Woman. A study in the fortunes of scholasticism and medical science in European intellectual life*, Cambridge, 1980

MCNEIL KETTERING 1983
A. McNeil Kettering, *The Dutch Arcadia. Pastoral Art and its Audience in the Golden Age*, Montclair, New Jersey, 1987

MCNEIL KETTERING 1988
A. McNeil Kettering, *Drawings from the Ter Borch Studio Estate in the Rijksmuseum*, 2 vols., The Hague, 1988

MCTAVISH 1984
D. McTavish, *Pictures from the Age of Rembrandt*, Agnes Etherington Art Centre, Queen's University, Kingston, Ontario, 1984

MAHON 1967
D. Mahon, *I disegni del Guercino della collezione Mahon*, Bologna, 1967

MÂLE 1932
E. Mâle, *L'Art religieux après le Concile de Trente*, Paris, 1932

MANCHESTER 1857
Catalogue of the Art Treasures of the United Kingdom, Collected at Manchester in 1857, Museum of Ornamental Art, Manchester, 1857

MANCHESTER 1957
Art Treasures Centenary: European Old Masters, City Art Gallery, Manchester, 1957

VAN MANDER 1604
K. van Mander, *Het Schilder-Boeck*, Haarlem, 1604

VAN MANDER 1604A
K. van Mander, *Den grondt der edel vry schilder-const*, Haarlem, 1604

VAN MANDER/MIEDEMA 1994–9
K. van Mander, *The Lives of the Illustrious Netherlandish and German Painters* (1604), with an Introduction and Translation, H. Miedema (ed.), 6 vols., Doornspijk, 1994–9

MANSFIELD 1980
Alan Mansfield, *Ceremonial Costume. Court, civil and civic costume from 1660 to the present day*, London, 1980

MANUTH 1987
V. Manuth, *Ikonographische Studien zu den Historien des Alten Testaments bei Rembrandt und seiner frühen Amsterdamer Schule. Mit einem kritischen Katalog der biblischen Gemälde des Amsterdamer Malers Jan Victors*, PhD diss., Freie Universität, Berlin, 1987

MANUTH 1993–4
V. Manuth, 'Denomination and Iconography: The Choice of Subject Matter in the Biblical Painting of the Rembrandt Circle', *Simiolus*, vol.22, no.4, 1993–4, pp.235–52

MARTENS 1970
'Het kasboek van Carel Martens, 1602–1649', in *Jaarboek Oud Utrecht*, 1970, pp.154–211

MELBOURNE/CANBERRA 1997–8
A. Blankert (ed.), *Rembrandt: A Genius and His Impact*, National Gallery of Victoria, Melbourne; National Gallery of Australia, Canberra, 1997–8

MIDDLETON 1878
C.H. Middleton, *A descriptive Catalogue of the etched Work of Rembrandt van Rijn*, London, 1878

MIEDEMA 1973
H. Miedema, *Karel van Mander: 'Den grondt der edel vry schilder-const'*, 2 vols., Utrecht, 1973

MIEDEMA 1987
H. Miedema, 'Kunstschilder, gilde en academie. Over het probleem van de emancipatie van de kunstschilders in de Noordelijke Nederlanden van de 16de en 17de eeuw', *Oud Holland*, vol.101, 1987, pp.1–34

MIEDEMA 1989
H. Miedema, *Kunst historisch*, Maarssen/s-Gravenhage, 1989

MILLAR 1958–60
O. Millar (ed.), 'Abraham van der Doort's Catalogue of the Collections of Charles I', *The Walpole Society* 37, 1958–60, pp.1–243

VON MOLTKE 1965
J.W. von Moltke, *Govaert Flinck, 1615–1660*, Amsterdam, 1965

VON MOLTKE 1994
J.W. von Moltke, *Arent de Gelder, Dordrecht 1645–1727*, Doornspijk, 1994

MONCONYS 1667
B. de Monconys, *Journal des voyages*, Paris, 1667

MONGAN/SACHS 1946
A. Mongan and P. Sachs, *Drawings in the Fogg Museum of Art*, Cambridge, Mass., 1946

MONTIAS 1982
J.M. Montias, *Artist and artisans in Delft: A Socio-Economic Study of the Seventeenth Century*, Princeton, N.J., 1982

MOORE 1994
C.N. Moore, ' "Niet de geboorte maar de gewoonte". Johan van Beverwijcks *Van de wtnementheyt des vrouwelicken geslachts* in een Europese context', in *De vrouw in de Renaissance*, A.-J. Gelderblom and H. Hendrix (eds.), Amsterdam, 1994, pp.28–41

DU MORTIER 1984
Bianca M. du Mortier, 'De handschoen in de huwelijkssymboliek van de zeventiende eeuw', *Bulletin van het Rijksmuseum*, vol.32, 1984, pp.189–201

MULLER 1981–2
J.M. Muller, 'The Perseus and Andromeda on Rubens's house', *Simiolus*, vol.12, 1981–2, pp.131–46

MÜNZ (+ NO.)
See MÜNZ 1952

MÜNZ 1952
L. Münz, *A Critical Catalogue of Rembrandt's Etchings*, 2 vols., London, 1952

MÜNZ 1953
L. Münz, 'Rembrandts Bild von Mutter und Vater', *Jahrbuch der kunsthistorischen Sammlungen in Wien*, vol.50, 1953, pp.141–90

NÉMETH 1996
I. Németh, 'De portretten van Jacob Trip en Margaretha de Geer door Nicolaes Maes in Boedapest', *Oud Holland*, vol.110, no.2, 1996, pp.79–84

NÉMETH/VAN LEEUWEN 1992
I. Németh and R. van Leeuwen, 'Onthullingen over onze Jacob Trip', *Mauritshuis Nieuwsbrief*, vol.5, nos.3–4, 1992, pp.8–9

NEW HAVEN 1983
C. White, D. Alexander and E. D'Oench, *Rembrandt in Eighteenth Century England*, Yale Center for British Art and British Studies, New Haven, Connecticut, 1983

NEW HOLLSTEIN 1993–
The New Hollstein: Dutch & Flemish etchings, engravings and woodcuts, 1450–1700, Rotterdam, 1993–

NEW YORK 1995–6
H. von Sonnenburg, W. Liedtke, C. Logan, N.M. Orenstein and S.S. Dickey, *Rembrandt/Not Rembrandt in The Metropolitan Museum of Art: Aspects of Connoisseurship*, 2 vols., The Metropolitan Museum of Art, New York, 1996

NEW YORK 1997
M. Bisanz-Prakken et al., *From Dürer to Rauschenberg: A Quintessence of Drawing: Masterworks from the Albertina*, The Solomon R. Guggenheim Museum, New York, 1997

NEW YORK 1998–9
M.W. Ainsworth et al., *From Van Eyck to Bruegel: Early Netherlandish Painting in The Metropolitan Museum of Art*, The Metropolitan Museum of Art, New York, 1998–9

NEWTON 1975
S.M. Newton, *Renaissance Theatre Costume and the Sense of the Historic Past*, London, 1975

NICOLSON/VERTOVA 1989
B. Nicolson, *Caravaggism in Europe*, second edition, revised by L. Vertova, Turin, 1989

NOORDAM 1987
D.J. Noordam, 'Lust, last en plezier: vier eeuwen seksualiteit in Nederland', in *Een kind onder het hart. Verloskunde, volksgeloof, gezin, seksualiteit en moraal vroeger en nu*, R.E. Kistemaker (ed.), Amsterdam, 1987, pp.127–70

NOORDEGRAAF/VALK 1996
L. Noordegraaf and G. Valk, *De Gave Gods. De pest in Holland vanaf de late Middeleeuwen*, Amsterdam, 1996

NOTTINGHAM/KENWOOD 1991
The Artist's Model: Its Role in British Art from Lely to Etty, University Art Gallery, Nottingham; The Iveagh Bequest, Kenwood, 1991

ORBÁN 1985
A.P. Orbán, 'Het middeleeuwse antifeminisme', in *Middeleeuwers over vrouwen*, vol.2, R.E.V. Stuip and C. Vellekoop (eds.), Utrecht, 1985, pp.121–33

ORENSTEIN 1996
N.M. Orenstein, *Hendrick Hondius and the Business of Prints in Seventeenth-Century Holland*, Rotterdam, 1996

ORNSTEIN-VAN SLOOTEN/HOLTROP/SCHATBORN 1991
E. Ornstein-van Slooten, M. Holtrop and P. Schatborn, *The Rembrandt House: The Prints, Drawings and Paintings*, Zwolle/Amsterdam, 1991

PALFIJN 1724
J. Palfijn, *Ontleed-kundige Beschryving, van de Vrouwelijke Deelen, die ter voort-teeling dienen*, Ghent, 1724

PARIS 1970–1
J. Foucart et al., *Le Siècle de Rembrandt: Tableaux hollandais des collections publiques françaises*, Musée du Petit Palais, Paris, 1970

PARIS 1988–9
J. Foucart, *Peintres rembrandtesques au Louvre*, Musée du Louvre, Paris, 1988

PARIS 1988–9A
M. de Bazelaire and E. Starcky, *Rembrandt et son école, dessins du musée du Louvre, Cabinet des Dessins*, Musée du Louvre, Paris, 1988–9

PARIS 2000
P. Jean-Richard, *Gravures et Dessins de la Collection Edmond de Rothschild et du Cabinet du Dessins*, Musée du Louvre, Paris, 2000

PARIS/ANTWERP/LONDON/NEW YORK 1979–80
F. Stampfle, *Rubens and Rembrandt in their Century. Flemish and Dutch drawings of the 17th century from the Pierpont Morgan Library*, Institut Néerlandais, Paris; Koninklijk Museum voor Schone Kunsten, Antwerp; British Museum, London; Pierpont Morgan Library, New York, 1979–80

PARIS/HAARLEM 1997–8
M. van Berge-Gerbaud, *Rembrandt en zijn school: Tekeningen uit de Collectie Frits Lugt*, Institut Néerlandais, Paris; Teylers Museum, Haarlem, 1997–8

PARIS/LYON 1991
H. Buijs and M. van Berge-Gerbaud, *Tableaux Flamands et Hollandais du Musée des Beaux-Arts de Lyon*, Institut Néerlandais, Paris; Musée des Beaux-Arts, Lyon, 1991

DE PASSE 1641
Crispijn de Passe, *Les abus du mariage. Misbruick des Houwelycx, waer in klaerlijck word uitgebeeldt de boosheden en lossheden zo wel tusschen Mannen als Vrouwen gepleeght, om malkander behendigh te bedriegen. Hier zijn bygevoeght eenige nutte en noodige leeringh, streckende tot verbeteringe der hedendaeghsche bedorven huyshoudige*, Amsterdam, 1641

PAULY 1979
Der Kleine Pauly. Lexikon der Antike in fünf Bänden, vol.2, K. Ziegler and W. Sontheimer (eds.), Munich, 1979

PELS 1681
A. Pels, *Gebruik en misbruik des tooneels*, Amsterdam, 1681

PENNINGTON 1982
R. Pennington, *A Descriptive Catalogue of the Etched Work of Wenceslaus Hollar 1607–1677*, Cambridge, 1982

PEPYS/LATHAM 1970–94
R. Latham, W. Matthews (eds.), *The Diary of Samuel Pepys. A new and complete transcription*, 11 vols., London, 1970–94

PHILADELPHIA/BERLIN/LONDON 1984
Masters of Seventeenth-Century Dutch Genre Painting, Philadelphia Museum of Art; Gemäldegalerie, Staatliche Museen Preussischer Kulturbesitz, Berlin; Royal Academy of Arts, London, 1984

PHOENIX/KANSAS/THE HAGUE 1998–9
Copper as Canvas: Two Centuries of Masterpiece Paintings on Copper, 1525–1775, Phoenix Art Museum, Phoenix; The Nelson-Atkins Museum of Art, Kansas City; Mauritshuis, The Hague, 1998–9

PILES 1699
R. de Piles, *Abrégé de la vie des peintres avec des réflexions sur leurs ouvrages, et un traité du peintre parfait, de la connoissance des desseins & de l'utilité des estampes*, Paris, 1699

PLOMP 1997
M.C. Plomp, *The Dutch Drawings in the Teyler Museum: Artists Born Between 1575 and 1630*, Haarlem/Ghent/Doornspijk, 1997

VAN DE POL 1988
L.C. van de Pol, 'Beeld en werkelijkheid van de prostitutie in de zeventiende eeuw', G. Hekma, H. Roodenburg (eds.), *Soete minne en helsche boosheit. Seksuele voorstellingen in Nederland, 1300–1850*, Nijmegen, 1988, pp.109–44

VAN DE POL 1996
L.C. van de Pol, *Het Amsterdams hoerdom. Prostitutie in de zeventiende en achttiende eeuw*, Amsterdam, 1996

POLLMANN 2000
J. Pollmann, 'Women and Religion in the Dutch Golden Age', *Dutch Crossing*, 24, 2000, pp.162–82

PORTEMAN 1986
K. Porteman, 'Vondels gedicht "Op een Italiaensche Schildery van Suzanne"', in G. van Eemeren and F. Willaert (eds.), *'t Ondersoeck leert. Studies over middeleeuwse en 17de-eeuwse literatuur ter nagedachtenis van prof. dr. L. Rens*, Leuven/Amersfoort, 1986, pp.301–18

RALEIGH 1956
Rembrandt and His Pupils, North Carolina Museum of Art, Raleigh, North Carolina, 1956

RANG 1988
B. Rang, '"Geleerde Vrouwen van alle Eeuwen ende Volckeren, zelfs oock by de barbarische Scythen". De catalogi van geleerde vrouwen in de zeventiende en achttiende eeuw', in *Geleerde vrouwen. Negende Jaarboek voor Vrouwengeschiedenis*, T. van Loosbroek et al. (eds.), Nijmegen, 1988, pp.36–64

RÉAU 1955–9
L. Réau, *Iconographie de l'art chrétien*, 6 vols., Paris, 1955–9

REYNOLDS 1801
J. Reynolds, *The Works of Sir Joshua Reynolds, Knight, Late President of the Royal Academy*, 3 vols., revised edition, London, 1801

REZNICEK 1977
E.K.J. Reznicek, 'Opmerkingen bij Rembrandt', *Oud Holland*, vol.91, nos.1–2, 1977, pp.75–107

RIBEIRO 1986
Aileen Ribeiro, *Dress and Morality*, London, 1986

VAN RIJCKEVORSEL 1932
J.L.A.A.M. van Rijckevorsel, *Rembrandt en de traditie*, Rotterdam, 1932

RIPA 1644
C. Ripa, *Iconologia, of uytbeeldinghe en des verstands, uyt het Italiens vertaelt door D. Pietersz Pers*, Amsterdam, 1644

ROBERTS 1998
B. Roberts, *Through the keyhole. Dutch child-rearing practices in the 17th and 18th century. Three urban elite families*, Hilversum, 1998

ROBINSON 1987
W. Robinson, 'The *Eavesdroppers* and Related Paintings by Nicolaes Maes', in *Holländische Genremalerei im 17. Jahrhundert: Symposium Berlin 1984, Jahrbuch Preußischer Kulturbesitz*, special vol.4, H. Bock and T.W. Gaehtgens (eds.), Berlin, 1987, pp.283–313

ROBINSON 1989
W. Robinson, 'Nicolaes Maes as a Draughtsman', *Master Drawings*, vol.27, no.2, Summer 1989, pp.146–62

ROBINSON 1996
W. Robinson, *The Early Works of Nicolaes Maes, 1653–1661*, PhD diss., Harvard University, Cambridge, Mass., 1996

RODING 1986
J. Roding, *Schoon en net. Hygiëne in woning en stad*, The Hague, 1986

ROODENBURG 1990
H.W. Roodenburg, *Onder censuur. De kerkelijke tucht in de gereformeerde gemeente van Amsterdam, 1578–1700*, Hilversum, 1990

ROODENBURG 1996
H. Roodenburg, 'Eer en oneer ten tijde van de Republiek: een tussenbalans', *Volkskundig Bulletin* 22, 1996, pp.129–47

ROSCAM ABBING 1993
M. Roscam Abbing, with P. Thissen, *De schilder en schrijver Samuel van Hoogstraten, 1627–1678: Eigentijdse bronnen en oeuvre van gesigneerde schilderijen*, Leiden, 1993

ROSCAM ABBING 1994
M. Roscam Abbing, 'Houbrakens onbeholpen kritiek op de Rembrandt-ets "De Zondeval" (B.28)', *Kroniek van het Rembrandthuis*, vol.46, no.2, 1994, pp.14–23

ROSCAM ABBING 1999
M. Roscam Abbing, *Rembrandt toont sijn konst. Bijdragen over Rembrandt-documenten uit de periode 1648–1756*, Leiden, 1999

ROSENBERG 1959
J. Rosenberg, review of BENESCH 1954–7, *The Art Bulletin*, vol.41, no.1, March 1959, pp.108–19

ROSENBERG 1964
J. Rosenberg, *Rembrandt: Life & Work*, second revised edition, London, 1964 (1948)

ROTTERDAM 1988
Een gloeiend palet: Schilderijen van Rembrandt en zijn school/A Glowing Palette: Paintings of Rembrandt and His School, Museum Boijmans-van Beuningen, Rotterdam, 1988

ROTTERDAM/FRANKFURT 1999–2000
A. Blankert (ed.), *Hollands Classicisme in de zeventiende-eeuwse schilderkunst*, Museum Boijmans Van Beuningen, Rotterdam; Städelsches Kunstinstitut, Frankfurt am Main, 1999–2000

ROYALTON-KISCH 1988
M. Royalton-Kisch, *Adriaen van de Venne's album*, London, 1988

ROYALTON-KISCH 1993
M. Royalton-Kisch, 'Rembrandt's Drawings from his Prints: Some Observations', in G. Cavalli-Björkman (ed.), *Rembrandt and his Pupils. Papers given at a Symposium in Nationalmuseum Stockholm, 2–3 October 1992*, Stockholm, 1993, pp.173–92

RUESSINK 1989
H. Ruessink, 'Hendrickje Stoffels, jongedochter van Bredevoort', *Kroniek van het Rembrandthuis*, 1989, no.1, pp.19–24

RUTTEN 1997
W. Rutten, '*De vreselijkste aller harpijen'. Pokkenepidemieën en pokkenbestrijding in Nederland in de achttiende en negentiende eeuw: een sociaal-historische en historisch-demografische studie*, Wageningen, 1997

VON SANDRART 1675
J. von Sandrart, *L'Academia Todesca della Architectura, Scultura et Pictura: oder Teutsche Academie der Edlen Bau-, Bild- und Mahlerey-Künste*, 2 vols., Nuremberg, 1675

SANDRART/PELTZER 1925
Joachim von Sandrarts Academie der Bau-, Bild- und Mahlerey-Künste von 1675, A.R. Peltzer (ed.), Munich, 1925

SAXL 1923–4
F. Saxl, 'Rembrandt und Italien', *Oud-Holland*, vol.41, 1923–4, pp.145–60

SCARISBRICK 1993
D. Scarisbrick, *Rings, Symbols of Wealth, Power and Affection*, London, 1993

SCARISBRICK 1995
D. Scarisbrick, *Tudor and Jacobean Jewellery*, London, 1995

SCHAMA 1985
S. Schama, 'Rembrandt and Women', *Bulletin of the American Academy of Arts and Sciences*, vol.38, April 1985, pp.21–47

SCHAMA 1987
S. Schama, *The Embarrassment of Riches. An Interpretation of Dutch Culture in the Golden Age*, New York, 1987

SCHAMA 1999
S. Schama, *Rembrandt's Eyes*, London etc., 1999

SCHATBORN 1981
P. Schatborn, *Figuurstudies: Nederlandse tekeningen uit de 17de eeuw*, The Hague, 1981

SCHATBORN 1981A
P. Schatborn, 'Van Rembrandt tot Crozat: Vroege verzamelingen met tekeningen van Rembrandt', *Nederlands Kunsthistorisch Jaarboek*, vol.32, 1981, pp.1–54

SCHATBORN 1981–2
Figuurstudies. Nederlandse tekeningen uit de 17de eeuw/Dutch Figure Drawings from the seventeenth century, Rijksmuseum, Rijksprentenkabinet, Amsterdam; National Gallery of Art, Washington; The Hague, 1981–2

SCHATBORN 1983
P. Schatborn, 'Rembrandt: From Drawings to Prints and Paintings', *Apollo*, vol.107, no.256, June 1983, pp.452–60

SCHATBORN 1985
P. Schatborn, *Tekeningen van Rembrandt, zijn onbekende leerlingen en navolgers/Drawings by Rembrandt, his anonymous pupils and followers (Catalogus van de Nederlandse Tekeningen in het Rijksprentenkabinet, Rijksmuseum, Amsterdam)*, vol.4, The Hague, 1985

SCHATBORN 1986
P. Schatborn, review of *Corpus*, vol.1, *Oud Holland*, vol.100, 1986, pp.55–63

SCHATBORN 1993
P. Schatborn, 'Rembrandt's late drawings of female nudes', W. Strauss, T. Felker (eds.), *Drawings Defined*, New York, 1987, pp.306–18

SCHATBORN 1993
P. Schatborn, 'Rembrandt: from Life and from Memory', in G. Cavalli-Björkman (ed.), *Rembrandt and His Pupils. Papers given at a Symposium in Nationalmuseum Stockholm, 2–3 October 1992*, Stockholm, 1993, pp.156–72

SCHATBORN/ORNSTEIN-VAN SLOOTEN 1984–5
P. Schatborn, E. Ornstein-van Slooten, *Bij Rembrandt in de leer/Rembrandt as teacher*, exh. cat. Museum Rembrandthuis, Amsterdam, 1984–5

SCHELLER 1969
R.W. Scheller, 'Rembrandt en de encyclopedische kunstkamer', *Oud Holland*, vol.84, 1969, pp.81–147

SCHELTEMA 1853
P. Scheltema, *Rembrand: Redevoering over het leven en de verdiensten van Rembrand van Rijn, met eene menigte geschiedkundige bijlagen meerendeels uit echte bronnen geput*, Amsterdam, 1853

SCHENKEVELD-VAN DER DUSSEN 1979–80
M.A. Schenkeveld-van der Dussen, 'Anna Roemers Visscher: de tiende van de negen, de vierde van de drie', *Jaarboek van de Maatschappij der Nederlandse Letterkunde te Leiden*, 1979–80, pp.3–14

SCHENKEVELD-VAN DER DUSSEN 1997
Riet Schenkeveld-van der Dussen et al. (eds.), *Met en zonder lauwerkrans. Schrijvende vrouwen uit de vroegmoderne tijd 1550–1850: van Anna Bijns tot Elise van Calcar*, Amsterdam, 1997

SCHILLEMANS 1987
R. Schillemans, 'Gabriel Bucelinus and "The Names of the Most Distinguished European Painters"', *Hoogsteder-Naumann Mercury*, no.6, 1987, pp.25–37

SCHILLEMANS 1989
R. Schillemans, *Bijbelschilderkunst rond Rembrandt*, Utrecht, 1989

SCHILLEMANS 1991
R. Schillemans, '"Rimprant, nostrae aetatis miraculum" (Rembrandt, het wonder van onze tijd)', *Kroniek van het Rembrandthuis*, vol.43, no.1, 1991, pp.17–20

SCHINKEL 1851
A.D. Schinkel, *Nadere bijzonderheden betrekkelijk Constantijn Huygens en zijne familie*, 1851

SCHNACKENBURG 1996
B. Schnackenburg, *Staatliche Museen Kassel, Gemäldegalerie Alte Meister, Gesamtkatalog*, 2 vols., Mainz, 1996

SCHNEIDER 1990
C.P. Schneider, *Rembrandt's Landscapes*, New Haven, Connecticut, 1990

SCHNEIDER/EKKART 1973
H. Schneider, with a supplement by R.E.O. Ekkart, *Jan Lievens: Sein Leben und seine Werke*, Amsterdam, 1973

SCHRADER 1984
C.G. Schrader's Memoryboeck van de vrouwens. Het notitieboek van een Friese vroedvrouw 1693–1745, M.J. van Lieburg (ed.), Met een verloskundig commentaar van G.J. Kloosterman, Amsterdam, 1984

SCHREVELIUS 1648
T. Schrevelius, *Harlemias, ofte, om beter te seggen, de eerste stichtinghe der stadt Haerlem*, Haarlem, 1648

SCHWARTZ 1984
G. Schwartz, *Rembrandt: Zijn leven, zijn schilderijen*, Maarssen, 1984, English edition 1985

SCHWARTZ 1985
(English edition of Schwartz 1984)

SCHWARTZ 1989
F. Schwartz, '"The Motions of the Countenance": Rembrandt's Early Portraits and the *Tronie*', in *Res: Anthropology and Aesthetics*, nos.17–18, Spring–Autumn 1989, pp.89–116

SEILERN 1961
Count A. Seilern, *Paintings and Drawings of Continental Schools other than Flemish and Italian at 56 Princes Gate*, London, 1961

SEWEL 1691
W. Sewel, *A large dictionary English and Dutch*, Amsterdam, 1691

VON SIMSON/KELCH 1973
O. von Simson and J. Kelch (eds.), *Neue Beiträge zur Rembrandt-Forschung: Rembrandt Kongress, Berlin, 1969*, Berlin, 1973

SLATKES 1973
L.J. Slatkes, review of C. White and K.G. Boon, *Rembrandt's Etchings*, 1969, and C. White, *Rembrandt as an Etcher*, 1969, *The Art Quarterly*, vol.36, 1973, pp.250–63

SLATKES 1992
L.J. Slatkes, *Rembrandt, Catalogo Completo*, Florence, 1992

SLIVE 1953
S. Slive, *Rembrandt and His Critics 1630–1730*, The Hague, 1953

SLIVE 1970–4
S. Slive, *Frans Hals*, 3 vols., London/New York, 1970–4

SLIVE 1980
S. Slive, in *Armand Hammer Collection: Five Centuries of Masterpieces*, J. Walker (ed.), New York, 1980, pp.46–9

SLIVE 1988
S. Slive, review of AMSTERDAM/BOSTON/ PHILADELPHIA 1987–8, *The Burlington Magazine*, vol.130, no.1022, May 1988, pp.395–8

SLUIJTER 1986
E.J. Sluijter, *De 'Heydensche Fabulen' in der Noordenederlandse schilderkunst circa 1590-1670. Een proeve van schilderijen met verhalende onderwerpen uit de Klassieke mythologie*, diss., Leiden, 1986

SLUIJTER 1993
E.J. Sluijter, *De lof der schilderkunst: Over schilderijen van Gerrit Dou (1613-1675) en een traktaat van Philips Angel uit 1642*, Hilversum, 1993

SLUIJTER 1993A
E.J. Sluijter, 'Rembrandt's Early Paintings of the Female nude: Andromeda and Susanna', G. Cavalli-Björkman (ed.), *Rembrandt and His Pupils. Papers given at a Symposium in Nationalmuseum Stockholm, 2–3 October 1992*, Stockholm, 1993, pp.31–54

SLUIJTER 1998
E.J. Sluijter, 'Rembrandt's Bathsheba and the Conventions of a Seductive Theme', in A. Jensen Adam (ed.), *Rembrandt's Bathsheba Reading King David's Letter*, Cambridge/New York/Melbourne, 1998, pp.48–99

SLUIJTER 1999
E.J. Sluijter, 'Emulating Sensual Beauty: Representations of Danaë from Gossaert to Rembrandt', *Simiolus*, vol.27, 1999, pp.4–45

SLUIJTER 2000
E.J. Sluijter, *Seductress of Sight. Studies in Dutch Art of the Golden Age*, Zwolle, 2000

SLUIJTER 2000A
E.J. Sluijter, *De 'heydensche fabulen' in de schilderkunst van de Gouden Eeuw. Verhalende onderwerpen uit de klassieke mythologie in de Noordelijke Nederlanden, circa 1590–1670*, Leiden, 2000

SMITH 1829–42
J. Smith, *A Catalogue Raisonné of the Works of the Most Eminent Dutch, Flemish and French Painters …*, 9 vols. (including 1842 supplement), London, 1829–42

SMITH 1982
D.R. Smith, *Masks of Wedlock: Seventeenth-Century Dutch Marriage Portraiture*, Ann Arbor, Michigan, 1982

SMITH 1988
D.R. Smith, '"I Janus": Privacy and the Gentlemanly Ideal in Rembrandt's Portraits of Jan Six', *Art History*, March 1988, 1, pp.42–63

SMITS-VELDT 1994
M. Smits-Veldt, *Maria Tesselschade. Leven met talent en vriendschap*, Zutphen, 1994

SOKOLOWA 1998
I. Sokolowa et al., *Danaë*, St Petersburg, 1998

SPIES 1986
M. Spies, 'Charlotte de Huybert en het gelijk. De geleerde en de werkende vrouw in de zeventiende eeuw', *Literatuur* 3, 1986, pp.339–50

SPIES 1993
M. Spies, 'Oudejaarsavond 1675', in *Nederlandse literatuur, en geschiedenis*, M.A. Schenkeveld-van der Dussen (ed.), Groningen, 1993, pp.282–7

SPUFFORD 1995
M. Spufford, 'Literacy, trade and religion in the commercial centres of Europe', in *A miracle mirrored. The Dutch Republic in European Perspective*, K. Davids and J. Lucassen (eds.), Cambridge, 1995, pp.229—83

STECHOW 1942
W. Stechow, 'Rembrandt and Titian', *The Art Quarterly*, vol.5, 1942, pp.135–46

VAN DER STIGHELEN 1987
K. Van der Stighelen, *Anna Maria van Schurman of 'Hoe hooge dat een maeght kan in de konsten stijgen'*, Leuven, 1987

VAN STIPRIAAN 1996
R. van Stipriaan, *Leugens en vermaak. Boccaccio's novellen in de kluchtcultuur van de Nederlandse renaissance*, Amsterdam, 1996

STOCKHOLM 1992–3
Rembrandt och hans tid: Människan i centrum/ Rembrandt and His Age: Focus on Man, Nationalmuseum, Stockholm, 1992

STONE-FERRIER 1983–4
L.A. Stone-Ferrier, *Dutch Prints of Daily Life: Mirrors of Life or Masks of Morals?*, Spencer Museum of Art, University of Kansas, Lawrence, Kansas; Yale University Art Gallery, New Haven, Connecticut; Huntington Gallery, University of Texas at Austin, 1983

STONE-FERRIER 1985
L.A. Stone-Ferrier, *Images of Textiles: The Weave of Seventeenth-Century Dutch Art and Society*, Ann Arbor, Michigan, 1985

STRAUSS/VAN DER MEULEN 1979
W.L. Strauss, M. van der Meulen (eds.), *The Rembrandt Documents*, New York, 1979

VAN STRIEN 1989
C.D. van Strien, *British Travellers in Holland during the Stuart Period*, diss., Vrije Universiteit, Amsterdam, 1989

SUMOWSKI 1979–92
W. Sumowski, *Drawings of the Rembrandt School*, 10 vols., New York, 1979–92

SUMOWSKI 1983–95
W. Sumowski, *Gemälde der Rembrandt-Schüler*, 6 vols., Landau/Pfalz, 1983–95

SWANN 1995
C. Swann, 'Ad vivum, naer het leven; from the life: defining a mode of representation', *Word & Image*, vol.11, 1995, pp.353–72

SWEERTS 1678
H. Sweerts, *De tien Vermakelikheden des Houwelycks*, Amsterdam, 1678

TAYLOR 1983
L. Taylor, *Mourning Dress, a Costume and Social History*, London, 1983

TAYLOR 1992
P. Taylor, 'The Concept of Houding in Dutch Art Theory', *Journal of the Warburg and Courtauld Institutes*, vol.55, 1992, pp.210–32

VAN THIEL 1976
P.J.J. van Thiel et al. (eds.), *All the paintings of the Rijksmuseum in Amsterdam: A completely illustrated catalogue*, Amsterdam/Maarssen, 1976

VAN THIEL 1999
P.J.J. van Thiel, *Cornelis Cornelisz van Haarlem, 1562–1638*, Doornspijk, 1999

VAN THIENEN 1930
F. van Thienen, *Das Kostüm der blütezeit Hollands, 1600–1660*, Berlin, 1930

TOLEDO 1997–8
A. Lowenthal, *Rembrandt's Holy Family with Angels*, The Toledo Museum of Art, Ohio, 1997-8

TRNEK 1992
R. Trnek, *Die Holländisches Gemälde des 17. Jahrhunderts in der Gemäldegalerie der Akademie der Bildenden Künste in Wien*, Vienna, Cologne, Weimar, 1992

TÜMPEL 1968
C. Tümpel, 'Ikonographische Beiträge zu Rembrandt I', *Jahrbuch der Hamburger Kunstsammlungen* 3, 1968, pp.95–126

TÜMPEL 1969
C. Tümpel, 'Studien zur Ikonographie der Historien Rembrandts. Deutung und Interpretation der Bildinhalte', *Nederlands Kunsthistorisch Jaarboek*, vol.20, 1969, pp.107–98

TÜMPEL 1970
C. Tümpel, with A. Tümpel, *Rembrandt legt die Bibel aus: Zeichnungen und Radierungen aus dem Kupferstichkabinett der Staatlichen Museen Preussischer Kulturbesitz, Kupferstichkabinett*, Berlin, 1970

TÜMPEL 1971
C. Tümpel, 'Ikonographische Beiträge zu Rembrandt: Zur Deutung und Interpretation einzelner Werke II', *Jahrbuch der Hamburger Kunstsammlungen* 16, 1971, pp.20–38

TÜMPEL 1973
C. Tümpel, 'Beobachtungen zur "Nachtwache"', in O. von Simson, J. Kelch (eds.), *Neue Beiträge zur Rembrandt-Forschung: Rembrandt Kongress 1969*, Berlin, 1973, pp.162–75

TÜMPEL 1986
C. Tümpel, *Rembrandt*, Antwerp, 1986

TÜMPEL 1993
C. Tümpel, *Rembrandt: All Paintings in Colour*, second edition, Antwerp, 1993

TURNER/HENDRIX 1997
N. Turner and L. Hendrix, *Masterpieces of the J. Paul Getty Museum. Drawings*, London, 1997

UTRECHT 1993
P. van den Brink (ed.), *Het gedroomde land. Pastorale schilderkunst in de Gouden Eeuw*, Centraal Museum, Utrecht, 1993

UTRECHT/BRAUNSCHWEIG 1986–7
A. Blankert and L.J. Slatkes, et al., *Nieuw licht op de Gouden Eeuw: Hendrick ter Brugghen en tijdgenoten*, Centraal Museum, Utrecht; Herzog Anton Ulrich-Museum, Braunschweig, 1986

VALENTINER 1905
W.R. Valentiner, *Rembrandt und seine Umgebung*, Strassburg, 1905

VALENTINER 1908
W.R. Valentiner, *Rembrandt: Des Meisters Gemälde*, Klassiker der Kunst in Gesamtausgaben, Stuttgart, 1908

VALENTINER 1924–35
W.R. Valentiner, *Rembrandt: Des Meisters Handzeichnungen*, Klassiker der Kunst in Gesamtausgaben, 2 vols., Stuttgart, 1924–35

VALENTINER 1948
W.R. Valentiner, 'Rembrandt's Conception of Historical Portraiture', *The Art Quarterly*, vol.11, no.2, Spring 1948, pp.117–35

VASARI 1568 (1996 ED.)
G. Vasari, *Le vite de' piú eccelenti pittori, scultori ed architettori (1568)*, trans. G. du C. de Vere with introduction by D. Ekserdijian, 2 vols., London, 1996

VELDMAN 1986
I.M. Veldman, 'Lessons for ladies: a selection of sixteenth and seventeenth-century Dutch prints', *Simiolus*, vol.16, 1986, pp.113–27

VIENNA 1969
E. Mitsch, *Die Rembrandt-Zeichnungen der Albertina*, Graphische Sammlung Albertina, Vienna, 1969

VIENNA/AMSTERDAM 1989–90
Begegnungen, Ontmoetingen, Graphische Sammlung Albertina, Vienna; Rijksprentenkabinet, Rijksmuseum, Amsterdam, 1989-90

DE VILLE 1628
I. de Ville, *T' samen-spreeckinghe, Betreffende de Architecture ende Schilder-konst*, Gouda, 1628

VIS 1965
D. Vis, *Rembrandt en Geertje Dircx: De identiteit van Frans Hals' portret van een schilder en de vrouw van de kunstenaar*, Haarlem, 1965

VIS 1996
G.N.M. Vis, *Van 'vulliscuyl' tot huisvuilcentrale. Vuilnis en afval en hun verwerking in Alkmaar en omgeving van de middeleeuwen tot heden*, Hilversum, 1996

VISSER AND VAN DER PLAAT 1995
J. Visser and G.N. van der Plaat (eds.), *Gloria Parendi, Dagboeken van Willem Frederik stadhouder van Friesland, Groningen en Drenthe 1643-1649, 1651-1654*, The Hague, 1995

VLIEGHE 1987
H. Vlieghe, *Rubens portraits of identified sitters painted in Antwerp*, Corpus Rubenianum Ludwig Burckhard, vol.19, London, 1987

VONDEL 1927
J. van den Vondel, *Hymnus of lofzangh vande Christelycke Ridder (1620)*, in *De werken van Vondel*, vol.1, J.F.M. Sterck et al. (eds.), Amsterdam, 1927, pp.447–58

VOSKUIL 1975
J.J. Voskuil, 'Van onderpand tot teken. De geschiedenis van de trouwring als beeld van functieverschuiving', *Volkskundig Bulletin* 1, 1975, pp.47–79

VOSS 1905
H. Voss, 'Rembrandt und Titian', *Repertorium für Kunstwissenschaft* 28, 1905, pp.120–3

DE VRIES 1989
L. de Vries, 'Tronies and Other Single Figured Netherlandish Paintings', *Leids Kunsthistorisch Jaarboek*, vol.VIII, 1989, pp.185–215

DE VRIES/TÓTH-UBBENS/FROENTJES 1978
A.B. de Vries, M. Tóth-Ubbens and W. Froentjes, *Rembrandt in de Mauritshuis*, Alphen a/d Rijn, 1978

WAAGEN 1854
G. Waagen, *Treasures of Art in Great Britain: Being an Account of the Chief Collections of Paintings, Drawings, Sculptures, Illuminated MSS., &c &c (1854)*, 4 vols. (including 1857 supplement), London, 1970

VAN DER WAALS 1987
F.W. van der Waals, 'Doorbraken in de verloskunde', in *Een kind onder het hart. Verloskunde, volksgeloof, gezin, seksualiteit en moraal vroeger en nu*, R.E. Kistemaker (ed.), Amsterdam, 1987, pp.13–56

WASHINGTON 1985
G. Jackson-Stops (ed.), *The Treasure Houses of Britain – Five Hundred Years of Private Patronage and Art Collecting*, National Gallery of Art, Washington DC, 1985

WASHINGTON/AMSTERDAM 1996–7
H. Perry Chapman, W.T. Klock, A.K. Wheelock Jr. et al., *Jan Steen, Painter and Storyteller*, National Gallery of Art, Washington; Rijksmuseum, Amsterdam, 1996-7

WASHINGTON/DETROIT/AMSTERDAM
1980–1
A. Blankert et al., *Gods, Saints & Heroes: Dutch Painting in the Age of Rembrandt*, National Gallery of Art, Washington DC; Detroit Institute of Arts; Rijksmuseum, Amsterdam, 1980–1

WASHINGTON/LONDON/HAARLEM
1989–90
S. Slive et al., *Frans Hals*, National Gallery of Art, Washington DC; Royal Academy of Arts, London; Frans Halsmuseum, Haarlem, 1989–90

WASHINGTON/LONDON/THE HAGUE
2000–1
R. Baer, A.K. Wheelock Jr. and A. Boersman, *Gerrit Dou 1613–1675. Master Painter in the Age of Rembrandt*, National Gallery of Art, Washington DC; Dulwich Picture Gallery, London; The Mauritshuis, The Hague, 2000–1

WASHINGTON/LOS ANGELES 1985–6
Collection for a King: Old Master Paintings from Dulwich Picture Gallery, National Gallery of Art, Washington; Los Angeles County Museum of Art, 1985–6

WEGNER 1973
W. Wegner, *Die Niederländischen Handzeichnungen des 15.-18. Jahrhunderts, Kataloge der Staatlichen Graphischen Sammlung München*, 2 vols., Berlin, 1973

VAN DE WETERING 1976–7
E. van de Wetering, 'Leidse schilders achter de ezels', in LEIDEN 1976–7, pp.21–31

VAN DE WETERING 1982
E. van de Wetering, 'Painting materials and working methods', *Corpus*, vol.1, pp.11–33

VAN DE WETERING 1986
E. van de Wetering, 'Problems of apprenticeship and studio collaboration', *Corpus*, vol.2, pp.45–90

VAN DE WETERING 1991–2
E. van de Wetering, 'De symbiose van Lievens en Rembrandt', in LEIDEN 1991–2, pp.39–47

VAN DE WETERING 1995
E. van de Wetering, 'Rembrandt's "Satire on Art Criticism" reconsidered', in *Shop Talk: Studies in Honor of Seymour Slive, Presented on his Seventy-Fifth Birthday*, Cambridge, Mass., 1995, pp.264–70

VAN DE WETERING 1997
E. van de Wetering, *Rembrandt: The Painter at Work*, Amsterdam, 1997

WETHEY 1975
H.E. Wethey, *The Paintings of Titian: Complete Edition*, 3 vols., London, 1975

WEYERMAN 1729–69
J.C. Weyerman, *De levens-beschryvingen der Nederlandsche konst-schilders en konst-schilderessen, met een uytbreyding over de schilder-konst der ouden*, 4 vols., The Hague/Dordrecht, 1729–69

WHEELOCK 1995
A.K. Wheelock Jr., *Dutch Paintings of the Seventeenth Century (The Collections of the National Gallery of Art. Systematic Catalogue)*, Washington/New York/Oxford, 1995

WHITE 1969
C. White, *Rembrandt as an Etcher: A Study of the Artist at Work*, 2 vols., London, 1969

WHITE 1982
C. White, *The Dutch Pictures in the Collection of Her Majesty The Queen*, Cambridge, 1982

WHITE 1984
C. White, *Rembrandt*, London, 1984

WHITE 1994
C. White, review of TÜMPEL 1993, *The Burlington Magazine*, vol.136, no.1100, November 1994, p.767

WHITE 1999
C. White, *Rembrandt as an Etcher, A Study of the Artist at Work*, second edition, New Haven/London, 1999

WHITE/BOON
C. White and K.G. Boon, *Rembrandt's Etchings: An illustrated critical catalogue in two volumes (Hollstein's Dutch and Flemish Etchings, Engravings and Woodcuts, vols.18–19)*, Amsterdam/London/New York, 1969

WIJNMAN 1959
H.F. Wijnman, 'Rembrandt als huisgenoot van Hendrick Uylenburgh te Amsterdam (1631–1635): Was Rembrandt doopsgezind of libertijn?', in *Uit de kring van Rembrandt en Vondel: Verzamelde studies over hun leven en omgeving*, Amsterdam, 1959, pp.1–18

WIJNMAN 1968
H.F. Wijnman, 'Een episode uit het leven van Rembrandt: de geschiedenis van Geertje Dircks', *Jaarboek van het genootschap Amstelodamum* 60, 1968, pp.103–18

DE WILDT 1995
A. de Wildt, '"Wijckt oudt cout vel, al sijt ghij rijcke". Oude vrouwen en mannen in taferelen van ongelijke liefde', in *Lange levens, stille getuigen. Oudere vrouwen in het verleden*, M. Stavenuiter et al. (eds.), Zutphen, 1995, pp.22–37

DE WINKEL 1993
M. de Winkel, *Het kostuum bij Rembrandt*, M.A. thesis, University of Amsterdam, 1993

DE WINKEL 1995
M. de Winkel, '"Eene der deftigsten dragten": The Iconography of the "Tabbaard" and the Sense of Tradition in Dutch Seventeenth-century Portraiture', *Nederlands Kunsthistorisch Jaarboek* 46, 1995 (*Beeld en Zelfbeeld in de Nederlandse kunst, 1550–1750*), pp.145–67

DE WINKEL 1998
M. de Winkel, 'The Interpretation of Dress in Vermeer's Paintings', in *Vermeer. Studies in the History of Art 55, Center for Advanced Study in the Visual Arts, National Gallery Washington*, New Haven/London, 1998, pp.327–40

WNT
M. de Vries and L.A. te Winkel (et. al.), *Woordenboek der Nederlandsche Taal*, 29 vols., The Hague/Leiden, 1864–1998

WORP 1911
J.A. Worp, *De briefwisseling van Constantijn Huygens (1608–1687)*, 6 vols., The Hague, 1911–17

WURZBACH 1876
A. von Wurzbach, 'Ein deklariertes Porträt der Saskia', *Zeitschrift für bildende Kunst* 11, 1876, p.287

YAMAGUCHI 1994
Y. Kobayashi-Sato, 'The Portrait and the *Tronie* as Seen in the Art of Rembrandt', in E. de Jongh et al., *Faces of the Golden Age: Seventeenth-Century Dutch Portraits*, Yamaguchi Kenritsu Bijutsukan, Yamaguchi etc., 1994, pp.11–17

YOKOHAMA/FUKUOKA/KYOTO 1986–7
C. Brown, E. Haverkamp-Begemann and C. White, *Rembrandt and the Bible*, Sogo Museum of Art, Yokohama; Fukuoka Art Museum, Fukuoka; National Museum of Modern Art, Kyoto, 1986–7

ZANDER-SEIDEL 1990
J. Zander-Seidel, *Textiler Hausrat. Kleidung und Haustextilien in Nürnberg von 1500–1650*, Munich, 1990

Royal Academy of Arts, London

The Honorable and Mrs Eugene Johnston
Mr William W Karatz
Mr Gary A Kraut
Mrs John P McGrath
Ms Elizabeth McHugh-Kahn
Mrs Mark Millard
Mrs Anne Miller
Mrs Barbara T Missett
Mr Paul D Myers
Mr and Mrs Wilson Nolen
Mrs Richard D O'Connor
Mr and Mrs Jeffrey Pettit
Mr Robert S Pirie
Mrs Rochelle W Prather
Mrs Nanette Ross
Mr and Mrs Derald H Ruttenberg
Mrs Frances G Scaife
Ms Jan Blaustein Scholes
Mr and Mrs Stanley D Scott
Mr James Sollins
Mrs Frederick M Stafford
Mr and Mrs Stephen Stamas
Ms Brenda Neubauer Straus
Mr Arthur O Sulzberger and Ms Alison S Cowles
Ms Britt Tidelius
Ms Sue E Van de Bovenkamp
Mrs Vincent S Villard Jr
Mr and Mrs Stanford Warshawsky
Mrs Sara E White
Dr and Mrs Robert D Wickham
Mr Robert W Wilson
Mr and Mrs Kenneth Woodcock
and others who wish to remain anonymous

Friends of the Royal Academy

PATRON FRIENDS

Mrs Meg Allen
Mrs Elizabeth S Alston
Mr Z Aram
Mr Paul Baines
Mrs Yvonne Barlow
Mr P F J Bennett
Mr and Mrs Sidney Corob
Mrs S Dawson
Mr David Duncan
Mr Michael Godbee
Dr and Mrs Alan J Horan
Mr David Ker
Mrs Joyce Lacerte
Dr C McFadden
Dr Abraham Marcus
Mrs Maureen D Metcalfe
Mr R J Mullis
Mr and Mrs David Peacock
Mr and Mrs Derald H Ruttenberg
Mrs C A Sellars
Mr Alan K Simpson
Mr Nigel J Stapleton
Mr Robin Symes
Mr J A Tackaberry
Mrs K L Troughton
Mr and Mrs Timothy Vignoles
Mrs Cynthia H Walton
Mrs Roger Waters
The Hon Mrs Simon Weinstock
Mrs I Wolstenholme
and others who wish to remain anonymous

SUPPORTING FRIENDS

Mr Richard B Allan
Mr Peter Allinson
Mr Ian Anstruther
Mr Brian A Bailey
Mr Keith G Bennett
Mrs Susan Besser

Mrs C W T Blackwell
Mrs J M Bracegirdle
Mr Cornelius Broere
Mrs Jean Burton
Mrs Anne Cadbury OBE JP DL
Miss E M Cassin
Mr R A Cernis
Mr S Chapman
Mr and Mrs John Cleese
Mrs D H Costopoulos
Mr and Mrs Chris Cotton
Mrs M F Coward
Mrs Nadine Crichton
Mrs Saeda H Dalloul
Mr Julian R Darley
Mrs Belinda Davie
Mr John Denham
Miss N J Dhanani
The Marquess of Douro
Mrs Nicholas Embiricos
Jack and Irene Finkler
Mrs R H Goddard
Mrs D Goodsell
Mr R Gow
Mr Gavin Graham
Lady Grant
Mrs Richard Grogan
Miss Susan Harris
Mr Malcolm P Herring
Mr R J Hoare
Mr Charles Howard
Mrs Manya Igel
Mr S Isern-Feliu
Mrs Jane Jason
Mrs G R Jeffries
Mr Roger A Jennings
Mr Harold Joels
Mr and Mrs S D Kahan
Mrs P Keely
Mr and Mrs J Kessler
Mr N R Killick
Mrs L Kosta
Mrs Carol Kroch
Mrs Joan Lavender
Mr and Mrs David Leathers
Mr Owen Luder CBE PRIBA FRSA
Mrs Gillian M S McIntosh
Miss Julia MacRae
Mr Donald A Main
Lord Marks of Broughton
Mr J B H Martin
Mr R T Miles
Mr J Moores
Mrs A Morgan
R Naylor and C Boddington
Mrs Elizabeth M Newell
Miss Kim Nicholson
Mrs E M Oppenheim Sandelson
Mr Robert Linn Ottley
Mr Brian Oury
Mrs Anne Phillips
Mr Ralph Picken
Mr D B E Pike
Mr Benjamin Pritchett-Brown
Mrs Elizabeth Ridley
Mr F Peter Robinson
Mr D S Rocklin
Mrs A Rodman
Mr and Mrs O Roux
Dr Susan Saga
Lady Sainsbury
The Rt Hon Sir Timothy Sainsbury
Mrs Susanne Salmanowitz
Dr I B Schulenburg
Mrs D Scott
Mrs E D Sellick
Mr and Mrs Richard Seymour
Mr R J Simmons CBE
Mr P W Simon

Mr John H M Sims
Miss L M Slattery
Dr and Mrs M L Slotover
Mrs P Spanoghe
Professor Philip Stott
Mr James Stuart
Mrs J A Tapley
Mrs Andrew Trollope
Mr W N Trotter
Mr and Mrs Ludovic de Walden
Miss J Waterous
Mrs Claire Weldon
Mr Frank S Wenstrom
Mrs Sheree D Whatley
Mr David Wilson
Mr W M Wood
Mr R M Woodhouse
and others who wish to remain anonymous

Corporate Membership of the Royal Academy of Arts

Launched in 1988, the Royal Academy's Corporate Membership Scheme has proved highly successful. With 104 members it is now the largest membership scheme in Europe. Corporate membership offers company benefits to staff and clients and access to the Academy's facilities and resources. Each member pays an annual subscription to be a Member (£7,000) or Patron (£20,000). Participating companies recognise the importance of promoting the visual arts. Their support is vital to the continuing success of the Academy.

Corporate Membership Scheme

CORPORATE PATRONS

Arthur Andersen
Bloomberg LP
BNP Paribas
BP Amoco p.l.c.
Debenhams Retail plc
Deutsche Bank AG
The Economist Group
Ernst and Young
GE Group
GlaxoSmithKline plc
Granada Media
Merrill Lynch
Morgan Stanley International
Royal & Sun Alliance

HONORARY CORPORATE PATRON

Credit Suisse First Boston

CORPORATE MEMBERS

Apax Partners & Co. Ltd.
Athenaeum Hotel
Aukett Europe
AXA UK plc
Bacon and Woodrow
Bank of America
Barclays plc
Bartlett Merton Ltd
Bass PLC
Bear, Stearns International Ltd
BG plc
The Boston Consulting Group
Bovis Lend Lease Limited
British Alcan Aluminium plc
The British Land Company PLC

BT plc
Bunzl plc
Cazenove & Co
CB Hillier Parker
Chase Fleming Asset Management
Christie's
Chubb Insurance Company of Europe
CJA (Management Recruitment Consultants) Limited
Clayton Dubilier & Rice Limited
Clifford Chance
Colefax and Fowler Group
Consultivity
Cookson Group plc
Credit Agricole Indosuez
De Beers
Diageo plc
Dresdner Kleinwort Benson
Eversheds
Foreign & Colonial Management plc
Gartmore Investment Management plc
Goldman Sachs International
Heidrick & Struggles
H J Heinz Company Limited
HSBC plc
ICI
John Lewis Partnership
J Sainsbury plc
King Sturge
KPMG
Lex Service PLC
Linklaters & Alliance
Macfarlanes
Man Group plc
marchFIRST
Marconi Ltd
McKinsey & Co.
MoMart Ltd
Newton Investment Management Ltd
Old Mutual Asset Managers
Ove Arup Partnership
Pearson plc
The Peninsular and Oriental Steam Navigation Company
Pentland Group plc
Provident Financial plc
Raytheon Systems Limited
Reed Elsevier (UK) Limited
Rowe & Maw
The Royal Bank of Scotland
Schroder Salomon Smith Barney
Schroders Investment Management Limited
Sea Containers Ltd.
SG
Skanska Construction Group Limited
Slaughter and May
SmithKline Beecham
Smiths Group plc
The Smith & Williamson Group
Sotheby's
Strutt & Parker
Telegraph Group Limited
Tiffany & Co.
Travelex
Trowers & Hamlins
Unilever UK Limited
UPC Services
Whithead Mann GKR Ltd

HONORARY CORPORATE MEMBERS

All Nippon Airways Co. Ltd
A.T. Kearney Limited
Cantor Fitzgerald
London First
Reuters Limited
Sony UK Limited
Yakult UK Limited

Sponsors of Past Exhibitions

The President and Council of the Royal Academy thank sponsors of past exhibitions for their support. Sponsors of major exhibitions during the last ten years have included the following:

Allied Trust Bank
Africa: The Art of a Continent, 1995*
Anglo American Corporation of South Africa
Africa: The Art of a Continent, 1995*
A.T. Kearney
Summer Exhibition 1999
Summer Exhibition 2000
The Banque Indosuez Group
Pissarro: The Impressionist and the City, 1993
Barclays
Ingres to Matisse: The Triumph of French Painting, 2001
BBC Radio One
The Pop Art Show, 1991
BMW (GB) Limited
Georges Rouault: The Early Years, 1903–1920. 1993
David Hockney: A Drawing Retrospective, 1995*
British Airways Plc
Africa: The Art of a Continent, 1995
BT
Hokusai, 1991
Cantor Fitzgerald
From Manet to Gauguin: Masterpieces from Swiss Private Collections, 1995
1900: Art at the Crossroads, 2000
The Capital Group Companies
Drawings from the J Paul Getty Museum, 1993
Chase Fleming Asset Management
The Scottish Colourists 1900–1930. 2000
Chilstone Garden Ornaments
The Palladian Revival: Lord Burlington and His House and Garden at Chiswick, 1995
Christie's
Frederic Leighton 1830–1896. 1996
Sensation: Young British Artists from The Saatchi Collection, 1997
Classic FM
Goya: Truth and Fantasy, The Small Paintings, 1994
The Glory of Venice: Art in the Eighteenth Century, 1994
Corporation of London
Living Bridges, 1996
Country Life
John Soane, Architect: Master of Space and Light, 1999
Credit Suisse First Boston
The Genius of Rome 1592–1623. 2000
The Dai-Ichi Kangyo Bank Limited
222nd Summer Exhibition, 1990
The Daily Telegraph
American Art in the 20th Century, 1993
1900: Art at the Crossroads, 2000
De Beers
Africa: The Art of a Continent, 1995
Debenhams Retail plc
Premiums and RA Schools Show, 1999
Premiums and RA Schools Show, 2000
Deutsche Morgan Grenfell
Africa: The Art of a Continent, 1995
Diageo plc
230th Summer Exhibition, 1998
Digital Equipment Corporation
Monet in the '90s: The Series Paintings, 1990

The Drue Heinz Trust
The Palladian Revival: Lord Burlington and His House and Garden at Chiswick, 1995
Denys Lasdun, 1997
Tadao Ando: Master of Minimalism, 1998
The Dupont Company
American Art in the 20th Century, 1993
Edwardian Hotels
The Edwardians and After: Paintings and Sculpture from the Royal Academy's Collection, 1900–1950. 1990
Elf
Alfred Sisley, 1992
Ernst & Young
Monet in the 20th Century, 1999
eyestorm
Apocalypse: Beauty and Horror in Contemporary Art, 2000
Fondation Elf
Alfred Sisley, 1992
Ford Motor Company Limited
The Fauve Landscape: Matisse, Derain, Braque and Their Circle, 1991
Friends of the Royal Academy
Victorian Fairy Painting, 1997
Game International Limited
Forty Years in Print: The Curwen Studio and Royal Academicians, 2001
The Jacqueline and Michael Gee Charitable Trust
LIFE? or THEATRE? The Work of Charlotte Salomon, 1999
Générale des Eaux Group
Living Bridges, 1996
Glaxo Wellcome plc
Great Impressionist and other Master Paintings from the Emil G Buhrle Collection, Zurich, 1991
The Unknown Modigliani, 1994
Goldman Sachs International
Alberto Giacometti, 1901–1966. 1996
Picasso: Painter and Sculptor in Clay, 1998
The Guardian
The Unknown Modigliani, 1994
Guinness PLC (see Diageo plc)
223rd Summer Exhibition, 1991
224th Summer Exhibition, 1992
225th Summer Exhibition, 1993
226th Summer Exhibition, 1994
227th Summer Exhibition, 1995
228th Summer Exhibition, 1996
229th Summer Exhibition, 1997
Guinness Peat Aviation
Alexander Calder, 1992
Harpers & Queen
Georges Rouault: The Early Years, 1903–1920. 1993
Sandra Blow, 1994
David Hockney: A Drawing Retrospective, 1995*
Roger de Grey, 1996
The Headley Trust
Denys Lasdun, 1997
The Henry Moore Foundation
Alexander Calder, 1992
Africa: The Art of a Continent, 1995
Ibstock Building Products Ltd
John Soane, Architect: Master of Space and Light, 1999
The Independent
The Pop Art Show, 1991
Living Bridges, 1996
Apocalypse: Beauty and Horror in Contemporary Art, 2000
Industrial Bank of Japan, Limited
Hokusai, 1991
Donald and Jeanne Kahn
John Hoyland, 1999

Land Securities PLC
Denys Lasdun, 1997
The Mail on Sunday
Royal Academy Summer Season, 1992
Royal Academy Summer Season, 1993
Marks & Spencer
Royal Academy Schools Premiums, 1994
Royal Academy Schools Final Year Show, 1994*
Martini & Rossi Ltd
The Great Age of British Watercolours, 1750–1880. 1993
Paul Mellon KBE
The Great Age of British Watercolours, 1750–1880. 1993
Mercury Communications
The Pop Art Show, 1991
Merrill Lynch
American Art in the 20th Century, 1993*
Midland Bank plc
RA Outreach Programme, 1992–1996
Lessons in Life, 1994
Minorco
Africa: The Art of a Continent, 1995
Mitsubishi Estate Company UK Limited
Sir Christopher Wren and the Making of St Paul's, 1991
Natwest Group
Nicolas Poussin 1594–1665. 1995
The Nippon Foundation
Hiroshige: Images of Mist, Rain, Moon and Snow, 1997
Olivetti
Andrea Mantegna, 1992
Park Tower Realty Corporation
Sir Christopher Wren and the Making of St Paul's, 1991
Peterborough United Football Club
Art Treasures of England: The Regional Collections, 1997
Premiercare (National Westminster Insurance Services)
Roger de Grey, 1996*
RA Exhibition Patrons Group
Chagall: Love and the Stage, 1998
Kandinsky, 1999
Chardin 1699–1779. 2000
Botticelli's Dante: The Drawings for The Divine Comedy, 2001
Redab (UK) Ltd
Wisdom and Compassion: The Sacred Art of Tibet, 1992
Reed Elsevier plc
Van Dyck 1599–1641. 1999
Reed International plc
Sir Christopher Wren and the Making of St Paul's, 1991
Republic National Bank of New York
Sickert: Paintings, 1992
The Royal Bank of Scotland
Braque: The Late Works, 1997*
Premiums, 1997
Premiums, 1998
Premiums, 1999
Royal Academy Schools Final Year Show, 1996
Royal Academy Schools Final Year Show, 1997
Royal Academy Schools Final Year Show, 1998
The Sara Lee Foundation
Odilon Redon: Dreams and Visions, 1995
Sea Containers Ltd
The Glory of Venice: Art in the Eighteenth Century, 1994

Silhouette Eyewear
Wisdom and Compassion: The Sacred Art of Tibet, 1992
Sandra Blow, 1994
Africa: The Art of a Continent, 1995
Société Générale, UK
Gustave Caillebotte: The Unknown Impressionist, 1996*
Société Générale de Belgique
Impressionism to Symbolism: The Belgian Avant-Garde 1880–1900. 1994
Spero Communications
Royal Academy Schools Final Year Show, 1992
Texaco
Selections from the Royal Academy's Private Collection, 1991
Thames Water Plc
Thames Water Habitable Bridge Competition, 1996
The Times
Wisdom and Compassion: The Sacred Art of Tibet, 1992
Drawings from the J Paul Getty Museum, 1993
Goya: Truth and Fantasy, The Small Paintings, 1994
Africa: The Art of a Continent, 1995
Time Out
Sensation: Young British Artists from The Saatchi Collection, 1997
Apocalypse: Beauty and Horror in Contemporary Art, 2000
Tractabel
Impressionism to Symbolism: The Belgian Avant-Garde 1880–1900. 1994
Union Minière
Impressionism to Symbolism: The Belgian Avant-Garde 1880–1900. 1994
Vistech International Ltd
Wisdom and Compassion: The Sacred Art of Tibet, 1992
Yakult UK Ltd
RA Outreach Programme, 1997–2000*
alive: Life Drawings from the Royal Academy of Arts & Yakult Outreach Programme, 2000

* Recipients of a Pairing Scheme Award, managed by Arts + Business. Arts + Business is funded by the Arts Council of England and the Department for Culture, Media and Sport.

OTHER SPONSORS

Sponsors of events, publications and other items in the past five years:

Country Life
Dolce & Gabbana
Foster and Partners
Goldman Sachs International
IBJ International plc
John Doyle Construction
Michael Hopkins & Partners
Morgan Stanley Dean Witter
Prada
Richard and Ruth Rogers
Strutt & Parker